CONTENTS

First I must thank Carol McNicoll who I met in 1981 and who introduced me to craftswomen and men of her generation and made me realise that the history of twentieth-century art and design should encompass the crafts. Martina Margetts helped this process of learning by giving me the opportunity to write on a wide range of topics in *Crafts* magazine. My thanks to Geraldine Rudge, the present editor, for also allowing me to write as I pleased. Eileen Lewenstein showed me Michael Cardew's draft manuscript autobiography and made me realise the complexities of writing a history of the craft movement. I want to thank Julia Mount for introducing me to the Arts pages of *The Spectator* and to my editor there, Jenny Naipaul, who gave me a column boldly headed *Crafts*, and who was unfailingly encouraging. Tom Sutcliffe and Michael Church on *The Independent* and *The Independent on Sunday* also gave me opportunities to reach a wider public.

During the course of writing this book Ewan Clayton, Margot Coatts, Peter Cormack, Nicola Gordon Bowe, Mary Greensted, Ann Hechle, Susan Haskins, Wendy Kaplan, Robin Kinross, Jen Lindsay, the late Norman Potter and Alan Powers read parts of the manuscript and made helpful suggestions. A Visiting Fellowship at UEA under the auspices of Eastern Arts helped shape my thinking. Alison McFarlane, Veronica Sekules, Victoria Mitchell and Stefan Muthesius were all a support at that time. I have benefited from discussions with June Freeman, Abigail Frost, Malcolm Haslam, John Houston, Mike Hughes, Rosemary Hill, Bill Ismay, Pamela Johnson, John Keatley, Henry Rothschild, Ralph Turner, Moira Vincentelli, Edmund de Waal, David Whiting and Tim Wilcox. The late Peter Dormer was a constant support. Jacqui Sarsby gave me a fuller understanding of the crafts in the Cotswolds. The work of Oliver Watson and Yuko Kichuki was an inspiration. Elizabeth Cumming gave me insights into the crafts in Scotland. Tim Hilton gave me invaluable advice.

The Crafts Study Centre at the Holburne Museum, Bath was a home from home for several months. Barley Roscoe has my thanks. Jill Betts at the Rural History Centre at the University of Reading was extremely generous with her time and knowledge. The staff of the National Art Library and the Archive of Art and Design have been unfailingly helpful. Jennifer Harris of the Whitworth Museum made Margaret Pilkington's papers available. Her exhibition *William Morris: Questioning the Legacy* helped me shape my ideas about the transition from the Arts and Crafts Movement to a twentieth-century crafts movement.

A summer at Wenford Bridge reading Michael Cardew's letters was crucial to my research and I would like to thank Seth Cardew. Rosalind Richards let me study her father Rolf Gardiner's photograph albums and showed me Springhead. David Beasley and Victoria Lane made me welcome in Goldsmiths' Company Library and shared their expertise with me. Maggie Giraud at Dartington Hall was the most welcoming of archivists. Christian Barnes at Abbot Hall Art Gallery, Kendal was helpful in difficult circumstances. Catherine Moriarty and Lesley Whitworth made research at the Design Council Archive at the University of Brighton a pleasure. Vanda Foster at Pitshanger Manor and Jane Kidd of Paisley Museums and Art Galleries were helpful beyond the call of duty. Diana Eccles at the British Council provided useful leads. Robert Elwall at the RIBA introduced me to important collections of photographs. Stewart Drew at the Crafts Council was a patient guide to their archive of images while Anne French and John Whiddett helped with endless enquiries. The photographers John

Donat, Peter Kinnear and Irene Winsby were generous with their files and their time. David Cripps and Phil Sayer provided some of the most striking images in the book. My son Hugo Harrod provided sustained assistance with picture research and Ziella Bryars helped with the index. Eleanor Fletcher was an efficient research assistant at an earlier stage.

I want to thank the Society of Authors for a grant at an early stage of work on the project. The Director of the Crafts Council, Tony Ford, was always sympathetic and interested, and the Crafts Council helped to make the book possible with a generous grant to my publishers. I am delighted that the Bard Graduate Center for Studies in the Decorative Arts, New York, should have chosen to include this book in their series on the decorative arts.

Conversations with many artists and makers helped me to write this book but I must especially mention the late Peggy Angus, Ian Auld, Hilary Bourne, Ralph Beyer, Alison Britton, Michael Casson, Kenneth Clark, Bill and Geoffrey Clarke, Peter Collingwood, Emmanuel Cooper, Ruth Duckworth, Murray Fieldhouse, Gerda Flöckinger, Patrick Heron, Constance Howard, the late David Kindersley and Lida Cardozo Kindersley, David Leach, the late Janet Leach, Mary Little, John Makepeace, Ella McLeod, Gwen and Barbara Mullins, Dicon Nance, the late William Newland, Colin Pearson, Patrick Reyntiens, the late Marianne Straub, Ann Sutton, Caroline Swash, Margaret Traherne and Robert Welch. Invaluable advice at the proof stage was generously given by Robin Kinross and Carol McNicoll.

Finally, I must thank John Nicoll at Yale University Press for his commitment and enthusiasm and Sally Salvesen for editing and designing the book with such care.

During a period of doubt Alan Crawford provided generous constructive advice; without his encouragement this book would never have been completed. My dear friend Azam Torab and my sister Fiona Ledger listened and discussed, laughed and encouraged. My husband Henry and my children Hugo and Horatia were always good-humoured and loving about a project which must have seemed endless.

This book begins with an ending. The crafts movement in England in this century has an apparently obvious ancestry. William Morris and the Arts and Crafts Movement tower over any discussion of modern handwork. Morris's career got under way in the 1860s; the Arts and Crafts Movement was given a name and a public identity with the founding of the Arts and Crafts Exhibition Society in 1888. Morris and the men and women in the Movement left behind a powerful set of buildings, objects and interiors together with an important body of writing. But by the time of the First World War, it is invariably argued, the Movement had lost its way and its energies had become depleted.

This moment of ending is explored in the first chapter. I take issue with the narrative of design historians who concentrate on the Arts and Crafts Movement at its internationally admired height in the 1880s and 1890s, and then shift their attention to industrial design and mass production in Germany, Central Europe and Scandinavia in the early twentieth century, as if England had no more to offer. The ending is also a beginning. A second history of English craft, which is the subject of this book, examines a less familiar, twentieth-century craft movement which was both modern and anti-modern, which embraced a whole range of notions about handwork and design, and which continues as an identifiable constituency up to the present day.

Chapter One also takes issue with the idea that the Arts and Crafts Movement suddenly failed or went away. Around 1916, paradoxically, there were thoughts of new beginnings in which industry would be comprehensively rejected or the English would learn lessons from the 'enemy' and catch up with the German design reform movements. The cataclysm of the First World War, so often invoked by historians to mark the demise of the Arts and Crafts Movement, actually seemed to provoke it into new life. I have chosen to capitalise on this complexity and paradox, treating Chapter One as a series of sketches which deal with notions of the crafts from the death of Morris until the end of the First World War.

Firstly there is William Morris himself, bustling, contradictory and ubiquitous. Then there is his 'legacy' which includes the Arts and Crafts Movement, its Exhibition Society and its Art Workers' Guild and a host of smaller groupings. By 1910 there were some sharply written critiques of the Movement, both from within the world of making and from the wider worlds of economics and sociology. By 1915 the founding of the Design and Industries Association (DIA) and the redefinition of a craft workshop in the shape of Roger Fry's Omega suggest an increasing fragmentation. For instance, the members of the DIA loved simple, well-made things, but were committed to design for manufacture. Fry, on the other hand, had a horror of mass-produced goods, but his Omega Workshop products flouted most of the procedures and processes associated with good handwork.

These kinds of paradoxes raise the question of definition. What should a book on twentieth-century British craft set out to encompass? I hope that by the end of the book readers will have a very full sense of what the crafts are, but I don't set out to define them; although I do write a good deal about *other* people's attempts to do so. The process of defining is a part of the history of the twentieth-century crafts movement and continues to be so. In order to make craft persuasive and meaningful in the twentieth century, worthy of funding and of the interest

of private and public collectors and patrons, both writers and practitioners have sought to create boundaries, arguing over the definition of handmade, examining why objects of craft are different from fine art or design or why they are just as important and should be seen as part of a continuum embracing all the visual arts. Status is an important factor here. Definition can confer status - as when Leonardo da Vinci in his *paragone* writings explains what painting *is* in order to demonstrate its superiority to sculpture.

In my book I have — as it were — chosen to *watch* the crafts over the century, watch as the crafts have endlessly redefined themselves, and redefined their various practices in relation to fine art, design, modernism, education, patterns of consumption, class, politics and all sorts of currents in social and cultural history. I hope to demonstrate just how multivalent and constructed the idea of craft is. Ultimately, for me, it is this shifting identity which makes a study of contemporary crafts so absorbing.

What emerges as craft in the period I cover — roughly from 1916 up until the end of the 1980s — tends to mean 'made and designed by the same person'. But that of course could encompass painting and sculpture which is why my idea of what *might* be craft depends to a large extent on where people chose to exhibit their work — with, say, the Arts and Crafts Exhibition Society in the 1920s and 1930s. It depends on who wrote about individual work and where that writing appeared. The variousness of this in practice suggests something of the fragile identity of the crafts. For instance in the 1930s the potter Michael Cardew exhibited with the National Society of Painters, Sculptors, Engravers and Potters alongside sculptors like Leon Underwood and Barbara Hepworth. He sold at the New Handworkers' Gallery alongside other studio potters and furniture makers. And he gave demonstrations at agricultural shows and tried to design prototypes for industry at Stoke-on-Trent. And, yes, he did get confused about where he belonged.

Craft could encompass blind ex-servicemen making nets just after the First World War at the philanthropic workshops set up by the charity St Dunstan's, miners' wives in the Rhondda valley, South Wales making quilts under the aegis of the Rural Industries Bureau in the Depression of the late 1920s and hand block-printed textiles designed and made by Phyllis Barron for the Duke of Westminster's yacht *Flying Cloud* in the early 1920s. Any definition of craft could also take in lots of handwork in industry and surviving vernacular craft such as hurdle making or basketry. After the Second World War the situation becomes, if anything, more complex.

But this book begins by concentrating on a world of craft dominated by middle-class men and women who saw themselves as 'artist craftsmen' - a popular inter-war phrase applied to both sexes. It encompasses ceramics, weaving, hand block-printing of textiles, embroidery, stained glass, silversmithing, jewellery, bookbinding, lettercutting and calligraphy, some stone carving, furniture making. It could, therefore be argued that this is a book about the applied or decorative arts. Yes, but I do not use those terms much because they were not used by those involved, at least not until the 1980s when the word craft became a positive hindrance. Why this was so is something I explore at the end of the book.

The relationship between the crafts and modernism necessarily emerges as an important theme, especially in the inter-war sections of the book. Until recently it would have seemed absurd to consider the crafts in such a relationship. Craft activity was seen as a cultural cul-de-sac to most historians of design, fine art and architecture. Its almost essential connection with handwork seemed fundamentally at odds with modernism. But over the past ten years there have been many fresh readings of modernism. We might call them postmodern interpretations but perhaps it would be more accurate to see them as non-partisan attempts to cultivate a period eye.[1] For example, Peter Wollen identifies a decorative modernism in Paris circa 1910 centred on the Orientalism of Matisse, Paul Poiret and the Ballets Russes and sets it against the canonical histories of modern art which are dominated by analytical cubism.[2] Christopher Reed has discussed the marginalisation of the domestic in modern art and architecture and its negative effect on the reputation of the Bloomsbury Group of painters and the Omega Workshops.[3] Penny Sparke has analysed the masculinisation of modernism and the consequent

marginalisation of the home and the woman designer.[4] Pat Kirkham's biography of the husband and wife designers Charles and Ray Eames throws new light on the decorative and fantastical aspects of the work of these two designers.[5] Marshall Berman's wide ranging study of modernism and modernity has argued that, paradoxically, 'to be fully modern is to be anti-modern'.[6]

All these insights have a clear relevance for a history of the twentieth-century crafts. A pluralist approach explains why some craftsmen and women in the inter-war years, especially in the 1920s, clearly considered their activities to be modern. In fact, as I argue in Chapter Three, in the context of inter-war England it is possible to propose an alternative eclectic modernism, dominated by women designers and based on hand processes. This lost modernism hovers creatively between developments in fine art and in design. Activity in this 'third space' can be pieced together from objects and contemporary writing. Modernism was weak in some craft disciplines and strong in others. Nonetheless, how to be modern while remaining committed to hand processes was an issue that affected all the crafts and continues to do so.

What do I mean by modern? I use 'modern' and 'modernist' un-capitalised to indicate an allegiance to a set of under-theorised ideas associated with Roger Fry and Clive Bell's writings on pure form and their concomitant canon of greatness in art. The eclectic modernism of the inter-war British crafts movement was inspired by that set of values. Where I mention the Modern Movement I mean to indicate something more self-conscious and theorised with roots in Central European design and architecture. I also use the terms *art moderne* and *Art Déco* to indicate the kind of luxury style associated with the Paris 1925 *Exposition des Arts Décoratifs et Industriels Modernes*. Here I have to declare a bias. I tend to refer to the popularisation of *moderne* styles dismissively. In this I echo the voices of inter-war craftsmen and craftswomen who would have used terms like 'modernistic', 'Jazz' and 'pseudo-cubistic' to dismiss much commercial design inspired by *art moderne*. Thus although this book is not a polemic, it is shot through with sympathy for certain standards and aesthetics in which modernism remains an on-going and incomplete project.[7]

This is a book about the crafts in Britain. Nonetheless Scottish, Welsh and Northern Irish practitioners may feel that my coverage of their activities has been exiguous. Although I have tried in particular to characterise the crafts movement in Scotland, English questions are at the heart of the book. I have also tried to avoid imposing potted histories of international developments in craft, art and design on the reader. While I grant that much of British visual culture in the twentieth century has been embarassingly dependent upon developments in Europe and North America, I would argue that this is not altogether the case with the crafts. Obvious linkages like the impact of School of Paris painting on the crafts in the 1950s are indicated but, for example, the tendency of 1950s and 1960s craft furniture makers to imitate Scandinavian and North American design does not lead into a discussion of the influence of individual major designers like Ray and Charles Eames. The links are too diffuse and superficial to warrant such treatment. Indeed it is only possible to make sense of what occurred here by refraining from too much wistful reference to activities 'abroad'.

Finally, a word about distance. Part III of this book ends at the close of the 1980s. I had grave doubts about coming so close to the present. Even in the context of the crowded 1970s and 1980s this book cannot pretend to be all encompassing. The organisation of Part III therefore differs from Part I and Part II. The two decades covered in the last part of the book are better documented and crowded with work and practitioners. A craft-by-craft survey of individual makers who come to maturity in this period has not been attempted. Instead I have adopted an entirely thematic approach. To do otherwise would have required a separate volume. In my defence I would argue that this is not primarily a work of reference. It is, I hope, a book of ideas and arguments.

PART I

1916–1939

THE CRAFTS AROUND 1916

THE LEGACY OF WILLIAM MORRIS

It was difficult for English craftsmen and women in the early twentieth century to avoid the memory of William Morris. One way or another, they defined themselves against what he and his followers seemed to stand for. The best known of them, the potter and artist Bernard Leach, was nine years old when William Morris died in 1896. Morris belonged to the world of Leach's parents and grandparents. When Leach was an art student, getting to know the Chelsea art world and a member of Vanessa Bell's Bloomsbury discussion group, the Friday Club, the life and work of this visionary designer and socialist might have seemed an irrelevance. But in 1908 Leach learnt etching from Frank Brangwyn who had worked for Morris from 1882 to 1884, tracing and enlarging Morris's designs on point paper.[1] And from 1909, after Leach left London for Japan, Morris's designs and writings began to gain significance for him. In his early Japanese diaries he writes of forming a 'group on William Morris lines' for 'the combined necessary making of a living and the pursuit of art'.[2] In Japan his youthful, ardent friendship with the artist Kenkichi Tomimoto and the fledgling philosopher Soetsu Yanagi was reminiscent of Morris and the painter Edward Burne-Jones' enthusiasm for art and ideals at Oxford and at Red Lion Square in the 1850s. In Japan Leach had furniture made to his own design and a series of workrooms and living quarters built, not quite on the scale of The Red House, but in the same Utopian spirit (Fig. 1). Much later, in *A Potter's Book* of 1940, Leach identified himself as an inheritor of Morris's values, as one of the 'artist-craftsmen' who, since the days of William Morris, were 'the chief means of defence against the materialism of industry and insensibility to beauty'.[3]

But Morris's design reform ambitions encompassed a whole range of decorative arts, while Leach restricted himself to a single craft, ceramics (with a few excursions into furniture and textile design).[4] Morris, in the form of Morris & Company, set up a business that was financially sound, that was supported by the skills of trade craftsmen, and which by the time of his death was well known throughout Europe and the United States. Leach, using low level technology, was unable to construct a successful business venture and was dependent on the patronage of the Elmhirsts of Dartington Hall throughout the 1920s and 1930s. Morris was deeply conscious of architecture, both as a setting for his designs and as an art form in its own right. Leach's interest in this context for his work was limited. Morris's various houses are well documented and continued to be important extensions of his design vision after his death (Fig. 3). Leach, at various points in his career lived in a caravan and a wooden hut (Fig. 2). He ended his days in a small flat. Finally, Morris was a revolutionary socialist while Leach chose to put himself above or outside politics, concentrating on a synthesis of Eastern and Western philosophies and aesthetics.

But Morris also stands in a problematic relationship to the Arts and Crafts Movement, especially in its late phase, roughly the decade and a half before the First World War. This was partly because the Movement first flourished in the 1880s, when his view of things was intensely political. In 1885 T.J. Cobden-Sanderson, who had taken up bookbinding two years previously, recorded in his journal that Morris had dismissed his bindings as being too costly.

1. Bernard Leach's studio constructed to his own design in 1916 on Soetsu Yanagi's property at Abiko. It is pictured just before it was destroyed in a fire in May 1919. (Holburne Museum and Crafts Study Centre, Bath).

2. The Cabin, Shinner's Bridge, Dartington Estate. Built in 1937 by Bernard Leach with the help of a carpenter. Here Leach wrote his classic *A Potter's Book*. (From the Dartington Hall Archive).

3. The dining room at Kelmscott House, Hammersmith Mall. The embroidered wall hanging was designed by May Morris and completed by Mrs Battye in about 1900, four years after Morris's death. (Hammersmith and Fulham Archives and Local History Centre).

Morris had argued that he 'did not want to multiply the minor arts' and had gone on to say that 'some machinery should be invented to bind books.'[5] By a stroke of irony Cobden-Sanderson had bound Morris's treasured copy of Karl Marx's *Le Capital* (Morris read it initially in French) the previous year. It is an object to meditate on. It reifies the contradictions of the Arts and Crafts Movement with some power, poised almost risibly between luxury and revolution (Fig. 5).

Cobden-Sanderson had been admonished by Morris the successful businessman who also, confusingly, happened to be a revolutionary Socialist. But there was another contradiction at the heart of Morris's life and work. His vision of a 'glorious art, made by the people and for the people, as a happiness to the maker and the user'[6] was at odds with his own practice as a designer. He worked out his designs on paper and though he went to great lengths to master the technicalities of certain crafts, his designs were carried out by professional craftsmen.

4. The textile printing shed at Merton Abbey. An illustration in Morris & Co, *Chintzes, Silks, Tapestries etc*, 1912.

5. William Morris's copy of Karl Marx's *Le Capital* bound by T. J. Cobden-Sanderson in green leather tooled with gold. Completed in October 1884. Sold at Christies, New York, for $50,000 on 19 May 1989. 29 × 21.6cm. (J. Paul Getty KBE, Wormsley Library. Christies Images).

What is more, most of them were complex flat repeat patterns which, when hand-printed as wallpapers or textiles, required what the design historian Peter Floud described as 'a kind of niggling, repetitive handwork' altogether different from Morris's picture of 'the happy medieval stonemason' expressing himself in stone (Fig. 4).[7] Thus Morris, as a sound businessman, kept practice and philosophy separate, apparently believing that only after a full blooded revolution would it be possible for a new art to develop.[8]

Morris was not, as he has sometimes been portrayed, a Luddite. 'It is not this or that tangible steel or brass machine which we want to get rid of', he wrote, 'but the great intangible machine of commercial tyranny, which oppresses the lives of all of us.'[9] He believed that the making of things by hand using simple tools was a pleasurable and worthwhile activity, but in practice he never made a shibboleth of handwork. Neither did the founders of the Arts and Crafts Exhibition Society, who were primarily designers who turned over their designs to commercial firms or to professional trade craftsmen or women. Yet part of the Morris legacy was an antipathy to 'machines' whose evils were discussed, interminably, on into the 1930s.[10] This was, in truth, more the legacy of John Ruskin. His great sweeping attack on nineteenth-century taste and modes of production in *The Nature of Gothic*, a chapter in the second volume of *The Stones of Venice* (1853), introduced a Luddism which was fierce, symbolic and undiscriminating. Ruskin's identification of the social misery which he saw behind the production of the fittings and furnishings of a middle-class drawing room stood unchallenged until the 1960s when, belatedly, the designer David Pye went doggedly through the text, demonstrating its illogicalities and the limitations of Ruskin's understanding of manufacturing processes.[11]

In practice, it is not easy to define the handmade or even to draw a clear line between machines and tools. Few things are made by the hand unaided and many tools are guided by some kind of jig.[12] The issue is further confused if we differentiate between hand and power tools. What we can say is that by the 1920s the simplest tools and processes were preferred in craft circles, as middle-class men and women embraced Morris's hopes for 'pleasure in labour'. This care about the means of production had striking artistic consequences that form one of the themes of this book. Nothing could be more immediate and heart-stopping than the hand block-printed textiles and the stoneware pots dripping with ash glazes created between the wars (Figs 6, 8). But a preference for direct processes meant that the craft movement after the First World War became a narrower affair than the Arts and Crafts of the previous century – simply because it cut itself off from industrial production.

6. Complexity: *Cray*, hand block-printed cotton designed by William Morris, 1884. Thirty-four blocks were required to print this pattern. (William Morris Gallery, London).

7. Eric Gill as a young man *c.* 1908 standing before a tablet for Lowes Dickinson – 'Full of noble device; of all sorts enchantingly beloved' – which forms part of a four-sided memorial in Kensal Green cemetery. (Art Collection, Harry Ransome Humanities Research Centre, the University of Texas at Austin).

The preference for direct processes and small workshops – and the consequent possibilities for self expression (or self indulgence?) – went hand in hand with the popularisation of the crafts. The fundamental texts for this dissemination of handcraft values were the Artistic Crafts Series of Technical Handbooks edited by W.R. Lethaby, the architect and first Principal of the Central School of Arts and Crafts. Appearing from 1901 until 1916, they communicated a precise message. All were directed at the putative designer-maker and were purist and populist and anti-industrial. Lethaby's limpid, idealistic prefaces suggested that preferably the designer should also be the maker and that a living could be made from craftwork. In *Hand-Loom Weaving* (1901), one of the first books in the series, Luther Hooper argued that there had been no improvements in weaving appliances since the mid-eighteenth century; later developments had only served to separate 'the art of design from the art of weaving'.[13] Christopher Whall's *Stained Glass Work* (1905) similarly preached a unity of designer and craftsman in the production of stained-glass windows that would have been foreign to Morris. The purism of the Artistic Crafts Series suggested an economic innocence which was soon picked up by critics of the Arts and Crafts Movement.

CRITICISMS AND NEW DIRECTIONS

Some early twentieth-century writers noticed a growing gap between the Movement and its earlier design reform ambitions, as it focused increasingly on the designer-craftsman and the

8. Simplicity: *Zwemmer*, hand block-printed linen. Designed and printed by Enid Marx, probably around 1932–3 when her textiles were exhibited at the Zwemmer Gallery. (Holburne Museum and Crafts Study Centre, Bath).

9. Graham Wallas. (The Society of Authors on behalf of the Bernard Shaw Estate).

small workshop. For instance A.R. Orage, a charismatic young Fabian with Arts and Crafts interests and a weaver wife, argued in a substantial essay 'Politics for Craftsmen' in the *Contemporary Review* in 1907, that the political objectives outlined so vividly in Morris's lectures and in his utopian novel *News from Nowhere* had never materialised. Instead the crafts had turned into a 'lamentable series of little Guilds, hole-in-the-corner institutions, associations for the sale of petty craftwork, cunning devices for attracting the wealthy, fantastic designs to attract people of no taste, and all the indications of a movement that has ceased to be a movement at all'.[14] Orage's answer was a return to the medieval system of guilds which would take responsibility for standards of workmanship. To believe that trades unions could take on that role in 1907 was strikingly unrealistic, especially against the background of endemic industrial unrest which only ended with World War I. But it is significant that well into the 1920s such ideas had currency as an unthreatening form of socialism among a middle-class intelligentsia anxious to retain Morrisian ideals in any future ideology of work.[15]

Orage's views were echoed a couple of years later by a practising craftsman and fellow Fabian, the letter cutter Eric Gill (Fig. 7), in his 1909 article 'The Failure of the Arts and Crafts Movement' in the *Socialist Review*. Like Orage, Gill reiterated the need for a guild system. In medieval times, he argued, this had cut out the middle man and had made each town a 'craft university'.[16] Gill believed that the Arts and Crafts Movement had failed because 'Its object was to raise the condition of ordinary workers and the quality of ordinary workmanship, and it had not even begun to do it.' The artist craftsman 'would sooner die than be ordinary and do ordinary things'.[17] Gill contrasted this with the trades unions – 'a gigantic working class movement'.[18] He believed that once the trades unions had gained the right to decent pay and conditions, they would move on to demand the right to create good work. In contrast with Orage, Gill placed great faith in organised labour. His essay was sub-titled 'A Lesson for Trade Unionists', and he argued 'Is it not notorious how the workman absolutely loathes a shoddy job?'[19]

Orage and Gill saw the Arts and Crafts Movement and its Exhibition Society as discredited by the first decade of the twentieth century. Nonetheless both men proposed impractical solutions, very much in the spirit of the early Movement and of Morris's *News from Nowhere*. Graham Wallas's *The Great Society*, published on the eve of the Great War, took a less romantic view of 'the workman'. Wallas (Fig. 9), a founder of the London School of Economics,

10. Roger Fry *c.*1913–14 seated in an armchair upholstered with an Omega printed fabric, his own design *Amenophis*. (King's College Library, Cambridge).

11. (*opposite*)Nina Hamnett, Sketch of an Omega interior, late 1916/early 1917. Pencil and oil on board 46.9 × 30.7 cm. Used to illustrate Roger Fry's article *The Artist as Decorator* published in *Colour* magazine in April 1917, it shows a number of Omega products, including a rug, a marquetry tray designed by Duncan Grant, a pair of large earthenware vases and the Omega chair designed by Fry. (Courtauld Institute Galleries, London: Fry Collection).

dismissed the guild solution, pointing out that the medieval guilds had degenerated into stagnant hereditary monopolies. But Wallas recognised that modern industrialised society had brought about something difficult to quantify or measure – a loss of happiness in work coupled with a feeling of dispossession among ordinary people. Much of *The Great Society* is nostalgic in tone; it is a modern book which looks backwards. Wallas's ideal society was to be found in the craft-based villages and small towns of Norway. He contrasted skilled craftwork with Taylorism and the production line. He quoted a translation of a Sinhalese potter's song with its 'indescribable sense of delight in the work'. He also quoted William Morris: 'how nice it will be when I get back to my little patterns and dyeing, and the dear little warp and weft at Hammersmith.' But then come the hard, dismissive economics. Wallas calculated that each citizen in Morris's ideal community would have to work 200 hours a week 'in order to produce by the methods he advocated the quantity of beautiful and delicious things which they were to enjoy'.[20]

As early as 1899 the maverick American economist Thorstein Veblen had taken the virtuous humility of the Arts and Crafts, its rejection of modern industrial production, and turned it on its head. Veblen had made a pilgrimage to see Morris in 1896, the year of the great man's death. Morris had been immersed in the fine detail of the luxurious volumes of his Kelmscott Press and the meeting was not a success. Three years later in his brilliantly satirical *The Theory of the Leisure Class* Veblen argued that in an industrialised society, handmade products inevitably become more prestigious than mass-produced goods. The Arts and Crafts Movement, in particular, was dismissed as a source of items of 'conspicuous consumption' (Veblen's memorable phrase) to be classified in sociological terms with elaborate, impractical upper-class dress, highly bred dogs and horses and the display of large numbers of idle servants. Kelmscott Press books were held up for particular scorn.[21]

The Theory of the Leisure Class was read by the connoisseur and art critic Roger Fry (Fig. 10). Fry knew a good deal about Arts and Crafts philosophies. He had formed a youthful friendship with C.R. Ashbee, whose Guild of Handicraft attempted to combine socialism and crafts. Fry was genuinely interested in applied art, reviewing Arts and Crafts shows for the *Athenaeum* from 1900. This interest developed in tandem with his discovery of the paintings of Cézanne and the Post-Impressionist exhibitions which he organised at the Grafton Galleries in 1910 and 1912. In the first of these Fry included earthenware and stoneware pottery by painters like Henri Matisse, Maurice Vlaminck, André Derain, Pierre Girieud and Othon Friesz, emphasising the links between advanced art and the crafts.[22] But the setting up of the Omega Workshops by Fry and others early in 1913 was essentially a critique of the Arts and Crafts Movement. It introduced a re-alignment of positions that was to be of great importance for future craft work.

Omega was essentially a job creation scheme for fine artists, who painted on objects rather than making them. There were few craft principles operating, but at the same time the aesthetic was anti-industrial. An Omega brochure of 1914 explained that their artists were 'working with the object of allowing free play to the delight in creation in the making of objects of common life'. They refused to spoil 'the expressive quality of the work by sandpapering it down to a shop finish, in the belief that the public has at last seen through the humbug of the machine-made imitation of works of art'. Instead Omega aimed to 'keep the spontaneous freshness of primitive or peasant work while satisfying the needs and expressing the feelings of the modern cultivated man'.[23]

Omega was eclectic, selling ladderback chairs designed by Ernest Gimson and made by Edward Gardiner, as well as buying in a mix of cheap commercially made furniture to be decorated. In its modesty of materials and expressiveness, Omega seemed remote from the complex products of the Arts and Crafts Movement. At Omega the relationship of art, design and craft was flexible, even casual. Crudely painted candlesticks jostled with splendid machine woven carpets, Fry's handsome lacquered 'Omega' chairs, marquetry trays and large screens (Fig. 11), which were vehicles for ambitious passages of early modern painting. In one area, that of printed textiles, Omega anticipated the cubist-inspired craft activities of the hand

block-printers in the 1920s and early 1930s[24] while in the case of ceramics Fry also created an aesthetic standard for the studio pottery movement through his writings; he endorsed early Chinese wares and English medieval pottery and dismissed the industrialised perfection of Wedgwood.[25] In part at least because of Fry and his shaping of English modernism, the crafts of the inter-war years look the opposite of Veblen's 'conspicuous consumption'. 'Conspicuous parsimony' would better describe inter-war textiles and ceramics.

THE ARTS AND CRAFTS EXHIBITION SOCIETY

By 1916 it was becoming clear that the Arts and Crafts Movement was failing to recast its activities in an energetic modern idiom. The *Studio Year-Book*'s regular and excellent coverage of German, Austrian and Hungarian architecture and design from 1907 until the outbreak of war revealed what could be achieved if craftsmen, designers, manufacturers and the State collaborated to raise the quality of mass production. But for many in the Arts and Crafts Movement commercial firms were plagiarists, whose cheaper production methods undermined attempts at social and political experimentation and independence based on handwork.[26] While in Germany craft research and development were put to the service of industry, in England experimentation with materials and techniques and all the pleasure in making seemed to become ends in themselves. The Arts and Crafts Movement in the early twentieth century was in the process of decommoditisation, of cutting loose from realistic economics.

This purist approach was reflected in the work shown by the organisation at the heart of the Movement, the Arts and Crafts Exhibition Society. The collaboration with wallpaper and textile manufacturers which had been such a marked feature of earlier exhibitions was replaced by handwork. For instance, the Society's 1906 exhibition included six examples of hand-loom weaving. By 1912 this had risen to seventeen pieces, and by 1916 to sixty-three.[27] This shift in emphasis had important gender implications that have a bearing on any discussion of 'the failure' of the Arts and Crafts Movement. In 1906 the Arts and Crafts Exhibition Society had nineteen women members while by 1916 there were thirty-four. If the rhetoric of design reform from the 1880s onwards was led by men, by the inter-war period the crafts were offering women a space in which to operate as designers.

The 1912 Arts and Crafts Exhibition was a financial failure and by 1913 there was the grim possibility of no funds for future shows. New ideas were clearly needed and to generate them the silversmith Harold Stabler formed a sub-committee which in October reported back with well-worked-out plans for a saleroom.[28] But the stained glass artist Christopher Whall wrote a minority report repudiating the ideas both of a shop and of a plan for associate members. Whall had the support of Walter Crane, the Society's President, and of W.R. Lethaby. Commerce was firmly rejected by the most distinguished members of the committee, even though Crane had designed a mass of textiles and wallpapers for industry and Lethaby had used adventurous new materials in his practice as an architect.

This decision to reject a commercial role has rightly been seen as a turning point in the Society's fortunes – the beginning of the end for the Society and the Arts and Crafts Movement which were, in any case, soon to be snuffed out by World War I. Within the Society from this point on there was an identifiable old guard and changing groupings of younger dissatisfied members – some committed to design for industry and others devoted to neo-primitivist hand processes, inspired by the immediacy and power of objects from non-European cultures. But for a brief period the First World War acted as a stimulus to the Society and the Movement. It is not surprising that the Arts and Crafts Movement should become a source of national pride in wartime.[29] But at the same time it became something more radical and subversive. The crafts were pressed into service as 'a bit of old England', as they were to be in the Second World War. But war also inspired Arts and Crafts leaders to take up political and social issues in the spirit of Morris at his most revolutionary. Ordinary working men were laying down their lives. Their surviving comrades might return as heroes, but, it was argued, only a craft revival would prevent them returning to dull, montonous lives as mere wage slaves.

Henry Wilson (Fig. 12), the architect and silversmith, was a passionate exponent of the social and political importance of the crafts. He was President of the Arts and Crafts Exhibition Society from 1915 until 1922, an old guard choice, a man from the heart of the nineteenth-century movement. At the outbreak of the First World War he was in his early fifties, at the height of his powers as an artist and a designer, and he believed he could give the Arts and Crafts Movement a context in a very straightforward and, he hoped, patriotic way. He was a visionary and a rebel, sympathetic to Morris's vision of a Utopia in Albion, set out in his political speeches and in *The Dream of John Ball* and *News from Nowhere*. Wilson intended to revitalise the Exhibition Society, but not to compromise with what he held to be Morris's intentions for the Movement. Wilson's nationalism was shot through with radicalism.

Wilson saw education as the key, deploring a culture based almost entirely on book learning. He took part in the New Ideals in Education annual conferences from 1914 onwards, and read the writings of Dalcroze and Montessori. In 1916 he wrote in the *Manchester Guardian* of a future 'when every child shall have a trade, and every trade give livelihood – that lovely word and lovelier fact so little understood'.[30] Speaking to the New Ideals in Education group, he linked this dream of an education based on learning-by-doing to the experience of war. Returning soldiers, he argued, would be the vanguard of a process of deindustrialisation. The experience of army life had provided the working classes with the equivalent of a public school education and with the social and political skills to reject 'the disguised servitude incidental to industry' and the lie of competitive trade: 'they have gained the priceless sense of comradeship in death and danger. They have been sobered by mental sacrifices.'[31] The curious idea that war was an ideal preparation for an Arts and Crafts revival (and the concomitant collapse of industrial capitalism) came to dominate the Arts and Crafts Exhibition Society's thinking. It also gave purpose to Wilson's major project as President. This was the organisation and design of the eleventh Arts and Crafts Exhibition, staged by the Society in the autumn of 1916 at Burlington House.

12. Portrait of Henry Wilson by E. R. Hughes, July 1901. Pencil on paper. (Private Collection).

13. Angel with a scroll, Holy Trinity, Sloane Street, London. Part of the altar rail designed by Henry Wilson and completed in 1903. (Conway Library, Courtauld Institute of Art).

The site must have seemed like a triumph. It was the parochial rejection of the applied arts by the Royal Academy, the occupant of Burlington House, which had led to the formation of the Arts and Crafts Exhibition Society in 1888. For Wilson, this was a crucial opportunity to suggest the future context of the Movement. He wanted to restore its architectural possibilities at a time when most Edwardian public architecture was neo-Georgian in style, with steel-frame construction and classical detailing.

Neo-Georgian architecture was emphatically not Wilson's taste. His admiration for Ghiberti and Michelangelo inspired his maverick belief that sculpture and the applied arts preceded architecture in the development of the arts. In lectures and talks he took pleasure in refuting the old shibboleth that architecture was the 'mother of the arts'. 'A building is constructed decoration'[32] he would pronounce; and his finest achievements were exactly that, created out of complex figurative and vegetal forms and employing arcane personal iconographies. His contribution to Sedding's Holy Trinity, Sloane Street (Fig. 13), his chapel in Welbeck Abbey in Nottinghamshire, the pulpit of Ripon Cathedral, the 1905 bronze doors of the church of St John the Divine in New York and his extravagant Michelangelesque tomb for Bishop Elphinstone in Aberdeen show how much of his original inspiration came from the point at which the Arts and Crafts Movement and the New Sculpture had overlapped in the late 1880s. His later, richly organic jewellery and enamelling shaped the style of other Arts and Crafts silversmiths, such as John Paul Cooper and Edward Spencer. The modernity of his ideas about education, and the intellectual framework which he set upon the eleventh Arts and Crafts Exhibition, were striking, but they might also be seen as growing out of his work, as if ideas which he had embodied in symbolic sculpture were now being applied to the world of words and social organisation.

Wilson's emphasis on an architectural context for the crafts and the numerous specially commissioned murals attracted a good deal of comment – much of it positive. But *The Builder* felt that a contextualising approach had not solved the problems of mounting such a mixed display: 'the general effect of the show is that of a huge bazaar in which a myriad variety of goods is displayed'.[33] The shaming sobriquet 'bazaar' was to haunt craft exhibitions from then on and was precisely the effect that Wilson intended to avoid. And if we listen to the voices of exhibitors, critics and pundits as regards the rest of the exhibition, the messages were mixed. The exhibition included a substantial retrospective section, a memorial room with work by Morris, Edward Burne-Jones, Dante Gabriel Rossetti and Ford Madox Brown, dominated by Burne-Jones's last, unfinished work, the plangent, mysterious *Sleep of King Arthur in Avalon*. It suggested a movement which had once had great creative strengths, but which had now lost its way. Wilson wrote optimistically in the catalogue of 'the rebirth of the art of England', but most of the reviews of the exhibition argued differently and xenophobically. Again and again it was pointed out that British Arts and Crafts pioneers had inspired foreign competitors, above all the Germans. British ideas had been 'stolen' and adapted for mass production abroad.[34]

The *Daily News* found the exhibition trivial and overly individualistic beside a 1914 exhibition put on in Cologne by the progressive Deutsche Werkbund.[35] With buildings by architects of the stature of Henri van der Velde, Bruno Taut and Walter Gropius, Cologne could hardly have been a greater contrast to Wilson's neo-Byzantine plasterboard creations. The commonest complaint made by reviewers was that of an excess of individualism, a sense of privileged people working to please themselves. The sub-text was a lack of social responsibility, the kind of criticism made by Gill, Orage, Veblen and Wallas. As *The Builder* pointed out, the exhibitors 'ignore the existence of the lower ranks of society'.[36] Exhibits were clearly aimed at a prosperous middle class who could subscribe to the fantasy of the rural idyll which so many of the exhibits suggested (Fig. 14).

Two sets of exhibits stood for a very different kind of making. One was a display by Omega Workshops. Fry described the Exhibition committee which came to see him in less than flattering terms: 'three sour and melancholy elderly hypocrites full of sham modesty and noble sentiments…[who]…represented to perfection the hideous muddle headed sentimentality of

the English – wanting to mix moral feeling in with everything…They wanted to put me in a sort of dark cupboard and I got really angry.'[37] His contempt measures the distance between himself and the leaders of the Society. Born in 1866, Fry was actually only two years younger than Henry Wilson, but in terms of artistic vision he belonged in another, newer world.

Few critics even mentioned Omega, preferring instead the pastoral floriated decoration that characterised so much of the ceramic, jewellery and embroidery on show in 1916. A thoughtful review came from C.R. Ashbee. He was full of loyal, gentle praise but he could not help observing that 'We are living too much in the past' and pointed out that Arts and Crafts men and women 'have not enough work of the right sort…The exhibition shows clearly how these rooms of ours have to be swept out, the unrealities and fluff cleared away.'[38] Ashbee identified Omega as belonging to the future and also noted a display put on by the Design and Industries Association as being 'somehow right'.

The Design and Industries Association had been formed in 1915 by the disaffected members of the Arts and Crafts Exhibition Society, whose demands for a commercial arm for the Society had been rejected in 1913. The founder members – Harold Stabler, the architect Cecil Brewer and the manufacturer Harry Peach – had been inspired by the Deutsche Werkbund and saw the DIA as similarly bringing together designers, craftsmen, manufacturers and retailers. Its display at Burlington House concentrated on the beauty of ordinary industrially made objects like stoneware jars for Crosse & Blackwell and tableware by Wedgwood. This plainest of plain pottery was shown alongside machine-printed cottons of startling exoticism from Charles Sixsmith's Bentinck Mills near Bolton. They were not usually sold in Britain, except, in fact, by Omega, as they were intended for the West African market and designed in collaboration with their West African consumers. Their impact was

14. *Domus No. 1* at the 1916 Arts and Crafts Exhibition, Burlington House. Note the pastoral mural 'England is a Garden' by J. Walter West, the walnut four-poster bed by Ambrose Heal and in the foreground, on a Heal's dining table, a painted ebony and walnut cabinet designed and painted by Louise Powell and made by Sidney Barnsley. The complexity and fine workmanship of the embroidered panels and furniture on show in this room would have contrasted sharply with the Omega and DIA displays. Illustrated in *The Studio*, 1916.

tremendous – as *The Builder* wrote: 'Here we find the strong vivid patterns that so many people have been praying for for years, brought to the reach of the modest purse by the exigencies of war.'[39] In terms of the future of the crafts, it was Roger Fry's Omega which pointed the way. The most innovative craftsmen and women of the inter-war years sought qualities closely linked to developments in fine art. Touch, spontaneity and a freshness with materials (paramount qualities for Fry) became essential goals.

LAST THOUGHTS

The founding of the DIA had seemed like a direct threat to Wilson. In September 1915 he asked members of the Arts and Crafts world for their thoughts on the future of the Society. This call to arms provoked a mass of letters, and slowly a set of ideas came together which can be seen as the last thoughts of the Arts and Crafts Movement proper. C.R. Ashbee wrote of the problem of 'getting a body of very individualistic, self-centred and "difficult" men and women to combine'. He felt that the barriers were not aesthetic but more to do with organisation and livelihood, 'of adjusting the conditions under which Arts & Crafts can be practised in the mechanical environment of our time. In that sense our difficulty is social, human, ethical.'[40]

The architect and furniture maker Ernest Gimson took a very different line. 'What ever we do, don't let us become commercialised and babble about the inherent possibilities of machines' he wrote.[41] Gimson, by his own admission neither a public speaker nor a willing writer, was inspired by Wilson's call for ideas. He wrote of a scheme to put 'some muscle and backbone into the Arts and Crafts'.[42] When Gimson's plans finally reached Wilson in 1917 they proved to be both ambitious and rooted in rural life. The intention was to repudiate entirely the industrial world. Gimson proposed an 'Association of Architecture, Building and Handicraft'.[43] He believed that one of the chief problems facing the Arts and Crafts in the second decade of the twentieth century was its gradual alienation from architecture and the building crafts, and he envisaged a close association with architects as the basis for his programme. He disliked the high prices of Arts and Crafts goods, and accordingly planned a craft village of about 200 handworkers for 'making in quantity things of common use at prices within the reach of average incomes'. The workshops in the village would be overseen by eminent makers, with Gimson himself supervising architecture, furniture and plasterwork. Nothing came of this scheme chiefly because Gimson died in 1919. But his detailed plan helps account for the emphasis on rural reconstruction that briefly dominated the Arts and Crafts Movement's agenda after the First World War.

Other members pledged their support for Wilson, even if they did not come up with such ambitious solutions. Selwyn Image, the stained-glass designer and Slade Professor of Fine Art, wrote critically of those members who 'go a whoring after this Satan disguised as an angel of light'.[44] He meant those who admired German efficiency and had joined the DIA. Though Image later became a DIA member himself, in 1915 he recommended a period of introspection and self-examination for the Arts and Crafts. Christopher Whall wrote on the proper role of the Arts and Crafts:

> The only thing valuable in the movement is the sincere practising of Art & Craft for its own sake. The whole thing arises out of the doing so by some half score of idealists. It has spread – and has been watered down – and now is in danger of being *captured*. Our immediate business is not to 'link it up with other things' or other people but to 'set' ourselves 'right'.[45]

The most passionate attack on the DIA came from the metalworker and jeweller Edward Spencer, a philanthropically minded employer who trained orphan boys at his Artificers' Guild. He warned against collaboration with industry and thus criticised what many would regard as the best achievements of the nineteenth-century Arts and Crafts: 'We have all had specially designed cretonnes and wallpapers by eminent hands and we are sick of the best of them simply because they are reproduced in such quantities as to deprive our homes of the very individuality they were designed to preserve.'[46] Spencer believed that the DIA wanted to

harness the craftsman to the 'easy wheels' of capitalism. For him, the only justification for machines was that they would free the workers for self-expression and allow them to make art. It was the bright future set out in Morris's *News from Nowhere* all over again. For Spencer, as for Gimson and many Arts and Crafts practitioners, the crafts were central to a larger, anti-industrial social revolution.

HANDICRAFTS AND RECONSTRUCTION

The First World War left one and a half million men weakened permanently by wounds or gas.[47] Gruesomely, so much damage and despair gave new purpose and publicity to the crafts. 'From the bed of pain they offer us this flower of beauty, which has healed them as it grew' wrote Henry Wilson excitedly at the height of the war.[48] He had seen embroidered landscapes, inlaid beadwork and metalwork made by a group of convalescent sailors. In Leicester hospitalised soldiers were offered off-cuts of cane for basket-making supplied by Harry Peach's firm Dryad. This was the impetus for the founding of Dryad Handicrafts which today continues to supply materials and equipment for hobby craftsmen and women.

During the war the Art Workers' Guild and the Arts and Crafts Exhibition Society had published *Some Provisional Suggestions on the Training of Wounded and Disabled Soldiers and Sailors*, which they submitted to the Ministries of Labour, Pensions and Reconstruction.[49] This curious document envisaged a craft renaissance in which soldiers and sailors would be co-opted for handwork. It was argued that they possessed the necessary adaptability and handiness, acquired apparently during their time in the trenches. Because of 'the therapeutic, recuperative and educational value of handicrafts', the pamphlet argued for a whole range of productive workshops embracing the building trades, metalwork, carpentry, joinery and other woodwork. This workshop culture would not only take in the wounded and disabled, but it would gradually replace art school training and would do away with the division of labour which prevented workers from realising 'the real extent of their capacities'. Individual craftsmen also drew up reconstruction schemes. Ernest Gimson submitted his ambitious plans for a series of country workshops in the Cotswolds, and Douglas Cockerell, the bookbinder, involved himself with the Fordingbridge Craft Settlement with the support of the Order of Woodcraft Chivalry and wrote a pamphlet for the Arts and Crafts Exhibition Society on *Vocational Training for Able-Bodied Sailors and Soldiers* (1918).[50] Even Roger Fry, writing a paper *On the Encouragement of Design in British Manufactures* in 1919, suggested that disabled soldiers might be trained technically and employed in workshops of experimental design.[51] Surprisingly the site for all this activity was seen to be the countryside, racked by poverty and unemployment and already the focus for government concern before the war.

The DIA also submitted a memorandum to the Government. This was more realistic about the usefulness of crafts as a future for discharged soldiers, noting that semi-philanthropic village industries had often produced inferior work in the past; the workers were open to exploitation by employers who 'sweated' them, or dependent on the whim of 'wealthy enthusiasts'. Pure handwork was judged uneconomic by the DIA; they wanted to free rural industries from what they called 'the Philanthropic Taint'. Thus the DIA suggested the setting up of small rural factories involved in anything from furniture making to food preservation.[52]

As we shall see in a later chapter, despite the recommendations of the DIA the crafts continued to be invoked in a philanthropic context. In 1922 a list of philanthropic workshops that trained and employed disabled ex-servicemen was drawn up for a Parliamentary Select Committee.[53] Several, including Lord Roberts' Memorial Workshops, the Princess Louise Scottish Hospital, Leeds Tuberculosis Ex-Servicemens Co-operative and St Dunstan's (for the war service blinded), offered training in a range of handicrafts, from basketry, upholstery and tailoring to bootmaking and rough woodwork (Fig. 15). None of these bodies was exploitative, but neither did they generate the creative flowering and de-industrialisation which had been anticipated by Henry Wilson.

The Arts and Crafts Movement's final collective dream for post-war reconstruction was a book of essays published in 1919, *Handicrafts and Reconstruction*. It is full of elegiac memories

15. St Dunstaners blinded in the First World War learning to make net bags. (St Dunstan's, London).

of vernacular crafts glimpsed in decline, mixed with thoughts on Englishness and marked by despair at the cultural poverty of rural and village life. Most of the essays focused on the countryside and espoused a respectable critical regionalism for architecture. The problems specific to towns and cities were hardly touched upon. It was a book written by practical men (and one woman, May Morris) which succeeded in sounding distinctly impractical. Even W.R. Lethaby writing on 'Education for Industry' drifted into Utopian idealism – 'Every village should have a folkmote for the promotion of the common life...The proper function of Trades Unions is not only to see that labour is fairly paid, but also to keep up quality; and they might incidentally bring back some festivals to the people.'[54] Festivals for the people, Wilson's 1918 plans for a vast fanciful 'pageant of peace' celebrating the history of Britain,[55] starting in 2000 BC and looking into the future, small workshops in rural places manned by fulfilled ex-servicemen making affordable handcrafted goods, life best thought of as service – ideals of this kind were simply not central to the craft movement as it developed in the 1920s and 1930s. *Handicrafts and Reconstruction* reads like the last gasp of the movement's social philosophies. In certain places such dreams lived on until the Second World War and even beyond, in the Cotswolds and among the craft community initiated by Eric Gill at Ditchling in Sussex. In the main, however, the craftsmen and women of the twentieth century were more concerned with artistic fulfilment than with social issues.

The crafts did not become a mass movement as Wilson had hoped and dreamt. Craft practice was increasingly eclipsed by the emerging design profession and by avant-gardism in fine art. And in contrast with the nineteenth-century leaders of the Arts and Crafts Movement, the principal craftsmen and women of this century were not versatile designers. With the exception of Eric Gill, they worked obsessively in one medium, trying to discover its essence, often deliberately ignoring hundreds of years of hard-won technological expertise. Their taste and the resulting work – pots, weaving, hand block-printed textiles, lettercutting – have a marked visual coherence and form a far from negligible part of the story of modernism in the visual arts in England. Their story begins in Chapter Two.

SETTING THE SCENE

In 1934 an inter-war craft grouping was firmly sketched out by Bernard Leach for Japanese readers. He singled out the hand block-printer of textiles Phyllis Barron, the weaver Ethel Mairet, the calligrapher Edward Johnston and the letter-cutter and sculptor Eric Gill as the artist craftsmen and women who 'in following their artistic intentions faithfully' had 'responded to the underlying need of their time' and given the crafts 'new life during the last twenty years'.[1] What was the nature of this alliance and how did their work differ from the Arts and Crafts generation born between 1850 and 1870, who were old enough to have known William Morris, to have gone to him for advice and read his writings as they appeared? The most striking difference was a marked emphasis on simplification, with startling visual results.

Mairet's plain weaving, dependent on the vivid colours of vegetable dyes and on the texture of hand-spun yarns, looked rougher and less finished than the patterned damask and silk fabrics created by the Arts and Crafts drawloom weaver Luther Hooper, let alone the machine-woven Jacquard fabrics designed by Morris and the architect C.F.A. Voysey. Mairet's weaving went to the essence of the craft, the basic interaction of warp and weft. The same can be said of Johnston's researches in calligraphy. Mairet looked to the folk weavers on the margins of Europe and to the Far East. Johnston, studying early manuscripts in the British Library at the turn of the century, deduced the tools and materials used, in particular the broad-edged pen. He went on to create what he called 'Essential Forms, beautiful in themselves'.[2] Johnston revived a dead skill but Phyllis Barron, as a hand block-printer, chose to simplify and primitivise a technique which throughout the eighteenth and nineteenth centuries had achieved complex and accurate effects. Gill set up in deliberate opposition to academic sculpture, looking to medieval and Indian carving for inspiration. Leach, trained as a painter and etcher, was drawn while living in Japan to the spontaneity of low-fired *raku* wares, to the earliest glazed stoneware of China and to Korean Yi dynasty wares. There was a deliberate setting aside of skill in some of this work but also a sophisticated response to the act of making. Touch and the sense of a hand process were essential components of these makers' early researches. In contrast with the leaders of the Arts and Crafts Movement, Leach, Gill, Mairet, Barron and Johnston were designers, tool makers and artisans all in one. And for them making often involved rough dirty work, mixing clay bodies, boiling up leaves, twigs and urine, attacking the stone directly.

Three of Leach's favoured makers – Gill, Johnston and Mairet – lived in the Sussex village of Ditchling. This suggests a fairly restricted geography for the crafts movement in the inter-war years. Ditchling was special because Gill had moved there in 1907 and by 1920 had formed the Guild of St Joseph and St Dominic, a religiously based Roman Catholic association of craftsmen centred on Ditchling Common. The Guild continued to flourish after Gill's departure in 1924. Neither of the other two Ditchling residents, Johnston and Mairet, were members but they were part of the wider community and clearly found living in proximity to other makers congenial. In general terms the inter-war crafts movement was strongest in the south of England and, significantly, in spots further afield which were visited by tourists, like the Lake District. Some crafts signalled their difference by being almost exclusively urban. Silversmiths and stained-glass artists were dependent upon a whole range of semi-industrial

services. They could exist outside cities – for instance the silversmith Dustan Pruden moved to Ditchling in 1932 – but in practice rarely chose to do so.

STUDIO POTTERY

Between the wars ceramics emerged as a new art form, recognised as the quintessence of formal abstraction, compared by critics to advanced sculpture and modern music.[3] The complexity and variety of the so-called 'art pottery' fashionable during the last quarter of the nineteenth century held few charms for the men and women who came to be described as 'studio', 'modern' or 'artist' potters. In the eyes of studio potters 'art pottery' was found lacking on two counts, techniques and sources. Most art pottery came out of experimental studios within the industry where there was division of labour.[4] There was no question of a single potter following through every ceramic process, digging the clay, creating the clay body, building a kiln, throwing, decorating, glazing and firing. Even the most admired figure working within the Arts and Crafts Movement, William De Morgan, was not concerned with the business of forming shapes and some of his most beautiful work was painted onto industrially made tiles. Similarly the artists employed at Doulton's Lambeth Pottery were chiefly concerned with surface decoration. In addition the sources for art pottery were diverse, and closely followed fashions in art, design and collecting. Thus William Burton and the team at the Royal Lancastrian pottery specialised in high-temperature single colour and flambé glazes of the Chinese Ch'ing period. William De Morgan's rich lustre wares were inspired by Hispano-Moresque pottery and his brilliantly coloured green and blue enamels drew on Persian Iznik. By the 1920s all this kind of work seemed to lack what Bernard Leach called 'sincerity'.

The ceramics produced from 1873 by the Martin Brothers might be thought an exception because the four co-operated as a close team, throwing, modelling and experimenting with glazes to make vases with incised and modelled decoration and their famous grotesque bird and face vessels (Fig. 16). But by 1923, when the young would-be studio potter Michael Cardew was taken to the Art Workers' Guild for an evening discussion of Martin ware, their work seemed merely quaint, an array of over-elaborate objects which Cardew felt 'obliged to be polite about'.[5] The early studio potters rejected the decorative eclecticism of art pottery.

16. Martin Brothers, a pair of salt glaze stoneware 'Wallybirds' made in June 1902. h.25 cm. (Pitshanger Manor & Gallery, London Borough of Ealing).

17. Reginald Wells, stoneware vase and tripod bowl c.1922. h. 17.5 and 9 cm. (The University of Wales, Aberystwyth. Photo Neil Holland).

Instead they substituted what became a modernist orthodoxy which favoured the relatively rough facture and austere shapes of early English pottery and early Chinese wares.

The first real opportunity to see early Chinese ceramics came in 1910 when the collector members of the Burlington Fine Arts Club put on the exhibition *Early Chinese Pottery and Porcelain*. It was rich in pots owned by George Eumorfopoulos, one of a handful of collectors buying early wares which were being excavated in quantity in the wake of Chinese railway construction at the turn of the century. They quickly became part of a modernist canon of greatness in art. Sung ceramics, as Roger Fry pointed out in a seminal article of 1914, were marked by a strong sense of form,[6] a quality he sought in contemporary painting and sculpture. And the founding of Omega in 1913 by Fry initiated a challenge to the traditional hierarchies which separated the applied and fine arts, non-Western and 'primitive' art and Western art, and the trained artist from the naive or vernacular artist. For Fry's acolyte Clive Bell, 'Significant Form' could be found in a swathe of different media: 'Sta Sophia and the windows at Chartres, Mexican sculpture, a Persian bowl, Chinese carpets, Giotto's frescoes at Padua, and the masterpieces of Poussin, Piero della Francesca, and Cézanne.'[7] As Bell asserted in 1914: 'No one ever doubted that a Sung pot or a Romanesque church was as much an expression of emotion as any picture that ever was painted.'[8] This recognition of the formal beauties of these austere early examples of ceramics meant that potters inspired by early Chinese wares or by what Fry had called 'the noble and serious'[9] early English wares were assured of an informed, if small, audience often with avant-garde tastes. Omega pottery, perhaps surprisingly, drew on rather different sources – principally French country pottery and Mediterranean tin-glaze wares.

The most important potter in terms of the future direction of the studio pottery movement was the sculptor Reginald Wells. He had been making slipware inspired by seventeenth-century English examples from about 1900. But in 1910, the year of the Burlington Fine Arts Club exhibition, he turned to early Chinese ceramics for inspiration. His simple, rather lifeless shapes were clothed in mottled running glazes which recalled Chün and Yüan wares (Fig. 17). Already famous for his small boldly modelled bronzes of labourers and countrymen inspired by the painting of Jean-François Millet, Wells's pots seem like a move towards abstraction, a response to the crisis of sculpture before the First World War.[10]

Many of the first efforts inspired by English slipware and Chinese Sung had an undeniably archaeological air. W.B. Dalton, headmaster of Camberwell School of Art from 1899 until 1919, was an early experimenter but his quiet pots were less important than his decision to

18. Denise Wren, earthenware vase with a raised Celtic knot pattern in blue, 1920s. h.16 cm. (The University of Wales, Aberystwyth. Photo Robert Greetham).

19. William Staite Murray, bowl, Yeoman Pottery 1915/19, earthenware, diameter 17.9 cm. (Photo David Cripps).

set up a pottery class at Camberwell in 1909, initially taught by Richard Lunn and from 1915 by Alfred Hopkins. Roger Fry, Reginald Wells and a key figure in the future studio pottery movement, William Staite Murray, all learnt the rudiments of pottery there. From 1919 Charles and Nell Vyse were making thrown stoneware and porcelain directly inspired by early Chinese wares. Nell Vyse was a knowledgeable glaze chemist and they recreated tenmoku, celadons and Chün glazes, carving and incising in the spirit of Tz'ŭ-chou pottery.[11] The Vyses lived near George Eumorfopoulos, studied his collection and were encouraged by him. But to some members of the new studio pottery movement their pots looked like reproductions and were dismissed as too 'competently commercial'. This harsh verdict delivered by the potter Katharine Pleydell-Bouverie suggests the hierarchies and groupings which swiftly developed within this new movement.

That there was a more populist sympathy for entirely handmade pottery is suggested by the career of Dora Lunn, the daughter of Richard Lunn, who set up her Ravenscourt Pottery in 1916.[12] It received publicity as an all-woman enterprise and as a fresh air workplace – 'Pottery in the Garden'. Clear simple shapes and deliberately crude decorations characterised her early work but by the twenties she was following a developing trend and making pots inspired by early oriental wares. Denise Wren, another figure on the margins of this new aesthetic, learnt to throw from a local flowerpot maker in Surrey and set up her pottery at Oxshott in 1919 making pots incised with Celtic designs inspired by Archibald Knox, her tutor at Kingston School of Art (Fig. 18).[13] She and her husband Henry Wren were what would now be called 'enablers', producing useful how-to-do-it books, selling kiln designs and holding two-week crash courses in pottery technique.

These early experiments began to seem like a movement after the First World War. A government report on the 1925 Paris exhibition made a sharp distinction between the art pottery produced by firms like Doulton, Pilkington, Moorcroft and Bernard Moore and the 'British Studio Potters' – men and women working alone or in small workshops designing and making pots and figurines.[14] By then there were two further key figures working in clay, William Staite Murray and Bernard Leach, each of whom inspired a band of gifted pupils and who shaped the movement through their personal charisma and a body of proselytising writing.

The special status of studio pottery in the 1920s and 1930s owes most to William Staite

Murray.[15] Destined for a career in his father's seed and bulb firm, Murray escaped into the world of 'abstract painting and abstract sculpture' just before the First World War.[16] It was a serendipitous moment and by 1915 he was on the fringes of the London art world, studying Buddhism, painting, experimenting with bronze casting and making earthenware plates at the Yeoman Pottery, Kensington with the Vorticist painter Cuthbert Hamilton (Fig. 19). Making pots in a small workshop in the first two decades of the twentieth century (like direct carving in stone, printing expressively with wood blocks or designing for the ballet) was one way of avoiding the potential academicism of easel painting. Murray might have seen the ceramics at Fry's 1910 Post-Impressionist show or known of the pottery experiments made by the German Expressionist group *Die Brücke* around 1912.[17] At the Yeoman Pottery Murray painted abstract designs on plates which suggest that he had studied work by Vassily Kandinsky, who had been a regular exhibitor at the Allied Artists Association exhibitions since 1909.[18] But in 1919, like other early studio potters, Murray began to explore the techniques of early Chinese stoneware.

Within a couple of years Murray had gone beyond the faithful emulation of Chinese wares which characterised the work of Charles and Nell Vyse. His finest pieces from the mid 1920s onwards were monumental forms, occasionally powerfully incised and often painted with abstract marks or stylised birds or fishes. From the late 1920s major pots were given poetic titles – *Cadence* (1928), *Vortex* (1929), *Mare* and *Persian Garden* (1931) (Fig. 20). Functional wares were of no interest to Murray who took his cue from the budding art critic Herbert Read, who had declared that pottery was 'plastic art in its most abstract form'.[19] In the same

20. William Staite Murray, *Persian Garden*, 1931, stoneware, h. 56.5 cm. (York City Art Gallery).

21. T.S. Haile, *Triumphant Procession*, 1937, stoneware. h. 42 cm. (Southampton Art Gallery. Photo David Cripps).

22. Murray, the 'canvas free artist', decorating a pot at Bray c.1930. (Pitshanger Manor & Gallery, London Borough of Ealing).

year Murray was arguing that 'A finely proportioned Pot…is an abstraction, and once we experience pleasure in contemplating it as such, we shall discover the underlying principles of beauty in more evolved forms, in Sculpture and Painting. The forms are abstractions and as such readily contemplated as pure form.'[20] From 1924 onwards ideas about thrown pots being 'abstract' or representing a branch of abstract sculpture became commonplace in discussions of studio pottery partly because Murray himself remained close to debates on abstraction in the fine art world. In 1927 he became the sole potter member of the Seven & Five Society, elected at the suggestion of the painter Ben Nicholson. That year he also shared an exhibition with Ben and Winifred Nicholson and Christopher Wood and the following year showed with the Nicholsons alone.[21] He exhibited in the final Seven & Five show in 1935 from which all figurative work was excluded. By 1930 Herbert Read took Murray's pots as a demonstration that 'all art is primarily abstract' (Fig 22).[22] Other critics, in the extensive coverage of Murray's exhibitions, also identified him as an abstract artist or saw his work as a synthesis of abstraction in painting and sculpture.[23]

In 1925 Murray was appointed pottery instructor at the Royal College of Art and was swiftly elevated to Head of Department. Though a practical man, he kept technical instruction to the minimum. Instead his students became aware of his interest in the vitalist ideas of Henri Bergson, the writings of Lao-Tsze and the koans of Zen Buddhism. Murray's group of students rapidly made an impact on the London art world, exhibiting frequently and forming a recognisable grouping, hailed in 1930 as 'canvas-free artists' by Herbert Read.[24] His most adventurous pupil, Thomas Samuel Haile, carried forward Murray's ambitiousness for ceramics (Fig. 21).[25] Haile was also a painter, allying himself with the English Surrealists in 1936 and joining the Artists International Association in 1937. The decoration of Haile's pots made plain his interest in School of Paris painters like Pablo Picasso, Paul Klee and Joan Miró – they were the inspiration behind his powerful slipware of the late 1940s. Murray's other favoured pupils – Henry Hammond,[26] Margaret Rey,[27] Heber Mathews, R.J. Washington and Philip Wadsworth – all made pots which remained close to his vision of ceramics as a fine art.

Like many inter-war craftsmen and women Murray's career faltered in the mid-1930s.[28] His elevated perception of pottery as an art form equal to painting and sculpture found less favour in a period of economic crisis. Many fine artists felt morally obliged to think in terms of design for industry. Murray never entertained such ideas, pointing out that 'You can't make love by proxy.'[29] In 1939 he travelled to Rhodesia, was caught there by the Second World War and decided to make East Africa his home. An attempt to make a pot using local native

techniques – handbuilding and firing without a kiln – failed and, remarkably, although he lived until 1962, his career as a potter ended at that point. Haile was killed in a car crash in 1948 while Margaret Rey turned to sculpture, R.J. Washington became a chicken farmer and art inspector, only returning to ceramics in the 1980s. Henry Hammond devoted himself religiously to teaching at Farnham School of Art. Murray's precipitate disappearance from the world of ceramics in 1939 meant that his reputation was largely eclipsed by Bernard Leach who carried on working, lecturing and publishing into the 1970s.

It is hard not to think of Murray and Bernard Leach as rivals. A coldness sprang up between the two men over Murray's Royal College of Art job and it has been argued that they represented different groupings, with Murray charging high prices for ceramics as art and Leach creating 'a living tradition of studio pottery'.[30] The truth was more complicated. They both wrote romantically about the making of pots, both seeing it as semi-mystical activity. Bernard Leach's background was grander than Murray's but he too had been discouraged from becoming an artist.[31] In 1903–5 he studied at the Slade where he learnt to draw with fluent grace. After an unhappy spell in the Hong Kong and Shanghai Bank he attended the London School of Art, met a young Japanese artist named Kotaro Takamura and fell to thinking about his early childhood, spent with his grandparents in Japan. In 1909 he set sail for Japan, planning to teach etching.

Leach's absence from England for the next eleven years meant that, unlike Murray, he missed the crucial years just before the Great War when exhibitions mounted by Fry, Frank Rutter and the Allied Artists Association and other groupings and galleries introduced virtually the entire canon of modern European art to London.[32] Leach's contact with European modernism was more tenuous, taking place at long range, among the wealthy Europhile group of artists, writers and thinkers who formed the avant-garde Shirakaba group in Tokyo. Leach's Oriental experiences will be discussed in greater detail in Chapter Four but most importantly in 1911 he attended a *raku* party where pots decorated by guests were immediately fired. Leach was fascinated by his own efforts and immediately set about learning the craft. He saw Sung pots in China on visits between 1914 and 1916. For Leach pottery became a metaphor for dreams of an East/West synthesis which he shared with the young Japanese philosopher Soetsu Yanagi. Pots also became a practical demonstration of how the East could, as Leach wrote, 'exercise a wonderful influence upon the soulless mechanical output of Europe'.[33]

In 1920 Leach returned to England. In Japan he had read Bell's ideas on significant form with excitement and he must have arrived home with some optimism. With the help of Shoji Hamada whom he met at the end of his time in Japan and who accompanied him to England, he established his pottery by a stream just outside St Ives (Fig. 23).[34] Hamada returned to Japan in 1923 but continued to exhibit in England throughout the 1920s and 1930s, offering an 'authentic' neo-Orientalism which helped give weight to Leach's own work. The link with Japan was kept up by the arrival of Tsuneyoshi Matsubayashi who helped Leach rebuild his traditional Japanese three-chambered climbing kiln and generally gave technical advice (Fig. 24). In those early years Leach was friendly with Murray and he, Hamada and Murray exchanged technical information, with Murray eager to learn Oriental brushwork from Hamada and the St Ives team interested in Murray's oil-fired kiln.

Leach's early output in England was notable for its range. Almost from the start he worked with stoneware, porcelain, *raku* (this chiefly to entertain tourists who paid to decorate a swiftly fired pot) and slipware, decorated with a range of techniques. The contrast with Murray, who restricted himself to stoneware, was striking (although the price paid was a high proportion of kiln failures and a swift slide into financial difficulty). Nothing can detract from the beauty of the best of Leach's early work. Pieces could be monumental or delicate, and painted, carved or incised with a repertoire of stylised graphic motifs Leach had built up in Japan – the Tree of Life, the Wellhead, fishes, horses eating seaweed on the seashore and images of 'the peaks of the High Japan Alps' (Fig. 25).[35] But in the *grand amateur* circles in which he had moved in Japan most technical problems were solved either by his teacher Ogata Kenzan VI or at his Abiko pottery by 'the trustworthy and experienced potter who managed my workshop and kiln so

23. Bernard Leach studying a slip-combed dish in the pottery at St Ives in 1923. (Pitshanger Manor & Gallery, London Borough of Ealing).

24. A three-chambered climbing kiln painted by Bernard Leach on a stoneware tile, part of a panel of twenty-five tiles exhibited in 1929. 10 cm. sq. (York City Art Gallery. Photo David Cripps).

25. Bernard Leach, *Wellhead and Mountains*, panel of stoneware tiles exhibited in 1929. h. without frame 68.5cm. (York City Art Gallery).

26 (*opposite*) Bernard Leach, stoneware vase with leaping fish painted in black on a cream glaze, c.1960, h.35.6 cm. (Leicestershire Museums, Arts and Records Service).

admirably, demonstrating by his behaviour the right relationship between artist and artisan'.[36] In England, however, the 'right relationship' with artisans proved harder to establish and as a result many uncertain pots were produced.

From the start Leach made functional wares, pleasing cups and saucers and improbably lumpy looking teapots. Part of the reason was economic. For instance he saw tile-making, to which he turned in 1927 and which allowed his genius as a draughtsman full rein, as a 'bread and butter' solution.[37] In *A Potter's Outlook*, an angry pamphlet of 1928 written for the New Handworkers' Gallery, he argued that the lack of 'any acknowledged classic standard of pottery' (Fig. 26) in England was forcing him in the direction of utility. But he retained vestigial Arts and Crafts ideals in which handwork could save men's souls and halt the progress of industrialisation and in which a country pottery making a broad range of wares had a place. At times he also thought in terms of a small factory with some division of labour – Morris's 'Factory as It Might Have Been'. These ideas were reinforced by the visit of Hamada and Yanagi to England in late 1929, bringing with them ideas about the unselfconscious beauties of functional work made by teamwork, a philosophy of art which they called *mingei* or 'art of the people'.[38]

From 1923 Leach had taken on a succession of eager upper-middle-class pupils including Michael Cardew, just down from Oxford, Katharine Pleydell-Bouverie, a boyish, intelligent aristocrat who had taken a few pottery lessons at the Central School, and Norah Braden who had spent six years at the Central School and the Royal College of Art. They in turn set up their own potteries, Cardew at Winchcombe in 1926, Pleydell-Bouverie at her family home at Coleshill in 1925, to be joined there in 1928 by Braden. Other pupils before the Second World War included Charlotte Epton, who married the painter Edward Bawden in 1932, and Sylvia Fox-Strangways who went on to teach at Dartington School in 1926. Harry Davis, a

27. Katharine Pleydell-Bouverie throwing in her pottery at The Mill, Coleshill, Wiltshire in the 1930s. (Pitshanger Manor & Gallery, London Borough of Ealing).

28. Michael Cardew throwing at Winchcombe Pottery, 7 August 1937. (Pitshanger Manor & Gallery, London Borough of Ealing).

29. (opposite) Katharine Pleydell-Bouverie, bottle with cedar ash glaze, 1930.h. 24.8cm. (Crafts Study Centre. Photo David Cripps).

fiercely idealistic autodidact, came to St Ives in 1933 as an employee and married another pupil, May Scott, the granddaughter of the founder of the *Manchester Guardian*, who arrived in 1936.[39] They set up their Crowan Pottery in Cornwall in 1946. Leach's son David joined the pottery in 1930, a decision which was to have important implications. David Leach trained at the North Staffordshire Technical College in Stoke-on-Trent from 1934 to 1936, acquiring the technical know-how that enabled the pottery to flourish after the Second World War. In 1938, at his suggestion, a local boy, William Marshall, was taken on as an apprentice. He proved an ideal 'artisan' and after the Second World War threw handsome large pots for Leach to decorate.

Leach, therefore established a small 'school' of followers which included three potters of great talent. Norah Braden and Katharine Pleydell-Bouverie were seen by the critics as abstract artists, celebrated for the pure forms of their stoneware and the subtle effects of their wood ash glazes (Figs 27, 29).[40] Michael Cardew, on the other hand, was hailed both as the guardian of the English slipware tradition (Fig. 30) and as a Gauguin manqué living in poverty in Gloucestershire (Fig. 28). He was certainly difficult, an abrupt handsome figure, brimming with disdain for a London art world which intermittently courted him.[41] Leach himself was less famous than we might suppose during the 1920s and 1930s. He was admired by the same collectors and curators who bought Murray's pots. He had fewer connections in the fine art world than Murray. But he presented himself first and foremost as an Occidental who understood the Orient, constantly setting the aesthetics of the Far East against the materialism and superficiality of the West. His thinking appealed to his key patrons between the wars, the wealthy idealistic Elmhirsts of Dartington, and they funded Leach while he wrote *A Potter's Book* during 1938–9. Its publication in 1940 was timely. His sweeping rejection of industrialisation, his promise of spiritual enlightenment and his confidence about aesthetic standards went far beyond the step-by-step didacticism of a how-to-do-it book. Instead Leach offered the promise of a spiritually fulfilling way of life. For those in search of certainties *A Potter's Book* became a bible for a war-torn generation and after the Second World War Leach began to seem like the founder of the studio pottery movement. Murray's work and ideas slipped from view.

The men and women in Leach and Staite Murray's circles had a sharply defined vision of what constituted studio pottery. Their elevated discourse was dominated by the act of throwing on the wheel which was granted semi-mystical status. Both Leach and Murray liked to assert that 'a pot is born rather than made'.[42] The critics, as we have seen, drew frequent attention to the abstraction of thrown pots and it was this branch of studio pottery which dominated the famous collections made by Eric Milner-White,[43] Henry Bergen[44] and George Eumorfopoulos and the purchases made by the Victoria and Albert Museum.[45] The two canonical surveys of the studio pottery movement, George Wingfield Digby's *The Work of the Modern Potter in England* (1952) and Muriel Rose's *Artist Potters in England* (1955) also remained loyal to what Leach came to call in *A Potter's Book* 'the Sung standard'.

George Wingfield Digby (curator and subsequently keeper in the Textile Department of the Victoria & Albert Museum) and Muriel Rose (founder of the inter-war Little Gallery) helped give studio pottery an identity which also excluded any kind of collaboration with industry. Neither discussed the work of Alfred and Louise Powell, who worked and exhibited throughout the interwar years. The Powells are interesting because they continued aspects of the Arts and Crafts project, particularly a concern for the creative satisfaction of a less privileged work force, into the 1930s. Their decorative language owed something to the art potter William De Morgan but it was more reticent, a precise and lyrical version of pastoral, based on the study of wild flowers and plants (Fig. 31). Both possessed many craft skills. Alfred Powell, like Henry Wilson, had been trained as an architect in the office of John Dando Sedding, an architect with a supreme sensitivity to workmanship and materials. From 1903 Powell specialised in creating designs for Wedgwood to be painted under-glaze on the firm's pottery blanks. In 1906 he married Louise Lessore and from then on they worked as a team, training women to paint their designs freehand in factory conditions at Wedgwood, thus

30. Michael Cardew, earthenware bowl with a slip 'fountain' decoration. *c.* 1937. d. 37 cm. (Photography courtesy of the City Museum and Art Gallery, Stoke-on-Trent).

'uncovering the love of beauty-in-work.'[46] The mystical musings of Leach or Murray would have irritated the Powells. Their avowed aim was 'freshly inventive and delightful crockery, as full of fancy as a wood of leaves.'[47] Both in the Cotswolds and at Stoke-on-Trent they sought to encourage creativity among all classes of men and women.

The Powells were greatly admired by another important potter with industrial links. Dora Billington had grown up in Stoke-on-Trent, her grandfather and father had been associated with the potteries and she had trained at Hanley School of Art, and then at the Royal College of Art where she took over as instructor on the death of Richard Lunn in 1915. In 1919 she started teaching at the Central School of Arts and Crafts in the School of Painted and Sculptured Decoration and by 1936 was giving lectures on pottery materials and chemistry that were so precise and helpful that Murray's students from the Royal College flocked to hear them.[48] In 1937 she published *The Art of the Potter* which argued for a homegrown or European tradition. She had little time for Orientally inspired stoneware, preferring the Powells' decorated wares and enjoying Vanessa Bell and Duncan Grant's 'spirited experiments' in maiolica.[49] She designed for industry as well as working in her own studio, arguing for the unity of ceramic practice. Her real influence was felt as a teacher at the Central School. After the Second World War her anti-Orientalism bore fruit, taking the form of a maiolica revival among her more gifted students. They celebrated the ceramic arts of Southern Europe and Picasso's wartime experiments with clay and combined throwing and hand-building to create light-hearted figurines more suitable for the coffee bar than the museum or the collector's cabinet.

Between the wars some studio potters had made figurines. The Vyses made a series of urban

Madonnas with high cheekbones selling balloons and lavender (Fig. 32). Reginald Wells made ceramic variants of his small bronzes. Many of these inter-war figurine makers were women and because figurines were excluded from Wingfield Digby and Rose's accounts of the history of studio pottery these women were retrospectively marginalised.[50] A period eye is needed here. Reginald Blunt's *Cheyne Book of Chelsea China and Pottery* of 1924 makes it plain that figurines had their own band of admiring collectors in the inter-war years. Some collectors bought both figurines and studio pots. The ceramics purchased by the architect Sydney Greenslade for the immensely wealthy Davies sisters of Gregynog included 'art' and 'studio' pottery and figurines.[51] Gwendolen Parnell's characters from Sheridan's *School for Scandal*, Stella Crofts's animals, Madeline Raper's minaturised tudor cottages and Harold and Phoebe Stabler's garlanded putti riding bulls modelled for Carter, Stabler & Adams at Poole were often exhibited alongside pots by Leach, Murray and their pupils.

In 1925 the art critic Frank Rutter reviewed the British ceramics shown at the Paris Exposition of that year. He had been founder of the Allied Artists Association, the radical director of the Leeds City Art Gallery from 1912 until 1917 and had organised the 1913 Post-Impressionist and Futurist exhibition at the Doré Galleries which had included the most wide-ranging group of European modernist art yet seen in London.[52] Rutter praised pots by Reginald Wells and Leach but he reserved his greatest admiration for the 'daintiness of invention and execution' of figurine makers like Gwendolen Parnell, Harry Parr and the Vyses.[53] This seems surprising. Both his response and inter-war buying and exhibiting patterns suggest that studio ceramics encompassed a more varied practice than the later histories of the movement allow – even if ultimately the thrown abstract vessel came to represent modernism in ceramics. *The Times* art critic Charles Marriott was voicing a consensus in 1943 when he argued that there were no British sculptors to compare with Brancusi but that 'pottery is, precisely, abstract sculpture' and that here British artists were proving themselves 'second to none'. In 1946 W.B. Honey, the then Keeper of Ceramics at the V&A, explained of a series of

31. Tall vase decorated by Alfred Powell. h. 30 cm; porcelain Wedgwood mug decorated by Alfred Powell, bought by Sydney Greenslade for the Misses Davies in 1921, h. 8 cm; charger decorated by Louise Powell, bought 1928. d. 32 cm. (University of Wales, Aberyswyth. Photo Neil Holland).

32. Charles and Nell Vyse, *Barnet Fair*, first produced 1933, earthenware, slipcast and joined, h. 24.2 cm. (Collection Richard Dennis. Photo David Cripps).

33. The Weaving School for Crippled Girls stall at the Red Rose Guild exhibition of 1936. (Holburne Museum and Crafts Study Centre, Bath).

early pots ranging from pre-dynastic Egyptian to nineteenth-century English country pottery: 'They are compositions in line and mass and as such are examples of what is usually called abstract art.'[54] Finally, after the war, T.S. Eliot, a director of Faber & Faber, which published the writings of Honey, Leach and Read, put a discussion of the pure form of pottery and its superiority to painting and sculpture at the heart of his play *The Confidential Clerk*.

TEXTILES

By the 1920s studio ceramics had an identity rooted in early modernist aesthetics. So too had textiles. The spectacular neo-primitivism of inter-war hand-weaving and hand block-printing contrasts sharply with the fineness and complexity of their Arts and Crafts equivalents. And the success of the inter-war craft textile movement altered the gender balance in the craft world in favour of women as creative innovators. But in one important area textile activity had its roots firmly in the late nineteenth century. Of all the crafts, textiles dominated philanthropic projects organised by upper-middle-class women with the dual aims of providing work and preserving old skills.

The political implications of the survival of craft philanthropy into the twentieth century will be explored in Chapter Three, but, in fact, such projects were less remote from innovative craft textiles than might be supposed. The Weaving School for Crippled Girls at Stratford-upon-Avon (Fig. 33), Fisherton de la Mere Embroideries made by disabled ex-servicemen and a host of other charitable enterprises showed alongside experimental work at craft exhibitions and in craft shops between the wars. Yet it is difficult not to feel uneasy about the juxtaposition. The Swiss textile designer Marianne Straub, who made her career and home in England, was once asked why, despite her close relations with Ethel Mairet, she chose the hurly burly of the textile industry in preference to a studio workshop. She explained that she had been crippled by tuberculosis as a child and thereafter associated hand-weaving with vocational training for the disabled.[55]

Looking at the textile scene in England in the mid-1920s through the eyes of Helen FitzRandolph and Doriel Hay, two field workers surveying rural industries for the Oxford Agricultural Economics Research Institute, it is easy to see what Straub meant. Many textile enterprises employed the most vulnerable members of society – the disabled, epileptics, the blind, and, after World War I, wounded and shell-shocked ex-servicemen. FitzRandolph and Hay visited the Stratford Weaving School for Crippled Girls founded in 1913 where residents worked a seven-hour day handweaving lengths of tweed.[56] They visited the Cambridge branch of the Artificers' Guild where under the direction of Florence Eley, herself handicapped, men and women with special needs were trained to weave, but not design, a range of fabrics.[57] They reported on the 'Semington Homespuns' produced by the Trowbridge Institute for Feeble Minded Girls which sold at five shillings per yard, undercutting other craftwork.[58] FitzRandolph and Hay found that creativity was not encouraged in these places and that low pay was endemic. Lace-making was the most extreme example. The desire for 'authenticity' meant that originality and development by individual lacemakers working for the philanthropic Lace Associations of Bedfordshire, Buckinghamshire, Northamptonshire and Devon were strongly discouraged. In addition the craft was assumed to be both therapeutic and pleasurable. But as FitzRandolph and Hay noted: 'no one was found making lace for her own pleasure or own use. Laceworkers generally appeared, to judge from their surroundings, to be the poorest inhabitants of the village.' The Oxford researchers concluded that: 'lace making is either a sweated industry, practised only by the most needy, or a delightful hobby for leisured people whose time is not reckoned in terms of the necessities of life.'[59]

On their travels FitzRandolph and Hay visited Haslemere in Surrey. Workshops employing local women had been set up in 1894 by Maude King and her husband Joseph, a wealthy barrister, and Maude's sister Ethel and her husband Godfrey Blount, a creative Slade-trained eccentric with a passion for Ruskin, Tolstoy and Kropotkin.[60] Blount and his wife started up a Peasant Arts Society and by 1900 they had founded the Fellowship of the New Crusade which preached the revival of handicrafts, 'country life and country labour', folk music and dance.

The New Crusade formed the spiritual background to the various crafts practised by the Blounts and the Kings and their employees – with the Kings' Haslemere Weaving Industry producing plain and coloured linens, plain and striped cotton and some figured weaving designed by Blount. The Peasant Arts Society founded by the Blounts specialised in bold naively figurative appliqué embroidery on linen designed by Blount and known as 'Peasant Tapestries', together with hand-knotted rugs, ironwork, plasterwork, bookbinding, lino-cuts and wood carving (Fig. 34).

All these goods were sold from 1901 at the Peasant Arts Society's London outlet at 8 Queens Road, Bayswater and the Haslemere Weaving Industry was still trading in 1931.[61] 'Peasant Arts' brought fame to Haslemere and attracted other weavers. Luther Hooper arrived in 1901, setting up his Green Bushes Weaving House with his son and three weavers from Ipswich producing damasks, brocades, velvets and carpets until 1910. From 1902 Edmund Hunter and his St Edmundsbury Weavers made luxurious silk brocades for an ecclesiastical market on Jacquard looms before moving to Letchworth in 1908. In 1922 two members of the local gentry, Ursula Hutchinson and Hilda Woods, founded Inval Weavers after training in spinning, dyeing and weaving in Ditchling with Ethel Mairet. By 1924 they employed three village girls and a dressmaker who needed all her skills to tailor their loosely woven lengths into skirts and jackets.[62] All this sounds like a pleasing example of rural reconstruction. The Blounts and the Kings, however, had a semi-feudal attitude to the crafts, wanting to control the taste of country people who would be guided towards making 'wholesome things in simple ways'.[63] Their collective dislike of the city and its organised workforce suggests that there was a repressive, political edge to their activities.

If women ruled the world of philanthropic textile enterprises, sometimes with a rod of iron, the most creative end of the hand-spinning, dyeing, weaving, hand block-printing and embroidery world was also dominated by women. Like the aristocratic philanthropists they too tended to rely on cheap labour – employing village girls as well as taking on paying gentlewomen as pupils. But the atmosphere of creativity in these workshops was a good deal more chaotic, improvisatory and joyful. Many of these creative women had trained as painters in London art schools in the first two decades of the century. In a male dominated Edwardian and Georgian art world few women sustained full successful careers as painters or sculptors. The crafts offered the possibility of greater artistic equality and a broader definition of artistic practice. There were good male/female artistic partnerships (like Thérèse Lessore and her first husband Bernard Adeney, Eve and William Simmonds or Vanessa Bell and Duncan Grant) as well as examples of patriarchal obliteration of female talent (Thérèse Lessore and her second

34. St Cross, Haslemere, the Blounts' weaving and appliqué embroidery workshop illustrated in the *Art Journal* 1906.

35. Ethel Mairet weaving at the Norman Chapel, Broad Campden in about 1909–10. (King's College Library, Cambridge).

36. Ethel Mairet, jacket with an indigo collar in plain weave, vegetable-dyed eri silk with buttons made by her brother Fred Partridge. Early 1920s. l. 64 cm. (Holburne Museum and Crafts Study Centre, Bath. Photo Artis Inc.).

husband Walter Sickert) in our period. Nonetheless the women who achieved the most tended to move sideways from the fine arts into the crafts, many of them into textiles. These women were responsible for bringing together modernism and the crafts, thus transforming the identity of the Arts and Crafts Movement.

In the case of hand-weaving it is tempting to see Ethel Mairet (Fig. 35) as the catalyst for the entire creative movement.[64] She was born in 1872 in Barnstaple, North Devon, the daughter of a Non-Conformist dispensing chemist. Both Ethel and her brother Fred Partridge went to art school, Ethel in Barnstaple and Fred to Birmingham Municipal School. In 1902 Fred joined C.R. Ashbee's Guild of Handicraft but little is known of his sister's life between 1891 and 1902. At some point in the 1890s she studied music and worked as a governess in London and Bonn. In 1902 she was back in Barnstaple and there she met a wealthy young Anglo-Ceylonese geologist Ananda Coomaraswamy while fossil hunting on the beach. They married in June 1902: he was twenty-five and she was thirty years old. Her independent early life had culminated in an unusual mixed-race marriage which was to last only eight years but which had great bearing on her artistic development. Perhaps it is worth noting that both she and her brother Fred were strikingly good looking and unusually dressed. They looked and lived as the embodiment of early modern freedoms.

From 1907 till 1911 Ethel and Ananda were settled at Broad Campden in Gloucestershire, drawn there by Fred Partridge's connection with the Guild of Handicraft. The subsequent years, with weaving studios at Shottery near Stratford-upon-Avon and from 1918 at Ditchling in Sussex, were devoted to research into vegetable dyes and yarn quality. She brought out *The Future of Dyeing* in 1915, read with interest by May Morris, and *A Book on Vegetable Dyes* in 1916. Most important of all, she rejected pattern design and the careful drafting of designs on point paper in favour of plain weaving (Fig. 36). Much of her inspiration was derived from non-industrial cultures, from the colours and textures which she had observed in Ceylon and India during geological study trips in 1903–6 and 1910 with Coomaraswamy and on subsequent visits to study the indigenous crafts of Yugoslavia and Scandinavia.

In 1918 Ethel wrote *An Essay on Crafts and Obedience* with her second husband Philip Mairet. They argued for a Christianised sense of service and, in the face of commercialism, the

maintenance of a workshop tradition. Philip Mairet was a young artist who had been employed as a draughtsman by Ashbee at Chipping Campden and whom Ethel married in May 1913, separating stormily in 1930. By the time her marriage to Mairet had ended Ethel had developed a coherent, sophisticated craft philosophy. The couple's catholic range of friendships remained a positive influence. Patrick Geddes, the Edinburgh biologist who made city planning a sociological discipline, was one shared hero. The other was Geddes's disciple, the American historian Lewis Mumford. He helped shape Ethel Mairet's thinking in a more direct way. The broad sweep of his syncretic work *Technics and Civilisation* of 1934 was optimistic and precise about the future of handcraft. Mumford predicted a neo-technic era in which electricity produced by new clean energy sources like wind and waves would power machinery employed communistically for the good of all. Basic production of goods would be efficient while cheap 'green' energy sources would power subsidiary small experimental workshops. In this Utopia handicraft workshops would play an important role in experimentation for machine production.

37. Complex weaves from the Gospel workshop Sample Books III, VI and XII. (Holburne Museum and Crafts Study Centre, Bath. Photo Artis Inc.).

38. Elizabeth Peacock spinning. (Holburne Museum and Crafts Study Centre, Bath).

Technics and Civilisation became Ethel Mairet's key text. Mumford's vision seemed less far-fetched when Mairet travelled to Scandinavia and Germany and made contact with European weavers, designers and architects. In 1933 she had met the handloom weaver Elsa Gulberg in Stockholm and was impressed by her fruitful collaborations with industry. In the same year Marianne Straub, the Swiss textile designer who had had both a Bauhaus-inspired craft training in Switzerland and an industrially based technical training in Bradford, visited and stayed at Gospels, Mairet's home and workshop at Ditchling. Straub introduced more complex weaving into the workshop (Fig. 37). By 1934 Mairet declared her position to the Guild of Weavers, Spinners and Dyers, arguing that in a machine age handloom weaving should primarily be a resource of experimental ideas for mass production.[65]

Mairet's pupils were, ironically, often more skilled than her. But they lacked her gift for self-publicity and her desire to find a modernist context for handweaving. In contrast they inhabited a mysterious world where achievement was measured differently, where the economics did not add up and where the actual *matière* has often vanished or been eaten by moths. Hilary Bourne, who briefly trained with Mairet and whose career developed after the Second World War, succinctly elucidated the art and technics that divided male and female weavers. Male weavers might be good technically, she argued, but they tended 'to weave like machines'.[66] For women research was as important as results. Thus we have a figure like Margery Kendon. She was acclaimed in Mairet's circle for her deep understanding of spinning, weaving and knitting learnt travelling on the margins – in Wales, Ireland, remote parts of continental Europe and in Egypt – and recorded in marvellous letters sent to members of her circle. Her friend Thomas Hennell, the artist and recorder of country crafts, saw her as the Cecil Sharp of textiles, collecting skills and techniques like folk songs.[67] By the 1970s she seemed to Alan Crawford, Ashbee's biographer, to be a 'frail old maidish sort of person'[68] and indeed Kendon was the kind of woman who might have simply stayed at home in Kent as an unmarried daughter and aunt. In fact all through the 1920s and 1930s she was adventurous, travelling throughout Europe and beyond; textiles gave her spaces to explore and a measure of fame within a rarefied circle.

Kendon's friend Elizabeth Peacock (Fig. 38) was similarly liberated by her craft.[69] She had remained a semi-invalid at home until in 1916 at the age of thirty-six she suddenly defied her family and joined Ethel Mairet's first workshop at Shottery in Stratford-upon-Avon. Suppose she had lacked the courage? Radcliffe Hall's novel of 1924, *The Unlit Lamp*, sets out the consequences. The heroine Joan is too fearful to leave her tyrannical mother and ends her days caring for a capricious mentally handicapped old uncle.[70] Peacock's life story worked out better. She moved with Mairet to Ditchling and found a life long companion in Molly Stobart, the daughter of a local landowner. By 1922 Molly's family had built them a home, 'Weavers', and provided a smallholding at Clayton under the South Downs, with Peacock's brother contributing a workshop across the yard.

Elizabeth Peacock was a purist weaver with great expertise. She studied the regional variations of English wools. She watched Mrs Murray, a Shetlander who worked as a housekeeper near Clayton, for long evenings until she understood the principle of spinning wool. Unlike Mairet she learnt how to finish cloth properly so that it retained its shape. In 1931 she co-founded the Guild of Weavers, Spinners and Dyers whose magazine became the chief forum for debate within the weaving movement. In 1939 she went on a research trip to Brittany with a young teacher Ella McLeod to study linen spinners and weavers. From 1940 until 1957 she taught at Reigate School of Art. She was quietly famous. King Feisal of Egypt bought her lengths of handwoven cotton. Her shawls and dress lengths were bought by Schiaparelli. She was also ambitious artistically; the sequence of eight banners commissioned by Dorothy Elmhirst for the Banqueting Hall at Dartington, woven from 1930 until 1938, suggests her genius for abstract design on a large scale (Fig. 39). She also made links with Luther Hooper's circle of drawloom weavers, mostly living in West London, where a number of craft weaving enterprises had existed since the late nineteenth century.

They form another grouping and one with which Mairet would have had little in common

39. (*opposite*) Elizabeth Peacock, *Building*, 1930–8, weft inlay wool banner for the Banqueting Hall on the Dartington Estate. 240 × 102 cm. (Dartington Hall Archive. Photo David Cripps).

40. Alice Hindson, the frontispiece for Luther Hooper, *The New Draw-Loom*, Sir Isaac Pitman and Sons Ltd., 1932.

because all drawloom designs have to be worked out precisely on point paper. Hooper placed the highest value on the skill of seventeenth- and eighteenth-century male pattern weavers whose draw looms, operated by a weaver and a drawboy, were swept away by the invention of the Jacquard loom. In about 1924 Hooper invented a mechanism which enabled the weaver simultaneously to weave and to 'draw' or pull forward the cords that created the pattern.[71] Alice Hindson, Christine Hunter, Ursula Cooper, Aristide Messensi and Dorothy Wilkinson all took up drawloom weaving in the late 1920s with Hindson in particular producing attractive weaves with busy Scandinavian patterning (Fig. 40). But although there were a great many skills to be found in West London between the wars, from Miss Grassett's London School of Weaving in Bryanston Square to Dorothy Wilkinson's Kensington Weavers at 136 Kensington Church Street,[72] nothing could match the informal collaboration between Mairet and Straub for weaves that emphasised texture and structure.

Handloom weavers had a tendency to get lost in the intricacies of their craft. Hand block-printing on textiles was potentially an immediate, expressive medium. In the 1920s the technique was exploited by a remarkable group of women who had mostly trained as painters. These included Phyllis Barron, at the Slade from 1911, Dorothy Larcher, who trained and subsequently taught at Hornsey School of Art between about 1901 and 1905, Enid Marx, trained at the Central School and at the Royal College of Art from 1922 to 1925, who joined Barron and Larcher's joint workshop in 1925, Frances Woollard (Barron's partner from 1922 to 1923 and thereafter working independently) and the circle of women, many trained in wood-engraving at the Central School of Arts and Crafts, associated with the Hammersmith workshop Footprints and with the shop Modern Textiles trading in Beauchamp Place from 1926.[73]

Phyllis Barron appears to have been the pioneer in the hand block-printing movement. 'Victorianally, conventionally brought up'[74] in some style, Barron had a minimal school education, speaking good French but barely able to spell. In 1905, aged fifteen, she was taken by her elder sister on a painting holiday in Normandy where their tutor Fred Mayor bought some wood blocks with which she tried to print on paper and glass and finally, and decisively, on fabric. She went on to study painting at the Slade School in 1911, continuing with a parallel quest into textile printing, dye stuffs and dye-fixing. Like Ethel Mairet she pursued her craft in an essentialist spirit, consulting unlikely sources such as the process descriptions in the Patent Office and relying on an eighteenth-century handbook, Edward Bancroft's *The Philosophy of Permanent Colour*. Initially she kept away from the real expertise in the textiles industry. (For instance no visits were made to Morris & Company's Merton works to see indigo discharge printing). Barron read Mairet's *A Book of Vegetable Dyes* (1916) soon after it came out, finding inaccuracies. By then she had taught herself indigo discharge, and dyeing with cutch and iron to yield a brown and a black. In Mairet's book she discovered ironmould, a rusty yellow. She began to cut her own blocks. The first, *Log*, cut in about 1915 or 1916, was a jagged Vorticist design (Fig. 41).

Reading between the lines of her modest autobiographical lecture *My Life as Block Printer* it becomes apparent that Barron was close to the heart of London's avant-garde during the First World War. She was a member of the London Group from 1916 until 1921 and therefore in contact with the most progressive painters and sculptors in the British art world – among them members of the former Camden Town Group, the Vorticist group and a younger grouping from the Slade including Paul Nash and the sculptors Jacob Epstein and Henri Gaudier-Brzeska. The London Group was important because it was the first avant-garde exhibiting society to include a sizeable number of women – including Thérèse Lessore, Jessie Etchells, Sylvia Gosse and Ethel Sands.

In 1917 Barron had her first textile exhibition in the studio of Boris Anrep, a fellow London Group member. Roger Fry encouraged her and invited her to work at Omega. That she declined is of interest – she wanted to get on with her own research and she may have taken advice from Paul Nash, a fellow Slade student who had spent three unsatisfactory weeks at Omega in 1914,[75] or from the painter Bernard Adeney, who had been included in Fry's Second Post-Impressionist Exhibition in 1912 but by 1915 was exhibiting with the Vorticists.[76] His wife, Thérèse Lessore, was a close encouraging friend and from about 1916 Barron shared a house with them on Haverstock Hill, Hampstead and visited them in Tunley in

42. *Flying Cloud*, the Duchess's sitting room looking to port forward, 1923. Note the brass rods to secure the tables in rough seas. All loose covers and curtains designed and printed by Phyllis Barron. (Country Life Picture Library).

43. Phyllis Barron as a young woman in 1926. (Vogue/Condé Nast).

Gloucestershire[77] where she established other Cotswold links – with Eve Simmonds and with Louise (Thérèse Lessore's sister) and Alfred Powell.

In 1920 Barron showed some block-printed textiles in the 12th London Group show but the following year she resigned and devoted herself completely to textiles. In about 1923 she met Dorothy Larcher.[78] Their networks intertwined. Larcher also had Cotswold and Arts and Crafts connections. She had been at Hornsey School of Art with Philip Mairet from about 1901 and her greatest friend at Hornsey, Alice Richardson, eloped dramatically to India with Ethel Mairet's first husband Ananda Coomaraswamy in 1910. In that year Larcher also went to India as the paid assistant to Christiana, Lady Herringham. The two women spent the winters of 1909–10 and 1910–11 in a remote encampment recording the wall-paintings in the dark, bat-infested Ajanta caves. In these difficult conditions Larcher traced exquisite details of leaves, birds and flowers in outline and she appears to have stayed on in India after Lady Herringham's return to England in the spring of 1911.

The decade in India remains mysterious and undocumented – apparently Larcher taught English in Calcutta and learnt a little about Indian block-printing, only returning to England in 1921. But by 1923 she had supplanted Barron's working partner Frances Woollard, helping Larcher complete the first of many prestigious commissions for curtains and upholstery for *Flying Cloud*, the yacht owned by the fabulously rich Bendor, 2nd Duke of Westminster which was being refitted by the architect Detmar Blow (Fig. 42).[79] The Westminster connection was important. In one, admittedly exceptional, year Barron was paid £1490 for commissions. From 1923 Barron and Larcher exhibited, worked and lived together. Barron was tall and, as a young woman with an Eton crop, strikingly handsome (Fig. 43). Larcher was more delicate, more withdrawn. They shared Barron's dye expertise but each designed their own blocks – putting one a fortnight into production by the mid-1920s (Figs 44, 45). They printed on a surprising variety of materials – from the grey linen prison sheets Barron bought in the Caledonian Market to velvets, *crêpe-de-chines* and silk brocades. In 1925 they took on another gifted painter, Enid Marx (Fig. 47).[80] In 1927 she set up her own workshop and went on to produce on a much broader front than Barron and Larcher, designing a moquette for the London Underground in 1937, book jackets, book illustrations and stamps as well as writing three books on English popular art with her life's partner, the historian Margaret Lambert.

Painting in England in the 1920s largely retreated into still-life and landscape, but the work

44. (*above left*) Dorothy Larcher, *Large Feather*, hand block-printed linen. A variant of this design was used for the Combination Room at Girton College, Cambridge in 1932. (Holburne Museum and Crafts Study Centre, Bath).

45. (*above*) Phyllis Barron, *Small Captain*, hand block-printed linen. Barron created this design in about 1925 for Captain Cooper of the Duke of Westminster's yacht *Flying Cloud*. (Holburne Museum and Crafts Study Centre, Bath).

46. (*below left*) Ben Nicholson, *Princess*, hand block-printed cotton. A variant using one of the two blocks which make up this design hung in Herbert Read's Hampstead home. See Fig.136 (V&A Picture Library).

47. (*below*) Enid Marx, *Nig Stripe*, hand block-printed linen. This design was exhibited in *Artists of Today*, Zwemmer Gallery, 1933. What would be an unacceptably racist title today had a rather different resonance in the early 1930s, suggesting Marx's knowledgeable admiration for African textiles. (Holburne Museum and Crafts Study Centre, Bath).

of Barron, Larcher and Marx kept faith with the adventurousness of early English modernism. Roger Fry, in a 1926 review of a Barron and Larcher show at the Mayor Gallery in London, wrote with wonderment of the vitality of their prints and 'that quality of *matière* which has nothing to do with complexity of pattern, is, indeed most evident in the simplest forms'. There were other block-printers – like the group associated with the Hammersmith workshop Footprints (Fig. 131), founded by Celandine Kennington in 1925, and managed by Joyce Clissold from 1929 until the Second World War and beyond. As a designer Clissold lacked Barron and Larcher's colouristic restraint (the workshop used analine dyes) and her modernity was an entertaining variant on *art moderne*. By the early 1930s there were many women (and a few men) block-printing textiles but none matched Barron, Larcher and Marx's gift for pattern-making and their sensitivity to colour and texture.

Other painters and sculptors were also to experiment with the technique. Paul Nash, in particular, recognised block-printing as a new art form. From 1926 he was closely involved with Elspeth Anne Little's shop Modern Textiles, suggesting its name and designing its letterhead. Little printed some of his designs as did the Footprints workshop and, from 1929, Cresta Silks – but Nash was never happy with the results. Instead he greatly admired Phyllis Barron, 'an ideal worker' who designed, cut her own blocks and made her own dyes.[81] In 1933 Ben Nicholson and Barbara Hepworth exhibited crudely printed hand block fabrics (Fig. 48) at the Lefevre Galleries[82] and in the late 1930s his sister Nancy Nicholson, who in 1929 had set up her own hand block-printing workshop Poulk Prints, took over his blocks. His brother Kit's wife, the painter E.Q. Myers, experimented first with the fashionable craft of batik and in 1936 began hand block-printing. Similarly the sculptor Frank Dobson and his wife May worked as a team printing bold simple designs from around 1938. The Nicholsons' and the Dobsons' block prints share something of the immediacy of Barron and Larcher textiles.

Some designers did not seek the neo-primitive effects characteristic of Barron, Larcher and Marx's prints. The firm of Cryséde, founded in 1920[83] by the painter Alec Walker, was more like a small factory where Walker's designs were block printed on his family firm's Vigil Silk. On a 1923 visit to Paris Walker met Dufy and Zadkine, abandoned the dot, spot and check patterns he had been using and had Dufy-esque blocks made of his own watercolour sketches. A much admired show of Walker's textiles at the Independent Gallery in 1925 revealed the sources of his inspiration; with fabrics entitled 'Russian Ballet', 'Primitive', 'Dancer', 'Grotesque'. By 1933 Cryséde had twenty-two retail branches, mostly in the South of England, and a shop in Sloane Street, London. Cresta Silks,[84] set up by Walker's former manager Tom Heron in 1929 at Welwyn Garden City, similarly combined modern designs and presentation (the Cresta shops, letterheads and packaging were designed by Wells Coates) and hand block-printing. Artists like Paul Nash were commissioned to provide designs for these fashion silks. But the printing was contracted out and in general there was less control over the end product.

Allan Walton, an interior decorator and painter who also owned a family print works,[85] was another figure working closer to industry than to the crafts. Allan Walton Textiles, founded in 1930, employed fellow artists like Duncan Grant, Vanessa Bell, Frank Dobson, Cedric Morris and Bernard Adeney to provide designs. Nash records that Walton had a block cutter able 'to interpret, instead of copy the vagaries of the painter's technique'.[86] But by 1933 Walton had switched to screen printing, a new process which was able to capture the painterly qualities of a design and therefore made fewer demands on artists whose understanding of the disciplines of pattern design tended to be limited. Unlike Barron and Larcher, Walton had no particular loyalty to a specific process. Screen printing was ideal for short runs of individual designs intended for Walton's interior decorative schemes that ranged from eighteenth-century revival to neo-baroque. Barron and Larcher's heightened sensitivity to process did not survive the Second World War except in the work of their disciple Susan Bosence.

Block-printed textiles had a part to play in the modern interior in the late 1920s and early 1930s. This was also true of the abstract rug, often commissioned by the architect or interior decorator. Omega had led the way with rugs designed by Vanessa Bell, Roger Fry, Frederick

Etchells and Duncan Grant. The abstract rug was versatile, appropriate for sparse Modernist interiors as well the corridors of Arts and Crafts houses like Ernest Barnsley's Rodmarton Manor. Jean Orage, theosophist and estranged 'lover comrade' of A.R. Orage, had showed tapestries at the 1925 Paris exhibition and by 1929 was weaving abstract rugs in Chelsea which were admired by Paul Nash.[87] Jean Milne designed and made abstract rugs, some combining flat weaving and tufting which were produced by crofters under the trade name Shiant on the Isle of Skye (Figs 170, 217), while Theo Moorman wove kelim type rugs and wallhangings for Heal's from 1928 to 1930 before joining Warners in 1934.[88] But the dominant figure, dubbed by Dorothy Todd 'the architect of floors' was Marion Dorn.[89] She, after a brief spell as a batik artist, designed but did not make. Her most impressive rugs were designed for specific spaces such as Oliver Hill's Midland Hotel, Morecambe completed in 1930 or the music room designed by Brian O'Rorke for Mrs Solomon in 1932. Dorn and architects like Serge Chermayeff, painters like Francis Bacon and graphic designers like Dorn's husband Edward McKnight Kauffer all designed rugs which, handtufted by carpet manufacturers, hardly required the skills of hand-weavers.[90]

One area of textile practice remained firmly in an Arts and Crafts phase. The tapestry studio at Morris & Company's works at Merton had re-opened after the First World War. A repeat of two of the Holy Grail series, peopled with mournful chivalric figures drawn out by Edward Burne-Jones, was being woven between 1929 and 1932 and a version of his Pomona tapestry as late as 1937.[91] Merton tapestries never broke free from complex narrative scenes and after the deaths of Morris and Burne-Jones designs became increasingly banal. Belatedly inspired by Morris, the fourth Marquess of Bute established the Dovecot Studios outside Edinburgh in 1912 with two master weavers from Merton. This was an aristocratic exercise in romantic nationalism funded by immense profits from mining and quarrying. The thirty-two-foot-long *Lord of the Hunt* (started in 1912, interrupted by World War I and completed in 1926) and the slightly smaller *Prayer for Victory, Prestonpans*, painstakingly and lifelessly designed by Skeoch Cumming, depicted an imagined Jacobite and Highland community of good fellowship and hung in Bute properties. The unfinished *Raising of the Standard at Glenfinnan* was wisely not completed after World War II and can still be seen forlornly on the loom in the Dovecot Studios (Fig. 48).[92]

Dovecot was one man's fancy and in any case 'went modern' after the Second World War. But textiles and fantasy were braided together in Scotland. The classification of clan tartans and the image of the independent, fulfilled crofter weaving tweeds in the Western Isles are both aspects of an inventiveness about Highland history and culture.[93] Lively Scottish design and craft are better represented by embroidery as taught from the mid-1890s at Glasgow School of Art by

48. Dovecot Studios, *Raising of the Standard at Glenfinnan*, high loom tapestry, 384 × 571 cm. Designed by William Skeoch Cumming, put on to the loom in 1938, never completed. (Edinburgh Tapestry Company).

49. Eve Simmonds, dark brown linen waistcoat embroidered with cream. l. 52.1 cm. (Holburne Museum and Crafts Study Centre, Bath).

50. Ethel Nettleship, two lengths of lace photographed for the exhibition *Modern British Crafts*, toured by the British Council in the United States and Canada in 1942–3. (The British Council Collection).

Jessie Newbery and her successor Ann Macbeth.[94] From 1894 Newbery emphasised design over painstaking stitching and encouraged the use of cheaper materials and appliqué. Embroidery was given a place in the Scottish higher education system and Macbeth pioneered its imaginative teaching in schools, helping initiate the Needlework Development Scheme which from 1934 circulated parcels of inspirational work around schools in Britain and the colonies.

Glasgow embroidery should be set against the work of May Morris whose exquisite floriated designs influenced highly skilled embroiderers like Grace Christie, who taught at the Royal College of Art from 1909 to 1921. The younger Cotswold-based painter Eve Simmonds and the artist and china decorator Louise Powell continued this tradition with embroidery

which suggested flower-filled Elysian fields (Fig. 49). Glasgow stood for a different approach which was developed in the 1930s by women like Rebecca Crompton, Mary Hogarth and Marian Stoll. As Stoll argued in 1925: 'the idea is the thing, the stitches will come to order when required'.[95] By the 1930s it seemed reasonable that embroiderers should try to express 'the confusion of modern life' as Mary Hogarth advised.[96] Ethel Nettleship, Augustus John's sister-in-law, exhibited coarse lace of bold design (Fig. 50). Rebecca Crompton discovered that the sewing machine could be 'a useful tool in the hands of modern embroiderers' (Fig. 171).[97] In 1934 Lilian Dring appliquéed some cut-up old coats to create her *Thrift Rug*. By 1939 the Thrift Rug idea fitted into the make-do-and-mend culture of war time (Fig. 222) and Dring was advising teachers in schools: 'Stitches should be kept as simple as possible. I use few but the ordinary sewing stitches – hemming, over-sewing, herring boning, etc. Couching is very useful and easy.'[98]

FURNITURE

Inter-war developments in handcraft ceramics or textiles were not paralleled in craft furniture. The craft furniture story begins in the Cotswolds where in 1893 Ernest Gimson and the brothers Ernest and Sidney Barnsley had started designing and making. Ernest Barnsley concentrated on architectural work from 1905 but Ernest Gimson maintained a workshop of skilled cabinet makers at Daneway House, Sapperton until his death in 1919 while Sidney Barnsley designed and made independently in a thatched workshop in the garden of his house at Sapperton until about 1924. Although chronologically Gimson and Sidney Barnsley's careers largely fall outside the scope of this book, their activities and their milieu remained exemplary (Fig. 51); as late as the 1930s they were still seen, posthumously, as the pioneer creators of 'an authentic twentieth-century style'.[99] As a result, in furniture the Arts and Crafts legacy was extended rather than disrupted.

Craft furniture remained a largely male enterprise. Arts and Crafts ideals had led aristocratic women to set up wood-carving classes and to design furniture which was made in their estate workshops, often in association with the Home Arts and Industries Association. In the 1920s these networks still existed. Lady Plymouth designed furniture to be made on her husband's estates at Hever near Redditch and these were sold in Maria Pitt Chatham's shop, The Cottar's Market in Beauchamp Place, London, together with 'painted artistic furniture'. On a more professional basis Judith E. Hughes trained as a cabinet maker at the Central School of Arts and Crafts in 1933–4 and set up her workshop in the West Country in 1936.[100] But she was very much an exception.

Gimson's furniture continued to be admired partly because it seemed modern in comparison with a wider, safer taste for antiques and reproduction furniture (Fig. 52).[101] After his death, Lethaby, Alfred Powell and the architect and etcher Frederick Griggs put together a collection of lyrical essays full of closures for his followers, setting out the full extent of Gimson's separatism and his anger at urbanism and commerce.[102] No such book appeared to honour Sidney Barnsley after his death in 1926. His principle of working alone, not trusting to any trained cabinet maker whose taste had been undermined by trade practices, became part of the oral history of the craft movement and exerted its own powerful influence.[103]

The context for Gimson and Sidney Barnsley's work could not easily be replicated. At Sapperton all properties were owned or on land owned by Lord Bathurst.[104] Gimson and Sidney Barnsley's furniture reflected the social extremes of this semi-feudal ambience. Grandeur, in the form of elaborate cabinets, sideboards or writing desks (Figs 53, 54), and simplicity, in the form of the turned chairs Gimson learnt to make from Philip Clissett, cut out the typical middle-class clutter of late nineteenth-century drawing-room furniture. Massive chests were preferred to useful occasional tables. There were early Arts and Crafts precedents for these extremes, not least Morris's distinction between 'necessary work-a-day furniture' and 'state furniture'. But the acute borrowings from the fast-vanishing crafts of the wheelwright and from the products of woodland coppicing was new. Chamfered grids for bedheads, plate stands and chair- and sofabacks were inspired by waggon sides (Fig. 55). The

51. Group photograph taken outside Ernest Gimson's Pinbury Cottage in 1895. (*l. to r.*) Sidney Barnsley, Lucy Morley (his future wife), Ernest Gimson (seated), Alice and Ernest Barnsley and their daughters Mary and Ethel. (Cheltenham Art Gallery and Museum).

52. Cabinet of drawers on a stand designed by Ernest Gimson. The whereabouts of this piece are unknown but it illustrates why Gimson continued to be regarded as a modern furniture designer into the 1930s. (Design Council Archive, University of Brighton. Photo Dennis Moss of Cirencester).

53. Grandeur: the showroom at Daneway House on 18 May 1902 showing two of Gimson's fall-fronted cabinets based on the Spanish *vargueño*. Daneway House dates back to the thirteenth century with subsequent additions. It was leased by Ernest Barnsley and Ernest Gimson from Lord Bathurst. (Cheltenham Art Gallery and Museum).

54. (*opposite*) Grandeur: Cabinet veneered in English walnut with gilt gesso panels on an ebony stand, 1902. Designed by Ernest Gimson. 188 × 99 × 48 cm. (V&A Picture Library).

55. Simplicity: settee designed and made by
Sidney Barnsley in about 1919–21 for Eve and
William Simmonds's sitting room at Far Oakridge.
79.7 × 197.9 × 69.5 cm. Their friends Phyllis
Barron and Dorothy Larcher provided hand block-
printed fabric. The chamfered grid sofa back was
inspired by the sides of wooden waggons.
(Cheltenham Art Gallery and Museum).

construction of hayrakes and sculpted forms of axe hafts inspired the design of table supports
and stretchers. Both men had a genius for what we now call transferable technology. The visual
delight these lyrical tropes still provoke could hardly be developed further by the handcraft
furniture makers of the inter-war years.

In addition the small workshops of the inter-war years had to struggle; they were working
in the face of a far harsher economic climate, not least because they lacked the private incomes
enjoyed by Gimson and the Barnsleys. In 1920, after the disbanding of Gimson's workforce,
his foreman Peter van der Waals established a workshop in a former silk mill at nearby
Chalford. He reemployed some of Gimson's cabinet makers and, like Gimson, took on local
boys as apprentices. He brought high standards (and some additional tooling) to bear on
Gimson's legacy. Waals addressed the economics of the workshop rigorously and he installed
a treadle saw and saw bench, a larger circular saw and a mortiser.[105] He also made a greater
range of furniture types. But the aesthetic hauteur which made Gimson seem to Alfred Powell
artistically lonely, but grand in his loneliness, and which led Sidney Barnsley to work single-
handed, could not be sustained. Wisely Waals stayed close and true to his understanding of
Gimson's work and also carried out a few designs provided by Sidney Barnsley. He continued
collaborations with the Powells in which Louise Powell in particular painted flowers of fresh
innocence on chests and cabinets (Fig. 56). None the less a whiff of suburbia hangs about some
of Waals's designs for wardrobes, dressing tables and stick stands. He kept the faith absolutely
but did not develop it.

Edward Barnsley's (Fig. 57) career takes us even closer to the heart of the problem.[106]
Sidney Barnsley, like Gimson, had had an extended education in art and architecture; Edward's
is perhaps best described as a training. Schooling at Bedales kept his idealism intact. From 1919
to 1922 he worked for Geoffrey Lupton, a fellow old Bedalian and a former pupil of Gimson,
on the construction of Gimson's last architectural project, the Memorial Library at Bedales

(Fig. 107). It is significant that Edward made little of a year at the Central School of Arts and Crafts in 1922. His world was bounded by the South Cotswolds and subsequently by the wholesome insularity of the Bedales community.[107] In 1923 he took over Geoffrey Lupton's cottage and workshop in Froxfield, near Petersfield. It overlooks his old school and a great beech hanger which falls steeply away to the south east; it is a Sapperton landscape transposed to Hampshire.

Edward Barnsley's early work was close to the spirit of his father, marked by the use of solid wood, revealed construction, fielded panels and some chamfering (Fig. 58). But he looked out to the wider world of furniture making as it developed in the 1920s and 1930s, discovering *art moderne* and even something of the constructional rigour of true modernism (Fig. 59). After the Second World War he turned to a lightly constructed unadventurous neo-Georgianism. All the time he was preoccupied with the particular kind of excellence in construction and materials which had been cultivated at Sapperton.

A central drama in his workshop was his relationship with Herbert Upton, whom he took on as a boy apprentice in 1924. After the Second World War, Upton, by now a highly efficient cabinet maker who had worked in an aircraft factory throughout the war, wanted to introduce

58. Edward Barnsley, sideboard in English oak. 1930s, 94 × 144.2 × 54.6 cm. (The Edward Barnsley Educational Trust).

labour-saving power tools and methods of working. The conflict between these two men – Barnsley, shy with his workforce, impractical about money, and Upton, level-headed, mechanically minded and a born leader – encapsulates the strains of the class division outside the utopia of Sapperton. Arts and Crafts ideals put the worker first. The men in Gimson, Waals and Edward Barnsley's pre-war workshops made each piece from start to finish. But Upton introduced not only machinery but also the division of labour in order to make the workshop pay. In 1971 Barnsley wrote disconsolately to his friend Idris Cleaver about the introduction of a spindle moulding machine: 'before we bought the machine we had already lost something that only "hand" production can achieve. Things too accurate, too flat, too finished…'[108]

Furniture designing and making had started out as design reform at Sapperton. In the hands of lesser figures it became a question of self-fulfilment. Arthur Romney Green (Fig. 60), an unconventional mathematician, had visited Gimson's Daneway workshops in 1904,[109] becoming an admirer and imitator. More articulate and more of an intellectual than Edward Barnsley, his delight in being a 'small working master'[110] independent of big business was set out at length in articles and pamphlets and in an intense unpublished autobiography 'Work and and Play'. He set up his first serious workshop in Haslemere in 1907, drawn by the Blounts' craft community and the nest of intellectuals in that corner of Surrey. Two years later he eloped with the wife of a fellow Independent Labour Party member, taught for a while at Abbotsholme School and worked during World War I on the design of aeroplane propellers. By 1916 he was settled at Strand on the Green in West London, taking over Gill's workshop in Hammersmith, getting to know the architect and Guild Socialist A.J. Penty and the silversmith Edward Spencer. In 1919 he moved to Christchurch in Hampshire where he ran a workshop, taught mathematics, wrote poetry, and contributed to Philip Mairet's *New English Weekly*. His younger brother, the architect William Curtis Green, was influenced by him and put work his way and he found living in a 'beauty spot' useful, with holidaying masters from the major public schools placing substantial orders.[111] His politics, reviewed in Chapter Three, revolved around improving the lot of the 'bottom dog' and creating a viable context for small workshops. In effect he carried on thinking, somewhat erratically, where Gimson had left off.[112]

59. Edward Barnsley, walnut veneered cabinet made for the dentist Charles Hawkins in 1933. (The Edward Barnsley Educational Trust).

60. A. Romney Green stands fourth from the left outside the bow-fronted windows of his show-room at Christchurch, Hampshire in the 1920s with apprentices and 'gentleman' pupils, including Eric Sharpe, fifth from the left. (Abbot Hall Art Gallery and Museum, Kendal).

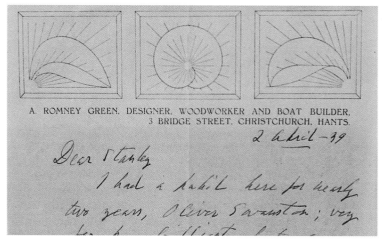

61. A. Romney Green, design for a chair from *Instead of a Catalogue* published by the New Handworkers' Gallery in 1928. Its 'geometrical refinements' were informed by his training as a mathematician.

62. Chair with what Romney Green called a 'wheatsheaf' back, the curvature of the splats determined by a mathematical equation, early 1920s. h. 93.7 cm. (Cheltenham Art Gallery and Museum).

63. A. Romney Green's letter heading with three mathematically generated designs. (Abbot Hall Art Gallery and Museum, Kendal).

Romney Green was self taught. He believed that he compensated for his lack of training in design by his understanding of mathematics: 'I am probably the first woodworker to use co-ordinate geometry in furniture design.' (Figs 61, 62, 63)[113] The results included chairs with elegant parabolic backs, boxes inlaid with geometrical spirals, distinctly odd hemispherical table bases and stretchers as well as sailing boats and architectural panelling. Romney Green set out his thoughts on furniture making in 1912 in a series of articles in *The Burlington Magazine* on the 'Principles and Evolution of Furniture Making'[114] commissioned by Roger Fry. This was followed by *Woodwork in Principle and Practice* published in 1918 at Ditchling by Douglas Pepler and *Instead of a Catalogue* published by the New Handworkers' Gallery in 1928. Romney Green was keen on 'healthy limitations'[115] and though he did not reject power tools on principle (but rather because it meant higher insurance for his employees) he was

passionate about the aesthetic and physical pleasures of basic activities like sawing and planing wood with a handsaw and a jack plane – 'the most exhilarating and satisfying work in the world…work for the whole man'.[116]

Romney Green had numerous pupils for he was a charismatic teacher of upper-middle class escapees who wanted to work with their hands. One of the most successful was Stanley W. Davies who built a workshop in Windermere in 1922. In 1924 his workshop made a loss of £119. By 1928 his profits were £78.[117] Luckily he was the son of a wealthy Quaker millowner. His promotional literature was cleverly written, signalling Englishness, solid workmanship and anti-industrialism. Handcraft principles were beguilingly presented. He argued for the superior strength and beauty of native timbers. He rejected veneering. Each of his workmen made a piece from start to finish and signed it.[118] Davies's furniture was conservative and restricted in scope. He offered a range of wholesome institutional furniture for school assembly halls, carved school trophies, wooden tablets for war memorials. He reinstated all the fussy paraphernalia of middle class living – magazine racks, occasional tables, nests of tables, drinks trolleys and firescreens – which Gimson and Barnsley had swept away. The 'Cotswold School' no longer seemed to stand for Utopian radicalism in design or facture, but for reassurance and anti-modernism at any price. Surprisingly Davies's revealed workmanship often concealed a mass of cheap screws. In a shared room setting (Fig. 64) at the Red Rose

64. Room setting at the Red Rose Guild exhibition, 1927 with textiles by Phyllis Barron, Dorothy Larcher and Ethel Mairet, ceramics and an etching by Bernard Leach and furniture by Stanley Davies. (Holburne Museum and Crafts Study Centre, Bath).

65. The ingle at Littleholme, the house designed for Arthur Simpson by C.F.A. Voysey in 1909–10. A mixture of romance (Voysey's massive tie beam) and practicality (the fitted drop-leaf desk designed by Arthur to the left of the fireplace, the adjustable armchair and the fender made from a section of railway track by a local blacksmith). (Jean Simpson).

Guild in 1927 his furniture had the effect of diminishing the work of Leach, Barron, Larcher and Ethel Mairet, creating a folksy rather than modern *mise-en-scène*.

For another Romney Green pupil, Robin Nance, who opened his workshop on the Wharf at St Ives in 1933, 'The Romney Green, Barnsley etc school of traditional work is now a back number and I think unsuited to modern needs.'[119] His simple plain furniture looked distinctly remote from the Arts and Crafts tradition. It was closer to the logic of the unit furniture designed by Serge Chermayeff and produced by Plan Ltd during the 1930s. Context was important. Davies's clients included wealthy tourists and second-home owners in the Lake District but artists, painting experimentally in peripheral regions like West Cornwall, tended to be poor. At St Ives Nance wanted to cater for 'people of modest means', in contrast, he felt, with the rest of the craft furniture movement.[120]

Not all craft furniture makers looked to Sapperton for inspiration. The Simpson family workshop and shop at Kendal was, like Davies's workshop, well placed to take advantage of tourism in the Lake District. Arthur W. Simpson opened The Handicrafts in 1901. In 1898 he had met and became friends with C.F.A. Voysey, making the elegant balusters with little inlaid hearts for Broadleys, the house overlooking Windermere which Voysey designed for the colliery owner Arthur Currer Briggs. In 1909 Voysey designed Littleholm (Fig. 65) for Simpson, a majestic low lying 'cottage'.[121] Contact with Voysey's refined elegant furniture designs strongly influenced the work of Simpson and his son Hubert, who took over the business in 1920. The Handicrafts also sold Morton Sundour fabrics, Donegal carpets and Torfyn rugs – goods which would have met with Voysey's approval. Revealed construction and chamfering were not part of the Simpsons' design language. They worked on two fronts – carrying out delicately carved ecclesiastical commissions and, by the 1930s, starkly simple domestic furniture that suggests an interest in the plainest Deutsche Werkbund design (Fig. 67). In the 1920s Hubert Simpson had introduced power tools to the workshop to keep furniture prices down and was lecturing on 'the use of machinery in preparing materials for handwork'.[122]

The Simpson workshop's delicate carving belongs to the Arts and Crafts revival of this skill, a movement within a movement which took George Jack's *Wood Carving* of 1903 as its guide. The 1920s and 1930s saw developments in carving which moved away from any connection with furniture and architecture. Sculptors like Leon Underwood, Maurice Lambert, Henry Moore and Barbara Hepworth were inspired to carve directly in wood by West African sculpture. But wood carving was also influenced by a growing interest in English popular art – in ships' figureheads, fairground horses and puppeteering. These researches into the vernacular will be discussed further in Chapter Four but William Simmonds (Fig. 66) stands out both as a maker and performer of puppets and as a carver in wood and ivory of intensely observed animals.

On the whole, as Bernard Leach pointed out in 1928 in a letter to Philip Mairet, English craft furniture worked on 'too narrow a gauge...scared to death of a curve'.[123] Leach was particularly fond of Chinese furniture and drew out for Mairet the flowing curvilinear lines of a Chinese hardwood bench (Fig. 68). In Japan Leach had designed some interesting organic looking furniture including three-legged chairs which he exhibited in 1919 in Kanda together with some textiles.[124] In 1935 he arranged an 'English-Japanese' room for an exhibition of crafts at Osaka.

69. (*opposite, above*) Bernard Leach's 'Anglo-Japanese' room for an exhibition of crafts at Osaka, Japan in 1935. (Holburne Museum and Crafts Study Centre, Bath).

70.(*opposite, below*) Sitting room in a cottage for Russell employees. Presumably a publicity shot. Note copies of *The Studio* (July 1927) and *The Architect's Journal* casually placed on the book stand and C.W. Whall's *Stained Glass Work* on the shelf below. (Gordon Russell Ltd).

71. (*above left*) English walnut cabinet inlaid with ebony, yew and box designed by Gordon Russell. This won a gold medal at the 1925 Paris exhibition. (Gordon Russell Ltd).

72. (*above right*) Seventeenth-century furniture repaired by the Russell & Sons workshop. (Corinium Museum).

A fitted desk and shelving, exposed beams and elegant chairs designed by Leach suggest that looking east might have benefited craft furniture as well as studio ceramics (Fig. 69).

One admirer of Gimson made a break with small-scale craft production in the inter-war period. In the early 1920s the Cotswold firm Russell & Sons of Broadway, Gloucestershire – which, ironically, had grown out of Gordon Russell's father's antique repair shop (Fig. 72) – was making furniture which was strongly derivative of Gimson's designs. An elaborate cabinet sent by Russell to the 1925 Paris exhibition was almost embarrassingly similar (Fig. 71). But Russell had survived the battles of Loos, Passchendaele, Somme and Ypres and this experience of the Great War, as much as the influence of Morris or Ashbee (whose Guild of Handicraft Russell had known as a boy in nearby Chipping Campden), lay behind his ambition to make affordable furniture for 'people of the artisan class'[125].

Russell sought advice from Percy Wells, the instructor in cabinet making at the Shoreditch Technical Institute whose simple inexpensive designs had been published in 1920 as *Furniture for Small Homes*. By 1925 the renamed Russell Workshops were tackling the economics of production by tooling up with a circular saw, bandsaw, an Elliot woodworker and a dimension table with, in 1929, the addition of two morticers, two spindle moulders, a tenoner and a thicknesser.[126] Nonetheless, as in other craft furniture workshops of the inter-war period, each piece was still completed by one man. There were some Ashbee-esque touches. Employees had access to a library, to evening classes and lectures on craft subjects.[127] There was pleasant furnished workers' housing (Fig. 70). It was a level of provision almost unknown in inter-war craft workshops, although Bernard Leach encouraged fireside discussions with his middle-class fee-paying students and Romney Green clearly viewed all his apprentices and employees as souls to be saved and re-educated.

There were elements of tradition and modernity in Gordon Russell's work of the 1920s.[128] By 1925 Russell had designed a boot cupboard and a sideboard that struck a Continental

73. R. D. Russell's A-8 Murphy radio cabinet designed in 1932 placed on an abstract rug designed by his wife Marion Pepler. The settee and walnut coffee table are less convincingly modern in spirit. (Gordon Russell Ltd).

74. The Isokon 'Long' chair, designed by Marcel Breuer, manufactured by the Isokon Furniture Company, London, 1936, 79.2 × 62.2 × 143 cm. (V&A Picture Library).

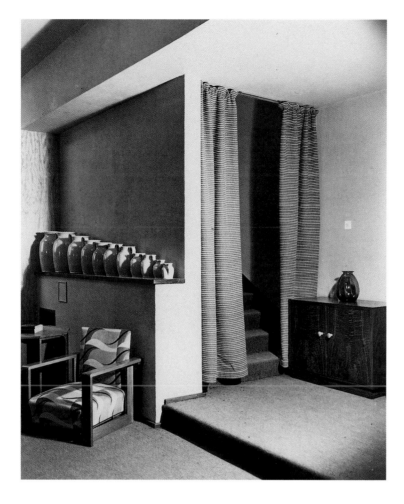

75. The dramatically lit interior of the Gordon Russell Ltd shop in Wigmore Street, 1935. Note the row of industrially made jugs, the Welsh tweed curtains designed by Marianne Straub and the frame construction chair covered with *Mendip* designed by Alec Hunter for Warners. (Gordon Russell Ltd).

observer, Nikolaus Pevsner, as coming close to European modernism. Russell told Pevsner that both pieces 'were guided by certain eighteenth-century precedents'.[129] By 1928 John Gloag, then editor of *The Cabinet Maker*, saw Gordon Russell as the acme of modern craftsmanship and of 'an enlightened alliance between handicraft and machine craft'.[130] Gloag was greatly struck by the powerhouse at Broadway with its handsome red gas boiler which 'with a rich soothing song' generated electricity for the power tools in the workshops. He noted its doors constructed out of Plymax, a quintessentially modern material. But at that date the firm was still making furniture stylistically derived from Gimson, and perhaps more pertinently, from the batch production designs of Ambrose Heal.

Pevsner observed that in 1930 Gordon Russell Ltd (renamed in 1929) 'suddenly turned modern in the sense and on the aesthetic level of the best continental furniture'.[131] The explanation for this was that in 1930 Gordon Russell gradually retired from furniture design, passing responsibility over to his brother R.D. Russell and Eden Minns, both recent graduates of the Architectural Association, and to Shoreditch trained W.H. 'Curly' Russell. Their modernism was largely free of *art moderne* influences even if they stopped short of the kind of furniture-as-equipment associated with Marcel Breuer and Ludwig Mies van der Rohe at the Bauhaus.

By 1930 Gordon Russell Ltd had moved into a quite different league from that of Arthur Romney Green, Edward Barnsley and Stanley Davies and the rest of the craft furniture makers with whom the firm had formerly exhibited at the Red Rose Guild and the Arts and Crafts Exhibition Society. In 1929 the committee of one of the leading craft exhibiting societies, the Red Rose Guild, had declared the display by Gordon Russell Ltd to be 'unsatisfactory' – probably because of the high level of batch production using power tools.[132] It signalled a parting of the ways and a subdued resentment about the firm in the craft world.[133] Indeed even a manufacturer like Ambrose Heal expressed a certain alarm when he heard of Gordon Russell's collaboration with Murphy radios (Fig. 73) that resulted in true mass production of radio cabinets from 1930.[134]

By the mid-thirties Gordon Russell Ltd's public face showed a real allegiance to European modernity. The firm's London shop in Wigmore Street, designed by Geoffrey Jellicoe in 1935, stocked designs by Alvar Aalto, bentwood Thonet chairs and Marcel Breuer's plywood chairs made for Isokon (Fig. 75). Isokon furniture still seems the quintessence of modernism in Britain, worlds away from the fussy range of furniture created by craftsmen like Stanley Davies. But the Isokon (short for Isometric Unit Construction) experiment demonstrates that the links between modernist design and true mass production could be tenuous. Isokon was set up in 1931 by a progressive businessman, Jack Pritchard, his wife Molly and the architect Wells Coates 'to promote building and furniture of strictly modern functional design'.[135] The production of Breuer's designs in a little workshop in the basement of Coates's Lawn Road flats in Hampstead, North London, was beset with difficulty. Their facture involved intensive handwork. The famous Isokon long chair (Fig. 74) was produced at the rate of three to six a week in 1938, as compared with 3850 radio cabinets a week flowing from the Gordon Russell Ltd factory in 1937.[136] But what is even more striking is that the speed of production of the Long Chair could have been matched by any of the inter-war craft furniture workshops. Modernism at that date was not defined by quantity production but more by attitude and approach.

SILVERSMITHING AND JEWELLERY

Silversmithing and jewellery were the craft activities that best exemplified the romanticism, love of detail and the self-taught recovered skills of the Arts and Crafts Movement at its height. Chalices, caskets, pendants rich with symbolism, tiaras, buckles, morses and clasps were made in lively opposition to the dead perfection of trade work. Semi-precious cabochon stones and bright enamel work were put to narrative purposes. As Henry Wilson explained in the Movement's textbook *Silverwork and Jewellery* (1902) design was 'formalised memory'. Archetypes jostled with environmental and racial influences. Wilson shared the workings of his mind with readers: 'We will suppose you have a moonstone you wish to set. If I were doing it I should probably reason in this way: "The moonstone suggests Diana. Her symbol is a stag. The subject shall be a running stag bearing the moon in his antlers".' (Fig. 76) To create a pendant of a nightingale in a bower of leaves the recipe was even simpler: 'To make a Nightingale. First go and watch one singing. There are happily numberless copses and woods near London.'[137]

Silversmithing sits awkwardly alongside the development of other inter-war crafts. Weavers, hand block-printers and potters, as we have seen, created a fresh identity for their crafts in the 1920s, tapping into the same sources which fed early modernism in painting and sculpture. Furniture, in contrast, stayed close to its Arts and Crafts roots, but seemed 'modern' in contrast with the British appetite for reproduction and antique furniture. The consumption of silver, on the other hand, was in decline. As Frank Pick's 1937 report on the trade pointed out, smaller houses and fewer servants meant the decline of silver tableware.[138] The market which did survive was for cups, trophies and ceremonial plate and these lent themselves to watered down versions of Wilson's 'formalised memory'. Nightingales were perhaps too personal but cast, chased and repousséed images of St George, with sword aloft or in combat with his dragon, dolphins and other fishy symbols of a seafaring nation and the floriated language of Tudor roses and oak leaves were all suitable emblems of 'Englishness' and were guaranteed to please collegiate and city patrons. This kind of work continued to find patrons up until the Second World War, with a surprising resurgence of such imagery in the 1980s.

Thus the inventiveness of Arts and Crafts work was academicised. Inter-war silversmiths were trained and returned to teach at a handful of key art schools, headed by the Central School of Arts and Crafts in London, the Vittoria Street School of Jewellery and Silversmithing in the jewellery quarter of Birmingham and Sheffield School of Art. These schools had important trade links, teaching day-release apprentices as well as full time art students.[139] The most gifted and determined of these trade apprentices, men like W.T. Blackband, H.G.

76. Henry Wilson, gold, jade, rock crystal and enamelled *plaque de collier*. Diameter 4.4 cm. (Wartski, London).

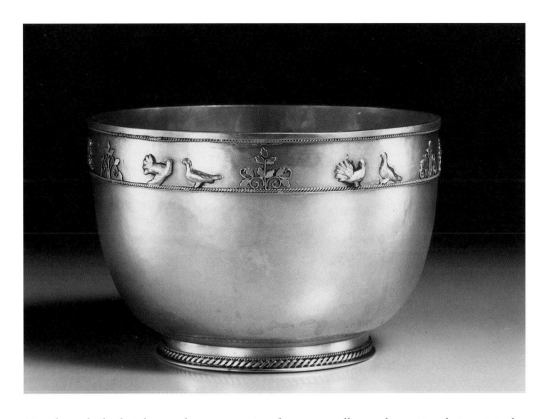

Murphy and Charles Thomas, became artist craftsmen, usually supplementing their artistry by teaching in the school in which they had originally trained. Their training and expectations were less wide-ranging than those of an earlier generation of Arts and Crafts men and women who had taken an interest in jewellery and silver, figures like C.R. Ashbee and Henry Wilson and creative women like Phoebe Traquair and Georgie Cave Gaskin.

Some artist silversmiths came from more intellectually or financially privileged backgrounds, but in the context of inter-war silversmithing they were the exceptions. The Sheffield silversmith Joyce Himsworth was the daughter of a partner in an important local firm of cutlers and silversmiths and able to set up her own workshop in the 1920s.[140] John Paul Cooper, a pupil of John Dando Sedding who had worked in loose partnership with Henry Wilson, taught for a while at the Birmingham Central School of Arts and Crafts but from 1911 ran a small workshop at Betsoms Hill, Westerham, Kent. Cooper was the son of a successful manufacturer and regarded his work as a mission to restore beauty to daily life. His son Francis Cooper recalled that 'what he made from his work could barely have paid the wages of his assistants.'[141]

The market for presentation and ecclesiastical silver lent itself to archaizing experiments. W.T. Blackband (Head of the Vittoria School from 1924 until 1946) devoted himself to the rediscovery of the Etruscan techniques of wirework and granulation (Fig. 77). His silver was archaeological in spirit and in 1936 he spoke out against 'cinema, music-hall, crooning, cheap literature…trashiness, cheapness and ugliness'.[142] Charles Thomas, another teacher at Vittoria Street was similarly disdainful. Contemporary art was 'The Art of a World gone Mad!'[143] Thomas exemplifies the persistence of complexity and narrative in silver. His *Cup of the Sea* made in 1937, was an uneasy amalgam of *art moderne* and Wilsonian complexity, engraved with crabs, shells and star fish, with carved ivory dolphins applied to the knop, with a lid concealing an enamel medallion of the birth of Venus (Fig. 78). He seems like a figure out of step with the century, with a range of Arts and Crafts interests in rare plant forms, Chinese calligraphy, jade and ivory carving.

There were exceptions to this antiquarian approach. Harold Stabler, teaching from 1912 until 1937 in the art department of the Sir John Cass Technical Institute, collaborated keenly with both the silversmithing trade and the pottery industry.[144] He had had a late Arts and Crafts training in the Lake District with the furniture maker Simpson of Kendal and at the Keswick School of Industrial Art. His loving cup of 1909 set with a painted enamel frieze of

79. Harold Stabler, crucifix, ring and brooch made for his wife Phoebe on their engagement. The Stablers married in 1906. (Photo courtesy of the Worshipful Company of Goldsmiths).

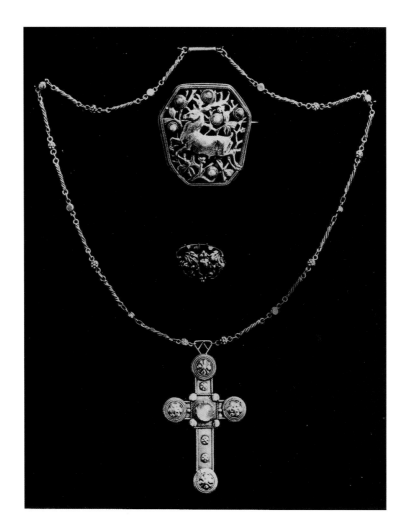

Diana hunting, embellished with carved ivory and with a lid set with moonstones and a band of tangled openwork thistles looks like a prescriptive Arts and Crafts offering as does his brooch, cross and ring made for his bride Phoebe in about 1906 (Fig. 79). But, as we have seen, in 1913 he led a militant sub-committee in a vain effort to update the Arts and Crafts Exhibition Society's policies and in 1915 he became a founder member of the DIA.

Stabler's versatility sets him apart from most silversmiths and raises interesting questions about inter-war craft and design. At the 1916 Arts and Crafts Exhibition he and Phoebe Stabler's cloisonné enamel plaques and medallions of turbaned boys and helmeted putti paid tribute to the Orientalism of the Ballets Russes and to Russian book illustration (Fig. 80). Their plaques were influential. Leeds City Art Gallery has a similar, cruder enamel medallion made by the young Henry Moore in 1923. From 1921 Stabler had an industrial base when he joined the ceramics firm Carter & Co to form Carter Stabler & Adams, Poole Ltd. By the late 1920s the influence of Stabler's extended visit to the 1925 Paris exhibition can be detected in a silver tea service for the firm Wakely and Wheeler in which Georgian shapes were embellished with stepped jazzy die-stamped bands. By the 1930s Stabler began an important association with Frank Pick, designing posters, tiles and decorative metal grilles for the London Underground all of which made pleasing pastoral play with the names of tube stations (Fig. 124). He also worked on a range of functional prototypes in the patented stainless steel 'Staybrite' for the steel manufacturers Firth Vickers and a tea set was put into production by the firm J. & J. Wiggin.[145] These, and a stylish tea set of the early 1930s made up of a rectangular pair of teapots, creamer and sugar basin neatly fitted onto a bakelite tray produced by Adie Brothers Ltd of Birmingham, look thoroughly modern and close to advanced design in France and Germany (Fig. 81). But Stabler's eclectic oeuvre, changing decade by decade, makes clear the design world's relative volatility. In contrast much craft activity, particularly ceramics and textiles, operated throughout the interwar period within a coherent modernist framework based loosely on the canon of pure form set out by Fry and Bell.

80. Harold and Phoebe Stabler, a pair of cloisonné enamel plaques shown at the Arts and Crafts Exhibition of 1916. diameter 7.3 cm. (Christies Images).

81. Harold Stabler, electroplated tea service designed for Adie Brothers Ltd., Birmingham produced *c.* 1936. h. of teapot 9.5 cm. (Christies Images).

Against Stabler's Frenchified modernism we can set the London silversmith, Omar Ramsden, busy with commissions until his death in 1939.[146] Ramsden, who started in partnership with Alwyn Carr in 1898 but from 1919 worked independently, exemplifies the transition from the delighted experimentation of Arts and Crafts movement to mere formula. 'Omar Ramsden Me Fecit' was engraved on all his pieces in deep, small letters. Visitors were impressed by the drawing room of St Dunstan's, his tapestry hung 'Studio Home' off the Fulham Road, where 'old world' panelling concealed artfully lit displays of silver and Italian and Chinese pots. In a speech made in 1928 to the Royal Society of Arts, he employed the rhetoric of the Arts and Crafts Movement, denouncing the fashion for antique and

82. Omar Ramsden, *Three Kings Mazer* 1937, silver with a cast frieze of heads of the royal family. diameter 32.4 cm. Exhibited at the Arts and Crafts Exhibition of 1938. (Honourable Society of the Middle Temple, London).

reproduction silver and 'the revival of wage-slavery under the industrial revolution'.[147] Yet if an 'Arts and Crafts' approach is defined by a shared creativity within a small workshop then Ramsden does not appear to qualify. A complex piece of silver lends itself to the sub-division of labour and this was practised energetically in Ramsden's workshop. He would draw a rough sketch which was worked up by his draughtsman William Maggs. Jobs were assigned by his senior chaser and modeller A.E. Ulyett. Shapes were not raised by hand, but spun, then softened with hammerwork. Casting was contracted out. Turnover was speedy, enabling medieval forms to be given a topical twist. Ramsden's quatrefoil dish engraved with the word PAX to commemorate the Munich Agreement appeared embarrassingly quickly, in time for the 1939 Arts and Crafts Exhibition. It was accompanied by his equally topical *Three Kings Mazer*, a comment on the abdication of Edward VIII (Fig. 82). Arts and Crafts high-mindedness was better exemplified by another medievalising silversmith, Edward Spencer, noted for employing orphaned boys at his Artificers' Guild.

Around 1900 the Worshipful Company of Goldsmiths looked to its past and began to form a collection of historic plate. But from about 1925 the company became the key patron of contemporary silversmiths, largely thanks to the activities of the Clerk of the Company, George Hughes.[148] He was a bustling progressive figure, in sympathy with the DIA and in contact with most of the key figures in the British design world. Through competitions, evening debates and participation in the major design exhibitions of the 1930s Hughes sought to encourage a modern spirit – although this proved hard to define comprehensively. In 1925 Hughes had visited the Paris exhibition and was impressed by the cubist language of Puiforçat and Tetard Frères and by the simple refined silver designed by the Danish silversmith, Georg Jensen.

Hughes was an energetic pragmatist, able to admire a broad range of silver. He wanted the Company to fulfil some of the functions of a medieval guild and this included debate over aesthetics. By the mid-1930s Herbert Read's *Art and Industry* of 1934 set a standard. It was

83. *The Sea Beaker*, 1929, silver, designed by R.M.Y. Gleadowe, made by Murphy and Falcon, London and engraved by George Friend. h. 14 cm. (The Worshipful Company of Goldsmiths).

84. The *Calix Majestatis* designed by Frank Dobson and made by Wakeley & Wheeler. The stepped marble plinth represents royal dynasties since the reign of Egbert. It was made to commemorate the accesssion of Edward VIII and presented to him in 1936. Like Ramsden's *Three Kings Mazer* it was soon embarassingly out of date. (The Royal Collection © 1998. H.M. Queen Elizabeth II).

plentifully illustrated with the pure forms of seventeenth- and eighteenth-century English silver juxtaposed with Bauhaus coffee services and mass-produced stainless steel saucepans and tumblers. But Read, implicitly, demanded the abandonment of the varied decorative skills of Birmingham and London's intricate networks of trade workshops, each carrying out a separate silversmithing process. Read was undoubtedly influential. The variety of skills and processes were narrowed down. Bold concave fluting or simple forms embellished with some line engraving came to characterise much 1930s silver. Unadorned Georgian silver was held up as a model.

The lectures arranged under Hughes's aegis attempted to grapple with the lack of a convincing inter-war style. National identity, specifically focused on 'Englishness', became an issue. R.M.Y. Gleadowe, a Winchester art master who provided Gill-inspired line drawings for engraving on silver (Fig. 83), was a regular lecturer whose profoundly insular artistic vision was well received.[149] J.E. Barton, the progressive headmaster of Bristol Grammar School and an early broadcaster on design, spoke on *Modern Forms in Art*, showing slides of aircraft hangars, villas by Le Corbusier, Benin bronzes and Sung ceramics. This was the modernist canon indeed; but confronted with the silver problem Barton advised a 'more tentative and English' approach.[150] At another evening lecture, P.H. Jowett, the Principal of the Central School of Arts and Crafts, similarly recommended the study of early art but warned against contemporary Continental influences as a danger to the 'particularly English quality of English silver'.[151] Only the sculptor Frank Dobson suggested breaking loose, singling out the study of the 'primitive works of primitive races', Peruvian metalwork and pottery, African carvings, early Chinese bronzes and Cambodian sculpture.[152] Four years earlier, in 1935, Dobson had designed a Jubilee cup, the *Calix Majestatis*, for Wakely & Wheeler (Fig. 84). It illustrated the inter-war problem neatly. Dobson's vigorous neo-primitive modelling was made gaudy by the sheen of silver gilt and neutered by the sheer skill with which his design was translated into a precious medium.

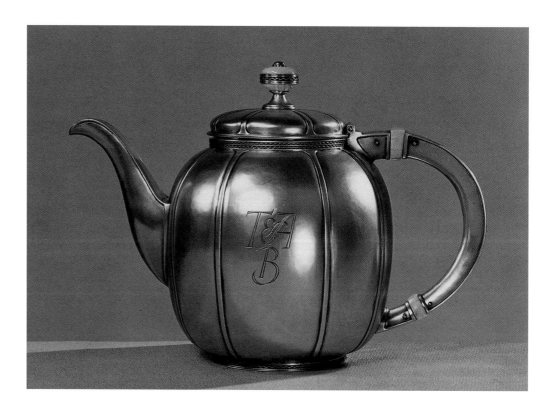

85. Silver teapot no. 9 designed and made by Bernard Cuzner for Mrs Birkett in 1933. (Collection Hugh Birkett. Photo courtesy of the Worshipful Company of Goldsmiths).

In the context of the 1930s the workable ideas tended to come from practitioners. In 1933 H.G. Murphy, head of silversmithing at the Central School, argued that the craft had its own logic which in the twentieth century demanded purity of form: 'straight lines, flat planes, simplicity of plan stand for and represent the great abstract quality of repose'.[153] Bernard Cuzner, an instructor at Vittoria Street from 1908 until 1942, was not consciously a modernist but in a manual for silversmiths he noted: 'In the best modern work we see evidence of a cool, clear, logical, intense spirit. Let us see to it that this manifests itself in our own work.'[154] He spoke up for the silversmithing skill of chasing, explaining its functional role in strengthening a vessel and in softening and breaking up a plain surface. Cuzner designed for industry but his masterpiece was his Teapot no 9, elegantly chased into ribs and panels (Fig. 85). This 'classical almost dateless design'[155] goes some way to validating the insularity of the inter-war years.

Change in silversmithing came immediately after the Second World War. It was dramatic, influenced by developments in contemporary sculpture and design and nurtured by George Hughes's successor at the Company, his son Graham. In 1951 Charles Thomas had written to George Hughes lamenting the 'degeneracy of modern art'. 'Do you intend to ask Henry Moore to design you a gold cup' he asked facetiously. 'It would be interesting to see where he puts the holes.'[156] Just six years later the rising young silversmith Gerald Benney designed and made a chalice clearly influenced by Moore. The hole, as it turned out, neatly pierced the knop of the chalice stem.

Craft jewellery in the inter-war years seems like a footnote to silversmithing. Not for lack of practitioners but because the work represented a marked falling off from the extravagant beauties of Arts and Crafts jewellery. Many of the inter-war silversmiths made jewellery. They offer few surprises. W.T. Blackband's rings had an archeological air. Ramsden braided Arts and Crafts lyrical narrative (a ring shank formed from intertwined angels) with the demands of the market (cut diamonds). Harold Stabler progressed from complex medieval imagery to bright, stylish enamels to sharply designed *art moderne* pieces. Clearly there were a great many jewellers working sporadically and part-time whose names and work have slipped into obscurity. Making jewellery did not require the level of equipment needed to create vessels in silver or gold, nor the outlay on materials. And many of these forgotten jewellers were women, exhibiting at the Red Rose Guild, the 'Englishwoman' annual exhibition and the Arts and Crafts Exhibition Society. There was some interesting 'provisional' jewellery, like the theatrical necklaces made by Catherine 'Casty' Cockerell (later Cobb) in 1935 from assemblages of

Nailsea glass, coral and beads. The daughter of the book binder Douglas Cockerell, she operated as an interesting bricolage jeweller and silversmith, later turning her attention to cutlery notable for exquisite fitted handles decorated with silver piqué (Fig. 86).[157]

Making jewellery neatly elided consumption and production for women. There were powerful role models from the turn of the century; May Morris made and collected interesting jewellery, Arthur Gaskin's wife Georgie Cave Gaskin was the key creator of jewellery in the partnership. In Scotland Phoebe Traquair made enamelled pieces of lush beauty. The purpose of Arts and Crafts jewellery was to cement and romanticise personal relations. Arts and Crafts jewellery was iconographically intense, and often closer to the world of the gift than the world of the commodity.[158] After the Great War, although craft jewellers did not join the silversmiths in their earnest quest to define a modern style, the work became less complex, brighter and less subtle. The two kinds of trade jewellery – the emerging category of costume jewellery designed in tandem with *haute couture* and jewels designed by firms like Garrards principally to show off precious stones – were presented with conviction. In contrast, craft jewellery seemed left behind by changes in fashion and by changes in women's sense of themselves.

George Hunt, working in Birmingham, and Sybil Dunlop, based in artistic West London, can stand for the many hundreds of inter-war craft jewellers. Hunt studied at the Margaret Street School in Birmingham from 1909 until about 1912. He wanted to carry forward the lusciousness of Henry Wilson and C.R. Ashbee's narrative jewellery and as late as 1936 he made a silver gilt brooch with an enamelled peacock entangled in leaves, set with garnets, moonstones and peridots (Fig. 87). His brooch *Sheba Regina* was made the same year in a rather different *art moderne* Egyptian spirit, using ivory to carve Sheba's face, and sharply cut mother-of-pearl to give an angular outline to the piece. Hunt was deaf and worked alone in what one assumes was a rich world of the imagination. His daughter donated a collection of his work to the Victoria and Albert Museum and her filial love enables us to see that artists and makers do not necessary conform to period. Hunt seems out of step with the clothes and customs of the 1930s, especially when cheap costume jewellery came flooding in from Germany, Czechoslovakia and the United States.[159]

Sybil Dunlop, from 1920 based at 69 Kensington Church Street, surrounded by other craft and art shops and galleries, was a less isolated figure. She was a 'character' who presided over her shop in a kaftan and Russian boots. She employed four craftsmen and cannily set them to

87. George Hunt, Peacock brooch, silver gilt openwork, enamelled, set with opals, moonstones and garnets, 1936. Diameter 5.4 cm. (V&A Picture Library).

88. Edward Johnston at Lincoln's Inn in 1902.

work in public view at the front of the shop. Set beside earlier craft jewellery her designs look crude. She favoured semi-precious cut stones in vivid colours set closely, jig-saw fashion, an effect she dubbed 'a carpet of gems'. In the context of trade jewellery, her work and that of her friend Dorrie Nossiter and contemporaries like Moshe Oved of Cameo Corner and Maud Eastman of Modern Etceteras, offered colour and a measure of eccentric Bohemianism.[160] The work's meaning and attraction was strongly dependent on the powerful personalities of designers who reigned supreme in their own shops.

FROM WRITING TO CARVING

Bernard Leach included Edward Johnston in his short list of pioneering inter-war makers (Fig. 88). His presence there might seem anomalous. Johnston, as an important teacher at W.R. Lethaby's Central School of Arts and Crafts at the turn of the century, appears at first sight to belong to an earlier generation. He was one of Lethaby's discoveries, an unworldly young man who had spent his boyhood making passionate forays into astronomy, algebra, toymaking, mechanics and calligraphy. In 1898 he had just abandoned studying medicine and on the basis of a few experimental pieces of decorative writing Lethaby introduced him to Sydney Carlyle Cockerell, William Morris's former secretary and librarian, who showed him Morris's own efforts at writing and illuminating. In October 1898 Cockerell walked him round the display cabinets of the British Library pointing out the best examples by early scribes. Other friendships were made, in particular with the poet Robert Bridges, who was deeply interested in the rhythms and structures of good handwriting, and whose wife Monica had just published the first modern manual to propose italic handwriting as an alternative to the copper plate of nineteenth-century copy books. On 21 September 1899, after a year of experimentation, Johnston held his first class at the Central School. It was to initiate a modern revival of calligraphy that still seemed revolutionary to Leach thirty-five years later.

Johnston had been chosen by Lethaby to carry forward an unfinished, under-researched Arts and Crafts project. By the mid 1870s illuminating, rather than calligraphy, had developed as a popular middle-class Victorian hobby, inspired by Owen Jones and Henry Shaw's books of chromolithographic reproductions of medieval work. But it was John Ruskin's collection of illuminated manuscripts and his belief that 'Perfect illumination is only writing made lovely'[161] which proved especially inspirational for members of the Arts and Crafts Movement. Ruskin treated priceless missals as teaching tools, dismantling, annotating and even cutting them up but he wrote profoundly about them and gave examples away to students, to friends and to the St George's Guild collections.[162] His enthusiasm inspired experimentation by the architect Harry Cowlishaw (who was to introduce Johnston to Lethaby) and by William Morris. During the 1870s Morris planned, wrote out and illuminated, in whole or in part, twenty-one manuscript books, many of which captured the richness and complexity of medieval and Renaissance examples.[163] Some were completed after his death by Charles Fairfax Murray, Louise Powell and Graily Hewitt, carrying Morris's particular vision of the calligraphic book into the twentieth century.

Calligraphy, just one of a multitude of crafts which Morris investigated, was to become Johnston's whole life. His approach was systematic and very different from that of Morris. He concentrated on writing and the genealogy of letter forms and he discovered the tools and materials used in the centuries before the invention of printing. His first models were the seventh-century uncial scripts used in the Book of Kells and the tenth-century Winchester manuscripts shown to him by Cockerell (Fig. 89). The latter he saw as 'an almost perfect model for a modern formal hand'[164] and these hands dominated *Writing & Illuminating & Lettering* of 1906, his magisterial contribution to Lethaby's Artistic Crafts Series. In 1923–4 Johnston began to develop a third powerful hand characterised, he explained, by 'compression, branching' with 'flourishing and slopingness'[165] and its energy and freedom bore only a loose relationship to the fourteenth- and fifteenth-century scripts from which it derived.

The special importance of Johnston's work was succinctly summarised by an early pupil, the printmaker Noel Rooke: 'Before Johnston, understanding of letter forms and their

structure had been lost for centuries…Books on the subject recommended drawing each side of a stroke with a mapping pen, and filling in the space with a brush'.[166] Johnston realised that the broad nibbed pen was central to formal writing and its use made his practice active, creative and performative: 'having cut the nib rightly you may, in a sense, *let the pen do the writing*'.[167] An analogy can be made with the rediscovery of early music at the turn of the century. Arnold Dolmetsch's revival could not have developed without the appropriate tools, which in his case demanded the craftsmanly recreation of harpsichords, clavichords and recorders.[168]

Johnston inspired men and women to take calligraphy seriously. By the inter-war period, as a direct result of Johnston's work, calligraphy had become an integral part of the curriculum in British art schools and so it remained until the introduction in 1961 of the Diploma in Art and Design. But, as Lethaby had hoped,[169] Johnston's work also had an influence on typography and book production. His direct involvement was limited but significant. In 1912 he designed – with great misgivings – an italic typeface for Count Harry Kessler's Cranach

90. Edward Johnston, a sheet of capitals with explanatory notes for the London Underground sans-serif alphabet, February–March 1916. (V&A Picture Library).

91. Edward Johnston, six lines from Plato's *Symposium* on vellum presented to Alfred Fairbank on 19 April 1934. (Private Collection. Photo Bodleian Library, Oxford).

Press. He later completed a black letter typeface used in Kessler's 1929 *Hamlet*, one of the most beautiful private press books ever produced. Johnston was unusually sensitive to the collaborative nature of type design, writing to Noel Rooke of the italic type: 'the punch cutter and the printer (not to mention the type founders) made it really a quite sound – shall we say mediaeval job'.[170] Johnston also designed a block alphabet for the London Underground Railway in 1916 which of course had a much wider impact. Still in use today, this sans-serif alphabet became the model for typefaces in both Britain and continental Europe (Fig. 90). Perhaps most important of all, Johnston's interest in the massing and spacing of texts had a subtle, fruitful influence on typographic design.[171]

Nonetheless, the craft's medieval associations had a natural attraction for Luddites. One of Johnston's best early students, William Graily Hewitt, abandoned a career in the law and established a scriptorium with his former students to carry out large-scale illuminated book projects in conscious emulation of monastic book production. Between the wars Hewitt cherished dreams of the widespread abandonment of printing in favour of the manuscript book. He saw Johnston's peripheral involvement with typography as a betrayal. In 1935 he wrote angrily to Sydney Cockerell of Johnston 'giving the world, without safeguard or explanation, his block letters which disfigure our modern life'. A further betrayal in Hewitt's view was Johnston's fondness for 'the calligraphic firework of the panel, which is the modern equivalent of the seventeenth-century writing master's tour de force: beautiful no doubt, but not the true business of the scribe – which to me has remained, as I learnt it at first, that of the scriptor librarius, not the conjurer.'[172] In 1931 Hewitt's manual *Lettering for Students and Craftsmen* endorsed one type of hand, fifteenth-century Italian, as a suitable model for students. In a review Johnston himself gently and presciently pointed out that Hewitt's narrow vision would prevent less adventurous students from exploring 'that infinite variety which is the life of the craft'.[173]

Hewitt's criticisms overlooked Johnston's developing calligraphic audacity and his genius for composition and spacing. In an inscription on vellum presented to Alfred Fairbank in 1934 handsome Greek uncials are juxtaposed with Johnston's powerful compressed variant of italic and four columns of elegant quickly written cursive notes. The result is a rhythmic formal composition, comparable to the figured verses of Guillaume Apollinaire or to the epigraphical arrangement of Ezra Pound's poetry (Fig. 91). Johnston believed in 'true spontaneity' which, he wrote, 'seems to come from *working by rule but not being bound by it*'.[174] In contrast Graily Hewitt's careful memorial rolls and exquisite, richly illuminated manuscript books of the inter-war years are closer in spirit to Morris's efforts of the 1870s in which the actual writing, as opposed to the page's adornment, seems underdeveloped.

Johnston's work and thinking unselfconsciously and innocently braid Arts and Crafts and early modern ideas and language. He had grown up in an age passionate about reproductions, when the mantelpieces of the cultivated Victorian middle classes were cluttered with Parian reductions of the Elgin marbles and their walls hung with Arundel Society chromolithographs of Italian frescoes. Like the twentieth century's early direct carvers, Johnston had a dislike of what he called 'Two great modern illusions' – 'Reduction and Reproduction'[175] – and he responded to similar authenticities in other crafts. As he wrote affectionately to his neighbour in Ditchling, the weaver Ethel Mairet: 'My Text was once your Textile and my writing *Line* your Linen Thread'.[176] He frequently spoke of pieces of work as 'Things' and believed the scribe's job was to create 'a real thing'[177] rather as in 1913 Ezra Pound argued for the importance of 'Direct treatment of the "thing"' in the context of poetry (Fig. 92).[178]

The fact that Johnston was a pioneer working alone had its limiting aspects. He said little to students about his alphabet for the London Underground Railway and could seem aristocratically remote about the business of making a living.[179] His lectures were a distillation of his own remarkable character, full of vivid homilies and quaint observations but entire in themselves, making no reference to other visual art forms or to calligraphic developments in continental Europe. As a result his early students tended not to look outside the world of calligraphy. If Leach admired Johnston he might have had reservations about most of his

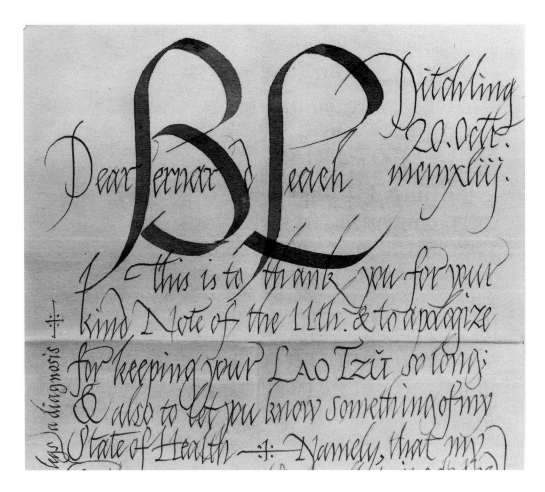

92. A real thing: letter from Edward Johnston to Bernard Leach, 20 October 1943. (Photo Holburne Museum and Crafts Study Centre, Bath).

acolytes, for few developed as freely and creatively as Johnston would have wished. A revealing insight is provided by Irene Wellington, easily his most imaginative pupil, who described how towards the end of the Second World War she went down to Ditchling to help Johnston with a piece of writing commissioned by Winston Churchill. Although she had been teaching at Edinburgh College of Art for ten years the master/disciple relationship remained unchanged and Wellington, then aged forty, found herself striving, heart in mouth, to carry out 'the master's' intentions.[180]

'Now that my working days are limited' Johnston wrote in 1936, 'I see no successor who will put his life and heart into the work that I love. There are plenty of *good* scribes to whom it is an occupation and a profession but apparently not a preoccupation and a dream.'[181] The activities of the Society of Scribes and Illuminators demonstrate that his disciples tended to be worthy but limited. The Society was formed in 1921, its rules intended to reflect Johnston's ideals. The 'spirit and attitude of a candidate towards the craft' were thought more important than 'mere technical ability or mechanical accomplishment'.[182] But the Society only honoured one aspect of Johnston's achievement – the establishment of a standard of fine writing. For Madelyn Walker, Honorary Secretary in 1926, the Society's purpose was 'to emphasise the superiority of the mss book to even the best printing as a work of art'.[183] The Society was a conservative body, taking a newly revived craft and attempting to regulate a standard to ensure its status. Its conservatism was reinforced by the patrons that the craft attracted – the church, public schools, the armed forces and city livery companies – few of whom would have responded to a radical approach.

In other ways the Society was pioneering. It was largely run by women for women. Madelyn Walker demonstrated gilding and described visits to Benedictine abbeys in France, Miss Hodgson discussed vellum preparation, Rosemary Radcliffe discussed the oblique O. The Society's secretaries gave advice on selling work, on learning the craft. They organised regular exhibitions in London, the provinces and abroad and wrote to potential patrons and pupils offering the services of members. In order to assist its members the Society formed a reference library and set up special research groups with committees to investigate the use of

skins for parchment and vellum, to study cursive writing, to look at gilding and heraldry. A record was kept of lectures and of discoveries. In addition, the Society had something of the function of a trades union, with a scale of charges committee stating in 1925 that £5 for a 40 hour week should be a minimum wage for a scribe and arguing that 'scribes should overprice rather than underprice'.[184] As Madelyn Walker explained to an anxious woman correspondent from Dublin: 'I, for one, entirely earn my living at the practising and teaching of the craft.'[185]

Thus the society actively sought to help women gain independence, led by strong versatile characters like Madelyn Walker, a superlative researcher who eventually took holy orders, Dorothy Hutton, who ran The Three Shields Gallery in Holland Street, Alice Hindson, who was also a successful drawloom weaver and Louise Powell who, as we have seen, also designed and decorated ceramics with her husband Alfred Powell and was a skilled embroiderer.

However, in artistic terms the calligraphic work produced by Johnston's followers looked cloistered, as if its practitioners had fallen in love with the craft's reassuring materials – the vellums, quill pens and gold leaf – and had forgotten to look out to a wider world. Compared to the experimental freedom of European calligraphers like Rudolf von Larisch and Rudolf Koch, the inter-war calligraphy world in England never strayed far from the medieval and Renaissance models recommended by Johnston.

An analogy can be made with bookbinding. The 'trade' binders set extremely high standards, achieved through the strict division of labour. What was lacking in the big London binderies was a certain tenderness of touch.[186] At his Doves Bindery from 1893 T.J. Cobden-Sanderson established a new standard of simplicity in decoration and care about good materials and honest structure. The Doves ideal was communicated by his former apprentice Douglas Cockerell as a teacher at the Central School of Arts and Crafts from 1897 until the mid-1930s and as the author of *Bookbinding and the Care of Books* (1901), one of the Artistic Crafts series edited by W.R. Lethaby. Like Edward Johnston's contribution to the series, *Writing & Illuminating & Lettering*, Cockerell's text had both an inspiring and a reductive effect. It helped create a school of artist craft binders, but its influence was stasis in the inter-war period.

Edward Johnston also exerted an indirect influence in further areas. One was day-to-day cursive handwriting. Here Johnston's contribution was slight. He had no mission to improve scrawled or illegible informal hands[187] and he acknowledged that his formal hands were not suited for speedy informal use. The matter of informal handwriting was of more interest to Roger Fry who was co-opted by Robert Bridges to preface a book of handwriting examples culled from the poet's friends and published in 1926. Fry's criteria for judging writing were

93. The hand of Gerard Manley Hopkins in *English Handwriting with Thirty-Four Facsimile Plates, Tract XXIII*, Society for Pure English, Clarendon Press, Oxford 1926.

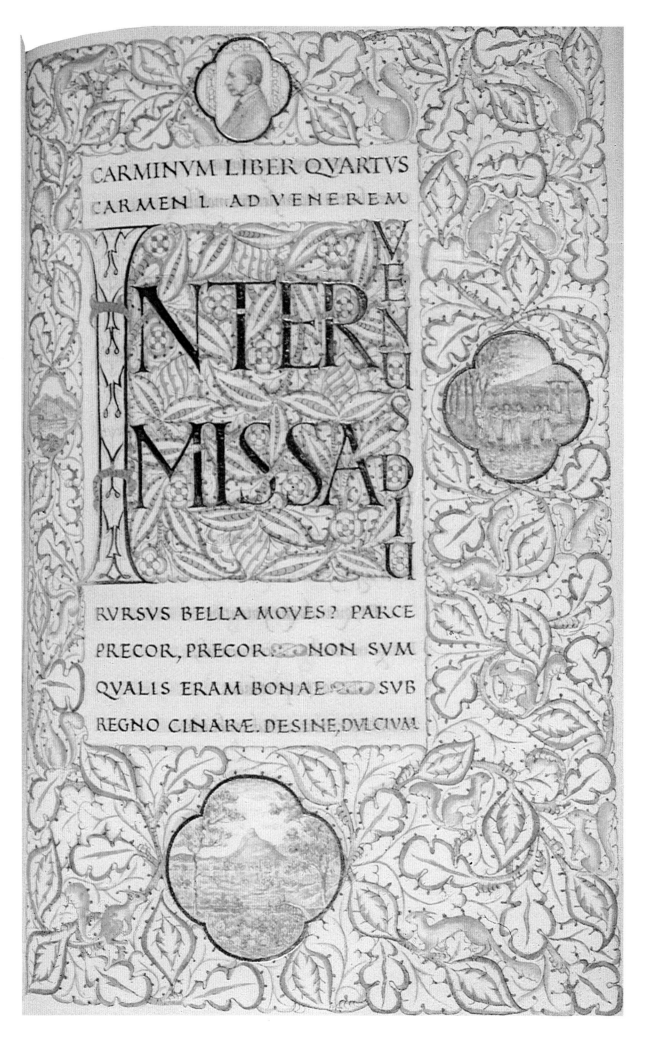

CARMINVM LIBER QVARTVS

CARMEN L AD VENEREM

INTER
MISSA

VENUS DIU

RVRSVS BELLA MOVES? PARCE

PRECOR, PRECOR. NON SVM

QVALIS ERAM BONAE SVB

REGNO CINARÆ. DESINE, DVLCIVM

close in spirit to his critiques of modern art. Fry admired Johnston but felt that the formal hands he had revived were too monotonous and unvarious. Fry sought rhythm in handwriting and singled out a hastily penned example by Gerard Manley Hopkins for particular praise (Fig. 93). Rhythm was also invoked as the basis of informal writing by Fry's friend, the teacher Marion Richardson. As the art mistress at Dudley Girls' High School in the 1920s, her approach to children's painterly creativity had won her fame. In 1931 she was appointed an LCC school inspector and began to think about writing in terms of 'easy movements of the hand and arms, such as are used in primitive forms of decoration and childish scribble'. She reduced such scribbles to six basic patterns which were adapted by her as exercises intended to prepare children for writing.

If Richardson advocated modernist expressiveness, Alfred Fairbank, a key figure in the revival of italic handwriting, stood for a subtler discipline rooted in suitable exemplars. Fairbank was the son of an engine fitter who worked his way up the civil service. His interest in writing had been awakened by his youthful study of William Morris and by evening classes with Graily Hewitt at the Central School in 1920. Fairbank's own exquisite, innocent-looking script was based on the sixteenth-century chancellery hands perfected by Italian writing masters like Ludovico Vicentino degli Arrighi. Despite working at the Admiralty he found time to collaborate with Louise Powell on manuscript books – he wrote and gilded and she illuminated (Fig. 94) – and on scholarly palaeographic researches into sixteenth-century scripts. In 1932 his writing cards for use in schools were published by Harry Peach's Dryad Press and, crucially, he persuaded the St Paul's Pen Works of Birmingham to mass produce italic pens. The neat writing hands employed by teachers and obedient pupils in the 1940s and 1950s owe much to Fairbank's dissemination of the italic hand. His interest in legibility and clarity in handwriting was shared by members of the DIA like Gordon Russell, Ambrose Heal and Harry Peach for whom clear handwriting was less an art form than a branch of good design.[188]

The crafts of letter carving and sign writing were another area of interest for designers and design reformers. Neither of these activities was moribund in the 1910s and 1920s but Johnston's identification of Roman Trajanic letter forms as the origin of good lettering was taken to heart by the Church in the form of the Diocesan Advisory Committees and by the State through the signage adopted by the Ministry of Works. Taste-forming bodies such as the DIA and the British Institute of Industrial Art also published guidelines which recommended Trajan for public lettering. The bloodless results led, ironically, to a marked renewal of interest in decorative Victorian vernacular letterforms. These were used, mischievously, on the cover of John Betjeman's *Ghastly Good Taste* in 1933 (Fig. 96) and propagandised enthusiastically in the late 1930s by the young lettering historian Nicolete Gray who, in flight from Trajan, proposed nineteenth-century ornamented typefaces as 'one of the folk arts of early industrial society'.[189]

The widespread adoption of inscriptional Trajan may be attributed in part to the influence of Eric Gill, Johnston's most brilliant and complex pupil (Fig. 8). But although he recommended it as a model in his essay on 'Inscriptions in Stone' in Johnston's *Writing & Illuminating & Lettering*, Gill was never narrow in his interests or in his art and his career sheds a crucial light on the problematic space occupied by the crafts in relation to design for industry and fine art. No one questioned the purpose of craftwork in an industrial age more passionately and vigorously than Gill. He was one of the few inter-war makers to continue the social and political debates initiated by Ruskin, Morris and Ashbee. In addition, Gill, almost accidentally, found himself briefly at the heart of a sculptural avant-garde in about 1910, an experience which gave some weight to his subsequent comments on the foolishness of the hierarchisation of the arts. Like Johnston, he was on Leach's short list of pioneers of the inter-war years.

Gill had joined Johnston's Central School class in 1901, an 'earnest and enthusiastic boy from the provinces'.[190] Seeing Johnston drawing on a blackboard for the first time was a revelation for Gill, recalled in his *Autobiography* as a 'thrill and tremble of the heart'.[191] Nonetheless Gill's interests in lettering swiftly developed away from calligraphy. He was

94. Alfred Fairbank and Louise Powell, *Odes & Epodes of Horace*, 1927–32 showing the beginning of Bk. IV with a portrait miniature of C.H. St John Hornby who commissioned the manuscript. (Sir Simon Hornby. Photo Bodleian Library, Oxford).

concurrently studying stone-masonry and inscriptional carving at the Westminster Technical Institute and by 1903 had left his day job in the office of the architect W.D. Caroë to become a full-time inscriptional carver – with plenty of commissions from architects and 'lay folk of more cultured circles' who were glad to find an alternative to the 'deadly corruption of the trade mason.'[192]

Gill's cut lettering, a rationalisation and simplification of Trajan, had a remarkable freshness and beauty. For Roger Fry writing in 1906, Gill had solved the artistic problems posed by carved inscriptions 'with absolute, undeniable completeness'.[193] Massing and spacing he had learnt from Johnston and he shared with Johnston a belief in the central role of the apt tool: 'Beauty of Form may be safely left to the right use of the chisel.'[194] He also shared Johnston's belief in direct representation: 'Letters are things, not pictures of things.'[195]

Gill was not a slave to Trajan. His workshop interpretation of the letter form, used by his assistants and apprentices, was principally designed to be both handsome and foolproof. Gill knew how to set out letters simply, in a fashion which touched the heart, and in the aftermath of the Great War a stream of private and collective patrons needed their grief assuaged (Fig. 95). The running of a workshop and his identity as a mason and as an inscriptional carver pleased Gill on political and moral grounds. As the painter and patron William Rothenstein recalled ironically, Gill 'liked to think of himself as a working craftsman, his work anonymous as a blackbird's song; and he charges so much an hour for his work.'[196]

Gill did not restrict himself to carved inscriptions. From 1906 lettering and powerful purposeful images were combined in numerous wood-engravings – a frieze of sisterly women done for the magazine *Labour Woman* in 1914, a satirical image of a music-while-you-work culture engraved for his 1933 pamphlet *Unemployment* (Fig. 97). In 1925 he designed his first typeface, not for a private press but for the Monotype Corporation. This was Montotype Perpetua, to be followed by Monotype Gill Sans in 1927, an intelligent adaptation of Johnston's sans serif alphabet. Gill's involvement with Monotype, and therefore with the world of machine composition and power presses, may seem surprising. But he disliked the

95. Eric Gill, war memorial tablet, Euville stone, lettering coloured red and blue, St Dominic's Priory, Southampton Road, London, 1921. (Courtesy of the Prior and Community).

preciousness of most fine printing and private presses. In *An Essay on Typography* of 1931 he argued for simplicity: 'Humane typography' will 'often be comparatively rough and even uncouth'.[197] Admittedly he designed for Robert Gibbings' Golden Cockerel Press between 1925 and 1931 but in this instance he introduced another kind of uncouthness with his floriated, often sweetly lubricious, engraved capitals introducing a populism and robustness to the private press world (Fig. 98). Gill's liveliest collaborations were with Douglas Pepler's St Dominic's Press and later with Hague & Gill, the printing press he established with his son-in-law René Hague in 1930 and for which he designed a range of typefaces. Both presses undertook jobbing printing the results of which seem remote from private press work.

In 1909 Gill carved a figure, a crouching woman in relief holding up some lettering caryatid-fashion. For Gill it was an extension of the directness of cut lettering: 'this new job was the same job, only the letters were different ones. A new Alphabet – the word made flesh.'[198] In that year he had published his attack on *The Failure of the Arts and Crafts Movement* and was increasingly turning for advice and encouragement to leading figures in the fine art world like the painter William Rothenstein and Roger Fry. Their immediate admiration for the archaic power of these first carved sculptures – a compact *Mother and Child* (Fig. 99), a semi-relief *Cupid* with a fan of hair and chubby genitals and a taut little figure known as *The Rower* (Fig. 100) – was an encouragement.

Gill's first sculptures were in sympathy with a Europe-wide avant-garde rejection of nineteenth-century sculptural practice. This had involved modelling in clay or plaster followed by casting in bronze or careful translation into stone using a system of measuring known as pointing. This renewed sensitivity to the distinction between the disciplines of modelling and casting and a desire to carve directly were sparked off in part by a rereading of sixteenth-century Michelangelesque art theory and a growing interest in so-called 'primitive' sculpture, often discovered through photography as well as first hand in the great ethnographic collections in London and Paris. A letter of 1910 to Count Kessler sets out Gill's position clearly: 'I want to be a stone carver...I do not particularly want to know how to reproduce accurately and expeditiously in stone a clay model'.[199] Gill had certainly read Vasari's recently translated technical introduction to his *Lives of the Artists*[200] which defined sculpture as carving rather than modelling. In 1917 he also made a more craft-based, Johnstonian distinction: 'The sculptor's job is primarily the making of *things*, not representations of things.'[201] We cannot assume that Gill knew much about developments in continental Europe. But Constantin

96. John Betjeman, *Ghastly Good Taste*, Chapman & Hall, 1933.

97. Eric Gill, wood engraving for *Unemployment*, Faber & Faber 1933. *Techne* does the work while the worker listens to *Poiesis* of a degraded sort on the radio.

98. Initial 'O' for the Shipman's Tale, *The Canterbury Tales*, vol. 11, Golden Cockerell Press, 1929–31.

99. Eric Gill, *Mother and Child*, Portland stone, late 1909–24 January 1910, h. 58.4 cm. Sold to William Rothenstein in February 1910. (Leeds City Art Gallery).

Brancusi's 1908 version of *The Kiss* which honoured the mass of the limestone block and was directly carved would have appealed to Gill's anti-realism and his search for 'the reality underlying appearances'.[202]

For a couple of years Gill was at the centre of a sculptural avant-garde, planning a collaborative 'twentieth-century Stonehenge' with Jacob Epstein whom Gill may have introduced to direct carving, and in 1912 appearing in Fry's Second Post-Impressionist show. The third direct carver in this early period, Henri Gaudier-Brzeska, never appears to have met Gill but in 1914 he wrote of sculpture in very similar terms: 'The sculpture I admire is the work of master craftsmen...No more arbitrary translation of a design in any material'.[203] Gill shared a canon of admired pre-Renaissance, non-Western art with early modernists. He studied medieval carving and in 1911 wrote to Rothenstein of his excitement at the sight of photographs of Indian wall paintings and sculptures.[204] Indeed, throughout his life his pantheon included modernist icons – early European, Indian, Chinese, Mexican and Egyptian art as well as all 'primitive' art.[205]

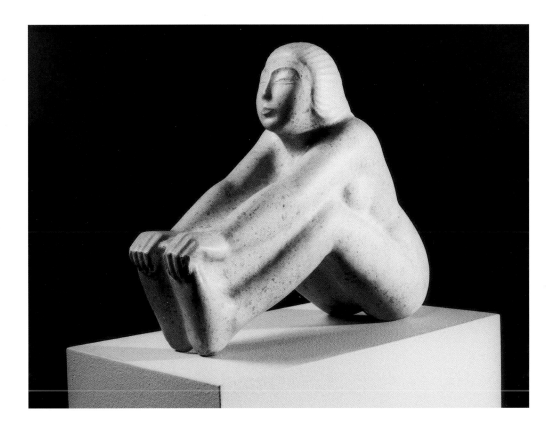

But from 1913 until 1917 Gill was working on the Stations of the Cross for Westminster Cathedral, a commission which was connected to his conversion to Roman Catholicism in 1912 (Fig. 101). These relief tablets had the distinctly traditional function of providing a legible Christian narrative for worshippers. Their particular kind of archaism owes more to Byzantine art than to the more fashionable non-European sources of the period. By 1915 Gaudier-Brzeska was dead and Epstein had embraced a modern iconography with far greater fervour than Gill. Meanwhile Gill was respositioning himself as a sculptor. In 1917 he contributed an essay on sculpture to *The Highway*, the journal of the Workers' Educational Association and not an artistic or literary magazine. In 1924 the same revised essay, incorporating 'a preface about God' envisaged another possibly overlapping audience – of committed Christians. Gill's politics and his Christianity had the effect of distancing him from the avant-garde. As he explained: 'Their views were both more simple and more mysterious than mine. They were essentially aesthetes; that was the awful truth…what they really believed in and worked for was aesthetic emotion as understood by the art critics.'[206]

After about 1913 Gill's work looked different, no longer fitting into the trajectory of twentieth-century modern British sculpture from Epstein to Gaudier-Brzeska to Barbara Hepworth and Henry Moore. The small compact secular pieces which so delighted Fry and Rothenstein – *Cupid*, *The Rower*, *The Boxers*, the first *Madonna and Child* – vanish from his oeuvre. Even the commitment to direct carving was set aside. Gill used stone in a matter-of-fact, craft-based way: 'because that is the material to hand or the material ordered by customers'.[207] After his conversion to Catholicism he was just as ready to make cheap plaster madonnas for religious use. Gill, unlike, Henry Moore, did not teach. He ran a jobbing workshop and he was careful to respond (however subversively) to the demands of a commission. This invariably involved readable narrative. But although Gill's later career as a sculptor appears to represent a move from art to craft, Gill's practice was anomalous even when compared with other leading makers of the inter-war years, with their austerely formalist stoneware pots and abstract textiles and their distinctly intermittent social concerns. Gill, by contrast, was a socio-political activist, arguing, debating and where possible putting religion, politics and sexuality into his work. What is interesting is the way in which the ambient culture successfully defused his radical ideas. Gill never lacked commissions, not least because he was regarded as a celebrity crank, an English Eccentric.[208]

101. Eric Gill, *IX Jesus falls a third time*, the ninth Station of the Cross in the nave of Westminster Cathedral and the last to be completed by Gill. Hoptonwood stone with coloured letters. Carved 4 December 1917–11 April 1918. 172.7 cm square. (Conway Library, Courtauld Institute of Art).

102. Christopher Whall, *Angels at the Resurrection*, part of the East Window of Chipping Warden parish church, Northamptonshire, 1902. (Photo Peter Cormack).

103. (*opposite*) Wilhelmina Geddes, *SS. Hubert, Christopher and Cecilia*, the South aisle West window at Laleham parish church, Middlesex, 1926. (Photo Peter Cormack).

In the relief panel:

NE LAE-TERIS, INIMICA MEA, SUPER ME, QVIA CECIDI, CONSURGAM: CUM SEDE-RO IN TENEBRIS, DOMINUS LUX MEA EST.

IX JESUS FALLS A THIRD TIME

STAINED GLASS

As we saw in Chapter One, stained-glass artists of the late nineteenth century differentiated themselves from Morris & Company's practice. They were greater purists. The key figure was Christopher Whall, an unsuccessful painter who began to take an interest in the medium after a design of his was made up crudely by a trade firm.[209] He set about learning the technicalities of the craft with the same kind of thoroughness that Edward Johnston gave to calligraphy and in 1887 established his own studio. Whall, like other second-generation Arts and Crafts artists, believed that there had been too much division of labour in Morris's glass production, although he recognised that Morris & Company glass was a vast improvement on the output of the commercial firms whose production depended upon intense specialisation at every stage. In Whall's view the artist needed to select his raw material and cut, paint and fire it. The business of glazing and installing the completed window would also be done under the artist's supervision.

Whall and his followers were able to exploit a kind of retro-technology in the form of a thick, uneven blown glass known as Early English or Norman Slab glass. It was made by blowing hot glass into a square mould and subsequently cutting the bottle shape into five pieces and from 1889 was being produced by the enlightened Southwark trade firm of Britten and Gilson.[210] Whall made full use of its texture and saturated colours (as well as its silvery whites and pale greens) and he combined these 'authentic' materials with a drawing style which owed a good deal to Burne-Jones's neo-medieval figure types and Morris's foliage patterning (Fig. 102). Late works, like his dramatic array of angels with flaming iridescent wings for the nave clerestory of Sedding's Holy Trinity, Sloane Street of 1904–23, go beyond Burne-Jones to suggest the colouristic influence of Continental Symbolist painters like Gustave Moreau.

To the Memory of
Percy Goldwin Belfour
of Laleham who died at the
organ here after evensong on
Sunday 1 Jan 1925 this window
was erected by his wife & family.

Whall had great influence as a teacher at the Central School from 1896 and at the Royal College of Art from 1901, and as the author of *Stained Glass Work* (1905) in Lethaby's Artistic Crafts Series. In effect he set the agenda for the inter-war years which at its best was rich in beautifully drawn, other-worldly androgynous figures and pleasing pastoral detail, made lovely by the shimmering lush quality of hand-blown glass. In 1922 he went into partnership with his gifted daughter Veronica as Whall & Whall Ltd and after his death in 1924 she completed his windows of Gloucester Cathedral and worked on independently until 1953.

In London the little renaissance Whall initiated was extended by the firm of Lowndes & Drury which had been set up in 1897 by his pupil Mary Lowndes and by Alfred Drury, formerly of Britten and Gilson. They set out to provide facilities and studio space for artists who wanted to work in the Whall spirit, with close control and involvement with every stage of the creation of a window. In 1909 the firm moved to Lettice Street in Fulham and throughout the inter-war years and beyond the Lowndes & Drury Glass House assisted a nest of stained glass artists around Fulham and over the river in Putney. It is worth noting that from 1916 onwards about half the best known practising stained glass artists were women.[211] This was despite the fact that the British Society of Master Glass Painters, formed in 1920, had no women on its council and rather few women members or 'Fellows'. None the less Whall and his leading pupil Karl Parsons had many women students and clearly had a positive attitude to women working in the craft. In addition, in the early part of the century Mary Lowndes was a leading figure in the women's suffrage movement and chairwoman of the Artists' Suffrage League and part of a close knit network of women in the Kensington/Fulham/Chelsea area.[212] Women associated with the Glass House, like Caroline Townsend and Joan Howson, tended also to be involved in women's suffrage.

That such a high proportion of women should take up stained glass nonetheless seems surprising. Like many in the inter-war craft movement, women stained-glass artists tended to come from privileged backgrounds: Evie Hone's father was a director of the Bank of Ireland, Joan Howson was the daughter of an archdeacon, Mabel Esplin was the daughter of a wealthy furniture manufacturer. But this explains little. Moira Forsyth, a pupil of Martin Travers at the Royal College of Art, noted of the craft: 'Not specifically a career for women, physically tiring and heavy work. But for the enthusiast for light and colour, perhaps the most wonderful medium in the world, though very tricky to handle.'[213] In the wider art world stained glass was seen to be a marginal activity, despite the ambitious and expensive commissions which glass artists carried out. In the mid-1930s Forsyth found that when she described herself as a stained-glass artist 'often the response was an incredulous shudder of distaste'.[214]

Stained-glass artists, both male and female, tended to be largely unaffected by modernism in other art forms. The women drawn to stained glass had a different sensibility from their contemporaries who were block-printing textiles, weaving and making stoneware pots. Good figurative drawing and a spiritualised realism characterised the best inter-war glass. Commissions were largely ecclesiastical and clients conservative. But in other ways the leading women glass artists led similar lives to women in other craft disciplines. Few married. Practice as a professional craftswoman was incompatible with conventional domesticity and instead many chose to work and live with a close woman friend.

Whall was an undoubted inspiration to the most impressive stained-glass artists of the inter-war years, Harry Clarke and Wilhelmina Geddes.[215] Both were Irish and were taught not directly by him but by a favourite pupil, Alfred Child. Child became instructor at the Dublin Metropolitan Art School in 1901 and by 1903 was managing a co-operative glass workshop, An Túr Gloine (Tower of Glass) which had been set up in Dublin along the lines of Lowndes & Drury. Harry Clarke looked to Continental Europe for inspiration and his glass was informed by a love of Symbolist and Decadent painting, by his immersion in the romantic nationalism of the Celtic Revival and by his skills as a colourist and draughtsman. His final project for the League of Nations International Labour Building in Geneva, completed in 1930, combined Beardsleyesque illustration, stylised idyllic landscapes and the social realism of the caricaturist. The result did not fit the Irish government's idea of the Free State's national

104. Karl Parsons, *The Archangel Michael*, War Memorial window in Christ Church, Fulham, London 1922. (Photo Peter Cormack).

identity and the panel was never installed. Clarke as an artist working in Ireland falls outside the scope of this book but Wilhelmina Geddes, after working at An Túr Gloine from 1912, moved to England in 1925 and rented a studio at the Glass House. In the context of inter-war stained glass she ranks in a class of her own.

A commemorative window at All Saints, Laleham in Middlesex, of 1926 was made soon after her arrival in England and reveals an original spirit, who completely set aside the formulaic beauties of her contemporaries (Fig. 103). Her work was tough, even awkward, and cannot be explained by her training with Child and, briefly, with Sir William Orpen. A scholarship visit to London in 1911 may provide a clue. Geddes could have visited the Cézanne and Gauguin exhibition at the Stafford Gallery in November of that year. Exposure to Gauguin's art and to Post-Impressionism could explain why she alone of the inter-war glass community threw off the late Pre-Raphaelitism that dominated English glass.

Geddes's pupil Evie Hone had a far more obviously modernist background.[216] Her glass career began in 1932 at An Túr Gloine followed by a period with Geddes in London. But she had lived in Paris in 1920, returning for regular visits until 1931, studying first with the painter André Lhote and then more seriously with the theoretician of cubism, Albert Gleizes, working on colour theory. Hone was also interested in early Irish carving, in twelfth- and thirteenth-century glass and in the work of Georges Rouault whose windows for Notre-Dame-de-Toute-Grace at Assy, Haute Savoie (1945) had a great impact on post-war glass in Britain. Hone's burst of creativity came after the Second World War but as her East window at Eton College of 1952 suggests, she was never as subtle a manipulator of the medium as Geddes.

Most other inter-war stained-glass artists developed along more predictable lines. Karl Parsons was one of Whall's most technically accomplished and adventurous pupils.[217] A visit to Chartres in 1924 led him to enrich his glass with textured pigments and acid etching. Parsons could draw beautifully, though in the late 1920s he was still employing a Pre-Raphaelite visual vocabulary. But he was a good designer, able to present the whole hierarchy of heaven in a convincing, awesome way (Fig. 104). Another pupil of Whall's, Louis Davis, was a greater experimenter, but he did little new work after World War I. Other pupils of Whall and Parsons – Henry Payne, Edward Woore, Payne's pupil Margaret Rope, her niece Margaret Aldrich Rope, Caroline Townsend, Rachel de Montmorency, Paul Woodroffe – used a similar visual language, made less fearsome and more pastoral. The Scottish artist Douglas Strachan carried the Whall project forward with great confidence, creating lush, memorable glass for Sir Robert Lorimer's Scottish National War Memorial (1927) in Edinburgh Castle.

The Whall 'school' can be contrasted with Sir Ninian Comper's pupils who include Martin Travers, Geoffrey and Christopher Webb and Hugh Easton. All worked in a recognisably 'Comperesque' style, leaving areas of clear glass against which figures and landscapes were silhouetted. The effect was restrained and vaguely reminiscent of a re-invented eighteenth-century glass idiom. But, tellingly, most accounts of stained glass between the wars cite the remarkable window by Alfred Wolmark at All Saints, Slough, commissioned by Wyndham Lewis in 1915. It is abstract and suggests possibilities which were only to be explored after the Second World War.

THREE

FINDING A PLACE FOR THE CRAFTS

A survey of individual craft disciplines inevitably suggests a series of separate worlds, each with their own particular standards and concerns. This chapter sets out to position the crafts in a wider context showing how handcraft occupied an often ambiguous space between the disciplines of architecture, design and fine art. With a few exceptions, creative craftwork ceased to be an integral part of architectural practice. The continuance of relatively strong links with church architecture in an increasingly agnostic century may even have served further to marginalise the crafts. On the other hand, certain crafts – particularly ceramics and textiles – found a role in the modern interior in the late 1920s. By the mid-1930s, however, there was a marked shift. The hand-made was increasingly dismissed by commentators interested in design. For them craft practice appeared an inappropriate response to the urgent economic needs of the 1930s. This chapter looks at the responses of the leading craft societies to this new orthodoxy, at the ways in which craftwork was contextualised in exhibitions and by shops and galleries and at the continuing role of traditional and trade crafts in the projection of national identity – especially in the context of the 1937 Paris exhibition. Finally these themes are drawn together in a case study of the craft and design activity at Dartington Hall in Devon. Here the crafts were put under the microscope and craft economics were analysed and found wanting. The Dartington experiment suggests that between the wars craftswomen and men had more in common with painters and sculptors than with designers. Despite claims by groupings within the craft world that the crafts functioned as a vital research tool for industry, on the whole makers acted as bearers of dreams rather than as problem solvers. Their role was shamanistic rather than functional.

COMBINED ARTS

Architectural collaboration had been central to the nineteenth-century Arts and Crafts Movement. Its leading practitioners had trained as architects and they thought in terms of adorning houses, churches, public buildings and creating 'beautiful cities'[1] as alternatives to the squalor and grime of the big nineteenth-century industrial conurbations. In John Dando Sedding's Holy Trinity, Sloane Street, London, built between 1888 and 1890, the trust between different artists, designers and craftsmen, nurtured at meetings and discussions at the Art Workers' Guild, was triumphantly displayed (Fig. 13). The period between the wars would see nothing like Holy Trinity. The crafts most closely connected to architecture – much stained glass, some carving in wood and stone, architectural metalwork, plaster and lead work – came to seem the most static. This was partly because the architecture changed too, and the building crafts became servants of a reticent neo-Georgianism which dominated the scene from 1910 onwards.

It is suggestive that none of the more vital and influential craft practitioners of the inter-war years had trained as architects. Nor did they belong to the Art Workers' Guild. Founded in 1884 by the decade's most imaginative architects, the Guild was the intellectual power house of the Arts and Crafts Movement, a forum for the exchange of ideas and theories. It continued to be active in the inter-war years and its talks and speakers reflect an alertness to contemporary visual culture. But Bernard Leach, Michael Cardew and Eric Gill did not

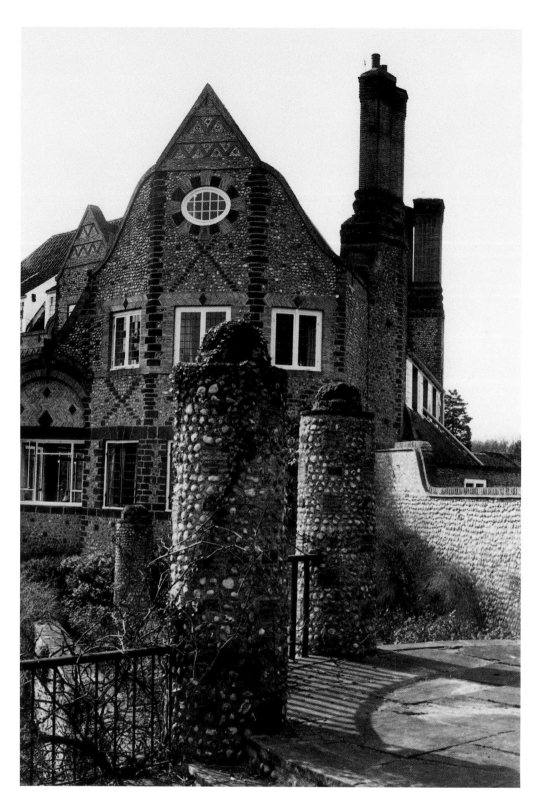

105. E.S. Prior, Home Place, Holt, Norfolk, (1903–5), a detail of the garden façade. (Conway Library, Courtauld Institute of Art).

belong, and major figures like the potters Dora Billington and Katharine Pleydell-Bouverie, the weaver Ethel Mairet and the hand block-printers Phyllis Barron, Dorothy Larcher and Enid Marx were barred from membership by virtue of their sex. The Art Workers' exclusion of women meant that many of the most important inter-war makers were simply not present at their picturesque revels or at their lectures and meetings. Even when finally admitted in 1964 the Guild was never to attract the most innovative women in architecture, craft or design.

In more general terms the loss of linkage between the crafts and architecture was both a liberation and a cul-de-sac. Lack of an integral architectural role made each craft autonomous, as design historian John Houston aptly put it, —'free to evolve, free to stagnate'.[2] Nonetheless collaborative work did not vanish overnight; the inter-war years saw a surprising number of

buildings conceived in an Arts and Crafts spirit and many which flaunted the forms if not the substance of Arts and Crafts domestic architecture.

The richest twentieth-century architectural examples are almost outside our period and belong to the Arts and Crafts Movement proper. E.S. Prior's Home Place at Holt in Norfolk of 1905 with its startling use of tiles, Norfolk flints, Carstone and timber, all won or made locally, is an exemplary building and a monument to Prior's respect for the co-operative crafts of masons and joiners (Fig. 105).[3] However, hard-won research into vernacular building crafts was not suddenly abandoned after the First World War. Ernest Barnsley, Alfred Powell and the rather younger architect Norman Jewson all valued local skills and materials over drawing board plans – which was why they made the Cotswolds their base for modest new buildings and subtle conversions like Jewson's 1925 work on the sixteenth-century Owlpen Manor and Powell's cottage at Tunley (Fig. 106). Each Cotswold town and village was a lesson in regional architecture and vernacular skills, making it easy for the furniture designer Gordon Russell to create a Building Department in the town of Broadway in the late 1920s which used traditional Cotswold techniques.[4]

For an influx of American tourists Cotswold vernacular represented Englishness. 'Why didn't they take the hill with it and the rest of the village?' asked the country writer H.J. Massingham satirically of Henry Ford's purchase of the Snowshill smithy and its contents.[5] Henry Ford employed Albert Kahn to design a 'Cotswold' manor house (in fact a concrete shell faced with stone) for his son Edsel outside Detroit. It was completed in 1929 and roofed by the Cotswold slater H.J. Gooding of Stow-on-the-Wold, who was specially brought over to United States together with carefully packed boxes of stone slates from the Eyford quarry.[6]

Ford was indulging in the purest denial in the face of serious social and economic unrest in the United States. In Britain, however, vernacular architecture in the 1920s meshed with the

106. Alfred Powell, Sherwood Hill (formerly The Thatched Cottage), Tunley, Gloucestershire. Partly eighteenth-century but alterations and additions made by Powell 1902–3 and by Sidney Barnsley in 1926. Note vertical timber boarding, ladder to bedroom loft and a frieze of Ernest Gimson plasterwork in the room beyond. (Maureen Batkin).

taste of socially concerned clients who by the 1930s would probably have commissioned a Modern Movement building. There was Ernest Gimson's Memorial Library at Bedales (1920), pure Arts and Crafts architecture with a soaring interior of timber wallposts, curved braces, tie beams, collar beams and crown posts (Figs 107, 108). It was furnished with turned chairs made by Edward Gardiner to Gimson's designs and great oak tables with hayrake stretchers designed by Sidney Barnsley and made at Geoffrey Lupton's workshop. Arguably this was a delayed pre-war commission, but nonetheless it is an interesting choice for a progressive school. Then there was William Weir's restoration of the Banqueting Hall at Dartington carried out between 1926 and 1936 for Dorothy and Leonard Elmhirst. The Elmhirsts' distinctly alternative society encompassed local Devon craftsmen shaping beams, collars, wall plates and rafters of local timber with adzes.[7] And although few figures in the inter-war craft world could afford to commission new houses, Gordon Russell's Kingcombe, near Chipping Campden (1924–6) was designed by Leslie Mansfield in a stripped down version of Cotswold vernacular while Ethel Mairet employed Sussex vernacular for her home and studio Gospels in Ditchling (1919–20). All these patrons were to take up modernist positions by the 1930s.

None of these projects matches the construction and furnishing of Rodmarton Manor, near Cirencester, Gloucestershire, begun in 1909 with Ernest Barnsley as architect and building and furnishing continuing until 1929 under the supervision of Norman Jewson.[8] Like E.S. Prior's Home Place, Rodmarton was a passionately regionalist enterprise. All the stone for the

108. Ernest Gimson, Memorial Library, Bedales School, 1920. (Photo Garrick Palmer).

house was quarried locally and cut and shaped on site (Fig.109). The timber for beams, internal panelling and furniture came from the estate and was prepared without power tools in a saw pit. The decision to saw the Rodmarton timber by hand instead of using a circular power-driven saw suggests a desire for a perceived authenticity, a wealthy client and, surprisingly, a lack of humanity.[9] Sawing in a pit, as a reading of George Sturt's *The Wheelwright's Shop* reveals, was arduous, miserable work.[10]

Nonetheless Rodmarton was an experiment in rural revival. The clients, Claud and Margaret Biddulph, spent £5,000 a year on its construction and the estate workshops employed thirty men at the height of the project. The interior furniture was made in the estate workshops, and in the workshops of Edward and Sidney Barnsley and Peter van der Waals. In the 1930s the Powells contributed large lustre painted platters and Alfred Powell designed floriated carvings and panelling. The lead work on the exterior was rich in details of birds and animals (Fig. 110). The painter Hilda Benjamin provided idealised country scenes to be embroidered in appliqué by the local Women's Guild. For the whole inter-war period Rodmarton's stark interior functioned as a centre for local life with, as William Rothenstein observed, Margaret Biddulph 'presiding over house and village like the abbess of some great medieval religious house'.[11] Rothenstein intended no irony and believed that 'a hundred people doing as the Biddulphs did would have gone far to transform the face of rural England'.

It is tempting to dismiss all this as an exercise in powerful local feudalism. But despite its

109. The building of Rodmarton Manor, about 1912. (Photo courtesy of Mr and Mrs Simon Biddulph).

110. Detail of leadwork by Norman Jewson.

111. The theatre room at Rodmarton Manor around 1930. (Country Life Picture Library).

magnificent frontage Rodmarton is an unusual country house. It is more like an extended cottage, only one room and corridor deep. In the 1920s and 1930s the larger rooms were given over to communal village activities (Fig. 111). Perhaps it would be most accurate to read the house and its co-operatively made furnishings as a rejection of the disengaged way of life led by the more plutocratic landowners of the inter-war years.

FASHIONS IN CHURCH FURNISHINGS

Rodmarton Manor was a remarkable continuation of Arts and Crafts ideals in domestic architecture. But it was ecclesiastical architecture and liturgical debate that did more to keep craft and architecture together between the wars, even if these collaborations were often formulaic. As with domestic architecture a degree of regionalism operated. Gloucestershire, not surprisingly, is rich in churches beautified by furnishings from the workshops of Sidney and Edward Barnsley, Ernest Gimson and, subsequently, Peter van der Waals, and with stained glass made by Henry and Edward Payne and silver work by George Hart. Christ Church, Chalford, refurbished in the 1930s, with its font carved by William Simmonds (Fig. 112), silver-plated dove topping the font cover by Norman Bucknell, Henry Payne stained glass, lectern and chancel screen designed by Norman Jewson and made in Waals's workshop and triptych painted by Nan Reid with a figure of Christ carved by Alan Durst. suggests the continuity of skills in Chipping Campden and the Sapperton area even after the demise of Ashbee's Guild of Handicraft and the death in 1919 of Ernest Gimson. On a smaller scale there was a richesse of stained glass in London due to the presence of Christopher Whall and his daughter Veronica and the workshop of the Arts and Crafts firm Lowndes & Drury in Lettice Street in Fulham. As a result West London has plenty of ecclesiastical glass by Whall, Martin Travers, Karl Parsons and Leonard Walker. Similarly the churches around Kendal tended to have good woodwork and exquisite carving commissioned from the Simpsons of Kendal. In the Midlands churches were likely to have stained glass by Richard Stubington and his pupils Nora Yoxall and Elsie Whitford. Early twentieth-century liturgical reform provided new kinds of work for craftsmen and women. Percy Dearmer's *The Parson's Handbook* of 1899 had argued for the revival of pre-Reformation English ceremonial. He reordered his own church of St Mary, Primrose Hill from 1903 onwards, whitewashing it and commissioning a great rood from the sculptor Gilbert Bayes, carrying a Risen Christ painted in a folkloric fashion.[12] Dearmer's Warham Guild set up in 1912 provided 'correct' church furnishings in the English medieval tradition, and the creation of thuribles, incense boats and processional crucifixes all gave valuable work to makers.

112. Christ Church, Chalford, Gloucestershire. A detail of the font carved by William Simmonds. (Photo Jacqueline Sarsby).

113. Illustration from Peter Anson, *Fashions in Church Furnishing 1840–1940*, 1960 showing William Butterfield's Gothic Revival St Augustine, Queen's Gate, South Kensington, with its Southern Baroque reredos designed by Martin Travers in 1928.

114. Valentine KilBride, chasuble, *c.* 1928 in handwoven eri silk. l. 133 cm. (Miss Hilary Bourne on loan to the Ditchling Museum Trust. Photo Artis Inc.).

However the interiors favoured by some High Church clergy and congregations offered less opportunity for individual makers. Conventional Edwardian High Anglican taste favoured George Bodley's meticulous late Gothic which was invariably highly crafted but which allowed for little original craft work. This academicism was carried forward by Ninian Comper and Temple Moore who designed every inch of their refined, delicately detailed church interiors. The parallel High Church fondness for the neo-baroque was equally at odds with an artist-craft approach. The stained-glass artist Martin Travers oversaw several neo-baroque refits, in which seventeenth-century Spanish or Italian furnishings were acquired and collaged with carving done to Travers's own design – most startlingly at St Magnus the Martyr in the City and St Augustine, Queensgate, in West London (Fig. 113).

Despite marked retrospective tendencies, groups and individuals consistently collaborated in supplying appropriate original designs for more adventurous ecclesiastical patrons and architects. In 1913 Eric Gill was received into the Roman Catholic church and during 1914–18 carried out his most important Roman Catholic commission, the austere relief carvings of the Stations of the Cross in Westminster Cathedral. In 1920 he led the formation of the Guild of St Joseph and St Dominic at Ditchling, open only to Dominican Tertiaries who practised a craft. He resigned from the Guild in 1924 but throughout the inter-war period there was a community at Ditchling eager to carry out specifically Roman Catholic commissions.[13] In particular, two craftsmen members of the Guild, the weavers Valentine KilBride and Bernard Brocklehurst, responded to the medievalising revival with plain vestments that fell in simple folds in handwoven plain silk with abstract orphreys (Fig. 114).[14]

Gill's views on church furnishings, as on most craft topics, were refreshingly radical. In a 1927 church architecture number of the *Architectural Review* he spoke up for simplicity: 'Is it reasonable, in the year 1927, to have sham Gothic or Byzantine or sham any other style of furniture? Of course it isn't.'[15] Gill's single work of architecture, St Peter's church, Gorleston-

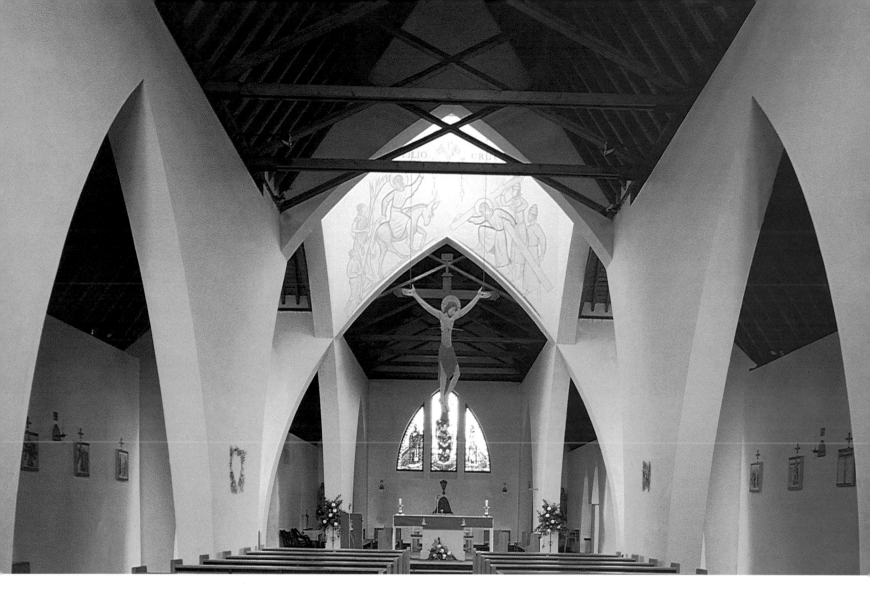

on-Sea near Yarmouth, underlines his point (Fig. 115). It is an exemplary essay in springing arches and plainness. In the same issue of the *Architectural Review* Hewlett Johnson, the left-wing Dean of Manchester, argued against commercial church furnishings – 'If our modern churches are to speak of God we must let our true artists and craftsmen loose in them.'[16] Hewlett Johnson, like Gill, had a vision of whitewashed interiors and flagged floors. On arrival at the medieval church at Thaxted in Essex in 1910 the Anglo-Catholic communist priest Conrad Noel swept away 'fretwork tiers of shelves with Brummagen brass candlesticks'[17] with

115. Eric Gill, St Peter's Church, Gorleston-on-Sea, Norfolk 1938–9. (Photo Elaine Harwood).

116. *Joshua and Caleb return from the Promised Land*, pargetting by Alec Hunter based on a design by his father Edmund Hunter, on the garden wall of The Market Cross, Thaxted, Essex, 1949.

117. The hammer and sickle surmounts crowns and mitres. A panel of a prayer book chest made and carved by Arthur Brown for Thaxted Church, Essex, 1920s.

118. Robert Lorimer, the Shrine of the Scottish
National War Memorial, Edinburgh Castle,
1924–7. Stained glass by Douglas Strachan, bronze
frieze by Morris and Alice Meredith Williams, fig-
ure of St Michael designed by Alice Meredith
Williams and carved by William and Alexander
Clow. (Crown Copyright: Reproduced by
Permission of Historic Scotland).

the help of the Arts and Crafts architect Randall Wells. Crafts, Communism and High Church
ceremonial inspired bright vestments and the Red Flag hanging in the chancel. A prayer book
chest by Arthur Brown was carved with the throwing down of crowns and dynasties
surmounted by a hammer and sickle (Fig. 117). The weaver Alec Hunter led the Morris
dancing and pargetted his house with sylvan scenes (Fig. 116), the parish magazine was printed
on handmade paper and from 1916 until 1925 Gustav Holst took charge of the church's music.

If left-wing clergy like Noel and Hewlett Johnson favoured grand simplicity, predictably it
was the public schools that commissioned some of the most elaborately adorned chapels in the
twenties and thirties, many of them as memorials for a generation killed in the Great War.
Their atmosphere – *vide* Uppingham, Radley and Charterhouse – was often claustrophobic,
even morbid. Uppingham had choir stalls by John Thompson and Radley has lushly carved
stalls by Simpson of Kendal. Admittedly the public schools were also clients for unadorned
furniture by Edward Barnsley, Stanley Davies and A. Romney Green. Their austerer lines of
oak furniture were often mixed in with another school favourite, PEL stacking chairs made
from canvas and steel, or Thonet bentwood chairs. Dartington School bought Alvar Aalto
stools and had simple modernist furniture made on the estate, marketed as the 'Dartside'
range.[18] But Rossall School War Memorial Chapel designed by the Scottish architect Sir
Robert Lorimer exemplifies the public school response to the crafts. It had only a Gill relief

123. Eric Gill, *East Wind* (*above*); Henry Moore, *West Wind* (*far right*) (1928–9) Portland stone reliefs on the seventh story of Charles Holden's 55 Broadway, Westminster (1927–9), the head offices of the Underground Railway. (London Transport Museum).

124. (*right*) Harold Stabler, plaster maquette for an iron grille installed in September 1932 in Turnpike Lane Underground Station, 39.5 × 145 cm. (Photo the Worshipful Company of Goldsmiths).

125. (*opposite, lower left*) Enid Marx, *Shield*, designed *c.*1935, upholstery moquette for underground trains on the Northern, Bakerloo and District lines photographed in 1949. (London Transport Museum).

126. (*opposite, lower right*) Eric Gill, detail of *Odysseus being Welcomed from the Sea by Nausikaa*, 1933, polished Portland stone relief for Oliver Hill's Midland Hotel, Morecambe Bay, 1932–3. (Conway Library, Courtauld Institute of Art).

consider the quality of BBC semination with the efforts of a simple countryman sowing corn! However it's their idea, not mine. Mine not to reason why…mine simply to carve a good image of a broadcaster.'[28] His carved stone relief for Oliver Hill's Midland Hotel (1932–3) at Morecambe was done in a similar spirit. In the robust context of a north of England seaside resort his choice of subject – *Odysseus Welcomed from the Sea by Nausicaa* – with its Homeric inscription 'There is good hope that thou mayest see thy friends' was sweetly bathetic (Fig. 126).

As the trade carver William Aumonier's book *Modern Architectural Sculpture* of 1930 reveals, a substantial body of integral sculpture was commissioned in the 1920s, especially from a band of craft conscious direct carvers like Eric Gill, Maufe's favourite Vernon Hill and the Croatian Ivan Mestrovic, the hero of Stanley Casson's *Some Modern Sculptors* of 1928. The young Henry Moore's figurative wall lights, heavy female forms clasping light bulbs, were also featured in Aumonier's book (Fig. 127).[29] But in 1934 Herbert Read published *Art Now*, a decisive study of contemporary sculpture and painting, written from an international position. Read included only two British sculptors, Henry Moore and Barbara Hepworth, setting a new standard after which architectural sculpture came to seem marginal both to architecture and to the development of modern sculpture. Figures like Gill, Hill and Mestrovic were excluded from the canonical accounts of the development of modern sculpture in Britain.[30] And as appropriate modernist sculptural activity became ever more sharply defined, decorative wall lights vanished from Moore's documented oeuvre.

The Underground Railway under the enlightened patronage of Frank Pick and with Charles Holden as architect encouraged good design, some by men and women who also worked in the crafts. For his 1929 stripped-classical head office for the Underground Railway (now London Transport) at St James's Park, Holden commissioned sculptures of the East, West, North and South winds from an array of artists as diverse as Henry Moore and the architectural carver Eric Aumonier. Eric Gill oversaw the project from 1928 until 1929. There was something tentative about the scheme. The sculptures were positioned some eighty feet above street level (Fig. 123) and only Jacob Epstein's *Night* and *Day* over the ground floor entrances make an impact.[25] As Gill wrote to his Harvard friend Graham Carey: 'The building is good and plain – iron with plain stone facings. We are quite out of place.'[26] The commissions for smaller Underground Stations were more effective. Harold Stabler designed pleasing decorative iron grilles (Fig. 124), and the posters, commissioned from the best graphic artists of the day, were outstanding. Holden's Uxbridge Station of 1938 had stained glass by Ervin Bossanyi. Enid Marx created fabric patterns for seat covers in the carriages, a craft intelligence informing these strong designs (Fig. 125). The most notable, and most long-lasting, contribution to Underground design was, however, the calligrapher Edward Johnston's block letter alphabet of 1916.[27]

Eric Gill, working as a sculptor and as a letter cutter, emerges as the craftsman who was most successfully involved in architectural commissions. Gill was always conscious of the redundancy of architectural sculpture and his attitude to his secular public commissions was mildly ironic. In 1929 he was commissioned to make sculptures for G. Val Myers's Broadcasting House in Portland Place. These included figures of Prospero and Ariel over the main doorway and a sculpture of the Sower for the entrance hall. Writing to his brother Cecil he explained that the subject was a pun – the Sower or Broadcaster. 'Comic thought when you

122. Frank Brangwyn, an Art Déco room setting for Pollard & Co., London 1930. (Archieffoto Stedelijke Musea Brugge).

120. Moira Forsyth, *Christ and the Children*, detail of the stained glass at the West End of St Thomas the Apostle, Hanwell, West London (1933–4).

121. Edward Maufe, the interior of St Thomas the Apostle, Hanwell, West London (1933–4) showing a timber screen decorated with (from right to left) 'flesh, fruit, fish, flower and fowl' by James Woodford. (British Architectural Library, RIBA, London).

Corner by Elizabeth Starling and small stained-glass windows by Moira Forsyth (Fig. 120). His collaborators were given their freedom but on a miniaturised scale that ended up looking reticent almost to the point of invisibility. Maufe had a particularly long-standing artistic relationship with Moira Forsyth and after World War II she made glass for his Guildford Cathedral and St Columba's, Pont Street.[21]

PUBLIC BUILDING

If churches provided opportunities for the crafts, progressive public architecture – offices, hotels and transport systems from the London Underground to the ocean liners – proved less welcoming. During the 1920s and 1930s shipping lines became active new patrons. They were imaginative in their demands but tended to favour the designer and fine artist rather than the individual craftworker.[22] The effects were often lavish and thus particularly suited the talents of Frank Brangwyn who created paintings, a frieze and designed chairs, crockery, lamps and carpets for the Canadian Pacific ship *Empress of Britain* launched in 1930.[23] Brangwyn fits uneasily into any history of British design and art in the twenties and thirties. His designs were carried out by commercial firms and for that reason he seems remote from the craft movement, while the sheer richness of his work distances him from modernism in design (Fig. 122). But he had a remarkable sensitivity to texture and colour and was strikingly versatile, throwing pots and designing furniture, panelling, stained glass and ceramics. Brangwyn also executed many murals, a craft-based art form which Henry Wilson had seen as the principal way in which artists would collaborate with architects after the First World War. But although a surprising amount of mural work was carried out between the wars culminating in the Tate Gallery exhibition of photographs *Mural Painting in Great Britain 1919–1939*, muralists and the issue of mural decoration played little part in the debates within the craft world.[24]

119. Edward Maufe, the exterior of St Thomas the Apostle, Hanwell, West London (1933–4) showing the East Window and Eric Gill's *Calvary Group*. (British Architectural Library, RIBA, London).

to temper its especially lavish medievalism. Lorimer died in 1929 but all his church architecture was remarkable for the lively complex work he drew out of teams of sculptors and painters and stained-glass artists backed up by the skills of trade carvers, metalworkers and stonemasons. His Scottish National War Memorial in Edinburgh Castle, completed in 1927, must stand as the richest and most complex example of this kind of collaboration and suggests that a full blooded Arts and Crafts Movement survived longer in Scotland than south of the border (Fig. 118).

By the 1930s ambitious modernism in church architecture tended to exclude individual artist-craftswomen and men. Francis X. Verlarde and Nugent Cachemaille-Day designed every aspect of a church's interior decoration themselves.[19] But Edward Maufe, influenced by Swedish architecture and by his wife Prudence who from 1915 was an interior decoration consultant at Heals and organised art and craft shows in the firm's Mansard Gallery, tried both to be modern and to work collaboratively with artists and makers.[20] The results were curious. His church of St Thomas the Apostle at Hanwell (1933–4) was an exemplary building with a Calvary group by Gill on the external East wall (Fig. 119) and keystone sculptures over doors by Vernon Hill. Inside there is plenty of individual work – a font carved by Vernon Hill, wood panelled screens carved with angels, fish, squirrels and birds by James Woodford (Fig. 121), cross and candlesticks by the Artificers' Guild, a mural of the Adoration in the Children's

127. Henry Moore, a study for a wall light in terracotta, c. 1930. (*Architectural Review*).

128. Chair upholstered in hand block-printed linen designed by Elspeth Little for Modern Textiles. c. 1930. (*Architectural Review*).

ROOM AND BOOK

Throughout the 1920s and 1930s the *Architectural Review* recorded the changing relationship between the crafts and architecture. In the 1920s neo-Georgian and Arts and Crafts architecture dominated its pages as well as associated building crafts – stonecarving, metalwork, plasterwork, woodwork and stained glass. Special craft supplements were illustrated with work by the old guard of the Arts and Crafts world, mainly the male members of the Art Workers' Guild. But in January 1930 an article by the painter and designer Paul Nash signalled a switch in emphasis.

By the early 1930s Nash was recognised as a major artist who was also keenly alert to changing tastes in design. His article *Modern British Furnishing*, published in an expanded form in 1932 as *Room and Book*, accompanied by an exhibition of the same name held at Zwemmer's in April 1932, posed an imaginary young architect a problem: how to fit and furnish a modern house?[31] Nash says little about this house but we can assume that he had in mind the kind of architecture admired by fellow painters like Frederick Etchells (whose 1927 translation of Le Corbusier's *Vers une architecture* Nash had read and admired),[32] Christopher Wood (who included Le Corbusier's Villa Savoie in his surrealist painting *Zebra and Parachute* of 1930)[33] and Ben Nicholson (who in 1930 had been deeply impressed by modern buildings he had seen in Paris).[34] There were few examples of Modern Movement architecture at that date in Britain, though the New Zealander Amyas Connell's *High and Over* at Amersham in Buckinghamshire was completed for Professor Bernard Ashmole in 1929[35] and Thomas Tait's *Le Chateau* for the Crittall window manufacturing family at Silver End in Essex in 1927. But the modernism of these indubitably modern buildings was tempered by their interiors which tended to be variants on the country house style, mixing eighteenth-century pieces with Arts and Crafts furniture and Oriental ceramics.[36]

Nash set out to support 'certain artists and craftsmen' who seemed to him to 'exemplify the modern movement in England'.[37] He had found that practically all admissibly 'modern' items for his imaginary house were being produced by hand on a craft basis. These included Edward Bawden's hand-printed wallpapers, pots by William Staite Murray and Bernard Leach, Henry Moore's figurative wall lights and the marvellous bronze door furniture, knockers and letterboxes designed and made by the sculptor Gertrude Hermes. Nash paid special attention to textiles, generously illustrating handblock prints by his friends Phyllis Barron, Dorothy Larcher, Enid Marx and Elspeth Little (Fig. 127).[38] He also included rugs designed by Allan Walton and Edward McKnight Kauffer, murals by Blair Hughes Stanton and batik by Marion Dorn. Nash's hunt for appropriate furniture for a modern home was more problematic; it began 'in the Tottenham Court Road and ended in the Cotswolds'. Nash had come to know the 'simple forms'[39] of Cotswold furniture through his friendship with William Rothenstein before the First World War. He especially admired Ernest Gimson and knew that work in Gimson's spirit was still being produced. But in a modern interior he found that 'their forms somehow would not do'.[40] In his *Architectural Review* article, in the spirit of Le Corbusier, Nash looked outside the domestic environment, proposing an operating table as an example of practical modern furniture. He also illustrated the stylish steel and glass tables, desks and lights designed and made in small quantities by the interior decorator Denham Maclaren (Fig. 129).

Nash's article, book and exhibition suggest that in the late 1920s and early 1930s an adventurous modern interior would necessarily include handmade objects. His own experience had already been paralleled by the attempts of government and design-conscious pressure groups to stage 'modern' exhibitions of British goods. The most striking example was the British contribution to the 1925 Paris *Exposition des Arts Décoratifs et Industriels Modernes*. The Board of Trade had not liked the French guidelines for exhibitors, asking for work of 'modern inspiration and real originality'. What was seen at Paris was a vibrant luxurious *art moderne* which, in the displays mounted by Central European countries in particular, drew heavily on surviving vernacular and folk art as well as being influenced by developments in fine art, particularly cubism. The British government's support for the exhibition was limited and the British contribution was widely seen as dull and conventional – partly because of the unwillingness of manufacturers, who were expected to pay for space, to participate. The studio crafts of ceramics, handweaving and hand block printing emerged as the most innovative areas of the British display.[41]

Similarly in 1927 when the Design and Industries Association contributed to an international exhibition on the development of design since the First World War held at the

130. Pottery and textile display in the British section of an international exhibition of modern design held at the Grassi Museum in Leipzig, 1927. (Holburne Museum and Crafts Study Centre, Bath).

131. *Chinese Bridge* block-printed on silk. Designed for Footprints in 1926 by Doris Scull and exhibited at Leipzig the following year. (Central Saint Martins College of Art and Design).

Grassi Museum in Leipzig, it was the studio pottery and hand-block printed textiles which gave a modern flavour to the selection (Figs 130, 131).[42] The British Institute of Industrial Art, set up with a Treasury grant in 1920, was also pushed in the direction of the crafts. The Institute's final exhibition in 1929 was strikingly rich in studio pottery, hand-woven and block-printed textiles, embroidery and hand-crafted silver.[43]

The work of Barron, Larcher and Marx in particular was seen by fine art galleries and design bodies alike as exemplifying modernism. Connections were made. It was surely no accident that in 1928 the Dorothy Warren Gallery chose to show a carved Hornton stone head by Henry Moore against Paul Nash's hand block-printed *Cherry Orchard*[44] or that a Moore sculpture in sycamore inspired by a pre-Columbian sculpture was shown at the Zwemmer Gallery against a background of hand block-printed textile by Enid Marx (Fig. 132).[45] In 1933 Zwemmer's made the link again with the exhibition *Artists of Today* which included Barron,

Larcher and Marx textiles, pots by Norah Braden, Katharine Pleydell-Bouverie, John and Walter Cole and William Staite Murray, sculptures by Henry Moore and Barbara Hepworth and paintings by Ivon Hitchens, Paul Nash and Ben Nicholson. The exhibition was 'equipped' by Wells Coates and David Pleydell-Bouverie. As Charles Marriott noted in *The Times* it was easier to appreciate the work of Henry Moore and Ben Nicholson in this context than 'when they are dumped down in a miscellaneous collection of closely representational art'.[46] In the late 1920s and early 1930s there was an acknowledged affinity between modern architecture, abstract hand block-printed textiles, stoneware pots, abstract painting and directly carved sculpture. The juxtaposition was at the heart of modernism in England at that date.

THE MODERN MOVEMENT IN ENGLAND

In 1930 *The Cabinet Maker and Complete Home Furnisher* profiled Serge Chermayeff, then director of the Modern Studio at the department store Waring & Gillow, showing how Chermayeff created complete interiors – furniture, fixtures, fittings. Later that year he wrote on modernism for the magazine, predicting: 'Our furnishing will thus gradually become simpler and clearer of expression, and the final elimination of fuzzy details should leave us, not with a skeleton, but with as pure a style as was finally achieved by the Greeks in the age of Pericles.'[47] Chermayeff's complete interiors designed right down to the last triangular ashtray left little scope for individual taste or, indeed, for the individual maker. Wells Coates, trained as an engineer, also proselytised for the complete interior. In his 1932 *Architectural Review* article 'Furniture Today – Furniture Tomorrow. Leaves from a Metatechnical Notebook',

133. Wells Coates, before and after photographs of 1 Kensington Palace Gardens refurbished for George Strauss MP, showing the entrance hall in 1893 and on 30 May 1932. (*Architectural Review*).

Coates argued for the architect's complete control, with furniture an integral part of the interior architecture (Fig. 133). He took as his model the calm interior of the Japanese home and envisaged the personal taste of the owner only being realised through the selection of books, pictures and sculpture.[48] Wells Coates's Lawn Road flats, completed in 1934 for Jack Pritchard, exemplified this interior simplicity, an austere modernist programme which offered no scope for eclecticism.

Another kind of completeness was provided by the example of British eighteenth-century interior design. In the 1930s the eighteenth and early nineteenth centuries came to be seen as a kind of proto-modernism for insular consumption. In 1930 Nash had singled out the Adam brothers as the creators of the last 'comprehensive style of interior decoration in England.'[49] Nash was not alone in his admiration for eighteenth-century interiors. Even Bruno Taut and Le Corbusier, mapping a design and architectural future for British 'islanders...more sheltered from those currents of thought than we are on the continent',[50] saw the 'wonderful calm and simplicity'[51] of the eighteenth-century London squares and streets as the most appropriate model.

Despite Chermayeff and Coates's ideas and the eighteenth-century ideal, the dominant modernism of the 1930s was essentially eclectic. As Moira Forsyth pointed out in 1930 in a series of reports on English design to the American Chinaware Corporation, the 'English school judiciously blends period pieces, tiles, embroidery, wall decorations as part of a harmonious whole'.[52] This kind of bricolage approach was cleverly catered for in the 1930s by London outlets like Muriel Rose's successful Little Gallery and Cecilia Dunbar Kilburn's shop, Dunbar Hay Ltd. For both women the key referents were the eighteenth century, folk crafts and a group of favoured handworkers led by Barron, Larcher, Marx and Leach. A modernist, or at least modern, position could be declared by an absence of Edwardian or Victorian furnishings and of what Nash had called 'commercial modern', that is to say *art moderne*. Muriel Rose's own modest Chelsea flat, plainer than her shop, exemplifies the look (Fig. 134). It was reductionist eighteenth-century, with a Georgian fireplace, abstract floor rugs and 'timeless' ladderback chairs.

The makers whose work Muriel Rose exhibited furnished their homes in the same spirit. Bernard Leach's 'vast, cold and empty'[53] plain granite early nineteenth-century house at St Ives was dominated by choice early Oriental pots, a red Ethel Mairet blanket on the back of a

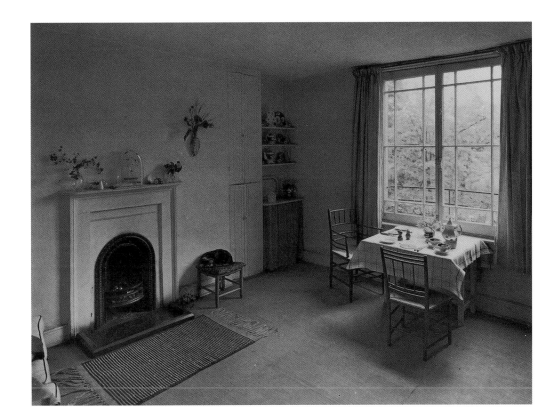

sofa, shells and other *objets trouvés* and the furniture he designed and had made in Japan. Katharine Pleydell-Bouverie's two homes were spartan but contained inherited blue and white china, seventeenth- and eighteenth-century furniture and her own Gaudier-Brzeska bronze, Sung pots, Tang figurines and studio pottery.[54] From 1930 Phyllis Barron and Dorothy Larcher lived in an elegant eighteenth-century house in Painswick in Gloucestershire, with Regency furniture juxtaposed with block-printed textiles and 'a lovely dresser with flowers, glasses, china and collections of small enchanting objects'.[55] Edward Bawden and John Aldridge's houses at Great Bardfield in Essex mixed eighteenth-century elegance with Victorian popular and vernacular art.[56] The furniture historian John Gloag mixed seventeenth-century chests, an elegant Empire bookcase and bare boards and rugs.[57] The interiors created by the novelist Ivy Compton-Burnett and her life-long companion, the furniture historian Margaret Jourdain, presented a modernism of 'bare walls, lino not carpet and one or two "good pieces" of light, "simple" Sheraton or Chippendale'.[58]

Artists shared this bricolage taste. For an instant snapshot of a specific interior there is the sculptor Barbara Hepworth's description in a 1934 manifesto of the Hampstead studio flat she shared with the painter Ben Nicholson:

> A scarlet circle on the wall, a slender white bottle on a shelf near it, a bright blue box and lovely-shaped fishing floats that rest in the hand like a bird, weighty pebbles, dull grey, some gleaming white, all these move about the room and as they are placed, make the room gay or serious or bright as a frosty morning. (Fig. 135)[59]

The interiors of the Mall Studios where Nicholson and Hepworth and Herbert Read lived in the 1930s (Fig. 136) were characterised by a shared aesthetic – kelim rugs, *objets trouvés*, hand block-printed textiles and white walls.[60]

In these relatively under-furnished interiors appropriate crafts had a potential context along with small sculptures, vernacular non-European objects and abstract paintings. We are tracking a domestic rather than a public modernism. That its very simplicity could seem subversive in certain situations is illustrated by Barron and Larcher's 1932–4 interior decoration of a new Combination Room and Fellows' Dining Room at Girton College, Cambridge.[61] Textiles, in the form of curtains and loose covers, dominated the two rooms, block-printed with bold semi-abstract designs. Oak tables, parchment lampshades, linen loose

135. Ben Nicholson photographed by Humphrey Spender c.1935. (By courtesy of the National Portrait Gallery, London).

136. Interior of 3 The Mall, Parkhill Road, Hampstead, London, 1933. This was Herbert Read's home from 1933 until 1939. (Benedict Read).

covers, kelim rugs, bare boards, simple glass flower vases and unpainted plaster walls completed the scheme (Fig. 137). That their handsome design met with opposition from some Fellows is of interest. The Fellows wanted dark walls, 'antiques' and 'curtains of a richer appearance'. Barron and Larcher's eclectic modernism was unsettling because it failed to suggest a masculinised institutional authority. The disaffected Fellows, consciously or unconsciously, wanted their furnishings to mirror the heavy grandeur of the men's colleges.

MODERN WOMEN

So far the word 'eclectic' has been used to define a specifically English reponse to modernism. But the useful term 'conservative modernism' has been coined to describe the work of inter-war women novelists like Ivy Compton-Burnett, Agatha Christie and Daphne Du Maurier whose writings, and, to an extent, whose way of life, can be seen as 'a deferral on modernity', able to 'accommodate the past in the new forms of the present'.[62] The Girton commission, neither 'Period' nor ultramodern, carried out by two women for a women's college, might, at first sight, appear an ideal candidate for this accommodating 'conservative modernism'. In England creative men and women alike subscribed to an adaptation of Continental modernism. The kind of polemical abuse of the home and of feminine influence in the home initiated by Adolf Loos and developed by Wyndham Lewis and Le Corbusier was marginal to the English debate between the wars.[63] Instead there was a shared desire to personalise modernism, to 'soften its bleakness, give it a human touch, and adapt it to our own hugely individual requirements.'[64] For many design commentators and practitioners the advanced design coming out of Central Europe lacked humanity and Swedish products and architecture were preferred to what John Gloag called the 'Mechanistic design' of Germany and Austria.[65]

As we have seen, the stained-glass artists of the inter-war years tended, with few exceptions, to work in a conservative spirit. So did the calligraphers. But in terms of English modernism, hand block-printed textiles, highly textured weaving and austere stoneware pots belonged to the most adventurous end of the design world in the 1920s even if, as we shall see, by the mid-1930s handwork began to be excluded from the design debate. In the area of textiles in particular, women were dominant. 'Eclectic' rather than 'conservative' modernism seems best to sum up their contribution.

Among women personal decisions had political overtones. The achievement of women in the inter-war crafts needs to be seen in context. Their major gain in the early part of the century, admission to the franchise, led to few other advances. The proportion of women in the professions moved very little; it was no higher in the early 1950s than it had been in 1914.[66] Thus the crafts provided an important creative space and income for middle-class women in a time of social and economic stasis for women in general. The crafts in effect operated as a 'third space' between the better defined activities of fine art and design.[67] A marked number of these women makers never married – a characteristically modern decision being made for the first time in the inter-war years – and were thus able to work without the problematic responsibility of childcare and of running a conventional household (Fig. 138). Some endured failed marriages and ended up alone like Ethel Mairet and Jean Orage. Many made their lives with other women, devotedly.[68] These unmarried women formed strong networks, with each other and with women patrons and retailers. Wealthy women like Margaret Pilkington and Dorothy Elmhirst created opportunities – in Elmhirst's case by commissioning work, and in Pilkington's case through involvement in exhibiting societies and

138. Norah Braden at The Mill, Coleshill, Wiltshire in the 1930s. (Pitshanger Manor & Gallery, London Borough of Ealing).

above all through her creation of the Red Rose Guild of Artworkers in 1921. As we shall see, the main retail outlets for the inter-war craft were run by women.

An unmarried status had consequences. It is striking how few letters and archives associated with inter-war women makers survive. The papers of Michael Cardew, Eric Gill, Bernard Leach, like those of male artists, designers and architects, were carefully preserved by their wives and children. But the nieces and nephews of many women makers saw no reason to honour the memory of an eccentric deceased aunt who wove, or made pots or stained-glass windows. Where archival material does survive it is striking how the personal letters have often been carefully filleted out.[69] All we have are fragments – like Katharine Pleydell-Bouverie and Norah Braden's more intimate letters to Bernard Leach with their records of tiffs between women lovers, visits to exhibitions, books read and battles with materials.[70] What we can discover of the untrammelled, buoyant lives of these women – financially independent, creative, cultivated, quarrelsome and loving – suggests that the special freedom conferred by staying outside the conventionalities of marriage was central to their creativity.

Women can drop out of the already fragile history of the crafts with alarming ease.[71] The career of Muriel Rose, the founder of the Little Gallery and author of *Artist Potters in England*, is well documented – chiefly because she left her papers to an archive she helped to found, the Crafts Study Centre at the Holburne Museum in Bath. But we know comparatively little about Rose's first employer, the calligrapher Dorothy Hutton, founder of the Three Shields Gallery, an equally important craft shop. Again, although Dora Billington was a key figure in ceramic education, teaching at the Central School from 1924 to the mid-1950s and the author of two books on ceramics, her career remains underdocumented.

In the world of ceramics the women we know most about were part of the Leach circle. Leach relied heavily on Katharine Pleydell-Bouverie for technical advice and his section on ash glazes in *A Potter's Book* is based on her painstaking researches. Nonetheless what is striking about both Pleydell-Bouverie and her partner Norah Braden is their self-effacing modesty. Other women of talent, because they worked outside the Leach and Murray circles, have been almost completely overlooked. For instance, Deborah Harding exhibited with the Red Rose Guild in the 1920s and 1930s, showing starkly simple modern stoneware, while an early potter Frances E. Richards had a studio in north London in the 1920s and, according to George Wingfield Digby, worked in 'poverty and obscurity…producing some good pots in a simple direct way'. But as Wingfield Digby points out what the studio pottery movement needed was 'a genius, a man of extraordinary powers'.[72]

That Bernard Leach was able to fulfil this role has as much to do with his writing as with his pots. Women wrote plenty of useful manuals relating to their disciplines – for instance Rebecca Crompton on embroidery and Billington on ceramics. They also contributed to the various journals associated with individual crafts, passing on detailed knowledge of techniques and materials. An analogy can be made with women travel writers in the late nineteenth and early twentieth century.[73] The women's travel narratives were less to do with exploration and domination and more to do with observation and the documentation of diversity. Similarly women's writing on the crafts differed from the ideological contributions made by Leach, Eric Gill, A. Romney Green and even by Michael Cardew. The male writers in the craft world attempted to construct intellectual systems which would accommodate their practice, as if the activity of craft on its own undermined their masculinity. This was hardly an issue for the women whose involvement in the crafts was rarely challenged. And as we shall see, the one woman who did publish a book with a strong ideological component, Ethel Mairet, came in for criticism from her male peers.

DESIGN AND INDUSTRY

In 1930 Paul Morton Shand, one of the most influential supporters of modernist design and architecture in Britain, explained in the German design periodical *Die Form* that the British were ignorant of modernist terms like 'type-form' and of the ideas which lay behind them. In Britain the 'technical vocabulary of modernism' was still in a 'primitive and embryonic

state'.[74] The root of the problem, Morton Shand argued, was the British belief in the superiority of handmade articles. By the mid-1930s this belief was being publicly challenged in a debate about the relations between craft and industry.

In 1934 Walter Gropius, the great German architect and director of the Bauhaus from 1919 until 1928, arrived as a refugee in England. In May that year he read a paper to the DIA which clarified the relationship of the crafts to modernism. Gropius dismissed the 'dilettante handicraft spirit'. In the modern world, he argued, skill in craftsmanship was 'merely a means to an end'. Gropius explained: 'Handicrafts are now changing their traditional nature. In future their field will be in research work for industrial production and in speculative experiments in laboratory-workshops where the preparatory work of evolving and perfecting new type-forms will be done.' Their products would be characterised by a basic uniformity displaying 'a common intellectual objective which superseded the old aesthetic conception of form as understood by the Arts and Crafts movement'.[75]

Post-war developments proved Gropius gloriously wrong in his predictions, but in the mid-1930s his ideas, which were set out at greater length in *The New Architecture and the Bauhaus*, were immediately taken up by the poet and critic Herbert Read. As we have seen, at the end of the 1920s Herbert Read had seemed like a friend of the artist crafts, especially ceramics. He worked in the Department of Ceramics in the Victoria and Albert Museum from 1922 until 1931 and became a supporter of William Staite Murray. Read's memorable phrase 'canvas-free artists' had been used to describe Murray and his pupils at the Royal College of Art.[76] In *The Meaning of Art* of 1931 he deplored the distinction between the applied arts and the fine arts, reiterating the purity, abstraction and freedom from 'any imitative intention' of ceramics.[77] But Read was a sensitive barometer of changing priorities in the visual arts. From the mid-1920s to the early 1930s ceramics seemed relevant to the defence of abstraction. In addition the 1920s had been a decade of individual effort in which makers could find a niche in an art world which valued spontaneity and primitivism. But the progressive thinkers of the 1930s, faced with mass unemployment and slump and with a flood of positive propaganda about the command economy in the USSR, argued that planning and communal effort should extend to all areas of craft, design, art and architecture. As Read explained in *Art and Industry*, endeavours to sustain the crafts were pointless:

> All attempts to revive such types of art, lacking economic and practical justification, end in artificiality and crankiness. The economic law is absolute and healthy; it compels the human spirit to adapt itself to new conditions, and to be ever creating new forms. It is only when sentimentality and a nostalgia for the past are allowed to prevail, that these forms cease to evolve in conformity with aesthetic values.[78]

Paul Nash similarly distanced himself from the crafts in this period. *Room and Book* was to be the culmination of Nash's public interest in a specifically craft contribution to interior design. The politics and social concerns of the 1930s took over and in 1934 Nash founded Unit One, an ambitious avant-garde association of painters, sculptors and architects. Significantly he did not invite any of the artist craftsmen and women he favoured to join even though, as the art critic Anthony Bertram observed, Unit One broke down 'the artificial fine and applied art distinction.'[79] This was to be done not through the involvement of makers but by Nash designing textiles and interiors, by John Armstrong creating murals and stage designs and by Ben Nicholson and Barbara Hepworth designing rugs and textiles (Fig. 46) and arguing that paintings were 'objects to be used decoratively'.[80] A book of statements by Unit members, edited and introduced by Herbert Read, set out a socially conscious programme for the group. It was centred on design and architecture and effectively marginalised any association with craft. Read wanted the group to be 'a practical unit in an industrial system'[81] and his introduction suggested collective activity, an international outlook and social responsibility.

The Depression and the rise of fascism pushed artists, designers and architects to question their practice and to take up semi-political positions. As we shall see, there was also debate among craftsmen and women, but few joined the left-wing planning and pressure groups

which proliferated in the 1930s. The Artists International Association (AIA), the Modern Architectural Research Group (MARS), the social research group Political and Economic Planning (PEP) – all known by snappy acronyms – evolved programmes and projects focused on new materials, technological romanticism and 'scientific' planning systems which had little place for the handmade object. Indeed, making things by hand in the mid-1930s began to seem economically and socially irresponsible. Makers at that date had to maintain their credibility in the face of Herbert Read's disparagement and the poet and critic Geoffrey Grigson's dismissal of studio pottery in favour of laboratory beakers and crucibles.[82] As we shall see, Bernard Leach planned to set up a small factory at Dartington Hall. Michael Cardew went to Stoke-on-Trent to try his hand as an unpaid designer. Ethel Mairet argued that handweavings were a crucial inspiration to industry.

The government-backed bodies put forward less clear ideas for design reform. In 1931 a committee was appointed by the Board of Trade under the chairmanship of Lord Gorrell to advise on the propagandising and production of good design. Evidence given to the Gorrell Committee dismissed the British Institute of Industrial Art's collection as: 'not sufficiently up to date, and…composed in many instances, of objects not reproducible in commercial quantities.'[83] But the final report was intellectually confused. It noted that the fundamental difference between 'the technique of industrial manufacture and of handicraft' made the problem of adapting designs to industry 'a wholly different one from the production of unique specimens of artistic worksmanship'.[84] But much that followed contradicted this view and suggests that only a few members of the committee understood the implications of design for mass production. There was talk of 'artistic advice' for manufacturers. The idea of an industrial designer – an individual trained to understand the specific problems of working with industry – seemed alien to the committee.

All this was picked up by Herbert Read in *Art and Industry*. Read pointed out that while the first part of the report had condemned the Victorian idea that art could be applied to a product, the report's conclusion seemed to suggest the opposite – 'the conception of art as something external to industry, something formulated apart from the industrial process, something which the manufacturer can 'take advice on' and import into his industry should he think fit'.[85] Read also queried the alternative memorandum appended by Roger Fry whose recommended 'Workshops of Decorative Design in Industry' sounded like a more structured version of his Omega experiment. Fry suggested that artists together with gifted child apprentices should work in a series of 'laboratories' or 'guilds' on what appeared to be pattern design intended for textiles and the adornment of pottery and painted furniture. This concentration on surface pattern puzzled Herbert Read who expressed surprise that Fry, the originator of a formalist approach to art criticism, could so easily favour decoration over form.

The Gorrell Report's recommendation that £10,000 per annum be spent on financing a new design body was initially rejected by Parliament.[86] The government's eventual decision to create the Council for Art and Industry in 1934 was partly due to the success of a privately financed exhibition held at Dorland Hall in London in 1933. *British Industrial Art in Relation to the Home* took the Gorrell Report as its guide and inspiration, quoting a passage from the report that suggested that a period of depression in world trade was an appropriate moment to improve British design.[87] The exhibition was limited to works suitable for mass production which displayed fitness for purpose and imaginative use of materials. The prospectus explained that 'Handwork will be admitted where complying with these principles, but this is not primarily an exhibition of arts and crafts.'[88] It was an architect-led exhibition and the most successful areas were the series of modernist rooms designed by Wells Coates, Serge Chermayeff, Oliver Hill and R.D. Russell and a striking entrance hall designed by Oliver Hill to display traditional tools and industrial stoneware (Fig. 139). The artist crafts were sparsely represented and this omission was to set the tone for the decade. The Council of Industrial Art was to be less friendly to the expressive handicrafts than the British Institute of Industrial Art, although, as we shall see, certain trade crafts continued to be promoted as emblematic of 'Englishness'.

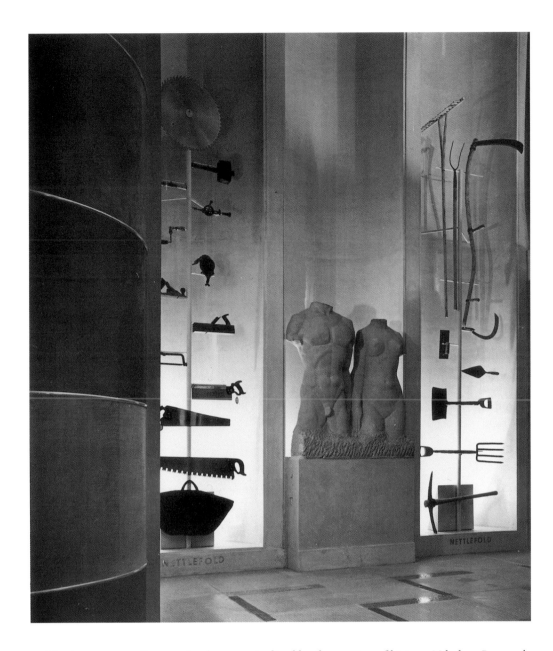

139. Entrance Hall, *British Industrial Art in Relation to the Home* (1933), Dorland Hall, Lower Regent Street, London designed by Oliver Hill. (British Architectural Library, RIBA, London).

The inter-war crafts were further marginalised by the writing of history. Nikolaus Pevsner's *Pioneers of the Modern Movement: From William Morris to Walter Gropius* appeared in 1936. Pevsner argued that 'Morris laid the foundations of the modern style; with Gropius its character was ultimately determined.'[89] He identified surviving participants in the Arts and Crafts Movement like C.R. Ashbee and C.F.A. Voysey (to their surprise) as proto-modernists. But the younger craftsmen and women – who had seen themselves as progressives, more 'modern' than the Arts and Crafts generation – were excluded from Pevsner's evolutionary line of progress from the Arts and Crafts to design for mass production. Elsewhere, in his *Industrial Art in England* (1937), Pevsner wrote of the continuing importance of studio pottery and small textiles workshops as places of experiment, nurturing a live understanding of materials[90] – but *Industrial Art in England* was a more specialist and less popular book.

HAND-WEAVING TO-DAY

So far the story seems to be one of lost ground, with support for the crafts in the late 1920s but with the 1930s seeing a marked shift of interest. In fact achievements in the crafts did feed into industry, albeit in an informal and often unacknowledged way. Of all the crafts it was handloom weaving which had the strongest influence upon its industrial equivalent. In the 1920s the coarse textures of hand-loom work made up into scratchy djibbahs had seemed distinctly amateurish[91] but by the early 1930s the textile industry was using yarns with hand-spun qualities – slubs, snarls, gimps and thick cotton chenille yarns. In *Art and Industry* Herbert Read

140. Tweeds woven by Ella McLeod's pupils, illustrated in the 2nd edition of Herbert Read, *Art and Industry*, 1939.

argued 'the object of all methods of weaving is to produce a *texture*' and to make the point in the book's second edition he used a photograph of tweeds woven by Ella McLeod's pupils at Howell's School, Denbigh (Fig. 140).[92] The importance of the hand loom for research and development was confirmed in surveys by Nikolaus Pevsner and Anthony Hunt. As Hunt advised very much in the spirit of Mairet: 'Think *in* cloth, not *on* paper'.[93]

Ethel Mairet, an admirer of Gropius and of the Finnish designer and architect Alvar Aalto, endorsed and was partly responsible for this new awareness. In *Hand-Weaving To-day* (1939) she urged a recognition of the hand-weaver's responsibilities towards industry and argued that the future context for handloom weaving would be the interior spaces of modern architecture: 'it can again spring into vitality to run parallel with the birth of modern architecture'.[94] As well as recommending collaboration with industry Mairet also wrote enthusiastically, in the spirit of Mumford's *Technics and Civilisation*, about small-scale workshops. The vital quality of the spinning and weaving in Welsh woollen mills was singled out, as was the co-operative work of the Highland Home Industries and Rodier's beautifully structured fabrics for couture houses produced by a network of hand-weaving artisans in Picardy. *Hand-Weaving To-day* is an expansive book which looks beyond England. Mairet's support for synthetic yarns and her passionate advocacy of the Bauhaus system of education seems remote from the parochialism of much of the inter-war weaving world and was greeted sourly in some sections of the craft world – 'Mrs Mairet says she wants to revolutionise the textile industry. I wish I knew how much was acting. I can guess but can't know', wrote the furniture maker Harry Norris to Leach.[95]

Mairet's ideas greatly influenced one of the most important inter-war textile designers. Marianne Straub worked for the textile industry from 1934 to 1975 but she always acknowledged the crucial influence of her time with Mairet – 'a new world opened out to me'[96]. As a designer for the Welsh mills, for Helios, for Warners and, after the war, for Tamesa, she always possessed her own spinning wheel and handloom and used them to work out weave structures (Fig. 141). Similarly the young Alastair Morton, the third generation of the textile firm Morton Sundour and the revitaliser of the firm's subsidiary, Edinburgh Weavers, chose to spend part of the Second World War spinning and weaving in Mairet's workshop. He had already worked with artists like Ben Nicholson, Barbara Hepworth, Winifred Nicholson and Ashley Havinden on the Edinburgh Weavers *Constructivist* range of textiles specially designed for modern interiors and notable for their abstract designs and contrasting textures. After the war he maintained a small group of hand-weavers, including the young Peter Collingwood, a former Mairet pupil.[97] The team worked on hand looms in Morton's Modern Movement house Brackenfell in the Lake District and their experiments had a marked effect on the textured quality of post-war Edinburgh Weavers fabrics. The complex yarns, neutral colours and abstract effects employed by modern minded textile firms like Donald Brothers, Edinburgh Weavers, Helios, the Old Bleach Linen Company and Warners all owed something to standards set by the craft weaving movement.

The importance of a hand-weaving background in the development of modern textile design is highlighted by the career of Alec Hunter, the Morris dancing son of the handloom weaver Edmund Hunter. In 1928 he had helped to establish Edinburgh Weavers as the experimental branch of Morton Sundour. In 1932 he moved to Warner & Sons where he was head of design till his death in 1958. It was his craft background that led him to introduce new weaving techniques and modern designs. These were often made on hand looms of which Warners had fifteen in 1930. In an address to the Royal Society of Arts in 1948 Hunter spoke of 'the touch of the fibres, on the spun yarns, of wool silk, cotton, flax or the many forms of rayon, the touch of threads on the loom and feel of the 'beat up' of the weft – it is by touch that really new designs are made'.[98] In 1934 Hunter was joined by Theo Moorman who set up a craft studio in the factory and worked experimentally with natural yarns, rayons, metallic strips and cellophanes (Fig. 142). It was an ideal craft/industry synthesis. Moorman created invigorating abstract designs while learning new techniques from the skilled craftsmen at Warners.[99]

THE CRAFT SOCIETIES

Gropius's dismissal of the 'dilettante crafts' naturally caused dismay among the craft intelligentsia. Since 1916 the Arts and Crafts Exhibition Society had been anxiously debating its role in relation to mass production. Henry Wilson had resigned as the Society's President in 1922 and his place was taken not by a younger figure but by W.R. Lethaby – then in his late seventies. That year Lethaby suggested a merger with the Society's old enemy, the Royal Academy[100] and in 1923 the Society showed in a section of the Royal Academy Winter Exhibition. The Academicians made the rules – no commercial firms to exhibit, no poster art, no theatre design.[101] As we have seen, Lethaby himself increasingly came to emphasise the role of the crafts as a therapeutic hobby at grassroots level and he wrote enthusiastically of bread-making, dressmaking, hat-trimming and housework.[102] The Society's thirteenth and fourteenth exhibitions of 1926 and 1928 received negative press coverage.[103] The critics found the 1926 show dominated by hobbyism and village industries and 'utterly out of touch with contemporary life'.[104] There was praise for Phyllis Barron's block printing, Bernard Leach and William Staite Murray's ceramics and William Simmonds's wood-carvings. But, ironically, the one craftsman whose work was hailed as 'frankly modern' was W.A.S. Benson, a founder member of the Society who had died in 1924 and whose well-designed machine-made lighting and other fittings were exhibited retrospectively in 1926.[105]

In 1928 Lethaby's successor St John Hornby had ruled that 'objects in the production of which the machine is the predominate element are inadmissible'.[106] St John Hornby was a director of W.H. Smith & Son and a founder member of the DIA. His business acumen was balanced by his Arts and Crafts interests. The calligrapher Alfred Fairbank called him 'a Florentine prince of a man'[107]: with some justification, for in 1894 he had set up the Ashendene Press and was wealthy enough to run it uneconomically and to employ skilled pressmen to realise his exquisite standards. He also commissioned some remarkable books written out, gilded and illuminated by, *inter alia*, Alfred Fairbank, Graily Hewitt and Louise Powell (Fig. 94). Hornby kept two kinds of ambition – for well-designed mass-produced goods and for luxurious handcraft – quite separate.

This cultural schizophrenia was commonplace in the inter-war years and symptomatic of an

anti-industrial spirit that permeated middle- and upper-class society. For instance Frank Pick's allusion in the Society's 1938 exhibition catalogue to those with the misfortune to be 'thrust into industry and commerce'[108] reads oddly coming from the chairman of the Council for Art and Industry and the chief executive of the London Passenger Transport Board. Similarly it is telling that industrial Manchester, the city described by J.B. Priestley as an 'Amazonian jungle of blackened bricks',[109] was home to the second major craft exhibiting society, the Red Rose Guild of Art Workers, founded in 1920. The initiative for the Guild came from Margaret Pilkington whose family were pioneers in glass manufacturing technology and the Red Rose Guild committee included some of the most powerful local textile manufacturers. The Guild, however, was dedicated to excluding any exhibits which seemed either 'commercial' or machine-made.[110] This endorsement of craft values by industrial magnates reads as another illustration of the Janus face of British culture in which the under-commoditised world of craft was granted special, sacralised social value.

The minutes of the Red Rose Guild's exhibiting committee set out in detail a range of petty definitions of the 'handmade'. Miss Drummond, a leatherworker, is criticised because of 'the constant use made of the machine in the stitching and of machine-made fitments.'[111] Similarly it is noted that Misses Williams, Brace and Pillsbury's stencil decorated tiles were machine-made.[112] In 1929 it emerged that Bernard Leach 'does not make his own tiles, only decorates them'.[113] On separate occasions Gordon Russell and another furniture maker, Harry Norris, asked the committee for permission to use machine-made textiles to upholster their furniture.[114] The glassmakers James Powell and Sons of Whitefriars exhibited with the Guild but the inclusion of a limited company with a relatively large workshop was regarded as controversial.[115] Commercial considerations were, however, not entirely in abeyance. The Guild charged an entrance fee for their annual exhibitions and some stalls were popular with the public but privately admitted by the committee to be of a low standard. Miss Todhunter of 'Goblin Market', Windermere, had since 1926 exhibited her 'Wee Folk' – leather covered flexible toys. These proved an embarrassment over the years. But she drew the crowds and therefore her presence continued, as the committee's minutes put it, to be 'a subject of debate and indecision'.[116]

The Red Rose Guild clung to these exclusionary principles throughout the inter-war period. But in the 1930s the Arts and Crafts Exhibition Society began stumblingly to address the machinery 'question'. In 1933 the Society held a symposium at which the young wood-engraver John Farleigh, famous for his 1932 illustrations to George Bernard Shaw's *The Adventures of the Black Girl in Search of God*, gave a paper bullishly entitled 'Welcome! Machinery'. The title was deceptive. Farleigh asserted 'we cannot doubt that handwork is better than machine work, except when the machine is making another machine'. The machine was merely a tool, but a tool that was liable to get out of hand and do something nasty. It was capable of multiplying its 'beastliness'.[117] Farleigh was to become a powerful figure in the craft world and for a while was an advocate of collaboration with industry. But his thinking on 'The Machine' suggested a superficial understanding of the relationship between design and production.

Farleigh and his allies, the critic Noel Carrington, Frank Pick, the engraver and Central School tutor Noel Rooke, the silversmith H.G. Murphy and the textile and packaging designer Reco Capey formed the pro-industrial grouping within and around the Society. In 1934 Carrington had suggested a useful focus for the Society's next exhibition, that the Society should ask itself: 'What does civilisation need that the machine cannot make.'[118] At the same meeting it was suggested that mass-produced articles be included if designed by craftsmen. The 1935 exhibition had a section devoted to such goods, included to demonstrate the influence of the crafts on industry. Several items – garden tables by A. Romney Green and door furniture designed and made by Gertrude Hermes – hardly seemed to qualify. But the printing and book production were impressive, Gordon Russell Ltd contributed two Murphy radio cabinets, Ambrose Heal sent a patent bed frame and Reco Capey showed his packaging and cosmetic jars for Yardley.

The debate would not die down and by 1937 the Society was in crisis over the design for industry question. From June to September that year those opposed to overt links with industry conducted a lively correspondence. Some of them – like Bernard Leach and Phyllis Barron – had represented a younger radical grouping within the Society and had consistently been praised in reviews of the Society's shows. But Leach (who had already embarked on his anti-industrial *A Potter's Book*) and Barron (who believed 'the society had gone from bad to worse for many years') shared in the opposition to what the bookbinder Roger Powell saw as the Design and Industry clique led by Farleigh. Powell and his fellow bookbinder Sydney 'Sandy' Cockerell, the furniture makers Edward Barnsley, Stanley Davies and Eric Sharpe, and Alfred and Louise Powell wanted, as Alfred Powell put it, a Society 'purified from those who wish to depend on mass and machine production'.[119] In his Report for 1936–7 the then President of the Society, the silversmith H.G. Murphy, had invited the members to 'decide whether its basis of membership would be extended to include craftsmen designing for machine production'. At the 1937 Annual General Meeting both Cockerell and Barnsley spoke against the proposal but Farleigh argued persuasively that to design for industry was the 'social duty' of every maker.[120] His ideas, very much the 1930s orthodoxy, won the day. At a special meeting held three months later it was resolved that the Society affirm 'the right and duty of its Members to raise the standard of design in industrial products as and when the opportunity occurs'.[121]

The debate within the Arts and Crafts Exhibition Society was mirrored by the Red Rose Guild in a remarkable correspondence between its honorary secretary Margaret Pilkington and her protégé Harry Norris (Fig. 143). Norris was a Bolton born and bred furniture maker, whose output was derivative of each and every inter-war furniture style from *moderne* to the revealed construction of the Cotswold school (Fig. 144).[122] More importantly, he was a quarrelsome autodidact who debated the policies of the Red Rose Guild in a stream of letters to Margaret Pilkington and other makers. Although in 1934 Norris took an interest in design for industry, by 1936 he was arguing for separatism. Craftwork, he argued, was 'passing out of the public consciousness of accepted ideas'[123] and by 1937 he called on the Guild to launch an active propaganda campaign attacking industry. He wanted the Guild's yearly exhibitions to abandon 'the medieval market idea' and instead put forward a cogent visual argument for an aesthetic in opposition to industry. What he saw as the exploitation of the crafts by educationalists, by so-called craft shops and by industry itself needed to be exposed.[124] Margaret Pilkington grew alarmed. She argued that industrialists were often the craftsman's best patrons and, as she pointed out,

> Your present chairman is a company director and retired managing director, your vice-chairman is a managing director and your Honorary Secretary is also a director of an industrial works and in addition owes her position and means to work for the cause of arts and crafts to money made in glass, in coal getting and to a lesser extent in tile making.[125]

But Norris's artisanal background gave his criticisms and obsessions extra clout among the Guild's middle- and upper-class members and patrons. As Leach explained to Michael Cardew in 1942, at the height of wartime planning for the future of the crafts, 'He (Norris) knows the world of commerce as few of us do and can hold his own in it. He is "Manchester" and hard and sharp and astute and farseeing in many ways.'[126]

Norris read Gill and took a distinction which Gill made between tools and machinery to heart. Norris, like Gill, saw things from the worker's point of view and he argued that in industry workers were merely 'one item of the machinery'.[127] He wrote angrily to Leach: 'the world of Gropius is inhuman and will perish by that fact. Gropius is either a fool or a fiend.'[128] Like Gill, Norris cherished a particular dislike for 'enlightened' DIA designers and pundits. H.G. Murphy, Harold Stabler, Reco Capey, Oliver Hill, Herbert Read and Gordon Russell were, he wrote, 'all eminent, but they inspire no confidence'.[129] In 1939 Norris called for the exclusion of 'unscrupulously commercial' and 'petrified' work in favour of 'a small group of truly modern truly creative craftsmen'.[130] Despite his own mediocre talents Norris had a good

143. Harry Norris in his workshop in 1988. (Courtesy of the *Bolton Evening News*).

144. Furniture designed and made by Harry Norris, cartoons for stained glass by Arthur Todd, Red Rose Guild Exhibition 1929. (Holburne Museum and Crafts Study Centre, Bath).

eye and saw his small group including Leach, Cardew, Barron and Larcher and the textile designer and hand-weaver Marianne Straub. Under Norris's influence the Guild stood in opposition to the Arts and Crafts Exhibition Society's post-1935 friendliness to design for mass production and Norris stepped up his campaign during the Second World War.

As the ground shifted in the 1930s and powerful theoreticians like Herbert Read set out their positions in the highly politicised atmosphere of the period, attitudes to mass production within the Red Rose Guild and the Arts and Crafts Exhibition Society as a whole polarised. The antipathy between the design and craft worlds and even between different camps in the craft world was often reinforced by taste, class and background. For instance Barnsley and Powell were much taken with Norris's thinking until Powell reported back with shock in 1942 on a Norris wardrobe which resembled 'some mass-produced article for a pretentious provincial hotel'.[131] The two priggish Bedalians were equally disapproving of Reco Capey whom Powell reported seeing at a railway station with a dubious looking female companion. The cosmopolitan textile and packaging designer was not their kind of craftsman. Many makers – including Leach and Cardew – believed that designers could not design effectively in all media and that industrial ceramics, for instance, should be designed by men and women with direct experience as potters.[132] Versatility was equated with superficiality. The fact that Keith Murray, an architect, was from 1933 successfully designing glass and ceramics for industry irritated both men as did Eric Ravilious's successful collaboration with Wedgwood.[133] Murray's designs seemed mere drawing board stuff, even if, ironically, they were hand-thrown by the Wedgwood workforce (Fig. 145).

The morality of mass production continued to be debated by makers throughout the 1930s. Those who argued that the machine was 'only a tool' concentrated on the end product while those who abhorred mass production, like the master printer J.H. Mason and the metalworker Edward Spencer, were primarily concerned with the fate of the operative.[134] The most powerful arguments that un-picked the machine-is-but-a-tool approach came from Eric Gill.[135] Gill's hostile attitude to mass production suggested a tougher grasp of the political, social and economic realities of factory work than that possessed by most middle-class makers.

SHOPPING FOR CRAFT[136]

The consumption of craft between the wars took place against a backdrop of economic depression which resulted in high unemployment not only for the unskilled but also for skilled workers in the great nineteenth-century industries – textiles, shipbuilding and coalmining. But artist crafts were largely made and consumed by the middle and upper-middle classes who in the 1920s and 1930s were enjoying a rise in their standard of living. If makers struggled it was

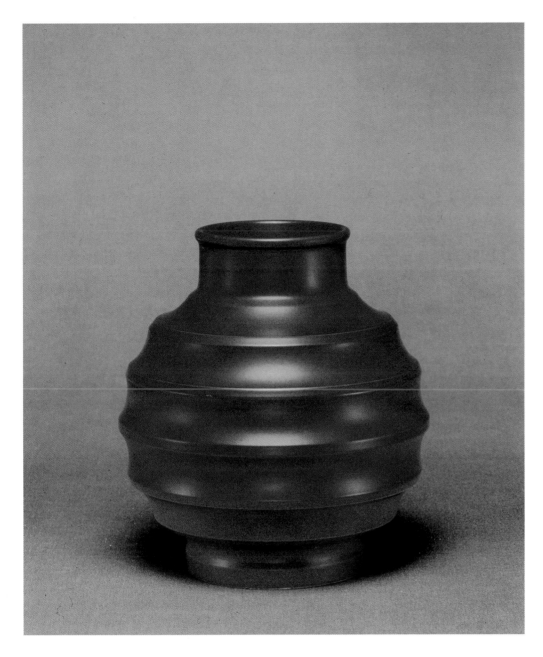

145. Keith Murray, *Vase*, handthrown and lathe-turned earthenware with a green matt glaze, introduced 1934, h. 23 cm. (By courtesy of the Wedgwood Museum Trustees, Barlaston, Staffordshire).

because of the rarefied nature of their work and, by the 1930s, because of a changed sensibility which responded to aspects of modernity like speed and technological advance. The heterodox outlets for the crafts reflect their uncertain identity.

The most obvious sources for craftwork were the shows mounted by the two main exhibiting societies, the Arts and Crafts Exhibition Society and the Red Rose Guild, and exhibitions put on by the specialist societies – for instance the Guild of Weavers, Spinners and Dyers and the Society of Scribes and Illuminators. As we have seen, in the 1920s design organisations like the DIA and the British Institute of Industrial Art also showed craft as exemplifying good design. At the other end of the spectrum many makers, especially women, exhibited in the numerous annual exhibitions which functioned like bazaars, with stalls for hire, and an emphasis on crowd-pulling craft demonstrations. One of the better known was the annual show put on by the Home Arts and Industries Association, dominated by the philanthropic crafts, and popular well into the 1930s.[137] Henry Wren, the husband of the potter Denise Wren, ran *The Artist Craftsman* exhibition each autumn in the Central Hall, Westminster from 1925 to 1938.[138] From 1924 the *Daily Mail* Ideal Home Exhibition included a Hall of Handicraft although by 1936 this had shrunk to a showing by a few charitable crafts organisations.[139]

The Englishwoman Exhibition of Arts and Handicrafts, organised and sponsored by the magazine of that name, was held at the Central Hall, Westminster from 1910 until the Second

World War. This was an overwhelmingly female occasion, with titled woman patrons and predominately women exhibitors. Charitable handicraft organisations like Fisherton-de-la-Mere Embroideries, the Coggeshall Tambour Lace Industry and the Barclay Workshops for Blind Women showed alongside the occasional distinguished exhibitor including the weavers Ethel Mairet and Elizabeth Peacock. Phyllis Barron remembered it 'as a rather terrible sort of Christmas bazaar. A lady next door to me sold brooches made of fishbones, and one on the other side decorated jam jars with oil paint.'[140] Out of London, apart from the local Guilds, there were agricultural shows where the Rural Industries Bureau exhibited as did some artist craftsmen and women. Agricultural shows were the favoured venue for two pupils of Ethel Mairet, the 'Inval Weavers', Ursula Hutchinson and Hilda Woods.[141]

Much craft was bought directly from the maker. Individual commissions were common in the areas of silversmithing, stained glass, metalwork, furniture, lettering and fine book production and some craftswomen and craftsmen made themselves accessible by having a showroom attached to their workshops. Bernard Leach, Arthur Romney Green, Gordon Russell and the Simpsons of Kendal all had showrooms, with the last two stocking other goods that seemed in sympathy with their work.[142] The Omega Workshops, before their closure in 1920, sold work designed and made by Omega artists as well as items, like the textiles for the West African market manufactured by Charles Sixsmith, which fitted into the Omega ethos.[143] Similarly the Artificers' Guild, with shops in London and Cambridge, sold textiles and pottery as well as Edward Spencer's silver and jewellery.[144] By the late 1930s Gordon Russell Ltd's London outlet in Wigmore Street (Fig. 75) was a centre for Modern Movement products from all over Europe, representing a marked shift from Russell & Sons' Broadway showroom of the 1920s which had restored and sold antiques.[145]

A surprising number of galleries in the West End of London exhibiting advanced painting, sculpture and prints also made space for artist crafts. As we have seen, the most adventurous applied art exhibition to be mounted between the wars was held at Zwemmer's, a bookshop and avant-garde gallery. *Room and Book* organised by Paul Nash in 1932 was followed by *Artists of Today* in 1933. But as we saw in Chapter Two ceramics were most written about by critics and most frequently linked to developments in fine art. Not surprisingly therefore studio ceramics were the craft most favoured by the West End galleries.

For instance, the Cotswold Gallery in Frith Street run by Mrs Finberg, the wife of the Turner expert, specialised in Turner and contemporary Cotswold artists but also gave Bernard Leach his first one man show and sold furniture from Peter van der Waals's Cotswold workshop (Fig. 146).[146] Frederick Lessore's Beaux Arts Gallery at Bruton Place was for a brief period particularly generous to ceramics, with a solo show for Reginald Wells in 1927 and a joint show for William Staite Murray, Ben Nicholson and Christopher Wood in the same year. Bernard Leach showed in 1928 and 1933, his Japanese friend Kanjiro Kawai in 1929 and Leach and Kenkichi Tomimoto had a joint exhibition in 1931.

William Paterson was another early supporter of studio ceramics. Bernard Leach's Japanese partner Hamada visited William Paterson's by chance in 1923, was impressed by the owner and asked to exhibit: 'He replied it was a rare thing to have a pottery exhibition'.[147] Hamada nonetheless exhibited in April and December of 1923. Murray was given a one-man show in 1924 and thereafter yearly till 1929. Paterson also stocked work by Leach's former pupils Norah Braden and Katharine Pleydell-Bouverie. Paterson's ceramics exhibitions were notable for their well illustrated catalogues. The Hamada catalogues of 1929 and 1931 included thoughtful introductions by Bernard Leach and by Soetsu Yanagi, the philosopher of the Japanese Arts and Crafts movement.

Other West End galleries showing the crafts in the late 1920s included the Brook Street Gallery, which exhibited hand-painted pottery by the Powells as well as block-printed fabrics by Phyllis Barron and woven textiles by Ethel Mairet, and Colnaghi's, which held annual studio ceramics shows in the late 1920s. The Leicester Galleries stocked pots by Murray and Katharine Pleydell-Bouverie. From 1932 to 1934 they also showed the Seven & Five Society, of which Murray was a member, and in 1935 they put on an important show of modern

needlework. The Rembrandt Gallery in Vigo Street specialised in etchings but gave Katharine Pleydell-Bouverie one-woman shows in 1936 and 1937. In the late 1920s the Redfern Gallery sold pots by Bernard Leach and figurines designed by Phoebe Stabler and acted as the sole agent for another figurine maker, Stella Crofts. It was generous to wood-engravers and in the 1930s the Society of Wood-Engravers held exhibitions at the Redfern. In 1936 the gallery showed rugs designed and made by Ronald Grierson.[148] Walker's Gallery in New Bond Street concentrated on topographical watercolours and pastels but also showed the potters Charles and Nell Vyse from 1928 till 1959, a remarkable run of thirty-two years. In an idiosyncratic way Walker's was generous to the crafts, with occasional shows for the Embroiderers' Guild in the 1930s and regular shows of paintings and craft by groups of women led by Estella Canziani from 1925 till 1935. In the late 1930s Mary Ireland 'the originator of fabric mosaics' and the jeweller Dorrie Nossiter were similarly given regular exhibitions. Between 1928 and 1938 Walker's produced a journal with useful articles on artists they promoted.

Of the diversity of 'craft' presented in these fine art galleries, ceramics probably fared the best in terms of presentation. Leach's work was handsomely displayed at the Beaux Arts Gallery in 1933, functioning as both sculpture and painting with major pots on plinths and groups of tiles framed and hung (Fig. 147). But in 1929 Murray had complained to the collector Eric Milner-White that his work 'seem caged and unhappy' in the discreetly grand interior of Paterson's.[149] In 1936 the Brygos Gallery was set up by Ulick and Denis Browne partly to answer the special needs of potters. Backed by the Applied Heat Company, Brygos specialised in pottery, terracottas, glass and enamels – all works of art that had been submitted to fire. As Denis Browne explained to Leach: 'the background, stands and lighting effects will be expressedly designed to show such exhibits to the very best advantage'.[150] In the two years of its life the Brownes' gallery put on a series of mixed ceramics, showed terracottas by sculptor Frank Dobson and gave one-man shows to T.S. Haile, Michael Cardew and Margaret Rey.

Studio pottery's special status was suggested by its inclusion in the National Society set up in 1930 to show painters, sculptors, engravers *and* potters. The National Society's first show was held in the Grafton Galleries in 1930 and thereafter in the Royal Institute Galleries in Piccadilly. The Society appeared to be a modernist version of the Arts and Crafts Exhibition Society intended to 'represent all aspects (of art) under one roof, without prejudice or favour to anyone'.[151] The first officers of the Society were an eclectic mix including C.R.W. Nevinson, Frank Dobson, Bernard Adams, Maurice Lambert, Leon Underwood and Charles Vyse and among other artist members in the 1930s were Mark Gertler, Henry Moore, Graham Sutherland, Eileen Agar, John Skeaping and Barbara Hepworth. It was not a close knit

146. Ceramic sign for the Cotswold Gallery designed by Phoebe and Harold Stabler. (Photo courtesy of the Worshipful Company of Goldsmiths).

147. An exhibition of stoneware pottery by Bernard Leach at the Beaux Arts Gallery in 1933. (Holburne Museum and Crafts Study Centre, Bath).

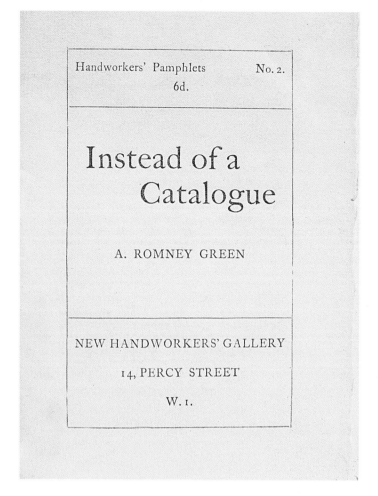

148. Footprints trade card, 1932. (Central Saint Martins College of Art and Design).

149. A. Romney Green, *Instead of a Catalogue*, New Handworkers' Gallery pamphlet, 1928.

150. Logo designed by Paul Nash for the shop *Modern Textiles*, 1926. (Courtesy Hazel Clark).

group – in comparison with, say, Paul Nash's Unit One – but it could loosely be described as modern and progressive. Michael Cardew, Bernard Leach, William Staite Murray, Katharine Pleydell-Bouverie and the figurine maker Gwendolen Parnell exhibited throughout the 1930s.[152]

Potter members were conscious of the boost the National Society gave them. As Cardew recalled: 'I think that this was the first time the new breed of potters had been admitted to a society devoted to the fine arts.'[153] The reaction to Cardew's work was interesting. In 1931 he sent in large slip-decorated earthenware vessels, romantic but ostensibly utilitarian. These were much admired, especially by Leon Underwood who introduced Cardew to a circle of painters and sculptors, including the wealthy Chelsea painter Maresco Pearce who 'told me I was a Fauve (but he had to explain what that meant) and said that my pots were like Gauguin's painting, the same kind of animal outburst'. For the potters the National Society was much more than just another outlet for their work. It helped them to define themselves as fine artists. This suited some better than others. William Staite Murray stayed with the Society till the Second World War. Charles Vyse was another stalwart. Cardew found that he could not, as he put it, 'travel in the fine art bag' and he ceased to exhibit in 1936.[154]

Textiles too had strong links with developments in fine art. As we have seen, Henry Moore sculptures were juxtaposed with textiles both at Zwemmer's and at the Warren Gallery. In 1926 Phyllis Barron and Dorothy Larcher had a two woman show of hand-block printed textiles at the Mayor Gallery while in 1925 the Independent Gallery put on a widely reviewed show of dress lengths hand block-printed with designs by the painter Alec Walker.[155] Walker's textiles, marketed under the name Crysède, were on show in a gallery 'where Augustus John and the French Post-Impressionists usually reign'.[156] Footprints, started in 1925 by Celandine Kennington, was another block-printing business which also bridged the art/craft divide by commissioning designs from fine artists like Paul Nash and Eric Kennington, Celandine's husband. From 1929 all designs were by Joyce Clissold and in 1933 Footprints opened its own shop in New Bond Street with a second shop opening in Knightsbridge (Fig. 148). Modern

Textiles, founded by Elspeth Anne Little in Beauchamp Place in 1926 with support from Paul Nash, also retailed Footprints fabrics, textiles by Phyllis Barron, Dorothy Larcher, Enid Marx and Frances Woollard, pots by Bernard Leach and Norah Braden, hand-painted batik by Marion Dorn, appliqué embroidery designed by the painter Claude Flight and wallpapers by Edward Bawden (Fig. 150).[157] Marion Dorn herself had an outlet in Lancashire Court from 1934 but this was more a design consultancy studio than a shop (Fig. 151).[158] On a much smaller scale the weaver Ethel Mairet ran a shop in Brighton between 1933 and 1951 which sold her work together with ethnic knitted goods imported from Yugoslavia.

The large department stores which retailed innovative applied art and design were few in number and more likely to be committed to the Modern Movement in design than to the crafts. But Geoffrey Dunn, who in the 1930s introduced modern design to his family firm Dunn's of Bromley, saw the point of displaying 'a lovely Bernard Leach dish' leaning up against a piece of Isokon furniture.[159] Of the other innovative stores such as Crofton Gane of Bristol, Rowntrees of Scarborough, Kendal Milne in Manchester, Barrows of Birmingham, and Waring & Gillow, it was the Mansard Gallery at Heal's which gave most encouragement to handicrafts. In the late 1920s Heal's ran a craft studio where makers worked under the direction of Jeanetta Cochrane and from 1917 Prudence Maufe ran the Mansard Gallery in Heal's specifically to show a mix of art, craft and design.[160]

Some shops and galleries were devoted entirely to imported folk art and to traditional British rural crafts. Several outlets specialised in Polish handicrafts (where vernacular craft traditions remained strong) while The Peasant Shop in Devonshire Street run by Phyliss Nott imported a range of European handicrafts. Until at least 1931 the Peasant Art Society retailed the products of the various craft experiments initiated by Godfrey Blount at Haslemere and the Rural Industries Bureau opened its retail outlet Country Industries Ltd in 1926. Mrs Summerley's Cromwellian Candle Company purveyed olde world lighting for Tudorbethan interiors in the late 1920s but also had 'Beautiful things for everyday' which included pots by Frances E. Richards, Norah Braden and Katharine Pleydell-Bouverie. In the mid to late 1920s The Cottars Market run by the aristocratic Mrs Nigel Playfair and Mrs Pitt Chatham sold painted furniture made on Lord Plymouth's estate to Lady Plymouth's designs as well as Portuguese shawls and leatherwork from a charitable North African workshop and other imported vernacular crafts[161].

A few specialist galleries concentrated on promoting the best of British artist craftsmen and women and these tended to be small, highly individual and short-lived. The New Handworkers' Gallery, set up in 1928 in Percy Street, attempted both to sell craft and to construct a philosophy for the continuance of handwork. Its proprietor was Philip Mairet, running it with his wife Ethel Mairet and with a Mrs Norsworthy whose attractions brought the Mairet marriage to an abrupt end.[162] The gallery, inevitably, had a strong Ditchling connection with Ethel Mairet, her brother Fred Partridge, her former pupil Valentine KilBride and Douglas Pepler all exhibiting. Although Mairet tried to respond to consumer demand – Michael Cardew for instance was set to making lamp bases, jamjars, soap dishes, casseroles and ink pots – the Gallery's aims were more than purely commercial. Mairet, always fond of intellectual groupings, wanted his 'New Handworkers' to be bound by common ideals and he commissioned a series of pamphlets from his makers.[163] To stimulate discussion the texts were circulated before publication within the group. Leach read Romney Green's essay *Instead of a Catalogue* (1928) to his workforce at St Ives and they debated Green's dependence on mathematical formulae as a source of design inspiration for furniture making (Fig. 149).[164] Douglas Pepler, who printed the pamphlets at St Dominic's Press at Ditchling, demanded, in vain, that all references to mechanisation in Leach's essay *A Potter's Outlook* (1928) be removed.[165] Cardew wrote to praise Mairet's pamphlet which 'stimulated me to write 2 pages of Aristotelian argumentation with the result that I haven't been able to make any jugs since'.[166]

Mairet's own *Idea Behind Craftsmanship* (1928) outlined a wider relevance for the crafts. Mairet argued that makers, 'the courageous association of free, individual workers', must

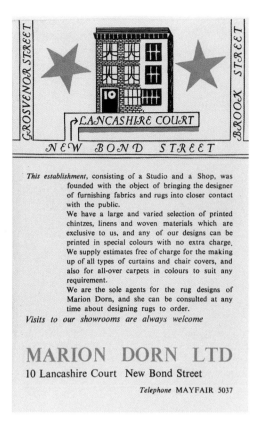

151. Trade card for Marion Dorn Ltd. (Holburne Museum and Crafts Study Centre, Bath).

152. The first floor gallery at the Arts and Crafts Bureau in 1928 with a sideboard by Bath Cabinet Makers, Bernard Leach pots, candle sconces designed by Gordon Russell, a carved chair by William Aumonier and figurines by David Evans. (The Arts and Crafts).

'purge the world of useless things which are now being done in the name of handwork' and join forces with religious, scientific and psychological groups. Mairet believed unexpected allies would emerge: 'engineers and physicists will understand their meaning, and join with them to revolutionise, by humanising, the whole organisation of men's work'.[167] Mairet's vision of a new world was inspired partly by Guild Socialism and partly by his intense friendship, coming close to a love affair, with the Serbian mystic Dimitri Mitrinovic. Mairet's ideas about co-operation were given a further framework through his study of the work of Alfred Adler, the Austrian psychologist who preached social interaction and co-operation as essential to mental health and he encouraged makers to attend lectures given by the Adler Society for Individual Psychology.[168] The other pamphlets in the series – Leach's *A Potter's Outlook*, Romney Green's *Instead of a Catalogue* and Gill's *Art and Manufacture* (1929) – all touched on co-operative ideas. Intellectual cut and thrust dominated Mairet's correspondence with his craftsmen.

Another craft outlet which took up an intellectual position also opened in 1928. The shortlived Arts and Crafts Bureau was spread over three floors of a former hotel in Bloomsbury Street (Fig. 152). It was guided by a council. Gordon Russell advised on furniture, Edward McKnight Kauffer on posters, William Aumonier on wood-carving, George Sheringham and Horace Shipp on 'theatre craft' and Claude Flight on woodcuts. It was backed and publicised by the magazine *The Arts and Crafts* until the demise of both magazine and gallery in 1929. 'Craft' was defined in a eight point 'Credimus' published in the magazine. The Bureau was at odds with the New Handworker ethic, arguing that it was 'folly to ignore the value of the machine'. The magazine was satirical about aspects of the inter-war crafts, mocking its associations with philanthropy, its narrow class basis and its amateurism. The Bureau's definition of craft was broader than most: 'the whole question of hand *versus* machine resolves itself by reference to efficiency, and that product is best which is the most efficient expression of an idea.'[169] Poster art and theatre design were seen as part of the craft continuum. Mairet saw the Bureau as a competitor and persuaded his makers not to exhibit. Leach, always eager for involvement, advised on ceramics before finding himself 'increasingly at variance with the Bureau's policy and practice'.[170] The magazine's satirical edge, including amused attacks on Leach himself and cartoons about fashions in art and design (Fig. 153), and the Bureau's interest in early Victorian applied art would hardly have appealed.

Mairet's business inefficiencies had drawn sharply worded communications from Phyllis Barron.[171] That she did not enter the debate which Mairet was trying to foster is further

evidence that male makers felt impelled to write and justify their practice but, with the exception of Ethel Mairet, women makers did not. Similarly, galleries run by women concentrated on a sensitive response to consumer demand, contextualising the crafts visually rather than intellectually. This was true of Modern Textiles, Marion Dorn's outlet in Lancashire Court and the Three Shields Gallery in Holland Street, off Kensington Church Street. Founded in 1922 by a Central School-trained calligrapher, Dorothy Hutton (later a founder member of the Red Rose Guild), the Three Shields Gallery was an early success, showing watercolours and prints as well as pots by Frances Richards and Deborah Harding, slipware by Bernard Leach, textiles by Barron and Larcher, Enid Marx, Ethel Mairet and silver and shagreen work by John Paul Cooper.[172]

Two of Dorothy Hutton's employees, Muriel Rose and Margaret Turnbull, set up their own concern, The Little Gallery in Ellis Street off Sloane Street in 1928.[173] The strikingly simple interior was designed by Raymond Erith. Constance Spry inspired the ever-changing flower arrangements (Fig. 154). Muriel Rose sent her staff to study the making processes at the Leach Pottery and at Barron and Larcher's workshop at Painswick (Fig. 155). But handicraft did not dominate the Little Gallery. With the needs of her customers in mind she also stocked Wedgwood china, Orrefors and Whitefriars glass, lustreware designed and painted by Louise and Alfred Powell and a range of imported folk crafts that included Swedish wooden bowls, rugs from India and Mexico, Romanian embroideries as well as antique and new quilts made by the miners' wives of Durham and South Wales. Stationery boxes and albums covered with patterned papers by Enid Marx were also sold (Fig. 156). In 1935 Muriel Rose put on a show of Japanese goods brought back by Leach – lacquered spoons, fabrics, pots, pens, inks and handmade papers, as well as the fruits of his joint firing with Hamada. By the late 1930s she was catering for a Regency taste, exhibiting wallpapers by Edward Bawden and John Aldridge in 1939 and encouraging Jean Milne's heavily symbolic tapestries and the high camp artistry of Samuel Smith, whose dolls' houses, music boxes, puppets of Britannia and seaside pianists hovered between popular art and Victorian revival. Unlike Mairet, Muriel Rose was an efficient business woman, assembling a prestigious list of clients, headed by Queen Mary and including Charles Laughton, Gerald Du Maurier, Gertrude Lawrence, Naomi Mitchison, and Bridget d'Oyly Carte. After five years the Little Gallery began to operate at a profit but like many London galleries it closed in 1939 and did not re-open after the war.

The Little Gallery had its imitators, in particular Dunbar Hay Ltd which was opened in

153. Cartoon in *The Arts and Crafts*, June 1928. (The Arts and Crafts).

154. The interior of the Little Gallery. (Holburne Museum and Crafts Study Centre, Bath).

155. Publicity card for the Little Gallery showing hand block-printed textiles by Phyllis Barron and Dorothy Larcher and an earthenware jar by Michael Cardew. (Holburne Museum and Crafts Study Centre, Bath).

156. Hand block-printed papers by Alice Hindson, Enid Marx, Dorothy Larcher and Charles Tomrley sold at the Little Gallery. (Holburne Museum and Crafts Study Centre, Bath).

1936 by a former sculpture student from the Royal College of Art, Cecilia Kilburn Dunbar (later Lady Sempill) and the Registrar at the College, Atholl Hay.[174] The shop was intended to bring together young designers and manufacturers. Like the Little Gallery in the late 1930s it catered for the prevailing neo-Georgian/Regency taste in interior decoration. Cecilia Sempill paid a retainer to Eric Ravilious, a former fellow student at the College, and he designed stylish neo-Georgian chairs (Fig. 157) She also brought Ravilious into contact with Wedgwood and his designs were among the firm's best sellers. There was a good deal of historicism about her taste, which did not extend to Continental modernism or, indeed, to Keith Murray's designs for Wedgwood. Instead, as a friend of Tom Wedgwood, she placed special orders for selected eighteenth-century designs (Fig. 158), and for multi-coloured ceramic balls for playing carpet bowls. This was a country house pursuit and tells us something about her clientele. Her gallery stocked a large selection of textiles, dominated by Allan Walton and Edinburgh Weavers. Just before the war she started an embroidery section using designs supplied by Duncan Grant and Vanessa Bell. Enid Marx was 'a willing and exciting contributor' who showed her block-printed fabrics together with machine and appliqué embroidery by Grace Peat and Rebecca Crompton, pots by Cardew, Pleydell-Bouverie and Braden, Bawden wallpapers, Powell glass and Sam Smith Christmas cards. Dunbar Hay had similar clients to those of the Little Gallery and exhibited many of the same makers and manufacturers but showed markedly less interest in the crafts.

Overall the contrast with the relatively structured exhibiting patterns for painting and sculpture is striking. The diversity of venues for exhibiting the crafts between the wars was bewildering. A single maker might exhibit or sell work in a New Bond Street gallery, at the Arts and Crafts Exhibition Society, with the British Institute of Industrial Art or at a humble agricultural show. Nothing illustrates more vividly the cultural ambivalence of the handwork project and the problematic nature of its significance to both makers and consumers. No

158. Josiah Wedgwood & Sons, coffee cans and saucers in cream earthenware produced for Dunbar Hay Ltd. *c.* 1936. Coffee can h. 5.8 cm. (The British Council Collection).

157. Armchair designed by Eric Ravilious and made by H. Harris for Dunbar Hay Ltd, 1936. 87 × 51 × 54 cm. (V&A Picture Library).

wonder Bernard Leach asked in his New Handworkers' pamphlet: 'Who are we? What kind of person is the craftsman of our time?'[175]

NATIONAL PROJECTION: PARIS 1937

Two exhibitions offer further insights into the multivalent status of the crafts at the end of the 1930s. The first, *British Art in Industry*, was organised by the Royal Academy and the Royal Society of Arts with the patronage of the King and Queen, the involvement of the Prince of Wales and a distinguished general committee including Stanley Baldwin and Ramsey MacDonald.[176] Although the best of affordable British design was represented – for instance R.D. Russell's radio cabinets for Murphy and Keith Murray's designs for Wedgwood – the exhibition attracted almost universal criticism. In the context of 1935, with a million and half unemployed, a weak National Government and both Germany and Italy rearming, the inclusion of a substantial proportion of highly crafted luxury items – expensive furniture covered in crocodile skin and a stationery cabinet covered in Nigerian goatskin – seemed inappropriate. Both the craft world and those speaking up for progressive design were outraged. Highly crafted but not modern craft, billed as 'art in industry' but not design for mass production, the Burlington House exhibition was reified as a blowsy woman of easy virtue. Muriel Rose wrote to Bernard Leach describing part of the exhibition design: 'a bellying false ceiling of artificial silk in imitation of gold covered the ceramics room like a vulgar giant's eiderdown over one's head'. She concluded that the whole affair was ostentatious; £20,000 had been spent on the exhibition and artist craftsmen and women, apart from silversmiths, had been excluded.[177] For Raymond Mortimer, writing in the *New Statesman*, the standards the exhibition set were 'both costly and depraved', symbolised by emerald necklaces and 'revolving beds for expensive tarts'.[178]

If the Burlington House show suggested the tastes of a *poule de luxe* the British pavilion

159. Oliver Hill, photo-mural in the British pavilion, *Exposition Internationale des Arts et Techniques Appliqués à la Vie Moderne*, Paris, 1937. (British Architectural Library, RIBA, London).

designed by Oliver Hill[179] at the *Exposition Internationale des Arts et Techniques Appliqués à la Vie Moderne* held in Paris in 1937 could be anthropomorphised as an androgynous upper-middle-class huntress stepping crisply out of the pages of a novel by John Buchan.[180] In this propagandising projection of Britain organised by the Council for Art and Industry the artist crafts again had no obvious place. This was not because the chairman of the organising committee Frank Pick was a hardline modernist. Although the creator of what was then the most advanced and best designed passenger transport system in the world, Pick was steeped in the writings of William Morris and W.R. Lethaby.[181] He liked Lethaby's humane sounding simplification of the design process in which good art and design were compared to the orderliness of a naval squadron and to 'simple well-off house-keeping in the country, with tea in the garden; Boy-scouting and tennis in flannels'.[182] Pick shared Lethaby's fondness for tennis racquets, hand tools and sailing boats, writing in 1922: 'It is strange how all the things that matter turn on sport. The lines of hulls and sails are not artist's lines, are not really designer's lines. They are found in seeking spread of canvas and speed. They have the beauty of significance.'[183] As his inspiration for the British pavilion Pick took as his guide key words which had been transposed into the French – le sport, le tennis, le week-end.[184]

Pick's whimsical approach fitted in neatly with the official policy on the presentation of

Britain evolved by the Empire Marketing Board. In 1932 the Board's Secretary Stephen Tallents had written a pamphlet entitled *The Projection of Britain* which singled out the English countryside, her villages, fox-hunting and fine tailoring as some of the 'raw material of England's esteem in the world', together with qualities like fair dealing in commerce, quality and manufacture and fair play in sport.[185] British visitors to the national pavilion designed by Oliver Hill were both puzzled and irritated (Fig. 159). The Left in particular were dissatisfied by Pick's pastoral version of an England apparently devoid of an urban working class. Kingsley Martin observed in the *New Statesman*:

> When you went in the first thing you saw was a cardboard (Neville) Chamberlain fishing in rubber waders, and beyond, an elegant pattern of golf balls, a frieze of tennis racquets, polo sets, riding equipment, natty dinner jackets and, by pleasant transition, agreeable pottery and textiles, books finely printed and photographs of the English countryside. I stared in bewilderment. Could this be England?

Questions were asked in the House of Commons. The Labour MP George Strauss wondered why 'the three chief exhibits which the viewer sees on entering the British pavilion are a large model of people hunting, another of people shooting, and a large picture of the Prime Minister fishing?' Ellen Wilkinson, the Labour MP for Jarrow, wondered whether it was not possible for the exhibition 'to suggest that the British people occasionally do some work'.[186] J.M. Richards, editor of the *Architectural Review*, entitled his article *The Problem of National Projection*, noting that the whole effect was 'comfortingly like the foreigner's traditional idea of eccentric England'.[187]

As Richards pointed out, the Danes, Swedes, Finns and Austrians gave some idea of their national resources and their history. 'What occupies the equivalent position in the British pavilion? Gentlemen's suits, travel accessories, tennis racquets.'[188] Even members of the Council for Art and Industry were dismayed. Charles Tennyson noted that 'the man in the street' regarded the show as being 'too frivolous and too upper-middle-class'.[189] The only consolation was the contrast with the crude displays of Fascist power orchestrated by Italy and Germany.

A quasi-feudal invented tradition rather than modernity was being celebrated at Paris in 1937. Skilled high-quality handwork was emphasised in the selection. But it took the form of highly regulated, deeply conservative trade crafts such as saddlery, gunsmithing and tailoring. The effect was to marginalise both modernism in design and the artist crafts. The projection of Britain as a huntin' shootin' Merry England, carried even further at the New York World Fair of 1939, had no place for either form of radicalism.[190]

160. The young Dorothy and Leonard Elmhirst. (From the Dartington Hall Archive).

A CASE STUDY: THE DARTINGTON 'EXPERIMENT'

The complex relationship between artist crafts and industry, and between modernism and Englishness, was well illustrated by the experiments in design and production carried out by Dorothy and Leonard Elmhirst at Dartington Hall in Devon from 1925 until 1939.[191] Leonard was a disciple of the Indian philosopher, Nobel Prize winning poet and educationalist Rabindranath Tagore, with whom he founded an Institute of Rural Reconstruction known as Sriniketan in Bengal. Dorothy was a high-minded, immensely wealthy New York philanthropist who had helped fund Sriniketan – in 1925 her fortune was worth thirty-five million dollars. Her riches funded what Leonard called 'the great experiment' at Dartington. It also gave the Elmhirsts the freedom to be both radical and 'not quite contemporary' (Fig. 160).[192]

The crafts were to be central to the Dartington experiment: 'Be sure that your weavers and potters always keep in touch with your artists', wrote Rabindranath Tagore to Leonard. 'The practical work of craftsmen must always be carried out in partnership with the divine spirit of madness – of beauty – with the inspiration of some ideal of perfection.'[193] Dartington was centred on its progressive school which opened in 1926. The 'spirit of divine madness' was certainly encouraged there and the crafts, as with other experimental schools of that date, were an integral part of its learning-by-doing philosophy.[194] But craft practice on the estate

had to fulfil different goals. Leonard's work in India led the Elmhirsts to focus on the rural regeneration of the neglected Dartington estate. He had studied agriculture at Cornell and his approach to farming was 'scientific'; he pioneered the factory-farming of chickens, the artificial insemination of cattle (seen on a visit to the USSR) and the uprooting of hedgerows to create American-style prairie fields. The Elmhirsts were advanced in other ways; commissioning a number of undilutedly modernist buildings from the Anglo-Swiss architect William Lescaze and from Robert Hening and giving money to the construction of Maxwell Fry and Walter Gropius's Village College at Impington in Cambridgeshire.[195]

Thus Leonard Elmhirst's rural reconstruction aims had nothing in common with the inter-war organic farming movement which sought to repopulate the land by reverting to older labour-intensive farming methods. He was a left-wing planner who wanted the crafts, together with rural industries like cider-making and saw-milling, to play their part with the proviso that they operated within a realistic economic framework.[196] The estate's so-called secondary enterprises, which included the crafts, were expected to be efficient well-researched modern solutions to unemployment and poverty. Thus at Dartington from the late 1920s till World War II we find the crafts being included, but also being put under the microscope, their economics dissected and mostly found wanting.

Weaving had been recommended by Tagore and the first craft-based enterprise to be set up on the estate was the textile department. While out motoring in the Devon lanes early in 1927 Dorothy spotted a hand-weaving sign and thus, almost by accident, Heremon 'Toby' Fitzpatrick was given a quite remarkable opportunity to develop his ideas.[197] Fitzpatrick, an upper-class Anglo-Irishman who had been inspired by the surviving spinners and hand-weavers he had seen at work in the West of Ireland, had a vision of textiles at Dartington which struck a chord with the Elmhirsts. He passionately believed in hand-loom weaving and he planned to revive it as a profitable cottage industry for the surrounding area (Fig. 162). Wool preparation and spinning would, however, be done by simple machinery of the type used during the early stages of the Industrial Revolution. Such methods had survived in the comparatively primitive Welsh wool mills and Fitzpatrick anticipated fellow artist weavers like Margery Kendon, Marianne Straub and Ethel Mairet in recognising the beauty and individuality of Welsh yarns and textiles. In 1928 he toured the Welsh mills studying their low-level technology and purchasing old equipment including semi-mechanised spinning mules and carding machines.[198]

The generous patronage of the Elmhirsts enabled Fitzpatrick to take research back to

basics, initiating an expensive experiment in moorland sheep farming on Dartmoor to investigate the qualities of Shetland and Welsh wools. Leonard Elmhirst wanted all Dartington projects to involve extensive consultation with 'experts'. Fitzpatrick did not disappoint him. Wools were investigated. Dyes were discussed with craft weavers like Ethel Mairet, Elizabeth Peacock and Jean Milne and, from 1932, with the German firm IG Farben Industrie. A skilful self-taught engineer, Fitzpatrick refurbished nineteenth-century carding machines, invented his own version of the original spinning jenny or mule (Fig. 161) and modified handlooms to make production more efficient. He saw Dartington as the catalyst, providing work for local people by supplying them with high-quality yarns to be hand-woven in their homes while the resulting cloth would be finished and distributed at Dartington.

In common with other Dartington enterprises – forestry, farming, saw-milling – the textile department was given four years to find its feet and was then subjected to scrutiny by Dr Slater, a scientist, who, from 1929 was managing director of Dartington Hall Limited. Fitzpatrick's scheme was soon found to be economically unsound. He had failed to attract local outworkers and by 1935 he was employing five male hand-weavers paid at union rates – while most artist craft textile ventures survived by paying local women workers very little and by taking in apprentices who paid for the privilege. In fact Fitzpatrick was caught in a double bind. He was addressing the artistic issues common to the craft weaving world with remarkable vision and imagination – producing short runs and non-repeats of high-quality hand-woven tweed. But he was also paying proper wages. Fitzpatrick was 'retired' in 1935 and, tragically, committed suicide the following year. He was replaced by Hiram Hague Winterbotham, a young man with commercial textile experience.

Winterbotham drew up a report on the textile department that recommended a switch to power looms.[199] He discussed the economic problems faced by the mill and he argued that hand-weaving was an inhuman, monotonous and psychologically damaging occupation. The handcraft world, then as now, is so closely associated with personal satisfaction that Winterbotham's analysis makes surprising reading. He found that all five weavers employed were suffering from nervous disorders arising directly from their work. An activity usually deemed therapeutic and satisfying was apparently tormenting at Dartington. The reason is not hard to find. Winterbotham had imposed a new work regime on the men, tripling their output by insisting they wove continuously for virtually the whole day. Again, a contrast must be made with the humane and varied work routine in the workshops run by the great women hand-weavers of the 1930s.

There is an odd footnote to this sad story. In 1977 Mark Kidel, then a fledgling film maker, spent ten days on the shop floor of Dartington Hall Tweeds – as it was by then known. He concluded that the highly-mechanised Dartington Hall Tweeds was no better than any urban factory, that the work force seemed depressed, the work crushingly routine and the noise levels intense. He pointed out that there was no real link between the ideals associated with a 'Dartington' philosophy and what he saw as a grim industrial manufacturing environment, albeit in a rural setting.[200]

Kidel's report was written after the death of the Elmhirsts. But involvement with the crafts at Dartington proved paradoxical from the start. This was a utopia policed by stringent economies, exemplified in 1939 by the arrival of the accountants Price Waterhouse, invited by Dr Slater to address all the employees of the Trust. The Elmhirsts kept remote from this harshness and Dorothy, especially, proved imaginative and charming in her personal relations with makers. The commissioning of a series of banners for the Banqueting Hall at Dartington from the weaver Elizabeth Peacock was a striking example of her creative patronage. The task took from 1930 to 1938 to complete (Figs 39, 163). The banners symbolised each of the departments on the estate – poultry, building, textiles, orchards, farms, education, the arts and administration. Peacock interpreted these in an abstract fashion so that at first sight these remarkable banners seem prophetic of post-World War II post-painterly abstraction in both scale and organisation. For Elizabeth Peacock the commission was a challenge and a revelation and she was grateful to Dorothy Elmhirst for so comprehensively raising her sights.[201]

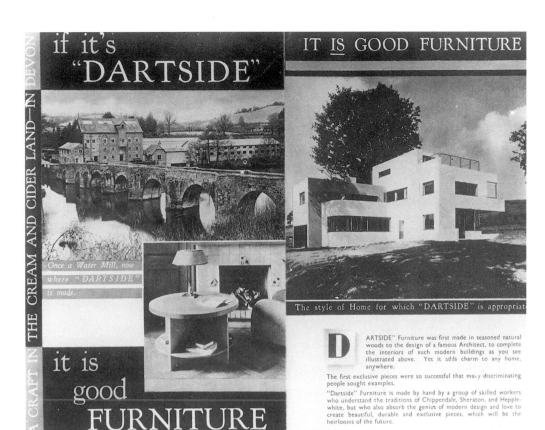

This was a one-off commmisssion, but Dartington created other small semi-industrial developments which like the textiles department combined a modern-looking product with a rural regeneration scheme. Furniture was successfully made at Dartington from the early 1930s. Rex Gardiner, the estate architect, created simple handsome self-assemble designs for garden furniture made at the estate sawmill that synthesised Arts and Crafts and modernism.[202] Just before the Second World War the mill shop also produced the Lamba easy chair that drew on all the talents of the estate. It was designed by the architect Robert Hening and Hein Heckroth, the stage designer for the avant-garde Joos Ballet, with upholstery and suspension by Hiram Winterbotham. This was a distinctly contemporary looking product but the Second World War put an end to its manufacture.[203] Another range of modernist furniture known as 'Dartside' was produced from 1933 by Staverton Builders Ltd – a company created by, but independent of, Dartington Hall Ltd. The Dartside brochure described employees working in sunny premises 'in the heart of coombes and tor, the cream and cider land' (Fig. 164). The furniture was 'made by hand by a group of skilled workers who understand the traditions of Chippendale, Sheraton and Hepplewhite'. Though the range was advertised as having been designed by a famous modern architect, either Hening or William Lescaze, the range was made 'in seasoned natural woods' and was 'the sincere expression of a peasant industry'.[204] It was an ingenious selling strategy that combined modernism with eighteenth-century skills and the moral probity of the Arts and Crafts Movement.

Dartington was meant to be classless and unhierarchical. But in fact those who were deemed artists were accorded the greatest privileges by the Elmhirsts – although, as in a princely court, these privileges could be suddenly withheld. Bernard Leach was one of these favoured individuals and was invited to set up a pottery department along the same lines as the textiles department and saw mill. The reports and research connected with this make it possible to construct the shaky economics of Leach's workshops in the inter-war years.

Leach first met the Elmhirsts, with whom he shared an interest in a synthesis of Eastern and Western thought, in 1925. He recommended a former pupil, Sylvia Fox-Strangways, as a suitable art instructor for the school. At Dartington she became known as Jane, established a pottery behind the Barn Theatre and taught with passionate commitment from 1927 to 1929. She also fell in love with Dorothy Elmhirst, encouraging her to buy good paintings.[205] Leach

was helpful in other ways, instructing Leonard in Oriental pottery aesthetics and advising him on the purchases of both contemporary pots and other pieces from China, Korea and Japan.[206] In 1928 Leach had outlined his dissatisfaction with the 'hand-thrown' 'handanything' world of the residue Arts and Crafts movement in his New Handworkers' pamphlet *A Potter's Outlook*. In the pamphlet, which he sent to Leonard, Leach appears to be embracing technology with plans for a change to oil firings and use of electric wheels and power-driven machinery to prepare clay and pigments. To satisfy the British perception of ceramics as principally utilitarian he also planned to design a range of semi-porcellaneous high-fired tableware. These ideas were backed by Leach's great friend, Soetsu Yanagi, the leader of the Japanese Arts and Crafts revival, who recommended that Leach join the Dartington experiment not just because of his 'inborn sense of Art' but also because of his interest in the social meaning of handwork.[207] But Leach held back. He had already spent a 'dream like interlude'[208] at Dartington but only in 1931, with his finances at rock bottom, did he agree both to teach at the school and to develop plans for a pottery department.

It is difficult to know what Leach had in mind when he proposed a pottery at Dartington. He intended that it should draw on the estate's progressive spirit, its experts and allied craftsmen and scientists and that 'the knowledge of a century could be gathered round the new craftsman – the factory to him instead of him to the factory'. Elmhirst suggested that Leach begin by visiting ceramic factories, though he feared the effect it would have on 'a sensitive spirit'. Leach in turn suggested sending his son David to train at Wedgwood, Sèvres or Copenhagen.[209]

Leach first established a small experimental pottery at Dartington which developed traditional slipware techniques, and in 1933 a larger building was put up at Shinner's Bridge. In 1931 Leach recruited Bernard Forrester, a former modeller at Minton, who had attended art school at Newcastle where Herbert Read introduced him to the beauties of Oriental ceramics. Forrester and Harry Davis, another recruit, were sent to St Ives to join a team whose wages were paid by Dartington. In 1934 Leach travelled to Japan, at the expense of the Dartington Research Grants Board, in order to research 'making stoneware in larger quantities and finer quality than I have been able to achieve under purely handmade conditions at St Ives'.[210]

His stay in Japan gave Leach a clearer idea of what he hoped to make on a large scale at Dartington:

> Thin Sung wares, ivory and light celadons are what I have in mind, and if you think of say a tea set in those terms you may get a faint picture of my hope, hard and fine and graceful, with quality of clay and glaze (that) a skin of lead on bone china will in its very nature never yield.[211]

But as Harry Davis discovered, technically the St Ives pottery was still primitive; the only vaguely industrial measure Leach had introduced was a system of division of labour which was bitterly resented by his workforce and abandoned after his departure for Japan.[212] By the end of the 1930s Leach, encouraged by his son David, came to feel a creative team was not needed in an efficient pottery. In *A Potter's Book* Leach warned against employing art students, and by extension, difficult middle-class workers – 'choose untrained local labour. Likely boys learn the jobs quickly, enjoy them and readily form a permanent team if sensibly handled.'[213] These pragmatic suggestions probably grew out of his ideas about a factory at Dartington.

On Leach's return to England he was writing to Dr Slater outlining his plans for new buildings, the immediate production of slipware, tiles and glazed bricks, the tiles to be sold at Staverton Builders' London showrooms. The production of stoneware was still at the experimental stage. Nonetheless Leach still proposed to 'step out from the studio…towards a small factory where quality of design and material is preserved, whilst science and organisation are put at the service of the artist and craftsman and not prostituted for the sake of easy sales'. This sounded promising but Leach went on 'I also want an absolute assurance that in matters of technical methods and artistic control I shall be free. I could not come

without this.'[214] He promised no profits for the first five years and running costs of £1310. Slater was unimpressed, responding with a sober memo – *Report on the Centralised Control of the Artist Craftsman* – which recommended that Leach take advice on consumer demand from the Dartington Sales Department. Slater explained to Leonard: 'You will realise that it is impossible to give him the freedom of design and technique which he requires. To do so would merely to be acting as a patron to a studio.'[215]

Some self-preserving instinct for art appears to have kept Leach from full commitment to Dartington (Fig. 165). By 1937 he had arranged a much more sympathetic deal – £3,000 to the Leach pottery over three years to finance experiments in stoneware.[216] Though Leach kept a base at Dartington till 1949, his rural factory never came into being. Perhaps the most tangible achievement that came out of the Dartington years was *A Potter's Book*, the writing of which during 1939–40 was funded by the Elmhirsts and which was fuelled by his inspirational visit to Japan in 1934. Ironically, Leach's adventurous earlier plans to bring the factory to the studio do not feature in *A Potter's Book* which instead placed heavy emphasis on self-fulfilment. The book can be read as a reaction against Dr Slater's materialism. Leach's other Dartington debt was in fact to Dr Slater, who by sending David Leach to Stoke while Leach was in Japan, enabled the Leach pottery to develop the Standard range of well-designed tableware which made it a solvent concern after the war and allowed Leach to get on with what he was best at, producing handsome, one-off pieces that functioned above all as Art.

The 'great experiment' could, in theory, have created a safe haven for the crafts in which handwork was maintained by subsidy, just as avant-garde music, theatre and dance were generously underwritten at Dartington between the wars. But the Elmhirsts, Leonard in particular, saw the crafts fulfilling a more practical regenerative role. As it turned out the lessons learnt from the various Dartington craft projects were melancholy ones. On the whole the economics did not add up. But the archives at Dartington Hall reveal just how thoroughly these economics were analysed and surveyed.

FOUR

IDEAS, ATTITUDES AND INSPIRATIONS

The inter-war crafts had their own specific artistic, emotional and intellectual concerns. Makers discussed themes which were central to their creativity such as truth to materials, their ambivalent attitudes to tools and skills, the search for spontaneous ways of working and relationships with their public. They were drawn to areas of political thinking that helped make sense of handwork in a highly industrialised society. They engaged with other cultures, seeking more genuine, 'organic' communities with experiences which ranged from the creative and fruitful to the tragic. The impact of traditional or vernacular craft on the inter-war crafts movement illuminates wider debates about cultural identity within Europe and relations between the Orient and Occident.

IDEAS: THINGS

A generalised anxiety about the material world, about things – things getting nastier or fast vanishing or being over-produced, using methods which worked at the expense of human happiness, was a part of design discourse by the late nineteenth century and was central to both the Arts and Crafts Movement and the subsequent development of the crafts in the twentieth century. It was a minority anxiety, reacting against the emergence of mass consumption and its many enticements and pleasures. As Raymond Williams has demonstrated, we can trace melancholy thoughts about progress back to the Middle Ages;[1] but a species of sharply written descriptions of a degraded object or set of objects – an interior for instance – appears first as a literary sub-genre in the late nineteenth century. Ruskin had set the tone with his characteristically heightened half-hysterical response to mass produced objects.[2] And although *Das Kapital* was not translated into English until 1886 no one wrote with more insistent excitement than Karl Marx about 'things', the grim conditions in which they were made and their subsequent magical transformation into commodities.[3] At a more popular level anxiety about things informs the descriptions of semi-animate objects and substances which crowd, even ooze, from the pages of Dickens's novels.[4] George Gissing, Gogol, Kafka and Tolstoy were all exponents of the genre. But so too was Roger Fry with his fraught description of the decoration of a railway refreshment room in his 1912 essay *Art and Socialism*.[5]

Over the same period we find correspondingly elegiac attitudes towards traditional objects and craft production. Such writing was commonplace among European poets, novelists and literary critics. To turn to older modes of production, to craft, was one creative response to the confusion of new objects and new processes. The German poet Rainer Maria Rilke admired the 'tangible and slow manual craft'[6] and counted watching a rope-maker in Rome and a potter in a small village on the Nile as experiences which had 'the real decisive influence on my life'.[7] He was disturbed by North American modernity and noted 'The animated experienced things that share our lives are running out, and cannot be replaced. *We are perhaps the last to have known such things.*'[8] The cultural theorist Walter Benjamin saw the work of the storyteller and the craftsman as both interrelated and threatened. He quoted Paul Valéry: 'The modern person only works at what can be abbreviated'.[9] The attitude of the poet and novelist D.H. Lawrence to pre-industrial production was passionate and sentimental. In *Women in Love*

the central character, Birkin, sees a rickety turned Georgian chair in a flea market. Lost skills are reified: 'When I see that beautiful chair...I think of England, Jane Austen's England...There is no production in us now, only sordid and foul mechanicalness'.[10]

Much of this writing reminds us of a recurring paradox of the period – that an important part of being modern was to be anti-modern. Modernism in all the arts was driven by dissatisfaction and a desire to reform and elevate contemporary life. Some of the sharpest observations were penned by architects like Frank Lloyd Wright and Le Corbusier. Both lamented the loss of folk culture, even if, in the opinion of Le Corbusier, artificial preservation was pointless. Both Le Corbusier and Frank Lloyd Wright were committed to controlling, even eliminating, the influx of objects which were entering the home.[11] For Le Corbusier, writing in 1925 in his magazine *L'Esprit Nouveau*, the objects of the future were gendered male and were to be found in offices, banks, ships' cabins and men's clubs.[12]

The simplicity and austerity which Le Corbusier admired was not entirely alien to English inter-war makers. But craftswomen and men sought these qualities not in the sheet metal filing cabinets and commercial glassware favoured by Le Corbusier but through a deep understanding of textures and organic materials. They applied the inevitably subjective doctrine of truth to materials with hysterical rigour. Again and again makers write of the quality, the very essence of things, threatened by new synthetic materials and mass production. Often descriptions of things or the special lovable quality of things are linked to childhood memories and thus we have an extraordinary phenomenon, an artistic movement continually refreshed by a sense of loss.

The furniture maker Romney Green, writing in about 1940, recalls his almost visceral disgust at the sight of laminated wood. A key modern design material, it was dismissed by Romney Green as 'this filthy compound' and he felt compelled to speak out against the threatening futuristic interiors – all mysterious synthetic materials – in H.G. Wells's 'dismal, drab' novel *A Modern Utopia* of 1905.[13] As a boy in the 1910s Michael Cardew was similarly disturbed by the 'nasty, dead, cold white' composition under the mottled glaze of the Whieldon wares in his father's china collection.[14] Of his childhood, Cardew recalled in 1952: 'I chiefly remember hating things'.[15] His sensitivity to texture and material did not lessen over the years. In 1942 he jeopardised a huge factory enterprise in West Africa's Gold Coast because he disliked his predecessor Harry Davis's scientifically formulated clay body.[16] Even Arts and Crafts products could seem untruthful and overwrought. Phyllis Barron dismissed Morris's textiles as mass production.[17] Katharine Pleydell-Bouverie, reviewing a book on the Arts and Crafts Movement, wrote: 'One can count on the fingers of one hand the objects on which the eye can contentedly focus...otherwise all is riot, ironwork sprouting on doors, handles flying off silver vessels, flowers, foliage and flames and birds.'[18] It was an unfair response, but her own work perhaps explains why inter-war makers felt so little sympathy for art pottery and did not care for rich enamel work or complex flat pattern. To see Pleydell-Bouverie (or Leach's) pots for the first time is to stumble upon some system of aesthetics centred on plainness and austerity.

The positive qualities of materials drew equally passionate responses. There were the 'warm and kind and generous' lips and rims of the earthenware Fremington pots which Cardew had encountered in his boyhood and which to some extent he set out to emulate.[19] Romney Green argued that there was a hierarchy of materials – first stone, then wood, then iron. The character of each needed to be respected.[20] Ideally these materials should not be mixed. A framed and panelled door was for Romney Green the acme of woodcraft and likened by him to 'a spirited horse curbed by a true sportsman'.[21] His pupil Stanley Davies also wrote tenderly of his raw material: 'We like to sense the living bond between the furniture we make and the forest trees that gave it birth; to manifest the 'woodiness' of our woodwork; to retain our hold on elemental nature'.[22] As Romney Green wrote to Philip Mairet in 1928: 'I believe to be *in love* with the material is almost a *sine qua non*'.[23]

In these writings on the nature of wood we find a strain of romantic nationalism. Romney Green and Davies preferred, when possible, to use English oak and walnut – even though

166. Rita Beales, detail of a stole in hand-spun, hand-woven linen, *c.* 1937. length 128 cm. (Holburne Museum and Crafts Study Centre, Bath).

English oak was, and is, notoriously knotty and difficult to work. The weaver Margery Kendon writing just before the Second World War argued that a feeling for cloth and wool was, equally, an innate part of our inheritance:

> Although we were the first country to become mechanised, the gap has been long, and we have lost much of the skill of the traditional weavers, I think no lapse of time could ever kill in us our inherited feeling for wool. It has been an unbroken growth since the Norman Conquest, or if you like, since we were rid of wolves…it is a great thing to have inherited an understanding of one's raw material. Given that, the gap in technical knowledge matters really very little.[24]

This sounds eccentric and isolationist. But a preference for English woods or for English wools was mirrored by Henry Moore's fondness for carving English stone, for Cumberland alabaster, for Hoptonwood stone, Portland, Hornton and Blue Ancaster. And in Scotland any craft designated 'traditional' such as Harris tweed was crucially defined by material, place and method.[25]

All the crafts of the inter-war years developed their own aesthetic codes of practice which to a greater or lesser extent centred on the question of truth to the qualities of specific materials. Sometimes this 'truth' depended upon industrial production. Stained-glass artists have always been particularly vulnerable as regards materials, being dependent upon glass manufacturers for their palette of colours and for the very texture of the glass itself. They could exert an influence on glass production but much depended upon the skills of innovative firms. Thus the thick uneven slab glass made by Britten and Gilson and subsequently by Powell's of Whitefriars in emulation of medieval glass remained an indispensable material for creative stained-glass artists from Christopher Whall onwards.[26]

Textiles sparked off complex debates among makers. There were discussions about what constituted hand spinning and whether machine spun yarns should be used for hand weaving. Two of the most important figures in the inter-war weaving revival, Rita and Percy Beales, believed hand spinning to be a fundamental preparation for hand-loom weaving. The research they conducted into the special qualities of wool and flax was clearly of a high order (Fig. 166). But because they were secretive about their work they represent the crafts at their most remote and unapproachable. The few allowed into Rita Beales's workshop had to have proved their dedication to hand-spun yarns only.[27] Such thinking exemplifies the negative side of this primacy of 'truth to materials' and was to dominate attempts by craft societies to set standards. These debates, marked by aridity and circularity, are still familiar enough in the craft world.

167. D. Davis of Cardiganshire with a spinnning mule with 200 spindles photographed for the Rural Industries Bureau. (Rural History Centre, University of Reading).

The most convincing attack on the limitations of this inter-war emphasis on truth to materials was mounted by the art historian Bernard Berenson. As part of his argument Berenson singled out for admiration a Greek vase.[28] Studio potters like Leach and Cardew nursed a positive dislike for 'degraded' Greek vases but Berenson saw the very lack of 'connection between the humble clay out of which it is formed and its Attic shape' as a mark of skill and civilised values. Berenson was an aesthete steeped in the history of Renaissance art, writing in defiance of the 'sublime irrelevancies of Ruskin'[29] and of 'passionate technicians' like Roger Fry.[30] Although he did not single out the crafts movement directly, he argued that the ascendancy of materials in the early twentieth century was linked to the neglect of draughtsmanship and the rejection of the human figure as the proper study of the artist and could only spell decline in the visual arts.

The 'truth to materials' ethic was associated with a belief in the superiority of the early stages of art and an admiration for what Berenson disapprovingly called 'Otherness' – in 'the incunabulae of Romanesque sculpture, in Negro wood-carving, South Sea idols and Tlinkit totem-poles'.[31] His respect for skill, complexity and decorativeness was out of step with the inter-war avant-garde. Only in the 1980s would his views come to seem presciently post-modern.

TOOLS AND SKILLS

Linked to this interest in materials was the belief that the development of tools and technology were corrupting. Twentieth-century makers were keen on rediscovering old tools; their correct use could be central to the revival of a craft. Edward Johnston's use of the broad-edged pen is an obvious example. What Johnston called 'the Essential Forms beautiful in themselves' could be created 'naturally from a rightly handled tool'.[32] Gill had similar ideas about the use of the chisel in letter cutting.

Romney Green blamed the development of sophisticated tools and techniques for the degeneration of furniture design from the sixteenth century onwards. The turning lathe, the moulding plane, the gradual transition to applied rather than integral ornament and the introduction of veneers were all seen as corrupting. Romney Green argued that the true craftsman 'will do wonderful wood-carving merely with a knife, or with sharp pieces of shell; he will cut his mouldings with a gouge rather than stop to draw his design on paper; and we can still on rare occasions admire the essentially craftsmanlike audacity of the man who works directly on the material without stopping to draw his pattern at all'.[33]

168. Edward Johnston, trial initials for a letter to the Bourne family. 26.1 × 36.5 cm. (Ditchling Museum Trust. Photo Artis Inc.).

169. Phyllis Barron, *Diamond*, hand block-printed cotton. (Holburne Museum and Crafts Study Centre, Bath).

Romney Green's ideas reappear in other contexts. Bernard Rackham, writing in 1926, argued that stained glass since World War I had been characterised by 'a reckless abuse of the unrivalled variety of 'palette' brought within the range of the glazier by recent advances in glassmaking technology'.[34] Heremon Fitzpatrick and Ethel Mairet were two of several hand-loom weavers interested in intermediate technology and in the woollen yarns and cloths produced in the surviving Welsh mills which employed more primitive carding and spinning mules and simpler finishing processes than the larger English mills (Fig. 167). As Marianne Straub explained in 1989: 'The question of technique was important. Mule spinning makes a much, much nicer yarn than ring or cap spinning, but they are much quicker processes. Whenever I see a pre-war Welsh yarn I could cry.'[35]

SPONTANEITY

The inter-war craft movement had an ambivalent attitude to skill. Spontaneity and vitality were more highly valued than technique. Charles and Nell Vyse were potters who were famously knowledgeable in all branches of ceramic technology, particularly Oriental glazes. But that did not prevent their work seeming 'competently commercial' to Katharine Pleydell-Bouverie.[36] She wanted her pots to make people think of 'things like pebbles and shells and birds' eggs'.[37] To achieve this natural effect she devoted her life to the study of ash glazes used on simple thrown shapes. Some were perfectly resolved, some were lumpy failures but none could be accused of looking commercial. Phyllis Barron's hand block-printed textiles were intentionally much cruder and more vibrant than their trade equivalents (Fig. 169). Relatively primitive technique was

170. Jean Milne, two hand-woven rugs. Before
1942. (*left*) 188 × 96.5 cm; (*right*) 122 × 76.2 cm.
(V&A Picture Library).

the key: Barron did not felt her blocks. Instead she applied the thickened dye direct to the wood
or lino to achieve a characteristic uneven colour effect.[38] Frances Woollard, briefly her partner,
described the importance of accidental effects in hand block-printing aided by using thin pieces
of linoleum in order to produce 'a ground of infinite variety and never twice alike'.[39]

Careful forward planning in the shape of drawings and models or even too much mental
preparation was also regarded as inhibiting. The lack of plans and drawing in traditional crafts
like quilting and waggon making were seen to produce vigorous work. As the artist and
recorder of country crafts Thomas Hennell noted: 'What is striking is that these carpenters have
never worked from plans or drawings; they work directly in the wood and think of their work
in no other way.'[40] Edward Johnston emphasised the need for freedom as well as expertise, for
what he called 'skilled and unaffected boldness'.[41] Irene Wellington recalls that he told her class
at the Royal College of Art in 1925: 'Thinking while writing is death to writing.'[42] He believed
in speediness: 'Begin your letters with a flying start and end them with a flying finish, and if your
pen is rightly cut you will get a really living kind of writing.' (Fig. 168)[43]

Hand-loom weaving is an art form whose facture is inevitably slow and dogged.
Nonetheless theories about the importance of spontaneity underpinned pioneer work in both
areas. For instance, Ethel Mairet was suspicious of weavers who carefully worked out their
designs on paper.[44] The sculptor Jean Milne, who took up rug and tapestry weaving in the
1920s, similarly set great store by non-preparedness.[45] She believed that to square up a pattern
on prepared paper – the weaver's equivalent of a cartoon or model – detracted from the
vitality of a design (Fig. 170). Milne worked from a clear mental image supported only by a

rough sketch, weaving her design as the available materials and techniques suggested. She constructed a vertical warp loom which enabled her to weave without rolling up her work – to see the whole design at a glance. The results were remarkable fluid designs that managed to avoid the look of translation that characterises so many 'painterly' textiles. Both Mairet and Milne's aims were comparable to those of the direct carvers. They wanted to avoid translating from one medium – drawing or painting in the case of textiles – into another. Traditional techniques could provide a model. Margery Kendon described swopping weaving patterns in County Mayo in 1936 using fingers in dumb show:

> Never before had those traditional weaving patterns seemed alive and real to me. Here, where squared paper and theory were unknown, the weaver's four fingers represent to him the four shafts of the loom, and the readings of these patterns has, like unwritten music, been handed down from one generation to another.[46]

Embroidery is another craft which seems remote from spontaneous creative processes. Professional nineteenth- and early twentieth-century embroidery, even as revived by the Arts and Crafts movement, involved labour intensive interpretations of designs on paper. Significantly it was women designers, above all the Scots Phoebe Traquair, Jesse Newbery and Ann Macbeth, who made embroidery more of an art form and less of a labour. But it was the inter-war period which saw the apogee of self-expression and spontaneity in embroidery. Rebecca Crompton's remarkable appliqués – often multi-layered, using machine stitching – shocked conventional embroiderers in the early 1930s (Fig. 171). 'Vital' and 'spontaneous' were key words for Crompton and she favoured collage, maintaining that any elaborate preparations which deferred contact with the material and the making process deprived an embroidery of life and vitality.[47] Her approach was developed by Lilian Dring, who in the mid-thirties used found materials – old coats and tailors' cuttings – to create her abstract thrift rugs (Fig. 222).[48]

An admiration for spontaneous creation extended to the most unlikely craft disciplines, like, for example, typography. Brocard Sewell worked for the printer Douglas Pepler from 1932 till 1937. He recalled that Pepler – who with Gill had founded the Guild of St Joseph and St Dominic in Ditchling – 'had a remarkable sense of design, and could create a beautiful title page or a striking poster extempore; standing at a composing frame and improvising; he never used any preparatory designs or layouts'.[49]

One important, widely read source for ideas about the intuitive, spontaneous nature of creativity was the writings of the French philosopher Henri Bergson. Bergson, who coined the term *élan-vital* to describe the energy that lay behind human creativity, argued for the supremacy of intuition.[50] His thinking fitted in with other identifiably modern ideas – for example, the superiority of early and child art and the futility of an academic artistic training. Bergson was particularly admired by the potter William Staite Murray. Bergson's vitalist ideas and the writings of Lao-Tsze and the koans of Zen Buddhism lay behind the high claims Murray made for the status of ceramics and underpinned two important essays on the relationship between ceramics and fine art which Murray wrote in 1925.[51] For Murray, and for Leach and Cardew, technique was highly spiritualised. The very act of throwing a pot and throwing repetitively was seen both as an intuitive meditative activity and as an emblem of creativity. The Zen roots of such ideas are apparent: 'when there is no self but only consciousness in the unconscious, in emptiness where the unhindered Creative Principle manifests itself, a pot is born not made' wrote Murray towards the end of his life.[52] Such ideas were made almost laughably manifest during Murray's idiosyncratic career as a Head of Pottery at the Royal College of Art from 1925 to 1939. Murray kept technical instruction to the minimum, following the Zen principle of teaching through not teaching, through silence and absence.[53] In this withholding of instruction Murray was ahead of his time – anticipating what became commonplace in art schools in the 1970s.

As we have seen, Murray's ideas were shared by Leach as was the phrase 'born not made'.[54] For Leach as for Murray the process of creation necessarily remained mysterious and resistant to regulation:

171. Rebecca Crompton, *Inspiration*, machine embroidery. 1939, 30 × 27.5 cm. (Private Collection).

172. 'under no particular pressure to earn a living': spinning and weaving class at Ethel Mairet's Gospels workshop photographed for the Rural Industries Bureau. (Rural History Centre, University of Reading).

The shape of a pot cannot be disassociated from the way it has been made, one may throw fifty pots in an hour, on the same model, which may only vary in fractions of an inch, and yet only half a dozen of them may possess that right relation of parts that gives vitality – life flowing for a few moments perfectly through the hands of the potter.[55]

Leach romanticised throwing – which he found difficult in practice. Often in an entirely unspontaneous way he drew shapes which were thrown for him by more technically skilled artisans, by Harry Davis in the 1930s and by William Marshall in the post-war years.

The inter-war makers had ideals based on truth to materials, simple tools and spontaneity. They educated each other. In 1923 Cardew first called on Leach at St Ives and was shown a Sung pot: 'My good angel protected me and made me hold my tongue. Of course I could make nothing of it, having never seen anything like it before.'[56] They also attempted to educate their clients. An innocent lady who asked Leach for 'something bright' for a niece's wedding was quickly put in her place.[57] Dorothy Elmhirst of Dartington Hall, attempting to commission a shawl similar to one which Elizabeth Peacock had exhibited at Burlington House, was told that to weave a simulacrum would be like 'pushing water backwards under a bridge';[58] Miss Peacock did not repeat designs. Marianne Straub recalled the individuality of Ethel Mairet's workshop. If a customer wanted seven yards of a fabric and Mairet only had four yards 'she would only make it up if she felt like it'.[59] In many instances it is apparent that makers were able to step outside the economic framework and resist the commoditisation of the goods they made. Leach had private means and in the 1930s depended on the patronage of the Elmhirsts. Romney Green went out of business for part of the 1930s and worked as a handicraft instructor in the Distressed Areas. In 1942 Cardew closed down his pottery at Wenford Bridge and set sail for West Africa and the security of a colonial employee's salary. The purist printer Guido Morris's financial problems were legendary and in 1958 he abandoned his craft and became a guard on the London Underground.[60] The Gregynog Press was only able to survive because of the generous patronage of the wealthy Misses Davies and until its closure it was run on aristocratic lines, losing many thousands of pounds each year.[61] K.R. Drummond, recalling Ethel Mairet's workshop in 1920–3, remembered students and apprentices as 'gentlewomen under no particular pressure to earn a living' (Fig. 172).[62]

The story of the inter-war crafts is, in part, the story of individuals caught between the cultural structures of commoditisation and their own personal attempts to bring a new order to the world of everyday objects.[63] The distaste and hostility felt by critics like Herbert Read

173. Michael Cardew, bowl, incised design, galena glazed, made at Winchcombe *c.* 1929. Diameter 18 cm. (Wingfield Digby Collection. Photo Peter Kinnear).

towards the crafts in the 1930s (however they may have rationalised them as being to do with the crafts' associations with amateurism, reactionary values and nostalgia) in truth owe a good deal to the fact that craft objects were unstable, unsatisfactory commodities. The fine art world with its well understood categories of painting and sculpture was, in contrast, far more effectively commoditised. Few painters or sculptors would have sympathised with the claim made by John Farleigh, a President of the Arts and Crafts Exhibition Society, that 'profit is the least concern of the real craftsman'.[64] The crafts movement had, and still has, a tendency to confuse categories. It is rich in objects which hover between commodities and gifts and which physically often look like necessities – in the form of simple earthenware bowls (Fig. 173) or plainly made furniture – but which in fact, as Veblen had pointed out at the end of the nineteenth century, operate more like luxuries. This hidden element of luxury had political implications too.

ATTITUDES

Inspired by the connections made by John Ruskin between art, morality and economics, the early Arts and Crafts Movement politicised design and architecture. William Morris engaged actively with the Social Democratic Federation and the Socialist League, Walter Crane provided a handsome iconography for socialism and C.R. Ashbee combined philanthropy and romantic socialism in his Guild of Handicraft. But what Ashbee had called 'a great social movement'[65] began to falter after Morris's death in 1896. By the outbreak of World War I, as Gill and A.R. Orage observed, the crafts no longer seemed relevant to the Labour Movement. As its power base grew its various strands identified less with Ruskin and Morris's ethically based politics.[66] Pay, working conditions and the ultimate goal, the collective ownership of the means of production in the form of factories, mines and systems of transport, took precedence over aesthetics or workmanship.

The Arts and Crafts Movement had made the making of objects a radical, even subversive, activity. For a figure like T.J. Cobden-Sanderson a bound and printed book from his Doves Press and Bindery was beautiful in itself but could also suggest a socialist future (Fig. 5).[67] It might seem that the Arts and Crafts programme of design reform coupled with social reform failed entirely and all that was left was a greater sensitivity to texture, pattern and form. But the social programme was not entirely abandoned. Socialism realised through revolution ceased to be the overarching inspiration, especially after 1917. Just as the craft movement fragmented into separate craft disciplines, so did craft politics. In any case, mainstream politics

firmly ignored the crafts until after the Second World War. Makers turned to marginal groups, many of them coming up with novel, often anti-industrial, remedies for the seeming impasse of shrinking markets and rising unemployment.

GUILD SOCIALISM

By the first decade of the twentieth century the Left had little to offer the crafts. This was well understood by A.R. Orage who as editor of *The New Age* began to explore radical vitalist alternatives to mainstream socialism, publishing a series of articles by his friend A.J. Penty on the revival of the medieval Guild system. Penty, a 'shaggy stammering architect',[68] furniture designer and former Fabian[69] had set out his alternative to socialism in his book *The Restoration of the Gild System* of 1906. Penty's ideas were powerfully un-Fabian in their romantic radicalism. He argued for the re-introduction of small workshops, local markets and control by the actual producers over standards and control of pricing (the Just Price of medieval commerce) through the mechanism of guilds. All this was inspired by Ruskin, by the harsh economics of running his own furniture business and by his experiences of price fixing in large department stores in New York and London.[70]

Penty's League was not alone in looking to the Guild model. By 1911 a less craft-orientated guild movement had sprung up. S.G. Hobson and G.D.H. Cole, the key theorists of what came to be called Guild Socialism, did not condemn machine production and the sub-division of labour outright. The programme drawn up by their National Guilds League in 1915 attacked 'Wage Slavery', seeking a more active thorough-going democracy in which industrial power passed into the collective control of self-governing workers' guilds.[71] The furniture maker Romney Green, the metalworker and designer Edward Spencer and Penty, then neighbours, all joined the National Guilds League. Together they drew up a detailed constitution for their branch in Hammersmith which reiterated the ideas set out in *The Restoration of the Gild System* with its emphasis on local, village-based Guilds. Romney Green records that the Hammersmith contribution was ignored, but, nonetheless, a shared pre-occupation with the well being of the worker meant that there was a good deal of sympathy for a craft voice among Guild Socialists.[72]

The National Guilds League was wound up in 1923. It had a weak working-class base and in any case the League's policy of 'encroaching control'[73] in which workers gradually and peacefully took over individual industries was clearly unworkable during a period of high unemployment.[74] But throughout the 1930s discussions about machine slavery with a Guild Socialist flavour crop up in the pages of the Rural Industries Bureau magazine *Rural Industries*[75] and in debates among members of the Arts and Crafts Exhibition Society and the Red Rose Guild. There were the pro-industrialists who argued that the machine was only a tool – John Farleigh, Noel Carrington, Frank Pick and John Gloag – and those like the printer J.H. Mason, Edward Spencer, Romney Green and Gill and his disciple Harry Norris – who were primarily concerned with the happiness of the operative. Some, like Norris, rejected industrialisation altogether. For Gill, at least, the answer was clear. As late as 1940 he continued to advocate a very pure form of Guild Socialism or syndicalism – 'i.e. that each *group* of workers in each separate undertaking should own the undertaking whether it be large or small'.[76]

Penty also carried on campaigning for his version of a guild revival, inspired by the writings of Ethel Mairet's first husband, Ananda Coomaraswamy. Coomaraswamy had researched the guild systems which had underpinned the production of art and craft in India and Ceylon until the advent of British rule. With guild revival in mind Coomaraswamy had coined the hopeful term 'Post-Industrialism'. In 1914 he and Penty had co-edited a collection of *Essays in Post-Industrialism* and the phrase was used as the title of Penty's 1922 book in which he restated his Guild ideas. Penty's radicalism had its less attractive side. In *Post-Industrialism* he argued that the unemployed should be compulsorily trained in craftwork and agriculture 'to enable them to take their place in the new social order'.[77] He took an interest in eugenics, arguing that factory work was producing a racially inferior sub-class. By the late 1930s Penty was describing himself as a Fascist, inspired by Mussolini's Corporate state with its Guild Socialism elements.[78]

Penty's writings in the 1920s and 1930s articulated a range of middle-class fears – the detrimental effect of urban factory life on working-class stock, the imminent collapse of industrial capitalism and the possibility of world war and a resultant disappearance of civilised values. In the nervous political atmosphere of the late 1920s the furniture historian and novelist John Gloag warned against the effects of the intensive sub-division of labour, predicting that in the event of a cataclysmic world war 'craftsmanship might perish from the earth'.[79] This Doomsday scenario emerged as a surprisingly important motive for the continued support for the crafts.

Contemporary novels touched on the theme of mass catastrophe and a return to barbarism. An early example was H.G. Wells's *The War in the Air* (1908) in which a futuristic over-industrialised world reverts to primitivism, with basic skills like weaving lost after a devastating war. Edward Shanks's *The People of the Ruins* predicted a savage peasant state two centuries hence. In the same genre the veteran suffragette Cicely Hamilton's *Theodore Savage: A Story of the Past or the Future* (1922) describes the emergence of a brutalised tribal society after gas warfare. The eponymous hero, a middle-class civil servant, painstakingly learns to hunt and weave baskets and till the soil. His efforts are tellingly contrasted with his working-class mate Ada, a former factory worker and 'a passive minor product of civilisation, machine-bred and crowd-developed – bewildered by a life not lived in crowds and not subject to the laws of the Machine'.[80] She is 'the product of the division of labour',[81] helpless and unable to adapt to her new situation. Significantly, in *Theodore Savage* only the middle classes and those reared on the land have the will and capability to rediscover handwork skills.

The belief that mass production corrupted workers' lives at their roots and that mechanical labour produced a demand for degraded amusements – the cinema, cheap magazines – is central to *Theodore Savage* and displayed a contempt for the urban and surburban proletariat shared by Penty and Coomaraswamy and by other members of the inter-war craft world. Part of the attraction of the guild revival for its middle-class supporters was that guilds would replace the trades unions – seen as potentially threatening and unsatisfactorily materialist. As John Gloag argued in 1926 the trades union movement was 'a largely class-selfish, protective organisation that attracts to its administration the pettifogging lawyer-like type of being instead of the real craftsmen, the men who know their trade, its conditions, materials and methods'.[82]

DISTRIBUTISM

Penty's medievalising brand of Guild Socialism had much in common with Distributism, another small inter-war political grouping. Distributism was publicised by the Distributist League, by its magazine *The Distributist*, by the periodicals *Eye Witness* and *The New Witness*, and finally by *G.K.'s Weekly* founded in 1925. The Catholic Land Association of England, founded in 1931, also supported the movement with its magazine *The Cross and the Plough*. Distributism's main exponents were Hilaire Belloc, who invented the term, G.K. Chesterton, the Dominican preacher Father Vincent McNabb and, intermittently, Eric Gill. Its inspirational text was Leo XIII's encyclical *Rerum Novarum* of 1891 which, directed against socialism and *laissez-faire* liberalism, had called for the fairer distribution of property and the means of production.

Belloc's *The Servile State* (1912) got the movement under way.[83] Inspired by *Rerum Novarum*, Belloc attacked the inequality between the owners of land and capital and their employees who, though increasingly protected by state legislation, were essentially unfree and obliged to labour for the property-owning classes. Belloc, as a Catholic, saw the dissolution of the monasteries as the transforming moment in English history. He argued that the consequent transfer of land to nobles, followed by enclosures of common land, resulted in the destruction of a native peasantry and the creation of a wealthy oligarchy well placed to dominate all the means of production during the Industrial Revolution. Belloc's analysis of English history – in effect Marx christianised – had a broad appeal for makers. For Gill: 'Renaissance, Reformation, Industrialism – these three are exactly antithetic to Poverty, Obedience and Chastity'.[84] For Romney Green enclosures and the sophisticated banking instituted after the

174. Philip Hagreen, 'Industrialism: Within the framework of the existing system', wood-engraving for *The Cross and the Plough*, June 1945. (Ditchling Museum Trust. Photo Artis Inc.).

"Within the framework of the existing system."

arrival of William of Orange heralded an age of slavery.[85] The writer on country crafts, H.J. Massingham, traced a materialist, malevolent Whig trajectory from the enclosures to 'Dutch William who sold his purse to the Bank of England' to the thinking of Adam Smith, Malthus and Darwin.[86] But Massingham saw an even earlier decline set in train by 'Richard II and his broken pledges to the peasantry. If that unfortunate had but kept his promises or been in a position to keep them, what a different, happier and stable England would have been the fruit of them'.[87]

Distributism called for the return of a peasantry through the redistribution of land and tools. Its practical application demanded a craft revival. In 1927 the League held an exhibition in Liverpool which, according to *G.K.'s Weekly*, showed how 'free men and women working singly or in tiny groups, can produce enormous quantities of all the commodities that reasonable men and women can need or want, and that these commodities can be of the finest quality and of the most ravishing beauty'. Readers were urged to favour small shops and businesses, to buy hand-made goods and make things themselves. The path to freedom lay in 'everybody making or doing something and by everybody knowing how most things are made and done'.[88] *G.K.'s Weekly* expected the good distributist to purchase handmade goods and clothing even at the risk of 'looking conspicuous and out of place in the society in which they are forced to live'.[89] What was demanded were 'sacrifices, on the part of producers and consumers, of many past habits, conveniences and comforts'.[90]

Most issues of *G.K.'s Weekly* carried a page of advertisements entitled 'Small Workshops' which urged readers to 'support these 'small' men who make by hand the necessary things of life in their own field'.[91] Romney Green, the weavers Leo and Eileen Cooper, individual members of the Guild of St Joseph and St Dominic at Ditchling and the London School of Weaving all advertised while Bernard Leach, Eric Gill, Douglas Pepler, Romney Green and the engraver Claire Leighton contributed articles. *The Distributist* had an Enquiry Corner for potential craftsmen and women and appointed technical advisers – Catherine Channer on lace and needlework, May Mohr on spinning and weaving, J. Selwyn Dunn on wood carving, M.G. Sewell of St Dominic's Press in Ditchling on printing, Romney Green on woodwork.[92] Michael Cardew declined the invitation to act as *The Distributist*'s pottery adviser but offered to talk to those interested in the craft and to seek out apprenticeships for them.[93]

The Guild of St Joseph and St Dominic at Ditchling in Sussex, formed by Gill and Pepler in 1920–1, with the advice of Father Vincent McNabb,[94] was the most important craft grouping directly inspired by the Distributist cause. All members were also members of the Third Order of St Dominic which Gill, his wife and Pepler had joined in 1918 and this Dominican association gave the Guild access to radical Dominican re-interpretations of the writings of St Thomas Aquinas which shaped their working practices. As the key neo-Thomist Jacques Maritain wrote in his *Art et Scolastique*, translated as *The Philosphy of Art* and as *Art and Scholasticism*, art was 'the undeviating determination of work to be done' and 'a habit of practical intellect…as the man is, so are his works'.[95]

The Guild, in an early statement, announced that all members would own their own tools, workshops and products of their workshops.[96] Pricing structures were carefully calculated on the basis of real costs rather than any perceived value that might accrue to an object as a work of art. A marked commitment to creating objects of utility gave a special flavour to Guild productions: 'the love of God means that work must be done to an absolute standard of serviceableness…Good quality is, therefore, twofold: work must be good in itself and good for use.'[97] Thus Pepler's printings at the St Dominic's Press were executed in the tradition of the 'jobbing printer'. Labels, handbills and leaflets were printed together with craft manuals, extracts from *Rerum Novarum* and from Jacques Maritain's *Art et Scolastique*. Valentine KilBride (joined 1925) and Bernard Brocklehurst (joined 1927) made ecclesiastical robes and lengths of tweed for suits as well as supremely functional hair shirts. Philip Hagreen (joined 1924) propagandised the cause with fiercely political woodcuts for *The Cross and Plough* (Fig. 174). George Maxwell (joined 1922) made hand-looms for weavers as well as furniture and joinery for the community.[98] He also kept an effective smallholding and fully endorsed the agricultural

basis for Distributism which he believed would keep the crafts 'in their place'. And as we have seen, after Gill's conversion to Catholicism in 1913 he never reverted to the purely sculptural pieces that had so delighted the art world before World War I. Indeed Gill's art cannot properly be understood without reference to Distributism's emphasis on usefulness and utility.

The Guild of St Joseph and St Dominic survived until 1989, a remarkable span of time. It was arguably the most successful craft community since Ashbee's Guild of Handicraft. Perhaps one reason for its longevity was its firm politico-religious base. Leo XIII's *Rerum Novarum* was a constant inspiration and in 1931 Pius XI had issued a reaffirmation of its ideals in the encyclical 'On the Reconstruction and Perfection of the Social Order'.[99] Indeed papal pronouncements during the first half of the twentieth century might be seen as a constant encouragement for the craft way of life. In 1939 *The Cross and the Plough* translated an attack by Pius XII on industrialism[100] while in 1948 the same journal translated Pius XII's address to Italian makers in which he explained: 'The church wants some limit set to the dwarfing of man…through the emergence and dominance of the machine and the continued expansion of large-scale industry'. He went on to praise handwork as 'greatly superior to impersonal and standardised mass-produced things' and argued that the intimacy of craft workshops was a model for employment: 'Craftsmen, then, are a picked militia also for the safeguarding of social peace and for the renewal and prosperity of the national economy'.[101]

Distributism was a Roman Catholic movement. Katharine Pleydell-Bouverie disliked the neo-medieval patriarchy of its craft manifestation at Ditchling – 'I met a bunch of 'em the other day. They made me rather angry.'[102] Michael Cardew was similarly 'repelled by the pervading religious dogmatism' but was impressed by 'the great impetus which the Catholic Neo-Thomists brought to all the old arguments of John Ruskin and William Morris in favour of craftsmanship and against the industrial system'.[103] Indeed craft and a retreat from the secular world often went together. One of Cardew's patrons and close friends in the 1930s was Alan (later Bede) Griffiths who in 1930, on leaving Oxford, 'passed at a single bound from the complexity of twentieth-century civilisation to a life which was primeval in its simplicity'.[104] He lived in a primitive cottage in the Cotswolds, studied the Bible and St Thomas Aquinas, worked the land and bought only local products, including Cardew's wares. He dreamt then of 'a new Toryism which should separate itself from Capitalism' and bring about 'a renewal of agriculture and craftsmanship'.[105] Significantly only a monastic life could accomodate his longings and in 1936 he became a monk at Prinknash (Fig. 175) and as Bede Griffiths developed an interest in syncretic religions. Seeking a unity between Eastern and Western thought after the Second World War he ended his days as a Swami or holy man on the banks of the Ganges.

SOCIAL CREDIT

For makers who had little sympathy with religious ideology but were conscious of the fragility of the craft economy Social Credit appeared to be the magical remedy.[106] Social Credit was a system of monetary reform, the brainchild of Major C.H. Douglas and first outlined by him in a series of articles in *The New Age* in 1919. Douglas argued that the credit power of the community belonged to the community and that therefore a share of the National Dividend should be paid to each adult on the undertaking that this income be spent, not saved. Spending would increase production, solve unemployment and prevent stagnation.

A regular state dividend seemed like a craftsman's charter and Philip Mairet's New Handworkers and his Chandos Group discussed Social Credit theory in the late 1920s, involving Romney Green and Leach.[107] The potter Harry Davis and Leach's friend the painter Reggie Turvey attended one of Major Douglas's conferences in 1934 and were impressed. As Turvey explained to Bernard Leach handcraft would not flourish until 'the economic condition of the world has been adjusted'.[108] Gill took an interest but ultimately rejected Social Credit in the 1930s because 'Dividends for All' did not address the problem of mass production.[109] Romney Green, who had been converted to Social Credit by reading Professor Soddy,[110] tried to improve on its mathematics, inventing a fair tax formula that gave a negative tax or subsidy

175. Bede Griffiths (*right*) as a young Benedictine monk at Prinknash Abbey. (Prinknash Abbey Archives. Courtesy of the Abbot & Community).

to those on low incomes.

Social Credit's anti-banking stance was shared by the Distributists. Pius XI had pointed out that the control of credit was the control of 'the very lifeblood of the people'.[111] But Douglas's own writings had a darker side, being marked by a virulent anti-Semitism. Writing in 1938 he declared: 'The Bank of England rules the country, and the Jews rule the Bank of England…The problem of the Jews themselves is one which will require a solution and it ought to be solved.'[112] The thinking of some Distributists (Hilaire Belloc for instance) was shot through with a casual anti-Semitism. Where did the crafts stand? The inter-war craft movement was not generically anti-Semitic. But it was mostly non-Jewish and non-metropolitan and its modernism was often arrived at in the course of a search for the organic and rooted as opposed to the overtly experimental.

COMMUNISM

Guild Socialism, Distributism and Social Credit were all marginal movements numerically. The appeal they had for makers suggests the equally marginal nature of the inter-war craft movement. During the 1930s politically minded fine artists (together with certain designers and architects) were more inclined to join or sympathise with the Communist Party – which also had a small membership but was undeniably part of a much larger international movement. The political activities of left-wing painters, sculptors, designers, architects and print-makers centred on the Artists International Association (AIA). Founded in 1933 it was an anti-Fascist, pro-Soviet organisation with many Communist members.[113]

Notably few makers joined the AIA. The potter T.S. Haile was a keen member but, while he exhibited his paintings in 1939, he never showed his pots. Though banners were designed and embroidered and there was a definite interest in printmaking and mural art, the crafts were not included in AIA exhibitions. In that sense the AIA was as exclusive as many Bond Street galleries. The exceptional craft member was, of course, Eric Gill. Gill contributed an essay to the 1935 AIA *5 on Revolutionary Art*, alongside Herbert Read, F.D. Klingender, A.L. Lloyd and Alick West, in which he argued that all art was propaganda and most academic art was propaganda for the values of the idle rich.[114] Together with Henry Moore, Duncan Grant, Augustus John, Laura Knight and Paul Nash he also showed in the 1935 AIA exhibition *Artists against Fascism and War*.[115] These links with a communist organisation dismayed the Roman Catholic hierarchy and Gill was forced to defend himself in the *Catholic Herald*.[116] His position was difficult. He believed in the Distributist goal of reallocating property but as he explained to Philip Henderson at the height of his involvement with the AIA: 'I incline to agree also that Communism is the only solution politically, but I think that a re-arrangement or reform of our monetary system would ease the situation.'[117] For Gill all the movements so far discussed had some validity as alternatives to 'the flatulent and decadent ideals of bourgeois Capitalism'.[118]

Although Michael Cardew and Bernard Leach were not members of the AIA both men came into contact with Marxist thinking through their friendship with Henry Bergen, an American Old English scholar, amateur potter and expert on the Japanese tea ceremony.[119] Bergen was an ardent Communist who encouraged Cardew to read Marx in the early 1930s, assuring him that in the Soviet Union the crafts were actively encouraged. In 1938, inspired by Bergen's positive attitude towards mass production, Cardew went to work for the Stoke-on-Trent firm Copelands on a self-financing project to design prototypes.[120] Nothing came of this but Bergen's influence may also explain Cardew's bold decision to take on the task of running a ceramics factory in West Africa in 1942. Leach too was close to Bergen from about 1924 onwards when the American visited St Ives in order to experiment with galena earthenware. Bergen's influence can be detected in passages in Leach's pamphlet *A Potter's Outlook* of 1928 which criticised the preciousness of the Arts and Crafts world. Bergen was brutally frank to Leach about what he believed to be the role of handicrafts, which he described as 'playthings for the upper classes'.[121] When Leach was working on *A Potter's Book* in 1937–8 the manuscript was closely edited by Bergen. In a lengthy correspondence Bergen set out a whole series of arguments informed by economic realities to which he believed Leach was blind: 'The art of

the people has to be mass produced';[122] 'Remember that the Sung pots you and I admire were made for the rich not the poor';[123] 'Your work goes only to the upper classes'.[124]

Of Leach and Cardew's output, with their high kiln losses, he pointed out 'No one can take you seriously as *producers*',[125] nor, he argued, could they have started without private capital. Bergen derided the idea of a Sung standard being applied to modern utilitarian wares. He pointed out that Leach's high claims for workshop collaboration and teamwork were fanciful idealisations: 'You certainly don't consult other people at the moment the idea for a design comes into your head.'[126] Bergen urged Leach to read design theorists like Pevsner, Herbert Read and John Gloag.[127] He pointed out that it was conceited to attack the ceramics industry, that Leach was ignorant of social conditions and that he should strive to produce a straightforward textbook along the lines of Edward Johnston's *Writing & Illuminating & Lettering* or Dora Billington's *The Art of the Potter*. He advised Leach, 'cut as much cackle and prancing and self consciousness as possible'.[128]

Leach was, however, getting very different advice from Richard de la Mare, his editor at Faber & Faber, who clearly saw that it was the autobiographical quality of *A Potter's Book* that would attract readers. '*Please* don't let Bergen spoil the book, as I fear that he may if you allow him to banish all the atmosphere from it' wrote Richard de la Mare to Leach.[129] As it turned out de la Mare was right. *A Potter's Book* was a remarkable success after World War II, appearing in a second edition in 1945, reprinting in September of that year and again the subsequent September, precisely because it was more than a textbook. Leach's idealised description of his workshop, with its critical give and take between father and son and its 'simple living and hard work' struck a chord with many readers who had never thought of making a pot but were impatient with the rationing and rule book existence which had been their lot in the war. It is also an apolitical book, offering the promise of a satisfying way of life focused on individual fulfilment.

The fact that communism, socialism and collectivism were not political movements which offered much solace to makers between the wars may seem ironic in the light of William Morris's activities as a revolutionary socialist. In turn the Left had little time for the crafts. This antipathy was maintained after the Second World War when the left-wing historian Eric Hobsbawm came to reassess William Morris's legacy. Writing in 1948 in the pages of the Communist magazine *Our Time* he dismissed what he called the 'arty-crafty movement', reiterating the 1930s orthodoxy that the true heirs of Morris's artistic achievement were the pioneers of the Modern Movement in continental Europe.[130] Nonetheless, other voices, writing in *Our Time*, pleaded for a space for craft work. And the crafts, ever chameleon, emerged post-war as a less elitist activity, as an educational and therapeutic aid to the creation of a New Jerusalem.

PILGRIMS TO THE RIGHT

On balance the far Right might have seemed a more likely political haven for the crafts. National Socialism in Germany was a potentially inspirational movement for makers. Hitler's regime supported handicrafts, both as emblems of national pride and as part of a new iconography for the home which rejected 'bolshevik' designs such as tubular steel furniture. It was Hitler's personal 'wish and will' that 'German handwork rooted in sacred tradition' should be encouraged.[131] Furniture for the domestic interior promoted under Nazism in fact closely resembled the mix of Arts and Crafts and simplified Georgian admired by the DIA and exemplified by Gordon Russell's war-time Utility designs (Fig. 176).[132] In 1938, against government advice, George Hughes, the Clerk of the Worshipful Company of Goldsmiths, took an exhibition of British silver to the Berlin International Exhibition of Handicrafts. He was moved to tears by the maypole dancing and by a march past of craft guilds – 'Here was a thing which should be introduced bodily into England' – but a cohort of the Labour Front bringing their spades down with a crash like rifle shots gave Hughes 'a cold shudder'.[133]

It is hard to find a single maker who could be described as a fellow traveller of the far Right in the 1930s, apart from A. J. Penty. In the world of design W. J. Bassett-Lowke, the model train

176. The Labour Minister's room in the Reich Ministry in Berlin illustrated in *Deutsches Heimatwerk Berlin*, 1938. (Hochschule der Künste Berlin, Hochschulbibliothek, Abt. Bildende Kunst und Architektur).

manufacturer and patron of Peter Behrens, was a similar exception.[134] On the other hand there were landowners who campaigned for an ecologically sound rural revival in England who either embraced or came close to embracing fascism. The most interesting of these inter-war Greens was Rolf Gardiner, the founder of the Springhead Ring, an attempt at rural revival based at his estate at Springhead in Dorset which involved organic farming and the revival of folk dance and song and rural festivals (Fig. 177).

Springhead was, according to H. J. Massingham, an 'utterly different thing from the Arts and Crafts movement'.[135] Gardiner had progressed from Guild Socialism to an interest in Social Credit to a guarded sympathy with National Socialism by the early 1930s: 'What is Nazism but fanatical impatience?'[136] He believed that all land should revert to the Crown and that landowners should be Crown tenants working relatively small estates. At Springhead he emphasised links between the land and ritualised dance, song and harvest festival. He took an interest in flax production and weaving, and in basket making.[137] There were torch-lit processions on the Downs and folk dancing on Maumbury Rings.[138] Gardiner intended Springhead to be an experiment in rural reconstruction (in which the crafts would have their place). Dartington Hall was the obvious model and in 1933 he spent six months there on a forestry course. His experiences, however, highlight the differences between the leftish liberal enterprise that was Dartington and Gardiner's vision for Springhead. For Gardiner Dartington lacked soul – 'You've no magic makers' he told Leonard Elmhirst. He disliked the cosmopolitan nature of the place, singling out in particular the American Margaret Barr's dance group: 'it has nothing to do with England'. He deplored the rearing of battery chickens and the lack of self sufficiency at Dartington; for instance the estate saw mill did not buy its timber from the estate forestry department. He disliked the emphasis on costing and production: 'What if Dartington floods the already flooded market with better produced goods?' Dartington, he felt, should not be a place of production but of '*induction, consummation*. The old masques, rituals and festivals were never productions, they were inductions from the life of society, social consummations – yet they involved high craftsmanship'.[139]

Very few makers wanted to involve themselves with the kind of all-embracing semi-militaristic life of service envisaged by Gardiner, although the weaver Alec Hunter was a member of Gardiner's group of dancers, the Travelling Morrice, and Gardiner persuaded the young David Leach to sample the comradeship of a German workcamp in the summer of 1933.[140] Makers were too individually creative. Even if they lived in rural places they were too middle-class and

177. Rolf Gardiner (*centre right*) leads a sword dancing team on Plough Monday, January 1938, through the streets of Dorchester. The Springhead carpenter made the oak plough; the village tailor made the dancers' and the fool's outfits; the steel swords were made by the blacksmith in Skelton-in-Cleveland. (Photo courtesy Rosalind Richards).

too cosmopolitan to wish to vanish into a world of revived rural industry however bright with pageantry. Gardiner believed there should be a 'revolt against intellect and individualism in Art'.[141] But makers seem to have chosen other ways to revolt against the intellect and they tended to be individualists. Fascism and the far right, like Communism, was not for them.

By no means all makers were interested in politics. Beliefs could be defined obliquely. The religious affiliations of makers tended to range outside the normative Church of England to embrace Quakerism, Buddhism, the Bahá'í faith and Roman Catholicism. In addition the male craft world included a substantial number of conscientious objectors and non-combatants in both World Wars. Some, like Philip Mairet and the weaver Percy Beales, were ostracised for their pacifism. Many grew up in the shadow of the Great War, but were too young to fight. They formed part of an alienated generation who, as Rolf Gardiner suggested, 'trod lonely and frustrated paths'.[142]

POLITICS IN PRACTICE: HANDICRAFT AND THE UNEMPLOYED

As we saw in Chapter One, during the inter-war years the disabled, the weak of mind and the village poor were not in a strong position to challenge the belief that for them handicraft, usually in the form of weaving or embroidery, was an appropriate activity. But in the 1930s handicrafts were seen as a panacea for the troubles of a more organised and politicised group. These were the unemployed, above all in the designated Distressed Areas of the North East of England and South Wales. The response of the 1929–31 Labour government and of Ramsey MacDonald's subsequent coalition (1931–5) to the phenomenon of mass unemployment was limited.[143] Help of a basic kind was to be supplied by voluntary groups. What was interesting was the way in which middle- and upper-class men and women who gave a portion of their time to voluntary work brought their values to bear on the unemployment problem. The process was under way in the 1920s. The Quakers had opened an educational settlement, Maes Yr Haf, in the Rhondda in 1927,[144] while the Workers' Educational Association set up the Lincoln Service Club in the same year. The central body that co-ordinated voluntary philanthropic associations was the National Council for Social Services (NCSS). By 1932, with the backing of American money from the Carnegie Trust and the Pilgrim Trust, the NCSS was overseeing 700 voluntary schemes. That year the NCSS was given a £20,000 government grant to act as official co-ordinator for voluntary occupation schemes for unemployed men and women.[145] The meagre government contribution was much remarked upon. Thomas Jones, the secretary of the Pilgrim Trust, described it as 'a miserable grant of a few thousand a year' adding 'we were all at one in holding that these occupational clubs should not be allowed to mislead the public into thinking that a solution of the unemployed problem had been found.'[146] By 1935 there were nineteen regional councils under the aegis of the NCSS. A thousand Voluntary Occupational Centres for men and three hundred for women had been set up together with five residential training centres offering six months to fortnight long courses.[147]

What went on in the Voluntary Occupational Centres? It is revealing that handicrafts – toymaking, woodwork, French polishing, upholstery, boot repairing, mat making, quilting, sewing – together with drama and art, were central activities. Handicrafts were deemed therapeutic (as they were thought to be for the disabled). They contrast sharply with the highly developed leisure activities of working-class men and women in work – betting associated with sport, all kinds of 'fancying' associated with the selective breeding of birds and animals.[148]

But the fact that the crafts were potentially economically marginal was important. Goods produced by the unemployed could only be made for family and friends or donated. Paid work was vetoed. A Pilgrim Trust researcher told of a Means Test official asking an unemployed man who had use of a workbench if he made anything on it for other people: 'You needn't answer, for we'll get to know almost before you do it. Someone will write and tell us.'[149] Nor could men and women be trained at the Centres in any skills that would take work from the employed. This was a principle vigilantly monitored by the Trades Unions who also objected to men working productively without pay and therefore undercutting those in work. Writing

in 1938 the sociologist and pioneer of Gallup Polls, Henry Durant, explained of the unemployed: 'It is literally impossible to find any work which does not interfere with the normal economic process'.[150] The only solution was what Durant called 'arty' work and common benefit schemes such as digging a swimming pool or building a club house. The crafts were encouraged as a way of teaching men and women how to spend their enforced leisure. A special unemployment issue of *Rural Industries*, the RIB journal, spotted the fallacy: 'it will be difficult, over a period of years, to sustain interest in the production of non-essentials.'[151]

Not surprisingly it was the middle classes, whose attitude to industrialisation and urban life was ambivalent, who viewed these craft initiatives most positively. For instance J.B. Priestley, during his *English Journey*, 'a rambling but truthful account of what one man saw and heard and felt and thought during a journey through England during the autumn of the year 1933', was moved to see men in an occupational centre in Blackburn making 'toys for Christmas, clumsy but effective wooden engines and model airplanes'. The men seemed proud of their handicraft and Priestley applauded the 'emergence of the natural craftsman that is buried somewhere in everyman'.[152] Priestley spoke as a progressive left winger as did Ellen Wilkinson, the Labour M.P. for Jarrow, who also wrote positively about craft activity in her constituency, in particular the sophisticated cabinet making she saw in one of the clubs there. Nonetheless she recognised an element of unreality about the solutions offered, noting that in the 1930s it 'became fashionable to do something for the unemployed'.[153]

Members of the extreme Right and Left united in condemning the Voluntary Occupational Centres – even if the solutions they each proposed were very different. Alan Hutt, whose 1933 study of working-class conditions had a preface by the Communist leader Harry Pollitt and was written with the help of the Communist-dominated Labour Research Department,[154] believed that the government was evading its responsibilities. He disliked the 'occupations' on offer at the voluntary centres: 'we have this preposterous paradox: in the most industrialised country in the world, with huge factories idle, the unemployed workers are offered charity work at petty handicrafts.'[155] Another voice from the left, that of Harold Stovin, mounted a passionate attack on all kinds of inter-war voluntary organisations from Toc H to the Boy Scouts to Buchmanism. Stovin devoted a chapter of his book *Totem* to the Voluntary Occupational Centres, criticising in some detail a centre at Llandudno which taught furniture making, mat making and pewter work:

> Here in the middle of a prosperous seaside resort – a complex mechanism – we have a twentieth-century 'Swiss Community Robinson' – a negation of economics, a revel of romanticism (for pewter and handicrafts flourish here) a paradise of philanthropy.[156]

Stovin argued that those who saw the crafts as a panacea were 'the romantics who wish to use the unemployed as an antidote to urbanisation; a mode of life which they fear, because they have not mastered it'.[157]

On the political right Lord Lymington, farmer and founder in 1930 of the supremely nasty proto-fascist English Mistery (later the English Array), was inspired by the work camps of Italy and Germany. He dismissed the NCSS 'classes in fretwork' and preached rural repopulation through organic farming.[158] This would revive the 'real' crafts of hurdlemaking, blacksmithing and thatching. Rolf Gardiner of Springhead, a less extreme admirer of aspects of Fascism, believed that 'folk art is the matrix of all arts'. During the 1930s Gardiner travelled, invariably with a team of Morris dancers, to Cleveland, to South Wales and the Midlands. He learnt sword dancing from the ironstone miners of Cleveland and set up summer schools and harvest camps at Springhead where the unemployed were made welcome. On his Dorset estate he investigated flax growing, processing and spinning and sought 'The Music of an older Europe, the culture of pre-industrial England, the wonder of landscapes haunted by the ghosts of the remote past'.[159] For Gardiner, as for Lymington, the unemployed would have contact with handicraft, not in special centres, but as part of an ambitious programme for the repopulation of the land which would come about naturally as England reverted to older more labour-intensive farming methods.

178. Unemployed men constructing a wooden villa at the Grith Fyrd camp at Godshill, Hampshire, 1932. (HultonGetty).

Gardiner sympathised with another land-based venture organised by the Order of Woodcraft Chivalry, a cranky small-scale break-away scout movement founded by Ernest Westlake in 1916. In 1932 the Order set up its first (and, as it turned out, only) Grith Fyrd camp at Godshill in Hampshire (Fig. 178). Its aim was to provide an alternative to life on the dole. Men between eighteen and twenty-five were eligible to join, paying their dole into a kitty in return for an outdoor life aimed at self-sufficiency. Men remained at the camp for at least a year and a half, part of which time was spent travelling on an educative tour of England:

> They will see its craftsmen and its machine-minders at work and compare the goods they turn out. They will experience its incomparable beauty and its casual sordidness, appreciating the former to the full, and discussing what is to be done about the latter.[160]

By the autumn of 1932 there were twenty-five men at the camp, including carpenters, boot repairers, a wood carver and a clay modeller. A loom was built. The intention was to become self-sufficient in all goods. Press photographers were sent to the camp to record the men's apparently idyllic forest existence. In 1936 the scheme came to an end after a fire. The network of camps did not develop, though between 1932 and 1936 three-hundred men had passed through Godshill.

Members of Grith Fyrd were effectively outside the economic system and for that reason Harold Stovin saw the camp as the negation of freedom – a Swiss Community Robinson indeed. Grith Fyrd sounds similar to the National Homecroft Association, the subject of many articles in the Distributist *G.K.'s Weekly*. The Association was founded in 1926 to help the unemployed by settling small groups of about ten families on crofts of land with the aim of self-subsistence – as a challenge to both communism and capitalism.[161] The Wigan Subsistence Production Society was a similar attempt to create a separate economic community for the unemployed based on a system of barter. As well as agriculture and light industry there was a good deal of handicraft at Wigan, especially furniture making. The families involved, who were exempt from Means Testing, had a higher standard of living as a result of joining the scheme. But despite the Society's utopian ambitions, working for no wage was, as a researcher for the Pilgrim Trust reported, 'contrary to deeply engrained working-class habits…For the bulk of the members the feeling of being the forerunners of a new order of society was entirely absent.'[162]

The men and women who attended Voluntary Occupational Centres and these land

Fig. 5

179. *Woodwork for the Unemployed*: A panelled wardrobe designed by A. Romney Green illustrated in *Rural Industries*, Spring 1934.

180. The Porth quilting class in the Rhondda, South Wales, late 1920s. (Holburne Museum and Crafts Study Centre, Bath).

settlement ventures inhabited a different world from that of the creative artist craftsman and woman in the inter-war years. Not surprisingly the attitude of the unemployed to handwork was ambivalent and often negative. At the dole queue the Occupational Centres were invariably dismissed as 'dope' even if there is evidence that attendance at the Centres did give pleasure and a sense of self worth.[163] In the final analysis however, the 'work' on offer there was not work at all – it led, in terms of Western capitalism, nowhere. What was more worrying was that the few men who actually tried to make a living out of the crafts in order to stay off the dole invariably failed. The Pilgrim Trust survey records that an unemployed man who set up as a maker of leather mats found a week's work earned him 2 or 3s as opposed to 17s on benefit.[164] It was, after all, only creativity and access to luxury markets that enabled members of the artist craft world to survive in an industrialised society.

One member of this privileged artist craft group came to know the plight of unemployed craftworkers well and recorded the irony of their situation. Romney Green spent two years as Technical Adviser to the woodworking shops of the Occupational Centres – an experience which he recalled as 'a black nightmare streaked with silver and gold'.[165] Romney Green wrote poems about his experiences – 'Heads and hard hearts! But here the wreckage lies'[166] – and he was shocked that the men he taught had to buy their materials out of their dole money and could not sell their work (and by the sight of hungry men fainting over their work benches). He tried to teach sound construction despite the hostility of the Trades Unions. In a series of essays on *Woodwork for the Unemployed* which appeared in 1933–4 in the RIB journal *Rural Industries* he stressed the intellectual and physical pleasures of designing and making, illustrating designs for handsome pieces of furniture he had encouraged his pupils to make (Fig. 179).[167] Romney Green encouraged economic and political discussion among the men, railed against profiteering and predicted revolution. His combative anti-paternalist talk shocked local patrons and in 1934 his post was abolished.

Romney Green was recruited via the Rural Industries Bureau. It was the RIB who were to initiate the most successful handicraft intervention in the Distressed Areas. The quilts of North East England had been 'discovered' by the Women's Institute in the 1920s. The craft was encouraged by Alice Armes, a Durham member and the Institute's National Handicrafts organiser.[168] Examples were exhibited at the Institute's National Exhibition in 1927. The Rural Industries Bureau became interested during the following year when their Woman's Advisory Committee investigated conditions on the borders of the South Wales coalfields. Two exhibitions of quilts were held in 1928 – at the RIB's commercial outlet Country Industries Ltd and at Muriel Rose's Little Gallery. Both were an immediate success and by December

Mr Hunter Middleston Moor

Pipeband feathers — *Slow*

Husband has left her.
Has one boy in work.

wants work

Learnt from her mother —

Very good flowing feathers
pen feathers in frame

An interesting centre
called umbrella

Also a handsome centre
with P. of Wales feathers

181. A page of Muriel Rose's diary of visits made to quilters in South Wales and the North of England. (Holburne Museum and Crafts Study Centre, Bath).

182. A model wearing a quilted evening cloak. (Holburne Museum and Crafts Study Centre, Bath).

1928 £800 worth of orders had been received and seventy women were on the RIB register.[169] By Spring 1929 the Bureau had started classes in South Wales led by experienced quilters supported by a grant from the Lord Mayor's Fund (Fig. 180). By December 1929 there were 170 registered makers in South Wales and Durham.[170]

What had hitherto been practised as a thrift craft, using cheap cotton and worn-out blankets as filling, was now being promoted as a luxury product (Fig. 182). Muriel Rose supplied quilters with high quality material – silk, sateen, and cotton poplin and silk thread – all of which had to be kept immaculately clean in a small miner's cottage. Muriel Rose kept a diary of visits made to quilters in the North of England in 1934 and to South Wales in 1939 (Fig. 181). It is a poignant document recording the particular skills of each quilter but also noting the speed of work, cleanliness of each home and a kind of informal Means Testing – the degree of neediness.[171] Both the RIB and Muriel Rose were interested in authenticity. As with the lace associations it was considered vital to preserve old designs and to discourage invention and novelty.[172] But quilting was to some extent adapted for this new London market to include quilted dressing gowns, tennis cardigans, motor rugs, cushions and scarves as well as traditional wholecloth quilts.

Aristocratic support, taking the form of exhibitions in the London houses of grandees like the Earl and Countess of Strafford, Sir Philip Sassoon and Lord Howard de Walden, suggests what a fashionable success the quilts were.[173] The fact that they were made in the Distressed Areas, and that to purchase them was a charitable act, was central to their appeal. They also seemed appropriate in the stylish, all-white modern interiors of the kind created by the interior decorator Syrie Maugham. A large order for quilts for all the bedrooms in Oswald Milne's new wing for Claridges in 1932 showed them to advantage in glamorous *moderne* interiors with fitted furniture by Bath Cabinet Makers.[174] On the other hand, the intricate beauties of traditional quilt patterns harmonised equally happily with the kind of Tudorbethan interiors regularly celebrated in the pages of *Ideal Home*.[175] And the quilts were made with the 'spontaneity' admired by inter-war makers. Mavis FitzRandolph, who became the RIB's officer

on quilting, wrote of the 'quilt wives' talent for creating beautiful complex designs, which were planned without the help of pen and paper. '"The pattern? Oh! I just make it up" she says lightly, quite unaware it has any relation to art.'[176] FitzRandolph saw the quilts as illustrative of Arts and Crafts principles: 'design in any craft ought to be – and can best be – evolved by the craftsman and not by an "artist" who is not himself a worker in that craft'.

How helpful was the quilting initiative in alleviating poverty? An RIB Report of 1936 announced that whole families had been saved from utter destitution.[177] This seems an exaggerated claim even if the quilting women clearly made a valuable contribution to household finances. In 1931 RIB quilters were paid 1s 10d per square foot for sateen and cotton work and 2s 9d for silk: 'the Quilt wife seems to think herself fortunate if she can earn from 2s to 4s 6d for a day's work – part time of course, but representing probably 3–5 hours'.[178] But this top sum of over £2 a week may have been optimistic. Mavis FitzRandolph, who actually toured the Distressed Areas visiting quilters in Durham in 1932 estimated weekly earnings at £1 to 25s. But she noted that this figure was possibly too high: 'a woman when asked to do a quilt as quickly as possible, may return it in two weeks and receive £5 or more, but she has had a neighbour or daughter to work with her…the poverty is appalling'.[179]

In 1930 Margaret Bondfield, the Minister for Labour (and incidentally the first woman to hold a Cabinet post), opened an exhibition of quilts at the RIB's shop, Country Industries. Miss Bondfield spoke of the value of the quilting scheme for the distressed mining areas, arguing that 'by encouraging and fostering the old and beautiful quilting craft, far more than merely financial help was being given to the quilters'. She spoke of the need to stimulate individual effort and self-help and concluded that with mass production on a scale undreamt of fifty years ago 'there was a danger of shutting out from our lives the originality and the creative power of the old craftsmen'[180] Thus these women, making quilts in the grimmest conditions imaginable, were charged with the responsibility of keeping a dream alive, that of a pre-industrial, pre-lapsarian England. The unease of the hegemonic class with the facts of industrialisation and the sprawl of the city – in fact with the well-springs of British prosperity – certainly manifested itself in odd ways. None more so than the encouragement of craft work among the unemployed between the wars.

POLITICS IN PRACTICE: ARTISANS AND ARTISTS

Inter-war makers were often surprisingly impractical folk who relied on artisans or trade craftsmen for basic knowledge. Ernest Gimson's encounter with the chair bodger Philip Clissett is a case in point but there were many later art craft/trade craft crossovers. Romney Green, entirely self taught, would hire country joiners and covertly watch them at work.[181] When Michael Cardew bought an old pottery at Winchcombe in Gloucestershire in 1926, he re-engaged and learnt from the potter Elijah Comfort who had worked there in the first decade of the century. He also relied on a young boy, Sidney Tustin, to solve most of the technical problems. Douglas Pepler embarked on printing in Ditchling with the help of 'old Dawes', a veteran figure who had learnt the craft some fifty years previously.[182] The way in which upper-middle-class men and women depended on and were inspired by artisans and their practical know-how is neatly encapsulated in a 1923 photograph of Bernard Leach, Shoji Hamada (Fig. 183) and Leach's son David intently watching Mr Pascoe of the Truro Pottery pulling a handle. Class difference manifests itself in clothing – with Leach and Hamada in overcoats and Trilby hats and Pascoe in his cloth cap and shirt sleeves – and in attitude. Pascoe knows how to make a jug handle by pulling out a lump of clay. But Leach can provide an exegesis for handle-pulling: 'pleasure in the making, pleasure to you in the using, pleasure of your friends, pleasure in the work'.[183] Three men in particular – Dicon Nance, Sidney Tustin and Harry Davis – give an insight into the class-complexities of the inter-war crafts movement captured in this photograph. All three came to the crafts from a perspective rooted in skill rather than artistry. All emerged puzzled and disaffected from their encounters with the artist crafts.

Dicon Nance was a Cornishman, the brother of the furniture maker Robin Nance (Fig. 184). His father was Robert Morton Nance, a painter, Cornish speaker and historian of

183. Mr Pascoe of the Truro Pottery, Cornwall demonstrating pulling a handle to (l. to r.) Shoji Hamada, David Leach (with boy scout hat), Bernard Leach, 1923. (Photo courtesy Barry Huggett).

Cornwall.[184] Regarded by his parents as 'not an intellectual' Nance had little formal schooling and thus became a *déclassé* figure. Between the wars he worked at the Leach Pottery as a general maintenance man, making wheels and carrying out all kinds of repairs. There he became conscious that while 'Bernard Leach was an artist and I was not', from the technical point of view the pottery was badly run. Leach's pots were often ruined, for instance, because in his eagerness he would open the kiln too soon. For Nance there seemed no connection between the local country potteries of his boyhood and what he perceived as the incompetent artist potters he met at St Ives.

From 1942 to 1945 Nance was in West Africa helping first Harry Davis and then Michael Cardew run a pottery at Achimoto. In Cardew, Nance encountered another artist potter who made endless technical mistakes and who disregarded practical advice. Cardew, Nance recalled, could 'make you feel very small; he was so obviously a vastly superior person'. Back in England in 1945 Nance embarked on a partnership with his brother Robin. In a matter of days he learnt how to make turned ladderback chairs from Edward Gardiner, a craftsman originally employed by Ernest Gimson. These became the staple of the Nance workshop. But from the early 1960s until her death in 1975 Nance worked for Barbara Hepworth as an assistant.

184. (*l. to r.*) George Wilkinson and Dicon Nance in the late 1960s when working as assistants to Barbara Hepworth. (Alan Bowness).

This spelt his final disillusion with the art world. There were problems of authorship. Towards the end of her life Nance was carving pieces for Hepworth which were based on sketches and occasionally on Nance's intuitive response to a piece of wood or stone which he would carve in a Hepworthesque fashion – 'You had done it. She would not even give a drawing. A piece of wood or stone has a shape – the shape was in it. I found it and made it.' These may seem like naive claims. Ultimately Nance felt like an outsider in the artist-craft and art world. His skills – best displayed in his chairmaking and in a series of remarkable scale models of nineteenth-century industrial machinery – were exemplary. But Nance never worked as a creative artist in his own right and his odd, interesting career illustrates the difficulty of defining 'the crafts'. He worked with his hands as a problem solver and interpreter but was nonetheless alienated from, even hostile to, the fine art end of the craft world.

Sidney Tustin worked for Michael Cardew at the Winchcombe Pottery from 1927 (Fig. 185).[185] We would know nothing of his thoughts and experiences but for an interview conducted with him in 1994 by the National Electronic and Video Archive for the Crafts. Tustin was a local lad, taken on as a fourteen-year-old boy. As Leach was to recommend in *A Potter's Book*: 'choose untrained local labour. Likely boys learn the jobs quickly.'[186] From the start Tustin was given a whole range of crucial tasks, including creating a fireable clay body and working out how to fire the old existing kiln. When Tustin was seventeen Cardew made a formal apprenticeship arrangement with Tustin's mother but he felt that he learnt nothing from Cardew. As he explained: 'He was an indoor man, not an outdoor man. He was a real educated man but when you got him outdoors doing anything he was a real dunce.' Cardew, whom Tustin called 'the Master', loved to throw large handsome pots while the practical problems were left to young Tustin (Fig. 186).

185. (*l. to r.*) Elijah Comfort, Charles Tustin, Michael Cardew, Sidney Tustin by the horse-drawn pug-mill at Winchcombe in 1934. (Pitshanger Manor & Gallery, London Borough of Ealing).

Tustin remained a wage-earner throughout his fifty years at Winchcombe. When the pottery was sold to Ray Finch in 1946 there was no question of Tustin becoming a partner even though his responsibilities were undiminished – for Ray was another educated 'indoor man'. Over the years Tustin developed into a skilled thrower but he was confined to making small fiddly items like cruet sets which in the 1960s he produced in quantity for Cranks restaurants. The National Electronic and Video Archive interview ends with Tustin's *cri de coeur* that his sensibilities had been ignored, largely one suspects because of class barriers. 'I've never made the pots I was capable of making. Big pots – I used to long and long and long to make big pots – I'd really have loved to have made some nice big pots.' But nobody asked and clearly throwing large pots was a special activity, at the art end of the spectrum from which an artisan such as Tustin was excluded.

The third man who emerged bruised from his encounter with the artist crafts was the potter Harry Davis (Fig. 187), who as we have seen, worked for Bernard Leach from 1932

until 1937. His background, like Nance's, was middle class, but underschooled. Aged seventeen he landed a trainee job at a pottery in Poole making tourist giftware. Like Nance he was intensely practical, a brilliant low-level technologist, able to make all the equipment needed to run an efficient pottery. On joining the Leach Pottery in 1932 Davis immediately became aware that he had stepped outside normal economics – as indeed he had, for the pottery was subsidised by the Elmhirsts of Dartington. He was surprised to find that neither Cardew nor Leach was a particularly skilled thrower – in the sense of being able to produce runs of identical forms.[187] He also noticed that both men hated machines: 'I realised that this was because their ignorance of them was total. Coming from middle-class backgrounds tools for them were alien things and machines were something worse.'[188] Writing in 1985 Davis recorded his disillusion with the handcraft world, arguing that 'handcraft pottery with its complacent standards of doubtful competence and extravagant pricing only flourishes because it is functioning in a society of extreme affluence'.[189] By the mid-1960s Davis had become a serious low-level technologist who had worked in West Africa, Peru and New Zealand.

As with Nance and Tustin, Davis was perplexed about the 'art' ingredient in the craft movement and felt bitter about his contact with those middle-class artist-craftsmen who used but barely appreciated his technical skill. We have seen how skill as such was not valued in the inter-war craft world. Perhaps Davis and Nance lacked an education in art but they both (unlike Tustin) had read William Morris. Part of the problem was that for Nance and Davis the phrase 'craftsmanship' had social and political resonances which appeared to have vanished from the artist craft movement. There is a marked contrast with the spirit of classless comradeship and brotherhood (with veiled homosexuality as perhaps a crucial element here) fostered by C.R. Ashbee from 1902 to 1908 at his Guild of Handicraft just north of Winchcombe at Chipping Campden.

The radical politics (and radical sexuality) espoused by Ashbee helped soften class barriers and encouraged a co-operative spirit in which Guild members were able to develop their creative skills. In contrast, in the 1930s Leach introduced division of labour into the pottery at St Ives. In a letter of 1935 Davis wrote 'Well – it *didn't bloody* well work! and for *God's sake don't ever* be argued into agreeing with such methods again.'[190] An intimate interchange, but as Davis records, on a day to day basis

> none of us were permitted the familiarity of calling him Bernard. For me he always remained B.L. or B. Leach...such things can be ticklish in a class-ridden society and this was so at that time, even among people who thought of themselves as part of an artist's community.[191]

Ashbee's brand of socially cohesive Arts and Crafts idealism is not much found in the inter-

war years. Instead Nance and Davis found class barriers and what they perceived as privilege coupled with mysterious aesthetics.

PLEASURE

Tustin, Nance and Davis were fine craftsman but they seem like outsiders, denied, among other things, the intensity of pleasure experienced by practitioners of the crafts. Artistry and pleasure appeared to go hand-in-hand and middle-class makers liked to articulate these experiences in print. In the crafts pleasure has a political dimension. For images of pleasure in handwork we have to look to the most creative and gifted heirs of the Arts and Crafts Movement. These tended to be members of the middle and upper classes. Sir George Trevelyan records starting as an apprentice in 1929 in the furniture workshop of Peter van der Waals: 'That springtime for me has never faded. There was such endless joy in losing oneself in the making of things.'[192] Gordon Russell writes in a similar vein about designing furniture in the 1920s: 'this was sheer delight – like visiting an enchanting woman on a May afternoon, or eating the first oysters of the season'.[193] This almost erotic sense of pleasure is echoed by Eric Gill's account of first seeing Edward Johnston's calligraphy in 1899:

> the first time I saw him writing and saw the writing that came as he wrote, I had that thrill and tremble of the heart which otherwise I can only remember having had when I first touched her body or saw her hair down for the first time, or when I first heard the plain chant of the church.[194]

We find it again in J.H. Mason's 1933 account of creating a private press book: 'it is almost like falling in love, with all the delighted service and bringing of presents, and decorations, illustration, and fine garments of hand-made paper and binding.'[195]

Two principal types of joy are recorded – that of the skilled craftsman like Mason entering a new world where work was elevated above mere efficiency and cost effectiveness and taken closer to the practice of art. Mason, on joining T.J. Cobden-Sanderson's Doves Press in 1900 after an earlier career at a commercial printing house, remembered 'a real atmosphere of exaltation, as though we were concerned with some high service to something outside and above us, and were truly working for the work's sake'.[196] Such figures became rarer as the century wore on and we are more likely to read of the release felt by an upper- or middle-class individual – George Trevelyan or Romney Green – on turning from intellectual to physical work. As Romney Green wrote of the drudgery of planing wood in his autobiography: 'there is no lovelier exercise in the world than that of planing up a figured oak board with an old fashioned jack. It taxes every muscle in your body from the soles of your feet to the tips of your fingers.'[197] But against that should be set David Pye's account of the Welsh spoon maker James Davies of Abercych or the experiences of the handweavers of Dartington Hall. As a boy in the 1920s Davies carved spoons for twopence each. At that price this gave him just time to finish a spoon, check it, throw it over his shoulder and start another.[198] And as we have seen, at Dartington Hall in the early 1930s handweavers were found to be suffering from nervous exhaustion. Mass production by hand is no fun at all. Which is why positive responses to handicrafts tended to be rooted in choice, creativity and a degree of prosperity. Where this is lacking, resentment, monotony and even pain come to the fore.

INSPIRATIONS

As we saw in Chapter Two progressive inter-war makers were strongly influenced by new hierarchies of excellence in art which had been shaped by modernist criticism. Clive Bell had argued that 'Significant Form' was to be found in the art of all periods and regions but above all in early art (untroubled by narrative and descriptive concerns) and in the art of non-Western cultures. Timelessness was emphasised: 'It is the mark of great art that its appeal is universal and eternal.'[199] Inter-war makers, educated in this way of thinking, were particularly inspired by five distinct areas of discovery and rediscovery.

Firstly there were the vernacular crafts of Britain, to be found in remote corners of England

and in Scotland, Ireland and Wales. Then there were the arts of the Indian sub-continent – known chiefly through the destructive intimacy of colonial rule. The fact of Empire was important to English crafts, providing a 'timeless' aesthetic and social inspiration underpinned by a mass of Orientalising scholarship. The arts of the Far East, less familiar, but perhaps more admired than those of the Indian sub-continent, had been studied and consumed since the sixteeenth century but twentieth-century interest shifted to Japanese and Korean folk art and the early art of China. And the philosophies and religions of the Indian sub-continent and the Far East became almost as important as their artefacts to the practice of the crafts in Europe. Colonial adventures also created contacts with the arts of Africa south of the Sahara. There was a hazier photographically based awareness of South American indigenous and Pre-Columbian art. North America was largely ignored. Little interest was taken in American native art and instead North America had a scapegoat role, representing modern life in its most crude and consumerist form.

THE ORGANIC COMMUNITY

In the 1920s and 1930s interest in specifically English vernacular craft went beyond the small world of artist craftsmen and women. Designers and design pundits, as we have seen, had ambivalent attitudes to artist craft but the beauties of vernacular objects like hayrakes and scythes were not lost on them. This was a simple enough formalist response, a recognition of good design arrived at by custom and long practice. But for commentators on the 'condition of England' and for a handful of literary critics the maintenance of country crafts and customs was seen as essential to the 'health' of English cultural life. And their ideas meshed with the taste and attitudes of a broad swathe of the educated middle and upper middle classes, to take in a literary intelligentsia, readers of 'country writing', politically wayward organic farmers and first-time car owners who from 1933 were able to explore the countryside with the help of the Shell County Guides. These were written and edited by artists and writers such as John Betjeman, Paul Nash and John Piper whose taste mapped an England and Wales rich in dramatically photographed ruins, follies and prehistoric remains.

Ideas about a lost 'organic community' were most vigorously set out in the pages of *Scrutiny*, the small-circulation literary magazine first published in May 1932 and edited by L.C. Knights and Donald Culver, joined in 1933 by F.R. Leavis and Denys Thompson. The phrase 'organic community' also peppered the pages of Leavis and Thompson's book *Culture and Environment* of 1933. This was an attack on mass advertising, the mass media and 'Levelling-Down', intended for use in schools as a primer to train 'taste and sensibility'.[200] That a thinker as rigorous as Leavis should respond to the encroaching barbarism of popular magazines and music, television, cinema and radio with invocations of the land and the past, suggests a stasis amounting to a crisis in English cultural life which worked to the benefit of craft practice.[201] In the pages of *Scrutiny* and in *Culture and Environment* George Sturt's *The Wheelwright's Shop* was identified as a key text. *Scrutiny* set lost rural values against the poverty of suburbanism which was 'paralysing true feeling at the source'.[202]

Such ideas – a horror of the suburbs and of popular culture – were shared by makers. For Gordon Russell creative life began when his father moved from an 'ugly, monotonous, little suburban home in Tooting'[203] to the Cotswolds. Leach spoke out against 'music while you work' and 'jazz, cinema and wireless, and all the dope which clogs the release of healthy talent'.[204] Ever practical, Katharine Pleydell-Bouverie reported making bamboo pipes for playing folk tunes to 'village kids'.[205] Cardew, as a keen country dancer and as a talented flautist and recorder player, read Leavis and Thompson's *Culture and Environment* with enthusiasm.[206] He also read the country writer H.J. Massingham's study of cultural origins, *Downland Man*,[207] and was friendly with another country writer, the artist Thomas Hennell, both of whom were favourably reviewed in *Scrutiny*.

The popularity of 'country writing' went far beyond the rarefied pages of *Scrutiny*. Writing about the countryside in the inter-war years could be a lucrative occupation for a literary man or woman. A torrent of books appeared, mostly published by Batsford and Longmans, on rural life and customs. But the attitude of recorders of country crafts like Freda Derrick, Dorothy

188. Thomas Hennell, Winchcombe Pottery illustrated in his article 'Country Craftsmen: The Potter', 1943. (*Architectural Review*).

Hartley, Thomas Hennell and H.J. Massingham to the artist crafts is of interest. In her *Made in England* (1939) Dorothy Hartley surveyed and illustrated quarrying, mining, brickmaking and all crafts relating to woodlands and excluded 'arts and crafts' and 'studio'[208] items from her 'plain record of country work written as simply as possible'.[209] On the other hand, Freda Derrick's interest in the vernacular was matched by her admiration for Morris and the Cotswold artist-craftsmen.[210] Hennell was a gifted artist as well as a writer, illustrating four books by H.J. Massingham with hallucinogenic precision. Unusually, he was friendly with a number of inter-war makers, seeing in their work an important series of revivals. Thus, when Hennell sought an authentic example of the country slipware tradition for his series of articles on country crafts which appeared in the *Architectural Review* at the beginning of the war, he visited and drew Cardew's Winchcombe, not one of the surviving country potteries which in many instances had gone over, disappointingly, to 'Art' pottery and giftware (Fig. 188).[211] Hennell's *British Craftsmen* (1946) was especially sympathetic to the artist crafts, ending with details of the work of the hand block-printers Barron and Larcher, the weaver Luther Hooper and Ethel Mairet and her pupils.

Massingham, on the other hand, was a friend and admirer of Rolf Gardiner and took up an extreme purist position: 'Our future is in our past, our pre-industrial past.'[212] His dreams of rural regeneration led him to collect old tools and 'by-gones', adzes, axes, augers and lace bobbins. These were housed in his thatched summer house for future revivals: 'They would be of service to posterity should England again recolonise with small farming communities'. Tools were links with an older England: Massingham wrote emotionally of seeing breast ploughs being used in the north-west Cotswolds, 'uncouth' implements that appeared to antedate the Anglo-Saxon plough drawn by oxen (Fig. 189).[213] A wooden seedlip or box used to broadcast seed evoked

> an unenclosed England…an organism of independent workers who, if poor, were not paupers, if labouring all their lives, had their feasts and plays and processions, if only living for subsistence, knew nothing of the worse-than-bestial embitterments of 'economic man' nor of the diabolical philosophy of Hobbes nor of the horrors of industrialism. (Fig. 190)[214]

Massingham dismissed 'Arts and Crafts playboys'[215] and a movement which 'trains the young to avoid utility in handwork'[216] even though he respected 'that great artist Ernest Gimson'.[217] For Massingham, as for Leavis, the key word was 'organic', writing of the 'organic linkage between agriculture and rural industry'[218] and of a farm in which the interaction between man, tools and the land worked as 'one organic whole'.[219]

189. Thomas Hennell, pencil drawing of a breast or turf plough, 38 × 22.7 cm. (Rural History Centre, University of Reading).

190. Seedlip obtained by H.J. Massingham from the Sexty brothers of Bangrove Farm, Oxenton Hill, Gloucestershire, and repaired by Harold G. Greening of Winchcombe. (Rural History Centre, University of Reading).

The response of craftsmen and women to the vernacular was more pragmatic than that of the country writers and the Scrutineers, even if they went to the same places and sought the same timelessness and were, at times, perceived as guardians of the old traditions. In fact, in their eyes England was short on authentic models. Nonetheless makers were drawn to isolated areas like the Cotswolds, rich in local customs and above all in the building crafts. J.B. Priestley on his *English Journey* of 1933 had found the Cotswolds the quintessence of mystery: 'the little valleys were as remote as Avalon'.[220] But Priestley makes an important point, that the whole of the region, 'though it now seems so Arcadian, is actually a depressed industrial area'.[221] This stasis, outside time, was an attraction for the makers and architects who settled there from the late nineteenth century onwards. The emptiness and relative poverty of the Cotswolds enabled creative men and women both to reinvent the countryside and, with the confidence of Empire builders, even to teach its inhabitants how to be country folk.[222]

Because English survivals were few and far between, makers also travelled to the margins of the British Isles, to remote impoverished sites like Cornwall and Devon. For Leach, Cornwall was not quite England, a place that 'grows upon aliens like me'.[223] Wales drew craft weavers – Ethel Mairet, Elizabeth Peacock, Margery Kendon, Marianne Straub, Heremon Fitzpatrick – who individually 'discovered' the yarns mulespun in the small Welsh water-powered wool mills (Fig. 167). Makers and designers alike were struck by the 'economy and purity of form'[224] of traditional spoons and axe hafts made by carvers and turners like William Rees of Carmarthen and James Davies of Abercych in Pembrokeshire (Fig. 191). In Ireland a privileged aristocracy and intelligentsia had began to anthropologise the margins of their own country at the turn of the century.[225] Visitors from England found the same authenticity. Margery Kendon, whose researches Thomas Hennell compared to those of Cecil Sharp, visited County Mayo in Ireland in 1935 and 1936 to record techniques such as spinning on a traditional big wheel and spindle and the craft of indigo dyeing.[226] Ireland was also a place of pilgrimage for Eric Gill and Michael Cardew, providing a less specialised but nonetheless authentically 'primitive' experience.

The Highlands and Islands of Scotland offered similar experiences. May Morris, writing in 1919, recalled how moved she was by the unforced beauty of an Orkney Island spinning room and by the colours and patterns of Fair Isle knitting: 'the design is just that of a remote people handling material and process with surety – almost one's idea of Phoenician borderings or Peruvian'.[227] As late as 1938 the design writer Amelia Defries described how in the Shetlands a girl will 'spin, dye and weave' a plaid 'to give her husband on his wedding day, to cover and

191. James Davies of Abercych, Bonath, Pembrokeshire, ladle and spoon, carved and turned sycamore, pre-1945. l. 45.8 cm., l. 46.2 cm. (Rural History Centre, University of Reading).

keep him from all weathers for the rest of his life'.[228] Within Scotland the story of the inter-war crafts was split between an urban stylish continuation of an architecturally based Arts and Crafts Movement centred on Glasgow and Edinburgh art schools and dominated by painted ceramics, tapestry, stained glass, enamel work and silver[229] and the aristocratic and philanthropic patronage and maintenance of traditional craft.

For textile artists in particular, parts of Europe also became places of pilgrimage. Elizabeth Peacock went to Brittany in 1939 to study flax spinning and linen weaving. According to Ella McLeod three days spent with two Brittany weavers 'revolutionised Elizabeth Peacock's handling of linens'.[230] Ethel Mairet visited Eastern Europe in 1927 to study traditionally created yarns, textiles and embroidery. In Scandinavia and Finland, which she visited on four occasions in the 1930s, she saw handweaving of a high standard based on tradition and encouraged and supported by the State.[231] Macedonian embroidery seen in Belgrade in the early 1920s turned sculptor Jean Milne into a textile artist.

Both the country writers and artist craftsmen and women sought authentic traditional practice. Thus studio potters like Leach and Cardew did not admire instances of creativity or development among English rural potteries. Leach dismissed attempts by country potters to find new markets by making fancy or 'art' pottery and he taught Cardew to see Edwin Beer Fishley's 'green-glazed 'decorative' ware as a modern deviation and the pottery's functional wares as the 'authentic channel of expression'.[232] An analogy can be made with Cecil Sharp's campaign to collect folksongs from 1903 onwards. Sharp and other upper-middle-class collectors rejected songs of recent date and cleansed old songs of contemporary interpolations.[233] Rural people, the Folk, were only valued inasmuch as they transmitted the old shapes and the old songs (Fig. 192). Remote places and people were of interest because they existed outside the present. Their inhabitants were in effect anthropologised although the accounts given by these amateur ethnographers were highly idealised. Country people were, for instance, invariably recorded as lamenting the passing of old ways and as positively enjoying arduous handwork. According to the gentleman carpenter Sir George Trevelyan, Peter van der Waals's foreman had 'sawed the great logs at Sapperton, for a trivial wage, but with a joy and delight in great and manly workmanship'.[234] Accounts of craftsmen who delighted in new materials, tools and processes were, on the other hand, never presented positively by inter-war makers and country writers.

The Rural Industries Bureau, set up in 1921 to alleviate unemployment and poverty in the countryside, might be assumed to have taken a less narrow view of country crafts.[235] The

192. Edwin Beer Fishley's grandson William Fishley Holland at Clevedon Court, Somerset, with his son George and daughter Isabel making 'Old English Slip Ware' copied from original specimens in the British Museum, 1935. (HultonGetty).

immediate impetus for its founding came from the Ministry of Reconstruction formed during the Great War. In 1918 the Ministry commissioned a special report on rural revival which was complemented by a document submitted that year by the DIA. This, as we saw in Chapter One, highlighted 'the philanthropic taint' that characterised poorly paid village industries and the dangers of sweating in cottage and home industries and recommended rural factories such as food processing plants as offering the best solution for rural employment.

The Bureau turned out to be more purist that the DIA in its definitions of rural industry. The first two directors of the Bureau, John Brooke and George Marston, had trained as fine artists. Although Marston dismissed the popular philanthropic village craft of repoussé work as 'futile and meaningless',[236] the kinds of rural activities which were encouraged by the RIB tended nonetheless to have aesthetic appeal. The fact that until the late eighteenth century the countryside had been a site for industrial activity – textile production, quarrying and mining, the engineering work of major hedging and ditching projects – was overlooked by the Bureau's directors and advisers. Large rural firms and businesses in country towns were excluded in favour of small-scale village enterprises. Activities integral to the agricultural economy like hurdle-making or food processing were ignored at the expense of wrought-iron work, furniture making or quilt making. One craft, blacksmithing, received the lion's share of the RIB's attention. The livelihood of the blacksmith, who had previously made most of his living through farriery, was being threatened by the introduction of complex agricultural machinery backed up with efficient after-sales service. The RIB helped introduce oxyacetylene torches to enable smiths to repair this new machinery. But the Bureau also encouraged the creation of wrought iron work as a 'sideline' and from 1928 provided patterns for gates, weather vanes and outside lamps which were markedly picturesque and remote from the essentially functional nature of the farrier's work. In effect country crafts were being reinvented for consumption by a new kind of country dweller whose ties to the land were purely recreational.

Some RIB interventions were more adventurous in design terms. With intense application and formidable charm, the weaver Marianne Straub managed to transform design and production at a handful of Welsh textile mills. Her background in both industrial and Arts and Crafts practice helped her appreciate the special qualities of the yarns and cloths that these little mills produced and she found new markets for their textiles among modernist furniture manufacturers and architects (Fig. 75). Quilting was elevated, as we have seen, by the provision of more expensive materials and the introduction of a whole new class of fashionable buyer interested in supporting philanthropy in the Distressed Areas.

George Marston spoke of a need to 'impose our views as to what is good design and technique'.[237] The RIB acted as a design service through the provision of blueprints designed by artist craftsmen and women. As Brooke wrote in 1930 of a show of furniture at Barrows store in Birmingham 'the excellent display was only made possible by hiding the more atrocious exhibits from rural craftsmen, and obtaining, at the last moment, from artist-craftsmen of established reputation, many of the essential articles required.'[238] The RIB was not allowed to trade, but from 1930 a separate retail outlet, Country Industries Ltd, was set up together with the magazine *Rural Industries*. The shop and the organisation of trade shows in the early 1930s inevitably emphasised the artistry in country craft. We know little of the opinions of the grass-roots craftsmen and women being guided by the RIB. The discussions, both in the minutes of meetings and in *Rural Industries*, took place on a higher social level, with articles and other contributions by artist makers – by the spinner and weaver Percy Beales, by the furniture makers Romney Green and Stanley Davies and Peter van der Waals and by experts like Mavis FitzRandolph, the Bureau's quilt adviser. By the post-war period, with yet another artist director, the painter Cosmo Clark, the bias towards the Arts and Crafts end of pottery and hand-loom weaving was even more marked.[239]

The hard fact was that the crafts of the English countryside were depleted in comparison with Continental Europe. A significant group of artists and makers looked elsewhere, to what became known as 'popular art' – the post-industrial art of fairgrounds, ships' figure heads,

193. Barbara Jones, *Savage's Yard, King's Lynn*, painted for the *Recording Britain* project, 1942, water- and bodycolour, 55.3 × 37 cm. (Victoria & Albert Museum).

Punch and Judy, tinselled theatrical engravings, pub signs, gypsy caravans, bargee art. This, Enid Marx argued in 1946, was a more living tradition than any rural 'folk craft' and was marked by 'forthrightness, gaiety, delight in bright colours and a sense of well-balanced design'.[240] Her interest in areas of flat colour, strong elementary shapes and simple pattern was shared by artists and makers as diverse as Peggy Angus, Ben Nicholson, Barbara Jones, Phyllis Barron and Dorothy Larcher, Eric Ravilious and Paul Nash (Fig. 193).[241] All these men and women owned examples of popular art and to an extent shared a sensibility influenced by popular art's bold simplicities.

It was an aesthetic which explains the popularity of puppetry between the wars, an activity hard to define as either art or craft. It was almost the entertainment of choice in the craft world but puppetry's strong links with modernism in the fine arts and design were not in doubt. There had been experimentation with marionettes at the Bauhaus and among Russian Constructivists in the early 1920s and the avant-garde stage designer Edward Gordon Craig had seen puppets as an antidote to the stifling realism of Edwardian theatre.[242] In the first decades of the century there were performances at the Omega Workshops and at the Art Workers' Guild.[243] At Ditchling Douglas Pepler was an enthusiast, publishing his *Plays for Puppets* in 1929 and taking up masked mime in the 1930s. The toys and automata of Sam Smith, admired and proselytized in the late 1930s by Muriel Rose and shown at her Little Gallery, were not strictly speaking puppets, but they drew heavily on the same popular art sources. Rolf Gardiner, in search of 'real music making', introduced masques and Harro Siegel's puppets from Germany into his Wessex Festival Schools, first held in 1933. In the early 1930s

194. William Simmonds, *Flora* and two fauns, puppets photographed *c.*1936. (Tate Gallery Archive).

195. Eve Simmonds at her Dolmetsch spinet, wearing a skirt made up from the Barron and Larcher design *Peach*. (Tate Gallery Archive).

Dartington Hall had its own exotic puppet master, the American Richard Odlin of Seattle. His shows, which included a naked Josephine Baker marionette, were strictly for adults.[244] Helen Binyon's Jiminy Puppets, performing to music written by Lennox Berkeley and Benjamin Britten, had a similar avant-garde appeal.[245]

William Simmonds's productions were among the most remarkable.[246] Simmonds created small, perfectly realised worlds – the circus, a seaport town with sailors dancing the hornpipe, a gaudy Victorian drawing room, a forest glade through which flitted nymphs and fauns (Fig. 194). His puppets performed to Dolmetsch's arrangements of early music (Fig. 195). Thus many craft concerns were brought together in miniaturised form in his productions, from direct carving to an interest in early music and dance, in the popular arts and in country crafts. Puppets could suggest both tradition and innovation, appealing to the sophisticates at Dartington and to the right-wing rural revivalists gathered for Gardiner's Wessex festivals. Significantly, puppetry also looked out of Europe for inspiration – to Bali, to India and Japan and China. This was true of the crafts in general. The search for the 'organic community' was often best conducted far from home.

THE INDIAN CRAFTSMAN

A legacy of the Arts and Crafts Movement was an interest in the applied arts of the Indian sub-continent. In 1878 Morris, Burne-Jones, Millais and Crane had petitioned the British government for the preservation of India's indigenous craft industries.[247] William Morris had regarded India as 'the cradle of the industrial arts' and a vital source of inspiration for British designers, but added that 'Englishmen in India are, in their shortsightedness, actively destroying the very sources of that education – jewellery, metalwork, pottery, calico-printing, brocade-weaving, carpet-making.'[248] The early modern response went beyond handicrafts to include painting and sculpture. The main source for Morris's knowledge of Indian design had been Sir George Birdwood's *Industrial Arts of India* of 1884. Birdwood, the art referee for the Indian Section at South Kensington Museum and an anti-industrialist in the Arts and Crafts mould, had been a passionate admirer of Indian crafts. But he disliked what in Western terms would be designated its fine art. In 1910 the India Society was formed by William Rothenstein, Fry, W. R. Lethaby and E. B. Havell, the former head of Calcutta School of Art,[249] and its foundation signalled a second wave of interest dedicated to what Fry called 'a vast mass of new aes-

196. Dorothy Larcher, carbon tracing from the Ajanta caves showing two women in a palace garden. Published by the India Society in 1915.

197. Ananda Coomaraswamy. (Photo in the possession of the Ashbee family).

thetic experience'[250] – the study of Indian sculptures and wall-paintings.

The response of inter-war artist craftsmen and women to the arts of India was, however, more to do with philosophies than specific works of art. But there were some direct material encounters. As we have seen, the young artist Dorothy Larcher had spent 1909–11 in India with a founder member of the India Society, Christiana, Lady Herringham, copying the frescoes in the remote caves of Ajanta, perched on 'rough, locally made steps which swayed considerably',[251] with the help of a group of Indian assistants. On her return Larcher's interest in Phyllis Barron's block printing and her decision to go into partnership with Barron were enriched by her knowledge of block-printed Indian fabrics and embroidery and her designs echo the exquisite details of flowers, fruits, leaves and birds which she had copied in outline at Ajanta For Ethel Mairet (then married to Ananda Coomaraswamy) a stay in Ceylon from 1903 till 1906 and a visit to India in 1906 were important points of contact with the hand-spun, vegetable dyed and hand-woven textiles which laid the aesthetic foundations for her career as weaver. The raw materials of India continued to be an inspiration. When in 1924 the products of India and Ceylon were displayed at the British Empire Exhibition at Wembley both Mairet and her former pupil Elizabeth Peacock bought Indian yarns in large quantities.[252] Wembley, although mainly a celebration of the educative effects of Empire, also opened the eyes of visitors to the beauties of non-European art and craft. As Amelia Defries, an early woman design critic, pointed out: 'Never before have we had such an opportunity to study the development of human nature and to revise our aesthetic theories and standards of taste…the problem confronting the modern craftsman is to get back to this true outlook.' She responded with enthusiasm to African carvings and Indian textiles and made the connection between Ethel Mairet's work – which was also on show at Wembley – and its sources, observing: 'the coarse weaving by Mrs Mairet, who delights in savage design, is not equal to the races she copies, but it is good strong work'.[253]

The conditions in which the handicrafts of India had flourished stimulated social and educational reflections. The detrimental effects of Empire on Indian crafts, observed by William Morris, Sir George Birdwood and E.B. Havell, were argued with greater force in the writings of the Anglo-Ceylonese Ananda Coomaraswamy, who became an important interpreter of Indian and Ceylonese art and culture in the early twentieth century (Fig. 197).[254] Because he was of mixed race, Western ethnocentrism and the wrongs done to Indian

198. Ethel Mairet, documentary photograph of mat weavers in Ceylon, taken 1903–6 and published in *Medieval Sinhalese Art*.

culture were set out from a fresh perspective even if an English upbringing and education made Coomaraswamy's claims to 'otherness' a little tenuous.

In 1902, as we have seen, he married Ethel Mary Partridge (better known as Ethel Mairet) and they decided to make Broad Campden their home, a plunge into an Arts and Crafts way of life that was surely due to Ethel's influence. Coomaraswamy was wealthy, able to buy shares in Ashbee's Guild of Handicraft and to commission Ashbee to restore and extend the ruined Norman Chapel in Broad Campden. Furnishings were ordered from the Guild, from Morris & Co., from Romney Green and from Ceylonese craftsmen. Between 1903 and 1906 Coomaraswamy was in Ceylon carrying out a geological survey. But he soon developed an interest in Ceylonese art and culture. His first 'cultural' essay, *Borrowed Plumes*, published in Kandy in 1905, was strongly Morrisian in spirit, lamenting the effect of Western customs and imports on local dress and habits. It also reads like the work of a man rediscovering his roots. On his return to England he abandoned geology and worked on a magisterial history of *Medieval Sinhalese Art* published from Broad Campden in 1908. This was a joint enterprise with his wife. It was pioneering in its ethno-historical approach, based on observations of surviving crafts, and rich in oral history. Craft techniques were accurately recorded and beautifully illustrated with coloured lithographs and a generous selection of photographs taken by Ethel (Fig. 198). In part an impassioned attack on the effects of British rule, it was given greater force by elegiac accounts of the arts, crafts and social structures of the Kandyan kingdom up until the eighteenth century.[255]

Coomaraswamy was one of the great synthesisers of Eastern and Western ideas. His writings drew on occidental methodologies and information set down by British government servants and administrators like Birdwood and Havell.[256] He quoted A. J. Penty's *Restoration of the Gild System* in *Medieval Sinhalese Art* and in a later study, *The Indian Craftsman* of 1909. In turn C. R. Ashbee and Penty found his accounts of Ceylonese and Indian Guilds inspirational.[257] Coomaraswamy's interest in Ceylonese and Indian folk music and song went in tandem with an appreciation of early English music. In his exotic and elegant drawing room at Broad Campden one evening shortly after his return from Ceylon in 1908 he argued that European music since the Renaissance had declined into decadence as musical instruments had become more complex – just the sort of argument that Cecil Sharp or Arnold Dolmetsch might have employed.[258]

The set of ideas which Coomaraswamy preached with eloquence in Britain had, however,

rather more subversive connotations in India. From Broad Campden he used the Essex House imprint to publish *The Deeper Meaning of the Struggle* (1907), a partisan account of Indian hostility to British rule. Coomaraswamy had noted the British conviction of 'the absolute superiority of their own language, literature, music, art, morals and religion'.[259] He supported the Benghal Swadeschi movement of 1905–10 to boycott British goods. But he took it a step further, arguing that the alternative to British manufacture must be handicraft, not the products of Indian-owned factories.[260] In that way he acted as a direct inspiration to Mahatma Gandhi who read Coomaraswamy in South Africa in 1910 and who, on a visit to England in 1914, sought advice on hand-spinning and weaving from Ethel Mairet.[261]

If in India Coomaraswamy was a political voice, in England his appeal was more complex. The original Arts and Crafts movement was rooted in social reform and was essentially practical.[262] Its perceived failure as a political force by 1916 had the effect of making spiritual solutions to the industrialised world seem more promising than political ones. Thus Gill passed from Fabianism to Roman Catholicism and found much of value in Coomaraswamy's work and thought. He took on Coomaraswamy's aphorism 'The artist is not a special kind of man, but every man is a special kind of artist ' and made it his own.[263] It was the kind of non-hierarchical remark that made sense of the crafts. Coomaraswamy introduced Gill to Indian sculpture and in 1914 Gill wrote an introduction to a series of photographs of Indian sculpture selected by Coomaraswamy. Indian sculpture's frank sexuality appealed to Gill, and Coomaraswamy's dismissal of the drawing room art of the West and of the distinction between 'fine' and 'decorative' informed Gill's conclusion that 'An artist is a maker of *things* and not of pictures of things.'[264] Gill was not alone. Bernard Leach saw Coomaraswamy as 'rare and very important to the whole world'[265] while Ethel Mairet continued to correspond with him after their separation and her second husband Philip Mairet regularly published his ideas in *The New English Weekly*.

Coomaraswamy saw that the growing interest in mysticism and Eastern cultures in the West was symptomatic of what he dubbed 'The Discovery of Asia'. Engagement with the East, he argued 'has become to Europe no longer a piratical expedition, but a spiritual adventure'.[266] He was, in fact, just one of several guru-like figures who captured Western hearts and minds in the first decades of the century – figures like the charismatic Serbian Dimitri Mitrinovic, who had a powerful effect on Bernard Leach and on Philip Mairet, the Bengali Rabindranath Tagore and the Russian mystic George Gurdjieff. All these spiritual leaders combined an impressive familiarity with Western thought and literature with an ability to expound philosophies rooted in pre-industrial cultures. Philip Mairet, writing of Mitrinovic and Gurdjieff, neatly summed up the attraction of such figures – 'nurtured in conditions of what are now called relatively "backward" civilisations…deeply versed in the folklore of predominately peasant societies' but possessed of 'much modern metropolitan learning'.[267]

It is now impossible to discuss these apparently positive British attitudes to non-Western culture without reference to Orientalism. Until the 1970s the term had mostly been employed neutrally to describe the study of the languages, religions, customs and literature of the East. But in his book *Orientalism* Edward Said firmly linked such activities to Imperialism, and to a Western project of domination and control achieved by essentialising the East as pre-industrial, spiritual, timeless and static – 'the ancient East fundamentally unchanged' as Ashbee had put it.[268] Of course these were exactly the qualities which drew twentieth-century makers to non-European crafts and it even could be argued that the search for an 'organic community' at home led to a species of Orientalising activity in remote areas of the British Isles. Coomaraswamy's phrase 'Discovery of Asia' hints at something rather more complicated, in which the West paid homage to the greater wisdom of the East. That makers found non-European craft, art and philosophies inspirational is not in doubt. They were also drawn to guru-like gatekeepers and interpreters from the Orient. But the admiration and interchange cannot disguise the fact that many came with their minds partly made up, in search of all the essentialising Orientalising clichés.

THE FAR EAST

Contacts with the Far East, especially with Japan, suggest how problematic the search for 'organic communities' far from home could be. The period from 1870 until about 1920 marked a shift from a one-sided European *Japonisme* to an East–West interchange that was to prove crucial for the history of twentieth-century crafts in both Britain and Japan.[269] By the early twentieth century, as we have seen, a European and Japanese taste for early Chinese ceramics was also developing in tandem with modernist theories about pure form. In Britain a growing interest in such ceramics was enriched by the literary activities of Arthur Waley and Ezra Pound. Waley's *One Hundred and Seventy Chinese Poems* of 1918 and his *Zen Buddhism and its Relation to Art* of 1922 together with Pound's *Cathay* of 1915 based on Ernest Fenollosa's translations of poems by Li Po and his publication of Fenollosa's essay on ideograms *The Chinese Written Character as a Medium for Poetry* emphasised the purity, spontaneity and abstraction of Chinese and Japanese poetry and aesthetics.[270] Chinese painting in particular began to seem more accessible, especially if, as Fry advised, it was approached 'in the same mood of attentive passivity which we cultivate before an Italian masterpiece of the Renaissance, or a Gothic or Romanesque sculpture'.[271] Fry noted on a trip round the London galleries with Tenshin Okakura that the influential Japanese writer admired Anglo-Saxon illuminated manuscripts while Renaissance and later art left him at a loss: 'He failed to see any idea that lay behind that photographic vision.'[272] Okakura thus emerged as a natural modernist.

There was a certain randomness about much of Western interest in the Orient. Artists and writers took what they needed. Oscar Wilde's mischievous assertion that 'the whole of Japan is a pure invention'[273] was as true for the 1920s and 1930s as it had been for the 1890s. After all, Fry, Waley, Pound and potters like Murray never visited Japan or China.[274] The influence of Japan and medieval China was most evident in the world of studio pottery, but the calm beauty of Japanese interiors had an impact on the interior architecture of the 1930s. In particular Wells Coates was singled out by Paul Nash in 1932 as having been trained by Japanese builders with 'a sense of just those values which are needed today in modern architecture'.[275] Coates was no craftsman but in an article of the same year he took the interior of a Japanese house as a model for the integration of architecture and furniture by a single designer.[276] Coates may have romanticised his Japanese connections but he had certainly lived in Japan until the age of eighteen and his education was apparently a synthesis of East and West with his tutor teaching him drawing with a brush, paper making, printing, silk worm rearing, spinning and weaving, dyeing and boat building and ritual food presentation as well as shorthand and typing.[277] His early interiors, a flat for the actors Charles Laughton and Elsa Lanchester (both collectors of Orientally inspired studio ceramics) and a house for the Labour MP George Strauss, were striking for their simplicity, with fitted furniture and Japanese-type screens (Fig. 133).

In the field of textiles a more direct Japanese influence can be traced to Frank Morley Fletcher's 1916 handbook *Wood-Block Printing* for W.R. Lethaby's Artistic Crafts Series. Morley Fletcher realised that the Japanese method of wood block printing which he taught at the Central School of Arts and Crafts from 1899 until 1904 could have a wider application: 'Perhaps no work goes so directly to the essentials of the art of decorative designing for printed work of all kinds.'[278] As Paul Nash pointed out in 1926 at the height of the hand block-printed textile revival: 'it neatly synchronises with the revival of the art of wood engraving and cutting which has taken such a strong hold in this country during the last few years.'[279] A number of wood block textile designers, including Joyce Clissold and Elspeth Anne Little, trained at the Central where they would have had access to the School's impressive collection of Japanese prints. They also trained in the book production and design departments where wood-engraving, fostered by Noel Rooke, was treated as an independent art form. From 1928/9 the textile department at the Central School taught block cutting and printing skills.[280] But the simplicity of the Japanese block-printing method – with the paper pressed onto the block by hand without a printing press – was perhaps as relevant to block-printed textiles as the parallel wood-engraving revival.

In Japan a search for national identity in the face of the sweeping Westernisation introduced

199. Soetsu Yanagi in his Tokyo study in 1913 with a bust of Mme Rodin by Auguste Rodin, *Cypress* by Van Gogh and a Ukiyoe print by Eizan. (Nihon Mingeikan Collection, Tokyo, Japan).

200. The magazine *Shirakaba*, 1913, with a cover designed by Bernard Leach. (Nihon Mingeikan Collection, Tokyo, Japan).

by the Meiji Restoration from 1868 affected all areas of culture from historiography to anthropology to debates about design and craft.[281] In the visual arts there was the sense of a joint enterprise, involving artists and writers from both East and West liberated by the non-hierarchical, decontextualising formalism of Modernism. The process was concurrent with reassessments of Indian art from the 1880s onwards. The two sets of rediscovery represented the desire of Indian and Japanese intellectuals (and cross-cultural figures like Ananda Coomaraswamy and the American Ernest Fenollosa) to recuperate indigenous cultures from the economic and industrial onslaught of the West, employing contemporary occidental social and artistic theory.

Bernard Leach's career exemplified the synthesis between cultures in a complete if problematic way.[282] Leach had been born in Japan and was partly inspired to revisit his birthplace after reading the colourful writings of Lafcadio Hearn, an Irish Greek who had taught at Tokyo Imperial University in the 1890s. Hearn's accounts of 'Old Japan', though sentimental, suggested that the West could learn from contact with a religion of tolerance like Japanese Buddhism and with what appeared to be a society less fragmented and divided than the industrialised West.[283] Leach went to Japan to teach etching and soon encountered a privileged Westernised Tokyo intelligentsia centred on the magazine and the group known as the White Birch or *Shirakaba*. At that date, between 1910 and 1915, its members were immersing themselves in aspects of European culture, particularly in German Expressionism and French Post-Impressionism.

Leach, as a former Slade student and member of the Bloomsbury-based Friday Club, was well able to give and take in these debates and he established a particular rapport with a wealthy young philosopher, Soetsu Yanagi (Fig. 199).[284] Their relationship was marked throughout by a series of fruitful interchanges. Leach introduced Yanagi to the art and poetry of William Blake (Fig. 200) and the two men wrote on Blake in the April 1914 number of *Shirakaba*. Both were interested in the theories of Henri Bergson and the poetry of Walt Whitman and in anti-rational mystical writing. While Yanagi was busy completing a study of Blake in 1915, Leach was arguing for the destructive effects of Western art on Japanese culture in *The Far East*, an English language magazine published in Tokyo.

Leach chose ceramics as a model of this decline. He had taken up pottery in a lively amateur spirit after attending a fashionable *raku* party in February 1911. He and his architect friend Kenkichi Tomimoto were taught by Kenzan VI who was, therefore, sixth in line of succession to the first, seventeenth-century, Kenzan, a potter of heterodox gifts. According to Leach, Kenzan VI was not 'aesthetically conscious in the international and contemporary sense'[285] and he seems to have acted chiefly as Leach's technician, building him kilns and enabling him to

201. A page from Leach's article 'The Meeting of East and West in Pottery', 1915. (Holburne Museum and Crafts Study Centre, Bath).

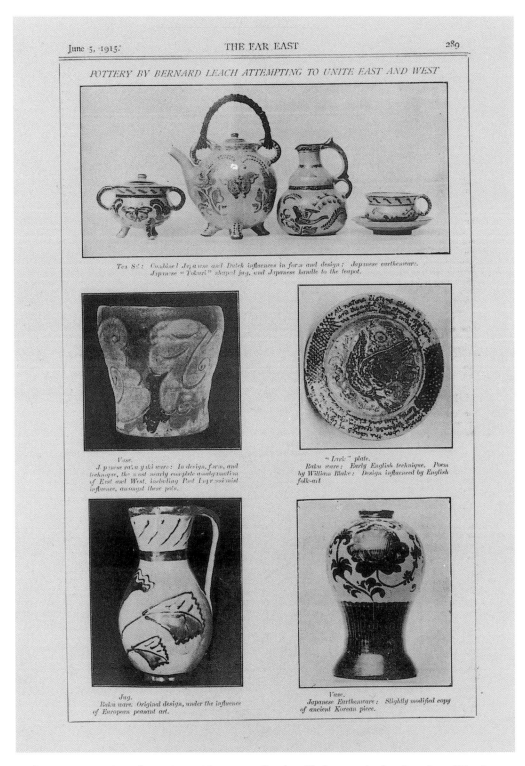

June 5, 1915. THE FAR EAST 289

POTTERY BY BERNARD LEACH ATTEMPTING TO UNITE EAST AND WEST

Tea Set: Combined Japanese and Dutch influences in form and design: Japanese earthenware. Japanese "Tokuri" shaped jug, and Japanese handle to the teapot.

Vase. Japanese raku yaki ware: In design, form, and technique, the most nearly complete amalgamation of East and West, including Post Impressionist influence, amongst these pots.

"Lark" plate. Raku ware: Early English technique. Poem by William Blake: Design influenced by English folk-art

Jug. Raku ware. Original design, under the influence of European peasant art.

Vase. Japanese Earthenware: Slightly modified copy of ancient Korean piece.

realise an outpouring of pots in a wide range of styles. He bequeathed to Leach and Tomimoto the joint title Kenzan VII, a succession which Leach would later invoke to give crucial credibility to his self-appointed role as an Anglo-Oriental potter.

In his articles in *The Far East*, Leach developed ideas about ceramics acting as a bridge between the cultures of the East and West. He had already asked 'Why should not a porcelain vase be as beautiful as a picture?'[286] and his reading of Clive Bell's *Art*, recently published, helped him to collapse the hierarchies of the arts and to make all kinds of cross-cultural, formal connections.[287] The illustrations for his articles were set out in a series of Puginesque contrasts. A Wedgwood vase exemplified the 'Unnatural, useless, false' in ceramics in contrast with early Chinese and Korean celadons.[288] There was an analysis of the formal beauties of early Chinese pots and a discussion of the 'complete system of aesthetics' which centred on the tea ceremony. A page of photographs of Leach's own raku and stoneware suggested the way forward (Fig. 201).[289] They reveal a remarkable mixture of sources. A plate was inscribed

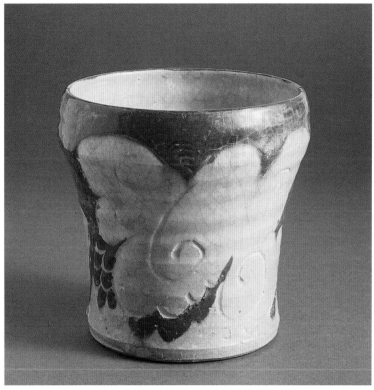

with Blake's poem *The Lark* in the style of English slip-ware, discovered through reading Lomax's *Quaint Old English Pottery*, given to him by Tomimoto (Fig. 202). A vase decorated with foliate passages of flat colour was described by Leach as 'In design, form and technique, the most nearly complete amalgamation of East and West, including Post Impressionist influence' (Fig. 203).

Leach admired but essentialised Japanese culture, arguing that while the West was dominated by cold, scientific materialism, the East had declined into decadence: 'the result of the exaggeration of the spirit; of self-expression degenerating into a general abandonment of selfishness or dreamy idealism'.[290] He believed that a synthesis of East and West, whether in pottery or in culture in general, could bring about that unity of the spiritual and the practical which would spark off 'the greatest developments in the history of human society'.[291] These ideas had a powerful influence on Soetsu Yanagi. By 1918 Leach had built a pottery at Abiko on Yanagi's land and he recalls talking about craftsmanship with Yanagi:

> the English movement under William Morris was the subject of much discussion, and I clearly recollect how he questioned me about an equivalent term for peasant or folk art in Japanese. No word existed and he finally composed the word *mingei*, which means 'art of the people' and had now become part of the Japanese language.[292]

It seems likely that Leach introduced Yanagi to the writings of Morris and that Morris's positive attitude to folk art and to non-Western art influenced Yanagi's growing interest in locating Japan's own 'organic community'.[293] Morris's anti-industrial arguments were adapted to the cause of a national design identity, found by Yanagi in its purest form in the folk art of remotest rural Japan and her colonies and peripheral regions.

Both Leach and Yanagi appear, unlike Morris or Coomaraswamy, to have put aesthetics before humanity in their search for inspirational craft. In the 1920s there were a number of Japanese Arts and Crafts workshops set up to encourage peasants to make craft and cultivate the land in a Guild Socialist spirit.[294] But Yanagi and Leach's interest in folk and 'primitive' artefacts was aesthetic rather than political and apparently free from social responsibility. Tellingly, Yanagi pointed out to Leach that Tolstoy would be remembered for his novels, not for his work as a social reformer.[295] Their joint interest in the crafts of Korea, which they visited together in 1918, was a case in point. It needs to be seen in the context of the

202. Bernard Leach, *raku* plate, decorated in red and blue slip with William Blake's *The Lark* and a lark in red slip, 1915. diameter 20.6 cm. (Formerly collection of Bernard Leach. Photo Peter Kinnear).

203. Bernard Leach, *raku* vase with ochre, red and cobalt blue slip, 1913. h. 14 cm. This vase, or one very similar, is illustrated in *The Meeting of East and West in Pottery*. (Formerly collection of Bernard Leach. Crafts Study Center, Holburne Museum, Photo Peter Kinnear).

204. Bernard Leach and Hamada opening a joint kiln with Sono Matsumoto at Mashiko, Japan, 1934. (Pitshanger Manor & Gallery, London Borough of Ealing).

annexation of Korea by Japan in 1910, followed in 1919 by a brutal suppression of a Korean uprising. For Leach, however, Korea functioned as an Edenic place whose inhabitants were 'childlike, spontaneous and trusting, making pots and other artefacts "naturally".'[296] As Yanagi explained in his 1931 essay *The Kizaemon Teabowl*, 'It is impossible to believe that those Korean workmen possessed intellectual consciousness. It was precisely because they were not intellectual that they were able to produce this natural beauty.'[297] For Yanagi Korean pots were 'healthy', not 'sickly or nervous' like much of modern civilisation. Leach's interests in child art and in the writings of Froebel, Pestalozzi and Montessori fed into this thinking. For Leach, Korea was outside time: 'We had something akin to this in Europe up to about the thirteenth century, when religion and life were all one.' But as he pointed out: 'Backwards we cannot go; a greater consciousness is our birthright; our difficult task is consequently one of deepening consciousness towards a new wholeness.'[298]

Their shared interest in Sung ceramics displayed a similar detachment from context and helped shape their ideas about the practice of the crafts. The formal beauty of Sung pots struck both men forcibly and both discussed the context in which such apparently unvaryingly successful forms were produced. As Yanagi argued in his 1927 manifesto *The Way of Craftsmanship*, Sung pots owed their beauty to the fact that they were communal products, not individualistic.[299] They were not made by artists. As Yanagi explained at a conference at Dartington Hall just after the Second World War Tz'ŭ Chou wares were decorated by 'boys around the age of ten, children of poor families, many of whom no doubt disliked the work and had to be forced to do it. Occasionally, as they worked, their eyes would be blinded by tears.' But the 'endless repetition' resulted in a 'total disengagement' and brushwork of a high order.[300] Nothing more remote from Morris's vision of the happy fulfilled medieval craftsman can be imagined.

Such ideas were endorsed by Hamada, the potter who returned to England with Leach in 1920 and who helped Yanagi formulate the concept of *mingei* and collect objects for the Japanese Folk Craft Museum in the later 1920s. The magazine *Artwork* reported in 1929 that for Hamada

> the effects of specialisation and division of labour has produced convictions at variance with some current theories of the West. In the East many specimens of handicraft which we admire have resulted from the apportioning of processes to separate craftsmen, each trained to a particular job. Child-labour, even, has been employed without loss of vitality in the whole effect.[301]

Yanagi and Hamada's belief in the virtues of repetitive work had repercussions in Leach's workshop practice and lay behind his ideas about team-spirit codified after the Second World War as 'a "we-job" instead of an "I job".'[302] Unlike Eric Gill, Leach did not believe that every man is 'a special kind of artist'. In 1928 in *A Potter's Outlook* he noted that 'In Japan a small pottery such as mine would have a sort of family of half a dozen expert craftsmen each trained to a particular job from childhood'.[303] This team needed to be led and Leach agreed with Yanagi that in the absence of a living folk tradition it was for the artist craftsman 'who had reached international mindedness' to set a standard (Fig. 204).[304] This explains Leach's decision to introduce division of labour in the mid-1930s. It explains his suspicion of art students and his preference for biddable local labour. It explains his cruel categorisation of his son David as a craftsman, not an artist-craftsman. It explains why he found working in Japan on return visits so pleasurable, for in Japan there were an abundance of 'expert craftsmen' who could help realise Leach's flow of ideas. Janet Darnell Leach, a left-wing Texan who was to marry Leach in 1956, was in Japan in 1954 and saw something she disliked in Hamada and Leach's agreement to 'a dribbling increase in the workman's pay…our so-called humanitarians wanting to take care of the little people, which actually only serves to keep them little'.[305]

Together Leach, Yanagi and their circle created a Japan of the imagination, constructed around their prejudices and sympathies. Leach and Yanagi's powerful personalities, however, made a form of avant-gardism into an orthodoxy. The taste of the potter William Marshall, a local lad taken on at the Leach Pottery in 1938, suggests that there were alternatives. Marshall

threw some of Leach's most handsome pots from the 1940s onwards. He learnt about Japan chiefly through conversations with Sono Matsumoto, a cultivated Japanese woman friend of Leach's and through reading and visiting exhibitions. His ceramic hero was the maverick potter Rosanjin, a figure never mentioned by Leach and his Japanese circle.[306] Ronsanjin was a drunkard, a womaniser, a restaurant owner and antique dealer who found the tea ceremony tedious and who got ideas from clipping images out of auction catalogues.[307] Yet he was a remarkable potter and Marshall's admiration for him, in the context of his long years of service at the Leach Pottery, seems a touch subversive. Or it might be seen as further proof that immersion in another culture is invariably a process of invention?

Privately Leach's association with Japan had its disappointments. By the 1930s he came to dislike the pottery of his friend Kanjiro Kawai and was horrified by the pace of Westernisation in Japan. On a visit in 1953–4 he even wrote harshly of Soetsu Yanagi in the privacy of his diary.[308] There had been disagreements with Tomimoto in the 1930s when the latter had embraced design for industry. In 1954 Leach found his pots 'overworked and meticulous'[309] and found himself again 'deeply unhappy' with Kanjiro Kawai's pottery.[310] His happiest moments on that visit were spent with the 'delightful unspoiled' hill-potters of Onda on the southern island of Kyushu. But even there he noted that the 'assimilative capacity' of the Onda potters had, like that of the potters of Fremington in Devon 'waned and requires new props'.[311] But in his public utterances he was never to abandon the early modern idea that East/West unity would bring mankind the best of both those worlds, bringing an end to the duality of faith and reason, the material and the spiritual. In a craft world which, as the century progressed, increasingly lacked ideas, this was a big idea and it continued to fascinate his disciples into the 1960s and beyond.

AFRICA

The art and craft of Africa south of the Sahara was a source of inspiration for artists and makers between the wars. In Britain it became fashionable to acknowledge innate African good taste. The DIA and the Omega Workshops publicised and sold Charles Sixsmith's machine printed textiles for the West African market – of particular interest because they were the result of an active collaboration with their African consumers. Then there was a Paris based avant-garde 'discovery' of African sculpture from 1905 onwards.[312] As with Japan and India comparisons were made with European medieval art. By 1920 Roger Fry was writing of African carvings: 'some of these things are great sculpture – greater, I think, than anything we produced even in the middle ages.'[313]

But Africa, like India, sparked off guilty musings in which Empire was perceived to be a destructive force. In 1929, writing in the specialist journal *Oversea Education*, William Rothenstein noted with dismay that the fine art training exported to Africa from England consisted in 'copying feeble outline maps – drawings they certainly were not – of English candlesticks, chairs and wash-stand jugs; nowhere was there any understanding shown of the beautiful shapes and swift rhythmical forms evolved by local genius.'[314] Rothenstein, by then Principal of the Royal College of Art, had an appreciation of African art mediated through early modernism. Against the 'feeble outline maps' he set a recent exhibition of drawings and paintings by pupils from an elite school, Achimota College in the Gold Coast – 'full of promise and redolent of West Africa'.[315] These students had been taught by G.A. Stevens, a youthful Slade-trained painter who was engaged on a recuperative project, persuading his students of the beauty of their native art forms. He found that they had a particular contempt for traditional craft activity:

These students knew that wood sculpture was connected with primitive religion and what they called 'the worship of idols', and they turned their backs on that when they left the bush. Pottery also smacked of the bush. It was dirty, and women's work anyway. Weaving? All right for villagers, but 'we are now civilised' and either wore European clothes or bought our cloths ready made from Manchester.[316]

For artists and teachers in West Africa the situation was full of irony. Among uneducated West Africans art seemed to be part of everyday life in a way that would have delighted William Morris or Eric Gill. These indigenous village crafts, Stevens believed, 'must form the basis for any vital African culture'.[317] Yet they were precisely the activities despised by the educated elite.

The crafts of West Africa were also the special interest of K.C. Murray, an education officer in Nigeria from 1927.[318] He studied with Bernard Leach while on leave in the late 1920s, was passionately interested in the indigenous pottery of West Africa and was highly critical of the 'futile pseudo-crafts' being taught in African schools by English teachers.[319] He found, for example, that the clay modelling taught in Nigerian schools was 'ill-adapted to a people who are accustomed to handle clay, and who in many instances make their own clay pots, the very young child learning from her mother'.[320] Murray's views were echoed by Margaret Trowell in East Africa. Trowell was the wife of a medical officer working in Nairobi who from about 1934 collected patterns and descriptions of craft processes. She worked among the wives of tribesmen dispossessed of their land, and was appalled by the poker-work blotters and raffia dinner mats associated with European craft training.[321]

Western admiration for African creativity was tinged with paternalistic and evolutionary ideas; that Africans should not make the 'blind leap' from 'primitive' to twentieth-century life and should, accordingly, undergo some kind of apprenticeship, reproducing the various stages of European development. As Margaret Trowell explained: 'We must tackle the problem as it was tackled in Europe in the Middle Ages when small groups of people were self-supporting.'[322] Given time, Stevens suggested, Africa would produce her Giotto, her Raphael and Michelangelo.[323] For artists and makers disillusioned with so-called 'progress' in Europe, Africa functioned as a tabula rasa, a chance to start the development of art afresh. As Stevens pointed out:

> The African has been led to take art as a matter of course; so far, at any rate there has been none of that silly self-consciousness which we find at home when 'educated' people say 'of course I'm not artistic!' An African takes art as he takes food and exercise, as a natural ordinary need, and he satisfies his need with joy and laughter, neither is there any straining and striving or any high-falutin' talk about the soul.[324]

G.A. Stevens, K.C. Murray and Margaret Trowell publicised their views in the journal *Oversea Education* and brought exhibitions of their pupils' work to England, making links between modernism, child art and so-called 'primitive' art. Murray in particular expressed doubts about teaching non-indigenous activities like painting and drawing in West Africa and was careful to avoid imposing European conventions such as perspective on his pupils. He restricted teaching to the practical mixing of colours and application of flat washes. Like Marion Richardson he encouraged pupils to make their own pigments from local materials. African tools only were used for wood-carving. Terracotta sculpture was made on traditional lines. Like Stevens in the Gold Coast, Murray had an essentialist belief in the natural creativity of his pupils – 'it can be assumed that there is a latent artistic talent in nearly every African' – and he was anxious not to destroy what appeared to him to be an innate racial sense of colour and form which incidentally made his pupils natural modernists.[325]

By the late 1930s a German-Russian sculptor Herbert Vladimir Meyerowitz became a dominant figure in British African art education. With a background in the Berlin Kunstgewerbeschule he was far more interested in the craft-into-industry possibilities of West Africa than in any innate African genius for art. But like Trowell and Murray he deplored the colonial training in schools and colleges. Describing an exhibition of arts and crafts held in Salisbury in Southern Rhodesia he recalled:

> the masses of doilies, embroidered cushions, horribly embroidered…I felt bitterly ashamed of all this trash for which we were responsible and which we had inflicted on these people in the disguise of education…while progressive educationalists had discarded all this stuff at the beginning of the century.[326]

205. Achimota College, Gold Coast, 1943, tile making using machinery salvaged by Harry Davis from an abandoned gold mine. (*Oversea Education*).

Meyerowitz came to Achimota College as an art master in 1937 and was soon discussing the possibility of an Institute independent of the school which would survey and record West African crafts, laws, languages and customs and set in train an upgrading of craft skills.[327] He was inspired by the French achievement at the Maison Artisanat at Bamoko in the French Sudan, a craft centre which introduced low-level technology – looms, potters' wheels – to supplement local skills.[328] He was also keenly aware of craft revivals in Sweden, Russia and Poland, as well as the well-publicised Mexican cultural missions to rural areas after the 1910 revolution.[329]

In a preliminary survey, carried out with his wife, Meyerowitz established that many Gold Coast crafts carefully described by the ethnographer R.S. Rattray in his classic *Art and Religion in Ashanti* were fast vanishing. But from the outset Meyerowitz planned that the production side would be a 'marriage of the old aesthetic skills and power to modern techniques'[330] – what Michael Cardew aptly described as the 'Bauhausing' of the crafts of West Africa.[331] His plans were given greater urgency after the outbreak of war in Europe. He began to see the Institute and its training as a means by which West Africa could become self-supporting, turning traditional crafts into new industries.[332] He picked on pottery as the craft best suited to begin this transformation. He brought out Harry Davis, who, as we have seen, was an untypical representative of the inter-war British studio pottery movement with a tremendous understanding of simple engineering and ceramic chemistry. Using salvaged and improvised equipment (Fig. 205), Davis set up a unit making water-coolers, previously imported from Germany, and a brick and tile works which became the basis for Meyerowitz's West African Institute of Arts, Industries and Social Science, formally recognised by the Colonial Office in 1943 with a generous grant of £127,000.[333]

By 1942 Harry Davis had decided to join his wife May in a craft-based Bruderhof community in South America and Michael Cardew was brought in as a substitute, together with Dicon Nance. As we have seen, both Davis and Nance were adept at low-level technological improvisation. But Cardew shared Leach's ambivalent attitude to 'machines'. He had been told by Christopher Cox, a former Oxford contemporary now at the Foreign Office, that he was being sent to the Gold Coast primarily as an art educationalist not as 'a mere competent technician'.[334] Nance recalls that from the start Cardew had no sympathy with the project: 'He was completely the wrong person. He did foolish things – he had no idea about firing and kilns and so on...he was a very difficult person to help.' (Fig. 206).[335] Indeed Cardew's letters to his wife, his diaries and autobiography reveal the extent to which his

206. (*above*) The kiln at Alajo, Achimota College, Gold Coast, 1943, designed by Michael Cardew using Bourry's *Treatise on Ceramic Industries*. (Seth Cardew).

207. (*top right*) Michael Cardew, Harry Davis and Dicon Nance photographed with the cooler-unit apprentices. On the back of this photograph, which Cardew sent to his wife Mariel, he fulminates against the exclusion of the labourers from the group. (Seth Cardew).

208. (*centre right*) Michael Cardew making small vases at Vumë, Volta River, 1947. (Seth Cardew).

209. (*bottom right*) Happiness: Kofi Athey and Michael Cardew at Vumë, Volta River, 1947. (Seth Cardew).

romanticism and highly developed aesthetic sensibility disrupted his ability to carry out tasks which Davis, with his more pragmatic approach, was able to handle successfully. Cardew found the pottery to be a 'bloody great factory'.[336] Davis's clay body felt horrible – 'very unplastic and short' – and was made with the help of a great deal of mechanical equipment. Cardew decided to abandon it and try to recreate the 'of course much less scientific' stoneware bodies he had learnt about at St Ives.[337] This was to prove disastrous. Cardew was never to create a glazeable body during his time at Achimota. Inscribed in his African experiences were all the prejudices and limitations of the British studio pottery movement.

Cardew's experiences at Achimota also exemplified the problematic nature of colonialism

and its cultural impact in Africa. To his horror, some of the unpleasant features of contemporary life in Britain were reproduced on the Gold Coast, particularly the look and atmosphere of the College itself: 'a filthy white suburb of a place'.[338] Cardew soon developed strong views about his workforce. There were two distinct groups – a relatively small number of apprentices, one or two of them with Achimota College connections, and a large number of labourers (Fig. 207). Cardew realised that for the educated African apprentices the decision to work as a potter was a bold one. Pottery was woman's work in West Africa but this barrier could be overcome because his pottery was using wheels, kilns and employing different processes. But, as we have seen, in West Africa manual work had no romantic connotations. Cardew found this hard to understand, observing naively that 'all the "educated" classes here are frightfully narrow and out date' about manual work.[339] Like many colonials, Cardew found he preferred uneducated and therefore 'unspoilt' Africans to the products of Achimota College.

His feelings of alienation were heightened when he formed an attachment to one of the labourers, Clement Kofi Athey. Partly to deal with these homosexual feelings – 'an emotional turmoil, a dilemma and a contradiction in myself'[340] – Cardew began to develop ways of working with the entire workforce, not just the apprentices. He conceived plans for a specifically African type of high-fired highly decorated pottery which he believed was adapted to the genius of the race. By the beginning of 1944 he was in a Rousseau-esque frame of mind: 'I really do rather strongly love these far-away, different, child-like people…always loveable and "capable of art" in a way Northerners hardly *ever are*'.[341] In un-Europeanised Africa it seemed to Cardew that art was completely integrated with everyday life. The realisation moved him deeply and permanently: 'it is the recognition that once – in the Golden Age, or before the Fall (that is, when we were very young) – we all had this "poetic" power.'[342]

In 1945 the Council of the Institute decided to close the pottery which made huge losses as a result of Cardew's policies. Cardew nonetheless decided to remain in West Africa. He saw that he was now of an age:

> to make potters as well as pots, to build a tradition; and I can do much more with Africans than with the English…at least they are not mean in Spirit, they have got the stuff, the instinct, waiting only to be guided, helped and developed…the flower of their sense of form had never been crushed by the slavery of Puritanism.[343]

More importantly, Cardew also began to develop his knowledge of indigenous pottery – partly through reading Rattray and partly by observation. He wrote to his wife of the Ashanti shapes his small team were making:

> w. decoration scratched *direct* onto clay after throwing, the fine lines made en masse by means of a corn cob (Ashanti women, see Rattray) & wavy lines with a porcupine quill and then the first lines partly rubbed out by fingers. Over that a thin white slip…If these pots come out at all as I *hope* they will, they will be the most exciting, and lovely pots *ever made* in modern times!![344]

Cardew was encouraged in his decision to stay in the Gold Coast by the sculptor Leon Underwood who was in West Africa in 1945 collecting carvings and other examples of African material culture for a British Council exhibition.[345] Cardew needed little persuading. He believed that in Africa he could make better pots and escape the unreality of which Leach had written in 1928, in which, as Leach put it, the life of the studio potter appeared to be a game.[346] Nonetheless he faced enormous difficulties. When he moved away from Achimota and upstream to the little village of Vumë Dugame to set up his own pottery he immediately changed status (Figs 208, 209). He became a more vulnerable figure without the colonial set-up to back him. All the problems which beset him at Achimota – the creation of a stoneware body and a fireable kiln – followed him to Vumë and transformed his rather casual attitude to skill and technology as he came to see that a pioneer potter needed a semi-scientific grounding.

The pottery was financially a failure but Cardew produced some pots he thought important (Fig. 210). Those that survived the invariably disastrous firings were given names – 'Volta', 'Defo', 'Gbeme'[347] – to signal their status as works of art, and shipped to England. He also was making water-coolers and domestic wares. The studio pottery ethic was not always appreciated by the expatriate community. The water-coolers had to look uniform and some traders would not take his bowls because they appeared flawed.[348] But in conditions of immense hardship Cardew evolved decorative motifs that were the beginnings of his new, African inspired style. In an exhibition held in Accra at the British Council headquarters in 1948 he included examples of native pottery and observed that 'this type of 'primitive' decoration can be effectively transferred to the decoration of glazed ware'.[349] This realisation, that Africa could generate new designs, had begun to be fully developed in Vumë and was carried forward with real success during his post-war career as Pottery Officer for the Department of Commerce and Industries in Nigeria.

There were many ironies and complexities about Cardew's work from 1952 from 1965 at the Pottery Training Centre which he set up at Abuja, Nigeria. Some of the most beautiful pots

211. A colonial pottery scheme at Ibadan, Nigeria in 1911. (Pottery Gazette).

212. Ladi Kwali hand-building a pot in the traditional Gwari fashion at Abuja in the early 1960s.(Photo Michael O'Brien).

made there were strange hybrids, the work of two women potters, Ladi Kwali and Halima Audu, who joined the pottery in 1954 and 1959 respectively. Cardew had first seen Ladi Kwali's pots on a 1950 tour during which he conducted a thorough survey of indigenous pottery in key areas of Nigeria. In the Emir of Abuja's house he saw her 'great storage jars, water pots, casseroles, bowls, flasks, and big jugs, all decorated with incised designs, partly geometric and partly in a stylised or schematised kind of naturalism: scorpions, lizards, crocodiles, chameleons, snakes, birds and fish'.[350] From the start Cardew had been determined that women, the natural potters of the region, should also train at the pottery. An earlier colonial pottery scheme at Ibadan at the beginning of the century had employed boy apprentices and completely failed to make use of the skills of the local women potters (Fig. 211).[351] At Abuja Ladi Kwali learnt to throw but the pots for which she and Halima Audu are best remembered were translations of their traditional water pots into high-fired, glazed stoneware (Fig. 212). As Cardew later recorded: 'it is arguable that there was something

213. Ladi Kwali, hand-built pot, stoneware, exhibited at the Berkeley Galleries, London 1962, where it was bought by the Dean of York, Eric Milner-White. h. 36.1 cm. (York City Art Gallery).

slightly false in the idea, seeing that they were too heavy and too expensive to be used as water pots or for any purpose other than decoration'.[352] Yet they exemplified Cardew's belief that Western intervention could, in theory, 'keep the primitive art instinct alive by making a modern channel for it' (Fig. 213).[353]

Cardew was following in the footsteps of K.C. Murray, whom he came to know and admire in Nigeria, encouraging indigenous crafts but introducing some Western skills. Thus Cardew offered Ladi Kwali a stoneware body and the use of glazes and kilns. Cardew, more than Murray, was fully aware that he was indebted to African art and culture. His growing intimacy with the pottery of Nigeria, and particularly with the pottery of Ladi Kwali's Gwari area, passed into his own shapes and decorations. He began to find himself making pots as 'naturally as a tree makes leaves or fruits'.[354] In Africa, ironically enough in the artificialities of the colonial situation, Cardew constructed a version of Leavis's 'organic community' and experienced the 'breath of reality' which was denied the studio potter in England.

WAR

As Michael Cardew's experiences demonstrate, during the Second World War individual work and expression were subsumed into a concerted war effort. In Britain raw materials were scarce or unavailable and in order to work at all makers had to apply for licences from the Board of Trade.[1] Most able-bodied men and women were either in the forces or in factories. The war years meant standardisation of production and regimentation of labour of a kind never before experienced in Britain. But it was accompanied by the development of new organisations like the Council for the Encouragement of Music and the Arts, the Central Institute of Art and Design (CIAD) and the War Artists Advisory Committee which were to form the foundation for post-war patronage and practice of the arts. Propaganda – in the form of films, broadcasts, paintings and photography – created some of the best art of the 1940s[2] and every kind of art form, from piano concerts to exhibitions of prints, was made more widely and more cheaply available to the general public.

'...THE VERY SOIL AND STUFF OF BRITAIN'

Where were the crafts in all this? Admittedly, the *practice* of craft was marginalised as workshops closed. It was calculated that before the war there were about 2,000 craftsmen and women working in Britain while just after the war only twenty workshops were still in existence.[3] But the *idea* of craft as an element of Britishness gained in importance and was connected to the way in which the national culture was propagandised during the war. Musings on what we were fighting for were typically set out in the pages of Edward Hulton's *Picture Post* as 'the cottage at the end of the lane and the old bridge by the mill...the very soil and stuff of Britain'.[4] There was nothing exclusive about the way in which this vision was presented; it was also made clear that victory would be rewarded by a fairer socialist post-war society. Thus J.B. Priestley's popular 'Postcripts' radio talks given in 1940–1 after the evening news were strongly socialist in mood but also included plenty of analysis of national character that centred on rural types, craftsmanship, the beauty of the land and the changing seasons, all of which were contrasted with German inhumanity and technocracy – the 'mechanised barbarians' of Churchillian rhetoric. Priestley's account of a night with his Local Defence Volunteers provoked thoughts of an earlier forgotten England: 'Even the rarer and fast disappearing rural trades were represented – for we had a hurdlemaker there; his presence, together with a woodman and a shepherd, made me feel sometimes that I'd wandered into those rich chapters of Thomas Hardy's fiction.'[5]

Kenneth Clark's *Recording Britain* project, set up at the end of 1939, funded by the American Pilgrim Trust and designed to give work to artists, also presented an England of ancient churches, country houses, follies and, not least, popular art and craft traditions as something to defend.[6] Enid Marx recorded Victorian shop signs in St John's Wood while Hennell contributed watercolours of a range of surviving vernacular craft workshops, including Cardew's Winchcombe Pottery. A.S. Hartrick painted Massingham's beloved breast plough being used at Tresham in Gloucestershire (Fig. 214). A series of photographic campaigns supported by the Ministry of Information told the story of individual villages – East Dean in Sussex and Kingston Blount in Oxfordshire. These pictured a breathtakingly pastoral England,

214. A.S. Hartrick, *The Breast Plough at Tresham, Wotton-under-Edge*, *c.* 1940, watercolour and body-colour heightened with chinese white. 36.5 × 48.2 cm. (V&A Picture Library).

with images of craft and agricultural skills and rustic figures in archaic dress; reinforcing a vision of Albion threatened by a soulless German war machine (Fig. 215). Films made during the war with the benefit of Ministry of Information guidelines also sought out an older England. Michael Powell and Emeric Pressburger's 1944 *A Canterbury Tale* was intended, according to Powell, to explain 'to the Americans, and to our people, the spiritual values and traditions we were fighting for'.[7] The plot of *A Canterbury Tale* was flimsy, even absurd, but the focus was on the bosky orchards and lanes of Kent and encounters with rural workers filmed in an actual wheelwright's shop and a smithy in Shottenden (a 'heavenly place', according to Powell).[8] Like Powell and Pressburger's slightly later film *I Know Where I'm Going*, *A Canterbury Tale* celebrated the continuity and value of the 'organic community' whose vulnerability F.R. Leavis had lamented in the inter-war years.

Elegiac feeling sprang up spontaneously. The Hon. Mrs Lyell described a last letter from her son killed in action to the editor of *Country Life*: 'he said that he found a copy of *Country Life* in a wood and that it was so lovely to read of what one was fighting for.'[9] A Mass Observation opinion poll conducted early during the war asked people what they believed they were defending. The response was rooted in a vision of England as a rural place.[10] In wartime men and women's thoughts apparently turned to meadows, elms and oaks, in short, to a pre-industrial England. As if in response to the public mood, the Gill–Massingham–Romney Green version of national development was set out majestically in G.M. Trevelyan's *English Social History*, written during the war years. It was published in the United States and Canada in 1942, appearing in Britain in 1944. Surveying six centuries, from Chaucer to Queen Victoria, it was full of pastoral evocations of the English landscape and tender descriptions of rural skills and craft set against later industrial loss.[11]

What Powell called 'Explaining to the Americans' motivated the 1942 British Council *Exhibition of Modern British Crafts* sent to ten cities in the United States and five cities in Canada.[12] National identity was recast, modestly, as a tradition of making; a great range of craft was put to the service of propaganda. Assembled in the Royal Library at Windsor just before the United States entered the war, the exhibition was initiated by Bernard Leach and Muriel Rose, whose Little Gallery closed in October 1939.[13] By the end of October 1939 they had the backing of Kenneth Clark and Dorothy Elmhirst and in August 1940 the British

Council Fine Arts Advisory Committee took responsibility for the show. John Farleigh, Leach and the bookbinder Anthony Gardner were on the exhibition committee, with Muriel Rose as exhibition secretary. The rationale for the exhibition was to show that the lamp lit by Morris 'is still burning'. There were disputes over the contents of the show. Eric Maclagan, the Director of the V&A, had little time for handwork[14] and a small number of industrially produced items were included, textiles by Edinburgh Weavers, table glass designed by Keith Murray, Eric Ravilious's designs for Wedgwood and good examples of modern book production. This annoyed Harry Norris of the Red Rose Guild, who furiously reiterated his belief that any collaboration with the world of mass production amounted to a betrayal.[15]

In fact we might wonder at the decision to send an exhibition of heterogeneous craftwork across U-boat infested seas. What were we explaining to the Americans? In his introduction to the catalogue, the critic Charles Marriott observed that to send an exhibition of design for mass production to the United States 'would have been rather like "sending coals to Newcastle".'[16] He went on to argue that the practical value of crafts would become apparent in an 'economically re-organised' post-war world when the crafts would help evolve 'typeforms for mass production'.[17] Marriott was quoting Gropius but what the Americans in fact got was a complete picture of the British inter-war craft world, presented in a deceptively idealised form as a seamless, harmonious continuum which took in Edward Barnsley's extension of the Gimson tradition, the modernism of hand block-printed textiles by Barron and Larcher, innovative weaves by Hilary Bourne, a shelving system designed by Brian O'Rorke, the surviving rural crafts (a hay rake, trugs, carved spoons by James Davies of Abercych, hand-knitted fishermen's jerseys, known as guernseys) and the quilts made by miners' wives in the Distressed Areas of South Wales and Durham. No one could do this better than the exhibition secretary Muriel Rose. Her taste, deemed 'impeccable', was behind the elegant room settings – country and town dining-rooms and bedrooms (Fig. 216), a music room with Edward Bawden wallpaper, a majestic Braque-inspired tapestry by Edward McKnight Kauffer and Jean Orage and Dolmetsch instruments (Fig. 217). It was emphasised that most of the exhibits, with the exception of the silversmith Cyril Shiner's Dunkirk Cup, had been made before the war and 'those who made them are in the fighting forces or munitions works or fallen in conflict'.[18]

Reporting on the show on its return in 1945, Muriel Rose argued that it had both confirmed American 'respect amounting almost to reverence for English craftsmanship' and that it also overturned a vision of British design as being essentially conservative. She argued

216. The Country Dining Room, *Exhibition of Modern British Crafts*, 1942–5. Table by Edward Barnsley, chairs by Edward Gardiner, chair seat *Auricula* by Phyllis Barron, curtains *Skate* by Phyllis Barron and *Spine* by Dorothy Larcher, dresser by Brian O'Rorke with pottery by Bernard Leach, Raymond Finch, Elijah Comfort and Michael Cardew. (The British Council Collection).

that this perception 'will perhaps be our strongest plank in competing for the United States export market'.[19] This was to become a matter of some urgency but in fact the real achievement of the show was its projection of Britain as an ally worth defending. It was, as one American museum director observed, 'more valuable than any more direct form of propaganda'. As it toured, *Modern British Crafts* won all hearts, as a 'most welcome and inspiring message' presenting 'such extraordinary evidence of British taste and skill and democratic culture' (Fig. 218). The democratic part was important to Americans and the exhibition managed to suggest a community of skilled men and women, untroubled by class difference, and therefore ideal representatives of the 'kind of life we are fighting to preserve'.[20]

Modern British Crafts was an example of visual propaganda aimed at an ally. The Stalingrad Sword was a munificent gift commemorating the lifting of the German siege of Stalingrad in November 1942. Its creation was initiated by the Foreign Office as part of a major campaign designed to generate support for an unpopular new ally who had signed a pact with the Nazis in 1939. The Worshipful Company of Goldsmiths organised a limited competition in February 1943 between R.M.Y. Gleadowe, and the silversmiths Percy Metcalf, Leslie Durbin and Cyril Shiner. Although Durbin and Shiner were given a week's leave from their airforce work on precision instruments to enter, it was Gleadowe's design for a two-handed fighting sword that was chosen by George VI. The blade was forged by the Wilkinson Sword Company and in all eighteen craftsmen including Durbin, the calligrapher M.C. Oliver and the metal engraver

217. The Music Room, *Exhibition of Modern British Crafts*, 1942–5. Wallpaper *Flute* designed by Edward Bawden, tapestry *Music* designed by Edward MacKnight Kauffer and made by Jean Orage, harpsichord designed and made by Arnold Dolmetsch, rug designed by Jean Milne and executed by the Shiant Weavers, Isle of Skye. (The British Council Collection).

218. American boy at the *Exhibition of Modern British Craft* at Worcester Art Museum, Massachusetts, posing with two objects from the show, C.J. Shiner's Dunkirk Cup and a rake. (The British Council Collection).

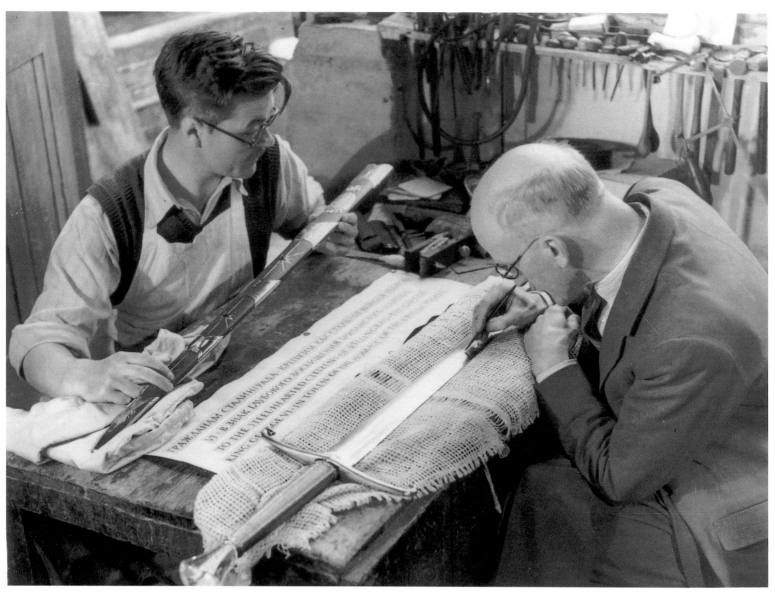

219. Leslie Durbin and G.T. Friend in 1943 working on the Stalingrad Sword of Honour designed by R.M.Y. Gleadowe. (Photo courtesy of the Worshipful Company of Goldsmiths).

220. Queueing outside Goldsmiths' Hall to see the Stalingrad Sword of Honour, October 1943. (Photo courtesy of the Worshipful Company of Goldsmiths).

G.T. Friend were employed to work with all speed on the sword. The stress of the project affected Gleadowe's health and after his disappearance into a nursing home suffering from nervous exhaustion the team was led by Durbin (Fig. 219).

The sword was the century's most striking British example of high craftsmanship working to create a diplomatic gift. Its propaganda value at home was milked to the full. R.R. Tomlinson, then Principal of the Central School argued, with touching optimism, that the collaborative nature of the commission showed craftsman and industrialist alike the 'way to a solution of the problem of securing a fair share of the world's markets' in the post-war world.[21] The sword was the subject of a British Paramount news reel and was exhibited in October 1943 at three London venues and subsequently toured Britain, attracting long queues (Fig. 220) and remarkable public interest before being presented to Stalin by Winston Churchill in Teheran on 29 November 1943. Hardly an example of innovative making, the Stalingrad Sword – with its scabbard bearing a gold-chased Royal coat of arms, its pommel of carved rock crystal held in place by a gold rose of England and its blade inscribed in English and Russian 'To the steel hearted citizens of Stalingrad' – showed British craftsmanship at its most precise, magnificent and formal.[22]

ARTE RUSTICA ITALIANA

When Bernard Leach travelled up to London from Cornwall to Central Institute of Art and Design committee meetings he constantly heard men on leave say: 'When this…show is over I will never go back to the old job: I want to do a job I can enjoy.'[23] War opened up new horizons. In particular serving overseas in remote areas introduced British men and women to very different societies. In many instances the experience proved memorable and life changing. There were encounters with vanishing skills and peasant communities – real 'organic communities' whose passing in England had been lamented by Leavis and Thompson. For Jocelyn Brooke, serving in the Royal Army Medical Corps in southern Italy, war meant contact with 'the most beautiful people I had ever seen, and the most civilised' and a way of life which had 'remained an art'.[24] Also in Italy, serving as a Signals officer, Henry Rothschild came across potters in Massa Lombarda near Bologna making freely decorated tin-glazed ware and he took care to ensure that their lorry loads of clay arrived safely. In the remoter rural areas of Italy he found further survivals of traditional weaving and pottery. In Florence he bought a handsome

221. The cover of Eleanora Gallo's *Arte Rustica Italiana*, 1929.

book of wood-engravings. *Arte Rustica Italiana* (1929; Fig. 221) by Eleanora Gallo surveyed Italy's indigenous folk art and pattern-making region by region with over two hundred illustrations of textile patterns, carvings on boats and carts, engravings on drinking glasses and ornaments on farm implements.

Jocelyn Brooke turned from wine merchant to writer after the war. Henry Rothschild had been destined for a career in the family metal business but instead he went in the footsteps of Muriel Rose and in 1946 opened his shop Primavera in Sloane Street, London, mixing vernacular basketry, high quality mass-produced textiles, studio ceramics and folk art from remote corners of Europe.[25] Geoffrey Whiting spent the war serving in India. He was a budding architect but the experience of watching three generations of potters at Nurgaou near Delhi turned him into a potter, a decision given practical inspiration when he read *A Potter's Book*.[26] As we have seen, Michael Cardew's war was spent in West Africa where his encounters with the indigenous pottery, the revelation of his technological deficiencies and his lack of artisanal know-how provided the inspiration and focus for the whole of his subsequent career.[27] Alec Pearson, subsequently a painter and weaver, completed his art education in the army, painting murals in canteens in Egypt, admiring trecento art while billeted in Siena, going to the opera and concerts in Hamburg, studying the German Expressionists in Düsseldorf and, just before demobilisation in 1947, spending a month at the Académie de la Grande Chaumière in Paris.[28] The potter William Newland, formerly a New Zealand drover and butcher, learnt to draw in a prison camp in Sudetenland: 'I had all the models in the world. Colours and lots of paints came from the Red Cross.'[29]

The home front also offered new experiences. Constance Howard, post-war to be a great innovator in creative embroidery, was at Kingston School of Art, teaching enthusiastic young soldiers and embroidering maps for the RAF with the help of her students.[30] The embroiderer Lilian Dring's hanging *In the Heaven Above* suggests the make-do-and-mend atmosphere of the time. It was made for a bombed out window from a rag bag of materials – wool, buttons, beads, net and rexine embroidered and cut to represent fighter planes, ambulances, broken glass and air-raid shelters and their sleeping inhabitants (Fig. 222).[31] Unfit for active service, the artist David Jones moved in 1943 from delicate watercolours to the creation of a series of semi-private painted inscriptions in Welsh, Latin and English which had something of the secret quality of early Christian catacomb inscriptions and which meditated on a buried mythological past and ancient wars – HIC IACET ARTHURUS – Here lies Arthur, the once and future King – and SQUALENTEM BARBAM – Virgil's powerful description of Hector, the defeated, wounded Trojan warrior (Fig. 223).

The war did not necessarily mean a retreat to simpler making processes. A whole generation of fledgling architects drafted into wartime operational research in fields as varied as camouflage or aircraft design learnt flexibility coupled with a hands-on approach which was to invigorate post-war architecture.[32] Craftsmen were affected also. Bert Upton, Edward Barnsley's foreman, worked in an aircraft factory during the war. His experiences there led him to argue successfully for a greater division of labour and for the introduction of machine tools in the Barnsley workshop after the war.[33] David Pye, a young graduate of the Architecture Association, spent the war behind a desk at the Admiralty drafting reports. He developed a prose style marked by clarity and strength which stood him in good stead as one of the very few post-war theorists of the craft movement.[34]

The decision not to fight could have repercussions. Two conscientious objectors and fine art students, Patrick Heron and Richard Kendall, ended up working at the Leach Pottery. Heron remained committed to painting, but as art critic for Mairet's *New English Weekly* and the *New Statesman* wrote some of the most perceptive analysis of the relationship of ceramics to modern art. Kendall married Leach's daughter Jessamine and was to become Head of the Ceramics Department at Camberwell School of Art where he assembled a remarkable teaching team. T.S. Haile, a former pupil of William Staite Murray, was another conscientious objector who left for the United States in 1939 and there experienced making pots in the well-funded lush pastures of Alfred University and Ann Arbor.[35]

SQVALENTEM·BA
RBAM·ET·CONC
RETOS·SANGVINE
·CRINES·VOLNERAQ
VE·ILLA·GERENSQVÆ·
CIRCVM·PLVRIMA·MVR
OS·ACCEPIT·PATRIOS·

223. David Jones, *Squalentem Barbam*, *c.* 1940, painted inscription, black and red on paper, 19.7 × 31.8cms. (By permission of the National Library of Wales).

If war interrupted people's lives with results that were often life-changing, some careers were brought to a close. David Jones's former teacher and guide, Eric Gill, succumbed to lung cancer in November 1940. His *Autobiography*, two books of essays and his selected letters appeared posthumously but his death marked the end of powerful socio-political thinking about the crafts. The career of Leach's rival William Staite Murray ended and was never resumed when he was stranded in Rhodesia during the war. Unable to obtain fabrics, Dorothy Larcher and Phyllis Barron gave up their work as hand block-printers. Subsequently Larcher was to concentrate on painting while Barron threw herself into local government.[36] Their former apprentice Enid Marx moved away from handwork, designing woven textiles for Utility furniture, an extension of her earlier work on a range of fabrics for seating on the London Underground. After 1945 she increasingly turned to graphic work, above all to the design of book jackets.[37]

In July 1942, faced with a need to regulate rising furniture prices, the Utility Furniture Advisory Committee was set up by the Board of Trade and in June 1943 a specialist Design Panel was formed to implement the state control of furniture production and its design. The moving force was the Panel's chairman Gordon Russell who, with his designers Edwin Clinch and H.T. Cutler, came up with a reasonable interpretation of the President of the Board of Trade Hugh Dalton's request for furniture of 'good, sound construction in simple but agreeable designs'.[38] The aesthetic imposed upon the nation by Utility was in fact a telling one, true to that strand of inter-war British modernism that was rooted in familiar materials and handwork (even if the 'wood' employed was often veneered hardboard). Historicism, in the form of elaborate carvings and mouldings, was eliminated. Good craftsmanship was endorsed. Joints were properly mortised or pegged.[39] Despite hints of 1930s *moderne* and the inclusion of a few vernacular forms like the Windsor chair, Utility represented a government enforced apotheosis of Cotswold craftsmanship adapted for mass production.

THE EMIGRES

The uprootings and diaspora of war meant that British crafts, design and architecture were revitalised by the influx of refugees from Europe. It has been argued that the émigrés who chose to settle in Britain – as opposed to those who moved on to the United States – were attracted by a sense of tradition and continuity and, as Perry Anderson suggests, constituted 'a "white", conservative emigration'.[40] Certainly the most established and powerful modernist architects and designers – Marcel Breuer, Walter Gropius and Erich Mendelsohn – left for the United States after relatively brief spells in Britain. Those who made England their home form an interesting group. The continental presence, with the contribution of figures like Hans Schmoller, Berthold Wolpe and F.H.K. Henrion, had an impact on British graphic design and book production.[41] In other areas, however, émigré designers were affected and changed by the strength of the craft movement here and by the conservatism of our manufacturing industries.

The potter Lucie Rie arrived in 1938 with a fully developed European modernist ceramic language which was soon to be challenged by Bernard Leach whom she met early in 1939.[42] For her the positive side of settling in an 'old' country was the value placed on handwork. Lucie Rie was swiftly made conscious that Anglo-Oriental studio pottery was invested with some of the status of high art among a small circle of curators, critics and collectors. Even if she rejected the oriental aesthetic and did not join in the debates, she appreciated the sense of value (Fig. 224). On the other hand, in continental Europe she might have designed for

224. Lucie Rie, earthenware tea service, c. 1947. height of teapot 19cm. A transitional example which suggests Leach's influence. (Christies Images).

industry but at no point during her distinguished career as a potter in England was her potential as a designer tapped.

For émigrés who arrived with a wealth of technical industrial experience, the very fact of being in Britain seemed to bring them closer to craft. For instance, Margarete Heymann-Marks, who studied at the Bauhaus from 1920 until 1922, had run and provided designs for the Haël-Werkstätten, a small factory with nearly ninety employees at Velten near Berlin. In 1935 she fled to England where she gradually moved from industrial design to handwork. On her arrival she taught at Burslem School of Art and then worked as a designer for Minton. In 1938 she launched her company Grete Pottery which closed on the outbreak of war. By 1946 she was teaching at Camberwell School of Art and gradually turned to individual studio production – arguably because of the problems posed by her encounters with the highly conservative British pottery industry.[43]

Respected European designers found that they were barely known in Britain. Walter Gropius's name meant nothing to the Board of Trade official who interviewed him in 1935.[44] The Bauhaus-trained textile designer Otti Berger arrived in England in 1937. Berger, famous in Europe for her innovative textiles, had a remarkable sensitivity to yarns and saw hand weaving not as an end in itself but as the ideal tool with which to develop prototypes. She designed some fabrics for Helios Ltd but of England as she wrote to a friend: 'I believe it takes 10 years before one has a circle of friends. I am always alone.' In 1938 she failed to get a USA visa and, homesick, she returned to her native Yugoslavia to visit her mother. In 1939 she was arrested and deported and she died in Auschwitz.[45] Her contemporary Margaret Leischner, who fled to England in 1938, was more fortunate. She had trained and taught weaving at the Bauhaus with Gunta Stölzl and had gone on in 1932 to become head of weaving at the Berlin Textil und Modeschule. In Britain she had a successful career as a designer for industry, creating novelty yarns for R. Greg & Company from 1944 until 1950 and playing an active part in the Colour, Design and Style Centre of the Cotton Board. In addition she taught at the Royal College of Art from 1948, becoming Head of Weaving in 1953.[46]

Émigrés observed English craft and reinterpreted it. The young Ralph Beyer arrived in England in 1937 as a sixteen-year-old apprentice to Eric Gill. Despite an interest in typographical design and a background steeped in European modernism, he ended up concentrating principally on letter cutting.[47] But almost from the start he was restless with the pervading craft orthodoxy which took the lettering on Trajan's Column in Rome as a model and by the mid-1950s he had developed informal cut letter forms inspired by the work of David Jones (Fig. 223) and by his father Oskar Beyer's researches into early Christian catacomb inscriptions. Tadek Beutlich, who arrived in Britain to be demobilised in 1951, similarly proved to be a radical innovator in his chosen craft. He had already studied in Poland, Weimar, and Dresden. As a Pole of German origin he was called up into the Germany Army but switched to the Allied side, fighting in the British Eighth Army with fellow Poles. When he was demobilised he was given a scholarship to study in Rome at the Art Academy and subsequently trained as a painter at the Sir John Cass School of Art and at Camberwell School of Art where he moved decisively into tapestry weaving.[48] Other émigrés who arrived young – for instance Gerda Flöckinger aged eleven, Ruth Duckworth aged sixteen and Hans Coper, slightly older at nineteen but untrained as an artist – went on to develop work that from the outset was innovative in British terms. Finally, though most of the new arrivals came from Europe, there was also a significant influx from the Antipodes. Demobilised ex-servicemen who ended up in London and decided to stay included painters like Arthur Boyd from Australia, the writer Dan Davin and two potters, William Newland and Kenneth Clark from New Zealand.

A poignant snapshot of displaced artists and makers is provided by the exhibition *International Craftsmanship Today*, organised by the short-lived International Craftsman Centre and held at Heal's Mansard Gallery in March–April 1940. The preface to the catalogue welcomes émigré makers: 'What will this fresh combination of British and Continental craftsmen produce? Will there be a tendency to break down hard and fast divisions between handcraft and multiple production, as there formerly was on the Continent?' Major figures in

225. Jupp Dernbach, *Head of a Girl*, gesso and tempera on wood, made at Huyton Internment Camp, September 1940, 25.5 × 30 cm. (Private Collection. Photo David Cripps).

British craft like Percy and Rita Beales, Dora Billington, Bernard Leach, Ethel Mairet and Katharine Pleydell-Bouverie contributed work alongside a host of exiles – Erna Bohne, a painter; Ernest Friedmann, once owner of the Berlin store Friedmann and Weber; Professor Ernst Stern, stage designer; Contessa Scarfetti-Scopoli, maker of artificial flowers. The presence of these shadowy figures suggests how difficult it was to start afresh in another land, especially England, where the craft practice carried with it such a weight of class and ideological meaning.[49]

Lucie Rie, whose work was also included in the exhibition, was resourceful and lucky. She moved in a sympathetic circle of influential fellow émigrés, including the fellow Viennese architect Ernst Freud, son of Sigmund Freud, and the ingenious Fritz Lampl who had employed her in his Bimini glassworks making glass and ceramic buttons. William Ohly, a German painter and sculptor who set up the Berkeley Galleries after the war, was another important link, finding work in 1946 in Rie's studio for two fellow German refugees, Hans Coper and the painter and printmaker Joseph (Jupp) Dernbach. Dernbach and Coper had first met in Huyton Internment Camp in 1940 where Dernbach, already an experienced and versatile artist, made some small, beautiful, figurative sgraffito panels (Fig. 225). At Rie's studio in Albion Mews Dernbach helped make buttons and he and Coper experimented with bold abstract sgraffito designs carved into manganese glazed platters. In the early 1950s Dernbach's business card listed his skills as encompassing 'Applied Art – mural – mosaic – sgraffito – ceramic – design – interior'. While Coper consolidated a career as a potter, Dernbach was almost too versatile, branching out into handsome Ecole de Paris inspired lacquer and gold-leaf panels in the mid-1950s and public sculpture by the early 1960s. These émigré artists and their patrons formed an alternative craft-art network throughout the post-war years. They shared a consciousness of European modernism but the inter-war ideological craft debates in Britain about standards meant little to them. They needed to make a living. The ceramics of Coper and Rie characteristically were presented without rhetoric; left, as it were, to speak for themselves.

BANDING TOGETHER

In sharp contrast with the émigrés, busy trying to survive in corners of blitzed London making stylish buttons and glass jewellery, the older non-combatant British makers turned their

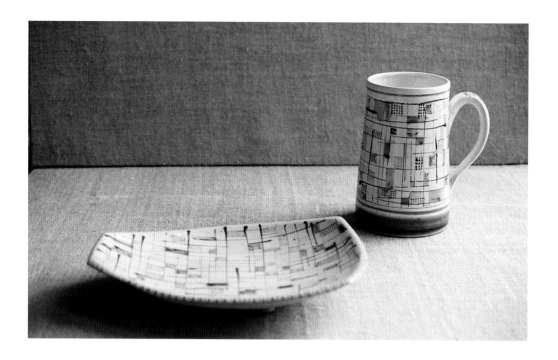

226. Rye Pottery, Tankard and dish, tin-glaze, late 1940s. (Rye Pottery).

energies to organisation for the future. They also, characteristically, debated and quarrelled. Harry Norris, secretary of the Red Rose Guild, maintained his extreme position during the war. His vehicle was the magazine *Crafts*, published by the Red Rose Guild from 1940 for the duration of the Second World War to enable Guild members to keep in contact. He used it to advance a series of anti-industrial polemics. Launched 'because the whole world was crumbling',[50] *Crafts* published the last thoughts of Eric Gill and essays by H. J. Massingham, by the purist flax spinner and weaver Percy Beales and by the civil servant and bookbinder Anthony Gardner. The latter's article 'Sodom and Gomorrah' lamented 'the over mechanised and factory conditioned state' and predicted that the post-war period would see a reaction that would bring about the wholesale rejection of mechanisation, with the maker as a crucial shamanistic figure in this process.[51]

After the outbreak of the Second World War Norris launched a final assault on the conscience of the chairman of the Guild, Margaret Pilkington. He attacked her grand friends whose wealth was rooted in industry and who 'have built lives in which the crafts have no real place – or at most or best as an interesting academic subject. They see no urgency in our problems and only have vague regrets at our passing.' He went on to criticise the Guild's annual shows, which allowed in work of a low standard, either to attract crowds or out of social obligation. He asked her to help him create a proper arts and crafts society – 'If you are willing we can organise a group of craftsmen that can cut a pattern across the morass of English art life as clear and distinct as the costume of a thirteenth-century herald.'[52] Pilkington held back, but Norris, in a letter to Cardew, quoted D. H. Lawrence's poem 'Work', the text of which had been sent to him by Bernard Leach – 'And work is life, and life is lived in work'– and went on to rail against the Arts and Crafts Exhibition Society with its soft line on industry.[53]

By 1942 Norris was attempting to consolidate the crafts as an exclusive brotherhood by initiating a Master Craftsman Group within the Red Rose Guild. This was to act as 'a thin strong line of cooperative action to maintain the crafts in being' with masters selected to represent individual crafts.[54] These 'masters' included Roger Powell in bookbinding, Stanley Davies in furniture making and Bernard Leach in pottery.[55] Perhaps most important of all, the Red Rose Guild also led the craft debate about the future of small workshops under wartime restrictions,[56] developing a craftsman's licence scheme and campaigning for state protection in the post-war period.[57] Norris in particular argued for the exemption of key craftworkers from war service in order to ensure the survival of craft skills.[58] These debates were to lead to the successful post-war campaign to protect makers from the punitive effects of purchase tax on works of craftsmanship.

The Arts and Crafts Exhibition Society was also trying to sort out its priorities during the war. A joint show was held with the Red Rose Guild in 1940 at Manchester City Art Gallery and London exhibitions were staged in 1941 and 1944. The 1941 catalogue was introduced by Nikolaus Pevsner, who predicted a bright future for the crafts after the war, arguing that 'the frightful mechanisation of twentieth-century warfare with its high efficiency destruction will also cause a reaction in favour of the individual' and 'a more thoughtful approach to the real problems of life, and more serious efforts to build up spiritual barriers against another still more deadly war'. He believed that 'the best designs from the factories' would educate consumers to return to the crafts to 'demand something nobler and more personal than industrial products can be'. But he warned against nostalgia, urging makers to identify with the present in order to express 'its *élan vital*'.[59] The 1944 Arts and Crafts Exhibition Society catalogue was less progressive with John Farleigh stressing 'the need to preserve the tradition of the craftsman so that he may play his part in future years of peace and reconstruction'.[60] During the previous year, Farleigh, then deputy president, had ceased to be the youthful firebrand who had lectured the Arts and Crafts Exhibition Society on the need to design for industry. By 1942 he had decided, partly under the influence of Edward Barnsley and Roger Powell, that the crafts needed special support and that the Arts and Crafts Exhibition Society should exclude industrially produced goods from future exhibitions. It was an important shift of emphasis.[61]

During the war the National Gallery in London, emptied of works of art, was transformed into its Director Kenneth Clark's personal kingdom, dedicated to preserving and supporting the arts and artists. The War Artists Advisory Committee's commissions and the Recording Britain commissions were exhibited in its galleries. The famous series of lunchtime concerts led by pianist Myra Hess, seen by Clark as 'an assertion of eternal values', was also held at the National Gallery.[62] In 1939–40 the Central Institute of Art and Design (CIAD) had opened its office in the basement. The CIAD brought together forty-seven art and design societies, including most of the main craft associations.[63] It had various sub-committees – dealing with church work and marine artists, for instance – as well as an Arts and Crafts sub-committee led by Sir Charles Tennyson, the CIAD chairman, and by the CIAD secretary T.A. Fennemore. Craft members included the potters Dora Billington and Bernard Leach, furniture makers Harry Norris and Edward Barnsley and the print makers John Farleigh and Margaret Pilkington.[64]

Their first achievement as a sub-committee was a memorandum to the Ministry of Labour, the Ministry of Health, the Board of Trade and Board of Education and the short-lived Ministry of Reconstruction concerning the training of the war-wounded and disabled. Perhaps with memories of the philanthropic uses to which the crafts were put after the Great War, this argued for the importance of aesthetic content and warned against 'bastard handicraft mass production', suggesting that makers should train the war-disabled until they become sufficiently independent to work 'freely and unconsciously within the bounds of a sound tradition'.[65] Their suggestions sounded impossibly patrician. Crafts were not seen by philanthropic organisations like St Dunstan's as the answer for the war-wounded after the Second World War. The mat making and basketry that had been taught to the casualties of the Great War were set aside in favour of office and factory work.[66]

Other crucial issues addressed by this committee echoed the concerns of Norris and the Red Rose Guild and included the alleviation of purchase tax and the problem of getting licences for small workshops. On 20 January 1943 a joint committee of the Arts and Crafts Exhibition Society and the Red Rose Guild met at the Art Workers' Guild to make plans to promote the crafts, to deal with the welfare of makers and to prepare an exhibition for 1943 provisionally entitled 'The Crafts in the Everyday Life of the Future'.[67] Though this attempt at unification failed Farleigh continued to work for unity in the craft world. The culmination of all this activity came in 1946 when a council representing five societies – the Arts and Crafts Exhibition Society, the Red Rose Guild, the Society of Scribes and Illuminators, the Senefelder Club (devoted to lithography) and the Society of Wood Engravers – held a series of meetings

at the Central School. The aim was to set up a permanent London-based centre for the crafts and that year Farleigh announced in *The Times* the formation of the Crafts Centre of Great Britain, and the promise of government support.[68]

The crafts had not only survived the war but they entered the post-war period with official recognition. After the war, in an increasingly prosperous consumer society, the practitioners of craft tended to examine their purpose less. It was, quite simply, less odd to be a potter or a furniture maker in a world where ex-servicemen took up chicken farming or went into the soft fruit business. The craft world became less intellectual just at the moment that large numbers of men and women – in reaction against the harsh disciplines of war – wanted to join in. Thus with surprising speed the crafts were democratised and urbanised and the physical objects being made began to look quite different – brighter, gayer, more accessible and more like commodities (Fig. 226).

indirect. Craftsmen taught designers by communicating sensitivity to materials. Craftsmen also had the freedom to experiment with new forms and materials. But Macpherson was well briefed. As David Kindersley bitterly pointed out: 'the whole of his statement sounds as if it may well have been written for him by the Council of Industrial Design.'[23] The crux of the matter was the Centre's active contribution to industrial design. This was assessed as minimal and therefore it was inappropriate that funds should come from the Board of Trade. In Macpherson's view craftsmen who did contribute to industrial design could naturally request to go on the Council of Industrial Design's register. And the Centre's turnover was, in his view, economically negligible: 'In 1960–1, the Centre raised only £1,225 from subscriptions – a good deal less than is collected in the average village for local purposes.'[24] This harsh remark caused John Farleigh to weep.

Kindersley had doubts about Gordon Russell's support for the Centre: 'Gordon Russell thinks that the Crafts Centre has missed the boat and that it would be better if it slid quietly into oblivion.'[25] This was not entirely true. In February 1963 Russell wrote a long report on *The Future of the Crafts Centre of Great Britain* for the Council for Industrial Design. He argued positively for 'the establishment of a highly selective, well displayed, selling exhibition of handwork in conjunction with but quite separate from the Design Centre'. For Russell fine craftsmanship 'can provide a continual point of reference on quality for industry. It can also prove a most valuable stimulus for machine made products if brought into close touch with a large factory.'[26] Thus Russell reiterated the Board of Trade's insistence that craft be justified in the context of Industrial Design. Paul Reilly, Russell's successor at the Council of Industrial Design, took a broader view. He wanted to collaborate with the Centre because he saw the crafts as an aid in educating the eye of consumers.[27] What is striking is that neither Russell nor Reilly was quite prepared to see the crafts in themselves as making a valuable contribution to cultural life.

The Council of Industrial Design had shown studio pots at its Haymarket Centre since the early 1960s and Reilly now offered to create an area to display the crafts, putting forward estimates to the Board of Trade for a reconstituted Crafts Centre within the Design Centre as well as asking for funds for a trial craft exhibition.[28] What emerged from the Council's discussions was a determination not to go, as Paul Reilly put it, 'down the arty-crafty road' but to recast the crafts as a handmaiden to design. In a confidential memo to the Board of Trade, the CoID argued that 'the Crafts Centre, with its narrow attitudes and its exclusiveness based on fine craft societies with more than a hint of medieval guilds, has tended to widen the gulf between the majority of craftsmen and industry'. The CoID would 'bring many craftsmen back into the main stream of modern, creative development'.[29] But at a September meeting Reilly announced that the Board of Trade had refused support for a crafts show on the grounds that 'the Crafts Centre image was not thought the right one for the CoID'. The Board of Trade wanted the Council of Industrial Design to concentrate on engineering in the wake of the Fielden Report.[30] Thus the Council of Industrial Design's interests shifted from consumer to capital goods – a change of direction that, as we shall see, was ultimately to marginalise the Council with the decline of heavy industry and the massive upsurge of domestic consumerism in the 1970s and 1980s.[31] Nonetheless, the Council determined to go ahead with a craft exhibition.[32] And one member of the Council, Misha Black, then Professor of Industrial Design at the Royal College of Art, spoke up for the crafts with an especial urgency, arguing that the pendulum had swung too far away from craft and that there was now a tendency to worship technology for its own sake. He warned that 'if this is allowed to continue, we should find that designers working for industry were starved of the basic inspiration which came from the arts and crafts.'[33]

Despite, or perhaps because of, the critical interest shown by the CoID in the Crafts Centre, the future of government recognition for craftsmanship still looked bleak. The Council of the Crafts Centre clutched at straws. In late 1963 Gordon Russell introduced Cyril Wood, a former BBC producer who had worked for the Arts Council and had founded the South West Arts Association, to the beleaguered Centre.[34] Wood had just staged an imaginatively designed

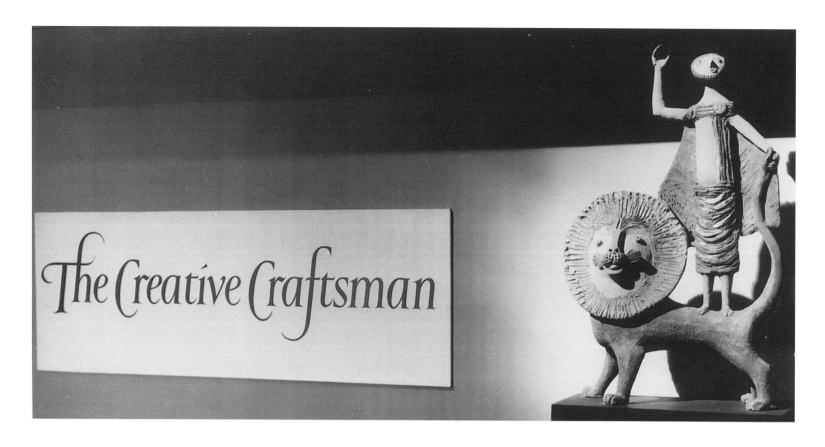

metal, did not belong to the Centre or to its associated societies. Only the pots of Ruth Duckworth gave Baynes 'some promise that the crafts really could deliver the goods in the form of beautiful objects to humanise our personal environment'.[18]

If to *Crafts Review*'s editor the Centre was run by 'a cluster of old hens brooding proudly and eternally over an egg that will never hatch out',[19] some of the younger members were determined to rethink its *raison d'être*. In 1961 a sub-committee was formed, led by the letterer David Kindersley and including the craft-loving James Noel White of the CoID, the potter Victor Margrie, David Thomas of the Arts Council and Gordon Russell, lately retired from the CoID. They worked on a strategy paper, *Image of a Crafts Centre*, which was completed in 1962. It was pointed out that the Centre had the unenviable role of filling gaps left by the CoID, the Arts Council, the Rural Industries Bureau and the commercial galleries. A broader base was suggested, to take in rural crafts, engineering and pure design. Other key ideas included removing direct control from the five societies which made up the Centre, the publication of a magazine, the creation of a photographic index, the appointment of a salaried director and a petition to government for a more generous grant and equivalent status to the CoID.[20] But money problems disrupted this attempt to reshape the Centre.

In December 1961 the Board of Trade decided not to renew the Centre's grant beyond 1962/3. In their view the Centre had failed to uphold a vital clause in its constitution, commitment to the improvement of industrial design.[21] In this crisis a surprising amount of parliamentary support rallied. On 21 April 1962 the Parliamentary Secretary to the Board of Trade, Niall Macpherson, faced a barrage of hostile questions from Labour and Conservative MPs[22] followed on 18 May by an adjournment debate on the future of the Crafts Centre led by the Labour MP Julian Snow, briefed by his constituent, the silk weaver Ursula Brock. Snow invoked a history, tracing the Centre back to the design reforms pioneered by William Morris and to the founding of the Arts and Crafts Exhibition Society in 1888. He argued that Germany, France, Finland, Denmark and Switzerland all had organisations to encourage the crafts. He admitted that 'it is not always easy to argue the economic aspect' of the crafts but that they added to 'the wealth of the cultural life of the nation'. He pointed out the contribution made by Crafts Centre members to the interior of the newly built Coventry Cathedral. Finally he asserted the relevance of the crafts to industrial design. This could be

229. The entrance to the *The Creative Craftsman* held at the RIBA in 1960. Lettering by David Kindersley, *Daniel and the Lion* by William Newland. (Courtesy Murray Fieldhouse).

228. Donald Jackson, sign for Cranks Health Food Shop, Marshall Street, London, 1968. Sandblasted British Columbian pine, carved *in situ*. Height of each letter 23 cm. (Donald Jackson).

business man with a social conscience, who in 1961 opened the first Cranks restaurant in Carnaby Street. Customers ate off Winchcombe stoneware and studied menus written out by the calligrapher Donald Jackson (Fig. 228). Canter was convivial about the crafts, organising Potters' Days with demonstrations of 'traditional' throwing by artisans from Wrecclesham[14] followed by evenings of cello music and folk songs. And although the CPA was largely run by makers, their views mostly harmonised, helped, no doubt, by the fact that during the 1960s the demand for stoneware pottery invariably exceeded supply. Cranks – organic and vegetarian – and the stoneware potters whose work sold in the CPA shop inhabited the same financially viable moral universe.

In contrast the Crafts Centre was at the mercy of the Board of Trade and the differing needs of its heterogeneous membership. In 1953 the Centre's grant was renewed for a further five years, starting with £2,500 if £1,500 was earned by the Centre (and £30 for every further £10 earned with a ceiling of £5,000).[15] It was a sum that made expansion impossible. As Sheila Pocock recalled, the Centre had some very distinguished lay members but 'I got the impression that the Establishment was quite happy about us but saw no reason to do much to help'.[16] In 1957 a broadening of the Centre's remit was discussed, going beyond the focus on 'Designer Craftsmen in the Fine Arts' outlined in the Centre's constitution. The furniture designer, wood turner and Royal College of Art tutor David Pye, a fierce critic of the Centre, read a paper recommending the inclusion of anyone 'who makes something and makes it superlatively well',[17] thus opening the door to trade craftsmen such as the gunmakers, cutlers and toolmakers whom he so admired. Greater co-operation with architects, in effect a return to the roots of the Arts and Crafts Movement, was also discussed. In 1960 a joint RIBA and Crafts Centre exhibition, *The Creative Craftsman*, made the case for collaboration (Fig. 229). *Crafts Review*, a short-lived (1959–61) but lively journal run by the potter Murray Fieldhouse and much given to attacking the CoID and the Crafts Centre, published a negative review of *The Creative Craftsman* by the designer and critic Ken Baynes (incidentally Gordon Russell's son-in-law). Baynes argued that while the ceramics were of a high order there was a good deal of what he called 'emasculated nonsense' in the exhibition. Why sculpture by Gill's nephew John Skelton and nothing by Moore or Hepworth? Why no stained glass by Geoffrey Clarke? Baynes had a point. Fine artists, even those like Clarke who had worked as applied artists in glass and

societies and headquarters on Hay Hill, a quiet street parallel to Piccadilly noted for its string of hairdressers' salons, the Centre's history was soon to be one of financial difficulties. Sir Gordon Russell, director of the CoID from 1947 until 1959, had doubts above the Centre's viability which emerged most fully in the early 1960s. He may have already had reservations in the 1950s. No one could doubt Russell's love for the crafts but he found machine haters like Harry Norris unbearably narrow in outlook.[9] A less critical friend to the Centre was the Duke of Edinburgh, who accepted its Presidency in 1953[10] and was an assiduous attender of exhibitions, regularly photographed at the Centre robustly quizzing makers on their work and ready with well prepared speeches on the continuing relevance of handwork (Fig. 227).

In April 1950 the Centre's showroom opened. With a interior designed by Sergei Kadleigh, the effect was contemporary and urban and from the start the Centre's exhibitions were committed to the young and innovative. But the quality and quantity of exhibits proved a constant problem. The anticipated stream of generous private donations was not forthcoming and the grant as renewed by the Board of Trade in 1953 remained small. The Centre's struggle for existence illustrated the fragile nature of the craft economy. Above all, its funding from the Board of Trade, dependent on craft's contribution to industry, was to prove a mixed blessing. Despite its showroom, the Centre was only partially successful in forging a new image for the crafts. A 1955 brochure published by the Centre, *What the Craftsmen Do*, could have appeared in the 1930s: it listed projects by older makers for public institutions – Edward Barnsley's furniture for the dining hall at Loughborough College, Roger Powell's restoration and binding of the Book of Kells, altar plate for Canterbury Cathedral by Reginald Hill, the calligrapher Dorothy Mahoney's Roll of Honour for a cathedral in Fiji. The Centre's Council relished protracted debates about standards while John Farleigh and Sheila Pocock, the Centre's formidably charming secretary from 1954 to 1964, threw their energies into getting media coverage for the Centre. Not all the members approved. At one meeting in 1951 Harry Norris of the Red Rose Guild launched an unpleasant attack on Farleigh, comparing the Centre to *In Town Tonight*, a gossipy radio programme which concentrated on 'celebrities'.[11] Yet the chief problem, as Farleigh often despairingly pointed out, was how to project the Centre and how to sell enough to stay solvent. He was continually disappointed with the quality of exhibits and with the Centre's failure to attract younger members.[12] Non-joiners like Lucie Rie and Hans Coper did not initially exhibit but from 1961 were assiduously and successfully wooed by Tarby Davenport, the Centre's lively exhibitions secretary who also mounted an important show of work by Shoji Hamada in 1963.

A useful parallel can be drawn with a rather more cohesive body, the Craftsmen Potters Association, set up some nine years after the Crafts Centre. In 1956 a group of potters, anxious about Purchase Tax, met to discuss ways of exporting their work under licence. This working party became a provisional council. Its members represented different interests – for instance F. J. Watson was a third generation flowerpot maker, while Keith Corrigan ran the aristocratically backed production pottery at Holkham Hall in Norfolk. Eileen Lewenstein, in partnership with Brigitta Appleby, ran the Scandinavian-inspired Briglin Pottery in Baker Street. Helen Pincombe worked alone and Rosemary Wren worked in partnership with her mother Denise at the Oxshott Pottery. By the summer of 1957 the group had formed the Craftsmen Potters Association of Great Britain (CPA),[13] promising a centre, help with public relations, marketing, export, legal and trade advice and plans to set up apprenticeships. Membership was initially non-selective, reflecting the left-wing politics of at least some of the founders.

In May 1960 the Association opened the Craftsmen Potters' Shop in Lowndes Court off Carnaby Street in London, the interior designed and decorated by enthusiastic members. The CPA was not restricted to production potters. Its membership was at first wide-ranging but the opening exhibition of Ray Finch's stoneware made at Winchcombe signalled that its financial success in the 1960s and into the 1970s was to be based on production ware, invariably stoneware inspired by the Leach Pottery Standard Ware produced at St Ives. In April 1958 David Canter became the CPA's Honorary Secretary. He was artistically minded, a

227. Prince Philip visiting the Crafts Centre of Great Britain, Hay Hill in 1954. (William Newland archive).

alleviating the desperate balance of payments crisis which Britain faced after the American withdrawal of Lend-Lease. The Centre was to provide a register of makers graded according to skill and creativity, whose work could be purchased by BHE for a trading mission targeted on the United States. The scheme failed because of supply problems which forced BHE to ignore 'fine craftsmanship' and unique objects in preference to buying in bulk from large semi-industrial workshops.[5] There was one final government approved role for the Centre, the administration of a Purchase Tax remission scheme for gold- and silversmiths, furniture and instrument makers and handweavers and textile printers. The scheme was demanding to run but was certainly of direct help to makers trying to earn a living in the immediate post-war period.[6]

John Farleigh and his first secretary Evelyn Fathy realised that something rather different was needed for Scotland.[7] Thus, though the London Centre's title insensitively encompassed 'Great Britain', a Scottish Crafts Centre was set up in Edinburgh in 1949 with the support of the Scottish Committee of the CoID. It was in part a flagship for Scottish national identity of the kind suggested by the exhibition title *Living Traditions of Scotland* put on by the CoID in Edinburgh in 1951. The Centre's first chairman was John Noble, one of the great philanthropists of the arts in Scotland and inheritor of the splendid Arts and Crafts house Ardkinglas designed by Robert Lorimer. By 1950 the Centre was housed in Acheson House, a 1630s town house which had been restored by the equally philanthropic Bute family. As Noble pointed out, the Scottish Crafts Centre's Council and panel of assessors did not include craftsmen or craftswomen. Instead we find the Scottish great and good – Earl Haig as president, Jean Bruce as vice president, and a council including Lady Sempill (born a Dunbar) and the Byzantinist David Talbot Rice. The Centre differed from its London counterpart in another way; it promoted some rurally based industrial crafts like knitwear and woven lengths and leather work in the form of sporrans, gloves and travel bags. Such products, redolent of the invented traditions of the nineteenth century, were of course not the whole story of Scottish craft, but 'traditional' goods were as important to the Scottish Crafts Centre and to its aristocratic patrons as Scotland's innovative tapestries, engraved glass and silver.[8]

In contrast with the Scottish Crafts Centre, the Crafts Centre of Great Britain presented a less united front. With a small grant, an unwieldy quarrelsome council representing five

GOVERNMENT AND THE CRAFTS

The crafts had a good war. Makers managed to organise themselves into one body recognised by the government. The Crafts Centre of Great Britain, under the chairmanship of John Farleigh was to be a shop, a retail presence in the heart of London. Back in 1913 the leaders of the Arts and Crafts Exhibition Society had firmly rejected a commercial role for the Society. It had taken thirty-five years to overcome the prejudice. But the Centre was not simply a shop. It was also an amalgamation of societies each of which had been formed to help define interest groups and act as guardians of standards. In addition the Centre's recognition came with strict limitations. In 1948 it was awarded a capital grant of £18,000 by the Board of Trade together with an annual grant of up to £3,000 which had to be matched pound for pound by the Centre. The fine arts and design were better served in terms of hard cash and independence. A Council of Industrial Design (CoID) had been announced in 1944 and in 1945 the post-war Labour government funded it generously via the Board of Trade. The work of the Council for the Encouragement of Music and the Arts (CEMA) was carried on from 1945 by the Arts Council of Great Britain, set up with a Royal Charter granted in 1946, and Treasury funding of £235,000 for the year 1945–6.[1]

What kind of craftsmanship did the Crafts Centre of Great Britain set out to support? Unlike the CoID and the Arts Council, the Centre had to grapple with minute problems of definition of the kind which had been debated endlessly by the Red Rose Guild and the Arts and Crafts Exhibition Society before the war. The Centre decided to support 'fine craftsmanship' 'as embodied in the work of the Designer Craftsman in the Fine Arts'.[2] Rural and vernacular crafts, which had been central to wartime propaganda, were excluded as was 'trade' craftsmanship such as saddlery, watch making or tool making. Nor was there to be space for the philanthropic crafts exhibited at the Red Rose Guild between the wars. Industrially produced goods were, of course, barred and therefore the crafts could not be contextualised, as they were in other shops, by being displayed alongside good design.

As it turned out, the Crafts Centre effectively defined the boundaries of 'fine craftsmanship' for government and arts policy makers for the rest of the century. But 'fine craftsmanship' as an end in itself was not quite enough for the Board of Trade and the Board's advisers at the Council of Industrial Design. At their insistence the Centre's constitution also endorsed the role of the crafts in improving industrial design.[3] The supposed positive influence of designer makers on industry thus became a key factor in the continuation of government support – with, as it turned out, disastrous consequences for the Centre. Readers who find the histories of institutions irredeemably tedious can pass on to Chapter Seven. But the twists and turns in the Centre's fortunes show how, paradoxically, just at the moment when increasing numbers of men and women were turning to the crafts, their government funding came with such a disabling limitation. One thing most makers secretly knew was that the influence of their work upon industrial design was negligible.

The final go-ahead for funding was granted by the Chancellor, Sir Stafford Cripps, on the understanding that the Centre would attract generous patronage and soon become self-supporting.[4] The Centre was also to service an export scheme chaired by his craft-loving wife. This was British Handicrafts Export (BHE), a modest attempt to involve the crafts in

1945–1969

PART II

craft exhibition. *The Mark of the Maker* was held at Swyre, a romantic house that he was renting in Gloucestershire, which he envisaged as developing into a 'Glyndebourne of the crafts'.[35] The emphasis was on visual drama. Rooms were painted white and carpeted with rush matting. One contained only a Rolls Royce engine on a plinth. In another he made an abstract arrangement of cushions by Ann Sutton, hanging them on the wall with nylon monofilament.[36] He saw himself as a self-appointed crusader for the crafts in their widest remit. He published a snappily designed brochure entitled *Craftsmanship is alive and kicking* which argued for an apprentice scheme for the crafts, a national register of makers and a well produced guide book to workshops.

Wood was articulate and well connected. In January 1964 his memorandum *Preliminary proposals for the establishment of a Crafts Council of Great Britain* was adopted by the Centre.[37] This document bore a striking resemblance to Kindersley's *Image of a Crafts Centre* but it was couched in more persuasive prose. Wood made a crucial point which Kindersley's sub-committee had overlooked, that the Ministry of Education, rather than the Board of Trade, would be a more suitable funding body for the crafts. But in the interim period Wood was confident of raising £200,000 from private donations. John Farleigh, who had given his life to the Crafts Centre over the past decade and a half, distrusted Wood. He resigned as chairman and severed all links with the Centre.[38] But Wood won the support of key figures like Edward Barnsley, with whom he conducted a voluminous correspondence, and with Farleigh's successor, David Kindersley. He was swiftly appointed Director of the Crafts Centre and Secretary of an entirely new body named the Crafts Council of Great Britain, launched in May 1964. Modelled on the Arts Council, it pledged itself to find funds to keep the Centre alive as well as to undertake setting up an index of makers and to carry out an ambitious educational programme.[39] After only a few months, to the horror of the Crafts Centre membership, Wood decided, with the support of the new Crafts Council of Great Britain chairman, Gordon Russell, that the Centre was a lost cause and should be closed down.[40] The world of crafts representation was to be bitterly split for the next seven years.

In 1966 Graham Hughes, the art director at Goldsmiths' Hall, took over as chairman of the Crafts Centre and oversaw its removal from Hay Hill to a spacious warehouse in Earlham Street, Covent Garden – at that date, a run-down area of London with 'potential'. The high ceilings, exposed brickwork and iron pillars were something Hughes exploited to suggest the Centre's remoteness from the average retail outlet.[41] Hughes ran the Centre like an enlightened despot, using a small youthful executive committee to make decisions, putting in a substantial amount of family money and using the connections he had made at Goldsmiths' Hall to facilitate overseas exhibitions. A change to the Centre's constitution in 1964 had limited the involvement of the five founder societies and Hughes was to remove their power entirely.[42] He publicised work by the brightest and best of the younger makers – batik artist Noel Dyrenforth, the jeweller Gerda Flöckinger (Fig. 230), the potter Anthony Hepburn, weaver Ann Sutton (Fig. 231) - and, alert to the spirit of the late 1960s, exhibited fashion, semi-mass produced work, highly priced jewellery as well as sculpture by the populist artist David Wynne. Concerts given by Donovan (England's answer to Bob Dylan) and the violinist Yehudi Menuhin further drew the crowds. In 1969, after a successful show of work by American glass artist Sam Herman, Hughes launched the Glasshouse in nearby Neal Street, the only place in Britain where the general public could see hot glass being blown.

Meanwhile Cyril Wood formed a heavy-weight Council for his Crafts Council of Great Britain, including the furniture maker Edward Barnsley, the book-binder Sydney Cockerell and the weaver Peter Collingwood, together with Viscount Eccles (then Minister for Education), the art-loving Dean of Chichester Cathedral, Walter Hussey, and five Conservative MPs. (Only the Labour victory in the October 1964 General Election made Wood's political bias seem misconceived.) The Council issued well-argued pamphlets and annual reports which continued to pursue the goal of an Arts Council for the crafts, starting with a lively manifesto *Craftsmanship* with messages of good-will from luminaries like Mervyn Stockwood, the Bishop of Southwark, the craft-loving engineer Professor Meredith Thring,[43] the architect Basil

230. Gerda Flöckinger at the Crafts Centre at Earlham Street in the late 1960s explaining to Prince Philip why she does not design jewellery for mass production. (Gerda Flöckinger).

231. Ann Sutton's solo show at the Crafts Centre in Earlham Street in 1969. (Photo Sam Sawdon).

Spence, the Principal of the Royal College of Art Robin Darwin and Judge John Maude.[44] Wood put on a handful of interesting shows including *Craftsmanship Today*, which coincided with a high-profile 'service of dedication' at St Paul's Cathedral to celebrate the Council's first anniversary.[45] Wood had already tackled the problem of demonstrating the links between industry and the crafts. The Council's first exhibition *Craftsmanship and Industry* of 1964, held at the Herbert Art Gallery, Coventry, included work by well-known makers alongside products lent by Jaguar Cars, Massey-Ferguson, Rolls-Royce, Rootes Motors and Alcan (UK) Ltd who contributed an aluminium 'fun palace'. As the catalogue pointed out 'It will, no doubt, come as a shock to some people to see, for instance, a gas turbine compressor motor side by side with a fine silver mace and silver centrepiece. But why?' After all, the catalogue argued, tools and sensitive hands were common to both and 'it is the right tools in the right hands that produces the quality'.[46] The Crafts Council promised an alternative to the exclusivity of the Centre, pledging support for the work of amateurs by the setting up of Craft Workshops, open to all, 'to anyone with a desire to work with their hands'.[47] On paper at least Cyril Wood's vision was an inspiring one.

The CoID's craft show, planned in 1963, opened on its new mezzanine floor in July and August 1965. It took the Gordon Russell approach, in which craft formed a continuum with design for industry. *Hand and Machine* included thirty-four craftsmen and women, including the silversmiths David Mellor (Fig. 232) and Robert Welch who both also designed for industry, as well as pure makers like Peter Collingwood, Mary Farmer and Tadek Beutlich (Fig. 233). Furniture, the area in which the craft tradition still continued to represent stasis, was represented by two figures remote from the Cotswold school of making. Peter Hoyte and the sculptor William Plunkett made steel and leather upholstered furniture by hand, perhaps less from choice than because the industry had failed to take up their designs. Ceramics were represented by Ruth Duckworth's austere handmade tableware, the work of Lucie Rie and the Chevron range produced by Denby – factory produced but involving a surprising amount of handwork. The show was imaginatively mounted and made a subtle case for the relevance of craft in the context of short-run production and as an indirect experimental force.[48]

When Labour came to power in October 1964, both the Crafts Centre and the Crafts Council petitioned Jennie Lee, Britain's first Arts Minister, for funds. Her White Paper *A Policy for the Arts: the First Steps* (1964–5), though guardedly sympathetic, made no special provision.[49] But in 1966 the Board of Trade offered a grant of £10,000 to be split three ways with £4,000 to the Crafts Centre, £5,000 to the Crafts Council and £1,000 to the Scottish Crafts Centre. Lobbying continued. The potter Audrey Blackman[50] knew the Leader of the Opposition, Ted Heath, and on the eve of the 1970 election he wrote to her agreeing that there was a case for making the Arts Minister responsible for the crafts and promising 'to end the years of virtual neglect by the government of the crafts in this country' if the Conservatives came to power.[51] Another instance of informal lobbying was mediated by the Labour MP Richard Crossman in the late 1960s. He brought a cross-bench group of political heavyweights to lunch with textile artist Ann Sutton and furniture maker John Makepeace at their showroom in Banbury. Ann Sutton recalls Lord Eccles asking some pertinent questions about craft funding.[52] Meanwhile

233. The Council of Industrial Design exhibition *Hand and Machine*, 1965. (*l. to r.*) Tadek Beutlich's hanging *Moon*, ceramics by Lucie Rie, macrogauze hanging by Peter Collingwood. (© Design Council/DHRC, University of Brighton).

Graham Hughes fired off a series of robust reports to the Board of Trade listing the Centre's improved fortunes.[53] The Crafts Council published *A Plan for the Future* in 1968 which suggested that a new non-trading grant-giving body should be formed along the lines of the Arts Council with a Royal charter.[54] But the situation remained precarious. In 1969 the Board of Trade agreed to continue grants to the Council, the Centre and the Scottish Craft Centre at the same level until 1970/71 at which point, the Board of Trade warned, the grant would finally cease.[55] It was a bleak end to two decades of struggle. What appears to have been over-looked was that the crafts were a success story in terms of public interest and a growth in the number of practitioners. But, as everyone connected with the crafts had come to realise, the Board of Trade was an unsuitable funding partner for the crafts.

SEVEN

ART EDUCATION AND THEORY

After the war the art schools of Britain were transformed. Grants were offered to demobilised servicemen and women without pre-entry qualifications,[1] together with a chance to study for a month at an art school in order to decide on a specialism.[2] The artistic scene was full of energy as this new intake flooded in, anxious to make up for lost time, mature and determined, some with wartime experiences which had inspired serious ambitions for a life in art. Those who eventually developed into craftsmen or women were unlike many of the inter-war makers. They were less privileged, more commercially minded and often unaware of inter-war 'traditions'. They were interested in current design and fine art in Europe. As soon as they could, they travelled, into France, Italy and Spain. The fact that art schools were producing a new kind of maker, ready to respond to and to initiate a contemporary fifties style, was not greeted with enthusiasm by the established figures in the craft world whose reputations had been formed before the war.

PRACTICAL KNOWLEDGE

With the exception of silversmiths, the leading makers of the inter-war years had developed their skills independently, in their workshops. The art schools' post-war ascendancy led them to make the case for their kind of informal education. Bernard Leach was the most passionate exponent of the workshop ethic, and its accompanying set of 'standards'. In a lecture given at the Royal Society of Arts in 1948 on the crafts and post-war reconstruction, Leach spoke out firmly against an art school training. Art schools, he argued, were places where 'crafts such as ours cannot be learned'. In his view, art school tutors lacked basic pottery skills in preparing clay bodies, repetition throwing, kiln building and glaze technology.[3] His dislike of art schools was coupled with doubts about all aspects of popular culture and he went on to deplore 'music while you work', jazz, cinema and wireless and 'all the dope which clogs the release of healthy talent'.[4] All this sounds distinctly reactionary, but Leach's great appeal for his post-war audience was oppositional – to the high levels of state regulation which had been imposed in the war and which seemed set to become part of daily life thereafter. *A Potter's Book* offered independence, attracting amateurs as well as fledgling professionals, and, by the late 1960s, even drawing in disaffected 'drop-out' members of the counter-culture.

Leach's ability to catch the mood of the hour was vividly demonstrated in 1952 at the Conference of Pottery and Textiles held at Dartington Hall.[5] The Dartington conference was initiated by Leach and Muriel Rose, partly because they were conscious that hard-won inter-war achievements might be forgotten by a new generation. As Leach explained to Philip Mairet: 'many young people were coming into the world of craftsmanship without knowing the best that we had produced between the wars, or, indeed, where they were going'.[6] The craft landscape was becoming crowded with unwelcome young aspirants to the craft way of life and galleries were being filled with 'half-digested assimilation…No other age has produced such ill-begotten craft'.[7] The accompanying exhibition at Dartington documented textiles and pottery over the past twenty-five years. Potters emerging from the London art schools were excluded and, indeed, their work was dismissed by one of the selectors, George Wingfield Digby, as 'novelty sailing under a pretentious flag'.[8] In addition to setting standards,

234. (*l. to r.*) Soetsu Yanagi, Bernard Leach and Shoji Hamada at the Dartington conference, 1952. (Holburne Museum and Crafts Study Centre, Bath).

the Dartington fortnight provided Leach with a platform for his spiritualised belief in an East/West synthesis.

As the United States and the Soviet Union took up increasingly confrontational positions, Leach's call to his audience 'to become citizens of the human race rather than merely citizens of one culture',[9] had an especial poignancy and appeared to go beyond a mere plea for fellowship among makers. Leach's ideas may seem cloudy and impractical but plenty of ex-servicemen were registered as Reservists and were threatened with recall to the armed forces under the 1951 Reserve and Auxiliary Forces (Training) Bill. Many, like the potter Murray Fieldhouse, had become pacifists during the war, keen readers of the *Community Broadsheet* circulated by the Community Service Committee and of the *Orchard Lea Papers* by Wilfred Wellock, the former Labour MP and Gandhian who published from his home in Preston, Lancashire. Wellock spoke out against re-armament and American influences and for regionalism and small craft-based communities.[10]

The conference was a gathering of the faithful who had come to listen to (and to watch, for there were demonstrations) the pioneers of the inter-war movement – Soetsu Yanagi and Shoji Hamada from Japan, Leach and Michael Cardew (Fig. 234). Despite the fact that there was a good deal of discussion of the importance of links with industry, the tone of the ten days was profoundly anti-industrial. The painter and critic Patrick Heron argued that 'craft must achieve the intensity of communication of art. Craft that is not art is not craft either.'[11] Craft and art needed to stand out against 'the encroaching enemy' and 'register protest' against 'technocracy'. Michael Cardew and the weaver A.E. Southern gave talks coloured by their experiences as colonial employees. In Nigeria they were witnessing the erosion of a rich crafts tradition by Western imports, just as the crafts in England had been destroyed by industrial products. Cardew explained that his interest in pottery sprang from a rejection of the products of industry: 'an inarticulate rebellion against this joylessness'.[12] And for Cardew, as time went on, 'this joylessness' came to encompass industrialised Britain as a whole, with West Africa fast becoming his personal Arcadia.

Dr Yanagi gave two talks, which presented an old Japan to his audience, alive with Buddhist wisdom. It was as if the expansionist imperialist Japan of the war years had never been. Instead he deplored Western culture's unhealthy individualism, its over-intellectualised educational system and its loss of a craft tradition.[13] Nonetheless, if the industrialised present in the West was unsatisfactory, it also became clear that there was little hope of the kind of major change in social and political structures dreamt of between the wars. The crafts emerged as having an essentially therapeutic, compensatory value. Leonard Elmhirst spoke of the crafts' role in education at Dartington School and their contribution to a post-war 'healing of the mind'.[14] Leach echoed Elmhirst, with talk of the crafts' importance in 'an age of leisure' – 'What are people going to do with their leisure? They can't spend it all on jazz and cinemas.'[15]

To outsiders, the Dartington event had an archaic quality. The accompanying exhibition was discussed by the art critic Robert Melville in the *Architectural Review* (Fig. 235). He noted:

> The general effect is of an ethnographical exhibit of the remains of a lost civilisation, of a village and town community of highly aesthetic peasants…Only the stoneware of Hans Coper and the porcelain of Lucie Rie remains outside the prevailing atmosphere of rural quietism. They alone make the point that the whole exhibition was presumably intended to make. They show that the artist craftsman is not necessarily an anachronism in our time, that it is not impossible for him or her to be, so to speak, with us.[16]

Set beside many of the other exhibits, the work of Hans Coper and Lucie Rie stood out. Coper in particular had felt uneasy at the conference.[17] For all Lucie Rie's friendship with Leach, their attitude to his ideas was ambivalent. They were certainly not proselytisers like Leach, with his ambitions for social and spiritual enlightenment.

The Dartington conference was part of a movement. During the 1950s and 1960s a whole series of alternative groupings sought to keep alive a workshop spirit and learning-by-doing and poured scorn on a liberal art school education. Some of this tendency's leading lights, like

235. *Pottery and Textiles, 1920–52, made in Great Britain by artist-craftsmen*, Dartington Hall, 1952. Stand E showing 'Mainly Slipware' by Bernard Leach, T.S. Haile, Michael Leach, Michael Cardew. (Holburne Museum and Crafts Study Centre, Bath).

Leach and Cardew, had formed their sensibilities before the war and they were joined by other younger makers, like the weavers Gwen and Barbara Mullins, the spinner Morfudd Roberts, the potters Murray Fieldhouse and Helen Pincombe and the potter and educationalist Seonaid Robertson.

Despite its parochialism, this learning-by-doing approach had a fruitful effect on craft teaching in primary and secondary schools. A gifted Schools Inspector named Robin Tanner remembered the Dartington conference as having 'a deep and everlasting influence' and from the mid-1950s till 1964 Tanner designed and directed Ministry of Education courses on art and craft which were held annually at Dartington Hall. These were learning-by-doing courses in which teachers splashed paints, drew, bound books, modelled in clay and cut lino blocks, and listened to talks by Leach, Phyllis Barron and her disciple Susan Bosence, very much in the spirit of 1952.[18] The Society for Education through Art (SEA) held its first conference at Chichester in September 1950, introducing teachers of art and craft to a whole range of fundamental craft skills. As the weaver Ella McLeod explained, these conferences were 'not in words but in doing'.[19] In the 1930s she had developed a heightened sensibility towards materials and processes, influenced by the weaver Elizabeth Peacock and her companion Molly Stobart. Between 1935 and 1942 she revolutionised craft teaching at Howell's School, Denbigh, turning the art room into a living workshop where girls produced tweeds of remarkable sophistication and technical assurance (Fig. 140). It would be incorrect to see McLeod as outside the art school world. From 1949 until her retirement in 1973 she taught weaving at Farnham School of Art. But her ideals were nonetheless workshop ones and she believed that young people should experience every stage of the making process, from spinning the wool to weaving the cloth.[20]

The characteristic activities at these SEA craft conferences brought teachers into close involvement with 'doing' at its most fundamental — pit and *raku* kilns were built, clay bodies were created from local materials, vegetable dyeing and spinning were taught, stone was carved.[21] The craft courses, weekends and demonstrations organised at Pendley Centre of Adult Education at Tring, Hertfordshire by the potter Murray Fieldhouse attracted a broader constituency. Pendley Manor was an early commune. Its Education Centre mixed sporting events and high culture for it had been set up by Dorian Williams, the upper-class son of a Guards officer who loved the arts, wanted to give opportunities to the 'common man' and

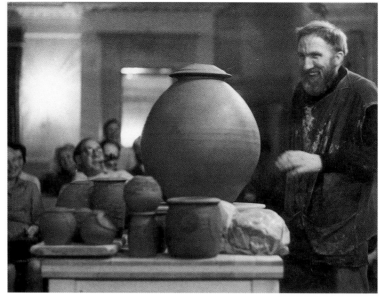

236. Pottery demonstrations at Pendley Centre of Adult Education: (*left*) Murray Fieldhouse throwing in the late 1950s; (*right*) Michael Casson in conversation in the mid-1960s. (Murray Fieldhouse).

237. Michael Cardew's Fundamental Pottery Course 1959: a visit to a Cornish ball clay pit. (*centre group l. to r.*) Janet Leach, John Reeve, Paul Barron. (Colin Pearson).

adored acting and riding to hounds in equal measure. Activities at Pendley ranged from peace conferences to a regular Shakespeare festival and craft weekends which echoed many of the activities at the SEA conferences – with Murray Fieldhouse throwing and turning, Helen Pincombe demonstrating raku and coiling, Michael Cardew and Michael Casson making pots before attentive crowds (Fig. 236). The good fellowship anticipated the Potters' Camps of the 1970s and included a visit to see the ceramics collection of Sir Alan Barlow nearby, a talk by archaeologist Cottie Burland on pots made without a wheel, jazz and early music recitals and, on the final evening, singing and sausages round the kiln.[22] Inevitably this hands-on approach worked better for certain crafts than for others. Crafts like furniture making, metalwork, silversmithing and stained glass depended on more complicated tools and processes and were therefore less open to a fundamental materials-based approach.

Ceramics in particular lent itself to this kind of investigative, demonstrative programme. The Craftsmen Potters Association brought practitioners together to swap ceramic information. Michael Cardew, on leave from Nigeria in 1959, set up a series of two-week courses at Wenford Bridge on *Fundamental Pottery with Emphasis on Geology and Raw Materials*. Its aim was to 'help individual potters who want to make the best use of natural materials without depending too much on the potter's "middleman".'[23] There were lectures on geology as a

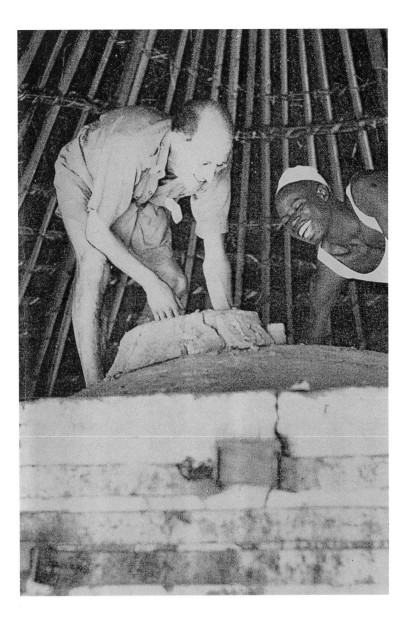

background to the creation of glazes, clay bodies and refractories. There were visits to quarries and clay pits (Fig. 237). The contrast with an art school approach was striking. Throughout the 1950s, students in art colleges relied heavily on technicians. Repetitive throwing and speed of production were not seen as part of a liberal education and this affected design. Cardew's course attracted educationalists and potters interested in process – Helen Pincombe, Paul Barron and Henry Hammond from Farnham School of Art, Gwyn Hanssen, Charlotte Bawden and Katharine Pleydell-Bouverie. It formed the basis for Cardew's book *Pioneer Pottery*, which articulated his belief that sweating through every step of the process of making had important aesthetic implications. It would enable Western potters to emulate the 'single mindedness of the primitives until at last we wake up and find that we too can make good pots'.[24] Cardew's Training Centre at Abuja in Nigeria run by him from 1952 until 1965, and then taken over by Michael O'Brien, was a model for the virtues of the fundamental approach (Fig. 238).[25]

Some of this activity recalled the philanthropic initiatives of the great and the good between the wars. In 1952 Gwendolen Mullins, the wealthy wife of a banker, set up a Crafts Centre in her Sussex village of Graffham because of her 'belief in the value to the community of all that lies behind the learning and practice of a craft'.[26] The Graffham Crafts Centre taught and practised weaving and dyeing, basket making, basic woodwork and bookbinding and there were also clay modelling classes for children. Gwen and her daughter Barbara were both weavers. Gwen made pile tapestries inspired by landscapes, while Barbara, much influenced by Navaho blankets, wove starkly geometric rugs. Neither woman had had a formal art education, and indeed they regarded art schools as 'hot-housing', in contrast with the more

239. Wedging clay at the Cross Roads Pottery, Verwood, Dorset, in the 1930s. (Rural History Centre, University of Reading).

natural workshop routine.[27] In 1950 the Mullinses had attended the SEA craft conference and met Ella McLeod, Henry Hammond and the young Morfudd Roberts. There they discovered some of the problems facing young makers and as a result Gwen set up the grant-giving Mullins Trust, in 1954, with capital of £10,000.[28] As weavers, the Mullinses were concerned with the raw materials of their craft and in 1959 they gave a grant of £2,000 to start Craftsman's Mark, which aimed to supply wool and silk yarns suitable for handweavers. It was run, at a loss, by Morfudd Roberts until her death in 1991 and was an example of high-minded service in the pursuit of quality. Roberts would select fleeces herself and have them spun, first at chosen Welsh mills and later at mills in Yorkshire and Scotland.[29] Thus, in a unobtrusive fashion, Gwen and Barbara Mullins exerted quite an influence on the crafts in the 1950s and 1960s.

These courses and the conferences present a somewhat risible image. To those outside the inner circle, the makers of the 1950s and 1960s might seem to have been pursuing a pleasurable but indulgent hobby, playing with clay and yarns, wheels and looms, with perhaps a bit of folk singing in the evenings. But those who attended were after a kind of knowledge which could *only* be communicated by demonstration. It would be hard to over-emphasise how difficult it was to gain basic technical information in those early years, despite *A Potter's Book* and a clutch of more utilitarian post-war publications. As Harry Davis observed, there were many skills – for instance, certain fingerings known to surviving country potters all over Europe – of which studio potters were ignorant.[30] The post-war generation paid greater attention to the handful of surviving country potteries. Some were just closing, like the Cross Roads Pottery at Verwood in Dorset which ceased to trade in 1952 (Fig. 239). But there were still discoveries to be made and in the late 1950s Helen Pincombe travelled north to the Littlethorpe Pottery near Ripon in Yorkshire. Attending demonstrations, visiting other potteries and serving an apprenticeship at the Leach pottery or at the Winchcombe Pottery were all ways of gathering 'know-how', of tapping into the kind of tacit knowledge that could not be communicated in a formal systematic way. What is regrettable is that links with the design world and other areas of the art world were virtually non-existent.

Of other 1960s gatherings, one stands out, because it had a strongly innovative feel to it, and because it brought makers, principally weavers, into contact with other kinds of artists. This was the Summer School at Barry run by South Glamorgan Education Authority, which in the early 1960s, under the visionary guidance of the County's Art Adviser Leslie Moore, attracted radical artist tutors in music, painting and sculpture and some crafts.[31] The sculptors Harry Thubron and Tom Hudson and the painter Terry Frost all taught there and, as we shall see, their pedagogic method, inspired by the Bauhaus *Vorskurs* and known as Basic Design, was to have a profound effect on craft and art teaching in the colleges of art. The constructionist artists Mary and Kenneth Martin were regular attenders, as were the young composers Cornelius Cardew, Gavin Bryars and Peter Maxwell Davies. The tapestry weaver Tadek Beutlich taught at Barry in the mid-1960s and the weaver Ann Sutton took over his course in the late 1960s. She changed its name to 'Textile Construction', urging her students to experiment with ways of weaving without looms[32] and collaborating with Systems artists like Michael Kidner, Jeffrey Steele and two composers with the same interests, Peter Maxwell Davies and Francis Shaw (Fig. 240).[33] Thus Barry was in no sense oppositional to art school activity – rather it disseminated avant-garde fine art practices (rather than the practical skills on offer at SEA conferences) to a wider audience than was usual.

WORKSHOP PHILOSOPHIES

In the workshop the student or apprentice learnt by observation. Skills were passed on through the process of making and through the opportunity to observe a master (or mistress) making. It was an old way of learning and, as education became increasingly formalised, a heterogeneous band of philosophers, scholars, designers and makers had begun to argue for a special value in knowledge thus acquired. As we have seen, F.R. Leavis and Denys Thompson rediscovered George Sturt's *The Wheelwright's Shop*, and offered it up in the pages of *Scrutiny*

from 1932 onwards as an alternative to the superficiality of contemporary culture between the wars. As Sturt had explained of wheelwrighting:

> the work was more of an art – a very fascinating art – than a science; and in this art, as I say, the brain had its share. A good wheelwright knew by art but not by reasoning the proportion to keep between spokes and felloes…there was no science in it; no reasoning. Every detail stood by itself, and had to be learnt either by trial and error or by tradition.[34]

Thompson in particular idealised 'that incommunicable knowledge which every workman must acquired afresh for himself'.[35]

It was this kind of 'incommunicable knowledge' which interested the philosopher and scientist Michael Polanyi; his book *Personal Knowledge* of 1958 identified a distinction between knowledge which can be formulated in written rules and precepts, and know-how or tacit or practical knowledge. Polanyi argued for an intuitive, intellectual creativity that went beyond what he saw as mere rationality and which was based on this kind of tacit knowledge.[36] The political philosopher Michael Oakeshott similarly described types of knowledge (he cited making an omelette) that could only be understood through demonstration. He argued: 'practical knowledge can neither be taught nor learned, but only imparted and acquired. It exists only in practice, and the only way to acquire it is by apprenticeship to a master, not because a master can teach it (he cannot) but because it can be acquired only by continuous contact with one who is perpetually practising it.'[37]

Oakeshott and Polanyi were non-practitioners, but another learning-by-doing theorist of the 1950s was a designer in flight from post-war design culture. John Chris Jones's extended essay 'Activities, Artifacts and Concepts: Some Thoughts on the Singularities of Modern Life' of 1957 included a critique of the limitations and rigidity of industrial design and its dependence upon scale drawings.[38] Designs that were unsuitable for use occurred, he argued, because existing methods operated on 'rigid principles that preclude re-adjustment and adaptation to unforeseen effects'[39] and because design based on scale drawing was remote both from users' needs and manufacturers' problems. Jones was inspired by his discovery of Sturt's *The Wheelwright's Shop* and its description of traditional craft processes and he observed: 'Farm waggons and carts were not designed at all in our sense of the word. No single person had ever sat down to conceive them as a whole…(but) they were what we would call good designs.' A craft approach came to seem a model for Jones. Out of his interest in the craft emphasis on

Norman Potter

Stick furniture

Cabinet-makers Shop Corsham Wiltshire

In production 1952 at the new workshop : scaffolding system of minimal storage and stick furniture ; its strictly utilitarian character being patent in its simple assembly & jointing

Designed to be inexpensive and freely adaptable to individual requirements, the basic framework of hardwood section is free-standing, stable, and accessible all sides ; unit assembled and fully demountable without special tools

For direct connection to the scaffolding are certain accessories conforming to the structural module : pre-cut sheet materials providing shelving & cupboards ; bed frame at seating height to take all standard mattresses ; desk and/or table etc

Reference WN details and list prices per ft run/super

Froshaug printer . PZ

241. Norman Potter in his Corsham workshop in the early 1950s. (Robin Kinross).

242. Card announcing Norman Potter's Stick Furniture. Typography by Anthony Froshaug. (Robin Kinross).

designing-by-doing grew the system known as 'design methods', which emphasised collaboration, a mix of rationality and intuition, and which attempted to find alternatives to the drawing board as the principal method of evolving designs.[40]

A sharper, negative analysis of the craft approach is to be found in the writings of the designer and furniture maker Norman Potter (Fig. 241). Although he ran a small workshop in Corsham, Somerset, Potter felt no affinity with the crafts movement, despite having 'strong views about craftsmanship'. Because he quixotically attempted to honour the purest principles of the Modern Movement in his workshop, certain techniques carried an unwelcome symbolic freight. As Potter explained, at Corsham 'we went out of our way *not* to make dovetails, preferring where we could, to oversail.'[41] Potter's 'Stick furniture' system of 1952 – wooden rods and integral joints that could be assembled as furniture and storage space in combination with other materials – gives a good idea of his design principles (Fig. 242).[42] Potter's classic text *What is a Designer*, published in 1969, included a chapter on the 'Designer as artisan', which analysed the difficult social and cultural position of the maker, a figure classified by Potter as a blue-collar worker who was at an economic disadvantage and was out of place among both trade artisans and white collar designers. Cultural insecurity meant that craft workshops were often 'cut off from the intellectual currents of their time' producing work that was 'self-contained, sentimental and backward-looking'.[43] Yet Potter believed in the workshop principle: 'It is decidedly a mistake for design theorists to suppose that every serious design opportunity must refer back either to a type-form (a myth with Platonic overtones) or to the special conditions of mass-production.'[44] Although for Potter the Gimson/Barnsley tradition of fine one-off pieces was 'a deeply unattractive option',[45] nonetheless there were Arts and Crafts ideals which Potter applauded. He admired Lethaby. Lethaby had spoken of life as service, of joy in labour and had an admiration for non-literate cultures, the 'true' cultures of the shepherd, the sailor, the carpenter.[46] Potter similarly believed that the workshop should serve the local community. He envisaged a 'workshop that opened on Monday morning like a garage ready to make anything that wanted making locally.'[47]

Less highly theorised writing came from within the craft movement. Bernard Leach developed his belief in a workshop training in many articles and in major publications in which he transmitted the ideas of Yanagi and Hamada. Harry Davis set out more practical ideas about the ideal workshop in his privately printed pamphlet *In Defence of the Rural Workshop* (1954). He

argued that there were human and social virtues inherent in the small workshop and that hand-processes had inherent advantages. 'Subtleties, variations and new ideas can be incorporated at once, and the embarrassment of poor ideas frozen into a stock of moulds and master moulds does not arise as they can be discarded as soon as they are recognised as being inferior.'[48] He advocated recycling, creative salvage of second-hand machinery and no sub-division of labour. Davis was, like Ethel Mairet, inspired by Lewis Mumford's vision of the small workshop 'using machines on a human scale, directly under human control' and by Eric Gill's belief that art should not be 'something for which a man made an extra charge'.[49] In 1964 he and his wife had moved to New Zealand because they believed the Northern Hemisphere to be on the brink of nuclear war and in 1972 they set up a pottery project in Peru. The harsh demands of the Peru experience crystallised Davis's views about 'our inability to look at technology in human terms'[50] and his disgust at the contrast between the over-affluent west and the Third World.

His writings and broadcasts attacked the hierarchy of the arts and the consumer society, setting out a very specific role for the low-level technologies which he had investigated with such thoroughness:

> These novel, if somewhat primitive skills have a special relevance as we stand today, dangerously on the brink of an atomic holocaust. This is not just something penniless peasants now need, but something that may become of supreme value if man persists in his lunatic brandishing of atomic weaponry. The ultimate blasphemy if it comes, alas, will leave the survivors in the direst need of such skills as these.[51]

Davis had returned to the old, early twentieth-century theme of a mass catastrophe, which would test, and find wanting, the limited skills of highly specialised factory fodder.

By the 1950s Michael Cardew had come to share some of Davis's fundamentalist views. His *Pioneer Pottery* of 1969 was an odd complex book, part geology and scientific formulae – a valiant attempt to master the technology which Davis had found to be lacking in the early studio pottery movement – part a passionate and poetic disquisition on standards in ceramics, and part a meditation on the role of the West in underdeveloped countries. But, despite his emphasis on functional pots and ceramic science, Cardew ultimately makes a convincing claim for the potter as artist. The maker is urged 'to play the immortal', to 'live on the frontiers of his art' and to be mindful of Malraux's definition: 'I call that man an artist who creates forms...I call that man a craftsman who reproduces forms.'[52] Some of Cardew's ideas echo those of Oakeshott. His experiences of pottery in West Africa from 1942 onwards had confirmed his suspicion of the dominance of literacy and book-learning in the West. He had a marked dislike of the alphabet – 'those bloodless abstract phonetic bricks'[53] which he contrasted with the beauties of Chinese calligraphy. He had a special respect for objects whose meanings simply could not be unlocked because their makers belonged to another culture.[54] Part of West Africa's attraction for Cardew was that he met people who had escaped – borrowing a phrase from Alan Moorehead's book of that title – the 'fatal impact' of European clerks and scribblers.

Part One of this book traced a heightened sensitivity to things and their textures and materials articulated in the writings of John Ruskin in the nineteenth century and in the work and ideas of figures like Michael Cardew, A. Romney Green, Margery Kendon and Ethel Mairet in the twentieth century. We have seen how concepts such as 'craftsmanship' and 'handmade' and 'truth to materials' were central to their notions of excellence and that a standard of 'handmadeness' operated within craft exhibiting societies, and remained an issue within the Crafts Centre of Great Britain after the war. But in the late 1960s a book appeared which poured cold water on the entire debate and introduced a new terminology to define what constituted 'craftsmanship'.

Its author, David Pye, was primarily a teacher, though in the 1950s he designed an eclectic range of furniture, some close to post-war Danish design, some distinctly Arts and Crafts and some American-inspired.[55] From 1949 he was a tutor at the Royal College of Art in the School of Wood, Metals and Plastics, and from 1964 to 1974 he was Professor of Furniture. Before

243. David Pye using his 'fluting engine', invented 1949–50. (Crafts Council/David Cripps).

244. David Pye, bowl, 1975 English walnut, the interior carved with Pye's 'fluting engine'. Diameter 32cm. (Crafts Council/David Cripps).

the war he had trained as an architect at the Architectural Association where he reacted against the Modern Movement orthodoxies that were on offer. He built boats and decided to specialise in wooden buildings, moving into furniture design after the war. But he was also a craftsman. His own workshop was small, solitary and very much in the spirit of the *grand amateur*. In it he made carved and fluted bowls using a remarkable fluting jig of his own invention (Figs 243, 244), turned, carved and fluted boxes and wooden sculpture that, with the exception of some ships' figureheads, tended to be abstract. It was a narrow, eccentric, but exquisite output. Pye was also interested in the craft aspect of mass production, in particular the making of tools, jigs, patterns and prototypes.[56]

His dismay at the narrowness and poverty of English design culture was expressed in his first major book, *The Nature of Design* (1964). There he attacked crude notions of functionalism (a term then interchangeable, among British designers and critics, with the notion of Modernism).[57] He argued 'Things simply are not 'fit for their purpose'…Everything we design and make is an improvisation, a lash up, something inept and provisional. We live like castaways.'[58] Pye also attacked the way in which unsophisticated British commentators such as John Farleigh referred to 'the machine'. Pye understood about tooling. Machines, in his view, had no intrinsic capabilities or any innate capacity for what Farleigh had called 'beastliness'. Good design was a matter of economics: 'Mass production is capable of making things both cheap and of very good quality, but mass production does not essentially depend on machine

tools or any other sort of tool. It depends upon the size of the market for your product and on how much you can afford to spend on organising manufacture.'[59]

Pye wrote from a very English parochial perspective. Continental architects and designers are never mentioned by him. But he was usefully critical of the emotive nature of the craft debate, arguing that "Handicraft' and 'Hand-made' are historical or social terms, not technical ones.'[60] Instead of the term craftsmanship, he proposed two precise alternatives – the 'workmanship of risk' – in which the quality of the result was dependent upon the judgement and dexterity of the maker – and the 'workmanship of certainty' – found in quantity production and above all in fully automated mass production. Within the category 'workmanship of risk' Pye proposed two sub-groups which he termed 'free' and 'regulated' workmanship. Free or rough workmanship – identified by Pye in some woodcarving, calligraphy and a great many traditional wood crafts such as hurdle making – involved design in action. Regulated workmanship suggested less flexibility; pre-planned ideas simply being carried out with precision, as in fine cabinet making. Pye argued that, until the coming of mass production, regulated workmanship was admired because it was hard to achieve. In the late nineteenth and early twentieth centuries, however, mass production created a longing for diversity in the form of free or rough workmanship.

Pye used his precise terminology to expose the flaws in Arts and Crafts thinking. He began with John Ruskin's influential chapter, 'The Nature of Gothic', in *The Stones of Venice*, which included an attack on nineteenth-century mass production and workmanship. Ruskin's lyrical account of early Renaissance building and stone carving in Venice was dismissed by Pye as propaganda for 'a certain strain of naive ornament and for free workmanship'.[61] Pye argued that Ruskin had little understanding of the processes of manufacture and was especially ignorant of the high standard of Victorian regulated workmanship of risk. When his ideas were taken up by William Morris, Pye argued, all kinds of confusion about the meaning of craftsmanship followed. But Pye understood that the workmanship of certainty, in the form of twentieth-century mass production, lacked diversity and he addressed the future of the crafts – 'that sadly tarnished name' associated with 'hairy cloth and gritty pots'[62] – in that context. The crafts were not superior to industrial products in his view, but they were needed as the 'salt – and the pepper' that would make 'the visible environment more palatable'.[63] Pye's gloomy but realistic prognosis was that high quality crafts would continue, but would be made 'for love and not for money'[64] by people who were earning their living in some other way. Thus Pye's writing both worked to free the crafts from a moralising handicraft *cul de sac* but also cut them down to size. They were to be the salt and pepper but hardly the meat and drink of our visual culture.

ART SCHOOLS IN THE 1950S

In his 1948 Royal Society of Arts speech Leach had dismissed the two-tier examination system for art schools, asking 'How can half a dozen crafts be acquired in two years?'[65] Yet the new testing, which had been introduced in 1946, represented a belated recognition by the government of the crafts as an artistic – as opposed to vocational – activity. From 1913 until 1946, the Board of Education's examination had fallen into two parts. After two years, students took Drawing Examinations concentrating on life drawing, drawing from the antique, drawing from memory and knowledge, architecture, anatomy and perspective, thus completely excluding practical craft work, although from 1935 the Board of Education had required candidates to send specimens of actual objects if they submitted designs for craftwork in drawn form. A further two years led to a second examination in which the crafts were similarly ignored, with students specialising in Painting, Pictorial Design, Modelling or Industrial Design. A substantial amount of craftwork was taught and carried out in art schools – either in trade classes or simply initiated by teachers with an arts and crafts background – above all at Birmingham and at the Central School of Arts and Crafts; but it was not built into the national examination system.

From 1946 the situation was changed. Students studied for two years for the Intermediate

Certificate in Arts and Crafts (its very title indicated a change of emphasis) which tested in eight areas – Drawing from Life, Drawing and Painting from Memory and Knowledge, Anatomy, Architecture, Drawing the Figure in Costume, Creative Design for Craft, Modelling and General Knowledge. This was followed after two further years by the National Diploma in Design (NDD), which also made provision for examinations in a whole range of crafts, including gold and silversmithing, printed textiles (hand or machine), weaving (hand or machine), knitwear, lace, book binding, lettering, writing and illuminating, stained glass, wood carving, gesso work, hand rug weaving and pottery.[66]

This seems like a remarkably generous provision for the crafts, especially in the context of the technologically minded 1950s, but in reality no college could offer the whole range. For instance, by the end of the 1950s Goldsmiths' College offered, at Intermediate level, courses in carving, pottery, wood engraving, fabric printing and embroidery, with NDD students eligible for embroidery and subsidiary subjects that included pottery and stone carving.[67] But the craft options were taken by relatively few students, the majority specialising in painting and illustration. In the first year of the system forty-two of the fifty-five NDD subjects attracted fewer than five candidates.[68] And both Intermediate and NDD were centrally examined. If, retrospectively, they seem like a thorough training for an artist, they were also restrictive, particularly in the case of the fine arts, where figurative work was expected and abstraction was failed outright.[69] In any case, not all post-war students had a positive vision of craft subjects. For example, the young Ann Sutton, studying embroidery and woven textile design for NDD in 1951–6 at Cardiff College of Art, did not want to 'boil up leaves in buckets: the Ethel Mairet approach was what I absolutely dreaded.'[70] Victor Margrie, trained at Hornsey College of Art, 1946–52, saw himself as a designer who happened to make studio pots.[71] For Sutton, Margrie and others attracted to the positive 'contemporary' atmosphere of the 1950s, the crafts of the inter-war years seemed remote and irrelevant – just as the inter-war makers had regarded themselves as more 'modern' than the survivors of the turn of the century Arts and Crafts Movement. Innovative crafts flourished independently of NDD – in art schools where there were inspired instructors – Constance Howard teaching embroidery at Goldsmiths' College, for instance, or Eric Clements teaching at the Birmingham School of Silversmithing and Jewellery.[72]

Throughout the 1950s the Central School of Arts and Crafts was a particularly lively training ground for both makers and designers. One of its strengths was that since its foundation in 1896 it had stood outside the art examination system, awarding a diploma of its own. The Central School was just one of many art schools which took on new staff after the Second World War. From the craft point of view, it was an exciting place to be, representing the greatest challenge to the pre-war supremacy of a workshop training, particularly in ceramics. Its dynamic new Principal, the painter William Johnstone, recognised that he had inherited a legacy of exemplary handwork in the Arts and Crafts tradition, above all in the fields of book production and metalwork and jewellery. This he sought to preserve, but also to enliven, conscious that at the turn of the century the Central School had, as he put it, acted as 'parent to the Bauhaus'.[73] Some of his appointments may have seemed distinctly anti-craft. They included members of the Independent Group, a loose network of artists, designers and architects interested in popular culture and Americana who met at the ICA.[74] But in fact their influence proved stimulating to craft activity. It was at the Central School that the teaching method known as Basic Design had the greatest impact on craft practice.

What was Basic Design? At first sight a course conducted on Basic Design principles might not seem an appropriate start for a budding craftsman or woman. It had a strongly analytical flavour and was inspired by the teaching of Paul Klee and Kandinsky and by the *Vorkurs* (the introductory course) initiated at the Bauhaus by Johannes Itten in 1919. Basic Design was the antithesis of the Leachean workshop approach; it set out to educate, but not to train. Students were given modest, untraditional materials and were expected to use them experimentally. Maurice de Sausmarez, in his 1964 primer, recommended plywood, dowel rods, *papier mâché*, drinking straws, plaster of paris (for carving) and wire mesh. Traditional techniques like life

245. Basic Design exercise devised by Richard Hamilton: 'taking a small piece of lino, cutting successive marks and making adjacent prints after each additional cut'. Illustrated in *The Developing Process*, ICA 1959.

drawing, stone carving and bronze casting were abandoned in favour of construction and mark and pattern making. The ideal was 'works of substance by insubstantial means'. The approach was, as de Sausmarez put it, 'an attitude of mind not a method.'[75] A key aim was to free students from acquired technical tricks and from any kind of preconception about the nature of art. For instance, the painters Victor Pasmore and Richard Hamilton asked their students to spend several days simply making charcoal dots on paper: 'This had the temporary effect of bringing everyone, no matter what his accomplishments had been in previous art education, to similar levels of competence.' (Fig. 245)[76]

At the Central School the Independent Group member William Turnbull taught a Basic Design course in the late 1950s in the School of Interior Design and Furniture (which included Pottery and Stained Glass). Several staff who came and went at the Central in the 1950s – Alan Davie, Nigel Henderson, Eduardo Paolozzi, Victor Pasmore – also had an interest in Basic Design. Johnstone sent Mary Kessel, Richard Hamilton and Alan Davie[77] – painters all – to teach in the School of Silversmithing and they had a powerful impact. Davie taught at the Central from 1949 to 1955 and reintroduced a free, spare decorativeness and new sources in 'primitive' and pre-Columbian artefacts, culminating in 1952 in the show *Contemporary Jewellery*, a ground-breaking student and tutor show (Fig. 246). In his *Hidden Order of Art* the art theorist Anton Ehrensweig recalls the powerful effect Davie's teaching had on the young trade silversmiths. He used Basic Design techniques, whereby students worked on eight designs simultaneously, inserting into each design a simple element – a square or a circle – but varying its size and position each time. This had the effect of putting students 'into an unfamiliar situation which allowed of no ready made solution.'[78]

As Johnstone explained, the fine artists were intended to act as Masters of Form (to employ Bauhaus parlance) whilst the more traditional staff, noted for their making skills, fulfilled the role of Masters of Crafts. Johnstone moved quickly to modernise, sacking John Farleigh, the head of the Department of Book Production, and replacing him in 1949 with Jesse Collins, a graphic designer who had worked with the modernist designers Misha Black and Milner Gray. In the same year the typographer Anthony Froshaug was brought in to teach advertising design. Froshaug, steeped in Central European New Typography, was a figure wildly remote from Farleigh's artistic and intellectual gentilities. In a similar fashion, the textile department was enlivened by the introduction from 1950 to 1955 of another Independent Group member,

the sculptor Eduardo Paolozzi, who was startled by tutors in 'handmade yeoman's smocks' and a 'thoroughly parochial and sterile' atmosphere engendered by the 'Arts and Crafts movement of the 1950s'.[79] Johnstone had already appointed the architect Freddie Lebensold to shake Interior Design and Furniture out of its 'arty-crafty' attitudes and to bring it in line with modern thinking'.[80] The school graduated designers like Terence Conran, Bernard Schottlander and David Hicks, and focused on design for industry.

The Central School produced potters who rejected the dominant Oriental aesthetic. By 1947 Dora Billington was head of the pottery department in a newly created School of Furniture, Interior Decoration, Pottery and Stained Glass. As we have seen, she had little time for Orientally inspired stoneware.[81] By 1953 she was able to endorse a new school of English studio potters led by William Newland, who worked in vividly coloured tin-glaze, often figuratively.[82] In the mid 1950s she was succeeded by Gilbert Harding Green, an elegant Georgian figure, fond of gardening, who presided over a second wave of talent led by figures like Gordon Baldwin and Ruth Duckworth. Harding Green 'created things through other people' and in Ian Auld's view was 'the best ceramic head of department that one has ever known'.[83] The department was enlivened by the occasional presence of Paolozzi, the painter Louis le Brocquey and William Turnbull. Gordon Baldwin, on Turnbull's Basic Design course in the 1950s, discovered that it was possible just to 'do a decoration, to be in the act of doing it, make it up as you went along'. Basic Design taught him that he could 'just wander a line along'[84] (Fig. 247) and introduced him to the possibilities of art created with the help of chance and systems. Gillian Lowndes also had positive memories of Basic Design at the Central School in the late fifties. The spontaneous intuitive quality of her subsequent work,

248. Plaster carving: exercises in three dimensional Basic Design by students taught by Aidron Duckworth at Kingston School of Art, 1962. (Photo John Donat).

247. Just wander a line along: Gordon Baldwin, *Vessel from the Belvedere Series*, buff clay with engobes, oxides, stains and glazes, 1988. h. 96.5 cm. (Photo David Cripps).

249. Introductory student exercise set by Gerda Flöckinger at Hornsey College of Art, mid-1960s. (Gerda Flöckinger).

and of the work of potters like Ruth Duckworth and Lowndes's husband Ian Auld, was arguably Basic Design's contribution to ceramics in the 1960s and 1970s and represented a move away from utility and towards fine art.

Basic Design spread out quickly to other colleges of art. The jeweller Jacqueline Mina remembers the tensions at Hornsey in the 1950s, with older tutors who favoured calligraphy, bookbinding and stained glass being outstripped by younger tutors who began to introduce Basic Design, colour theory and ergonomics.[85] The embroiderer and stained-glass artist Margaret Traherne sought out Basic Design teaching with Harry Thubron in the mid-1960s, with important implications for her subsequent work in glass and as a banner maker. At Kingston School of Art Aidron Duckworth the furniture designer addressed one Basic Design problem. He noted that many teachers of the system were painters or sculptors with little interest in skills. In an article in *Architectural Design* he illustrated a powerful group of objects made by his students, and by himself and his wife, the potter Ruth Duckworth. These combined exploratory exercises in plaster, wire, metal and wood with a high standard of craftsmanship (Fig. 248).[86] Similar exercises were introduced by the jeweller Gerda Flöckinger at Hornsey School of Art where she taught from 1962 to 1968 (Fig. 249).[87]

The role of craft in art schools during the 1950s was, however, problematic and became increasingly so because of the lead taken by the Royal College of Art, Britain's most prestigious graduate school. There it had been recommended in 1936 that the College return to its original role which had been outlined in 1911, and concentrate on 'the direct practical application of the arts of manufacture'.[88] In 1948 Robin Darwin – 'an amateur artist of no great talent' according to William Johnstone[89] – was appointed Principal. By 1955 Darwin had negotiated new salary scales based on University rates, which made it possible, the College Prospectus claimed, to attract 'the most distinguished designers of the younger generation'. Significantly 'highly skilled craftsmen' were appointed to each School, but as technicians only, thus allowing the students 'to concentrate on the primary aim of becoming good designers rather than expert craftsmen'.[90] For Johnstone at the Central, the Royal College approach was anathema: 'I disliked the professional elitist movement away from skilled craftsmanship towards "designing" or "directing".'[91]

Each School was to provide specialised training 'with a view to direct assistance to industry' but some schools were kinder to an artist craft approach than others. Wood, Metal and Plastics (renamed Furniture Design in 1954) declaredly did not aim to train craftspeople. Ceramics under Robert Baker announced its close links with the industry at Stoke-on-Trent and this

meant marginalising studio pottery. In 1948 Cardew, looking for a job, had been interviewed by Robin Darwin and told bluntly that 'there was no place for him under the new regime'.[92] Cardew wept in the galleries after that encounter and then walked across to the Geological Museum to study the properties of the mineral Zircon. Textiles, too, were industrially orientated but Silversmithing and Jewellery did cater for the artist craftsman as well as the industrial designer, although it was stated that training in craftsmanship would be secondary to training in design. Graphic Design, similarly, concentrated on innovation but also had a place for bookbinding and lettering and fine printing. In 1956 the typographer John Lewis was put in charge of the College's own private press, The Lion and Unicorn Press.[93] Out of the same department came the college magazine *ARK* which initially at least was full of typographical nostalgia.

Despite this commitment to design for industry a sense of naturally conservative thinking comes over strongly among the staff. For R.D. Russell, the 'coldly unemotional quality' of the Modern Movement 'struck a chill into the hearts of the public'. Russell described the best English furniture of the inter-war years as being made 'largely by hand and in small quantities'; furniture, in fact, which sounds very like the products of his brother's firm, Gordon Russell Ltd, largely designed by R.D. Russell himself. For Russell, as for so many English commentators, English eighteenth-century design represented 'an unparalleled degree of elegance and distinction'. The aesthetic standards of the eighteenth century were contrasted with 'the ill manners and squalor of the twentieth century'. He lamented the fate of his students, who would not have the aristocratic patronage enjoyed by eighteenth-century furniture makers. Instead their designs would have to cater for 'housewives' in 'dreary little suburban homes'.[94] The Rector, Robin Darwin, also saw the eighteenth and early nineteenth centuries as a high point and the two men agreed on the need for the 'discreet enrichment' of furniture and interiors.[95] Their vision for modern furniture was encapsulated in a College gift to the Queen to mark the christening of Prince Charles, a partly handcrafted Danish-influenced child's bed designed by a student, Frank Guille, and ornamented with silver enamel escutcheons made by Philip Popham, a tutor in the School of Silversmithing and Jewellery. Or, again, in the machine-cut patterning resembling inlay devised by another College student, Robert Heritage. Or in the monoprints by another student, Geoffrey Clarke, which were

250. Discreet enrichment: Robin Day, sideboard with a panel incorporating a Geoffrey Clarke print embedded in laminated plastic, shown at the Milan Triennale 1951. Note the Hans Coper jug and plate and the Lucie Rie lemonade set. (Courtesy Geoffrey Clarke).

laminated with clear plastic and used to enliven former student Robin Day's sideboard, designed for the firm Hille and shown at the Milan Triennale (Fig. 250). The real impetus for innovation at the College, both in the fields of design and craft, came from the students themselves. In the stained-glass department the work of two students, Geoffrey Clarke and Keith New, caught the eye of Basil Spence and led to the remarkable commission for ten stained-glass windows for Coventry. In the School of Jewellery and Silversmithing it was the students who worked out a new framework for making a living by combining craft and design.

For many students, it was the craft component in the humble Art Teachers' Certificate (ATC) that turned them from fine artists and potential teachers into craftsmen and women. At the Institute of Education a number of painters taking ATC – including William Newland, James Tower, Nicholas Vergette, Ian Auld and Margaret Hine – subsequently embarked on a lifetime commitment to pottery. Similarly at Goldsmiths' College a student with a Fine Art background taking ATC, like Christine Risley, was able to 'discover' embroidery under Constance Howard's lively guidance. In Howard's view the fine artists had helped to revolutionise embroidery. Thanks to them: 'a gradual change in outlook took place, with freer technique and stitching often invented to express what they had in mind'.[96] But teacher training could offer a different experience. At the East Midlands Training College, later Loughborough Training College, Peter van der Waals was art adviser on design from 1930, succeeded in 1937 by Edward Barnsley. At Loughborough, therefore, student teachers were introduced to furniture making in the Cotswold tradition. It was a different world from the ATC taken by metropolitan art students and was closer to a workshop training. By 1963 the handicraft department at Loughborough was seen to be old-fashioned and in 1966 became part of a Department of Creative Design. Barnsley retired two years later, conscious that an increased emphasis on design and technology in schools spelt a threat to the high standards of craftsmanship he had fostered among his students.[97]

ART SCHOOLS IN THE 1960S

In 1957 the National Advisory Committee on Art Examination suggested greater autonomy for art schools in both planning courses and examining students. This was accepted by the Minister for Education but he went a step further and suggested that schools judged capable of creating new courses should be free to examine their own students subject to external assessment. In the following year, a National Advisory Council on Art Education (NACAE) was set up under the chairmanship of the painter William Coldstream. The resulting Coldstream Reports of 1961 and 1962 appeared to marginalise the crafts. The first report argued for 'courses conceived as a liberal education in art' in which students were taught in five broad areas – Fine Art (painting), Fine Art (sculpture), Graphic Art, Three-Dimensional Design and Textiles and Fashion.[98] Fifteen per cent of the course was to be devoted to the history of art and complementary studies. The crafts were only touched on briefly. An art school which was 'particularly concerned to foster a tradition of fine craftsmanship and in which crafts were studied as an end in themselves might well place some of them in the fine art area'.[99] The second report looked at training in studio pottery, wood and stone carving, hand-made furniture, silversmithing, jewellery, calligraphy, bookbinding, hand-printed and hand-woven textiles and embroidery. It was argued that students in this category 'will never be numerous'. It was hoped that art schools could provide this kind of training from local resources 'perhaps, with help from local craftsmen'.[100] No system of national certification was provided for this kind of training. Clearly, despite all the emphasis on the crafts' relevance to design for industry enshrined in the Crafts Centre of Great Britain's constitution, the crafts were not seen by the NACAE as an innovatory force that could feed into industry. The low esteem in which the concept 'crafts' was held was confirmed in 1964 in the third report of the NACAE which looked at Post-Diploma Studies in Art and Design. In the context of post-graduate work craftsmanship was only mentioned in terms of staff backup for student designers – in the form of 'an adequate staff of technical assistants, including craftsmen. Students should learn to work with craftsmen as an integral part of their training.'[101]

251. Jacqueline Poncelet, cast, carved and unglazed bone china, 1975. h. (*left to right*) 11.5 cm; 10.3 cm; 10.1 cm. (Jacqueline Poncelet/Crafts Council).

Although the Coldstream Reports appeared to marginalise or ignore the crafts it would be wrong to suppose that the implementation of the Diploma in Art and Design (Dip AD) had an entirely negative effect. Rather the reverse. The period when colleges were being assessed for DipAD status by the National Council for Diplomas in Art and Design led by Sir John Summerson was a chaotic and painful time for art colleges. But determined course leaders were able to ensure DipAD status for courses that were essentially artist-craft courses. Thus Constance Howard at Goldsmiths' College gained DipAD status for her specialism though she recalls that she 'had to fight for that Diploma. They had completely forgotten embroidery.'[102] Luckily she knew a member of the Council, Stewart Mason, the Art Director for the Leicestershire Schools, who had a fondness for innovative embroidery. For Howard DipAD meant better work: 'The fact that the crafts were now regarded as on the same level as Fine Art, that drawing was a common basis as well as art history, to be studied by every student on the new course, aided and abetted this standard.'[103]

But the five main areas did not readily accommodate all the crafts. Fine Art (painting) and Fine Art (sculpture) stood apart and did not obviously relate to any specific crafts except perhaps work in clay. Graphic Design could take in calligraphy, bookbinding and fine printing, but in fact calligraphy turned out to be a casualty of the new system.[104] It had been discontinued at the Royal College of Art as early as 1953. Other areas specifically mentioned in NDD – lace, gesso work, wood carving, die-sinking, mosaic work, inlay, marquetry and veneer, terracotta work, lacquer work, leatherwork, plasterwork, wrought iron work (a whole range of specific decorative arts) – appeared to vanish, only to re-emerge on occasional vocational and conservation courses. But other crafts found a place. Fashion and Textiles in some colleges accommodated embroidery, hand-weaving, and hand-painted textiles. Most crafts came under Three-Dimensional Design which took in silversmithing and jewellery, metalwork, furniture, ceramics and glass. Many very specific craft skills continued to be taught, hidden within DipAD courses. The better equipment and technical backup available on the new courses under the Three-Dimensional Design umbrella were often used in surprising ways. For instance the fledgling potter Jacqueline Poncelet, at Wolverhampton College of Art from 1965 to 1969, was captivated by industrial techniques, particularly mould making. But in the 1970s she adapted the skill to artistic ends, making cast bone-china vessels which she then painstakingly carved and polished (Fig. 251).[105]

The Diploma in Art and Design course was preceded by a statutory one-year foundation course which in many art schools after 1961 was in effect a Basic Design course. Although

252. The kiln site at Harrow School of Art, 1972. (Colin Pearson).

253. Student glazing pots, Harrow School of Art, c.1971. (Colin Pearson).

Basic Design proved liberating for many students, members of the craft world who believed in the primacy of a workshop training were inevitably unsympathetic to the liberalism of both Basic Design and DipAD. In 1966 an evening meeting was held by the Craftsmen Potters Association to discuss the appropriate training for a potter. It was a stormy occasion, with little sympathy lost between those like Gilbert Harding Green and Henry Hammond (his counterpart at Farnham) whose courses had been granted DipAD status and workshop potters like Bernard Leach's son David. The latter saw art schools as spawning a race of part-time makers who simply went back into the art schools to teach. In David Leach's view the Coldstream recommendations for a 'liberal general training' did not make a professional potter. He argued that 'we need more students to accept the slower, radical, disciplined drill of the workshop'.[106] Also at this meeting were Victor Margrie and Michael Casson, creators of the Diploma in Studio Pottery at Harrow School of Art. This course, which had got under way in 1963, had not been granted DipAD status and was, indeed, the antithesis of the wide-ranging DipAD approach. It was intended to provide something close to a workshop training.

The course at Harrow was responding to a fashionable consumer demand for a certain kind of robust stoneware table and ovenware.[107] It concentrated on communicating the skills required by these kinds of production potters. Students were often older than average, wanting to drop out of a nine-to-five existence. Self-sufficiency, intermediate technology, workshop practice and business sense were all emphasised. Throwing, especially repetition throwing, was the cornerstone of the curriculum. All students left having made a wheel and able to make their own tools and build a kiln. Creative salvage and low-level technology were encouraged (Fig. 252). One tutor, Walter Keeler, helped his students perfect an oil burner which could be made from cheap plumbers' fittings. By the mid-1970s, bricks and burners were being salvaged from power stations being decommissioned after the discovery of North Sea gas. Glaze and clay body technology were taken seriously and the course was responsible for a major revival of salt glaze in studio pottery from 1970 onwards led by Walter Keeler and

brilliant students like Sarah Walton. But, arguably, the Harrow pottery course provided instruction rather than teaching, learning by imitation rather than an education. The powerful style of tutors like Michael Casson and Colin Pearson could often be recognised in the work of students and this 'Harrow Style' – an odd hybrid of the contemporary and the oriental, with bold handles and rims and cylinder forms – became too characteristic and therefore a target for criticism (Fig. 253).[108] This was inevitable in a course that was deliberately designed to be narrow, to prepare students in short time (the course lasted two years) with all the skills to run a business that functioned as an alternative to a highly organised technocratic society.

CRAFT AND THE COUNTER-CULTURE

In many ways the Harrow course was a practical response to the 1960s counter-culture. So much so that it was free from the student revolt and uprising that peaked all over Europe in 1968. In England Hornsey School of Art had led the way in May 1968 followed swiftly by Guildford School of Art and the West of England College of Art at Bristol.[109] It may seem curious that students should have chosen to reject a course structure as liberal and as generously funded as DipAD. At Hornsey the perceived elitism of DipAD came under attack, including the requirement for five O levels, the course's written component in the form of liberal or complementary studies and the general ambition for a degree equivalence with universities. The documents and papers which poured forth from Hornsey from May for some three months condemned the distinction between diploma and vocational studies. The exam requirement, it was argued, favoured middle-class students while the separation of departments into Fine Art, Graphics, Three-Dimensional Design and Fashion and Textiles was anathema to young people interested in informal networks and flexible systems.[110]

The crafts were not singled out for special mention. Art students in the late 1960s wanted to move freely between film making, performance and fine art activities which were becoming increasing conceptual. Work in clay or textiles in particular could play a part in all this if done in the right spirit – a spirit remote from utility and any kind of tradition. But outside the art schools the counter-culture and the underground movement certainly did have a place for more traditional craft activity and for a craft ideology. Its members appeared to share some of the oppositional ideals espoused by craftsmen and women before World War II and subsequently expressed at the Dartington conference. Underpinning much of the revolt was a horror of technocracy – the key text was Jacques Ellul's deeply pessimistic *The Technological Society* (1964). There was a sense of helplessness in the face of technological advance and a conviction that the 'freedoms' of Western democracies were illusory. This was the basic argument of a key campus text, Herbert Marcuse's *One Dimensional Man* (1964). If, between the wars, mass production was viewed with disdain by many makers, by the mid-1960s 'the technocracy' was regarded with something approaching paranoid fear.

As Theodore Roszak explained in *The Making of the Counter Culture*, first published in the United States in 1968, the aim of technocracy (defined as 'industrial society at the peak of its organisational integration') was 'to level life down to a standard of so-called living that technical expertise can cope with – and then, on that false and exclusive basis, to claim an intimidating omnicompetence over us by its monopoly of the experts'.[111] The Cold War, the escalating war in Vietnam and, for North Americans, the reality of the draft made the technocracy even more fearsome. As Roszak pointed out, technology oscillated between 'the production of frivolous abundance and the production of genocidal munitions'.[112] At the heart of the 1960s counter-culture was a sense of powerlessness.

Like the inter-war oppositional figures in the craft world and elsewhere, the youth of the counter-culture fell on key texts, often identical to those revered by figures like Leach, the Mairets and Eric Gill.[113] William Blake was high on the agenda, as he had been for Leach and the youthful band of intellectuals he introduced to Blake's art and writings in Japan around 1914. Other religions and systems of thought – types of Buddhism (particularly Zen), mediated through the commentaries of Dr Suzuki and Alan Watts, and the writings of Chuang Tzu and Lao Tzu would also have been familiar to thoughtful inter-war makers. Twentieth-

century writers like A.R. Orage, whose *Psychological Exercises and Essays* were reprinted in 1968, and Lewis Mumford, much read by the Mairets, continued to exert an influence, supplemented by the visionary writings of Buckminster Fuller. It was texts like Fuller's *Inventory of World Resources, Human Trends and Needs* (1963) which inspired Stewart Brand, a well educated and wealthy American drop-out, to put together *The Whole Earth Catalog* in 1968.

With its sub-title 'Access to Tools' the *Catalog* was a guide to alternative living, published in revised editions from 1968 to 1975. It was read all over Europe as well as in the States, offering by mail order all the reading matter and equipment for a life style independent of 'the system', a counter-culture of organic farming, solar energy, wind power, geodesic domes, potters wheels, looms and other aids to a self-sustaining existence. The inter-war Distributists, with their advocacy of smallholdings and the ownership of tools for production, would have approved. Recommended books included Patrick Reyntiens on *The Technique of Stained Glass*, George Sturt's *The Wheelwright's Shop*, David Pye's *The Nature and Art of Workmanship*, Bernard Leach's *A Potter's Book*, Peter Collingwood's *The Technique of Rug Weaving*, Edward Johnston's classic *Writing & Illuminating & Lettering* together with a whole range of more basic how-to-do-it books on spinning, weaving, knitting, batik, leathercraft, candlemaking and jewellery. Michael Cardew's *Pioneer Pottery* was hailed as being 'complete in a systems way' and as 'an honest book that looks you right in the eye'.[114]

At the Dartington conference of 1952, the painter and critic Patrick Heron had identified technocracy as the enemy, arguing that 'even the crankiest, wobbliest pots, the lumpiest cloth and the dottiest pictures are all effective in one single respect: that they register *protest*'.[115] The practice of the crafts by the counter-culture was in this spirit. The function of craft was to enable its maker to earn a livelihood and stay out of the system. Much of the craft work took the form of candles and jewellery and other appurtenances of the hip economy. As the *Catalog* review of David Pye's *The Nature and Art of Workmanship* observed: 'seems like just about everybody I know is making things lately – pots and dishes and clothes and bags and belts and blouses. I read in *Newsweek* or somewhere that this is the new Renaissance. Mebbe so. But it doesn't feel good to see a lot of home made things when they are also poorly made.'[116] In the late 1960s London's key underground paper *International Times*, known as *IT* and with a circulation of 43,000 in 1970, carried advertisements for psychedelic jewellery, batiks and hand-painted silks and publicised *IT*'s own Uncommon Market held at the Roundhouse in Chalk Farm in London. The advertisements hint at the limitations of this kind of craft practice: 'embryo productive commune seeks girl. Baby and interest in toys, jewellery, printing welcome. East Anglia.'[117] More robustly: 'Who makes useful artistic crap for me to sell in my new shop opening in Brighton. Stuff to wear, stuff to look at.'[118] Money did not seem to be a problem: 'We have been given a shop in Glastonbury – anyone who would like to make things for the shop get in touch with Charlotte Younge.'[119]

The counter-culture gurus who contributed to *IT* debated the place for craftwork in their dreams of a new order. The Buddhist anthropologist Gary Snyder, a friend of Allen Ginsberg and Jack Kerouac, explained:

> Nationalism, warfare, present day heavy industry and consumership are already out dated and useless…The next great step of mankind is to step into the nature of his own mind – the real question is 'just what is a human being?' – and we must make the most intelligent and creative use of science in exploring these questions. The man of wide international experience, much learning, and leisure – the most developed product of history – may with good reason wish to live simply, with few tools, and handmade clothes, close to nature.[120]

But as the revolutionary Hyde Park Diggers (contactable through *IT* and *Gandalf's Garden*) pointed out: 'We cannot go back 100 years or 1000 and this type of nihilistic thinking can only do harm to the Diggers. We must be masters of our machines and not the exploiters of labour. We will start producing things for the open market in a syndicalist atmosphere.'[121] Other visionaries ignored the detail. Julian Beck, founder of the nomadic Living Theatre, promised in his poem *Paradise Now*:

and
one
day
we will
stop using
money
we will do
only useful work
we will
plan ways ahead of time
to bring apples to the city
we want to feed
and to fuck
every body.[122]

Beck's was an impractical, if attractive, agenda. Emmanuele Petrakis, in an *IT* article entitled *Underground*, looked at ways of being alternative from a historical perspective. He mentioned Gandhi's campaigns for self-sufficiency in India and the Israeli kibbutzims and noted: 'In this country we have progressive individuals who set themselves up as toymakers (wooden or soft cuddly toys) producers of hand-made hippy clothes, bead necklaces etc.' He went on to suggest other kinds of handwork – silkscreen printing, painting on plastic plates, knitted ties – that would fund an alternative existence.[123] In fact this kind of 'craft' sounds like the ideal stock for the lower quality 'craft shops' which began to spring up in touristy rural areas and was remote from the world either of the art school or of the workshops propagandised by Leach and his followers.

Another counter-culture phenomenon, the burgeoning arts centres of the late 1960s, tended to ignore the crafts. The Institute of Contemporary Arts (ICA) had been an early harbinger of the arts centre idea and in 1968 Jim Haynes set up his rather more radical arts lab. But the arts labs, as they proliferated from Surrey's Redhill to the cathedral city of York, specialised in alternative cinema, theatre and 'performance'. In 1968 the Anti-University of London opened its doors at 49 Rivington Street. At first sight it resembled Ezra Pound's radical 'College of Arts' of 1914. But though courses were offered in psychiatry, led by R.D. Laing; poetry and the sociology of world revolution, taught by the painter Jim Dine; a sculpture course on 'space', taught by St Martin's School of Art rebels Barry Flanagan and John Latham; and music, taught by Michael Cardew's revolutionary son, Cornelius, there was no craft. In the late 1960s serious craft lacked a revolutionary edge, seeming uncool to these radicals. But there was Burleighfield, an alternative art school and arts centre in Buckinghamshire run from 1964 by the painter Ann Bruce and the painter and stained-glass artist Patrick Reyntiens. They set up workshops for stained glass, tapestry, printing and ceramics. Locals were made welcome. Burleighfield, unlike Haynes's Arts Lab, anticipated some later community projects but it was sufficiently free-wheeling and bohemian to attract the ire of the men in suits whom Reyntiens had persuaded to put in money. On a surprise summer visit in 1979 Burleighfield's financial backers came across Reyntiens and Bruce enjoying a pleasing, vinous picnic which was still in full swing at four o'clock in the afternoon. The clerks and scribblers triumphed and the centre was summarily shut down.

EIGHT

'MORE POSSIBILITIES'

NEW PATRONS

Inter-war craftsmen and craftswomen had a kind of exclusivity. We encounter them, formally or quaintly dressed, intently watching vernacular crafts being performed, supervising a team of local 'girls' over the dye buckets, travelling with patrician confidence to some remote part of Europe or the Far East, standing in the autumn sunshine with a group of fellow makers outside an ancestral Palladian house, sitting up late at night communicating ideas about the crafts in long letters to fellow makers in fluent elegant prose. After the war a quite different set of equally striking images present themselves – a mass audience watching a lyrical BBC programme interlude of a potter's hands at work on the wheel; eight and a half million people visiting the South Bank Exhibition of the Festival of Britain in 1951 and finding that craft was part of the 'Island Story'; a conference at Dartington in 1952 ending with the great hall being cleared and over a hundred weavers and potters taking to the floor in a celebratory dance; Leach, Yanagi and Hamada speaking to an audience of one thousand in Los Angeles in 1953; Leach taking wing to Honolulu; Leach surfing on Waikiki beach; long queues waiting to visit the newly consecrated Coventry Cathedral in 1962. The post-war period saw a new audience for the crafts, a host of new practitioners and, above all, new kinds of patronage, a shift from private to public. This was exemplifed by the role of craft in the Festival of Britain of 1951 and the part craft played in post-war ecclesiastical architecture, two areas which are treated as case studies in Chapter Nine. Among the most important new patrons of the crafts were the Local Education Authorities (LEAs), engaged on ambitious school building projects in the late 1940s and 1950s.

The generous purchases of craft work by LEAs is suggestive, telling us a good deal about the humanism of the post-war schools policy. This was despite the 1944 Butler Act's divisive separation into elite grammar schools, secondary modern and technical schools. In fact, the patronage of contemporary work by schools (as opposed to the purchase of casts and reproductions) had been recommended by the Council for Art and Industry back in the 1930s.[1] But it was the post-war atmosphere of egalitarianism and 'fair shares for all' which led to these recommendations being implemented by Local Educational Authorities. Cambridgeshire was the pioneer. Contemporary paintings and sculpture, were purchased for the Cambridgeshire 'village colleges' which had been created by the county's Chief Education Officer Henry Morris to revive rural communities as 'an organic whole'.[2] In 1944 Morris appointed an art adviser, the painter Nan Youngman,[3] to buy for Cambridgeshire schools as part of his vision for true community education. From 1947 Youngman also ran *Pictures for Schools*, exhibitions of contemporary art for sale to all education authorites under the aegis of the Society for Education through Art. These shows included craft, in the form of so-called 'embroidered pictures', as well as paintings, and were an important outlet for innovative embroiderers in the 1950s.[4] After his retirement from Cambridgeshire Morris went on to found the Digswell Arts Trust in 1956 which provided cheap studios and workshops for fine artists and craftsmen and women (including the stained-glass artist Keith New, the weaver Peter Collingwood and the potter Hans Coper) and brought them into contact with industry, town planners and architects and with new patrons in the new universities and technical Colleges.[5]

254. Margaret Traherne, *St Guthlac*, early 1950s, stained glass panel, 82.5 × 108.5 cm. for Guthlaxton College, Leicestershire. (Margaret Traherne).

Morris's vision was developed by Hertfordshire's Chief Education Officer John Newsom, appointed in 1940. He operated a ⅓ of 1% for art scheme which bought sculptures for specific schools as well as commissioning murals and specially designed appliqué stage curtains in assembly halls. The market for these was cornered by the designer Gerald Holtom, who produced a marvellous range of site-specific curtains for schools around the country.[6] In addition, a distinguished circulating collection of sculpture, paintings and lithographs was put together by Newsom's art adviser Audrey Martin.[7] But the most important buyer of craftwork, as opposed to fine art, was Stewart Mason, the Director of Education for Leicestershire from 1947 until 1971 and a former Inspector of Schools (HMI) in Cambridgeshire. The new schools built in Leicestershire during the 1950s and 1960s were models of spatial clarity, full of light, surrounded by green playing fields and often with village colleges or village centres attached. Mason explained: 'Every school has some sculpture and starts off its life as owner of some original painting and ceramics.'[8] These permanent collections were supplemented by a circulating collection of art, design and craft. The paintings and sculpture selected by the architectural historian Alec Clifton-Taylor,[9] appointed art adviser in 1947, were the most famous part of the Leicestershire collections but the crafts were also central to Mason's vision. In the 1950s Mason and Clifton-Taylor bought substantial amounts of ceramics and embroidered pictures[10] and Mason also commissioned a series of remarkable stained-glass panels from one artist, Margaret Traherne, which were sited permanently in designated Devotional Rooms in nineteen schools (Fig. 254).[11]

Mason was a passionate humanist who had been introduced to neo-Romantic art by Clifton-Taylor when both men worked at the Admiralty during the war. Favoured fine artists included John Piper, Julian Trevelyan, Mary Fedden and Keith Vaughan with their mix of

255. William Newland working on *The Flight into Egypt*, one of several ceramic groups of this subject done for Leicestershire schools in the 1950s. (William Newland archive).

256. Margaret Traherne, *Noah and the Dove*, embroidered picture, black cotton on a coloured ground, 1954, for Castle Rock School, Leicestershire. (Margaret Traherne).

INDIVIDUAL CERAMICS
BY ARTIST CRAFTSMEN
2

We no longer live in fragmented societies of men divided and alone, and most of our necessities are produced by machines in factories. Because of this much of our pottery has lost its diversity in design, and your cup and saucer is likely to be exactly the same as thousands of others. The machine has enriched our lives by a plentiful supply of goods and, even if these products are often a little dull we now have enough to go round.

MODERN CONDITIONS
HAVE CHANGED THE
POSITION OF THE HAND
CRAFTSMAN IN SOCIETY

The need for the unique hand-made object remains. Each of us is a different and unique personality. Because of its individuality, the hand-made object affirms our own individuality. Modern artist craftsmen seek to fulfil this need.

THE CRAFTS ARE
CHANGING IN NATURE

Today, the frontiers between the visual arts are dissolving modern sculpture and painting now overlap and the barriers are going down between the artistic crafts and the so-called fine arts. Many modern craftsmen in ceramics are moving away from pots as such towards sculptural form. This is illustrated by some of the examples in this exhibition.

THERE ARE MANY
NATIONAL SOCIETIES
IN BRITAIN CONCERNED
WITH THE DEVELOPMENT
OF THE HAND CRAFTS IN
RELATION TO MODERN
NEEDS. THE WORLD
CRAFT COUNCIL SEEKS
TO FURTHER THIS AIM
INTERNATIONALLY

257. Individual Ceramics by Artist Craftsmen: 2, boxed display, ILEA Circulating Scheme. (Camberwell College of Arts, The London Institute).

industrial realism and arcadian, brightly lit Mediterranean scenes. Arcadia was also presented to Leicestershire school children in the form of colourful figurative maiolica ceramics, stained glass and embroidery inspired by School of Paris painting. Accessible iconographies were favoured. The *Flight into Egypt* was a popular theme. The image of the vulnerable Mother and Child seated on a Picasso-esque donkey was embroidered by Traherne and made in several poignant ceramic versions by the potter William Newland (Fig. 255). Mason sought modern art which spoke to children. The crafts, domestic in scale and familiar by virtue of their materials and facture, were well able to fulfil this role.[12] 'Embroidered pictures' in particular were a homely way of making the tropes of modern art familiar (Fig. 256).

Other education authorities followed Mason's example and good school circulating collections were built up in Nottingham and Derbyshire. Bristol had a particularly impressive craft and design collection, started in 1959 and largely purchased from exhibitions at Primavera and from a similarly innovative shop, the Bristol Guild of Applied Art, which under the direction of Ken Stradling showed craft and good Continental design from 1948 onwards. From 1952 the London County Council and the CoID collaborated on a scheme which circulated boxed displays of craft and design to schools (Fig. 257). In 1958 this was taken over by Dennis Stevens, the Art Organiser for the Greater London Council. He bought paintings, drawings and prints but also substantial collections of folk and vernacular craft, textiles and ceramics and product design.[13] The ILEA Schools Circulating Design Collection was less personal and more overtly pedagogic than the Leicestershire schools collections, but the same principle operated throughout the various education authorities – that children should experience good modern art and craft at first hand (Fig. 258).

The sheer variousness of visual material bought by the authorities suggests a multiplicity of educational aims. In part the collections were designed to educate the consumers of tomorrow in the same spirit as the exhibitions and booklets pushed out by the Council of Industrial Design. But the collecting of craft also related to post-war attitudes towards children's creativity. As a Schools Inspector in Cambridgeshire, Mason had already noted that in schools 'where the art was exceptional all the other subjects seemed to show more verve and originality',[14] and such ideas were given a special intensity by the visual and tactile

deprivations experienced during the war. Teachers were influenced by the work of Marion Richardson and by Herbert Read's *Education through Art* of 1943 which had declared that art was the 'the basis for education'. *Education through Art* dealt exclusively with painting but the same year Read was arguing that visual taste was built up from touch and practice: 'the fingers must feel the clay, the crisp substance of the wood, the tension of the molten metal, there must be sensuous contact of hand and eye with the grain and grit.'[15] As we saw in Chapter Seven, educationalists and teachers took such experiential ideas to heart. The direct contact with hand-won clay, with wool fleece, with native wood and stone, which had meant so much to inter-war makers, was democratised after the war by being introduced into the classrooms of state schools.

If the schools were relatively generous to the crafts, the new universities built during the 1960s revealed the limited interest in modern craft among practising architects and the academic community. The new universities were built using variants of a 1960s vernacular which was recognisably indebted to the Modern Movement and was, to a greater or lesser extent, part of the tendency known as the New Brutalism. They were constructed, in the main, of pre-cast components with plenty of shuttered concrete externally, combined with the internal use of concrete and exposed brick. Such architecture made its point through a lack of adornment. Craft tended to be restricted to innovative silverware for ceremonial dining and maces for ceremonial occasions, much of which was given to the new universities in a series of generous presentations of silver made by the Worshipful Company of Goldsmiths (Fig. 259).[16]

At the University of East Anglia a capital grant of £10,000 was made in 1968 by the university council to form a collection of twentieth-century art. It was decided to concentrate on non-objective constructivist art, design and architecture. The collection was a scholarly one, which developed in the 1970s, encompassing painting, sculpture, furniture, architectural models and photographic documentation. A rug by Winifred Nicholson and a tapestry by Mary Farmer designed along constructivist lines were the only objects purchased which could be defined as craft. The collection was rightly seen as appropriate to Denys Lasdun's ziggurat terraces which were in themselves a constructed sculptural composition.[17] (A substantial ceramics collection – dominated by the work of Hans Coper and Lucie Rie – came to the University in 1978 as part of the Sainsbury collection, but this exemplified the private taste of the donors Robert and Lisa Sainsbury.) At Sussex Basil Spence persuaded Ivon Hitchens to donate a large painting *Days Rest Days Work* (1960) for a special site in his double height refectory. That seems to be Spence's only artistic intervention. Generous gifts of silver were made in 1965 by the Goldsmiths' Company, appropriate for a new university which saw itself as Balliol-by-the-sea, including a mace (1963) and nine staves (1965) and pairs of silver water

jugs by Gerald Benney, Gerald Whiles, Robert Welch and Keith Redfern. Spence's Meeting House was eventually adorned with some craftwork thanks to patronage from the Caffyn family in the 1970s. There was a John Piper tapestry *Be Still and Know* (1978) woven by the Edinburgh Tapestry Company and two Hans Coper candle holders (subsequently sold off) as well as a ceramic font (1979) by the potter Ursula Mommens. But the purchases made in the 1960s by an informal group of academics favoured the status quo – which at that date meant a medley of rather undistinguished abstract paintings and prints.[18] There was more art at Warwick University, where the architect Eugene Rosenberg of Yorke, Rosenberg and Mardall took a personal interest. He made the first purchases, mainly of prints, which included ten lithographs by Le Corbusier, prints by Josef Albers, Karel Appel, Robert Motherwell, Ad Reinhardt and Frank Stella. He also chose sculptures by William Pye and Bernard Schottlander and persuaded Alastair MacAlpine to donate large abstract paintings by Patrick Heron, Terry Frost and John Hoyland. Aside from a Goldsmiths' presentation of forty silver beer mugs made by Geoffrey Clarke, there was no craft. A contrast can be drawn with the collection formed by the nearby Coventry College of Education from 1949 to 1977 which was strong on neo-Romantic art and included textiles by Peter Collingwood and Noel Dyrenforth and a collection of studio pottery brought together by Richard Dunning, the college lecturer in ceramics during the 1960s and 1970s.[19] It is, of course, significant that the history of applied art was scarcely studied at universities and the studio crafts of the twentieth century not at all. Collections of pots and textiles seemed appropriate for schools and teacher training colleges because they reflected the art activity in those institutions. But the universities, on the other

259. Hussein Abbo, *Three Catenary Bowls*, 1968, silver with bands of parcel gilt, largest bowl 13.25 × 64 × 31 cm. The design was meant to reflect Stirling University's concentration on Engineering Science. (Stirling University/Photo courtesy of the Worshipful Company of Goldsmiths).

260. Michael O'Connell, *The Murder of Thomas à Becket*, 1950s, batik on cotton, 125 × 202 cm. (Seamus O'Connell/Rural History Centre, University of Reading).

hand, formed collections which were scholarly in terms of the study of the history of art (as at UEA) or perceived as a complement to modern architecture (as at Warwick).

A much more important public patron was the Circulation Department of the Victoria and Albert Museum, whose Keeper from 1947 to 1960 was Peter Floud. His interest in William Morris and in the applied arts of the late nineteenth century meant that he had doubts about the twentieth-century crafts' emphasis on handwork for its own sake. But in certain crafts of the 1950s, particularly ceramics and embroidery, he hailed the abandonment of inter-war austerity and pure form and a return to the rich complexity of the 1890s.[20] In ceramics he admired the figurative maiolica potters bought by Mason, seeing their work as a return to the eclecticism of Victorian art pottery. The freedom and boldness of the creators of embroidered pictures also appealed to him, as did the accessible batik hangings made by Michael O'Connell (Fig. 260), and he believed that the Royal College of Art and the Central School had the potential to produce jewellers with the boldness of C.R. Ashbee. So while few regional museums purchased craft consistently in the 1950s and 1960s, the Circulation Department built up strong holdings of every kind of studio pottery, radical embroidery, new jewellery and some stained glass.

A DESIGN VACUUM

Post-war shortages, the fact that quality manufactured goods were earmarked for export well into the 1950s and the unadventurousness of British manufacturing created a design vacuum in the late 1940s and early 1950s. In Britain there was no equivalent to the small technologically flexible workshops which enabled Italian designers to go into innovative production immediately after the war. This lack of consumer goods made the crafts an attractive option for retailers in search of a 'New Look' in product design. Heal's, with their Craftsman's Market, took a special interest in the crafts during the difficult post-war period,

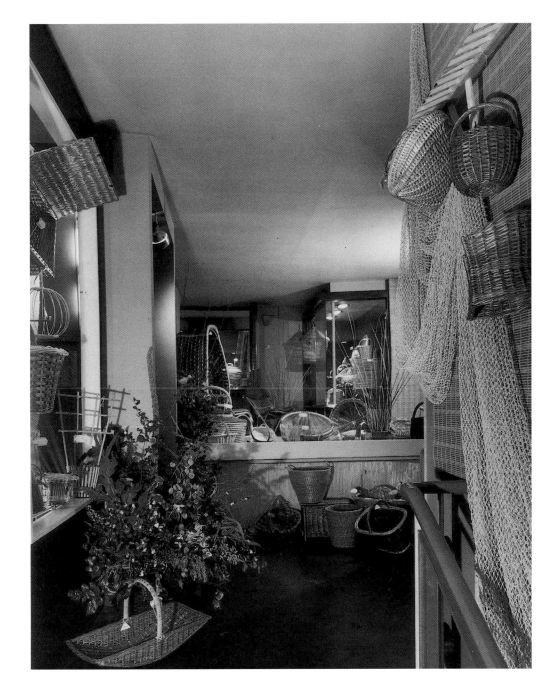

261. Henry Rothschild's first exhibition, *Baskets for Town and Country*, held at the Tea Centre, Regent Street, 1953.(Courtesy Henry Rothschild, reproduced by permission of the Shipley Art Gallery, Gateshead, Tyne and Wear Museums).

as did other department stores.[21] David Leach recalls that just after the war Mrs McDermott from Peter Jones offered to buy the whole output of St Ives Standard Ware because their shelves were empty.[22]

Potters' workshops had been undermined by wartime restrictions and many had closed. But studio pottery in particular indirectly benefited from the war and the subsequent post-war austerity measures following the sudden withdrawal of Lend-Lease by the United States. If a Board of Trade licence could be obtained, the period just after the war was a good time to start a production pottery. There was a crucial gap in the market caused by the unavailability of any industrial pottery except whiteware as all decorated wares were reserved for export. This ban on decorated wares for home consumption, in force till 1952, transformed the fortunes of the Leach Pottery and gave Harry Davis a flying start when he and May Davis started the Crowan Pottery. It encouraged a small slipware renaissance and enabled Brigitta Appleby and Eileen Lewenstein to start Briglin Pottery, producing Scandinavian inspired earthenware, and the Cole brothers to start the Rye Pottery making colourful tin-glaze and slipware (Fig. 226). It sustained the émigré artists Hans Coper and Lucie Rie. The trade paper *Pottery Gazette* recorded the founding of numerous small potteries during this period – many inspired by Leach's ideals, others quick to compromise and pander to market forces.[23]

Craft production was a vital component of Henry Rothschild's highly succcessful shop Primavera which had opened in Sloane Street in 1945. As seen in Chapter Five, Rothschild had had a memorable wartime encounter with the folk arts of Italy. His stock for Primavera, which was put together with help from the Rural Industries Bureau rather than the CoID, encompassed rural basketry and the urban ceramics of Lucie Rie.[24] He took up some of Muriel Rose's favoured exhibitors like the toymaker Samuel Smith, the potters Bernard Leach and Katharine Pleydell-Bouverie and the weaver Jean Milne. Initially Rothschild even designed and made some goods himself, printing hand block designs on coupon-free linen and parachute silk, and offering up dyed fisherman's nets as room dividers (Fig. 261). But, unlike the Crafts Centre of Great Britain, he had no ideological need to restrict himself to handwork. He was soon importing Scandinavian textiles and stocked the best British textile manufacturers, in particular Edinburgh Weavers and Donald Brothers as well as hand weavers like Barbara Sawyer. By 1949 Rothschild was commissioning furniture, especially designed for Primavera in short runs by Neville Ward and Frank Austin and by Nigel Walters, which was shown alongside ladder-back chairs made by old Edward Gardiner following the designs he had evolved with Ernest Gimson at the beginning of the century. Apart from Gardiner, Rothschild avoided the Cotswold school in favour of modern furniture and lighting to match – the Walters standard lamp, Danish and later Japanese paper shades and slatted beech plywood shades designed by Eric Aldhouse. Like the Little Gallery, Rothschild stocked interesting folk craft from abroad, from India, Peru, Poland, Italy, Holland and Mexico. Primavera's combination of good mass-produced design and craft made visual sense. The flour scoops from the Val d'Aosta in Northern Italy sold at Primavera were just one example of the affinity between vernacular craft and the 'good design' based on the 'sound simple shapes' being propagandised by the Council of Industrial Design.[25]

Design inertia and an unwillingness to take risks among manufacturers affected designers as well as retailers. Ambitious young designers were forced into displaying handmade prototypes, just as adventurous British furniture designers continue to do today. In March 1952 the twenty-year-old Terence Conran staged the exhibition *Ideas and Objects for the Home* at Simpsons in Piccadilly. His wallpapers were hand-printed, the fabrics screen-printed. There were potholders made of plaster on metal stands, metal frame tables with slate tops and lighting improvised from rods set in marble cubes. A surreal looking plaster of Paris hand was cast in a rubber glove.[26] This early Conran exhibition was comparable with the opening of Mary Quant's Bazaar in the King's Road in 1955. Initially all the clothes, hats and bags were made by Quant, while the jewellery had been bought by her from art students and recent graduates like the young Gerda Flöckinger.[27] Similarly Laura Ashley started block-printing tea towels in 1953, selling them at John Lewis and at Primavera.

Conran had been taught at the Central School by Eduardo Paolozzi whose career as a sculptor in the 1950s was underpinned by design work, mostly executed on a short-run craft basis, often for individual commisssions. Textiles and wallpapers were an important area for Paolozzi.[28] Anton Ehrensweig, who in the 1950s worked as a technician at the Central School, recalled how Paolozzi 'made silk screens that could be overprinted on top of each other in almost any position'. For instance, a wallpaper for the offices of Ove Arup and Partners superimposed semi-realistic images on an architectural grid. Ehrensweig recalls that the decorators were left to put up the paper according to chance – 'Again any result made sense. Paolozzi made good any small roughness in the joins.'[29] Paolozzi explained that his designs were inspired by 'primitive art, micro-zoology, the natural patterns formed by organic objects, and Picasso in all his periods'.[30] These, incidentally, were very similar to the sources which inspired the forms and surface decoration of much 1950s studio pottery.

Though Paolozzi also designed for innovative textile manufacturers like David Whitehead Ltd, in 1954 he went into a fruitful partnership under the name Hammer Prints Ltd with a fellow Independent Group member, the photographer and collagist Nigel Henderson. At Henderson's home at Thorpe-le-Soken in Essex, Hammer Prints produced mosaics, ties, scarves, tiles for panels and table tops and silk-screened textiles using powerful abstract

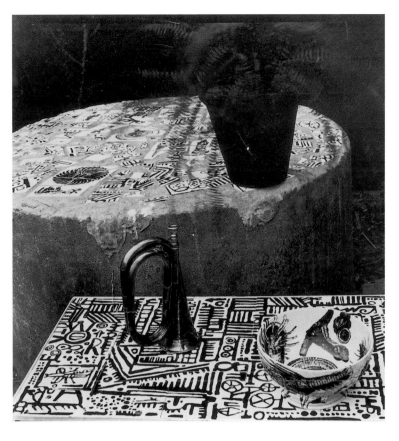

262. 'It is the object of Hammer Prints Ltd that an attack be made on the craft field using silk-screen as the medium to be exploited': tiled coffee table and a bowl, both silk screened with Hammer Prints Ltd designs. Photographed at Thorpe-le-Soken, 1950s. (Tate Gallery Archive).

263. 'Pieces of inked canvas, arranged and re-arranged to form a multi-evocative pattern' — *Hessian*, textile and wallpaper design produced by Hammer Prints Ltd, 1955.(Tate Gallery Archive).

designs and wittily decontextualised details of Victorian trade engravings (Fig. 262). Wallpapers were produced by Cole's of Mortimer Street in London (Fig. 263). Screen printing was a crucial process for these short runs, a bridge between the labour intensive craft of block-printing and the expensive technology of industrial roller printing. Together with batik and tie and dye, screen printing became the expressive printing method of the 1950s.

In 1956 Paolozzi and Henderson contributed to *This is Tomorrow*, a series of radical collaborations between architects, fine artists and designers staged at the Whitechapel Art Gallery. Paolozzi and Henderson worked as a team with the architects Peter and Alison Smithson on a space entitled *Patio and Pavilion*. Although they used a silk screen Hammer Print

264. A display of Hull Traders' goods shown at Lord & Taylor, New York, 1958 with silk-screen cotton *Portobello* designed by Eduardo Paolozzi, silk-screen tiled tables by Nigel Henderson and Eduardo Paolozzi, wooden platters by David Pye, rug by Peter Collingwood. (Courtesy Elspeth Juda).

design on the floor, the spirit of the project was conceptual rather than practical; to create two spaces 'furnished with symbols for all human needs'[31] (Fig. 382). Context was all and Hammer Prints looked more domesticated when seen in the opening exhibition *Time Present* which in 1957 launched Tristram Hull and Stanley Coren's firm Hull Traders. *Time Present* included ceramics by Lucie Rie, Ann Wyne Reeves and her husband Kenneth Clark and tiles and mosaics by Nicholas Vergette – all potters who had rejected the neo-Orientalism of inter-war ceramics. In addition there were carved dishes by David Pye, rugged low yew coffee tables (bark intact, displaying the shape of the tree) by Arthur Reynolds, semi-abstract tapestries by the painter and potter Gordon Crook, mats and rugs by Barbara Sawyer and bold abstract rugs by her former assistant Peter Collingwood (Fig. 264). It was in fact a display of hand-made prototypes and a substantial amount of pure craft, intended, as the organisers explained, to 'affect industrial design as racing has improved the performance of everyday motoring'.[32]

The 1950s witnessed a creative reaction against inter-war craft 'traditions' characterised by timelessness and pure form, in favour of light-hearted decorativeness. New materials had an impact. Polystyrene might not seem immediately relevant to craft practice but Geoffrey Clarke, metalsmith, stained-glass artist and sculptor, used it to cast ecclesiastical commissions in aluminium[33] just as John Piper and Patrick Reyntiens used it to cast concrete surrounds for their glass at Liverpool Cathedral (Fig. 265).[34] They and other stained-glass artists also took to new epoxy resins that were used to fix stained glass (though this ultimately proved an unreliable technology). Weavers Ann Sutton and Peter Collingwood corresponded excitedly about new glues and the delights of nylon monofilament.[35] Screen printing transformed textile design, creating a new experimental area between mass production and laborious hand block-printing.

Practitioners of different crafts made their own discoveries just after the war. As with

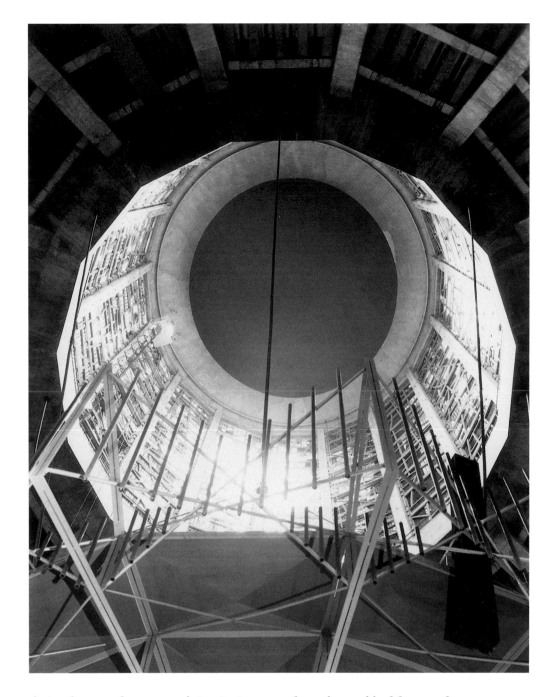

265. View of the interior of the tower of Liverpool Cathedral showing the glass by John Piper and Patrick Reyntiens, 1967.(Henk Snoek/British Architectural Library/RIBA, London).

design for manufacture, much inspiration came from the world of fine art, from sources as diverse as Picasso's pottery, Jackson Pollock's paintings, the 'new landscape' revealed by micro- and high-speed photography, the 'mobiles' made by the sculptor Alexander Calder and the rediscovery of Brancusi's sculpture after his death in 1957. Surface decoration owed much to the paintings of Klee and Miró and other School of Paris painters and sculptors (Fig. 266). The potter Dora Billington made a telling analogy with high fashion when she identified the non-Oriental studio ceramics of the early 1950s with 'the New Look'.[36] As we shall see, a 'New Look' also characterised post-war silversmithing and jewellery, embroidery, weaving, bookbinding, stained glass and lettering. Furniture was the one area in which a craft approach continued to produce stasis. The exciting furniture of the 1950s was designed for mass production and much influenced by developments in continental Europe and the United States. Otherwise the emphasis was on new techniques and materials, on lively contacts with fine art and on heightened expressiveness. Although government funding depended on the crafts' role in improving industrial design, in fact they provided a lively counter-point to the form-follows-function doctrines of the Council of Industrial Design.

All this pleasurable experimentation resulted in objects which were more visually beguiling that the craft of the inter-war years. Indeed by the 1970s and 1980s makers were creating

266. Nicholas Vergette, bowl, earthenware, tin glaze, 1954, h. 16.8 cm. (V&A Picture Library).

objects that played so wittily and ironically with histories of art and applied art that they literally ravished the eye. But the post-war period also saw a watering-down of the complex philosophies and ideologies which had engaged inter-war makers. And to choose to be a craftsman, or craftswoman, but perhaps more especially a craftsman, seemed much less of a rebellious or odd decision after the war. There was political consensus and growing prosperity. There was even a real dream of increased leisure. The crafts had a place in this 'New Jerusalem'. In T.S. Eliot's odd verse play *The Confidential Clerk*, first performed at the Edinburgh Festival in 1953, the crafts stand for self-fulfilment. Sir Claude wants to be a potter, to enter 'a world where the form is the reality',[37] but caution prevails and he enters the family business. Eliot presents him as wealthy and powerful, unfulfilled and disappointed. But many men and women took the risk and became makers, going through the art schools with grants and sustained thereafter by returning to teach. There was less to fret and dream about and, paradoxically, the crafts were diminished intellectually just at the moment that they became more visually eclectic and adventurous. Each craft has its own story, but in most it is possible to trace a tension between inter-war 'traditions' and a new generation of makers.

CERAMICS

In ceramics new groupings and allegiances emerged. In 1940 Bernard Leach's *A Potter's Book* appeared and was respectfully reviewed by Herbert Read as a work with 'universal significance'.[38] As soon as the war was over, it began to sell, appearing in a second edition in 1945, reprinting in the September of that year and again in the following September. Its narrow aesthetic was echoed by George Wingfield Digby and Muriel Rose's post-war surveys

of studio pottery which put neo-Oriental ceramics at the centre of the studio pottery movement. But Leach's growing band of followers and admirers carried forward his neo-Oriental project with a different emphasis. It was not Leach's handsome jars, bottles and great slip-ware dishes which caught the imagination of a new generation. The period saw instead a more practical commitment to designing and making utilitarian tableware. The model was the Leach Pottery Standard Ware which had been evolved by David and Bernard Leach before and during the war, made by a team at St Ives as what Leach called 'a we job rather than an I job' (Fig. 267). Leach, often in the role of the interpreter of the thoughts of Yanagi and Hamada, continued to develop ideas about the benefits of unselfconscious modest handiwork in major books which appeared throughout the 1960s and 1970s. As he wrote to fellow potter Geoffrey Whiting in 1955: 'I believe we have to go through a stage beyond nineteenth-century individualism. Yanagi and Hamada also constantly reiterate the necessity of throwing hundreds of pots from the same pattern and I would add for as normal a use as possible.' Leach went on to make a point of some subtlety: 'Of course when I say "use" I do not merely mean utilitarian.'[39]

The distinction would have been lost on many of Leach's followers. They certainly threw hundreds of pots to the same pattern. Indeed they developed new patterns to make the process speedier – for instance cylinder forms with throwing rings left unturned.[40] They became increasingly technically adept and prolific. But instead of subsuming their individualism, they were engaged on mass production by hand. They were able to make a living for a decade or so because they catered for a very particular consumer demand. Their stoneware was suitable for new fashions in cooking, in particular the faux simplicity of the country cuisine described by Elizabeth David in her *Mediterranean Food* (1950) with its neo-Romantic illustrations by John Minton and in her classic *French Provincial Cooking* (1960). At David Canter's restaurant, Cranks, stoneware pottery was the norm. By the mid-1960s the consumer demand for handmade production pottery was having an effect on the ceramics industry. Existing

268. Publicity shot for Heal's showing the 'changing face of Wedgwood' and featuring David Puxley, their in-house designer potter, 1960s. (British Architectural Library/RIBA, London).

269. Stoneware cup and saucer and plates with tea-dust glaze made by Ray Finch at the Winchcombe Pottery, 1950s. (Courtesy Henry Rothschild, reproduced by permission of the Shipley Art Gallery, Gateshead, Tyne and Wear Museums).

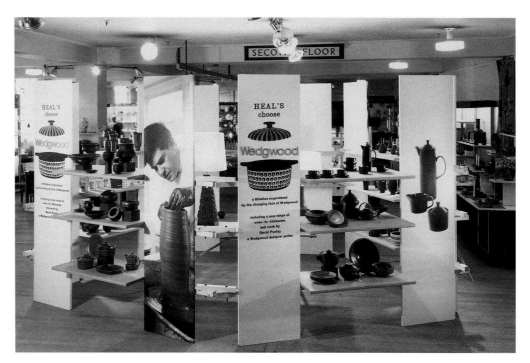

stoneware lines like those made by Wedgwood and by Joseph Bourne Ltd (Denby) were remarketed and new designs in stoneware were put into production (Fig. 268).[41]

Winchcombe Pottery (bought by Ray Finch from Michael Cardew in 1946) was one of the most successful of the potteries devoted to production wares.[42] Winchcombe stoneware (its slipware was abandoned in 1964) was of high quality, non-chippable and devoid of kiln accidents, happy or unhappy (Fig. 269). There was no division of labour at the pottery but each member of the team made a limited range of standard shapes. Thus, as we saw in Chapter Four, Sidney Tustin, Cardew's former boy helper, was restricted to making small pieces such as condiment sets for the whole of his career there.[43] A 1961 review of work on show at the Craftsmen Potters' Shop raised an interesting question. The writer noted that Winchcombe and the production wares made by Harry and May Davis at Crowan and by David Leach at Lowerdown Pottery

> all provide us with examples of breathtaking proficiency. Beside them Bernard Leach and Michael Cardew appear mere amateurs. Yet some quality distinguished the latter's work that makes it recognisably superior. Can a potter be too good? When the actual making of a pot ceases to be a struggle does it lose something? Are pots best made by fundamentally incapable people and how incapable must they be?[44]

A key figure was David Leach, whose technical expertise had made the Leach Pottery commercially viable (Fig. 270). His career was hedged about with ironies. There is something curious about such intensely Oriental work, particularly the bottle shapes and the brush decoration, being produced by a man who was only to visit Japan after the death of his father. His father had dismissed an art school training as a preparation for the life of a potter and had welcomed David's decision to become his apprentice. Thus in every way, apart from a brief technical training at Stoke-on-Trent, David was formed as a potter by his father. But in 1977, in a published assessment of David's work, Bernard described him dismissively as a fine 'artisan' and this indeed was how he had always perceived his son.[45]

David Leach established an independent pottery at Lowerdown in Devon in 1956, at first making slipware and, by the early 1960s, working in stoneware and porcelain. In 1967 he published a recipe for a throwable and translucent porcelain body and by 1970 he had improved it for commercial production by the ceramic suppliers Podmores.[46] His strength lay in his technical precision. It would be difficult to better the design of his production wares, in particular his fluted porcelain tea and coffee services. He was also a practical ambassador for the craft, teaching and lecturing. He straddled two worlds. He had grown up amongst the

inter-war craft aristocracy for whom philosophical ideas and an artistic sensibility took primacy over practicalities, but he also participated fully in the useful exchange of knowledge which helped ensure the success of production pottery after the war. His son John, in turn, belongs firmly to the post-war world, making sturdy yet elegant pots for every-day use, an integrated middle-class artisan.

David Leach's practicality, undervalued by his father, was taken a long step further by Harry and May Davis at their Crowan Pottery. After working for Leach in the 1930s Harry Davis developed an oppositional workshop philosophy based on recycling and labour saving low-level technology. The Davises deplored any attempt to define pottery as 'art'. Functional wares were not, as at the Leach Pottery, a way of subsidising larger more ambitious one-off pieces for exhibitions (Fig. 271). Davis was committed to matching the standards set by the pottery industry and providing 'toughness, durability and resistance to thermal shock as well as the more obvious demands of function, like smooth drinking edges, non-scratching bases and spouts that pour'.[47] Decoration tended to be wax resist and not specifically 'Oriental'. The Crowan range included flatware, in particular dinner plates, normally unpopular with studio potters both because they were difficult to make and because there were no models in early Oriental wares or medieval English pottery. Prices were kept low. Davis could throw sixty dinner plates in an hour and for all shapes a 'determined set of fingering, involving no unnecessary movements, is repeated exactly with each piece.'[48] To echo the anonymous *Pottery Quarterly* reviewer, can a potter be too good? Crowan Pottery (and, after their emigration to New Zealand in 1964, Crewenna Pottery) offered good design and high quality at low cost. Bernard Leach, however, was dismissive of Davis's technical brilliance. He admired his 'moral drive' but disliked the Crowan wares, wishing that Davis's early training had had 'more depth'.[49]

Leach's closest associates from the inter-war years would have shared this view. They were not over-troubled by the practical concerns which many post-war potters saw as central to good potting. Norah Braden virtually ceased to make after the war. Katharine Pleydell-Bouverie continued to produce handsome bottles, vases and bowls which, with aristocratic disinterestedness, she sold at low prices. Other Orientalists like Murray's former pupil Henry Hammond never involved themselves in the niceties of cruet sets or dinner plates but continued to make pleasing bottles and bowls. The exception was Michael Cardew, whose Pottery Training Centre set up in 1951–2 at Abuja in Northern Nigeria made a range of useful

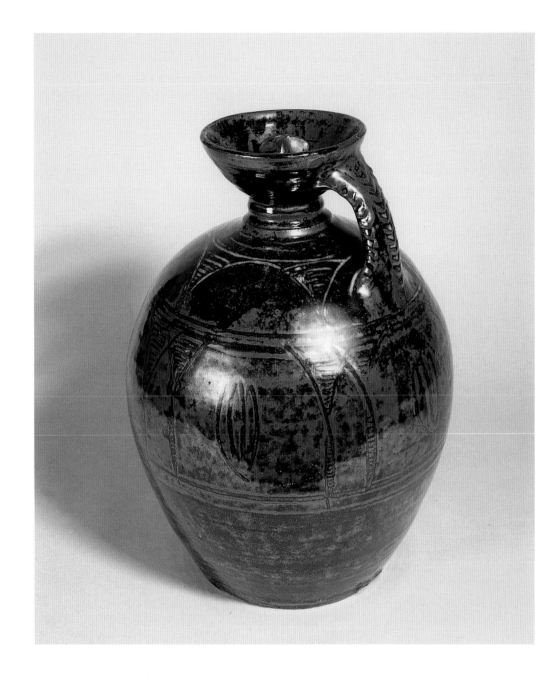

272. Michael Cardew, *Heart of Darkness*, stoneware oil jar, made Abuja, Nigeria, exhibited in London 1959, h. 37.5 cm. (York City Art Gallery).

plates, tea and coffee pots and cups directly inspired by West African pots.[50] Lidded casseroles, made on his return to England in 1964, were based on a local Gwari equivalent. But these functional wares shaded off into large bowls and bottles like an oil jar of the late 1950s made by Cardew and romantically entitled *Heart of Darkness* (Fig. 272)[51] or the non-functional water-jars by his protege Ladi Kwali, fought over by collectors at a succession of exhibitions held at the Berkeley Galleries in 1958, 1959 and 1962 (Fig. 213).[52] Cardew was forced into practicality by the exigencies of working in West Africa. He discovered that working as 'pioneer potter' gave his troubled life shape and meaning.

For most of the younger functional potters working in the Leach 'tradition' in the 1950s and 1960s, the answer seemed to lie in production without too much analysis, though immersion in Zen Buddhism could provide a comforting context for so much repetitive work. It was best to remain as artistically innocent as possible; an art school training could only militate against unselfconsciousness and besides, except at the vocational course set up at Harrow School of Art in 1963, art schools were weak on throwing and kiln building skills. This emphasis on practicality, as opposed to a liberal artistic education, meant that men and women with limited artistic or design gifts took up pottery with confidence. They form part of the social rather than artistic history of the craft. Nonetheless a few gifted figures with functional ambitions emerged.

273. Michael Casson, stoneware jug made at Prestwood, Buckinghamshire in 1976, h. 45.2cm. (Buckinghamshire County Museum).

Stoneware pottery's populist side is encapsulated in the career of Michael Casson, the co-founder in 1963 of the vocational ceramics course at Harrow School of Art. During the 1950s his pots were inspired by a range of Mediterranean influences, but by 1959 Casson had reread *A Potter's Book* and turned to stoneware with his wife Sheila. Together they designed practical tea and coffee sets, while he concentrated on more individual pots, ruggedly thrown and displaying his increasing knowledge and technical know-how. No Sung standard informed his pots. Instead their idiosyncratic shapes and decoration flowed from the act of making and from a desire to experiment. By the late 1960s Casson was beginning to concentrate on his most characteristic forms, tall jugs and jars which looked immensely reassuring but whose usefulness was more symbolic than actual (Fig. 273).

Casson made the life of the potter seem an ideal one. In a 1973 interview he explained 'I revel in physical work; after 44 days solidly making pots I want to make more pots'.[53] And he wanted others to join him, almost regardless of talent, in a communal celebration of the joys of claywork: 'People talk to me about pottery that is not significant. I say, O.K., perhaps it's not significant pottery, but it is significant in terms of that man's life…He's not a good potter, but he's had a good life…Pottery did something for him and I think that's worthwhile.'[54] Like Leach, Casson perceived pottery as a force for the good, but Casson's vision was more genuinely egalitarian, classless and uncritically inclusive – 'No one must be missed out!'. He was one of the great popularisers of the craft, especially in the 1970s when he presented the TV series *The Craft of the Potter* (1975) and began to play a key role at the CPA Potters' Camps which grew out of David Canter's early gatherings at Oxshott. But he simultaneously helped to create an inward-looking world, a safe area in which glaze recipes and stories of difficult firings might be swapped and in which the medium became as important as the message.

Among the sombre domestic stoneware pottery of the 1950s and 1960s, the maiolica and lustreware from Alan Caiger-Smith's Aldermaston Pottery seems an anomaly, inspired by the Middle rather than the Far East.[55] But, in terms of teamwork and division of labour, Aldermaston is an interesting response to the Leachean ideal. Caiger-Smith set up his pottery in 1955. He initially worked alone and was joined by Geoffrey Eastop from 1959 until 1960. By the early 1960s he was building up a team of co-workers. Caiger-Smith used the tin-glaze favoured by his tutor Dora Billington at the Central School to create brush painted decoration with a strongly calligraphic quality. He was a scholar in that area of ceramic history, co-editing a translation of Piccolpasso's *Three Books of the Potter's Art*, and writing comparative studies of tin-glaze and lustrewares in Europe and the Islamic world. Like many modern artists, Caiger-Smith used Oriental calligraphy as an inspiration for abstract mark making (Fig. 274). More remarkably, he trained all his team to decorate freely in the same spirit. All members of the Aldermaston team learnt to throw shapes and decorate using broad brushes – 'a week at the wheel and a week with the brush'.[56] Caiger-Smith believed that unless each member of the team both made and decorated his or her own pieces 'they would miss the tranformation and lose the heart of the matter'.[57] In his autobiography *Pottery, People and Time: a Workshop in Action* Caiger-Smith paints an idyllic picture of his co-operative venture. He was from the same upper-middle-class background as Bernard Leach but he created a little classless paradise at Aldermaston: 'an open, collaborative workshop at a time when most of my contemporaries were establishing private studios'.[58]

The team and the collaborative workshop proved elusive for Leach's most impressive followers. Richard Batterham learnt to pot as a Bryanston schoolboy.[59] He spent two years at the Leach Pottery, setting up on his own in Dorset in 1959. Inspired by Korean pots, not signing his work, wisely avoiding imitative Oriental brushwork, his ceramics encompassed grapefruit squeezers and plates as well as monumental tall bottles. His pots were recognised to be 'well designed', indeed were featured in the CoID's *Design* magazine[60] and selected for sale in the designer silversmith David Mellor's shops alongside Mellor's own CoID award-winning cutlery. But they also had a strong poetic charge, suggesting a 'tradition' that, unexpectedly, turned out to be the creation of one man working singlehandedly (Fig. 275).

Geoffrey Whiting also experimented with pottery as a small boy and worked alongside the

despised low caste potters at Nurgauo outside Delhi while serving as an officer in the army during and after the Second World War. In 1948 he returned to England, read *A Potter's Book* and started a workshop at Avoncroft College near Bromsgrove, moving in 1955 to a larger workshop in Hampton Lovett. Whiting was a good designer whose teapots could well have served as models for industrial production.[61] He scorned exhibitions and believed pots should be made for use – though at Red Rose Guild exhibitions he adopted the Leach model, showing Avoncroft pots separately from his more expensive individual bottles and bowls.[62] Self-taught, he became an inspirational teacher within sharply defined Orientally inspired limits. There was a marked restraint about his work. Whiting's pots were deeply influenced by Sung and Korean ceramics and intellectually he was an ascetic, drawn to Japanese perceptions of beauty, philosophy and, above all, to the Zen writings of D.T. Suzuki.[63] And yet he never visited Japan. This was also true of William Marshall, Leach's right hand-man, for whom Japan was a place of imagination and hope. But for Marshall, this constructed Japan acted as a liberating force, especially in 1977 after he left the Leach Pottery and began to work on his own.[64] For Whiting, on the other hand, Japanese concepts like *mu* –translated as 'nothingness' – and the adjective *shibui* – untranslatable, but suggesting 'austere' or 'subdued' – and notions of quiet service narrowed and limited his artistic horizons.[65] Whiting had one brilliant schoolboy pupil, Edmund de Waal, who did visit Japan and whose career got under way in the 1990s. He made restrained porcelain domestic ware – bottles, teapots and vases – and in 1998 wrote a patricidal assessment of Bernard Leach's career which sought to demolish Leach's claims for a special understanding of Japanese culture.[66]

> I think the concept of bread and butter lines as opposed to individual pieces very dangerous. It is the term 'bread and butter' that is dubious. The concept 'I am doing this because it gives me the money to do that.' Making pots is such a whole thing and your life is so whole you can't make these distinctions without something being lost.[67]

Gwyn Hanssen thus clumsily articulated the philosophy of potters who believed virtue lay

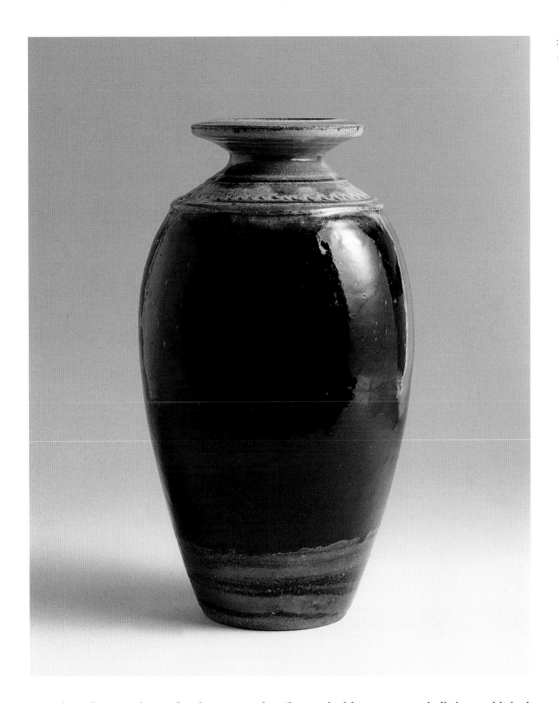

275. Richard Batterham, stoneware bottle, early 1980s, h. 35.5 cm. (Photo Peter Kinnear).

in making functional pots for their own sake. She worked her way round all the established potteries, from the Leach Pottery from 1958 until 1960, to Cardew's Cornish pottery at Wenford Bridge and to Alan Caiger-Smith at Aldermaston in 1960 and 1961. She then set up her own workshop in London. Until her return to her native Australia in 1973 she worked in London and in Achères, a French wood-firing pottery centre.[68] There was nothing obviously Oriental about Hanssen's pots. They are stripped down to essentials, Ur-forms, undecorated and functional. But a group of them have all the power of a Morandi still life and in 1993 she acknowledged the connection by exhibiting her bottles and bowls in carefully arranged groups that suggested the dependence of the early modern still-life on simple, domestic forms (Fig. 276).[69]

Potters like Batterham, Whiting, Marshall and Hanssen have been called 'potters' potters', the implication being that only the initiated would fully appreciate the quiet subtleties of their work. As David Canter put it: 'anything worth aesthetic enjoyment needs to be worked at. You listen to a Bach fugue and it's a set of old notes until you understand something about music and then you get enormously increased pleasure and this I think is what stoneware has to offer.'[70] The smugness of Canter's outlook might seem laughable, but austere, patrician figures like Batterham and Whiting certainly had uneasy relations with a potential audience. Despite

276. Gwyn Hanssen (Pigott), *Still Life*, three bottles, bowl and beaker in porcelain, 1992. height of largest bottle 23.5 cm. (Galerie Besson).

the little brown mugs for sale at every craft fair, the high ground of the Orientalist movement was little appreciated and understood in the 1950s and 1960s or beyond when a new generation – Mike Dodd, Jim Malone and Phil Rogers – carried the project forward while Clive Bowen magnificently developed the English slipware tradition in the spirit of Michael Cardew's inter-war work.

The shift to production pottery by 'Leach-type' potters was in part symptomatic of the democratisation of all the arts just after the war. But for many young artists, Leach's life and work was no model whatsoever. They felt no ambivalence about an art school education, indeed most of them were associated with the Central School of Arts and Crafts, whose ceramics tutor Dora Billington had been seeking an alternative to neo-Orientalism since the 1930s. She disliked the 'aura of solemnity and preciousness' of neo-Oriental ceramics in contrast with the 'amusing' and 'contemporary' 'New Look' being created by her pupils. Figurative ceramics, firmly excluded by Leach and Murray from the ceramic canon, were reinstated by these young men and women. They looked not to the Far East for inspiration but to the ceramic traditions of industrial Britain and to painting and sculpture as it had developed in France between the wars. They took an interest in contemporary design. The Italian magazine *Domus* was required reading.

In 1950 the Arts Council had toured *Picasso in Provence*, an exhibition of paintings, sculptures and twenty-one ceramic works which Picasso had made during the war at Antibes and Vallauris, in the South of France. The subject matter – nymphs, fauns and satyrs – celebrated the arrival of peace[71] but Picasso's venture into ceramics was regarded with suspicion by 'proper' potters and with embarrassment by the fine art world.[72] Bernard Leach, who had previously admired Picasso as 'perhaps the most creative artist alive', was dismissive – Picasso 'simply was not a potter' and he dubbed his ceramic admirers 'Picassiettes'.[73] But for younger

artists entering the art schools after the war, the light-hearted casual nature of Picasso's zoomorphic and figurative ceramics seemed inspirational,[74] drawing painters and sculptors, as well as potters, to ceramics. An exhibition at the Redfern Gallery in 1952 included ceramics decorated by painters and sculptors like Peter Lanyon, Kenneth Martin, Victor and Wendy Pasmore, Eduardo Paolozzi and Ceri Richards as well as work by the potters Margaret Hine, William Newland, James Tower and Nicholas Vergette.[75] The Picasso-inspired shift away from neo-Orientalism was suggested by the exhibition sponsored by *The Observer*, *Ceramics for the Home* of the same year, staged at Charing Cross Underground Station. Leach and Cardew were included but it was the ceramics of William Newland, Margaret Hine and James Tower, together with pieces by Lucie Rie and plates decorated with a broken spiral motif by Victor and Wendy Pasmore which attracted attention and which reminded one reviewer of the rows of Picasso's 'exuberant pitchers and platters' at his museum at Antibes.[76]

The New Zealander William Newland was the archetypal 'new potter' of the 1950s (Figs 255, 277). His horizons had been broadened by the war and he was able to take advantage of the free art school education offered to demobilised ex-service and women. In 1945 he went to Chelsea School of Art to study painting and on to the Institute of Education in 1947–8. There he discovered a natural facility with clay, attended Dora Billington's classes at the Central School and read Marion Richardson's writings on education and art, adopting her

277. William Newland, *Bull*, 1954, earthenware, brown and white tin-glaze. h. 35.9 cm. (V&A Picture Library).

278. Margaret Hine, large earthenware plate with tinglaze decoration, *c.* 1955, diameter 40.5 cm. (Paisley Museum and Art Gallery).

279. Exhibition at the Studio Club, Swallow Street, 1953, showing figures by Margaret Hine and dishes, cactus holder and cat by Nicholas Vergette. (Murray Fieldhouse).

dislike of prescriptive art teaching. He saw himself doing for ceramics what she had done for painting. In ceramic terms this meant a healthy suspicion of the certainties in Bernard Leach's *Potter's Book*. He did not like the idea of 'sitting in Bloomsbury painting bamboo leaves on pots with a Chinese brush'.[77] In 1948 he became pottery instructor at the Institute and his charm, energy and ability drew numerous painters taking an art teacher's diploma to ceramics, including his future wife Margaret Hine (Fig. 278) from Derby School of Art, Nicholas Vergette from Chelsea School of Art and James Tower from the Slade.[78]

Newland, Hine and Vergette's 1953 show (Fig. 279) at the Studio Club suggests the strong influence of Picasso's ceramics[79] combined with an awareness of the charm and gaiety of nineteenth-century Staffordshire figures. Their accessible humanism was recognised by

280. Nicholas Vergette, ceramic mural for The Moo Cow Bar, Victoria Street. late 1950s. (Marcus Vergette).

Stewart Mason who bought quasi-religious pieces like Newland's *Daniel and the Lion* (Fig. 229) and Hine's charming *Fishing* dish for Leicestershire schools. Although Newland's magnificent large bowl of 1955, the first of a series with a brushed image of Europa and the bull,[80] suggests his capacity for a grand gesture, much of Hine and Newland's joint work of the 1950s and early 1960s enlivened the interiors of coffee bars and restaurants with prancing Minoan bulls, figurative groups of fishermen and harlequins and women releasing doves (Fig. 381) or seated on donkeys, moving on in the 1960s to playful interiors for the Kaye brothers' Golden Egg chain of restaurants.[81] Nicholas Vergette was working in a similarly light-hearted spirit, making stylised cats, handsome maiolica bowls and striking press-moulded platters as well as decorating the Moo Cow milk bar in London's Victoria Street (Fig. 280). By 1956 he was experimenting with mosaic panels set into metal coffee tables or applied to walls. In the same spirit Ann Wyne Reeves developed narrow press-moulded dishes, little cast birds and triangular platters on tripod feet. Her tile designs, decorated with semi-abstract spikily drawn birds, flowers and fish inspired by Paul Klee, were marketed by Kenneth Clark Pottery, a firm she ran with her potter and designer husband.[82] Steven Sykes was another maiolica potter. His tiles and dishes with sprigged and stamped motifs inspired by popular art were given a good deal of exposure at the 1951 South Bank Exhibition. An exhibition at the Apollinaire Gallery the following year was dominated by bizarre thrown and altered planters in the form of birds, animals and figures; work which put Peter Floud in mind of the late Victorian Martin Brothers' ceramic grotesqueries.[83]

Another pupil of Newland's, James Tower, took a different route.[84] Newland and Tower had sparked each other off creatively,[85] and, with the encouragement of Dora Billington, began to develop their maiolica techniques, using glaze on glaze, wax resist, washes of pigment and sgraffito, incised, combed, brushed and scratched.[86] In 1949 Tower took up a post at Bath

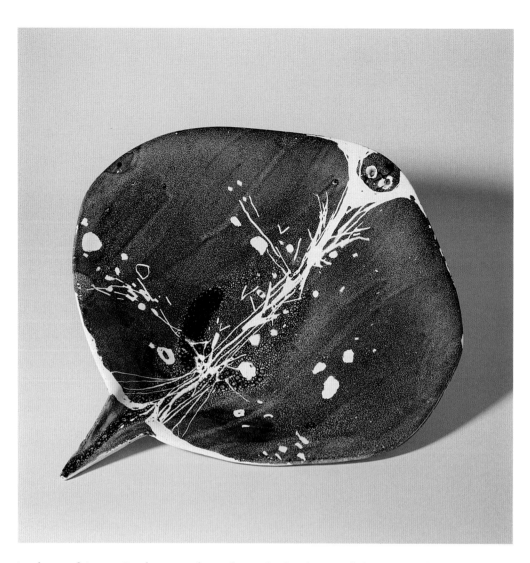

Academy of Art at Corsham, teaching alongside the then English avant-garde in painting – Terry Frost, Peter Lanyon, William Scott and Bryan Wynter. Tower's Corsham connections, his regular exhibitions at Gimpel fils and the developing intensity and seriousness of his work set him apart from the other Picassiettes. From the mid-1950s he abandoned throwing and used moulds to create vessels with a strong frontal emphasis, often heavily scored and ribbed. His narrow platters were very much of the period but there were also remarkable dishes inspired by the elegantly menacing shapes of skate and sting rays (Fig. 281). His surface decoration is best described as organic abstraction, drawing on the pigmentation of exotic shells and on the cell structures, studied with interest by many artists in the early 1950s.

Lucie Rie (Fig. 283), as Dora Billington recognised, was also part of this new, urban anti-Orientalist movement[87] but her work was far more restrained and functional and she had no interest in figurative experimentation. Her contact with the English studio pottery world, after a distinguished pre-war career in Vienna, had first a mainly negative effect. But, as we have seen, the high status of ceramics in England among a small circle of collectors and museum curators (and her friendship with Leach) inspired Rie with a new ambitiousness for her work.[88] Hans Coper, who became her assistant in 1946, encouraged her to reassess her pre-war pots and take them as a starting point. In 1949 she abandoned earthenware in favour of stoneware and porcelain, but there her links with the neo-Oriental aesthetic ended. Thinly potted, thrown forms were often squeezed to form ovals or skilfully thrown asymmetrically. Her colours were vivid and she made elegant use of sgraffito scratched into the raw clay. She avoided the spontaneity and evidence of facture which marked the work of orientally inspired potters. Pieces were carefully turned and highly finished (Fig. 282).[89] Rie was a private person. Unlike Leach she did not discuss her sources of inspiration or put forward any philosophy, but she was clearly influenced by Scandinavian ceramics of the 1930s and 1940s.[90] Her 1950s

designs for Wedgwood, which were never put into production, suggest the contribution which she might have made if the British ceramics industry had encouraged the kind of collaboration with studio potters common in Scandinavia.[91]

Hans Coper was a still more enigmatic figure.[92] In Germany he had briefly studied textile engineering, arriving in England in 1939 aged nineteen, two years after his Jewish father had committed suicide in Dresden. Interned by the British government as an enemy alien, he met an older German artist, Jupp Dernbach, who inspired him to paint and draw. In 1946 another German refugee, William Ohly, the owner of the Berkeley Galleries, sent him to work for Rie, where he assisting her in making buttons and then tableware. As we have seen, Dernbach was also her assistant from 1946 until 1950 and in moments of free time the two men experimented on large platters with sgraffito. They borrowed Rie's techniques but put them to bolder effect; on an early Coper jug of 1952 the sgraffito was a blend of archaic sources and School of Paris draughtsmanship (Fig. 284). Coper was more actively interested in modern painting and sculpture than Rie. He admired Brancusi and tried to meet him in Paris in 1956. Picasso, Braque, Naum Gabo, Ben Nicholson, Marino Marini and Giacometti were other heroes.[93] He got to know the Cycladic, Egyptian and Etruscan collections in the British Museum and saw African art at William Ohly's gallery. He was also interested in Kandinsky and in Bauhaus teaching, and this informed the four years he spent at the Digswell Arts Centre from 1959 to 1963 designing cladding, acoustic bricks and even washbasins for architects. He disliked most British studio pottery, especially the work of Leach and his circle. In the early 1950s he made some monoprints and semi-abstract ceramic heads clearly influenced by Picasso as well as a sensitively modelled portrait head of Lucie Rie.

By the early 1960s Coper had established a rather aceramic decorative technique in which surfaces were scratched with a serrated tool, painted with manganese dioxide, then sanded,

282. Lucie Rie, a selection of 1950s stoneware tableware. (Photo David Cripps).

283. Lucie Rie in her studio in Albion Mews, c. 1958. (Murray Fieldhouse).

284. (*opposite*) Hans Coper, stoneware jug with sgraffito design, 1951, h. 35 cm. (Crafts Council/David Cripps).

285. Hans Coper, two lobed tube forms on cylindical bases, (*l. to r.*) 1967, h. 31 cm.; *c.*1972, h. 26 cm. (Private Collection. Photo Steve Rees).

white slip painted on and then sanded again. The results looked abraded and impoverished and set off the purity of increasingly powerful forms which were often constructed out of thrown parts, heavily turned and, by the 1970s, joined in a fashion – with glue or with a knitting needle thrust between two sections – which appalled potters concerned with process (Fig. 285). Michael Cardew, for instance, detested the constructional aspect of Coper's pots.[94] As one Leach-inspired production potter put it, Hans Coper makes 'those ghastly pots that he scrapes down on the outside with manganese and china clay. The sort of pots that architects like.'[95]

Coper, like Rie, avoided interviews and wrote no books or articles but he contributed a short statement on his work and aims to the catalogue of a 1969 exhibition at the V&A shared with the weaver Peter Collingwood. Its final section came to be an almost sacred text for adventurous potters who came to maturity in the 1970s:

> Practising a craft with ambiguous reference to purpose and function one has on occasion to face absurdity. More than anything, somewhat like a demented piano-tuner, one is trying to approximate phantom pitch. One is apt to take refuge in pseudo-principles which crumble. Still, the routine of work remains. One deals with facts.[96]

Coper subtly changed the agenda for studio pottery, shifting it away from the certainties of *A Potter's Book* and from Billington's endorsement of decorativeness. Coper offered an ambiguous set of values, suggesting that there was something magnificently absurd about making pots by hand in the twentieth century. To the students he taught at Camberwell School of Art from 1963 to 1973 and at the Royal College from 1966 to 1975, who had grown up on a diet of Beckett and *Ubu Roi* and Colin Wilson's *The Outsider*, Coper's nihilism and quiet sense of irony were inspirational.[97]

Suffering from a degenerative muscle disease, Coper ceased to pot in 1975 and died in 1981. Nonetheless by the 1980s Coper and Rie were among the very few potters whose work commanded high prices in the sale rooms. Why did their pots become so highly commoditised? Why were they manifestly more acclaimed than other studio potters apart perhaps from Bernard Leach? Their visual consistency and discipline were surely important factors. Clay is an infinitely malleable material and in the 1960s, as we shall see, non-Oriental potters set few limits to their experimentation. Not so Rie and Coper, who explored sequences of formal themes with rigour in a fashion reassuringly similar to the developmental sequences associated with the fine arts at that date. And Coper, in particular, disciplined clay to such an extent that his pots related easily to abstract carving in wood and stone. They were indeed 'the sort of pots that architects like'. By the 1970s Coper was regarded as *the* potter with sculptural presence.[98]

By the early 1960s a new generation of non-Orientalist potters was emerging, who, like the Picassiettes, tended to have connections with the Central School. But, unlike Hine, Newland and Vergette, they did not work figuratively. Frequently firing to stoneware temperatures, their pots looked sombre in comparison with the Picassiettes' colourful tin-glaze. Nor did their work appear as resolved as that of Coper and Rie, partly because they employed a huge variety of experimental hand-building processes, from slabbing to coiling to pinching.[99] Dan Arbeid, Ian Auld, Gordon Baldwin, Ruth Duckworth, Gillian Lowndes, Bryan Newman, and the rather younger Ian Godfrey, Anthony Hepburn and Mo Jupp were just some of the many 1960s potters with sculptural ambitions and a keen awareness of developments in fine art. Gordon Baldwin, for instance, was directly influenced by Eduardo Paolozzi's notions of what could be done with clay. At the Central School he remembers Paolozzi 'bending bits of clay and glazing it – not making things, not making as we were taught to make – just bending bits of clay – and Paolozzi taking a lump and poking his fingers, his great podgy fingers in it – shouting for black stuff to make marks and not worrying two pennies about ceramic quality and feeling for clay.'[100] Baldwin studied and worked as a technician at the Central School between 1950 and 1954 where, as we have seen, he joined a Basic Design class run by another sculptor, William Turnbull.[101] In the late 1950s Baldwin was making totemic, archaic-looking earthenware sculptures, some of which he described as maquettes for larger pieces and which were close in mood and intent to the work of sculptors like Paolozzi and William Turnbull (Fig. 286). But he was endlessly versatile and by 1967 was making heavy bowls with bright interior glazes whose carved look was reminiscent of Brancusi. And already it was possible to detect his growing interest in artists like Arp whose ideas about art generated by the laws of chance were to dominate Baldwin's work in the 1970s and 1980s (Fig. 247).

But these potters' radicalism was not recognised by the wider fine art community in terms of critical appreciation and exhibition space. Their context remained domestic and they got far less coverage than had the neo-Orientalists in the inter-war years (Fig. 287). Although in the 1950s analogies *could* be made between potters like Baldwin and sculptors like Paolozzi, the avant-garde sculpture of the early 1960s was a different matter. Going no further than the materials – the pale tinted fibreglass used by Philip King and Tim Scott or the brightly painted steel rods and L Beams welded and bolted together by Anthony Caro – it becomes clear that the old isomorphism that made it possible to compare the pure forms of inter-war pots and inter-war sculpture no longer obtained.

The frustrating position of these sculptural potters is well illustrated by the career of Ruth Duckworth (Fig. 288).[102] She found her original voice as an artist when she turned from carving to clay in 1956. She studied at the Central School where she developed an extraordinary repertoire of delicate pinched porcelain pieces, heavy stoneware cylinders, coiled ovoid pots with rough, partially glazed surfaces and semi-figurative totemic forms. Duckworth also threw and slipcast functional wares of great beauty. In a tellingly entitled article of 1961, *Pottery in a Vacuum*, co-authored with her husband the sculptor and furniture designer Aidron Duckworth, she wrote of pottery: 'Perhaps we have never before had such a wealth of talent in the country as exists today. Whether it is to move forward in strength or

287. Context: a publicity shot for Heal's with a sculptural stoneware tripartite vase by Alan Wallwork on the sideboard. (British Architectural Library/RIBA, London).

whether it is to become debased and wither, is in the hands of the new patrons – industry, the architect and the State.'[103] But British industry, though ready to borrow ideas from the studio pottery movement, was never to show a serious interest in using studio potters as designers. Architectural commissions offered specifically to potters were few and far between. In 1964 Duckworth left for a job at the University of Chicago where she went from strength to strength, creating a sequence of large scale sculptures, ceramic murals and wall pieces for both public and private buildings.

Potters like Baldwin and Duckworth complicated the standards set by Leach. So did Ian Auld who had trained as a painter at the Slade, came under Newland's spell at the Institute of Education in 1951–2 and taught in Baghdad between 1954 and 1957.[104] In 1957 he set up a studio making press moulded and slab pots, often in heavily grogged clay, using ash glazes and incising or decorating with impressions made from handsome plaster of Paris seals. Auld revealed the possibilities of slab building, rather as Duckworth had imaginatively explored coiling and pinching.[105] His work had an architectural feel to it, calling to mind both the concrete austerities of the so-called New Brutalism and the unexpected forms captured in Bernard Rudofsky's *Architecture without Architects* of 1965. Auld was also steeped in the ceramic culture of Korean, Persian and Japanese pots. But he achieved Leach's touch and spontaneity by an altogether different route (Fig. 289). Auld saw himself, Dan Arbeid, Gordon Baldwin, Ruth Duckworth and Bryan Newman, as progressives, 'trying to break down the accepted values of our establishment predecessors like the Leach family, Hans Coper and Lucie Rie'.[106]

Ian Auld's wife Gillian Lowndes was another innovator. She started her career in 1957 in the sculpture department of the Central School. She switched to ceramics 'because there seemed to be more possibilities'.[107] As with Duckworth, the abandonment of sculpture took her from figuration to abstraction, from convention to innovation. William Turnbull's important classes at the Central had a powerful influence. Her work was eclectic; she made large bowls enlivened by Klee-like lines drawn in manganese; she coiled industrial looking pipe forms; and in 1966 she made a hollow drum with a softly curved interior which had formal affinities with work in moulded plastic by King and Tucker (Fig. 290).[108] In the early 1970s Lowndes and Auld visited Nigeria. At Abuja Auld criticised Cardew's pots 'as not being African'.[109] They seemed too shiny and solid amidst the ephemerality of African artefacts. Auld and Lowndes's constructed Africa was more pragmatic. They admired the *ad hoc* use of diverse materials – coats made of cowrie shells – and the improvisation – sculpture made from recycled metal parts.[110] After her African visit Lowndes virtually abandoned vessel forms nor could her work be described as domestic or decorative. Context was always to be a problem.

These sculptural potters had little time for Leach's virtually exclusive adherence to the thrown vessel. But the work of Leach's old associate, the Japanese potter Hamada, was admired by potters of every persuasion, even if they did not share his ideological position. Perhaps the most discussed ceramics exhibitions of the early post-war period were Hamada's shows held at the Crafts Centre of Great Britain in March 1958 and the winter of 1963.[111] Hamada's pots, with their relaxed, almost casual, grandeur, suggested the sculptural and painterly possibilities of the Oriental approach in a way that Leach's work did not (Fig. 291). Bernard Leach's third wife, the Texan potter Janet Darnell Leach, was Hamada's disciple and her apprenticeship with Hamada explains her independence from run-of-the-mill neo-Orientalism.[112] After meeting Leach, Hamada and Yanagi in the United States in 1952 she spent 1954 to 1956 in Japan, working, on Hamada's advice, in the country potteries of Mashiko and Tamba. From 1956 she managed the business side of the Leach Pottery and helped redesign, and some would say, spoil, its Standard Ware. She never made any pots which suggested the influence of her husband. Instead she evolved a unique response to Japanese pottery, particularly Bizen and Tamba ware, that put her work, though it was mostly thrown, into the heart of the 1960s sculptural camp (Fig. 292). The Canadian John Reeve, another admirer of Hamada's, who in fact trained with Leach in the 1950s, also demonstrated how Hamada's *tendresse* with moulded and slab-built clay could be adapted to an expressive sculptural approach.

288. Ruth Duckworth's studio in Kew in 1962. (Photo John Donat).

289. Ian Auld, stoneware slab-built pot with a handbuilt rim, late 1960s, h. 45.5 cm. (Buckinghamshire County Museum).

In the 1950s American painting and sculpture, notable for its scale and expressiveness, had had a powerful, even paralysing, effect on British artists just as American 'fibre art' had a similar if more creative impact on British weavers, and American calligraphy stimulated British letter arts. British potters were more resolute. Dan Arbeid recalled that 'American pots did not have any impact here. We were just getting on with our own work.'[113] This sounds a little disingenuous even if the key cross-overs came a little late. American pots were first shown in Britain at an exhibition at the American Embassy in 1960, with a second show in 1963.[114] Rose Slivka's article in the American Crafts Council magazine *Craft Horizons* on *The New Ceramic Presence* appeared in 1961, and in 1966 the V&A Circulation Department put on the exhibition *American Studio Pottery* which included work by Rudy Autio, Jerry Rothman, Paul Soldner and Peter Voulkos.[115] There were much earlier sightings of American pots in American magazines. But the sheer physical scale of American pots was never replicated in Britain and handbuilders like Arbeid, Baldwin, Duckworth and Eileen Lewenstein, and the younger Ian Godfrey and Mo Jupp, worked in a more considered, cerebral spirit.

Anthony Hepburn was one artist avowedly influenced by American ceramics. He had trained at Camberwell School of Art where he was taught by Coper, Rie and Bryan Newman. From 1963 to 1965 he took an Art Teacher's Certificate with William Newland at the Institute of Education.[116] Some of Hepburn's early work can be compared with the 1960s West Coast ceramics movement known as Funk, although Hepburn did not employ the bawdy locker-room images – tea pots with penis spouts for instance – favoured by the movement's leader Robert Arneson. Hepburn's work of the 1960s was dominated by slab-built boxes (Fig. 293) and plinths which supported slip-cast simulacra of milk bottles, telephones and a toaster (but no toaster with severed fingers peeping out in Arnesonian fashion). Hepburn was recognised as the embodiment of the late 1960s spirit by young practitioners in other crafts. For the weaver Ann Sutton, Hepburn's work was 'the first exciting craft ceramics of our time'.[117] Hepburn exhibited a gallery full of slip-cast and slab-built sculptural multiples at the Crafts Centre in 1969 in the

290. Gilliam Lowndes, stoneware drum form, c.1967. h. 14 cm. (Paisley Museum and Art Gallery).

291. Shoji Hamada, stoneware bowl with a tenmoku glaze, bought at his Crafts Centre show in 1958. diameter 26.5 cm. (Wingfield Digby Collection/Photo Peter Kinnear).

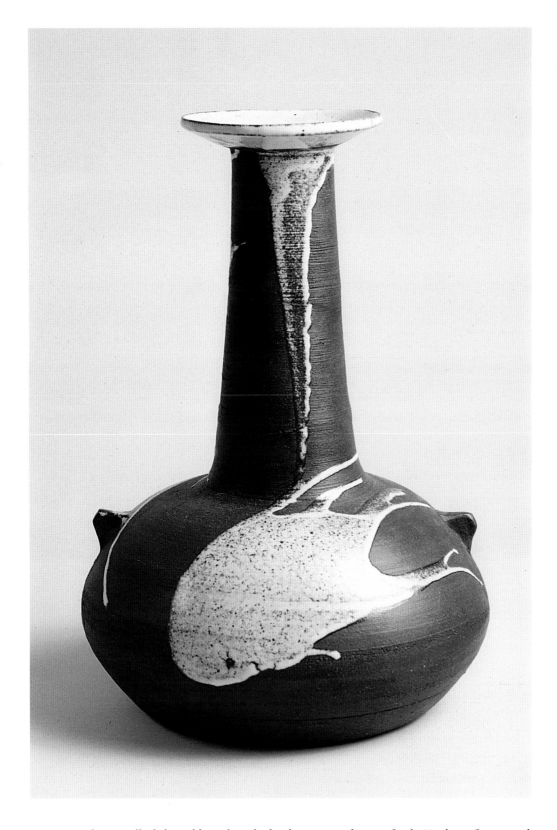

292. Janet Leach, bottle, unglazed clay darkened with chrome ore and bauxite, decorated with spashed white glaze, mid-1970s. (Photo Peter Kinnear).

company of an equally fashionable maker, the batik artist Noel Dyrenforth. Hepburn first visited the United States in 1969 and by 1970 was writing with some excitement about the energy and open-mindedness of the ceramics scene there. His article for *Ceramic Review* was illustrated with Arneson's *A Tremendous Teapot* with its lid in the form of a vagina and a phallic spout.[118] Heady stuff – but Hepburn's 1971 exhibition at Camden Arts Centre, with pieces in unfired clay and other materials, suggested a more formalist approach. His *Sixty Variations on a Cup* made in 1974 for the Chunichi Shimbun ceramics collection in Japan revealed what a keen ceramic sensibility Hepburn possessed. He was in fact a great admirer of Hamada, whom he met in 1969 on a Crafts Centre visit to Tokyo with Janet and Bernard Leach.[119] Inevitably perhaps, in 1979 Hepburn followed in the footsteps of Ruth Duckworth and moved permanently to the United States.

293. Anthony Hepburn, Slab-built box, stoneware, 20 × 23.5 × 21.2 cm. (Camberwell College of Arts, The London Institute).

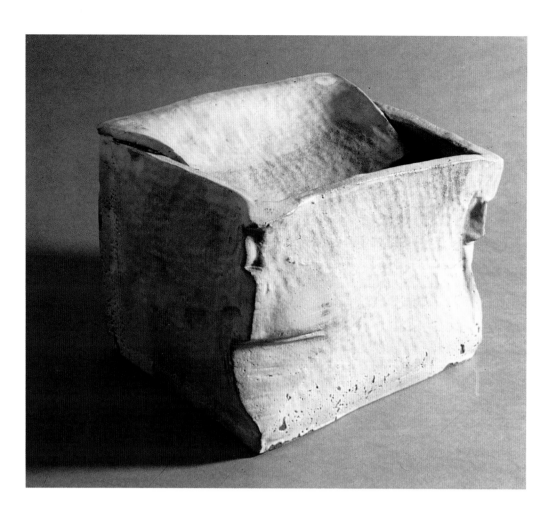

SILVERSMITHING AND JEWELLERY

Between the wars the silversmith Omar Ramsden's panelled rooms at St Dunstan's in Fulham suggested the continuance of a craft with its roots in a pre-industrial past. The silversmiths of the 1950s and 1960s, many of whom designed for industry, shuttling confidently between the Council of Industrial Design and the Worshipful Company of Goldsmiths, projected a necessarily more complicated image of their craft. With relatively large sums of money involved, their patronage and practice were sharply distinct from the cosier world of ceramics. The leading silversmiths of the 1950s were closely involved with the design world and were intermittent patrons of contemporary architecture. In the early 1960s both Robert Welch (Fig. 294) and David Mellor commissioned the architect Patric Guest of Gollins, Melvin & Ward to design single-story glass and steel wall homes – and in the case of Mellor, an adjacent office and workshop (Fig. 295).[120] Gerald Benney's mid-1950s workshop off Tottenham Court Road had 'a definitely modern feeling, of black and white with spots of colour and books and photographs'.[121] By 1965 Benney moved to Bankside, and then, in 1972, to new London premises whose handsome white interior complete with a large ceramic mural and prints by William Turnbull again projected a thoroughly modern image.

On the other hand, most silver was commissioned by clients who were members of 'the Establishment' – a phrase newly minted in the 1960s – who would have been reassured by the fact that from 1965 Benney also operated from Beenham House, a handsome Georgian mansion in Berkshire. Clients with a rather different sensibility responded to Welch's offices and workshops at Chipping Campden, in an old silk mill formerly used by Ashbee's Guild of Handicraft. Welch offered a seductive mix of old and new, for rickety wooden stairs led up into a modern showroom with elegant shelving, low tables and an iconic black and white photograph of a magnified thistlehead (Fig. 296). David Mellor was the most committed architectural adventurer. By 1975 he had transferred operations and his home to Broom Hall, a Georgian mansion on the outskirts of Sheffield which he restored from a ruinous state.[122] In

294. (opposite, above) The White House, Alveston, a single story house for Robert Welch by Patric Guest of Gollins, Melvin & Ward, 1962. (Robert Welch).

295. (opposite, below) 1 Park Lane, Sheffield, a single story house and workshop for David Mellor by Patric Guest of Gollins, Melvin & Ward, 1960. Note the Eames chair and ottoman, Pierre Soulages painting and Kaare Klint light. (David Mellor. Photo Henk Snoek).

296. Robert Welch's showroom and design studio in 1959/60 showing a selection of Welch's stainless steel for Old Hall Tableware, a prototype coffee pot (*top right*) to be made in silver for Goldsmiths' Hall, and a coffee table designed and made in the workshop. (Robert Welch).

1988 he commissioned a new factory in the Peak District from Michael Hopkins Architects, a circular masterpiece in brick, timber and lead. Its exquisite revealed construction underlined the firm's reputation for craftsmanship and as in Sheffield he lived on site, designing an adjacent house and a shop. Mellor also maintained strong links with his public through his handsomely designed shops, starting in 1969 with the cannily classless 'David Mellor Ironmonger' in Sloane Square.

From 1951 until 1982 Graham Hughes was the art secretary (a modest title later upgraded to art director) at the wealthy City livery company the Worshipful Company of Goldsmiths. Hughes was a crucial facilitator of what amounted to a post-war silversmithing renaissance. As we have seen, his father George Ravensworth Hughes had orchestrated the Company's patronage between the wars. His son's taste was more adventurous. Hughes allied himself firmly with silversmithing which displayed an awareness of developments in fine art.[123] The Council of Industrial Design's form-follows-function vision of design was not for him, and he constantly expressed anxiety about the absence of variety and surface decoration in contemporary design.

Most of the silversmiths Hughes admired had recently graduated from the Royal College of Art from a department headed by the architect Robert Goodden. Nonetheless they received a quite traditional training dominated by the skills of Leslie Durbin, the key craftsman involved in creating the Stalingrad Sword (Fig. 219) and the most eminent practising silversmith teaching at the College. Durbin's career points up the difference between the pre- and post-war generations of silversmiths. Most post-war silver can be related to the expressiveness of aspects of contemporary painting and sculpture or to the discipline of design for manufacture. Durbin, for all his consummate skill, seems aloof from both worlds. He came from a less privileged background than the post-war group, having gone to the Central School on a LCC scholarship followed by a rigorous apprenticeship to Omar Ramsden. He was thirty-two before he was able to set up his own workshop with Leonard Moss in 1945.[124] Durbin did not design for industry. He regarded mass production as a tragedy for the crafts, and the emphasis in his workshop was on the 'handwrought'. Durbin's skills were very much at the service of his clients and he could make complex ceremonial silver as well as sequences of inkstands, lecterns and carefully modelled animals. He was eclectic, moving from the *art moderne*-inspired style of inter-war silversmiths to the richly ornamented tradition of the Arts and Crafts Movement. A 1960 cross for the High Altar of Winchester Cathedral, made up of

stacked brass cruciform rods, was inspired by the constructionist Kenneth Martin whose work Durbin had seen and, rather surprisingly, had liked on a visit to the Tate Gallery.[125]

David Mellor was one of Durbin's outstanding pupils. His career reads like a critique of his tutor's anti-industrialism. Mellor reacted against the Arts and Crafts emphasis of the course at the RCA and, after a year at the British School in Rome, returned in 1954 with plans for designs for street lighting columns. That year he opened a design consultancy and workshop in Sheffield, and contracted to design for the firm Walker and Hall for whom he created his award winning Pride cutlery in 1953 and a further range of domestic silver. Mellor became an all-round designer with bus shelters, solid fuel heaters and traffic signals for the Ministry of Transport to his credit by the end of the 1960s. As I write the traffic signals remain unchanged, an integral part of the post-war landscape. He also designed hollow and flatware for the Ministry of Public Building and Works, including his 'Thrift' stainless steel cutlery of 1965 (which cut eleven-piece place settings down to an economical five) (Fig. 232)[126] and a handsomely simple range of silver for British embassies abroad (Fig. 297). The limitations and constraints of design for mass production worked in Mellor's favour. His best tableware and cutlery designs look thoroughly modern and yet are clearly inspired by eighteenth-century British silver. On the other hand, special handmade commissions in silver in the 1950s and early 1960s, both domestic and ecclesiastical, have a simplicity associated with the discipline of design for manufacture. In the early 1970s Mellor opened his own cutlery factory, first at Broom Hall and then at Hathersage, demonstrating that a small-scale approach and old Arts and Crafts concerns about joy in labour could feed into design for mass production. To alleviate workplace boredom he insisted his workforce participate in every manufacturing operation and this was made possible with an early design for cutlery, *Provençal*, which was both simple to make and, as its name suggests, intended for informal eating. But this avoidance of specialisation demanded the creation of specially designed machine tools rather than a high level of skill. The 'joy' therefore flowed from the variety of tasks and the strikingly pleasing surroundings which Mellor was committed to providing for his workforce.[127]

Robert Welch, like Mellor, developed a lively design consultancy practice after leaving the Royal College in 1955 but he maintained a greater commitment to handmade silver, both domestic and ceremonial.[128] While still a student, he had investigated the potential of stainless steel, inspired by the designs of Sigurd Persson for the Swedish manufacturer A.B. Silver & Stal. On graduating he set up his silversmithing workshop at Chipping Campden. He was appointed consultant designer for Old Hall Tableware and went on to design a whole range of

297. David Mellor, *Embassy* silver teapot with a black fibre handle, 1963, part of a range of silver commissioned by the Ministry of Public Buildings and Works for use in British embassies and made in Mellor's Park Lane workshop. h.18 cm. (The Worshipful Company of Goldsmiths).

298. Heal's publicity shot showing a selection from a range of Robert Welch's silver and rosewood tableware designed 1964–5. (British Architectural Library/RIBA, London).

299. Robert Welch, silver candelabrum, 1958, h. 39.4 cm. (The Worshipful Company of Goldsmiths).

products ranging from lighting to kitchen knives to ceramics. Welch was inspired by the design and architecture of the early Modern Movement 'totally, to the point of overdoing it'.[129] The market for handmade domestic silver was shrinking fast in the 1950s but Welch tried to overcome this with an up-to-date range commissioned by Heal's in 1964. Combining rosewood and silver, he designed an elegant series of softly rounded coffee and tea services, candlesticks, condiment sets and dishes which worked as a unified family of forms (Fig. 298). If Welch's domestic silver had a strongly eighteenth-century inspiration, tempered by his admiration for Scandinavian design, his ecclesiastical work, particularly crosses, was more unpredictable. Some of his most unexpected pieces were made for Goldsmiths' Company. A 1958 seven-branched candelabrum was inspired by a visit to a Jackson Pollock exhibition held at the Whitechapel Art Gallery in that year; Welch worked out its design not with his usual sequence of exquisite drawings, but by randomly assembling and reassembling a collection of turned wooden rods (Fig. 299).[130]

Hughes was supportive of Mellor and Welch, but his most ardent admiration was reserved for another Royal College of Art graduate, Gerald Benney. Benney was a consultant designer for Viners of Sheffield from 1957 until 1970 but he was above all a designer maker, albeit with a large workforce. As with Welch and Mellor, much of his domestic silver echoed eighteenth-century examples. But he was attracted to opulent effects and pioneered lush textured surfaces. By 1970 he had developed richly simple enamel finishes. He was also capable of remarkable bravura one-off pieces. Hughes wrote excitedly of Benney's 'exuberant fantasy' which he saw as 'a tonic in the cold clinical atmosphere of modern functional design'[131] and dubbed Benney 'the silversmiths' Henry Moore'.[132] As we have seen, Benney did indeed make one piece evocative of Moore – his chalice with a pierced knop and a textured surface (Fig. 300). But his early work had more in common with the expressiveness of 1950s sculpture. Benney's jewellery constructed from roughly soldered partly melted strips of silver echoes the skeletal, ribbed cage structures of sculptors like Reg Butler, Lynn Chadwick and Geoffrey Clarke. Giacometti was a source for a remarkable travelling altarpiece of 1959 with a reredos of attenuated rhodium plated silver rods. A group of daring and dramatic centrepieces and rosebowls (Fig. 301), which transformed the look of an essentially traditional item of silver, drew on another 1950s design source, the photography of cell structures, microscopic and natural forms.

Louis Osman was another of Hughes's favourite designers. Trained at the Bartlett School of Architecture and at the Slade, he was a largely self-taught silversmith, often acting as an impresario rather than a maker.[133] Osman's work was characterised by extravagance of design, materials and technique. An early dramatic example was an offertory plate, shaped by beating a thick ingot of cast silver with a sledge hammer, made for the exhibition *British Artist Craftsmen* which toured the United States in 1959 and 1960 under the auspices of the Smithsonian Institution. This mixed exhibition was filled with innovative silver, including Benney's chalice and travelling altarpiece, Welch's seven branched candelabrum, and an altar set and *Stations of the Cross* by Geoffrey Clarke (Fig. 304), mostly commissioned by Hughes for the Goldsmiths' Company. Osman's impresario role extended into his architectural practice. He commissioned Jacob Epstein to model a memorable Madonna and Child for his bridge link for the Convent of the Holy Child in Cavendish Square in 1953; he remodelled the interior of the Principal's Lodge at Newnham College in 1958 to include stained glass by Geoffrey Clarke; in 1967 he redesigned the interior of the Chapel of King's College Theological College in Vincent Square as well as designing and making its plate; he created a Treasury at Lincoln Cathedral, also in collaboration with Clarke. At the end of the 1960s he worked with the engraver Malcolm Appleby on the Prince of Wales's investiture crown which he boldly but perhaps unwisely decided should be made by electroforming (Fig. 302). The result was hieratic, theatrical and barbaric – hardly suitable for a timid young Prince.[134] A marked casualness about technique (suggesting a subversive insouciance about silver's intrinsic value) was typical of Osman's work and especially evident in his most ambitious contribution to ecclesiastical silversmithing. This was the so-called Ely Cross, designed in collaboration with Graham Sutherland, who modelled

301. Gerald Benney, *Beetle* bowl, 1962, silver parcel-gilt with pierced textured cover and peridots, diameter 53.2cm. (The Worshipful Company of Goldsmiths).

the crucified Christ for casting in gold. Completed in 1964, it was made up of forty-five separate parts with Christ set against a black nielloed silver heart. It is a dramatic disturbing object; too disturbing for the Cathedral authorities who rejected the finished work (Fig. 303).

Geoffrey Clarke was a still more maverick figure who trained as a stained-glass artist, engraver and sculptor at the Royal College from 1948 until 1951.[135] He showed sculpture at the 1952 Venice Biennale with Lynn Chadwick, Reg Butler, William Turnbull and Eduardo Paolozzi. From 1952 until 1956 he worked on the nave windows for Coventry Cathedral (Fig. 387) and again represented Britain with Paolozzi at the 1960 Biennale. He went on to create site specific works like the eighty-foot high bronze *Spirit of Electricity* (1961) for Thorn House in Upper St Martin's Lane, a sculpture which illustrates the links and cross overs between sculpture and the applied arts in the early 1960s. Despite its great size it looks oddly like a piece of jewellery, as does Lynn Chadwick's much earlier sculpture *Inner Eye* (1952) in which a piece of uncut glass is held in a cage of forged and welded metal. Clarke adapted his skills as a sculptor in iron and aluminium to make a dramatic contribution to the silversmithing and metalwork at Coventry, creating the silver-gilt cross for the high altar (Fig. 393), further crosses for the interior and the exterior and a Crown of Thorns for the Chapel of the Servant (Fig. 394). He went on to execute a range of commissions in the early sixties for Walter Hussey, the art-loving Dean of Chichester Cathedral, including a pulpit clad in aluminium, altar rails and spiky sculptural candlesticks.[136] His work was full of personal intensity (Fig. 304), best exemplified by his prints of the early 1950s peopled with semi-abstract figures seeking spiritual resolution.[137] In the 1952 Venice Biennale catalogue Herbert Read had

300. (*opposite*) Gerald Benney, silver chalice with hole in knop, parcel-gilt in bowl, 1958, h.30.5 cm. (The Worshipful Company of Goldsmiths).

302. A carefully staged photograph of Louis Osman at work on the design of the investiture crown for the Prince of Wales, 1969. (Photo courtesy of the Worshipful Company of Goldsmiths).

written of the sculptures by Clarke and his co-exhibitors: 'These new images belong to the iconography of despair' and he went on to write of 'collective guilt', 'excoriated flesh' and 'the geometry of fear'.[138] Clarke's work appealed to his ecclesiastical patrons precisely because its 'iconography of despair' reflected the doubts and tensions that beset the Church of England in the 1950s and 1960s. Clarke hardly fits neatly into the world of silversmithing but, as designer and maker of ecclesiastical work, he was a dominant figure until the mid-1960s with a sculptural practice so successful that he owned a helicopter in order to fly from site to site.

Clarke and Osman belong at the fine art end of the silversmithing spectrum, but Robert Welch and David Mellor's combination of hand and design work was echoed in the careers of Brian Asquith and Keith Redfern. Asquith was a sculptor by training who designed for industry. By the 1960s he was also running a silversmithing workshop at Youlgrave in Derbyshire.[139] Redfern's silver for universities and other public bodies was underpinned by designs for Walker and Hall and Elkington. Good design in which form followed function was the general principle that informed domestic silver by Welch, Mellor, Asquith and Redfern. As Welch explains, working by hand in silver allows enormous freedom – which can degenerate into self indulgence. But experience with designing industrial products 'comes to the rescue, helping to establish the appropriate functional form'.[140]

But not all Royal College of Art graduates subscribed to this philosophy, even in the 1960s. The Australian Stuart Devlin graduated in 1960, spent a period in the United States practising sculpture, returned to Australia (where he designed the Australian decimal coinage) and in 1965 returned to Britain. Though his student work at the Royal College had consisted of exemplary simple forms, inspired by the best Scandinavian work, Devlin swiftly established a high profile by avoiding 'good design' in favour of extraordinary opulence (Fig. 305). He created 'Surprise Eggs' for Easter – reminiscent of the luxury offerings of Fabergé, the nineteenth-century Imperial Russian jewellers and goldsmiths – and 'Christmas Boxes', complete with artfully modelled figures and studded with precious stones, as well as domestic silver heavily enriched with textured surfaces and filigree work. By 1970 he employed seventeen craftsmen and six apprentices. He also produced a stream of publicity material arguing that the products of his workshop acted as a useful antidote to the depredations of Modernism: 'we have penetrated the artificial wall of functionalist dogma dispensed to us through most of the design schools and organisations…it is not wrong to derive pleasure from surprise, intrigue, humour, richness, craftsmanship'.[141]

By the end of the 1960s Benney, Devlin and the jeweller Andrew Grima had moved into a different league, posing an alternative to long established firms like Garrard & Company, the Crown jewellers. They had large numbers of employees, prestigious commissions and

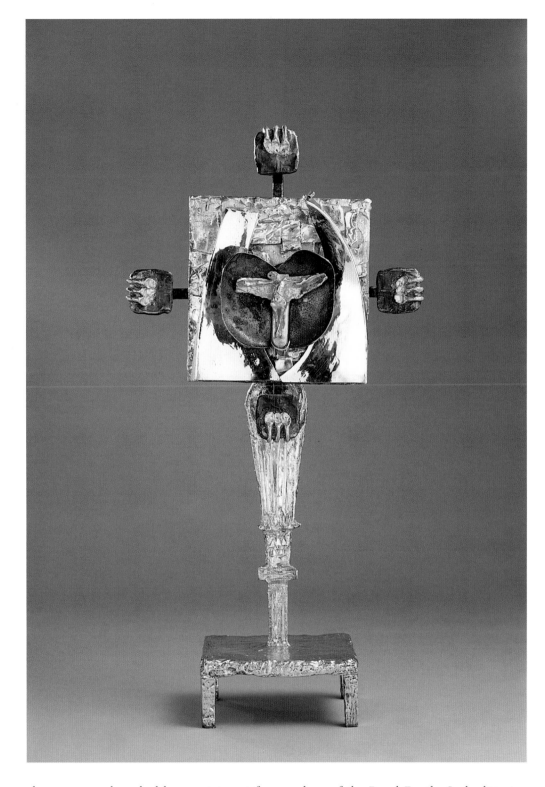

303. Louis Osman and Graham Sutherland, The Ely Cross, commissioned by the Dean and Chapter of Ely Cathedral in 1961 and rejected in 1964. Gold and silver, h. 108 cm, w. 55.9 cm. (Dallas Museum of Art, The Wendy and Emery Reves Collection).

showrooms and worked by appointment for members of the Royal Family. Such glittering figures did not exist in the other crafts, nor did their philosophies have much in common with the scraps of ideology which the crafts still clung to. Instead they looked back to the eighteenth century, when, as Benney explained, 'you went to your silversmith just as you went to your tailor'.[142]

Jewellery took a little time to catch up. In his 1955 update of Pevsner's *Industrial Art in England*, Michael Farr argued that the post-war mood did not favour high priced jewellery based on traditional models. He pointed out that the Modern Movement in architecture and industrial design had almost completely overlooked jewellery: 'in designing a brooch the modern designer obviously feels uneasy'.[143] Farr could only find two designers whose work seemed worthy of illustration and neither was British – Fritz Lampl was a Viennese writer and poet and refugee who started the Bimini Workshops in 1938 making glass jewellery (some in

304. Geoffrey Clarke, *Stations of the Cross*, 1958, iron, l. 221 cm. (Private Collection).

305. Stuart Devlin applying finishing touches to a handraised goblet. (Photo courtesy of the Worshipful Company of Goldsmiths).

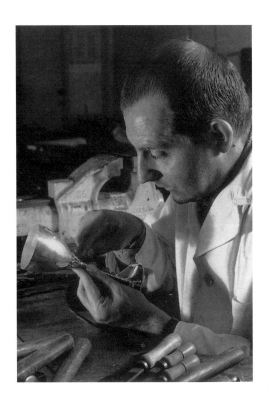

collaboration with Lucie Rie) – and the firm Georg Jensen Ltd was Danish. In the early 1950s, the Central School's Department of Silversmithing and Jewellery, transformed by the school's Principal William Johnstone, became the key training ground for adventurous jewellers. Gerda Flöckinger, who arrived at the Central in 1952, was one of the first post-war jewellers to respond to the new painterly and sculptural influences on offer. Her early work reveals her interest in the sculpture and jewellery of Alexander Calder, in Etruscan, Greek and Roman jewellery and in cell structures and micro photography (Figs 306, 307). She sedulously avoided learning traditional jewellery techniques and launched into a rediscovery of enamelling. Thus a typical piece made around 1956 combined wire sculpture, discrete cut-out shapes and a pendant enamelled with figures inspired by prehistoric cave paintings. She was a radical figure, who fitted uneasily into the conventional retailing of jewellery; in the early 1950s she showed at the Institute of Contemporary Art while cheaper pieces were sold in Mary Quant's shop Bazaar.[144]

But the limitations of the British jewellery scene in the 1950s were made plain in 1961 by a major exhibition organised by Goldsmiths' Hall and the V&A.[145] Some of the finest pieces were by painters and sculptors like Alan Davie and Mary Kessel, who had both taught at the Central School, and Kenneth Armitage, Elizabeth Frink, Terry Frost, Mary Kessel and Bernard Meadows (Fig. 308); these had been commissioned by Goldsmiths' jointly with the V&A especially for the exhibition.[146] The show was international in scope, but there were few interesting young British jewellers apart from Gerda Flöckinger and Gillian Packard and three jewellers who came to the fore in the 1960s – Andrew Grima, John Donald and David Thomas.

In 1960 a drastic reduction in purchase tax helped jewellers of all kinds and accounts for a new opulence in jewellery.[147] Rich surface finishes, organic shapes and uncut stones, mounted to reveal their crystalline structures, characterised the work of Grima, Donald and Thomas. Grima was a particularly high-profile figure.[148] His eye-catching shop in Jermyn Street in London's West End, embellished with a stone screen by the sculptor Bryan Kneale and a dramatic door made by Geoffrey Clarke, was opened by Lord Snowdon in 1966. Grima became the jeweller favoured by younger members of the royal family, who commissioned over 300 pieces, and by clients as various and glamorous as Ursula Andress and Edith Sitwell. A designer rather than a maker, Grima's dashingly accessible jewellery posed a fashionable alternative to the big jewellery houses.

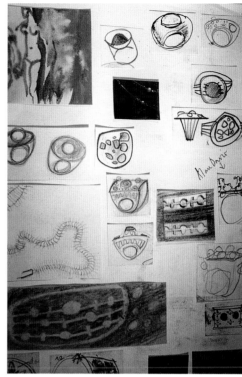

By the late 1960s Flöckinger's jewellery was also becoming more opulent, characterised by surfaces of melted metal and fused silver and gold wire set with large cabochon stones. Her new visual vocabulary – launched in her 1968 solo show at the Crafts Centre of Great Britain – had a good deal in common with a strand of decorative modernism exemplified by the early twentieth-century activities of the dress designer Paul Poiret, by the paintings of Henri Matisse and by the sets and costumes of the Ballets Russes.[149] This alternative, and necessarily more ephemeral, modernist tendency had made a subversive reappearance in the mid-1960s, fuelled by a surge of hedonistic consumerism which celebrated androgyny, the erotic and the ornamental. Flöckinger's late 1960s jewellery was at the heart of this revolt in style, similar in mood, for instance, to the posters designed by Michael English and Nigel Waymouth. Their draughtsmanship, characterised by an exquisite and rhythmic Beardsley-esque linearity, had a good deal in common with Flöckinger's own drawings of the period.[150] This new work dominated her 1971 show at the V&A shared with the glass artist Sam Herman. The catalogue of the show is of some interest. It was illustrated with Mark Hamilton's brooding, grainy black and white photographs. His images seemed like a critique of the 'normal' photography of jewellery which emphasised its reflective, bright and, not least, precious qualities (Fig. 309).[151]

By the 1960s Flöckinger was a less isolated figure. Helga Zahn arrived in England from Germany in 1957 to study at the Central School. By the mid-1960s she had evolved work that was a synthesis of sculptural influences from Henry Moore to Calder and marked by the use of found objects – stones, arrowheads and bones – in startlingly plain silver mounts (Fig. 310).[152] Two pupils of Flöckinger, Charlotte de Syllas and David Poston, began working with Surrealist flair in a range of unexpected materials (Figs 404, 426). Breon O'Casey, working in and around St Ives, developed the Celtic strain in Alan Davie's jewellery. He was joined in 1963 by Bryan Illsley. Both men were also painters; O'Casey went on to weave and Illsley was to develop into a maverick sculptor (Fig. 367).[153]

Ephemera and Pop values were celebrated by two graduates from the University of Reading, Wendy Ramshaw and David Watkins. They were to make their most majestic work in the 1970s but from 1965 until 1967 they launched a range in perspex under the name Optik Art Jewellery which made a light-hearted allusion to the art of Mondrian and Victor Vasarély. In 1967 they launched Something Special – brilliantly coloured paper jewellery purchased flat

306. Gerda Flöckinger, (l. to r.) ring, silver with an amethyst, 1955, 2 × 1.8 × 1.5 cm.; ring, silver with inlaid enamel, c. 1958, 2 × 2 × 1.6 cm. (The Worshipful Company of Goldsmiths).

307. Detail from a page of designs for rings from Gerda Flöckinger's notebooks, late 1950s. (Gerda Flöckinger).

308. Bernard Meadows, silver relief brooch, 1961. 5.7 × 5 cm. (The Worshipful Company of Goldsmiths).

309. Gerda Flöckinger, neckband, 1968, silver with gold, cultured pearls, cabochon garnet, amethysts, quartz, tourmalines, aquamarines, diameter 12 cm. (Photo Mark Hamilton).

310. Installation shot of Helga Zahn's retrospective at the Crafts Council in 1976 showing (top) pendant with collar, 1965, silver set with arrowhead and pebble, now Worshipful Company of Goldsmiths, (bottom) necklace, 1966–7, silver with black Cornish stones, now the Victoria & Albert Museum. (Photo John Donat).

311. Constance Howard, *Glass Bird*, 1945–6, appliqué polychrome embroidery, with sequins, beads and ric-rac, 48 × 41.5 cm. (The British Council Collection).

packed for self-assembly.[154] Rather more serious work, inspired by Constructivism and by mathematical sequences, was being made from the mid-1960s by Patricia Meyerowitz and Peter Hauffe.

TEXTILES

Embroidery

As we have seen, embroidery, framed and hung as 'embroidered pictures', represented a special kind of accessible modernism in the 1950s. Embroidery remained a highly gendered occupation as it had been throughout the nineteenth and early twentieth centuries, functioning as a personal, often private, creative medium for many women. It required little in the way of plant and equipment and the relevant skills were often acquired at an early age, ready to be utilised when the moment came. As the embroiderer Barbara Siedlecka recalled of growing up in the 1940s: 'I can't really remember how I learnt to sew in the first place, but I know my mother taught me, like learning to use a knife and fork I suppose.'[155] These gendered skills, passed on from mother to daughter, meant that women seeking careers in art colleges tended to be pushed into teaching embroidery whatever their gifts as fine artists. Segregation had its positive side; an embroidery class led by a powerful woman could create opportunities denied female students in the male dominated sculpture and painting departments. And as with ceramics, there could be 'more possibilities' in embroidery. It was a medium which lent itself to semi-abstraction and daring collage, in contrast with what Christine Risley, an early pupil

312. Margaret Kaye, *Lion*, c. 1945–6, appliqué polychrome embroidery, with fulled wool, velvet, organza, sequins and copper sheet, 48 × 58 cm. (The British Council Collection).

at Goldsmiths' College, remembered as the 'suffocating rigidity of 'reality' imposed by art school painting departments in the 1950s.[156]

At grassroots level, an important post-war initiative was the Needlework Development Scheme which had started in Scotland in 1934 and was revived and extended to cover the whole of Great Britain in 1945. Its aim was to improve design standards, both professional and amateur, by building up a study and lending collection and publishing booklets and bulletins. The scheme ran until 1961 and by the early 1950s was linked to art colleges, schools, youth clubs and women's organisations. The scheme brought in the painter Mary Kessel who collaborated with embroiderers at Bromley School of Art; drawings by Kessel and the resulting embroideries were toured in 1950 by the Arts Council. The scheme later commissioned other artists like Leonard Rosoman and Margaret Traherne and in 1957 put on 'Contemporary Needlework Design' which demonstrated the powerful influence of Swedish folk textiles in the 1950s, characterised by limited colour schemes and geometric stylisation of flower heads and birds.[157]

Within the world of art education the survival of embroidery depended on individual teachers at individual art schools. After the Second World War Constance Howard was a key figure (Fig. 311). As a student at Northampton School of Art and at the Royal College of Art[158]

she had embroidered in her spare time. In 1948 she began teaching the subject to trainee teachers at Goldsmiths' College and she began to see its potential as a live art school subject: 'They were good artists – painters, illustrators and sculptors – and we got a good standard very quickly. Technique is nothing really. You can learn that as you go along.'[159] As we have seen, Howard was to develop an adventurous embroidery course which was one of the few to be given Diploma in Art and Design status in the early 1960s.

By the mid-1950s Dora Billington, an ardent supporter of the new and fresh in the crafts, recognised this new spirit in embroidery. In an article in *The Studio* she singled out five women for discussion – Constance Howard, Margaret Kaye, Frances Richards, Christine Risley and Margaret Traherne. Billington reserved her greatest admiration for Margaret Kaye who also worked as a lithographer, a stained-glass artist and a designer for the ballet (Fig. 312). The spontaneity recommended so passionately by Rebecca Crompton before the war was evident in Kaye's work. So too was a rejection of skill as a virtue in itself. Kaye made no preliminary sketches and, as Billington pointed out, 'she also claims to know very little about embroidery.'[160] What Billington appreciated was Kaye's way of building up tones and half tones with pieces of scissored cloth held together by dramatic stitching. This she saw as painterly, indeed even outstripping painting in richness of colour.

Graphic art was another important source for the embroidery renaissance, in particular School of Paris book illustration. Frances Richards, wife of the painter Ceri Richards, was principally an illustrator and painter whose remarkable embroideries of the 1940s and 1950s – panels like *Hieratic Head* of the late 1950s (Fig. 313) – were influenced by Matisse's graphic work. For a panel inspired by Rimbaud's *Les Illuminations* she created in appliqué what looked like the pages or leaves of a book on which she stitched attenuated spare figures and snatches of text.[161] All Frances Richards's pieces were worked by hand using the simplest stitching while Christine Risley was a brilliant exponent of machine stitching. Her work of the 1950s and 1960s was richly fanciful with roots in surrealism and in English popular art. Machine embroidery, a subject on which Risley published several books, did much to alter the painstaking image of embroidery. To Risley it seemed disciplined 'but swift'.[162] Machine embroidery also proved the ideal technique for Margaret Traherne who used it with scissored black appliqué, to create heavy outlines reminiscent of the lead lines in her other favoured medium, stained glass (Fig. 256). But Traherne also employed the sewing machine as a sensitive graphic tool, as in the vigorously 'drawn' *Mother and Child* of the 1950s, now in the Victoria & Albert Museum.

Margaret Traherne was one of a number of artists, working in various media, who helped invigorate ecclesiastical art after the war. Another was Beryl Dean, an embroiderer who had trained at the Royal School of Needlework between 1929 and 1932. In 1958 she set up an ecclesiastical embroidery class at Hammersmith College of Art and Building and published a series of books on the subject. Dean was able to invest Christian symbols like the chi-rho with new vigour and her sources are set out in her remarkable introduction to her *Ideas for Church Embroidery* (1968). This took the form of a modernist visual primer which included micro- and stroboscopic photography, prints and graphics by Matisse and Picasso, pueblo pots and paintings by Mondrian. Dean also included a contribution from Dr Gilbert Cope, a prime mover in the 1960s Liturgical Movement, who urged that ecclesiastical embroiderers throw caution to the winds: 'They should feel under no obligation to use traditional symbols which are obscure, trite or currently meaningless…Nothing should be taken for granted and all assumptions should be questioned.'[163]

Was embroidery a feminist issue? The embroiderers of the 1950s and 1960s were more concerned to position embroidery within the fine art world than to make work which commented on gender. Fine art ambitions informed two societies set up at that time – the Sixty Two Group (1962) and the New Embroidery Group (1968). Feminist ambitions (which implied separatism rather than a desire to integrate with the male dominated fine art world) remained veiled in startling pieces like Lila Speir's haunting *Bird Woman* of the mid-1950s.[164] Not until the 1970s and 1980s do we find a consciously articulated and theorised feminism using embroidery as a means of expression.

313. Frances Richards, *Hieratic Head*, appliqué embroidery, 1950s. 54.5 × 49 cm. (Private Collection. Photo David Cripps)

Weaving, tapestry, construction

Ethel Mairet died in 1952 but her pupils found that shortages of good industrially produced textiles meant that some large scale architectural commissions went to handweavers rather than to industry. Hilary Bourne, who worked in partnership with Barbara Allen, had learnt weaving, spinning and dyeing in Palestine and had worked experimentally with Mairet from 1944 until 1945. Like Mairet she was a natural modernist and she was commissioned to make heavy reversible vegetable dyed fabrics for the meeting-room and the restaurant in the Royal Festival Hall (Fig. 314). Her open weave cloths with untarnishable thread were commissioned for modern interiors in London Airport, Potters Bar Comprehensive School and for passenger seating for the British Overseas Aircraft Corporation.[165] The new schools being built also provided imaginative patronage for textile artists. Another former pupil of Mairet's, Barbara Sawyer, made cellophane table mats and wove rugs for schools while, as we have seen, the designer Gerald Holtom created illustrational bespoke appliqué stage curtains for school assembly halls.

In the late 1940s the Arts Council, whose few craft interventions were strikingly influential because of their imaginative focus on developments in Europe, took a particular interest in tapestry, with the aim of encouraging it as a public art. In 1946 they staged an exhibition of work by the French tapestry designer Jean Lurçat, the originator of a modern movement in French tapestry. Two further French tapestry shows were put on in 1947 and 1949. The last of these shows, *Modern French Tapestries*, at the Victoria & Albert Museum made a deep impression on a young Polish painter Tadek Beutlich,[166] who abandoned his painterly ambitions and went

314. Hilary Bourne, curtains for the meeting room, Royal Festival Hall, 1951. (*Architectural Review*).

315. Tadek Beutlich seated before his tapestry *Harlequins and Birds*, c.1960. (Murray Fieldhouse).

to Camberwell to learn weaving from Barbara Sawyer, a key disseminator of Mairet's beliefs in the adventurous use of yarns. Beutlich's tapestries differed from their French counterparts in that he both designed and wove them single-handed. They were figurative, taking inspiration from folk art and continental modernism. *The Snowbird* (1957) could almost be an illustration to a folk tale while *Harlequins and Birds* (1962) was clearly influenced by Lurçat (Fig. 315). Gordon Crook was another artist tapestry maker who taught textiles at the Central School. He was a potter and painter who dyed his own wool and wove small tapestries which revealed an intimacy with School of Paris painting, particularly Braque's figurative work from the late 1920s onwards.[167]

Peter Collingwood was an exact contemporary of Beutlich but with a rather different background. He had qualified as a doctor and discovered weaving while working for the Red Cross in Palestine. A rigorous apprenticeship with Mairet from 1950 to 1951 was followed by periods working with Barbara Sawyer, and, as we have seen, with Alastair Morton who designed odd interesting warps for Collingwood to weave experimentally. In Morton, Collingwood found a role model: 'He showed me how the technical approach to weaving, so often the dominant one in a male weaver, can be linked to the aesthetic.'[168] Collingwood touched on an interesting point. Hilary Bourne's dismissive conclusion: 'men weave like machines', was exemplified by the technical perfection of the work of the Ditchling weaver Valentine KilBride.[169] Collingwood synthesised Mairet and Morton's influences, combining technical perfection with artistic innovation.

Collingwood soon developed a clear vision of what handweaving should aim for and from 1953 his ideas began appearing in the *Journal of the Guild of Weavers, Spinners and Dyers*, a broad church for textile artists, as it had been before the war. Some of Collingwood's values clearly derived from Mairet — for instance that it was pointless to do weaves that could be effectively accomplished on a power loom. He differentiated between what he termed 'craftsman weavers' (a reservoir of sound knowledge) and the 'artist weaver' — who would be 'alive to contemporary trends in fashion, decoration, painting and all the arts'.[170] His ideas were backed up by another lively subversive voice on the *Journal*. Ann Sutton was a designer of printed textiles, and a weaver and an embroiderer, then running a textile course at West Sussex College of Art. Her first contribution to the *Journal* in 1960 was a spirited plea for self criticism by weavers — 'nobody but a fellow weaver will ever know the agony and sweat which

went into a hand-spun from genuine Southdown, crottle-dyed dress length. So why bother?'[171] Collingwood, who by 1955 had an editorial role on the *Journal*, recommended a clutch of Scandinavian magazines to broaden the kind of exclusively craft-based outlook which Sutton deplored – *Kontor*, *Form*, *Ornamo*, *Kunsthandwerk* and above all the Italian *Domus*.

Collingwood was determined to survive as a full-time handweaver. This led him to experiment with techniques that allowed swiftness and economy of effort. For a series of large wall hangings, for instance, time and money precluded true tapestry techniques (Fig. 316).[172] The economic need to weave quickly was also appreciated by Theo Moorman. After the war she decided to concentrate on her handweaving and by 1956, as she explained in the Guild's *Journal*, she had developed 'an effect akin to tapestry weaving by a much quicker method'.[173] This, soon known as the 'Moorman Technique', had a cloth structure with two warps, one which could be woven swiftly with a shuttle, the other to carry inlay designs. At first Moorman felt unconfident about her design talents and collaborated with Austin Wright, a Yorkshire sculptor. But she soon found her own voice, going straight to the best of twentieth-century modernism, to Klee, Moore, Hepworth, Ben Nicholson, de Stael and Kandinsky for inspiration.[174] Her handsome *Dark Form* (Fig. 317) of the early 1960s (in which organic forms are transmuted into an abstract composition) shows the effect of these influences.

By the 1960s hand-spun, hand-dyed, hand-woven dress lengths seemed an anachronism as studio weaving moved sharply away from utility. In Eastern Europe, above all in Poland, the craft had received generous state support. The Polish contribution to the First Lausanne Biennale in 1962, especially the majestic hangings by Magdalena Abakanowicz, had suggested new possibilities of scale and of adventurous use of materials.[175] Another catalyst was the V&A exhibition *Modern American Wall Hangings* which was toured by the Circulation Department from 1961 to 1963 and had an impact on weavers comparable to British painters' responses to the 1956 Tate Gallery exhibition *Modern Art in the United States*.[176]

The sheer scale of the work and the daring use of unorthodox materials by Polish and American weavers had an immediate influence in Britain. Peter Collingwood visited the

316. Peter Collingwood, hanging for the National and Grinlay Bank made up of seven joined pieces using the switch-shafting technique, 1967, 183 × 640.5 cm. (Photo John Arthur).

317. Theo Moorman, *Dark Form*, early 1960s, woven linen and cotton, 134 × 59 cm. (N.F. Large).

United States in 1963, teaching and meeting weavers. He found much to admire. A piece like Leonore Tawney's *The Flame* made with linen thread disciplined with curved brass rods and folded brass and steel ribbon was an undoubted influence.[177] By the end of 1963 he had made a comparable 3D hanging in linen, brass and wire using the sprang technique.[178] By 1964 he created his first macrogauze wall hanging. These were quick to weave and generated an ongoing series which held the attention because of the tension between the ambiguity of their structure and Collingwood's logical use of mathematical sequences (Fig. 318).

Collingwood's *Macrogauze 1* was shown in the 1965–7 *Weaving for Walls*, another V&A touring exhibition organised in association with the Guild of Weavers, Spinners and Dyers.[179] This took a determinedly fine art direction, revealing the powerful influence of *Modern American Wall Hangings*. All the weavers involved pushed their art to its limits. Sutton, Beutlich, Moorman and Collingwood went furthest. Peter Glenn, one of the V&A curators, argued that Ann Sutton's *Sunspot* 'could well be a modern abstract painting'.[180] And many pieces went beyond painterly effects. At the time of *Weaving for Walls* Sutton first met the sculptors Kenneth and Mary Martin at the Barry Summer School. Their influence was evident in her *Pendant 10*, more mobile than weaving, incorporating sequences of plastic tubing, 'machine-sculpted' blocks of wood and mirrors inserted into an admittedly handwoven double cloth.[181] Theo Moorman also submitted radical work to *Weaving for Walls* in the form of two pieces which she called Space tapestries.[182] This three-dimensional approach was developed in *The Crucifixion*, an odd, ambitious piece made of discrete tapestry banners for Agnes Stewart School in Leeds in 1967. Tadek Beutlich was similarly adventurous; his *Moon* was a transparent linen and ramie wall hanging which incorporated all kinds of 'found' materials – charred wood, x-ray film and honesty seeds (Fig. 319).

By the mid-1960s Beutlich, Collingwood and Sutton in particular were aware of each other's work and conscious that they represented a new ambitiousness in textiles.[183] Collingwood's work developed steadily and inventively, exploring all the possibilities thrown up by altering and adapting handlooms, creating macrogauzes, rugs and abstract strip woven hangings. Architects and designers instinctively admired the logic of his work and examples were commissioned for all kinds of interiors from offices to conference centres. A comparison can be made with the work of Hans Coper, with whom in 1969 Collingwood shared an exhibition at the V&A (Fig. 320). In the catalogue Collingwood noted: 'Whose hand throws the shuttle is often immaterial; what are vital are the weaver's decisions as he controls the semi-mechanical process.'[184] Both Coper and Collingwood were handworkers but their pots and weavings had a coolly rational look and developed formal ideas in elegant sequences. Collingwood's inclusion in the 1965 Design Council show *Hand and Machine* which, as we have seen, examined the crafts' relevance to industrial design, is suggestive. Collingwood never designed for industry, but because his system of work depended on retooling his loom rather than on the actual act of making, his work hints at industrial possibilities on the brink of being realised.

Like Collingwood, Ann Sutton was interested in weave structures, Since 1964 she had been living and working with her husband, the furniture maker John Makepeace, at Farnborough Barn near Banbury. Their more adventurous work was subsidised by contract furnishing and a well-run showroom selling a range of mirrors, bowls, platters and coffee tables made by Makepeace, and ties, cushions and Welsh blankets designed and made by Sutton and a group of outworkers.[185] In 1969 Sutton had acquired a stocking knitting machine and used knitted tube to develop three-dimensional pieces in which the tubes enclosed and held glass discs, cylinders, bowls and sections of mirror.[186] In other pieces these tubes were stuffed with material and used to create giant knitted structures. Nylon monofilament was 'woven' on and around perspex sheets and cylinders (Fig. 321). In most cases the weave sequences were dictated by 'Number: systems, chance or random' and 'Structure: basically textile, known or invented, using textile substances (yarns, filaments, wires)'.[187] As Peter Collingwood pointed out in an admiring review – these avant-garde weavers were driven to reviewing each other for want of understanding art critics – Sutton's work represented such a 'new venture'[188] that

318. Peter Collingwood, *Macrogauze 33*, black linen and steel rod, shown at the exhibition *Coper/Collingwood*, Victoria & Albert Museum 1969, 155 × 101.6 cm. (Peter Collingwood).

there was little with which to compare it. Sutton knew that she was making 'textile constructions', working in the spirit of the Martins, and in 1971 she issued a rebuke to imitators: 'the term has been used by people who have never even heard of constructionism, let alone practised it. Haphazard, arbitrary pieces of knotting etc., do not qualify strictly as Textile Constructions.'[189]

Tadek Beutlich moved in a different direction. In 1962 he had started a workshop with fourteen girl assistants making *ryijy* rugs to his design in Malta. In his one-off pieces Beutlich was increasingly attracted to an expressive use of raw materials. In 1967 he moved into Ethel Mairet's former house and workshops at Ditchling and started weaving on a large scale with sisal and jute, using yarns that were often three to five inches in diameter. The resultant hangings were clearly influenced by the work of fellow Pole Magdalena Abakanowicz, who in 1966 had her British show at the Grabowski Gallery. Beutlich also exhibited there, and his large pieces had an overwhelming presence which was very different from the cool rationality of Collingwood's work. Some hangings, like *Archangel* of 1969, looked frankly sexual, perhaps proving too powerful for British sensibilities. They were most admired in the United States.[190] In 1974 Beutlich moved to Spain, feeling excluded by the British weaving and art world. There

his extraordinary inventiveness flowered anew, as he created what he called 'free warp' weaving, only using the local esparto grass and brightly coloured threads woven or wrapped without any weaving equipment.[191]

Beutlich had his disciples. Kathleen McFarlane learnt to weave in Norway in the early 1950s. Living in Newcastle-on-Tyne, she took in Basic Design principles as a part-time student at Newcastle University. In 1964 she moved to Norwich, became interested in abstract expressionism, read Tadek Beutlich's highly imaginative *The Technique of Tapestry Weaving* (1967) and at the start of the 1970s saw the work of Abakanowicz at the Stedelijk Museum in Amsterdam. Her weaving was transformed. Like Beutlich she began to use one of Abakanowicz's most disturbing motifs in her wall hangings, a central vertical gash, a furred and labial opening that conjured up thoughts of sexuality and parturition.[192]

The traditional tapestry weaving which Beutlich had abandoned was kept alive as an art form at the Edinburgh Tapestry Company's Dovecot Studios under the continuing patronage of the Bute family.[193] Before the war the Dovecot had existed to produce monumental tapestries for the fourth Marquess of Bute, but from 1946 it was decided to offer work for sale, mainly smaller panels designed by British artists. Despite this sensible step, the Dovecot

321. Ann Sutton, *Bristle Box*, 1969, perspex and nylon monofilament. The weave structure is determined by a numerical system of chance. (Ann Sutton).

went through a difficult phase until it was bought by John Noble of Ardkinglas and Harry Jefferson Barnes, later director of Glasgow School of Art. From 1954 until 1958 Sax Shaw was artistic director, contributing many of his own designs, heavily influenced by French tapestry and School of Paris painting.[194] In 1963 the Edinburgh Tapestry Company became a major artistic force under the directorship of Archie Brennan. Brennan had joined as an apprentice in 1947, had studied in France in 1956–8 and in 1962 had set up a tapestry department at Edinburgh College of Art. He brought a new vision to tapestry weaving, building up unusually creative collaborative relations with artists like Harold Cohen, Eduardo Paolozzi and Elizabeth Blackadder, culminating in the 1970s with a series woven for American dealer Gloria Ross based on work by leading American painters like Robert Motherwell and Helen Frankenthaler.

Brennan took this interaction with fine art a step further. Three-dimensional wall hangings, with their organic tangles of jute and sisal, represented an exaggerated 'truth to materials' of a kind that no inter-war weaver could possibly have envisaged. Analogies – to do with boldness, directness and scale – can be made with American Abstract Expressionism. But by the late 1960s, 'fine-art weaving' or 'fibre art' bore little relation to concurrent 1960s movements in painting, led by a third wave of Pop artists emerging from art schools in the early 1960s. By the late 1960s Brennan, who had designed spirited Lurçat-like tapestries in the early 1960s, started tapping into Pop for his inspiration. Some of his tapestries, for instance *My Victorian Aunt who really knew a thing or two* (1968), mixed nostalgia and irony. Other examples like his *Mohammed Ali* (1973) (Fig. 322) depended on a tension between an old technique (high loom weaving) and an ephemeral electronic image. Brennan's approach, comparable to Roy Lichtenstein's painstaking translation of comic strip into majestically scaled paintings, at a stroke took tapestry out of the closed world of fibre art.

The influence of Brennan's wit, coupled with his belief in the discipline of true tapestry weaving,[195] was central to the dandyish craft movement of the 1970s, surfacing in tapestries by Joanna Buxton, whom he taught at the Royal College of Art, and by Candace Bahouth. Maureen Hodge had been one of Brennan's pupils at Edinburgh College of Art and she went on to work at Dovecot in 1964 until 1973 when she became head of the weaving department at Edinburgh College of Art. Her large ambitious weaving *Underwood IV* had been included in the 1965 Lausanne Biennale. In 1970 she made *From the tower whilst half awake he answers*, a

three-dimensional piece and the first in an eccentric 'tent' series. With its tassels, plaiting and bells and woven text, it effectively captures the lyrical nostalgic aspects of hippy counter-culture while simultaneously displaying a whole range of textile skills.[196]

Hand block-printed textiles, tie and resist dyeing

Hand block-printed textiles had been among the most admired design achievements between the wars. Neither Phyllis Barron nor Dorothy Larcher resumed the craft in 1945. Joyce Clissold did carry on the hand block-printing business Footprints from her home in Brentford, Middlesex but her work lacked Barron and Larcher's subtle handling of designs and dyes.[197] From the late 1950s the painter Peggy Angus printed her bold tile designs, made in the 1950s for Carters of Poole, as linocut wallpapers and some fabrics but these only circulated among a tiny group of friends and admirers (Fig. 323).[198] Hand block-printing as a technique was largely eclipsed by screen-printing as an experimental process for short runs and innovative work – even though Terence Conran (in a perceptive guide to textiles published in 1957) recommended experiments with block-printing (using potato cuts and lino blocks) for budding designers.[199]

The outstanding post-war hand block-printer, Susan Bosence, was directly inspired by Barron and Larcher's pre-war work. She and her husband were part of the community at Dartington Hall and her first efforts were directly inspired by Dorothy Elmhirst's collection of Barron and Larcher textiles. In 1950 she visited the two women and, as her workshop developed, she had many discussions with Barron about dyestuffs, also taking advice from Muriel Rose, by then working as craft officer at the British Council.[200] Unlike Barron and Larcher she had had no training as an artist, though she emerged as a natural abstract pattern maker, employing a deceptively simple vocabulary of spots and stripes. Her textiles look like a minimalist version of the best inter-war block prints (Fig. 324). Bosence never produced work in commercial quantities, partly because her techniques also included stitch and wax resist dyeing as well as block printing. Barron found her approach unworldly, pointing out: 'I can only say that I feel your very slow methods of wax and paste resists, all put on by hand, (are) much more laborious than printing, and must make very high costs.'[201]

Bosence's use of tie and dye was characterised by exquisiteness but in the 1960s the

322. Archie Brennan, *Mohammed Ali*, 1973, high loom tapestry, 91.4 × 152.4 cm. (Edinburgh Tapestry Company).

323. Peggy Angus, *Sun and Moon*, hand block-printed wallpaper from block cut in the early 1960s.

324. Susan Bosence's exhibition at the Tea Centre, Regent's Street, 1961. (Photo John Donat).

325. Michael O'Connell, batik hanging in a canteen, 1950s. (Rural History Centre, University of Reading).

technique was used in a much cruder popular form to customise, and to give a counter-culture look, to T-Shirts and other mass-produced clothing. But there were practitioners of tie and dye of a higher quality. For instance Anne Maile made panels and collages in the 1960s and in 1963 published *Tie-and-dye as a Present-day Craft*, a text, incidentally, highly recommended in *The Last (updated) Whole Earth Catalog*. Batik was another marginal dye technique which had had a certain acclaim in the 1920s and 1930s as part of a generalised interest in the Far East and the arts and crafts of Java. Marion Dorn designed and made batik panels from 1925.[202] E.O. Hoppé was another exponent at that date as was E.Q. Nicholson who in 1926 spent six months learning the art in Paris.[203] But it was Michael O'Connell[204] who revived public interest in batik after the Second World War. O'Connell had emigrated to Australia in 1920, where he established a career as an artist and craftsman before returning in the mid-1930s. Just before the war his lino block prints were bought by Heal's and in the early 1950s he designed fabrics for Heal's using lino blocks and wax resist. He used sophisticated free-hand drawing in paste resists and he developed this technique to produce a stream of hangings in the 1950s and 1960s. Exhibitions at Heal's Mansard Gallery included hand printed curtains for 'industrial canteen and small theatres' (Fig. 325) and hangings loosely based on traditional pub signs and church brasses.[205] Stylistically he was influenced by folk art, African textiles and, as with the Central School potters of the 1950s, by the blithest, most arcadian examples of School of Paris painting, in particular Picasso's wartime murals made at Antibes. As Peter Floud recognised, O'Connell wanted his wall hangings to function as an affordable alternative to monumental tapestry, intended for village halls, schools, workplaces and restaurants.[206] They were, therefore, striking examples of the move from private to public patronage of the crafts after the war (Figs 260, 370, 371).

Despite the popularity of batik, virtually the only other adventurous exponent was Noel Dyrenforth, who saw the work of O'Connell at Heal's in 1962.[207] By 1965 he was successfully exhibiting batik panels and selling batik silk dresses, operating in both the fashion and craft world. Like the potter Anthony Hepburn, with whom he exhibited at the British Crafts Centre in 1969, Dyrenforth tapped into some of the quintessential imagery of the 1960s – the psychedelic effects of clubland lighting devices, the science-fiction inspired axonometric drawings of the Archigram Group led by Peter Cook and Ron Herron and Paolozzi's *As is When* sequence of silk screen prints. Dyrenforth offered a suggestive description of his work in an off-the-cuff 1967 interview in *The Times*: 'It's as though it is a painting. Everything is exclusive

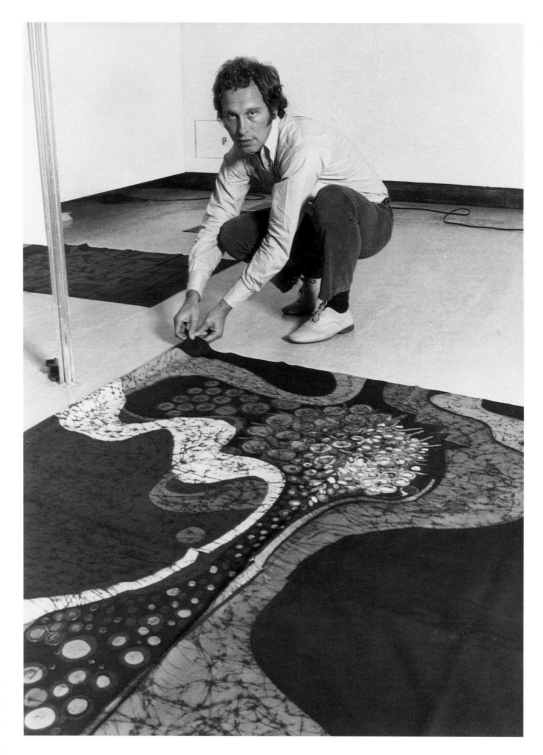

326. Noel Dyrenforth preparing to hang his exhibition at the Commonwealth Institute Art Gallery, 1967. (Noel Dyrenforth).

327. Sydney Cockerell using his 'ram' to impress Joan Rix Tebbutt's design on vellum, 1981. (Photo Phil Sayer).

and cannot be repeated. It is a laborious process which takes a long time to master.'[208] Personable and enthusiastic, Dyrenforth combined counter-culture imagery with sound craftsmanship and 'exclusivity' (Fig. 326).

BOOKBINDING

In 1949 the Arts Council staged an exhibition of modern English and French bindings. Like French tapestry, French bindings were seen to provide a model for developments in Britain. In his introduction Philip James, the first director of the Arts Council, suggested that all was not well with contemporary bookbinding, which he argued had not developed after its Arts and Crafts revival by T. J. Cobden-Sanderson. James identified only three innovative inter-war British figures, the artist Charles Ricketts who designed plain geometrical bindings, Sybil Pye who was self taught but who evolved a bold modern style of her own influenced by cubism, and George Fisher who created bindings at the Gregynog Press both to his own designs and

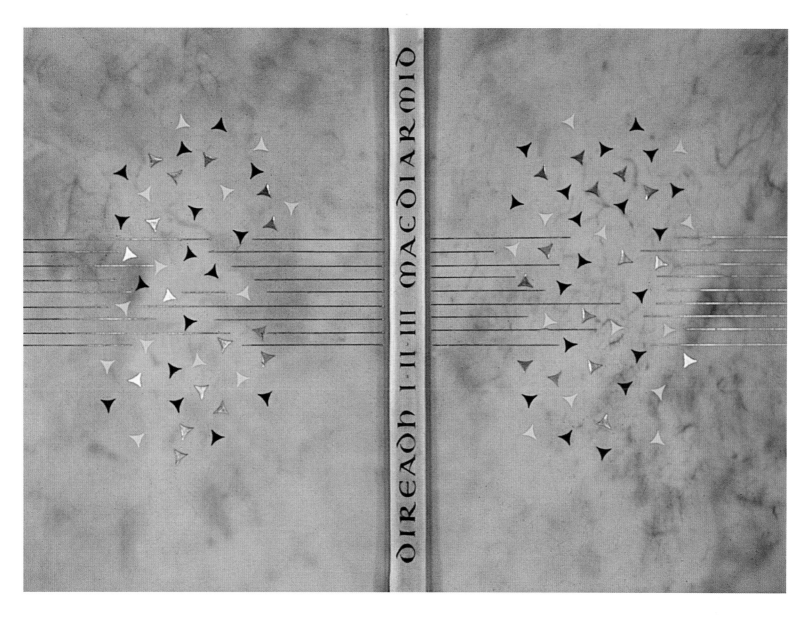

those by Blair Hughes-Stanton and William McCance.[209] In marked contrast, French binders like Pierre Legrain and Paul Bonet had drawn inspiration from a whole range of modern movements in painting, ranging from Fauvism to Cubism to Surrealism. They flourished under a highly evolved system of patronage, centred on *éditions de luxe*, which brought together artist illustrators, poets and binders. What was needed, argued James, was a school of British binders who would work in 'a style which springs from contemporary art forms.'[210]

But English binding had its strengths. Figures like Sydney 'Sandy' Cockerell and his sometime partner Roger Powell, whom James would have dismissed as part of the Cobden-Sanderson 'tradition', emerged as leading figures in the conservation and repair of books and as leading teachers of the craft. Powell's magisterial work on the Book of Kells followed by the Books of Durrow, Armagh and Dimma in the 1950s set a new standard in conservation and in simplicity and reticence of binding.[211] Sydney Cockerell was a superb technician who went beyond the principles laid down by his father because of the genius of his co-designer, the calligrapher Joan Rix Tebbutt. From 1947 onwards they produced a stream of memorable bindings (Fig. 328), the most interesting using plain vellum simply embellished with black lettering penned on the spine by Tebbutt, others decorated with gilt tooling, black ink and sans-serif type faces impressed into the vellum, using one of Cockerell's many inventions, a heating element attached to an old Adana printing press. In the 1950s Cockerell perfected his 'ram', a pneumatic press which enabled him to strike intaglio designs by applying pressure to areas of vellum (Fig. 327).[212]

Nonetheless, a school of binders conscious of developments in modern art only properly

328. Joan Rix Tebbutt and Sydney Cockerell, binding of Hugh Macdiarmid, *Direadh I–III*, toned calf vellum, coloured foils with black brush lettering, signed and dated 1977. 28.8 × 18.5 × 2.5cm. (K.D. Duval and Colin Hamilton).

329. Edgar Mansfield, 1958 binding of H.E. Bates, *Through the Woods*, goatskin, inlaid blues, greens, red and yellow, blind tooling, 26.9 × 20.2 cm. (Keatley Trust. Photo James Austin, Cambridge).

330. Ivor Robinson, 1969 binding of *The Wreck of the Deutschland*, black goatskin, gold tooled with beige, purple and black onlays, 18.5 × 41.2 cm. (Keatley Trust. Photo James Austin, Cambridge).

emerged after the 1949 Arts Council exhibition. The 1950s and 1960s saw a renaissance in bindings, comparable to post-war developments in ceramics, silversmithing and jewellery. An initial emphasis on expressive finishing shifted, in the 1960s, to structure and an increased attentiveness to the text of the book to be bound. The key figure in this renaissance was Edgar Mansfield who in 1949 became Lecturer in Design at the London College of Printing.

Mansfield had grown up and trained as an artist in New Zealand, coming to England in 1934 to study pottery at Camberwell, binding with William Matthews at the Central School and woodblock-printing at Goldsmiths' College. In 1936 he attended a course at the Reimann School of Industrial Design, staffed by practising designers who had fled Berlin in 1935, which opened his eyes to modern European art.[213] By 1937 Mansfield had abandoned traditional borders and axes in favour of stark geometrical tooling and onlays strongly influenced by modernism in architecture. Significantly, two especially fine bindings of this period were R.A. Duncan's *The Architecture of the New Era* and Paul Nash's *Room and Book*. He was influenced by the Continental bindings which he had studied and, as he explained in 1951, by 'modern

331. Jeff Clements, 1975 binding of
T.E. Lawrence, *Men in Print*, red brown goatskin
inlaid with cream, black and grey, blind tooling,
25.8 × 19.5 cm. (Keatley Trust. Photo James
Austin, Cambridge).

painters, especially in abstract art'.[214] By 1948 Mansfield began to use the grain of leathers as
an expressive medium and created a whole new language of tooling based on scattered abstract
mark-making inspired by his heroes Hans Arp, Paul Klee and Joan Miró.

There was an irony at the heart of Mansfield's approach. Strong organic abstract shapes
were relatively easily created using leather inlays and onlays but his fondness for a dancing
Klee-like line demanded handmade finishing tools, above all a great range of gouges filed to
perfect curves (Fig. 329).[215] An enormous amount of time and effort went into laboriously
tooling onto leather or vellum what looked like spontaneous drawing reminiscent of the
calligraphic scribbles of Mark Tobey or Jackson Pollock. In 1958 an article by Mansfield in *The
Studio* set out his ideals. In 'Bookbinding Design: the Contemporary Approach' he argued for
a kind of binding which embodied what he called 'expressive design'. This went beyond
traditional decoration in that it attempted to express the content of a book, not in a figurative
fashion but through 'line, area, texture, tone and colour'.[216] This was, of course, the language
of Basic Design, which, as we saw in Chapter Seven, provided new sources of inspiration for
virtually all the crafts in the 1950s.

Mansfield's influence on binding – his boldly abstract use of inlay, his fondness for a
wandering line, and his abandonment of symmetry and rectangular framing – was apparent by
the late 1950s. Ivor Robinson taught at the London College of Printing from 1953 until 1958,
having hitherto worked exclusively in the trade. Contact with Mansfield led him to take up
painting and drawing and acquaint himself with movements in modern art. Thus bindings like
his 1958 Lucien Laurens *Dialogues* use blocks of inlay to quote the late Cubism of Picasso, Gris
and Léger, while his late 1960s bindings with their remarkable gold tooling reveal a personal
response to the possibilities of abstraction (Fig. 330).[217] Trevor Jones,[218] who met Mansfield in
1955, and Jeff Clements (Fig. 331) were similarly inspired by Mansfield. Both developed a
language inspired by abstraction in painting using bold areas of inlay.[219] Expressive
bookbinding was a term which also describes the work of Anthony Cains – whose use of
puckered leather had been pioneered by Mansfield – and of Sally Lou Smith. Elizabeth
Greenhill belonged to a different generation and came late to original bindings, having worked
in the 1930s primarily as a restorer. But at the end of the 1950s, perhaps enlivened by this new
spirit in binding, she started creating original expressive work which owed little to Mansfield
and more to her training back in the 1920s under Pierre Legrain in Paris.[220]

Two quite unconnected events provided a focus for the development of post-war
bookbinding. Firstly, from 1955 the artistic end of the craft had its own society, the Guild of
Contemporary Bookbinders (in 1968 renamed Designer Bookbinders), with Mansfield as

332. Faith Shannon, 1973 binding of George Maw, *The Genus Crocus*, 1886, dark green Italian morocco leather, painted vellum, shatter-proof glass, gold tooling, 31.7 × 25 cm. (Hornby Library, Liverpool. Photo Tony Evans).

333. Detail of Faith Shannon, 1973 binding of George Maw, *The Genus Crocus*, 1886, showing the iris/eye/crocii watercolour on vellum coverd by a glass lens. (Hornby Library, Liverpool. Photo Tony Evans).

President.[221] The Guild held regular exhibitions and intermittently ran a magazine. As the craft became more experimental, and bindings became more *outré* and expensive, the society's exhibitions became a vital link with potential patrons. Secondly, in 1966 the floods in Florence, and the consequent involvement of so many British bookbinders in restoration work, gave the discipline a new inspiration. Some of the earliest printed books in the Biblioteca Nazionale had limp bindings and unusual sewing structures in which no adhesives were used. Mansfield had paid little attention to the structure of books, but the binders who had worked in Florence in 1966 were to develop this interest in the 1970s and 1980s.

One of the young binders who volunteered to work in Florence was Faith Shannon.[222] She had been encouraged as a student by Edgar Mansfield, had spent a scholarship year in London attending classes at Camberwell, the Central School and the London College of Printing, followed by teachers' training at Goldsmiths' College and three years at the Royal College of Art (1960–3). By the late 1960s she began to take Mansfield's expressiveness in a new direction. Her bindings were heterodox in the extreme, each a personal response to the text,

using her remarkable repertoire of skills as a miniature painter, as a botanical illustrator and embroiderer. Shannon belongs perhaps to the story of the 1970s and 1980s but her mature style, with its heightened almost hallucinogenic realism, was already signalled in her 1970 treatment of Siegfried Sassoon's *Something about Myself*, bound in brown velvet with a sunk glass lens covering an exquisite vellum portrait of a boy, and her *Genus Crocus* of 1973 in which a lens protects a surreal crocus-sprouting human eye painted on vellum (Figs 332, 333).

The other innovative binder of the late 1960s, Philip Smith, might be regarded as Mansfield's heir as regards expressiveness and ambitiousness for the artistic status of bookbinding.[223] Smith trained at the Royal College of Art from 1951 until 1954 and his earliest bindings reveal the influence of his tutor Peter Waters. Smith spent from 1957 until 1960 at Sandy Cockerell's bindery, and in 1966–7 he was part of the British Library team in Florence. His greatest strength was as a daring colourist, able to create the sensual impact of brush work and impasto using fragments of leather. These 'feathered onlays' (a term invented by the book dealer Bryan Maggs) were developed into a technique Smith was to call 'Maril', taken from the name Silmaril, a character in J.R. Tolkien's *Lord of the Rings*, but happily also an acronym for MARbled Inlaid Leather. Technically Smith was endlessly inventive but equally important was his passionate desire to make 'art objects'.[224] This was apotheosised in the first of his 'bookwalls' of 1968–9 consisting of seven sets of the three volume edition of *Lord of the Rings*. These were arranged with front and back covers *en face* in a double sided bookcase designed by Desmond Ryan (Fig. 334). The effect was of a pair of highly expressive abstract paintings, each in twenty-one sections. All kinds of 1960s counter-culture concerns – pop art, the writings of Carl Jung, meditation, popular psychology – surface in Smith's thinking and art. Revealingly, Smith explained that he admired Tolkien's cult masterpiece: 'because it offers a complete world, with its landscapes, its different psychological types…and its archetypal

334. Philip Smith, bindings of seven sets of the three volumes of J.R. Tolkien's *Lord of the Rings* creating one side of a 'bookwall' housed in a rosewood case by Desmond Ryan. 1968–9. (Private Collection. Photo Philip Smith).

symbols of man's quest for goodness, truth and individuality.'[225] Buoyed up by this invented world, Smith was able to preach a new importance for bookbinding with messianic enthusiasm: 'it happens in the heart as an act of love, not of function, nor of necessity.'[226]

CALLIGRAPHY AND LETTERING

In 1944 Edward Johnston died and the following year his achievements were commemorated in a comprehensive exhibition at the V&A and in a series of tributes paid at a meeting of the Society of Scribes and Illuminators (SSI). Only Sir Sydney Cockerell, friend and patron of all the key figures in the inter-war lettering reform movement, spoke negatively, suggesting that none of Johnston's pupils and followers had matched the standard of their master.[227] There were good reasons for a continuing stasis in the world of calligraphy. The Second World War provided plenty of work in the shape of Rolls of Honour and Books of Remembrance. The largest project, overseen by Alfred Fairbank, was the creation of the eleven RAF Books of Remembrance for St Clement Danes in the City of London which involved thirteen members of the SSI. A major commission of this nature was not the place for calligraphic experimentation. Other bodies like the Crown Office provided work creating letters patent and grants of peerages for illuminators like Vera Law and Margaret Alexander and scribes like Dorothy Hutton, Ida Henstock and Joan Pilsbury. And in significant contrast with Europe, after the Second World War very few English calligraphers used their expertise in order to design typefaces. The SSI itself embodied stasis. As we have seen, before the war it had been an essentially conservative body dedicated to the diffusion of Johnston's teaching. This determination to take a narrow but deeply researched view of calligraphy was carried forward in 1956 with the publication of *The Calligrapher's Handbook*, written in the main by Johnston's former pupils.[228]

None the less the SSI benefited from the upsurge of interest in all craft activity after the war. Their 1951 exhibition at the Crafts Centre of Great Britain was a great success, attracting royal visits and high attendances.[229] The exhibition generated an especial interest in handwriting and in 1952 the Society for Italic Handwriting (SIH) was founded under the Presidency of Alfred Fairbank.[230] In 1961 the SSI held another Craft Centre exhibition but a report by the organiser Heather Child noted that 'the writing on the whole lacked vitality and often a sense of being contemporary' while 'the brilliance and sharpness and loving care seen in work in the retrospective exhibit was lacking in some of the work today.'[231] Johnston's pupils – Irene Wellington, Dorothy Mahoney, Thomas C. Swindlehurst and the rather older Mervyn Oliver – had all exhibited. Of this older group, only Irene Wellington was an innovator. Her reverence for Johnston had not prevented her penning an entirely original calligraphic diary *26 Days and 25 Nights of Summer* in 1934. After the war she developed a series of exuberant collages and ebullient informal squibs addressed to her friends and to her patrons, the Marquess and Marchioness of Cholmondeley. Wellington's letter forms were in essence Johnstonian but her expressiveness came through in the dense, complex layout of her formal and informal pieces of writing (Fig. 335).

On the whole, however, in the 1950s the expressive possibilities of calligraphy were barely explored in Britain.[232] By the early 1960s there was a sense of crisis, not least because calligraphy was virtually excluded from the new Diploma of Art and Design system of examination. Younger members of the SII like John Woodcock, Madeleine Dinkel, Ann Camp, Donald Jackson, Sheila Waters and Wendy Westover, who had designed book jackets and taken an interest in developments in the United States, felt that the Society needed to widen its brief. Sheila Waters, in particular, worked as an a freelance designer for Penguin Books and had a lively interest in calligraphy's potential in book production and a consciousness that 'misconception and even antipathy exists between graphic and typographic designers on the one hand, and specialist calligraphers on the other'.[233]

In the 1950s and 1960s Nicolete Gray was a welcome alternative voice to the narrow SSI debates, able to look at lettering in its broadest sense.[234] She was the daughter of Laurence Binyon, the poet and scholar of Oriental Art. Her sister was Helen Binyon, artist and

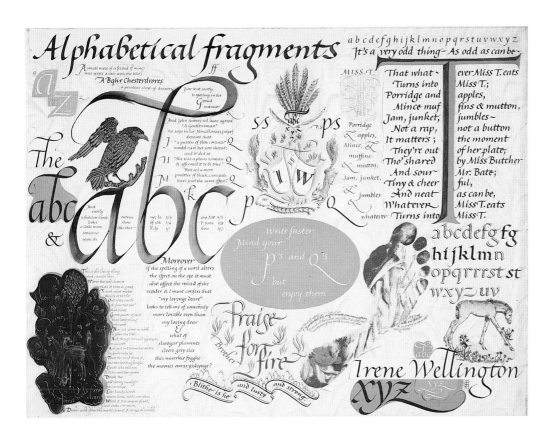

335. Irene Wellington, *Alphabetical Fragments*, 1957, a collage of calligraphic pieces on a background of Sydney Cockerell combed paper, 45.5 × 61 cm. (By kind permission of the Irene Wellington Educational Trust and the Holburne Museum and Crafts Study Centre, Bath).

puppeteer, and her husband was Basil Gray, an expert on Chinese painting, pottery and porcelain. She had had contact with a great range of non-European art and was buying paintings by inter-war modernists while still a schoolgirl. She was also a scholar of Dark Age Italian inscriptions. In 1938 she published *XIXth Century Ornamented Types and Title Pages*, which argued that ornamented types and Victorian jobbing printing represented 'one of the folk arts of early industrial society'.[235] Her taste for the unusual and fantastical in lettering brought her into the *Architectural Review* circle (where an interest in typographical and other kinds of Victoriana was already marked) and her rediscoveries influenced the light-hearted use of an ornamental slab serif in the official lettering for the Festival of Britain. Nicolete Gray's attitude to calligraphy was made clear in her *Architectural Review* articles of the early 1950s. She felt Johnston's search for 'Essential Forms' excluded variety and that the Johnstonian revival had hardened into an orthodoxy based on a single writing tool, the broad-nibbed pen.[236] She believed that calligraphy should ally itself with drawing and that it should function as 'some sort of abstract discipline'.[237] From 1949 she took a particular interest in the lettering of David Jones.[238] His painted inscriptions in Welsh and Latin (Fig. 223), full of invented letter forms, influenced her own occasional work as a lettering artist and by 1961 she regarded Jones as 'the most original and serious artist making lettering in England today'. She saw his unorthodoxy as 'a leaven, with incalculable effects' and remarked, prophetically as it turned out, that his work was likely to be much imitated.[239] For Gray, Jones's inventive expressiveness was comparable to that of Continentals she admired like Rudolph Koch and Karl Schmidt-Rottluff.

Gradually David Jones's work came to influence the calligraphy movement, though rarely with much acknowledgement. Free letter forms make their appearance by the mid-1960s. Stuart Barrie, Heather Child, Ann Hechle, Donald Jackson and even, by the early 1970s, Irene Wellington began to write more experimentally because of Jones.[240] Not all expressive calligraphy was in his debt. Hella Basu, one of the most experimental 1960s calligraphers, drew on pop art and psychedelic images to aid in the visual interpretation of poetry (Fig. 336). Pat Russell may also be seen as an 'experimenter', not in the sense of creating profoundly thought-out letter forms, but through her adventurousness with materials and presentation, especially in the context of embroidery and appliqué.

The best known letterer of the 1950s and 1960s was not a calligrapher at all, but a wood

336. Hella Basu, calligraphic panel, Lord Bryon, *The Isles of Greece*, 1973. (Hella Basu/Crafts Council).

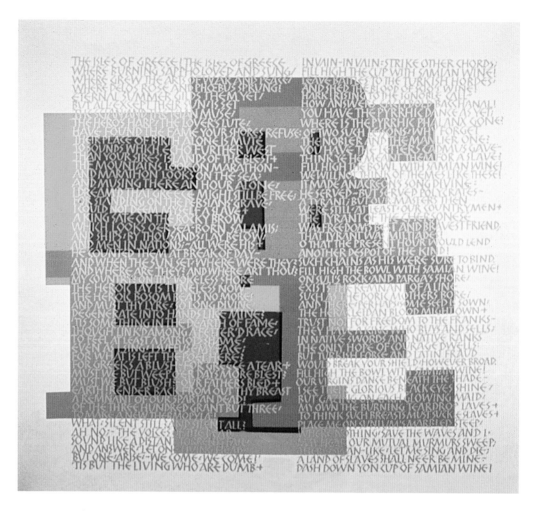

engraver who made a virtue out of artistic conservatism and isolation. Reynolds Stone, educated at Eton and Magdalene College, Cambridge, had trained as a compositor at the Cambridge University Press from 1930 to 1932.[241] This was not an apprenticeship; his position there was privileged. He spent a brief but formative fortnight in 1932 with Eric Gill at Piggotts and from the early 1930s engraved bookplates, letter-headings, often embellished with illustrations inspired by Bewick and Blake. In 1939 he taught himself to cut letters in stone and after the war cut headstones for a distinguished array of the dead, including T.S. Eliot, Ralph Vaughan Williams and Winston Churchill (Fig. 337). He was admired by Beatrice Warde and Stanley Morison, great figures in the world of printing. He was a designer as well as a craftsman, of banknotes, stamps, Royal Arms for *Hansard* and a masthead for *The Times*. In 1953 he was awarded the CBE and in 1956 made a Royal Designer for Industry.

Stone had little interest in the contemporary art and craft of the 1950s and 1960s, indeed actively disliked most of it. He owed his fame to the elegant bookplates he created for fellow artists and for the non-philistine upper and upper-middle classes, using light Trajanic capitals and a running script based on Renaissance handwriting (Fig. 338), all beautifully laid out and enlivened with arabesques and occasional emblematic motifs – pears and lutes for Peter Pears and Benjamin Britten for instance. Such work had a perfectionist neo-romantic certainty about it, even if comparable engraving by Gill makes Stone's oeuvre, especially his individual letter forms, seem over-refined to the point of monotony.

Stone had an outstanding pupil, Michael Harvey, who from the age of fifteen had worked as an engineering draughtsman, who read Gill's *Autobiography* aged twenty, learnt letter carving from Joseph Cribb in Gill's old Ditchling workshop in the summers of 1954 and 1955 and then worked with Stone for six years. In 1957 he started designing book jackets, creating 1200 designs over the next nineteen years. In 1961 he went freelance, working as a designer, type designer and letter carver. Harvey emerged as a gifted, passionate conservative. In his *Lettering Design: Form and Skill in the Design and Use of Letters* of 1975 he provided model alphabets, arguing for Roman letters as a basis for all lettering and warning against eccentric

338. (*above*) Reynolds Stone, bookplate for Jonathan and Phillida Gili, Stone's daughter and son-in-law, 1971, wood engraving. Actual size. (Jonathan and Phillida Gili).

337. (*left*) Reynolds Stone's studio, 1956, with his memorial tablet for Duff Cooper. (Michael Harvey).

flourishes and 'the revival of styles from lettering's least distinguished periods'.[242]

Eric Gill died in 1940 but his influence on letter cutting was maintained and rationalised by his former pupil David Kindersley, a dashing energetic figure, who turned out to be both more and less of a modernist than Gill.[243] In 1943 Kindersley set up his own workshop at Barton outside Cambridge with Kevin Cribb as an apprentice. In the 1950s and 1960s the Kindersley workshop (moving into Cambridge in 1967) carved predominately Trajanic letter forms. Informality, if not expressiveness, was suggested by Kindersley's use of italic and of flourishes that were eighteenth-century in inspiration. Layouts were formal and usually centred, with a fine eye for letter spacing. Technically, standards were of the highest. If a patron so desired, Kindersley could design an inscription that had a majestic quality which was considerably more stately than anything designed by Gill (Fig. 339).

Kindersley's work in letters was not confined to carved inscriptions. He designed film titles for the Shell Film Unit and for the British Film Institute. In 1948 he designed a serif and sans-serif alphabet for the Ministry of Transport.[244] In 1964 he created another alphabet for the

339. David Kindersley, tablet for Leonard Burrows, Bishop of Sheffield, in St Katherine's Chapel, Sheffield Cathedral, Yorkshire, 1957, Cumberland slate, carved, painted and gilded. 61.5 × 96.5 cm.(Cardozo Kindersley Workshop).

340. David Kindersley, Needham's Charity School, Ely, 1969, Welsh riven slate. (Cardozo Kindersley Workshop).

341. David Kindersley in the late 1960s at Victoria Road, Cambridge, working on a wooden form subsequently cast as a concrete pillar. One of his experimental alphabets cut in slate can be seen in the background. (Photo E. Leigh).

signage at the Cambridge University Press. But his devotion to Trajan meant that he was antithetical to most modernist typography – as his serifed designs for road signs of the early 1960s reveal. The virtues of the sans-serif system designed by Jock Kinneir and Margaret Calvert (adopted by the Ministry of Transport) were never acknowledged by Kindersley. On the other hand Kindersley evolved a computerised typesetting system LOGOS in which his sensitivity to letterspacing was adapted to modern typesetting. He designed several typefaces, the most effective being the quirky Octavian on which he worked with Will Carter from 1955 until 1961.

In the early 1960s Kindersley visited the United States, followed by a six-month stay in 1968 as Senior Research Fellow at the William Andrews Clark Memorial Library in Los Angeles working on the Eric Gill collection. On his return, Kindersley created a series of alphabets which were drawn for lithography and which were also cut in stone, wood and perspex (Fig. 341). These revealed new influences, including David Jones, art nouveau, Oriental calligraphy and the pop art of the period.[245] This outburst of calligraphic *jeu d'esprit* marked a change of direction, after which the workshop began using a greater variety of styles, beginning in 1969 with the geometric letter forms and informal inter-word punctuation used for a inscription for Needham's Charity School (Fig. 340).[246] But his most adventurous work, for instance, his 1978 incised brick wall in the foyer of Peterborough Law Courts in which he created a modular all-over pattern, was done in the 1970s and 1980s.

During the 1950s and 1960s lettering from the David Kindersley Workshop adorned many Cambridge colleges and historic buildings as well as the tombstones of the great and the good. But his work was markedly ignored by modern-minded pundits like Gray, James Mosley and James Sutton in their discussions of appropriate lettering for modern buildings.[247] Gray, in particular, disliked the Gill legacy of 'anaemic Romans',[248] finding little to praise in English inter-war architectural lettering apart from Harry Goodhart-Rendel's eccentric gold painted triangular wooden lettering for Hay's Wharf of 1930. Gray, Mosley and Sutton favoured the designer Edward Wright, whose relief concrete inscription for the new Churchill College, Cambridge (Fig. 342) and painted lettering mural for the 1961 South Bank Architectural Congress suggested a knowledge of lettering developments on the Continent. The only craft based letterer who made an impact on the world of advanced architecture and design in this period was Ralph Beyer.[249]

Beyer had come to England in 1937 to be trained in Gill's workshop. He stayed six months, followed by two years training as a sculptor at the Central School and at Chelsea School of Art. In 1953 he worked for about a year in David Kindersley's workshop mastering the Trajanic letter form. His background was important. Beyer had grown up aware of the New Typography movement, of the Bauhaus and of the calligraphic and typographical genius of

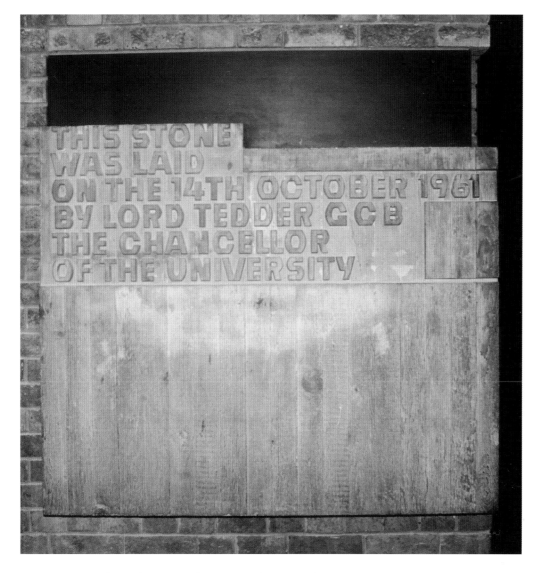

342. Edward Wright, foundation stone for Churchill College, Cambridge, 1961, cast concrete block, 113 × 136 × 62 cm. (Reproduced by kind permission of the Master and Fellows of Churchill College, Cambridge).

Rudolf Koch. The architect Erich Mendelsohn was a family friend and Ralph's father, Oskar Beyer, was to edit his letters, as well as writing a life of Koch. Oskar Beyer's 1923 survey of art, *Welt-Kunst*, illustrated with Egyptian, Pre-Columbian, Oceanic, Japanese as well as European art, reads like a source book for early modernism in the visual arts and was followed in 1927 by the first of his two studies of early Christian catacomb inscriptions.[250]

The turning point in Beyer's career as a letter cutter came in 1953 when he read Nicolete Gray's article 'Theory of Classical' in the *Architectural Review* in which Gray concluded that 'pure classicism is impossible for the creative letterer of today'. Her article was illustrated with the painted inscriptions of David Jones whose work reminded Beyer of the early inscriptions illustrated in his father's writings on catacomb art. The influence of both sources was apparent by 1954 in one of Beyer's first free-lance inscriptions for a new altar for the Royal Foundation of St Katherine, Butcher Row in East London (Fig. 343). This was the first of many collaborations with Keith Murray who was soon to go into partnership with the architect Robert Maguire. For the St Katherine's altar, and for Maguire and Murray's St Paul's, Bow Common, Beyer used expressive, irregular, invented letter forms (Fig. 398).

This expressiveness was given full rein in Beyer's monumental Tablets of the Word commissioned by Basil Spence for Coventry Cathedral in 1957 (Fig. 391). These were carved on thirteen- by six-foot panels ranged on each side of the nave. In preparation Beyer studied a whole range of informal lettering and discussed early Christian inscriptions with Spence. After Coventry, Beyer went on to make work which stands out sharply from most British inscriptional lettering (Fig. 344). Why did Beyer seem so much more modern than other British letter cutters? There were his free letter forms but also his informal, unjustified layouts which were strongly influenced by the principles of modern Continental typography. In

BEHOLD I LAY IN SION A CHIEF CORNERSTONE ELECT PRECIOUS

AND HE THAT BELIEVETH ON HIM SHALL NOT BE CONFOUNDED

343. Ralph Beyer, lettering and line carvings for the slate altar designed by Keith Murray, Chapel of the Royal Foundation of St Katherine, Butcher Row, London E14, 1954. (Photo John Gay).

344. Ralph Beyer, applied lettering in fibrous plaster, 1986 in the KITA day-centre for children, Berlin-Kreuzberg, architects Maguire & Murray. (Ralph Beyer).

ERBSE
BOHNE
LINSE
WIE MAN SE
KOCHT
SO SIN SE

contrast, letterers like John Skelton, Bryant Fedden, Richard Grasby, Keith Bailey, David Holgate and Richard Kindersley created inscriptions that were little affected by developments abroad. Bailey, Richard Kindersley and Holgate were trained by David Kindersley. They too were versatile. Fedden and Richard Kindersley worked in many media, and Richard Kindersley in particular was at home with architectural and public art commissions. All this richness and skill in letter forms and in variety of technique resulted in work that at best was often both striking and daringly informal. At worst, their attractive, novel solutions looked decorative and parochial.

GLASS

The development of stained glass after the Second World War can be compared with that of bookbinding and calligraphy over precisely the same period. All three crafts had been reformed by Arts and Crafts leaders before the First World War. In each case techniques and standards had been set out in detail in the relevant volumes of Lethaby's Artistic Crafts series. As with calligraphy, stained-glass artists were represented by a body – the British Society of Master Glass Painters – which before and after the Second World War took up an essentially conservative position.[251] The late 1940s and 1950s saw a surprising continuation of inter-war glass practice. A pleasing fairy tale quality characterised the best post-war work of this kind – by J.E. Nuttgens, Edith Norris (the wife of the troublesome Bolton furniture maker Harry Norris), the little Putney group of glass artists, Margaret Aldridge Rope, Joan Howson, Edward Woore and Rachel de Montmorency and the Cotswold artist Edward Payne. The Pre-Raphaelite imagination kept a strong hold over most glass artists while marked literalism characterised some of the war memorial commissions. A window for the Nurses Chapel in Westminster Abbey by Hugh Easton was dominated by heraldry and included a nurse in full uniform kneeling before the Virgin and Child and the interceding St Luke.[252] A window for Watton Church in Yorkshire by Christopher Webb portrayed in vivid detail the crew of a Pathfinder shot down over Germany, the Pathfinder map from England to Hamburg and a wealth of regimental heraldry.[253] Both men had been pupils of Ninian Comper and were influenced by his brand of realism and fondness for bright silhouettes against a background of clear glass.

The *Manchester Guardian* noted that by 1957 two million pounds had been spent on stained glass and argued that this had been money wasted on 'a noble, but in this country, almost moribund art'. The Dean of York, Eric Milner-White, firmly rejected this verdict.[254] He was an important advisory figure in the Central Council for the Care of Churches and in the Society of Master Glass Painters but his taste in glass was not as immaculate as his taste in stoneware studio pottery or modern paintings. His dislikes were well founded – too much bland realism, too much Comperesque white glass. But his fondness for the glass of the Hungarian Ervin Bossanyi[255] and his scheme for the windows at the Church of the Ascension in Southampton, carried out by A.K. Nicholson Studios, suggested an unexpected sentimentality.

The two most creative figures in the immediate post-war stained-glass world remained Wilhelmina Geddes and her pupil Evie Hone, both of whom had emerged from the remarkable Irish stained-glass revival of the inter-war years.[256] By an odd coincidence both women died in 1955 but not before they had carried out some important post-war commissions in England. Geddes, as suggested in Chapter Two, stood head and shoulders above all other British twentieth-century glass artists and her post-war commissions, such as the three lancet windows for the Lady Chapel of St Mildred's Church in Lee, Kent, suggest her undiminished powers. Hone's major post-war commission in England was the East window in Eton College Chapel completed in 1952 (Fig. 345). The Eton window, bold, hieratic, hotly coloured and intense to the point of crudeness, was worlds away from examples selected by the British Society of Master Glass-Painters for illustration in their journal in the 1950s and 1960s. Her death in 1955 meant that the remaining windows at Eton, all adventurous commissions, went to other artists. The North and South windows in the West

half of the Chapel were the work of Moira Forsyth. As with her work for Edward Maufe before the war, her designs tend to look miniaturised, nor was she always a great colourist. Thus her best windows – at Eton College and at Norwich Cathedral (1965) – were grisaille with plenty of her unusual and lively heraldry and lettering.

The late 1940s and 1950s saw a huge increase in work for glass artists. Bombing had blown out stained glass in churches the length and breadth of the land. Patronage was unproblematic; the War Damage Commission was pledged to underwrite the replacement of at least the East or principal window in a bombed church.[257] It was an extraordinary opportunity and there was an undeniable stained-glass renaissance in the 1950s, inspired, like most other post-war crafts, by Continental painting and sculpture and, more specifically, by modern French stained glass which drew on designs by major artists such as Matisse, Léger and Rouault. By 1951 a significant new school of glass had emerged at the Royal College of Art under the leadership of Lawrence Lee, Martin Travers's pupil and successor at the College on Travers's death in 1949.[258] At the re-organised College stained glass was a department in the Faculty of Fine Art, thus attracting a new kind of student. Lee was an admirer of the beautiful certainties of Fra Angelico and like Hone he had briefly joined an Anglican order in the 1930s. His department was galvanised by two students, Geoffrey Clarke and Keith New, who were ready to experiment technically and who were alert to School of Paris painting, to contemporary painting and sculpture in general and to Francis Bacon in particular.[259]

As we shall see in Chapter Nine, in 1951 Basil Spence, then RCA external visitor to the department of stained glass, saw the work of Clarke and New and boldly gave the commission for the ten seventy-foot nave windows of Coventry Cathedral to the two students and their tutor (Fig. 387).[260] The other major stained glass at Coventry was commissioned slightly later, in 1955, and introduces the most important collaboration of the 1950s and 1960s. Patrick Reyntiens first met the established painter John Piper in about 1952. Piper had long been interested in glass and Reyntiens was then working and learning with J.E. Nuttgens. He had the craft skills and had 'heard of Matisse'.[261] Their first collaboration was based on a gouache

345. Evie Hone, East window, detail showing (l. to r.) *Melchizedek, The Last Supper, The Sacrifice of Isaac*, 1952, Eton College Chapel, Eton. (Sonia Halliday and Laura Lushington).

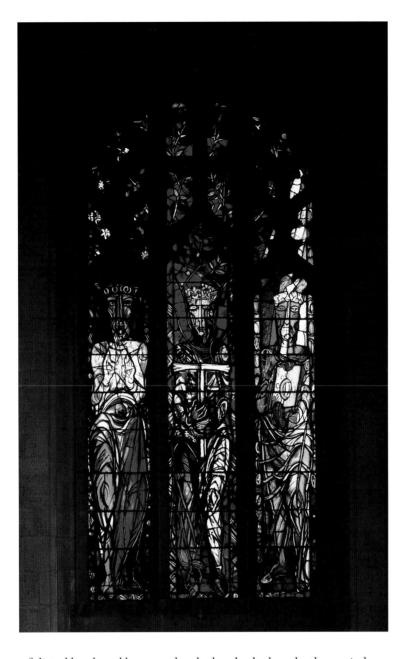

346. John Piper and Patrick Reyntiens, *The Way, The Truth, The Life*, left window, Oundle School Chapel, 1956. (Sonia Halliday and Laura Lushington).

by Piper of two Matissean foliated heads and by 1954 they had embarked on the three windows for Oundle School Chapel (Fig. 346). Both Reyntiens and Piper were committed Christians (stained glass, until recently, was the one craft where religious faith was usual and perhaps necessary). The windows, each with three lights, was figurative, depicting nine over life size figures of Christ in his different symbolisms as the Vine, the Bread, the Teacher, the Good Shepherd.[262] Both men were inspired by Gothic sculpture and by Braque and Picasso's figurative work of the 1940s and 1950s which made free with bold black outline, coincidentally reminiscent of the lead lines of stained glass. The Piper and Reyntiens windows in Eton College Chapel of 1959 to 1964 completed the sequence there and subtly depicted Parables and Miracles semi-abstractly while the large Baptistry window at Coventry was entirely abstract. The Reyntiens/Piper partnership was a creative collaboration in the fullest sense.[263]

Reyntiens's own work, particularly his abstract panels of the 1950s, and the much later figurative work of the 1970s and 1980s, never lost touch with developments in contemporary painting. Nonetheless his sense of decorum in glass was so great that he was ready, like the glass artist Brian Thomas, to employ imaginative pastiche where appropriate. Thus his windows for the hall at Christ Church, Oxford could at first glance be mistaken for Victorian glass (which in turn was imitating medieval glass) just as Brian Thomas's windows for Seely & Paget's reordered St Paul's, Covent Garden were skilful pastiches of eighteenth-century glass.[264]

By 1955 there was a sense of excitement about contemporary stained glass, signalled by the Arts Council exhibition *A Small Anthology of Stained Glass* selected by Piper and Reyntiens. Piper wrote a combative introduction attacking 'stereotyped Edwardian and Victorian saints standing bored on their pedestals against pink or green seaweed or ivy-leafed background' and quoting the poet John Betjeman on vicars and church councils who 'don't want a work of art but a transparent sacred illustration'.[265] The new spirit in glass was represented by the RCA graduates, Clarke and New, by Margaret Kaye (also a 'new' embroiderer), by the Scot William Wilson and by Tom Fairs who was later to teach stained glass at the Central School. Painterly abstraction was the norm. By 1960/1, when the Arts Council staged *Modern Stained Glass*, there were new names including a number of painters – Ceri Richards, Philip Sutton and Anthony Curtis – whose designs were carried out by Reyntiens. The show also included a 'Colour Construction' by the painter Peter Lanyon. Most were abstract but there was also kitchen sink realism by a RCA student Brian Milne. Clarke showed one of a series of panels which combined stained glass and cast aluminium relief (Fig. 347) and several exhibitors employed the *dalle de verre* technique imported from France in which thick glass slabs were set in concrete or epoxy resin.[266]

The remarkable career of one of the exhibitors in *Modern Stained Glass* exemplified the variousness of stained glass in the 1950s and 1960s. Margaret Traherne had, as seen above, a career as innovative embroiderer in the 1950s.[267] She was at the RCA during the Second World War, studying mural painting with Lawrence Lee and stained glass with Martin Travers. She admired the work of Evie Hone and in 1953 she returned to stained glass, spending a year studying at the Central School of Arts and Crafts. She was familiar with the French post-war glass renaissance, having gone on a tour of French churches arranged by the Reverend Gilbert Cope, a key commentator on liturgical reform and ecclesiastical art. Early glass by Traherne – a haunting exhibition panel of the *Mother and Child* (1956), *St Kenelm* (1959) at Wootton Wawen Church in Warwickshire (made in memory of the architect F.R.S. Yorke's father) and the panels commissioned by Leicestershire Education Authority – were full of Rouault-inspired painterly intensity and expressiveness (Fig. 254).

347. Geoffrey Clarke, *Fragment*, 1959, stained glass and lead relief, 94 × 74.4 cm. (Artist's Collection. Photo William Newland family archive).

348. Margaret Traherne, appliqué glass, 1964, L.C.C. Albion Primary School, East London, architect Eric Lyons. (Photo Stefan Buzaf).

Her knowledge of French glass led to experiments with *dalle de verre*, a technique which came to seem peculiarly appropriate for modern buildings (Fig. 388). The window became a screen of concrete pierced by rough openings filled with coloured light. A small experimental exhibition in 1958 led to a commission from Basil Spence for ten *dalle de verre* windows for the Chapel of Unity in Coventry Cathedral. Fifty-two feet high and a foot wide, they were described by Traherne as 'a chromatic abstraction'. They were the first of a series of abstract large-scale windows and screens using new techniques. Her *Fifteen Mysteries* (1961) at St Mary's, Locklease, Bristol used *dalle de verre* while the dramatic abstraction of her windows at St Chad's, Patchway (1964), also in Bristol, was created by glass set in resin. Windows for a primary school in Rotherhithe were strongly influenced by Pop art, with brightly coloured letters, numbers and biomorphic shapes collaged onto clear glass (Fig. 348). In the mid-1960s she attended summer schools run by the painter and sculptor Harry Thubron. As a pioneer of Basic Design teaching at Leeds College of Art, he continued to use Basic Design methods to force students to confront principles such as line, colour and tone. One of Traherne's subtlest sets of windows, for the Lady Chapel in Frederick Gibberd's Roman Catholic Cathedral at Liverpool (1967), suggests a new design and colour sensibility as a result of this teaching. She used amber glass made in three intensities of colour, flashed with opalescent glass which was etched away to create a repeat sequence of negative and positive forms. Traherne went on to experiment with kinetic light boxes and in 1972 made the first of a series of majestic sets of three-dimensional textile banners for the Tate Gallery in which her gifts as an abstract painter were strikingly displayed.

New techniques were used by practically all stained-glass artists from the mid-1960s onwards. Piper and Reyntiens used *dalle de verre* for the lantern at Liverpool Cathedral, Moira

Forsyth experimented with the technique as did Lawrence Lee and John Hayward. Hayward was particular fan of appliqué in which glass was stuck onto glass with adhesive: 'the very directness of the technique makes it almost akin to painting, the pieces of glass, some deliberately cut, some 'found' on the bench as the work progresses, almost conform to brushstrokes.'[268] Appliqué and *dalle de verre* worked best for abstract designs and in 1967 Margaret Aldrich Rope put in a plea for balance: 'after all, the Christian religion is not abstract.'[269] Brian Thomas, who remained loyal to painted and leaded glass, argued that by the late 1960s inventive abstraction 'has been almost exhausted, and is lapsing into a mere routine "crazy-glazing".'[270] But it was not until the 1980s that a figurative glass revival got underway, involving senior artists like Piper and Reyntiens and younger figures like Rosalind Grimshaw. In the intervening years the influence of the German glass artist Johannes Schreiter swept the art schools, in particular the stained-glass department at Swansea School of Art led during the 1970s by Tim Lewis. Schreiter's glass was abstract and technically flawless. Standards were raised. It was realised that many of the 'new' methods of fixing glass so popular in the 1960s were unstable. But by the 1970s Schreiter's influence resulted in glass which was notable for its alienating cold perfection and for its abandonment of readable symbolism.

Not all the glass at Coventry was stained and painted. The whole of the South end of the Cathedral was filled by a glass screen of flying, tumbling and running angels interspersed with English saints engraved with specially designed power tools by John Hutton, the New Zealand designer and muralist (Fig. 390). Hutton had met Spence in the Camouflage Unit during the war. His first ventures in glass, for instance his lunettes of angels for Maufe's Guildford Cathedral, were engraved for him by the London Sandblast Decorative Glassworks Ltd. They were in the illustrational style of John Farleigh – that is to say, sweetly Botticellian. But for

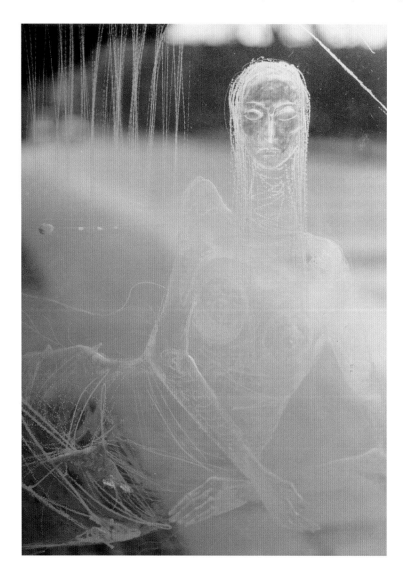

349. John Hutton, *Coventina, goddess of the well*, detail of glass screen, Newcastle Civic Centre, 1967. (City Repro).

Coventry Hutton evolved a set of highly stylised figure types inspired by carvings at Chartres and Vézélay, by Giacometti and by muralists of the 1940s like Hans Feibusch. Hutton's glass was best seen in less demanding contexts – at Plymouth Civic Centre (which also commissioned a ceramic panel by Kenneth Clark) with its frieze of sportive mermaids with Neptune and Amphitrite (1962), at the Shakespeare Centre at Stratford-upon-Avon which has thirteen panels of characters from Shakespeare and in his extraordinary screen of 1967 for Newcastle Civic Centre with its mythological and industrial iconography (Fig. 349).[271]

In 1975 Hutton became a founder member of the Guild of Glass Engravers but his massive schemes were not characteristic of that essentially private art – which had been revived by Laurence Whistler's neo-Romantic experiments in the mid-1930s.[272] At that date only three other artists were working seriously in the medium – Helen Munroe Turner at Edinburgh School of Art, William Wilson at Whitefriars Glass and a county planning officer named David Peace. Although Whistler felt aggrieved that the Royal Academy excluded engraved glass from its Summer Exhibition, his work was much admired, and popular with museums as well as private collectors. For the more old fashioned museum curator, Whistler's glass suggested a reassuring continuity in exquisite craftsmanship (Fig. 350). David Peace was to emerge in the 1950s principally as a letterer on glass, engraving windows and large screens.[273] By the late 1960s, though glass engravers worked independently, there was a small glass engraving movement – including Simon Whistler, Stephen Richard, Bryant Fedden, David Maude-Roxby and Alison Kinnaird.

Engraved glass in its various forms tended to remain bound up with conservative skills – calligraphy, the landscapes of neo-romanticism and heraldry. But glass was also being used in a more sculptural fashion, particularly at the School of Art at Stourbridge which since 1934 had had both hot and cold glassworking facilities. Pauline Solven took her NDD there in the early 1960s and remembers two tutors using glass in unusual ways. Eric Hilton carved sculptures out of large blocks and Harry Seager, a sculpture tutor, exhibited massive plate glass and perspex sculptures at Gimpel fils gallery in London. Although Solven learnt cutting, copper engraving, sandblasting and kiln work, the glass department at Stourbridge (and at Edinburgh and the Royal College of Art) taught students to design for the glass industry and glass blowing was carried out for students by technicians.[274] But in the 1960s a hot glass movement, analogous to the studio pottery movement of the early twentieth century, got under way in British art schools, characterised by an expressive hands-on approach.

The movement was pioneered in the United States by the potter Harvey Littleton, inspired by the swift unplanned creativity of painters like Jackson Pollock and potters like Peter

351. Sam Herman, blown glass vase with coloured inclusions, 1969, h. 26.7 cm. (The Trustees, Cecil Higgins Art Gallery, Bedford, England).

Voulkos. Littleton had seen small family-run glassworks in Murano in Italy and was attracted by the inter-war glass designed and made by the French painter Maurice Marinot. Littleton set about uniting designing and making in hot glass. With the help of Dominick Labino, he evolved small tank kilns that enabled hot glass to be created 'in studio'.

One of his pupils at the University of Wisconsin, Sam Herman, came in 1966 to Edinburgh College of Art on a Fulbright Scholarship. From 1967 to 1968 Herman was a Research Fellow at the Royal College of Art and built a small tank furnace in the Ceramics and Glass Department. During 1967 Solven (by then taking an MA at the College) and fellow students John Cook and Asa Brandt began blowing their own work. Their degree show in 1968 was the first to include student-made hot glass. Herman, who from 1969 was head of the Glass Department at the College, spread the word to other art schools. He visited Stourbridge to help set up a student glass blowing facility and in 1968 held an introductory course at the RCA for tutors in other glass departments. In 1969 he also set up the Glasshouse with the help of Graham Hughes and Susannah Robins as a workplace for post-graduates working in hot glass. The subsequent history of the hot glass movement belongs in Part III of this book, but by the end of the 1960s Herman had helped to lead British glass into the kind of expressive areas explored by other crafts in the 1950s. His own pieces, designated 'sculptures' in early exhibitions, came as close as possible to suggesting the molten and dangerous liquidity of hot glass (Fig. 351). He compared blowing hot glass to a dance between the artist and the material and the performative aspect of the hot glass movement was a part of this new craft's glamour and appeal.[275] But the move to expressive studio glass took other forms. For instance, Keith Cummings, a member of staff at Stourbridge with a Basic Design background, turned his attention to cast glass and over the next two decades fostered a quite different kind of 'studio' approach to glass.

FURNITURE

Most of this chapter has documented substantial change in individual crafts. These post-war developments took up what might be termed a 'third space' between fine art and design for mass production and in the 1950s managed to contribute to a 'contemporary' style. But the term 'contemporary' was most frequently used in the context of 1950s mass produced furniture which in Britain was heavily dependent on Scandinavian, Italian or North American design and characterised by soft organic shapes for seating off-set by spiky linear chair legs or, in the case of carcase furniture, by splayed legs and light construction and routed or laminated decoration.[276] It was a 'New Look' indebted to new materials like moulded fibreglass and laminated woods, which in turn lent themselves to design for mass production. Basil Spence's 'Allegro' chair of 1949, manufactured by Morris of Glasgow, was one example of a completely new principle of construction, derived from the laminated wood developed for Mosquito fuselages and the war-time manufacture of helicopter blades (Fig. 352).[277]

While studio ceramics, silversmithing, jewellery and even bookbinding were able, as we have seen, to tap into the 'contemporary' style, handcraft furniture was in a difficult position. As the *Studio Year Book* of 1957/8 pointed out, furniture designers now needed an understanding of all manner of new processes: 'pressing, forming and pre-fabricating processes, of moulding and laminating, bending and bonding'.[278] In the 1930s craft furniture makers had already seemed marginal figures, unable to break away from the Cotswold standard pioneered by Ernest Gimson and by the Barnsley brothers. The 1950s saw an apparent democratisation of objects and in this world of promising new materials and processes, and low-cost mass produced products, the handcraft furniture movement seemed especially trapped by its history.

Nevertheless disciples of the Cotswold school were numerous enough to warrant a sizeable book – A.E. Bradshaw's *Handmade Woodwork of the Twentieth Century* – as late as 1962. Here lineages were traced. There were the former pupils and apprentices of Ernest Gimson and Peter van der Waals like Sir George Trevelyan; Romney Green's former pupils, Stanley Davies, Eric Sharpe and Robin Nance; and Edward Barnsley's pupils Kenneth Marshall, Alec

352. Basil Spence, *Allegro* chair 1949, made H. Morris and Co. Ltd, Glasgow, laminated Honduras mahogany, Canadian betula, hide seat. 85.1 × 53.3 × 49.5 cm. (V&A Picture Library).

McCurdy, Robert Townsend and Oliver Morel (who in turn trained Hugh Birkett, an inspiration to the young John Makepeace). A handsome selection of work by Edward Barnsley's students at Loughborough Training College points up the fact that woodwork classes were on offer at most secondary schools throughout the 1950s and 1960s, if only as a second best training for boys (and, rarely, girls) who were deemed 'good with their hands'. Practically all the post-war furniture illustrated in Bradshaw was stylistically informed by the Cotswold School tempered by some rather more refined cabinet making inspired by Edward Barnsley's post-war fondness for Regency styles. Very little of this kind of beautifully made solid wood furniture seemed appropriate for a typical 1950s interior even if a couple of furniture makers featured in Bradshaw – A.J. Eves and Edward Baly – achieved a superficially 'contemporary' look by means of splayed and pointed legs.[279]

There were, however, a few examples of handcraft furniture which fitted in with the 'New Look' of the 1950s. Ernest Gimson's version of the traditional ladderback chair, which continued to be made by Edward Gardiner until 1958 and thenceforth by his former apprentice Neville Neal, was clearly seen as 'timeless' and was featured in Noel Carrington's determinedly 'contemporary' *Design and Decoration in the Home* of 1952 along with drinks trolleys and cocktail cabinets.[280] The range of turned solid wood chairs produced by the Ercolani family of High Wycombe was a commercial variant on another traditional design. Ercol Furniture Ltd was founded in 1920 as Furniture Industries Ltd,[281] but came into its own after the war with a range based on Windsor chairs cleverly restyled to emphasise splayed legs and lightness. The coffee table was a characteristic item of furniture of the period. Low coffee or occasional tables made as metal frame constructions mounted with mosaic, slate, tiles or glass, were produced in small batches by artists and designers as various as Jupp Dernbach, Robin Nance, Nicholas Vergette, Terence Conran and the

353. Alan Peters, storage cabinet in yew and aluminium, 1972. (Photo Alan Peters).

photographers Nigel Henderson and Michael Wickham. Magazine racks also offered plenty of scope for a small-scale sculptural statement, as well as signalling a new ephemerality in reading habits.[282]

The design dilemmas faced by younger craft furniture makers were epitomised by the careers of Sandy MacKilligin and Alan Peters. MacKilligin was a paying pupil of Edward Barnsley's from 1953 until 1955. An upper-middle-class dyslexic ex-Bedalian, he had worked as a farm labourer and briefly attended art school. Though he respected Barnsley and his craftsmen, MacKilligin realised that he needed a more sustaining design inspiration if he was to go on to work independently, and he applied for a scholarship to Denmark. There he came into contact with some top furniture designers such as Finn Juhl and Molgaard Nielson and worked as a design assistant at the factory of France og Daverkosen. The new Danish design of the 1950s with its elegance and airiness was to prove a key influence on his subsequent work – as was that supreme example of attenuated design, Gio Ponti's *Superleggera* chair. Operating from workshops in Surrey from 1957 onwards he found a niche through high quality craftsmanship and sensitivity to the needs of private clients, interior designers and architects rather than through marked originality.[283]

Alan Peters was an apprentice of Barnsley's from 1949 to 1956 and subsequently trained at Shoreditch College as a craft teacher and at the Central School as an interior designer. He set up his own workshop in 1962. He felt the need to go beyond the Cotswold/Regency approach which he had absorbed at Froxfield. But the only alternative model he could find was the industrial design of the period (Fig. 353). Peters, MacKilligin and the St Ives furniture maker Robin Nance were all stylistically influenced by Continental mass produced furniture (albeit mass produced furniture of a high standard). If the purpose of a craft approach was to innovate and experiment then they, like the majority of craft furniture makers between the wars, surely

achieved little. What they did provide for clients was a humane flexible approach at relatively low cost.

Intention was important. Despite the influence of mass production the work of Peters, Nance and MacKilligin belongs firmly in the handcraft camp. On the other hand, the architect Ernö Goldfinger's book of 1951, *British Furniture To-day*, included numerous one-off prototypes (including many of Goldfinger's own designs). This was also true of many of the pieces in the 1952 ICA exhibition *Tomorrow's Furniture*. In these instances the designer's aim was to move onto mass production if a manufacturer could be found. But 'mass production' could be a misleading phrase. As we saw in the case of Isokon, the most adventurous designs were often produced in relatively small quantities and furniture making was, and remains, a craft based industry.

It is especially difficult to categorise furniture which used materials normally not associated with a craft approach but which was nonetheless produced on a designer-maker basis. William Plunkett, a sculptor working in steel, designed and made his own chairs in mild steel and aluminium alloy in a well equipped workshop with bending jigs and power tools. Components were made by outside contractors but Plunkett assembled the final product himself. They looked like mass production of a high quality, with a modernist *élan* reminiscent of work by the French designer Jean Prouvé.[284] Similarly, Peter Hoyte initially made every component of his chairs – from metal pedestals to fibre-glass shells (Fig. 354). By 1965 these were contracted out but the upholstery and assembly was carried out by Hoyte and his two assistants.[285] Aidron Duckworth (husband of the potter Ruth Duckworth) had a fibre-glass shell design which was manufactured by Kandya in the late 1950s but he also produced short runs of a similar fibre-glass shell chair with elegant leather upholstery through his firm A. and R. Duckworth Ltd.[286]

These examples again raise the question of definition. Both Hoyte and Plunkett were on the Crafts Advisory Committee Index in the early 1970s along with Edward Barnsley, Martin Grierson, Richard La Trobe-Bateman, Sandy MacKilligin, John Makepeace and Alan Peters.[287] On the other hand the designer maker Norman Potter very definitely kept his distance from the craft world even though he had a workshop in Corsham in Somerset from 1949 until 1959.

354. Peter Hoyte with a fibre glass chair produced on a workshop basis, late 1960s. (CAA archive).

355. John Makepeace, chair with pine frame, slung rug handwoven by Ann Sutton, mid-1960s. (Ann Sutton).

356. Stand at Arkitectur und Wohnen, Düsseldorf, 1971 showing (*back*) two leather upholstered chairs on steel armatures by John Makepeace, (*foreground left*) chair with steel armature upholstered with knitted wool stocking with terylene and foam stuffing, a collaboration between John Makepeace and Ann Sutton, (*right foreground*) knitted tube floor cushion by Ann Sutton. (Photo Claus Wolde Pressefotos).

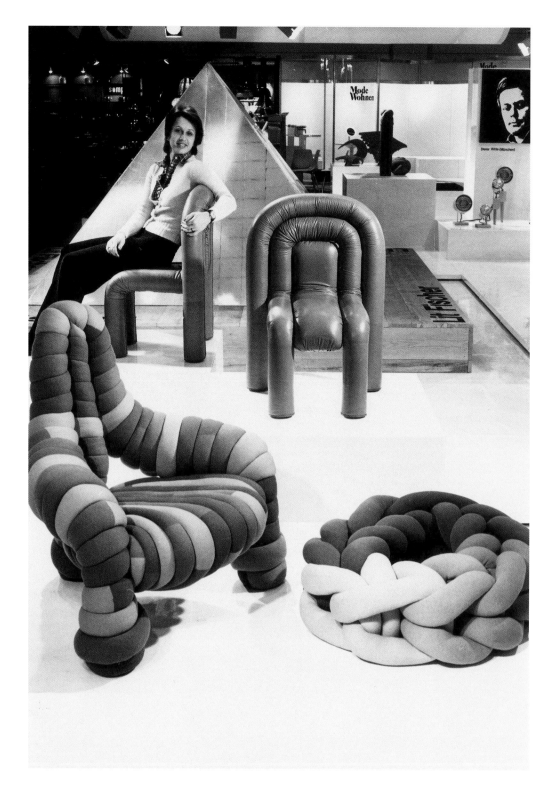

Potter produced self-assemble furniture from 1952 (Fig. 242) – as did Robin Nance and, rather later, John Makepeace. Flat pack and self-assemble demountable furniture was popular in the 1950s and 1960s as being low cost, easy to store and dispatch. Younger handcraft furniture makers were keen to emphasise affordability as one way of differentiating themselves from the older Cotswold inspired makers like Barnsley, Eric Sharpe and Stanley Davies.

John Makepeace had started off admiring Hugh Birkett's work – 'extraordinarily anachronistic but beautifully made'[288] and he trained with Keith Cooper, another craftsman in the Cotswold mould. Like Alan Peters he subsequently worked as a teacher from 1959 to 1962 but in 1963 he organised the exhibition *Designer Craftsmen 1963* at the Herbert Art Gallery, an attempt to define a forward looking group of craftsmen and women which included Peter Collingwood, Ann Sutton and Theo Moorman. Some of his own furniture at that date was still

357. Alan Peters, 13 drawer chest, 1982, solid Devon walnut with ebony and brass handles, h.91.4 cm. (Photo Alan Peters).

made in the Cotswold spirit.[289] Though Makepeace never went to art school he had travelled in Denmark in 1957 and in the United States in 1961. In 1964 he married Ann Sutton and began to work in a new way. They collaborated on interior design and demountable batch-produced coffee tables which were sold in Liberty's, Heal's and Habitat. Manufacturing was gradually sub-contracted to a firm in Yugoslavia. Here were the makings of a high turnover design business. Contract furnishing was taken on and this expanded in the late 1960s. But Sutton and Makepeace also experimented with startling frame construction sofas and chairs with slung rug seating (Fig. 355). By 1968 Makepeace had emerged as an eclectic innovator. There were soft organic forms – a dining area with circular seating and a round dining table for an Oxford professor – using materials ranging from expensive hardwoods and hide upholstery to birch ply and Drayon. Then there was starker frame furniture and flat-pack frame coffee tables with glass tops. Sutton was beginning to experiment with knitted tube weaves and these were used on Makepeace's upholstered chairs whose soft inflatable look echoed the Pop sculpture of the period (Fig. 356). By the early 1970s Makepeace had a staff of eight and could have expanded his design and contract work. Yet Makepeace, like Alan Peters, decided against entering the mass market and instead concentrated on more expensive one-off pieces. In effect they were returning to the exquisite craftsmanship of the early Cotswold furniture.

The turning point for Alan Peters was a Crafts Advisory Committee bursary to Japan in 1975, leading him to abandon his somewhat slick international modern style in favour of Japanese-inspired construction methods in solid wood (Fig. 357). Makepeace similarly ceased to make furniture which had visual links with mass production. In 1975 he was commissioned to make a dining table and chairs for Liberty. The chairs, with ball finials and joints, quoted seventeenth-century wood turning, while the table was made of four interlocking leaves cantilevered out from a remarkable pedestal carved in the form of a massive branched tree trunk (Fig. 358). As Peters pointed out, 'as craftsmen, as creative people, we cannot sit back

358. John Makepeace, Liberty table and chairs, 1975, limed oak, diameter of table 304.8 cm. (John Makepeace Furniture).

and leave it all to Habitat'.[290] Terence Conran's Habitat, which opened in 1964, had, in fact, helped define the agenda for handcraft furniture. Habitat offered handcraft or the semblance of handcraft – Windsor chairs made in Yugoslavia, salt glaze stoneware made in France, chicken bricks and elm bowls, Indian cotton durries, simple self-assemble furniture like the Summa range of the mid-1960s – but at costs which individual craftsmen and women could not match. The dream of affordable handmade furniture so dear to a maker like Robin Nance in the 1950s and 1960s proved unworkable in the face of the keen pricing at Habitat. Makepeace and Peters and a group of still younger makers withdrew from that kind of competition by the mid-1970s and bade farewell to some of the social principles which underpinned post-war attempts to make modern furniture by hand. The following decade and a half saw the creation of some of the most intensively crafted handmade furniture of all time and the emergence of a new kind of patron ready to pay for what Makepeace described in his lavish and highly professional promotional literature as 'a creative investment'.[291]

THREE CASE STUDIES

CRAFT AND FINE ART: ST IVES

A map marking out the innovative craft workshops just before the Second World War would show most activity in the South of England, in Sussex, Buckinghamshire and Hampshire and in the Cotswolds and Gloucestershire. From Somerset travelling west there would be fewer workshops and Devon might be as far as an eager collector would wish to go, unless of course, she decided to make a journey to the furthest tip of Cornwall, to the Penwith Peninsula to visit the Leach Pottery at St Ives. Leach's own attitude to St Ives in the inter-war years had been ambivalent. He went to London as often as possible and he was strongly attracted by the community of artists at Dartington Hall in Devon. Indeed, as late as 1945 he was jotting down parallel lists of the pros and cons for moving to Dartington. Dartington, he noted, offered a rich cultural life, easier travel to London and no censure of his complicated private life; St Ives had tourists who bought pots and a better climate and scenery.[1] What is clear is that before the Second World War, Leach felt intellectually isolated at St Ives despite its beauty. He was a member of the St Ives Arts Club and in 1927 he became a founder member of the St Ives Society of Artists. But he appears not to have exhibited much with the Society, who were, by the 1930s, a group of rather old fashioned *plein air* painters. During the Second World War, however, St Ives was transformed, becoming a key site for advanced painting and sculpture.

In 1939, just before war was declared, the critic and painter Adrian Stokes and his wife the painter Margaret Mellis took a house in Carbis Bay, to be joined later that year by Ben Nicholson and Barbara Hepworth and their triplets, and by the Russian constructivist sculptor Naum Gabo. Wartime and its privations meant that unexpected friendships sprang up. A former acrobatic dancer and would-be painter and sculptor, Sven Berlin, began working in Stokes's wartime market garden. Nicholson started teaching a young Cornishman, Peter Lanyon, and in 1940 a Scottish friend of Mellis's, the painter Wilhelmina Barns-Graham arrived. In 1942 Alfred Wallis, the primitive painter whose perspectival oddities had liberated Nicholson and Christopher Wood in the 1920s, died and Leach made him a handsome grave tablet in honey coloured tiles.

During the war the Leach Pottery had managed to keep going with a special licence, and in 1944 two former Slade students and conscientious objectors, Patrick Heron and Richard Kendall, arrived to work there. Leach joined the Home Guard, becoming friendly with Naum Gabo and Denis Mitchell, who had come to Cornwall in 1930 and had begun to paint as well as working as a market gardener, builder, and during the war as a tin miner.[2] After the war the influx continued with the arrival of more painters – including Bryan Wynter and Terry Frost in 1945 and 1946 – and an outstanding craftsman, the printer Guido Morris who in 1946 set up his Latin Press in a netting loft overlooking the sea. In 1949 the typographer Anthony Froshaug, former art editor of the communist paper *Our Time*, set up a hand and foot press in his cottage at nearby Ludgvan.[3] In 1946 Robin Nance re-opened his furniture workshop on the Wharf at St Ives in partnership with his brother Dicon Nance.

For about a decade St Ives was the site of some of the most advanced art being made in Europe. It was also a community which had a place for poets, designers and makers. In this community Leach was a senior figure – aged fifty-eight at the end of the war, three years older

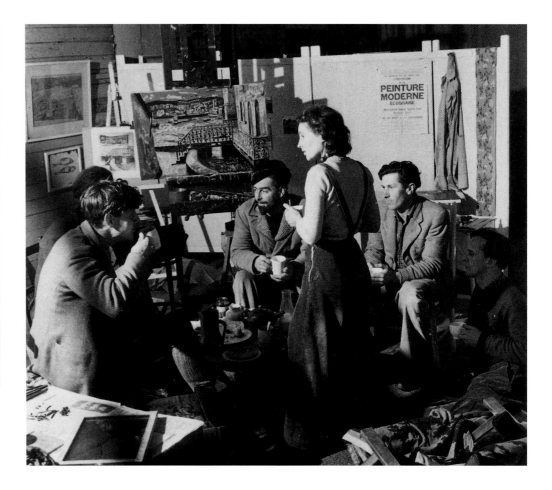

PETER LANYON
EXHIBITION OF
DRAWINGS AND
PAINTINGS AT
THE BOOKSHOP
OF GR DOWNING
FOREST ST IVES
MAY 31 – 12 JUNE
GM

359. Guido Morris, poster for a Peter Lanyon exhibition, 1949, Bembo capitals. (Tate St Ives/Biddie Morris).

360. The Crypt Group, 1947, (*l. to r.*) Peter Lanyon, Bryan Wynter (*obscured*), Sven Berlin, Wilhelmina Barns-Graham, John Wells and Guido Morris in Barns-Graham's studio. (Photo the Central Office of Information. Tate Gallery Archive).

than Gabo, seven years older than Ben Nicholson, twenty-five years older than Patrick Heron. Interesting creative connections sprang up between art and craft in St Ives just after the war. These owed something to the fact that Leach, with his knowledge of the Far East, seemed an impressive figure to the town's newcomers, and that for all his criticisms of art schools and developments in modern art, he in turn admired the new art being made at St Ives. Take, for instance, his relationship with Sven Berlin, who met him after seeing a Tang-inspired horse and rider which Leach had made for Adrian Stokes. For Berlin, struggling to find his way as an artist, Leach's friendship 'was unique and influenced my life'.[4] With Leach he discussed Zen while Leach cooked Japanese meals on a open fire in the pottery, with Leach he met Bryan Wynter, with Leach he read Wilhelm's translation of *The Secret of the Golden Flower* with a commentary by Jung. Berlin ended up feeling bitter about St Ives, but in his vengeful roman-à-clef, *The Dark Monarch* of 1962, one of Berlin's few affectionate portrayals was of Leach as Albert Mantis: 'a good man, not from innocence so much as lack of experience'.[5] Leach was a mediator, suggesting to Barbara Hepworth that she take Denis Mitchell on as an assistant (the beginning of Mitchell's career as a sculptor), writing to the Elmhirsts about Sven Berlin's book on Alfred Wallis after reading and criticising the manuscript, reading out a lecture sent to him by the departed Gabo from the United States to a circle of Gabo's friends at a meeting at the pottery,[6] and writing angrily to the *St Ives Times* to defend abstraction:

It is futile to attempt to judge abstract art by Victorian standards of representation – so-called 'correct' drawing, perspective, anatomy, tonal values etc. – even by accepted canons of European composition, rhythm and so forth – because in our own life-time all the doors of time and place have opened.[7]

The intellectual give and take among artists of all kinds at St Ives from the 1940s gave makers a heightened sense of value.

For instance, Robin Nance's desire to make affordable furniture became mixed with artistic ambition. He argued that the qualities of small-scale abstract sculpture (of the kind promoted by the Arts Council in its *Sculpture in the Home* exhibitions from 1946 till 1958) were also found

in some of the refinements of his workshop's furniture.[8] Certainly the fine lines, shaped and planed by hand, of the Nance workshop's chair arms and chair legs bear out this claim. And Nance himself went to evening classes in carving held by Denis Mitchell and started making small wooden sculptures, 'hand sculpture' meant to be held and turned about. His shop put on exhibitions which showed art and craft; for instance in 1949 Peter Lanyon, John Wells and Leach exhibited together. Nance's workshop also serviced the fine arts and crafts, making wheels for the Leach Pottery, frames for Ben Nicholson's paintings, bases for Hepworth sculptures and lettering cut in wood for 'Sign/House/Boat/Memorial'.[9]

The sense of community was one reason why Guido Morris found St Ives 'an ideal town'[10] for his 'fine printing of every description...carefully executed to the glory of the arts of peace'. Morris saw himself as a jobbing printer serving this rather unusual local community (as Douglas Pepler saw himself at Ditchling). He was ready to take on any work – letterheads, catalogues, bold posters for exhibitions held at Downing's Bookshop (Fig. 359), an ingeniously designed Japanese-looking invitation to the twenty-sixth anniversary exhibition of the Leach Pottery as well as his Crescendo poetry series which appeared in 1952 and which published poets living locally like David Wright and John Heath-Stubbs. Morris's richly-inked, heavy impressions on hand-made paper, his close spacing of type and odd word breaks, gave his work the quality of monumental inscriptions on stone. He wanted to make 'a semantic use of types',[11] an ambition suggestive of concrete poetry or figured verse. For Sven Berlin, Morris's printing formed a counterpoint to the work of the abstract painters and sculptors at St Ives who in turn 'immediately saw its beauty because of his architectural use of space and form'.[12] Froshaug did not get as involved as Morris, although he was, in typographical terms, the real modernist of the two printers. He was there because Cornwall was a cheap place to live and he handprinted because he trusted no one else with his experimental layouts.[13]

In 1946 a small group of younger artists, the painters John Wells, Peter Lanyon, Wilhelmina Barns-Graham, Bryan Wynter and the sculptor Sven Berlin, conscious that they had little in common with the membership of the St Ives Society of Artists, exhibited separately (Fig. 360). Guido Morris showed with their Crypt Group and also created the exhibition's memorable accompanying pamphlet. He explained that he had decided to use 'a device which had precedent at least from the early sixteenth century. The word "catalogue" was too wide to fit the measure of the page, and I set "catalo" in large capitals duly letter-spaced; and in much smaller capitals on the next line "gue of an exhibition".'[14] The typeface, the Monotype version of Bembo always used by Morris, was traditional but the effect of the line break was at once classical and modern (Fig. 361). Other printings by Morris were also included in the exhibition, something which Morris believed to be 'perhaps the first time anywhere printing had been exhibited side by side with drawings, paintings and sculpture'.[15]

The Crypt Group became the nucleus of the Penwith Society of Arts in Cornwall, formed in February 1949 after an exodus of modernists from the St Ives Society of Artists. Led by Barbara Hepworth and Ben Nicholson and including Sven Berlin, Denis Mitchell, John Wells and Peter Lanyon as founder members, the Penwith Society decided to include artists and makers and Bernard Leach, Guido Morris and Dicon and Robin Nance were also founder members. They were joined in the 1950s by David Leach, William Marshall, the wrought-iron worker Alec Carne, the embroiderer Alice Moore and Leach's third wife, Janet. Admittedly there was a classificatory system, A for representational artist, B for abstract and C for craftsman. This ruling caused much bitterness, chiefly among the artists where it was seen as a desire for control by the pure abstractionists, headed by Nicholson and Hepworth. As a result Peter Lanyon, Sven Berlin and Guido Morris resigned in protest in 1950.[16] The subsequent history of the Penwith was so troubled that it would be wrong to see it as some kind of Utopian site for art/craft interchange. Nonetheless, the membership of craftsmen and women in a society whose membership included such an impressive array of fine artists is worth meditating on. And, as it turned out, the crafts formed a bridge with the public at the Society's exhibitions, the subject, as one reviewer pointed out of 'immediate admiration' while the paintings and sculptures, which were mostly abstract or

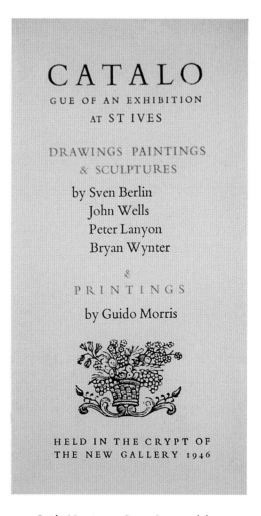

361. Guido Morris, 1st Crypt Group exhibition catalogue, 1946, pamphlet. (Tate St Ives/Biddie Morris).

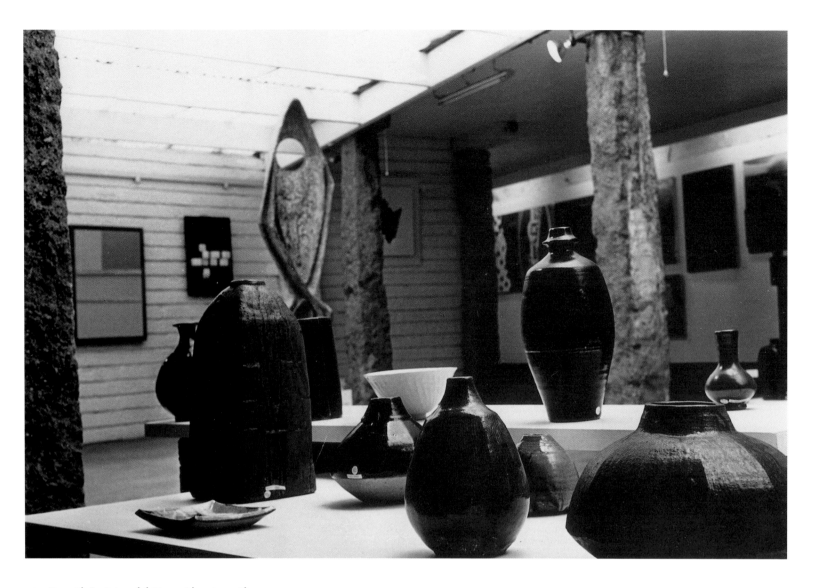

362. Penwith Society exhibition mid-1960s with (*foreground*) Janet Leach pots, (*background*) Barbara Hepworth sculpture. (Photo Irene Winsby).

which alluded very loosely to landscape, provoked 'puzzlement, or often amusement and scorn' (Fig. 362).[17]

One craft, pottery, or at least neo-oriental pottery, fitted in particularly well with the Penwith's early commitment to abstraction. Leach's admiration for non-Western art and thought was shared with the abstractionists. Indeed his artistic values, formed before 1920 in Japan, would still have seemed relatively avant-garde to Nicholson and Hepworth. And in the London art world, the formal canon outlined by Clive Bell in his *Art* of 1914 – the book Leach had read with a shock of admiring recognition back in Japan in 1915[18] – was still largely in place. For instance, one of the first exhibitions staged in 1947 by the newly formed Institute of Contemporary Art (ICA) was tellingly entitled *40,000 Years of Modern Art*, and its introduction by Herbert Read, incidentally President of the Penwith Society, argued for the timelessness and universality of great art. The exhibition was filled with objects ranging over all periods and cultures. These juxtapositions were hardly new ones but they still looked radical and inspirational. Only in the early 1950s was this high minded formalist standard undermined by the activities of the Independent Group, with their interest in consumerism and mass-media culture.

A sense of continuity with the inter-war years was marked in the writings of Patrick Heron. After his spell at the Leach Pottery he returned to painting and swiftly became a leading young British artist as well as a perceptive art critic, articulating the concerns of his fellow painters at St Ives. He also discussed ceramics and weaving in articles in the *New English Weekly*, the *New Statesman and Nation* and *The Listener*.[19] Heron was surprisingly sensitive to the crafts, partly perhaps because of his time at the Leach Pottery but also because of his background – his aunt Kathleen Heron had trained as a weaver with Ethel Mairet in 1916 and, as we have seen, his

363. T.S. Haile, Jug, 1947, slipware. h. 30.5cm. (Private collection).

father Tom Heron had managed the St Ives-based firm Crysède from 1925, setting up his own fine art-orientated Cresta Silks in Welwyn Garden City in 1929.[20] Heron's writing was usefully connective, in the sense of creating links with the dominant discourses of painting and sculpture. He recognised the importance of the pots of T. S. Haile (Fig. 363), killed in a car crash in 1948, pointing out that Haile had anticipated Picasso's pottery experiments at Vallauris with an 'essentially contemporary' decorative idiom rooted in pre-Columbian art, in 'primitive cave and rock paintings as well as the most calligraphic moments of Klee and Braque'. In Heron's view Haile's were 'the first modern pots that bore any relation to contemporary painting'.[21] To make Leach's work directly relevant to recent modern art was a more complex task. But Heron wrote of the 'massive blunt rhythms which seemed buried just below the surface of a pot' and saw a 'formal rhythm' in the ceramics of Leach, Hamada and Murray which he believed had much in common with the post-war paintings of Braque.[22] Here Heron made simple isomorphic links, seeing in Braque's 1942 *Washstand* a pot identical to the Leach Pottery's Standard Ware lemonade jug. Heron also, like Bell and Herbert Read in the late 1920s, saw studio pottery as an example of pure form. For Heron, the crafts of weaving and ceramics functioned as 'the most consistent receptacles of abstract art'.[23]

By the close of the fifties the cohesive community which had sprung up at St Ives after the war was crumbling. The presence of Barbara Hepworth and Bernard Leach, however, provided a sense of continuity (Fig. 364). They also provided work for would-be artists. Hepworth was at the height of her fame in the 1950s and 1960s and both artists and makers worked as her assistants, including the craftsmen Dicon Nance and, from 1959 until 1962, Breon O'Casey. Nance's sad brushes with Leach and Hepworth were discussed in Chapter Four. Things worked out better for O'Casey. He was the son of the playwright Sean O'Casey, educated into

364. Barbara Hepworth dressed as the sun and moon, Bernard Leach in evening dress, Penwith Society New Year's Eve party, early 1960s. (Photo Irene Winsby).

365. The New Craftsman, St Ives: Francis Bacon seated in an Arne Jacobsen 'Egg' chair with Hans Coper pots in the background, mid-1960s. (Photo Irene Winsby).

366. Janet Leach glazing a pot, the Leach Pottery, early 1960s. (Photo Irene Winsby).

bohemianism at Dartington School.[24] After the rigours of National Service he decided to become an artist. He ended up a painter, print maker, jeweller, and in the 1980s he took up weaving. He had briefly been to the Slade but St Ives was his real art school and he learnt from Denis Mitchell, for whom he worked initially, and from Hepworth. Other artists in St Ives were making jewellery and he took it up. The great German designer and jewellery maker Naum Slutsky had taught him metalwork at Dartington and he had seen photographs of Alexander Calder's jewellery. He studied African and Egyptian examples. His own work, in whatever medium, had an archaic purity. This was especially true of his jewellery which used 'timeless' materials – silver, turquoise, amber – in a 'timeless' fashion.

St Ives in the 1960s remained a good place for lost souls to look, learn and live in poverty. The extraordinary light and the neolithic landscape between St Ives and Zennor made up for a lot. Bryan Illsley arrived in Cornwall in the early 1960s. In the background was a working class childhood, an apprenticeship to a stonemason, National Service and a nervous breakdown. While in hospital he began to think of himself as an artist. Living in some privation, first at St Agnes, he educated himself along Basic Design principles:

> I bought a roll of paper...Each evening I painted on it, with Chinese ink and black ink, small squares. One after the other, in lines like writing and four or five lines per session. It was not exact but kept within limits. Neither too neat nor too loose, the only licence I allowed was the first square of each Sunday's entry could be painted red...before leaving, I unrolled it from one end of the room to the other. It was beautiful. That was abandoned at St Agnes.[25]

In 1964 he started working at the Leach Pottery as a packer and clay mixer. As Janet Leach recalled 'he would never have fitted into Bernard's programme at the Pottery, learning to make repeat ware, pre-designed, in numbers of 50 to 100.'[26] Janet herself was a subversive presence at the Pottery from 1956 onwards (Fig. 366). She did not much care for the Standard Ware and she saw herself as more of a modernist than Leach: 'He would stand in front of a Hepworth bronze and talk about Japan!' 'He never read Freud!' It was the contempt of a young wife for a man then in his late sixties. She was appalled by everyday design standards in Britain and brought good European and American design to St Ives when she opened her shop New Craftsman in the mid-1960s (Fig. 365). And the learning and interchange went on. She formed an intense friendship with Hepworth whose work she had loved as a teenager in Texas and Hepworth taught her about 'being professional'[27]. Illsley, meanwhile, began to make jewellery with O'Casey, becoming his partner in 1968. His personal work was odder, less

367. Bryan Illsley, *Tree with hanging limbs*, 1979, wood and iron. h. 28 cm. (CAA archive).

368. Bryan Illsley in his studio at St Ives. (Bryan Illsley).

comfortable to wear and to look at than O'Casey's jewellery. He had made rough slab-built pots at the Leach Pottery and started on wooden figures and frames, hacked into shape. He painted and drew. Encouraged by Janet Leach, he exhibited with the Penwith Society: 'a small black picture, a bit more crusty and textured than I would desire today'.[28] His was a kind of *arte povera* which was partly shaped by true poverty but also by his desire to transform and animate scraps of material. Like Harry Davis, Illsley was an inveterate recycler, 'a snapper up of unconsidered trifles', but unlike Davis he was a satirist and a surrealist (Figs 367, 368).

It could be argued that the pure form of Leach and Leach-inspired stoneware and the archaism of Morris's printings and Illsley and O'Casey's multiplicity of work were accepted at St Ives because of their inspirational links with the world of early modernism. Leach's pots, for instance, were free from the 'contemporary' look of the tin-glaze ceramics being made by the Central School Picassiettes. Certainly, the initial contact was made through the mutual recognition, by Leach and the artists who arrived in the war years, of a shared classical ground, based on pure form and abstraction. In the end, however, the equality of craft and art in St Ives proved non-exportable because it did not fit into the structures of the metropolitan art world. When in 1985 the Tate Gallery celebrated art at St Ives from 1939 until 1964, the work of Alice Moore and Robin Nance appeared in an 'archive display', while Guido Morris and

Anthony Froshaug were left out altogether and ceramics were given a separate section in the exhibition, and were tucked away separately at the back of the catalogue. The cultural gate-keepers at the Tate disregarded the sense of community special to St Ives, and the particular flavour of a time and place – in which unexpected friendships and allegiances were formed – became blurred. A small history was mislaid.

CRAFT AND DESIGN: THE FESTIVAL OF BRITAIN

If the story of St Ives was retrospectively simplified and skewed in favour of painting and sculpture, the Festival of Britain has mostly been viewed in terms of its presentation of British design at the South Bank Exhibition, dominated by iconic objects such as Ernest Race's 'Antelope' chair and the textiles and wallpapers inspired by the researches of the Council of Industrial Design's Festival Pattern Group. But the South Bank Exhibition was more than just a display of innovative design and architecture. Its purpose was more complicated. The Council of Industrial Design's first major project, the exhibition *Britain Can Make It*, held at the V&A in 1946, had been very much an exhibition of consumer goods, although, as its catalogue made plain, most of the products on display were still unavailable. The crafts were not included, save obliquely in one of the room settings in which imaginary families of different social classes were conjured up – a curate's wife living a modest existence in a small suburban villa collected 'modern pottery'.[29]

The South Bank Exhibition had quite different aims from *Britain Can Make It* and, indeed, from the World and Empire Fairs and Exhibitions of the previous one hundred years. It was not to be a 'trade show of British wares' but to tell 'one continuous interwoven story'[30] of 'The Land and the People' in an inclusive fashion which the whole of Britain would understand and enjoy. The initiative of a Labour government, it was put together in a spirit of war socialism. All the leading designers and architects of the day were involved and the exhibition was meant to be inclusive, honouring every class and region of Britain. The 'story' was worked out in early 1948 by the scientist Ian Cox who asked himself: 'What is it that gives the British character and British achievement such diversity?'[31] It was designed so that each visitor got 'a dress circle seat'[32] at the exhibition. According to the Director-General of the Festival, the editor of the *News Chronicle* Gerald Barry, it was to be 'the people's show, not organised arbitrarily for them to enjoy but put on by them, by us all, as an expression of the way of life in which we believe'.[33] Nonetheless there was a strong element of paternal control about the event and, as the painter Barbara Dorf recalled, 'very much of the Festival was alarmingly like a private club'.[34] If *Britain Can Make It* sought to channel and educate taste, the South Bank exhibition set out to establish 'a normative regime of pleasures and satisfactions'[35] for the nation. And because it was a story with 'a beginning, a middle, and an end' visitors were advised firmly by Ian Cox in the Official Guide to follow a recommended circulation plan, indeed to regard the exhibition as a book, with Hungerford Bridge separating 'the narrative into its two main volumes' each with chapters and paragraphs. Skipping, visitors were warned, might make the story 'mystifying and inconsequent'.[36]

Inscribed in the totality of the exhibition was a complex craft story – suggestive of craft's chameleon identity – which emerges if we, too, obediently follow the route laid down by the Official Guide.[37] In his introduction to the booklet *Design in the Festival*, the director of the CoID, Gordon Russell, explained that 'a small amount of our best hand-work' would be included as 'an important stimulus' to industrial design.[38] This narrow view, as we saw in Chapter Six, reflected the Board of Trade and the Council of Industrial Design's attitude to craft. But whatever view the CoID had of the crafts, Gerald Barry wanted the South Bank exhibition to include the 'whole realm of manufactured goods, handmade as well as factory produced'.[39] As a result when in 1949 the CoID began to create its '1951 Stock List' to provide 'a ready source of well-designed contemporary products for illustrating the story of the South Bank and other exhibitions',[40] the crafts, under the classification 'Handicrafts', were built into the operation. Alexander Murray was appointed CoID Handicraft Officer in 1949 and began making contact with the major crafts societies, visiting individual makers, local

369. Willi Soukop, *Hands grasping wheat* in F.H.K. Henrion's Country pavilion, South Bank Exhibition 1951, h. 366 cm. (© Design Council/DHRC, University of Brighton).

guilds and craft fairs as well as the Principals of art schools. Relations with the Crafts Centre were productive, those with the Art Workers' Guild less so. Murray found it to be 'mainly a talking shop' and 'living in the past'.[41] By 1951 Murray had drawn up a very full list of craftsmen and craftswomen in Britain, annotated with useful comments on the kind of work they produced. However, only a handful of makers on Murray's list was transferred to the main Stock List[42] which by 1951 included 20,000 photographs of products from 5,000 firms and which was available for consultation in the Design Review pavilion at the South Bank. Thus the position of the crafts was a curious one. Murray's list was to prove extremely useful for the designers and theme convenors of pavilions. But it was not fully endorsed by the CoID.

The CoID did not control the individual pavilions, each of which had an architect, one or two 'theme convenors' and a display designer. As it turned out, an exhibition 'designed to tell a story mainly through the medium, not of words, but of tangible things'[43] ended up involving craftsmen and women in a remarkable variety of contexts. Their contribution can be compared with that of the fine artists who operated as individual creators of paintings and sculptures, contributing for instance to the *60 Paintings for '51* exhibition commissioned by the Arts Council, and also working to order making narrative art for the South Bank exhibition. F.E. McWilliam's sculpture of *The Seasons*, Graham Sutherland's mural of *The Land of Britain*, Josef Herman's mural of *Miners* and Willi Soukop's giant *Hands* holding stalks of wheat (Fig. 369)

370. View of Michael O'Connell's *The Variety of British Farming* in F.H.K. Henrion's Country pavilion, South Bank Exhibition 1951. (© Design Council/DHRC, University of Brighton).

were all examples of art put to the service of 'the story' being told at the South Bank.

Visitors were invited to begin their tour a step away from Waterloo Underground Station in the stone-clad cave-like Pavilion devoted to 'The Land of Britain', dominated by Sutherland's majestic semi-abstract mural. Here, in a sequence of dimly lit chambers, was a survey of 'origins', that took in Britain's climate, geology, and geography and led into the brightness of 'The Natural Scene', the air filled with taped bird cries. Displays of plant and animal life in twelve widely differing environments from limestone uplands to the Norfolk coast to the chalky downs were enlivened by aquaria, a woodland garden of wild flowers and in the centre a massive plaster tree sculpted by Willi Soukop for F.H.K. Henrion, the pavilion's designer. Henrion was also the designer of 'The Country' section, housed in a Dutch barn and including real livestock and poultry and an array of agricultural equipment. Visitors entered via an upper balcony gallery where Henrion sited his largest craft commission, Michael O'Connell's *The Variety of British Farming*. The fifty-yard-long hanging, drawn and dyed on rayon cloth, looked like a richly coloured tapestry but O'Connell's paste resist batik was a far cheaper technique (Fig. 370).[44]

O'Connell took his commission seriously, travelling around Britain researching farming methods, starting at Wye College where he learnt about fruit and hop growing. Each of the main panels dealt with a different region, combining stylised but accurately drawn vernacular architecture (Fig. 371), aerial views of field patterns, figures engaged on farming processes, and regional produce – stooks of corn, fruit trees in bloom – set out in powerful heraldic grids. Henrion's other important craft commission, the embroiderer Constance Howard's eighteen-foot hanging of *The Country Wife*, was equally well-researched.[45] Howard showed the

371. Michael O'Connell, *The Variety of British Farming*, detail showing Cheshire haybarns. (Rural History Centre, University of Reading).

372. Margaret Kaye, *The Scottish Loom Worker* in F.H.K. Henrion's Country pavilion, South Bank Exhibition 1951. (© Design Council/DHRC, University of Brighton).

range of crafts practised by the Women's Institutes, from lace-making to basket-making to cookery. The figures of these women, made in padded stumpwork (a quintessentially English seventeenth-century technique) were to scale, each five-eighths life-size. Experts contributed miniaturised examples of each craft and its tools, which were regularly detached and carried off by members of the public until it was decided to put up a guard rail. A fellow embroiderer, Margaret Kaye, created one of a series of tableaux of rural crafts. Her *Scottish Loom Worker* was similarly inventive, using a collage technique to display types of tweed and to create a landscape glimpsed through the window of the weaver's bothy (Fig. 372). Kaye, O'Connell and Howard's personal styles of working were relatively inaccessible and, to an extent, influenced by School of Paris painting. But for these commissions they each set out to provide

373. The Smithy in F.H.K. Henrion's Country pavilion, South Bank Exhibition 1951. (© Design Council/DHRC, University of Brighton).

374. Straw lion and unicorn by Fred Mizen in Robert Goodden and R.D. Russell's Lion and Unicorn pavilion, South Bank Exhibition 1951. (© Design Council/DHRC, University of Brighton).

a detailed readable narrative whose Britishness was reinforced by technique – Howard's use of stumpwork – and genre – O'Connell's synthesis of topography and heraldry and Kaye's *faux naif* embroidered landscape.

In several of the pavilions the theme convenors and designers set up a dialectic, usually between old and new, past and future. These opposites reflected the ambivalence of the exhibition as a whole, which combined a neo-romantic celebration of the land with the promise of technological advance. Thus in 'The Country' pavilion, the advanced techniques of modern agriculture were contrasted with the enduring tradition of craft. The best of the vernacular was presented, including examples of regional basketry, ladles and spoons by the Welsh wood turner James Davies of Abercych[46] (Fig. 191) and Sussex rakes as well as ingenious tableaux – Kaye's loom worker, a basket maker, and a pair of hurdlemakers, the figures wittily woven by the basket maker Pat Tew. But the image of craft was open to question. For instance, a working smithy was to be provided by the Rural Industries Bureau. The RIB was determined to show 'the most up-to-date equipment which is appropriate to a rural workshop of this kind…A smithy showing merely a hearth and anvil would give entirely the wrong impression'.[47] Thus the smithy was manned by shifts of 'living exhibits', working on the anvil but also using an oxyacetylene torch and power tools (Fig. 373).

Against the RIB's determination to be modern must be set Henrion's decision to include work which could hardly be defined as country crafts, from the Crowan Pottery, the Leach Pottery, the Cole brothers' Rye Pottery, and even contributions from London-based Lucie Rie and Steven Sykes. Work in wood similarly included bowls by Dartington Hall Ltd, by Dicon and Robin Nance and by David Pye. The story of the crafts in the countryside emerged as a shaky one, less a seamless continuum of hurdlemakers and thatchers than a partly invented community of artist craftsmen and women.

Handwork had a similar dialectical role in the urban context of the 'Power and Production' pavilion. The main hall of the pavilion was arranged to give 'the impression of a symbolic factory' with machinery weaving carpets, making biscuits, wrapping sweets, complete with shifts of machine minders and even a 'factory manager' to deal with problems and disputes.[48] The visitor was invited to marvel, but was also reassured that there was still going to be a role for handwork. There were demonstrations of silversmithing and jewellery, and instrument making, boot and shoe making, paper making and glass blowing as well as examples of silver designed and made by H.G. Murphy and a young student at the Royal College of Art, David Mellor. Hand printing by Anthony Froshaug crept into a section on the 'The English Renaissance in Printing from 1920 to 1951'. There were fine bindings by Roger Powell, by Sydney Cockerell and Joan Rix Tebbutt and by the trade firm Sangorski and Sutcliffe. As Cox explained, machines had their limitations and there would always be 'craftsmen we cannot replace…We are proud of these men; they are basic to our way of life, of which machines will never quite take charge'.

Following the story round, through the 'Sea and Ships' pavilion and into the Dome of Discovery into the downstream section of the exhibition visitors arrived at the 'The Lion and Unicorn' pavilion. There, a different sort of dialectic was set up. The architects and designers were Robert Goodden and R.D. Russell, both Heads of Departments at the Royal College of Art. Russell, as we saw in Chapter Seven, shared with the RCA Principal Robin Darwin, a distinctly ambivalent attitude to modernity and 'the ill manners and squalor of the twentieth century'. Goodden and Russell's pavilion, in its exploration of the British character, managed to present an oblique critique of the twentieth century simply by omission. Its theme was neatly summed up by the heraldry of the Royal Coat of Arms, whose Lion was held to represent British realism and strength while the Unicorn stood for native fantasy, humour and imagination. The tone was set by Fred Mizen's strawdolly Lion chasing a Unicorn who was pulling a rope to open the door of a great wicker cage out of which flew a flock of white plaster doves, an image of pleasure and peace reified (Fig. 374). The Lion and Unicorn pavilion presented the nation as a family, more especially as a family able to share jokes. But many of the references would only have been familiar to its more privileged members. And in the

375. Entertainment in the home, part of a room setting designed by Robin Day, Homes and Gardens pavilion, South Bank Exhibition 1951. (© Design Council/DHRC, University of Brighton).

absence of the kind of mass culture firmly in place by the end of the century, craft and popular art were employed to bridge the gap with the pavilion's high culture of paintings by Constable and Shakespeare folios. Goodden and Russell believed that one aspect of Britishness – along with eccentricity, a sense of humour and instincts for liberty – was 'skill of hand and eye', expressed through a tradition of craftsmanship in cabinet-making, gun making, the making of fishing tackle and fine tailoring.[49] These highly regulated trade crafts, associated with upper-class leisure pursuits, were generously represented. A more fanciful, expressive kind of national identity was exemplified by lively embroidery by Constance Howard and Margaret Kaye, sprigged tiles by Steven Sykes on the theme of the British character, pottery by Bernard Leach, glasses engraved with insects and landscapes by Laurence Whistler, exquisite knives made by Catherine Cobb, a silver water jug by Leslie Durbin and a carved wooden Lion and Unicorn painted in a bright fairground fashion by Barbara Jones.

The adjacent pavilion presented craft in quite a different context. The 'Homes and Gardens' pavilion was full of goods from the CoID's Stock List. Here craft was co-opted as a branch of good modern design. So, although a 'Breakfast bar and Kitchen' was dominated by manufactured fittings, there was the reappearance of carved spoons by James Davies of Abercych, Harry and May Davis's hard-wearing Crowan pottery, further ceramics by Helen Pincombe and by the Rye Pottery, a set of beakers and a jug by Lucie Rie and a handwoven rug by the founder of Edinburgh Weavers, Alastair Morton. A hobby room for a farmer included bowls by David Pye, tiles by Steven Sykes and Hoptonwood stone panels with lettering cut by David Kindersley. A room devoted to 'Entertainment at Home', designed by Robin Day, concentrated on pleasurable stimuli (Fig. 375) – a cinema projector, a record player, a Dolmetsch lute, sculptures by Reg Butler and Barbara Hepworth, pottery by David Leach, Marianne de Trey, Steven Sykes, Hans Coper, Lucie Rie and William Gordon and rugs by Highland Home Industries designed by Jean Milne. Certain crafts and makers proved

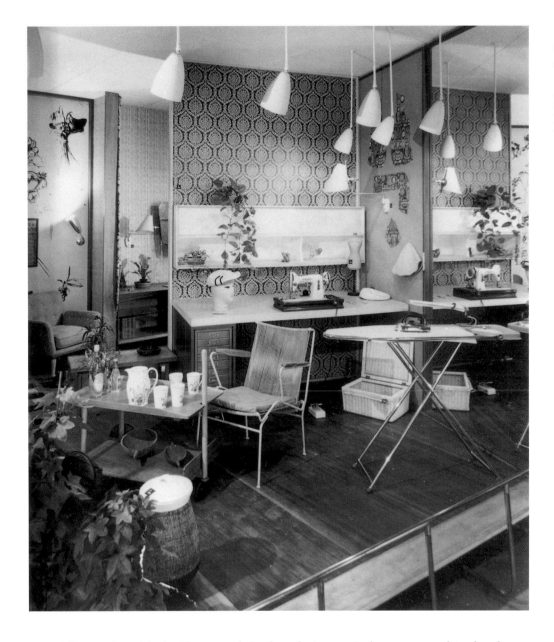

376. Hobbies and the home, room setting designed by Robert and Roger Nicholson, Homes and Gardens pavilion, South Bank Exhibition 1951. Note the lidded Lucie Rie jar in the foreground and on the trolley, David Pye bowls and Eric Ravilious's lemonade set for Wedgwood. (© Design Council/DHRC, University of Brighton).

especially popular with the Homes and Gardens designers. Basketry appeared in abundance. Handmade pottery was a popular alternative to industrial ceramics, led by the Leach Pottery, the Crowan Pottery and Lucie Rie and Steven Sykes. And no room in the 'Homes and Gardens' pavilion was complete without a carved platter or bowl by David Pye (Fig. 376). His work, like much other craft, was also shown in 'The Country' pavilion and the 'Lion and Unicorn' pavilion, illustrating the remarkable capacity of craft objects to carry multiple meanings.

At the South Bank show, and in its associated travelling exhibitions, craft provided the ideal narrative object, telling a multiplicity of stories with ease. Firstly – as shown by Constance Howard's hanging for 'The Country' pavilion and by the demonstrations by 'living exhibits' such as blacksmiths – craft was still able to provoke wonder through a display of technical virtuosity. Some craft – basket making for instance – conjured up 'timeless' rural communities. Other crafts – boot-making or silversmithing – stood for a disappearing urbanism of small workshops alive with skilled artisans. Craft, in 'The Lion and the Unicorn' pavilion, could suggest quirkiness and eclecticism while in the 'Homes and Gardens' Pavilion it could function as a useful adjunct to CoID approved modern design. In a generalised way, craft was a condensed way of suggesting 'Britishness' or perhaps, more accurately, 'Englishness'. Craftsmen at work making cricket bats and balls, tying fishing flies and stitching saddlery in the pavilion devoted to 'Sport' stood in for that part of the story (Fig. 377). In a more playful fashion, so did the silver tea service, designed and made by a team from the Royal College of Art, which was used by George VI and Queen Elizabeth at the

377. Cricket bats being made in the Sport pavilion, South Bank Exhibition 1951. (© Design Council/DHRC, University of Brighton).

378. Silver parcel-gilt tea service with embossed and chased decoration, 1950–1 designed by Robert Goodden and made by Leslie Durbin to be used by King George VI and Queen Elizabeth at the opening of the South Bank Exhibition 1951. h. (hot water jug) 25.7 cm. (V&A Picture Library).

opening of the Festival in May 1951. This was a charming essay in high camp, a prank dreamt up during a country house weekend, with cast snakey sea-monster handles and spouts, shell lids, chased wave motifs and engraved riddles in couplets composed by its designer Robert Goodden (Fig. 378).[50]

Finally, one of the triumphs of the South Bank was to present Britain as a united family, but a family made more varied and interesting by class difference. In 'The People of Britain' pavilion a series of tableaux charted our ancestors from the Stone Age to the Anglo Saxons. Waxworks were clothed in textiles spun, dyed and woven by Elizabeth Peacock who, on the instruction of the theme convenor Jacquetta Hawkes, embarked on a painstaking programme to create historically accurate outfits for these hirsute half-scale figures. The task was a daunting one, especially as it emerged that 'the cloths of early Britain were renowned

throughout Europe'. As Ella McLeod recalled, the different qualities of the dress of 'warrior and chatelaine, hut-dweller or high born child' were carefully researched: 'For the very finest textures Elizabeth resorted to merino and spun it herself'.[51] Thus visitors learnt that the British 'family' had always had its hierarchies and, thanks to Peacock's patriotic enthusiasm, an intangible was made tangible, through craft (Fig. 379).

The South Bank show and its travelling exhibitions were not the only sites for craft in the Festival. The Crafts Centre mounted its own general members exhibition while an exhibition of conservative contemporary church art was held at Lambeth Palace. In Scotland, craft and design were represented by extremes. In Edinburgh the Scottish Committee of the CoID arranged *Living Traditions of Scotland*, a survey of Scottish applied art and architecture, about a quarter of which were examples of contemporary craft, suggesting a Scottish pastoral continuum independent of England. In Glasgow a quite different Scottishness was projected by a sophisticated exhibition of *Industrial Power* which concentrated on the steel industry and shipbuilding. The differing images of Glasgow and Edinburgh were further underlined by two Festival book exhibitions – contemporary book production at Glasgow and eighteenth-century books for genteel Edinburgh.

At the Whitechapel Art Gallery, the Arts Council and the Society for Education through Art

commissioned the artist and collector Barbara Jones to mount a show of the kind of 'popular art' admired by Enid Marx and her circle before the war. Jones was heavily involved in the South Bank exhibition, but her show *Black Eyes and Lemonade* presented a harsher anti-pastoral folk culture of bargee and sailor art, of hobbyists and gypsies, mixed in with advertisements, trades union banners, seaside souvenirs, Valentines, Christmas cards and ribald seaside postcards. There was a 1951 fireplace in the shape of an Airedale dog, a three-foot-high model of St Paul's Cathedral in icing sugar, ships in bottles, a church made of matchsticks and a talking lemon extolling the virtues of Idris squash. Jones, by arguing that 'there is a flawless popular eye', cocked a snook at the CoID's propagandising activities.[52] She was a regular contributor to the *Architectural Review* and *Black Eyes and Lemonade* reflected the magazine's post-war ambivalence towards modernism and towards the CoID. The craft at the Whitechapel, much of it amateur and eccentric, would not have won favour at the Crafts Centre or at the CoID. But Nikolaus Pevsner, one of the *Architectural Review*'s editors, shared Jones's vision. His attitude to modernism had changed during the war and he now saw craft as an important counterpoint to design for manufacture, providing 'the personal, the fanciful, perhaps even the irresponsible'. Reviewing the CoID 1951 Stock List he noted: 'In Sweden and other countries the bodies – private bodies – promoting good design consequently concern themselves with craft as well as industry. Does the CoID? Should it? It does not seem very clear on this point.'[53] In fact, for the rest of the 1950s the CoID took little interest in the crafts, leaving its promotion to the Crafts Centre of Great Britain. As we have seen, in the 1960s when state funding for the crafts was withdrawn by the Board of Trade, the CoID was keen to take responsibility for the crafts, but only on its own terms – as a research and development tool for industry. In 1951, however, craft crept into the South Bank exhibition almost *faute de mieux*, and it is at the South Bank, amid what Dylan Thomas remembered as 'a place of trains, bones, planes, ships, sheep, shapes, snipe, mobiles, marbles, brass bands and cheese',[54] that we find the best summary of its uncertain mid-century identity.

CRAFT AND ARCHITECTURE: COVENTRY CATHEDRAL

In the wake of preparations for the Festival of Britain, the possibility of collaborating with architects was much discussed in craft circles.[55] The interest was, on the whole, one sided. Architects, especially those employed by local authorities, had little time for partnerships which seemed irrelevant to the urgent task of rebuilding. The *Architectural Review* posed some questions: 'the word craftsmanship has become hopelessly dated. Why? From its association with handicrafts. From its unsuitability as a definition of precision building and manufacture? Possibly.'[56] Hopes were raised by the inclusiveness of the South Bank pavilions, filled with sculptures, murals and hangings. And a handful of prestigious buildings of the early fifties, designed in the decorative style which came to be associated with the Festival, had a strongly crafted quality – even if they employed few artist craftsmen and women.

The Royal Festival Hall, completed in 1951, and the only permanent building on the South Bank site, was a remarkable example. It was the work of the LCC architect Robert Matthew in collaboration with Leslie Martin and Peter Moro. Because in the immediate post-war period few quality products could be ordered ready-made from catalogues, Moro, who took charge of the interior, designed most of the interior fixtures and fittings – from door handles to the auditorium music stands to the carpets. He and the other designers involved – Robin Day, Jesse Collins and Milner Gray – did not, of course create the furniture, door plates and engraved glass themselves;[57] but Hilary Bourne and Barbara Allen made a real craft contribution, designing and handweaving two sets of heavy reversible curtains of striking abstract design to screen off the restaurant and to function as a room divider in the upstairs meeting room (Fig. 314).

The 1953 Time-Life building in New Bond Street was another highly crafted 'Festival' building. Its interior was designed by Hugh Casson and Misha Black[58] and, according to Lionel Brett, writing enthusiastically in *Design*, it was intended to look 'consciously and deliberately British in character'. Brett pointed out that: 'No such brief would have been conceivable in the

'thirties, when the sole aim of advanced designers was to contribute to an international movement which was still too immature to have split into national channels.'[59] As with the South Bank 'Lion and Unicorn' pavilion, Royal College of Art tutors and former students were heavily involved and the whole scheme exemplified the early 1950s taste for the decorative at the Royal College. In the search for a new specifically British post-war modernism, Casson had, according to Brett, 'picked on the craftsmanship of the sub-industrial age, the coachbuilder, the bookbinder, the metalworker'.[60] Tooled leather and wood panelling dominated the interior, suggesting a light-hearted adaptation of the aesthetic which characterised London clubs like the Garrick and the Athenaeum. The emphasis on the urban trade crafts, rather than the expressiveness of the artist craft movement, was exemplified by a tooled and overlaid leather map of the world carried out by the trade bookbinders Sangorski and Sutcliffe and an elaborate banister designed by Robert Goodden in black cow hide tooled and patterned with lacquered brass studs (Fig. 380). The LCC architect and muralist Oliver Cox designed decorative panels bonded in plastic for the cafeteria. Neo-classical curtains designed by F.H.K. Henrion were block-printed by Michael O'Connell. Substantial sums were spent on commissioned fine art, with a mural by Ben Nicholson and sculpture by

380. Time-Life building, New Bond Street, 1952–3, interior designed by Hugh Casson and Misha Black, showing iron sculpture by Geoffrey Clarke, stoneware floor ashtrays by Hans Coper and Lucie Rie, Robert Goodden's balustrade with black tooled leather and brass studs and a mural by Ben Nicholson. (British Architectural Library, RIBA, London).

381. Baker Street coffee bar with a ceramic relief by Margaret Hine, 1950.(William Newland family archive).

382. Nigel Henderson, Eduardo Paolozzi, Alison and Peter Smithson, a view of 'Patio and Pavilion', their joint contribution to *This is Tomorrow*, Whitechapel Art Gallery 1956.

Geoffrey Clarke, Maurice Lambert and, most notably, by Henry Moore.[61] The only examples of pure artist craft were Hans Coper and Lucie Rie's handsome monumental ashtrays, disposed like boulders on the floor of the entrance foyer. A similar brand of Royal College of Art luxury characterised the interior fittings of the cruise liners *Canberra* and *Oriana*. These were all commissions that hovered between crafts and design, being prestigious, one-off and often delicately decorative. Another, less formal, off-shoot of the Festival style was developed by William Newland and Margaret Hine in their ceramic reliefs and figurines for coffee bars from the mid-1950s onwards (Fig. 381).

The Festival style, with its notable borrowings from Scandinavian public buildings and from the Milan Fair of 1948,[62] was endorsed by the *Architectural Review*, whose editors, in particular Nikolaus Pevsner, conjured up phrases like 'The New Empiricism' to suggest an adapted modernism for British consumption and argued for a return to the 'eminently English' Picturesque[63] as a way of humanising the cityscape. Such ideas were greeted with hostility and disapproval by architects for whom true Modernism remained firmly international, informed by the developing work and theory of Le Corbusier and of Mies van der Rohe. Alison and Peter Smithson, James Stirling and James Gowan, Colin St John Wilson and the rather older Denys Lasdun all saw themselves as part of this continuing Modern Movement project. That the Smithsons happily appropriated the sobriquet 'the New Brutalism' in 1953 suggests a serious rejection of the Festival Picturesque. Their historicism was different too; Rudolf Wittkower's pioneering *Architectural Principles in the Age of Humanism* of 1949, with its lucid exposition of the mathematical logic of Palladian architecture, was a key text. What was important from a

383. Concrete relief by William Mitchell, housing estate, Wandsworth, early 1960s.(Photo Henk Snoek/British Architectural Library, RIBA, London).

384. William Mitchell in the mid-1960s.(Photo Irene Winsby).

craft perspective was that although these architects paid particular attention to the structural use of brick, concrete, steel and glass, the materials were left to speak for themselves, unadorned.

The contacts made by these architects with other areas of visual culture were unlikely to lead in the direction of craft. The Smithsons formed a close working friendship with Eduardo Paolozzi and Nigel Henderson. If there was to be any adornment it would be primed by their tastes and interests and by that of other members of the loose association known as the Independent Group, centred on the ICA. In 1953 the Smithsons, Paolozzi and Henderson collaborated on a show for the ICA, *The Parallel of Life and Art*. They drew on scientific and technical journals, finding fresh imagery in x-rays of tumours in rats, in microphotography and charts of electronic circuits, mounted as an oppositional anti-aestheticism. As we saw in Chapter Eight, in 1954 Paolozzi and Henderson had started Hammer Prints which until 1961 produced short runs of textiles, wallpaper and tiles. But in 1956, working on the interior of the Smithsons' contribution to the exhibition *This is Tomorrow* at the Whitechapel Art Gallery, they moved with ease to a conceptual position. *This is Tomorrow* presented twelve collaborations between artists and architects, all of which challenged received views of painting and sculpture, let alone craft. James Stirling summed up the shared attitude: 'Why clutter up your building with 'pieces' of sculpture when the architect can make his medium so exciting that the need for sculpture is done away with and its very presence nullified. The painting is as obsolete as the picture rail.'[64] Paolozzi and Henderson, and indeed all the exhibitors, firmly rejected what passed for modernism at St Ives – the pure forms of direct carving so admired

by the ICA's founder Herbert Read, 'timeless' early art and the achievements of the great masters of the pre-war School of Paris – which were the main sources for the post-war craft renaissance.[65] Instead, they chose to 'furnish' the Smithsons' 'Patio and Pavilion' using photo-collage, some plaster sculpture, and junk *objets trouvés* as 'symbols for all human needs' – a rusty bike wheel, a toy plane, a light-box to stand for hearth and family (Fig. 382).[66] Craft, grounded in material and process, could hardly have conveyed the existential mood.

The wonder and strangeness of *This is Tomorrow* did not, however, generate collaborations with artists, not even the 'antagonistic co-operation' envisaged by Lawrence Alloway in the exhibition's catalogue. Instead the Smithsons, Colin St John Wilson, Stirling, Ernö Goldfinger and the other architects involved went on to design buildings with a marked lack of commissioned art.[67] As John Summerson pointed out in 1959, 'the architect's actual medium – the material of building – is being drawn out of his control…Today a man may conceivably have more influence on the world of appearance by devoting himself to the sectional profiles of pre-fabricated windows or curtain walling.'[68] By the late 1960s few architects would have regarded this dependence on a mass of subsidiary manufacturers as a drawback. It was a given and a spur to rational planning. Nonetheless, the bleakness of 1960s public housing in particular was recognised. But schemes to brighten up the entrances to high rise blocks did not call on the skills of makers and tended to be technically robust – mosaics made of broken commercial tiles, murals made from chipboard carved with a router and inlaid with coloured resin and the artist William Mitchell's reliefs made from shuttered concrete (Figs 383, 384).[69]

The church/chapel/cathedral was one building type where the crafts might have been expected to retain an unchallenged role. The organic humanism of Le Corbusier's chapel at Ronchamps, completed in 1955, pointed the way, while a homegrown renaissance in the crafts of stained glass, tapestry and silversmithing after the war suggested all kinds of collaborative possibilities. But even in the field of church architecture battle lines were drawn. An allegiance of sensibility brought together architects like the Smithsons and Stirling, architectural historians and critics like John Summerson and Reyner Banham and Church of England clergy involved in the Liturgical Movement in an ethically-based opposition to adornment. Of the many churches built in the 1950s and 1960s, two in particular came to stand for stasis and progress in ecclesiastical architecture – Coventry Cathedral, which occupied the architect Basil Spence from 1951 until 1962 and St Paul's, Bow Common, a modest church in Tower Hamlets by Robert Maguire and Keith Murray begun in 1957/8 and completed in 1960. Both had highly crafted interiors but came to craft by different routes and with markedly different results.

Dug in on the beaches of Normandy on an overlong D-Day, Basil Spence confided to a fellow officer that his ambition was 'to build a cathedral'. Spence, a former assistant to Edwin Lutyens, had built up a pre-war practice designing country houses in Scotland, some modernist and some vernacular and historicist.[70] His time in the Army Camouflage Unit led on to post-war exhibition design work, including *Britain can Make It* and the imaginative 'Sea and Ships' pavilion at the South Bank exhibition. In 1951 Spence won the competition to rebuild Coventry Cathedral (Fig. 385), beating submissions by Peter and Alison Smithson and Colin St John Wilson. From the start Spence had the great cathedrals of the Middle Ages in mind as a model – 'I would have aisles, stained glass, a marble floor, a great tapestry, choir stalls.'[71] His building was to be 'a jewel casket with many jewels inside'.[72] For an Edinburgh Scot, this kind of richness had a special meaning. In Scotland an architecturally based Arts and Crafts movement had continued into the 1920s, exemplified by Sir Robert Lorimer's remarkable collaborative National War Memorial of 1924–7 (Fig. 118) and Phoebe Traquair's elaborate mural schemes. Spence's Scottish background was one reason why Coventry was to be the greatest artistic opportunity offered to artist craftsmen and women in the twentieth century. Yet by the time it was consecrated in 1962, Coventry was seen as an anachronism and in histories of modern architecture it has tended to be quietly ignored.[73]

Spence worked in constant collaboration with the Bishop of Coventry and the Provost and Chapter. Coventry was nonetheless to inspire memorably negative comments from an

important avant-garde of clergy involved in the Liturgical Movement. Why so? The Liturgical Movement had emerged within the Roman Catholic church in Belgium, Germany and Austria between the wars. Its aims were radical – to examine the practice of the liturgy, in particular the celebration of the Eucharist, to remove ceremonial accretions in order to recover some of the simplicities of the early church, and to restore truly communal active worship. These ideas had important architectural implications, making, for instance, Spence's choice of a Latin cross plan appear old-fashioned. As early as 1958 the Reverend Peter Hammond, the Church of England's leading architectural theorist, predicted that 'the new Coventry promises to be a particularly spectacular example of architectural form following an inadequately conceived function'.[74] Spence had asserted that he wanted the Cathedral 'to turn a visitor into a worshipper'.[75] But for Hammond it was the active act of worship itself which was important. The Liturgical Movement required architects to forget 'all about apses, spires and stained glass'[76] and concentrate, like the architects of new schools and mass housing, on a 'functional analysis' of circulation and use-patterns in the context of religious practice. As Hammond pointed out 'it will be time enough to think about cathedrals when we have succeeded in creating a few 'liturgical sheds' of the most modest kind.'[77]

Hammond believed Christianity had been warped by the great churches of medieval Europe with their Latin cross plans, rich adornment and remote altars. During the Second World War priests conducted services in prison camps and on battle fields.[78] For Hammond, a chapel like Rainer Senn's Saint-André in Nice, built for a mere £50 for the Companions of Emmaus, a community of rag pickers, out of off-cuts of wood with a floor of loose pebbles, a central altar and a roof of bituminised paper summed up the beauty of holiness.[79] As a contributor to Hammond's *Towards a Church Architecture* of 1962 pointed out, 'you fall into dangerous aestheticism whenever you think of beauty by itself.' Ultimately the act of worship was the main thing – 'we must beware of giving the church building a significance it does not possess.'[80]

Spence believed in the significance of church building. He was also sensitive to an ideal of collaboration and he allowed his artist craftsmen and woman (Margaret Traherne was the solitary woman involved) remarkable creative freedom. His first commission went to Graham Sutherland, for the great tapestry planned for the East end of the Cathedral (Fig. 386). This was his most difficult partnership – partly because of the sheer scale of the commission and

386. (*opposite*) View down the nave showing the Graham Sutherland tapestry, Coventry Cathedral 1962, Sir Basil Spence and Partners. (Photo John Donat).

387. (*above*) Nave windows, Coventry Cathedral, (*left*) Geoffrey Clarke, detail of purple window, (*right*) Lawrence Lee, detail of red window showing Man and Woman lying between a diapered circle representing the seed of the Word of God flanked by symbols of the God of Sun and the Key of the Nile. (Photo Garrick Palmer).

388. (*below*) Margaret Traherne, experimental panel in *dalle de verre*. (Margeret Traherne).

the difficulties of translating Sutherland's design and colours into tapestry. The only other well established artist involved was John Piper, who designed the abstract Baptistery window. But Piper already had a close collaborative relationship with the stained glass artist Patrick Reyntiens and the success of their window owed a great deal to Reyntiens's interpretative skills. In other areas Spence picked young and less well-known collaborators who found themselves both wrestling with iconographic problems and making monumental work for the first time.

For the ten seventy-foot-high nave windows Spence turned to the Royal College of Art where the stained-glass department under Lawrence Lee had two students, Keith New and Geoffrey Clarke, producing innovative glass inspired by School of Paris painting. Spence saw the windows as 'a job for guild'[81] and commissioned the three to work as a team. Lee explained that Spence set out a colour scheme: 'green, red, multi-coloured, purple and gold to symbolise a progression from birth to death'.[82] No further iconographical programme was provided either by Spence or by the Provost and Chapter. The three studied the German calligrapher and typographer Rudolf Koch's *Book of Signs*, a collection of symbols including masons' marks, signs of the Cross and Byzantine monographs.[83] New's sketchbook for the commission shows that he was studying Koch and looking for an intellectual focus. His researches, touchingly dependent on the Third Programme inaugurated in 1946, could hardly have been more rooted in the period and involved cutting out religio-philosophical articles from *The Listener*, reading C.E.M. Joad on *The Recovery of Belief* and transcribing passages from T.S. Eliot's *Murder in the Cathedral* and snatches of C.S. Lewis and W.H. Auden. Clarke, meanwhile, was already a deeply spiritual young man whose 1952 RCA degree essay *Exposition of a Belief* argued for the importance of symbols in the search for 'the indefinable which is to

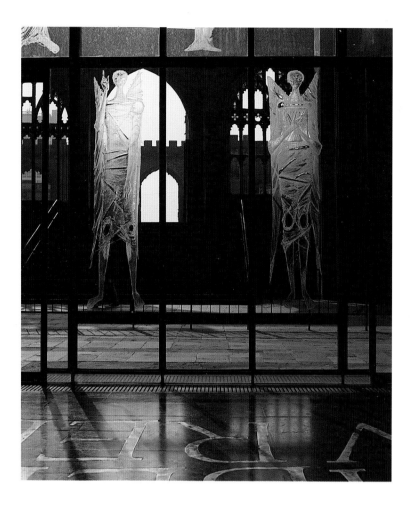

389. Steven Sykes, Gethsemane Chapel, Coventry Cathedral 1962, Sir Basil Spence and Partners. (Photo Henk Snoek/British Architectural Library, RIBA, London).

390. John Hutton, detail of the West window of Coventry Cathedral viewed from the interior showing (*left to right*) the Angel of the Resurrection and the Angel of Gethsemane. (Photo Garrick Palmer).

be revealed.' New and Clarke, exerting a modernist influence on Lee, managed to create a new language and new techniques for stained glass during the course of the commission. The way in which the glass was painted (with Clarke in particular inventing his own 'dabbing tools')[84] had a real affinity with the painting practice of the early 1950s, in particular with the work of Alan Davie and Graham Sutherland (Fig. 387).

Spence did his best to seek out artists who were taking their chosen craft to its limit. For instance, he saw a small exhibition of stained glass and *dalle de verre* glass held by Margaret Traherne in her flat in Cadogan Place in 1956 (Fig. 388) and commissioned her to make the ten soaring windows for the Chapel of Unity, completed in 1960. He sought out his friend from the Army, the painter Steven Sykes, whose sprigged ceramic panels had been so popular at the South Bank Exhibition. For Coventry Sykes used an experimental technique — cast concrete set with a mosaic of glass, tiles, and crystal. He made two panels for the little Gethsemane Chapel, of the angel Michael with a chalice and of the sleeping disciples. This was a Byzantine pastiche, vulgar but extraordinarily effective, the extensive use of gold leaf making it the brightest jewel in Spence's casket (Fig. 389).

Spence chose artists whom he believed capable of creating religious art in a contemporary idiom. John Hutton, another wartime comrade, who had subsequently worked on exhibitions with Spence, failed where the stained-glass artists, working abstractly, succeeded. For the engraved glass screen at the West end of the cathedral he created a stylised figure type for an array of angels and saints (Fig. 390). His sources, carvings he had seen at Vézélay and Chartres, were indisputably fine, but the end result was reminiscent, as Reyner Banham pointed out, of the 'forced and arty style'[85] of book illustration practised at the Royal College of Art. Its main flaw was not Hutton's fault. As a massive West window, which actually faced south, the screen was too reflective and let in too much light, to the detriment of the stained glass within.

A more fruitful collaboration developed with the letter cutter Ralph Beyer. In the original competition brief, provision was to be made for eight 'Hallowing Places' for private prayer. By 1957 the Provost decided that what was wanted was 'a series of sculptures (or possibly

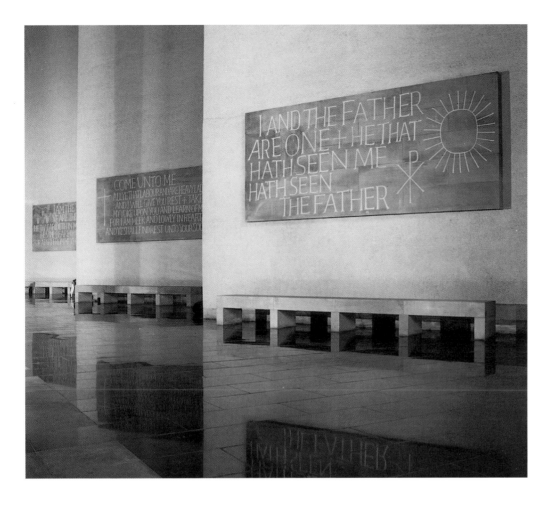

391. Ralph Beyer, three of the eight Tablets of the Word carved in Hollington stone, 1961–2, Coventry Cathedral 1962, Sir Basil Spence and Partners. (Photo John Donat).

392. Chapel of Christ the Servant with Geoffrey Clarke's cast aluminium canopy, two candleholders by Hans Coper on the altar designed by Anthony Blee and Hans Coper, lettering carved by Ralph Beyer, Coventry Cathedral 1962, Sir Basil Spence and Partners. (Photo Henk Snoek/British Architectural Library, RIBA, London).

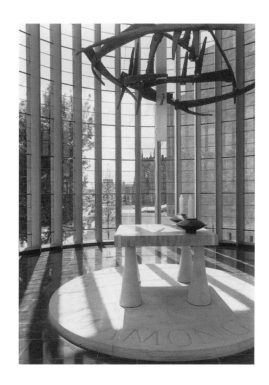

pictures) proclaiming the life of the Son of God on Earth...these should be clearly understood by the common people.'[86] Provost Gorton admired Eric Gill and saw his kind of relief sculpture performing the role of a *quattrocento* fresco cycle, educating a latterday crowd of Coventry groundlings. Spence, on the other hand, had since 1956 preferred the idea of inscriptional lettering[87] as a more appropriate way to communicate with 'the common people' in a country with universal literacy. Introduced by Pevsner, he turned to Beyer whose striking altar inscription for the Royal Foundation of St Katherine's in the East End of London of 1954 (Fig. 343) must have seemed a model. Beyer's line carvings of doves were based on the powerful simple drawings found in the Roman catacombs, the subject of his father Oskar Beyer's pre-war researches into catacomb art. In 1954 Oskar Beyer's *Frühchristliche Sinnbilder und Inschriften* appeared and Beyer showed this beautifully illustrated book to Spence. The linkage with the symbolism of the nave glass must have been immediately apparent and it was decided that Beyer should carve eight New Testament texts and appropriate symbols. Some, like Beyer's image of the Good Shepherd, were directly taken from his father's study.[88]

Spence recalled of these Tablets of the Word: 'We agreed that the letters should not be stereotyped Roman or Gothic or any other letter but should be 'felt' – some irregular, some smaller than others, but each one a piece of incised sculpture in its own right.'[89] Spence's main intervention was a significant one. He insisted that the lettering used in a trial panel be scaled up in size. This was a decision which conflicted with the intimate spirit of catacomb art; Beyer, after all, was carving into stones measuring fifteen feet by six. Thus Beyer made a remarkable success of a difficult commission, given that spontaneity and informality were difficult to combine with letter carving on such a grand scale (Fig. 391).[90] This was not the only instance of Spence's fondness for monumentalism. Coper's enormous candleholders on the altar (Fig. 393), the twenty-foot altar itself and the massive altar cross were other examples, suggesting that Spence had some inkling of the liturgical debate and sought to present the essence of religiosity through a kind of neo-primitivism and massification.

Perhaps the most remarkable contribution to Spence's jewel casket was made by Geoffrey

393. Hans Coper, three of the six stoneware candleholders for the high altar, Coventry Cathedral 1962, Sir Basil Spence and Partners. (Photo Henk Snoek/British Architectural Library, RIBA, London).

394. Geoffrey Clarke, silver-gilt high altar cross and candleholder 1962, Coventry Cathedral 1962, Sir Basil Spence and Partners. (Photo Henk Snoek/British Architectural Library, RIBA, London).

395. (*opposite*) The font, a concrete cast octagonal block holding a Doulton 19-gallon industrial stoneware 'copper' with a slate cover raised by a standard industrial hand-hoist, St Paul's, Bow Common, Tower Hamlets, 1961, Maguire & Murray. (Photo Robert Maguire).

Clarke, a multi-talented figure with a hands-on approach to making of all kinds. At Coventry, as well as designing and making three of the nave windows, he also proved to be an imaginative designer of sculptural crosses and altar sets. His first commission, completed in 1958, was a nickel bronze cross with inlaid crystal slabs that could be electrically lit for a chapel in the Cathedral undercroft. This was something of a novelty, but in 1961 Spence commissioned him to make the high altar cross. Spence was disappointed with a traditional design by Robert Goodden which he felt would have looked incongruous placed before the Sutherland tapestry. Clarke designed and cast a powerful silver-gilt cross which translated Sutherland's biomorphism into sculpture (Fig. 394). And he went on to design and make the dramatic aluminium Flying Cross for the Cathedral flèche, employing his invented method of sandcasting using expanded polystyrene. He also used this technique to make an aluminium Crown of Thorns for the Chapel of Christ the Servant (Fig. 392).

Despite Spence's commitment and dedication to the project, when Coventry was completed clergy like Peter Hammond found that their fears had been justified. Hammond deplored 'the primacy of the visual', arguing that a modern church should not be 'a sort of jewelled cave in which the solitary individual may find some kind of worship experience'.[91] His criticisms had some point. Coventry was unashamedly visual, its East end dramatically remote, dominated by the altar, which, Hammond pointed out, was unrelated to the human scale of a shared celebration of bread and wine. Hammond believed that for Spence the function of the altar was primarily sculptural, noting that 'its relationship to the worshipping congregation is far less important than its relationship to the great tapestry on the East wall.'[92] Hammond's view was shared by architecture critics like John Summerson, who before the cathedral was completed speculated as to whether Coventry would be the religious building of the century or 'only the most striking pavilion of religious art of the century'.[93] For Reyner Banham, an admirer of the Smithsons and a member of the Independent Group, Coventry was 'the worst setback to English church architecture for a very long time'. He dismissed the

396. The interior of St Paul's, Bow Common, Tower Hamlets, 1961, Maguire & Murray. (Photo Martin Charles).

Cathedral as 'trad, dad...a medieval long plan with aisles and off-lying polygonal or circular chapels, but executed in non-medieval materials (in part) and adorned with devotional art-work in various non-medieval styles'.[94]

Banham's hostility was based on a set of principles shared with architects he admired and with Liturgical Movement figures like Peter Hammond. He admitted he was almost seduced by the stained glass, by Sykes's eye-catching mosaic and by Spence's splendid entrance porch with its masterly handling of space. But, in Banham's view, Coventry was neither architecturally nor liturgically modern and he recommended as a panacea the 'quiet austerities' of St Paul's, Bow Common, in the East End of London.[95] This 'unpretentious parish church', the outcome of 'a systematic application of functional analysis', was also singled out by Hammond as a corrective to Coventry.[96]

Robert Maguire and Keith Murray's St Paul's, Bow Common (1958–61), was undoubtedly built to be an effective 'liturgical shed'. It also had its own craft aesthetic. The architects, who first met in 1952, came from different, complementary backgrounds. Maguire, who had trained at the Architectural Association, was steeped in modernism in fine art and architecture. Murray had started his working life at the Victorianate church furnishing firm Watts & Co, designing ecclesiastical embroidery. He subsequently trained in the silversmithing department at the Central School and, using the name Keith Feilden, collaborated on church work with the silversmith Michael Murray. In 1954 they worked with Ralph Beyer on the re-

ordering of the Royal Foundation of St Katherine in Butcher Row. The priest-in-charge, John Grocer, was interested in the Liturgical Movement and introduced Keith Murray to Gresham Kirkby whose Victorian Gothic church at Bow Common had been damaged by bombing. Father Kirkby was a left-wing priest who came to Bow Common in 1951. He was High Church and Communist in the Thaxted tradition. His curate, John Rowe, was a 'worker-priest' employed in a nearby brewery. Thus the St Paul's commission was shaped by Kirkby's radicalism, requiring Maguire and Murray to immerse themselves in the Liturgical Movement, mapping the interior functionally to create 'a pattern of relationships'[97] around a centralised altar and a processional outer aisle.

Maguire and Murray made a virtue of a limited budget, using cheap materials, stock bricks and a floor of pre-cast standard concrete paving flags, in order to 'celebrate the ordinary'.[98] The font was made from a standard industrial stoneware copper for boiling laundry set in concrete. Its cover was Welsh slate and it was lifted on a five-hundred weight industrial hoist made by a dockside firm (Fig. 395). The West doors, intended for ceremonial entrances such as weddings, rolled back on sliding tracks as in a warehouse. The corona was made up of standard rolled steel sections bolted and welded by a construction firm (Fig. 397). The steel L-beams of the ciborium were also of high quality. If tugged, the corona oscillates, an intentional feature which for Maguire made pleasing allusion to mobiles by Alexander Calder and for Murray made manifest an eleventh-century description of lights moving in Hagia Sophia in Constantinople.[99] There were little touches of luxury. The candle sconces on the corona were of purple glass, specially made in Murano. The ciborium was roofed in thin sheets of serpentine and white Carrara marble. The altar was of plain concrete but the altar cloth was of Thai silk designed by Murray and embroidered at Watts & Co.

Spence had wanted to 'turn a visitor into a worshipper'. This was not Maguire and Murray's aim but a concession to passers-by was made in the form of mosaics of angels above the colonnade which they believed would 'play their part particularly when the church is empty, helping those alone in the building to be aware of the relationship between their worship and the worship of heaven'.[100] Ultimately it was the organisation of space in relation to the altar which they saw as 'far more important than any of the bits and pieces which shape it'.[101] All the fittings in the church were intended to speak in an aesthetic language which the architects believed the congregation would understand and respect (Fig. 396). They had in mind a labour aristocracy who would appreciate 'the intrinsic value of cheap good materials and good work'.[102] Ralph Beyer was the only artist craftsman to be given a commission. At Coventry he

398. Shutter cast concrete lettering by Ralph Beyer for the porch of St Paul's, Bow Common, Tower Hamlets, 1961, Maguire & Murray.

carved in stone but at Bow he used humbler materials. The sight of Beyer's dramatic inscription THIS IS THE GATE OF HEAVEN,[103] shutter-cast in concrete over Murray and Maguire's bleakly functional porch (Fig. 398), made manifest the power of 'celebrating the ordinary':

> And lo, Christ walking on the water
> Not of Gennesareth, but Thames!

St Paul's was demonstrably highly crafted and had the effect of making Coventry seem overwrought because, in tribute to the priest and congregation, its architects sought to emphasise industrial craft skills rather than those of the artist crafts. Maguire and Murray went on to create some of the most humane architecture of the next two decades. But the austerity of Bow Common was replicated less intelligently in many other contexts in the 1960s, above all in public housing. Coventry, on the other hand, led nowhere. The crafts of stained glass, silver and metalwork and inscriptional carving had been given an opportunity which was not to be developed. (Frederick Gibberd's Roman Catholic Cathedral at Liverpool, completed in 1967, was really a populist rerun of Coventry, employing several of the same artists) (Fig. 265). In fact, in its grandeur Coventry hardly seems definable as 'craft,' in the sense of the work being shown at the Crafts Centre of Great Britain, at Primavera or at the Craftsmen Potters' Shop. But if it was not craft what was it? Applied art? Decorative art? A last gasp of the Arts and Crafts Movement? It is difficult to say. What Coventry achieved, however, was the translation of some of the painterly and sculptural concerns of the early part of the 1950s into other media. By the time Coventry was consecrated both the art and craft looked 'out of date'. And, as Chapter Eight suggested, art/craft transferences became less convincing as the 1960s wore on. Nonetheless the dream of architectural collaboration survived, privately, in the minds of makers, getting nowhere very much in the 1970s. By the 1980s, it suddenly seemed desirable to adorn buildings again. A handful of makers were ushered, blinking into the bright light of very different places of worship. Under the banner 'Craft Means Business', dreamt up by the reformed Crafts Centre (by then renamed Contemporary Applied Art) they were given the chance to work on a large scale, but in this instance to make corporate craft for the lush foyers of the enterprise culture.

1970–1990

'SHEER ENJOYMENT': THE 1970S

A WHIM OF IRON

In June 1970 the Conservatives won the General Election. The assumption in the craft world – that a Tory government meant less money for the arts – proved incorrect. Edward Heath's eve of election promise to help the crafts was fulfilled generously. On 3 December 1970 Lord Eccles, the Paymaster General (a Treasury post with responsibility for the arts, delegated from the Department of Education and Science), told the House of Lords that he was taking charge of the crafts together with his other responsibilities for the Arts Council and associated arts bodies.[1] On 28 July 1971, speaking in the House of Lords, Eccles announced the creation of a Crafts Advisory Committee (CAC) which was 'to advise the Paymaster General on the needs of the artist craftsman and to promote…a nation-wide interest and improvement in their products'. Lord Raglan, farmer and vintage car enthusiast, asked what exactly an 'artist-craftsman' was. The term 'designer-craftsman' had long been employed by the former Arts and Crafts Exhibition Society which in 1959 had renamed itself the Society of Designer-Craftsmen. 'Designer-craftsman', a distinctly contemporary sounding term suggesting useful links with design for industry, was also used in the 1948 constitution of the Crafts Centre of Great Britain. 'Artist craftsman', on the other hand, had been the hopeful, poetic job description employed by Bernard Leach in *A Potter's Book*.[2] Lord Eccles did not elaborate on the genesis of 'artist craftsman' but it was obvious where his sympathies lay: 'My Lords, I think I may say that this is a very difficult definition; but clearly there are craftsmen whose work really equals that of any artist in what one might describe as fine arts; there are others who are really very nearly industrial producers. Our intention is to go for quality first.'[3] The term continued to cause confusion and the CAC's first published report, *The Work of the Crafts Advisory Committee 1971–74*, explained that 'artist craftsman' described makers whose work 'although often rooted in traditional techniques, has an aim which extends beyond the reproduction of past styles and methods'.

Lord Eccles's interest in, and generosity to, the crafts both as a collector and as a minister contrasted with his hostile attitude towards the Arts Council. He was far more culturally conservative than his predecessor Jennie Lee, regarding the permissiveness of contemporary theatre as 'a cesspool' and expressing worry in the House of Lords at Arts Council funding for 'works which affront the religious beliefs or outrage the sense of decency of a large body of taxpayers'. For Lord Eccles, a patrician connoisseur, opinionated, self-assured and a shade priggish, the crafts represented a safe haven, an antidote to the libertarianism of radical theatre, 'happenings' and community arts projects (Fig. 399).[4]

At first the Crafts Advisory Committee had no formal legal status. It was initially under the wing of the CoID (from 1972 the Design Council) which provided accommodation until the CAC moved to 12 Waterloo Place off Piccadilly in London in 1973.[5] Its funding was minuscule compared with the Arts Council. Its first proper grant was £200,000 for the year 1971–2 as compared with the Arts Council's then annual grant of over £20 million. But it was on the same level, intended to be an enabler, with the power to give money to craft bodies. These included the battered, heroic Crafts Centre of Great Britain, suddenly dwarfed by Eccles's creation. Crucially, the CAC funding now came not from the Department of Trade and Industry (the former Board of Trade) but from the Arts branch of the Department of

399. Lord Eccles with his collection of studio pottery, 1981. (Photo Phil Sayer).

Education and Science.[6] Thus the Crafts Advisory Committee was swiftly able to establish a new image for the crafts, closer to fine art practice than to design. The humiliating need to prove to an unsympathetic Department of Trade and Industry that somehow the crafts were enriching industrial design came to an end. As a result the 1970s witnessed a virtual reinvention of the purpose of the crafts. Stripped of ideology and social responsibility, the crafts began to function unashamedly as treasure,[7] remote from the issues of design reform which had surfaced in the mid-nineteenth century, and from the earnest discussions of crafts and 'the machine' and links with industry which had dominated the previous three decades.

Even before the 1970s ended there was a strong sense that the decade had witnessed a remarkable craft revival.[8] Excited, misleading comparisons were made with the Arts and Crafts Movement of the previous century. A new kind of artist had been officially recognised by a gender-deaf government as the 'artist craftsman'. The Crafts Advisory Committee was able to launch its own magazine *Crafts* in 1973, start a full exhibition programme and, perhaps most encouraging of all, administer a grant scheme which included 'Young Craftsmen Grants' to enable craftsmen and craftswomen to start their careers. As we saw in Part II of this book, there had in fact been a remarkable efflorescence of activity in the 1950s and 1960s in which a whole range of crafts became more expressive. The 'new' era was, therefore, partly the result of a new institution's propagandising activities.

By the end of the decade the crafts had a history, mapped by the art critic and poet Edward Lucie-Smith. *The Story of Craft* was designed as a companion to Ernst Gombrich's classic *The Story of Art* but it was specifically written to provide a context for the 1970s renaissance. It was a sure-footed survey, moving briskly from neolithic flints to Renaissance goldsmithing to eighteenth-century furniture manufacture to the Industrial Revolution and, finally, to the Arts and Crafts Movement and the design movements of the twentieth century. To the careful reader it suggested the fragility of the social role of the modern maker, as compared with his eighteenth-, nineteenth- or even early twentieth-century counterpart.

Throughout the 1970s Lucie-Smith wrote perceptively about contemporary crafts and anatomised their success in a sequence of neat, perhaps too neat, sketches of cause and effect. He believed that the avant-garde fine art of the 1970s, minimal art and conceptual art which put 'less and less emphasis on the physical act of making or creating an object',[9] was inaccessible to all but a small coterie. A public hungry for displays of skill and virtuosity therefore turned to the crafts for solace. He argued that painting and sculpture departments in art schools continued to be male dominated but 'unlike the fine arts, the crafts have never been sexist'.[10] Thus the craft revival went hand-in-hand with the growth of feminism. The

success of the crafts was compared by Lucie-Smith with other cultural shifts such as the validation of science fiction as literature. Then again, there was a burgeoning green movement for which the crafts of the 1970s operated as a form of resistance to mass industrialisation. Thus the modern maker, in Lucie-Smith's view, had become 'an ideal, even heroic figure, living out in practice the values which most people could only half-heartedly aspire towards'.[11] This idea of the 'heroic' maker was also favoured by *Crafts* magazine; one of its early editorials identified a 'daring and arrogant creature who demands a life in which there is no sudden division between the personal and the professional…a free being'.[12]

All these ideas had some foundation. In particular the ecology movement of the 1970s did indeed call into question the very validity of product and industrial design. An apparent failure of nerve over technological progress had penetrated deep into the art schools (and, as we shall see, into the heart of the Establishment), to the benefit of the crafts. The writings of Misha Black, Emeritus Professor of Industrial Design at the Royal College of Art, documented a marked disillusionment with design as a profession among his own students. They sought validity for their discipline by concentrating on socially useful products like hospital equipment. This anti-design mood, buoyed up by books like Victor Papanek's *Design for the Real World* (1970), surprisingly gained Black's support and sympathy; Black saw the crafts as the antithesis of conceptual art's nihilism and as 'a reaffirmation of social value'.[13]

But for Black's colleague David Queensberry, Professor of Ceramics and Glass at the Royal College of Art, the drift away from design was worrying rather than reaffirming. In the early 1960s he decided to broaden his department's intake to include 'aspiring artists, designers, studio potters and sculptors using ceramic materials'. This 'wider spectrum' had initially worked well. But from the early 1970s he found that the majority of applicants for places at the College appeared to put 'an overwhelming emphasis on a fine art approach' and few seemed interested in careers in the ceramics industry. The students in his Department solved the dilemma of design morality which troubled Black's students by opting to work in a fine art spirit. Queensberry blamed the foundation courses in art schools which, he found, were invariably taught by painters and sculptors who typically projected a career as a designer as pedestrian and unexciting. Thus students, particularly in textiles, ceramics, furniture, silversmithing and graphic design, moved towards what Queensberry called 'para-art activity' where 'the emphasis is only to try to hold together a certain innate creativity.' These students, Queensberry explained, were working

400. Robert Marsden, a pair of silver cups, 1971, hand-raised bowls, lost-wax cast bases, h. 15 cm. (Private Collection).

401. Fred Baier, *Pattern Maker* chest of drawers, 1976, sycamore stained metallic grey, h. 122 cm. (Neil and Dot Henderson).

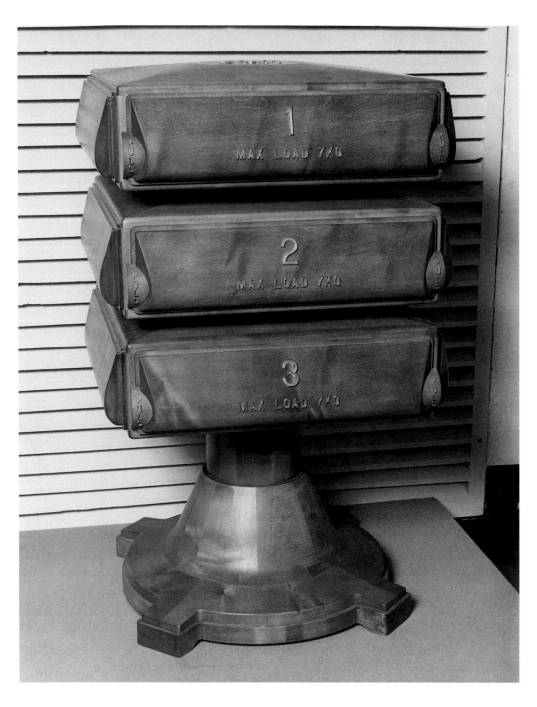

with a whim of iron. It is a fine art approach to subjects that have been from an historical point of view, related to products. It may well be that this approach is an escape from the problems of our time. And because of those problems people bury themselves in a private world of fantasy.[14]

Queensberry's 'whim of iron' was equally at work in the College's Department of Silversmithing and Jewellery where tutorial visits from modernist designers like David Mellor and Robert Welch were greeted with little enthusiasm and where two students, Robert Marsden (Fig. 400) and Michael Rowe, were making objects that would not have looked out of place in a Renaissance princeling's Kunst- or Wunderkammer. Rowe saw himself as a modernist, but he was clearly working in a spirit very different from, say, Welch. He was inspired by early modernism in the fine arts, music and literature rather than in the machine aesthetic. He believed in 'the sovereignty of the artist'[15] and was not interested in design for production (Fig. 415). Similarly, in the Department of Furniture in the late 1960s Richard La Trobe-Bateman had already begun to resent 'a hidden curriculum which decreed that all design had to embrace new materials, new techniques and new arrangements of the parts.'[16] Fred Baier, in the same Department from 1973 to 1976, rebelled against this 'hidden

curriculum' which he saw as a mixture of 'Form follows Function' modernism and Cotswold craftsmanship. In his degree show Baier paid ironic homage to Britain's declining industrial base, offering a chest of drawers which simulated the wooden pattern made for the moulds used to cast a piece of industrial plant (Fig. 401). Privately and rebelliously Baier had coined the term 'Form Swallows Function'.[17]

The 'new' crafts of the 1970s remind us how inter-war makers had been profoundly inspired by a mixture of modernist precepts ranging from truth to materials and spontaneity of facture to functionalism. An interest in the pure form of other cultures remote in time and place – the kind of vision which made possible an exhibition entitled *40,000 Years of Modern Art* – underpinned the inter-war craft enterprise. The approved sources of inspiration for the crafts remained largely unchanged after the war. The same canon of excellence had reigned – the great masters of the School of Paris, the sculptor Brancusi, the home-grown sculptors Hepworth and Moore, African carvings and pre-dynastic Egyptian pots. Equally, it was assumed that a proper appreciation of the crafts demanded a certain level of education. As we have seen, David Canter had compared stoneware pottery to Bach fugues, explaining that 'anything worth aesthetic enjoyment has to be worked at'.[18]

But at the start of the 1970s young men and women who had gone through the art schools in the late 1960s were ready for a reinvention of the crafts. If they were curious and intelligent, students of ceramics and jewellery and textiles had already absorbed a very specific new canon of excellence. Photos and surviving film of Dada and Surrealist events and the more poetic performative aspects of Bauhaus activity were studied in colleges of art with a delighted shock of recognition.[19] Perhaps less usefully Marcel Duchamp, the subject of a Tate retrospective in 1966, became many a student's chosen philosopher[20] and his negative counsel – that art should not be made unnecessarily, that it possibly need not be made at all – exerted a powerful hold. In the early 1970s two sociologists, Charles Madge and Barbara Weinberger, studied the interaction between students and tutors at a provincial art school and found an almost complete rejection of traditional painting and sculpting skills.[21] At foundation level, where a Basic Design approach dominated, students were encouraged to question the purpose and meaning of work conceptually. Ideas were as important as objects and this approach to art was institutionalised at the highest level. As the National Advisory Council on Art Education explained in 1970: 'We believe that studies in fine art derive from an attitude which may be expressed in many ways.'[22] The conceptual art of the late 1960s – manifesting itself variously as Body Art, Performance, Land, Process and Time Based Art – came to seem a model for a handful of young craftsmen and women.

Students were reading more and were taught design and art history as part of the compulsory complementary studies component of DipAD (from 1974 the degree was renamed Bachelor of Arts in line with university first degrees). The result was unexpected. As Reyner Banham pointed out, 'the teaching of Modern Design made students into Historicists, not Modernists.'[23] Departments of Three-Dimensional Design all over the country were producing students whose attitude to functionalist design was ambivalent. Reading Pevsner's *Pioneers of the Modern Movement* had the surprising effect of making students long for ornament.[24] There was a growth of interest in popular culture, which went beyond the rarefied researches of the Independent Group, while the first books on kitsch and 'Art Déco' appeared in the late 1960s and early 1970s. What the film maker Derek Jarman called 'Art Déco blight' swept the homes of David Hockney and Andy Warhol. Previously neglected historical styles were being investigated mixing, as the potter Alison Britton neatly put it, 'Sèvres with Krazy Kat'.[25]

The makers of the 1970s emerged as experienced consumers, aficionados of flea markets, ready to enthuse about an immense range of heterogeneous sources, both visual and literary. As a student Mary Restieaux started buying ikats from Pip Rau's shop in Islington and these were to form the basis for her own painterly variations on this weaving process.[26] For the potter Paul Astbury, a keen collector of tin toys, 'comics like *Eagle* and characters like Dan Dare took great effect'.[27] The furniture maker David Field made a 'Tardis' wardrobe for his

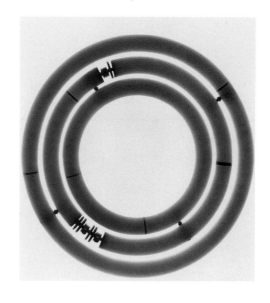

402. David Watkins, *Gyro* bracelet, 1974, gold and white acrylic, diameter 13 cm. (David Watkins/Crafts Council).

403. Slow work: Donald Jackson, detail of *Alpha and Omega* 1979, texts from Genesis and the Book of Revelations. Vellum coloured with gouache washes applied with a sponge. Written and illuminated with black Chinese stick ink, gouache, raised and burnished gold, gold leaf applied to gum ammoniac and powdered gold. 79.5 × 77.5 cm. Commissioned by the Victoria and Albert Museum. (Photo Donald Jackson).

1971 RCA degree show. The potter Glenys Barton was inspired by J.G. Ballard's *Terminal Beach* and by the precise eerie sets of Kubrick's film *2001 A Space Odyssey*[28] which, coincidentally, David Watkins had actually helped construct before turning to jewellery.[29] And Watkins's early dyed acrylic and gold neckpieces looked like the kind of ceremonial collars which might be worn by important extra-terrestrial visitors (Fig. 402). Silversmith Robert Marsden was reading *Lord of the Rings* and making cups to match. As we have seen, Tolkien's writings also captivated the bookbinder Philip Smith and were to inspire a remarkable calligraphic sequence by Donald Jackson.[30] Eclectic visual sources, filmic simulacra, super-realism and trompe d'oeil effects characterised the crafts of the 1970s. These objects were time consuming to make (Fig. 403). Carving an illusory knot in ivory was slow work for Caroline Broadhead while Elizabeth Fritsch would 'squander days, even weeks, on the making and painting of one vessel'.[31] The jeweller Charlotte de Syllas learnt a whole set of new skills each time she made a piece (Fig. 404). A hawk ring carved by Malcolm Appleby while at the RCA from a block of steel and inlaid with silver took nine weeks to make.[32] Touch, speed of facture and spontaneity were not central to the crafts of the 1970s. The result was an array of handmade objects with complex visual resonances. A potter like Elizabeth Fritsch or a silversmith like Michael Rowe had by the mid-1970s altered expectations of their disciplines. Both certainly made objects which came out of that 'private world of fantasy' which Queensberry found so alarming. The work tended to be peculiarly photogenic. It was also often ironic and subtly parodic (Fig. 405).

Irony lay behind one of the most successful textiles ventures of the 1970s. Ann Sutton's First International Exhibition of Miniature Textiles in 1974 was a tongue-in-cheek exercise, intended to deflate the increasingly large wall hangings being made for the Lausanne Tapestry

404. Slow work: Charlotte de Syllas, Head ring, carved chalcedony and gold; box, carved partridge-wood, 1968; ring 2.5 × 4 cm. (Photo David Cripps).

Biennale. Sutton discovered: 'It was not too difficult to start an International Movement…After the fourth show it had to be stopped for its own good.'[33] Indeed the makers of the 1970s can almost be divided into the knowing ironists and those who continued to be inspired by the old modernist canon. The former group rejected 'good design' in favour of complexity and excess. But their sophisticated, mannered comments on the nature of things were only a small part of the resurgence of the crafts in the 1970s.

The buoyant craft economy was firmly rooted in rather more straightforward work which satisfied a hunger for handmade objects among middle-class men and women. The 1970s saw new outlets for the crafts – in London the Majorie Parr Gallery, which had moved from St Ives, was beginning to show ceramics in the early 1970s, Amalgam had opened in Barnes in 1973, the Casson Gallery and Atmosphere both opened in 1974. In 1975 David Mellor reorganised his kitchenware shop in Sloane Square in order to show more studio pottery and glass. In 1969 the Craftsmen Potters' Shop had moved to handsome new premises in Marshall Street. Electrum showed innovative jewellery from 1971. Out of London, the Oxford Gallery had opened in 1968,[34] David Canter's Craftwork was in Guildford from 1971, with a branch in Newburgh Street from 1977, moving into Heal's from 1978 until 1980. Canter also helped fund the Cider Press Centre, selling crafts at Dartington in Devon from 1977. In 1977 Ann Hartree opened the Oxfordshire Prescote Gallery in farm buildings owned by Ann Crossman, the widow of the Labour minister, financed in part by the proceeds of the Crossman Diaries.[35] She concentrated on innovative furniture and helped set in train the furniture renaissance of the 1980s (Fig. 407). In 1974 Hugo Barclay opened Barclaycraft in Worthing. The existence of these galleries – and older establishments like Henry Rothschild's Primavera, by 1969 in

405. Slow work: Elizabeth Fritsch, *Optical Cup* 1975, stoneware, h. 20 cm, *Tall Optical Cup* 1975, stoneware, 26 cm, *Optical Mug* 1975, stoneware, h. 14 cm. (Photo David Cripps).

406. Stephen Rotholz, barbed wire necklaces, bracelet and brooch, mid-1970s. (Photo David Cripps).

Cambridge, Peter Dingley's Gallery in Stratford-upon-Avon, the Midland Group in Coventry and the Bluecoat Display Centre in Liverpool and above all the British Crafts Centre – suggests that the craft renaissance of the 1970s was a reality. (And these were just the best known galleries. In 1974 the magazine *Country Bizarre*'s guide to alternative life styles, *Country Bazaar*, listed over two hundred rural craft shops and galleries in England and Wales.[36])

The bread and butter of the mainstream shops and galleries consisted in selling work by makers who had come to the fore in the 1960s – well-made stoneware by Richard Batterham, Michael Casson, David Leach, Lucie Rie and Robin Welch, wall hangings by Peter Collingwood, blown glass by Sam Herman, Fleur Tookey, Annette Meech and Pauline Solven, wearable, relatively expensive jewellery by Gerda Flöckinger, Helga Zahn and Wendy Ramshaw.[37] The younger ironists had their own outlets. In 1972 Christopher Strangeways opened his eponymous shop at 105 King's Road.[38] He had wanted to show modern furniture designers but soon began a trawl through art school degree shows for desirable objects for young customers who were also collecting 'Art Déco' and reading books on kitsch. Ceramics soon came to dominate. The spirit was certainly 'anti-Leach', but it was also distanced from the seriousness of the sculptural stoneware of the 1960s. Roger Michell and Danka Napiorkowska's Walking Teapots,[39] at first made by hand in 1973 and later factory produced, generated huge sales by the mid-1970s as did Carol McNicoll's slip-cast flower vases simulating wrapped paper. Strangeways (and the shop Smith & Other backed by Strangeways from 1977 until 1984) were the first to show ceramics by two graduates of the Central School with a memorably surreal vision, Richard Slee and Edward Allington. Allington made subversive ceramic jokes – a teapot with a tea party on the lid, a classical urn covered with silk screen printing. Slee's 1977 show at Smith & Other was inspired by 'Azteckie things…and Las Vegas geometry and an animation thing from Disney' (Fig. 408).[40] Strangeways also showed jewellery by Gary Wright and Frances Robinson, creators respectively of kitsch super-realist 'Fly' earrings and 'Flying Ducks' brooches. Robinson and her brother went on to open Detail in Covent Garden in 1979, dedicated to anarchic stylish non-precious jewellery often made by non-jewellers like Stephen Rotholz. Rothholz was a drop-out graphic design student who in the early 1970s became a master of witty transferable technology put to the service of street fashion; dyeing wrap-around welding glasses black for punks and using PVC tubing, telephone cable, lorry brake hosing and barbed wire to make jewellery (Fig. 406).

Other outlets on the lookout for alternative craft included Nick Morris's shop Ablebest,

407. The interior of the Prescote Gallery, *c.* 1978 showing a chair by Rupert Williamson, a low table by Ashley Cartwright, a chair by Richard La Trobe-Bateman, a sofa by Floris van den Broecke, ceramics by Alison Britton, wooden bowls by Jim Partridge and Paul Caton, batik by Noel Dyrenforth. (Ann Hartree).

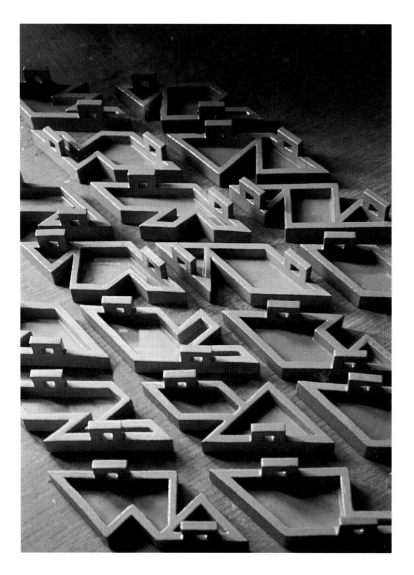

408. Richard Slee, *Twenty One Trays*, 1977, earthenware. (Richard Slee).

Flying Saucer, the Francis Kyle Gallery, the Anthony Stokes Gallery and Browns' Gift Shop run by Tricia Guild. The CAC excluded craft deemed commercial from its Selected Index, but the CAC and the British Crafts Centre were interested in the ironists. There were plenty of crossovers. Both Michael Rowe, a Crafts Advisory Committee favourite from the start, and Andrew Logan, whose broken mirror glass and resin jewellery was then quite outside the CAC remit, had studios at 401½ Workshops in South London set up in 1970 by the designer Michael Haynes to provide cheap space for recent graduates. Haynes chose his tenants carefully. Most had attended the same metropolitan art schools, all were making in a knowing, ironic, witty spirit and throughout the 1970s the Workshop housed talents that were taken up by the CAC, by Strangeways and its imitators, and occasionally by both (Fig. 409).[41]

Thus the craft renaissance was a hybrid, in part fuelled by the increasingly widely disseminated anti-technocracy ideals that led students to turn away from design for mass production to 'para-art' activity. This was matched by a consumer constituency in the connected worlds of fashion and rock music which snapped up the potter Carol McNicoll's ceramics as a rejection of 'good design' (Fig. 410). By the end of the 1970s her cups and saucers had been illustrated on record sleeves and had starred in a *film noir* commercial for Maxell tapes. A more mainstream disillusion with design and indeed with technological progress led middle-class men and women to value handmade goods. Thus part of the craft revival of the 1970s was a continuation of inter-war and 1960s anti-industrial ideas and was loosely linked to other 1970s movements like the Campaign for Real Ale (founded 1971) and SAVE Britain's Heritage (founded 1974). The 1970s renaissance was partly shaped and funded by the Crafts Advisory Committee, aided by a serendipitous situation in which, after four or more years at art school, graduates were able to get part-time teaching in other art schools. If we associate

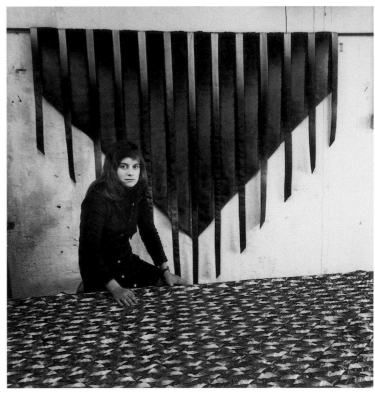

the 1970s with the oil crisis, the collapse of the Heath government, the uncertain Labour years which followed, culminating in the Winter of Discontent, we might forget that the economy was relatively buoyant. The hopeful experimentation of the 1960s lived on in all the arts, albeit in an increasingly alienated form. Traditions were there to be sent up, as when Central School ceramicists produced a private view card announcing a show of 'Twentieth Century Pots from a story by Bernard Leach'.[42] Traditional techniques were to be put to incongruous uses – as when Joanna Buxton translated crudely printed instructions on *How to Use Chopsticks* into high loom tapestry and created a memorable series of tapestries of women travellers using a collage of sources (Fig. 411). All of this began to add up to a culture which many cultural theorists

409. Members of the 401½ Workshop in the mid-1970s (*clockwise*), Carol McNicoll potter, Alison Britton potter, Diana Harrison quilter, Joanna Buxton tapestry weaver. (Photos Sue Wilks).

410. Carol McNicoll, Jug, 1978, slipcast earthenware, coloured slips and sgraffito, h. 25 cm. (Photo David Cripps).

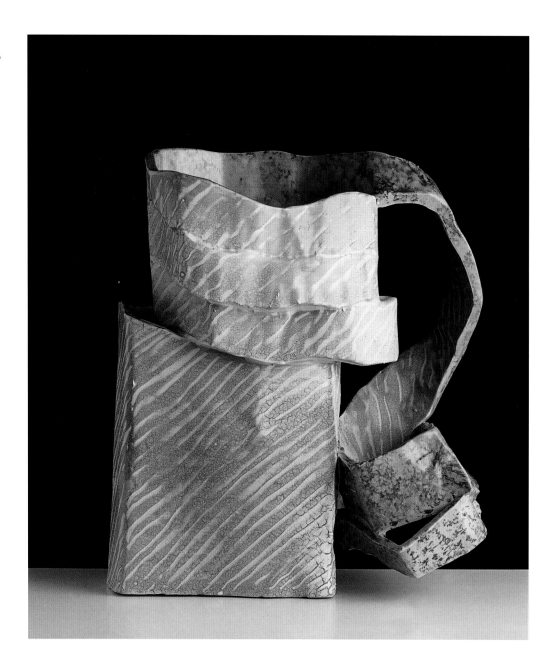

would call postmodern. What is clear is that the 'new' crafts of the 1970s reveal late- or postmodernism at its most playful and untroubled.

NEW DEFINITIONS: THE CRAFTSMAN'S ART

In December 1971 the potter Victor Margrie was appointed Secretary to the Crafts Advisory Committee. As we have seen, Margrie had been closely involved in the politics of the Crafts Centre of Great Britain, helping David Kindersley draw up the discussion paper *Image of a Crafts Centre*. In 1963 he set up the vocational ceramics course at Harrow School of Art. But his own work, exquisitely designed porcelain, had little in common with the sturdy functional stoneware produced by Harrow students and by his co-founder Michael Casson. At the CAC Margrie's taste developed confidently. From the start he had a very clear cut vision of the kinds of crafts the CAC should support, even if he was not particularly good at putting this vision into words. One moment he was recommending the study of Shaker furniture and extolling the achievements of the Bauhaus, the next he urged craftsmen to read Leach's translation of Yanagi's *The Unknown Craftsman*.[43] At the CAC the crafts he supported were modern (in the sense of being manifestly contemporary), exquisitely dandyish (as was his own work) and distinctly orientated towards the fine arts although confusingly he was also a constant advocate of 'good design'.

Led by Margrie the CAC acted to create peace between the existing craft organisations –

411. Joanna Buxton, *How to Use Chopsticks B*. 1978. The second of a series of three hangings, Gobelins technique. 30.3 × 44 cm. (Joanna Buxton/Crafts Council).

the Crafts Centre of Great Britain and the Crafts Council of Great Britain. The Centre merged with the Council in May 1972, creating a new body, the British Crafts Centre (BCC) which retained the old Crafts Centre's exhibition space in Covent Garden. The Crafts Council of Great Britain had had premises at 12 Waterloo Place which briefly became the responsibility of the British Crafts Centre but were taken over by the CAC in 1973. In a short time the Crafts Advisory Committee became an efficiently structured organisation with an array of sub-committees. Naturally the formation of the CAC and the unprecedented sums of money now available for the crafts attracted the attention of all kinds of interested individuals and organisations. But how were the crafts to be defined and what did Lord Eccles's sobriquet 'artist craftsman' really mean in terms of the CAC's patronage? The CAC's first exhibition *British Potters*, shown at the Design Centre and the British Crafts Centre in 1972 before touring Europe, signalled that the new body would look kindly upon ceramics. It was a catholic selection taking in Hans Coper, Lucie Rie, Bernard and Janet Leach and the younger Tony Hepburn and Mo Jupp. In February 1972, however, the committee decided to stage a major show provisionally entitled 'National Crafts Exhibition'.[44] This was to be a crucial event for the new body, creating both a very specific image for the crafts and a concomitant range of alliances, disappointed factions and semi-public schisms.

By March 1972 the exhibition had a venue. The director of the Victoria and Albert Museum, John Pope-Hennessy, conscious that the crafts lacked both commercial and museum exhibition opportunities,[45] offered Gallery 45 of the Museum for March–April 1973. This left a year in which to organise a major exhibition but the prestigious site was irresistible. At first things moved slowly as Margrie and Hugh Wakefield, Keeper of the Circulation Department at the V&A, struggled to work out the parameters of the show. By May it had been agreed 'to avoid on this occasion, the very rural types of crafts and the very sculptural ones…also borderline cases such as marquetry and lettering'.[46] By July Margrie explained to the newly appointed designer of the show, Barry Mazur, that he saw 'a very important vitality in crafts which often gets lost' and he wanted the 'exhibits shown as items with a part to play in everyday life but without an *Ideal Home* type of background'.[47]

It was decided that the first stage of selection should be handled at local level by the Regional Arts Associations, a demanding administrative task which not all the Associations were happy to take on. The press were informed that the CAC were keen to find new talent – 'the little man who hides his genius in a faraway village'.[48] Presciently, Lord Eccles was alarmed at the regional selection procedure which he believed would let in work of low

quality. Sir Paul Reilly, head of the Council of Industrial Design, hastened to reassure him that 'we would through our second stage London selection eliminate second rate work'. Eccles pointed out that this would inevitably offend the regions for 'if you ask the regions to help you, you will have to show regional work in the exhibition'.[49] By early September Wyndham Goodden, Robert Goodden's brother, an elegant dilettante figure who had been briefly head of textiles at the Royal College of Art, had been appointed organiser of the exhibition. He wanted a 'forward looking' show with plenty of 'impact' and 'quality'.[50] He was entrusted with the final selection of objects in London in January, with advice from a panel of expert assessors. Only in December was a title decided upon – The Craftsman's Art – chosen by Wyndham Goodden in the face of Sir Paul Reilly's backing for the more practical sounding 'The Living Hand' and 'Hand and Eye'.

Some 1,700 makers sent 5,900 objects to the twelve RAAs and to the Welsh Arts Council and the Arts Council of Northern Ireland. Regional selection narrowed this down to 1,200 objects sent by 440 makers.[51] A final selection was made by Wyndham Goodden in a warehouse in Covent Garden in early January. With only two months before the show was due to open, it emerged that the regional trawl had been a mistake – no unknown geniuses had emerged and many leading craftsmen and women had not sent in work. Some distinguished figures – the furniture maker Alan Peters, the embroiderer Lilian Dring, the weaver Hilda Breed – had had their work rejected. Edward Barnsley had submitted six carefully prepared items of furniture, only one of which was chosen. He withdrew entirely, partly in sympathy with younger furniture makers whose work, created especially for the show, had been rejected at regional level. Conciliatory letters from Sir Paul Reilly, alarmed at the defection of a name with such a distinguished Arts and Crafts ancestry, failed to move him.[52] Barnsley hoped that there would be a larger protest and was infuriated that an example of Gordon Russell Ltd furniture was to be included. He wrote angrily to his friend Idris Cleaver:

> What can be the justification for including Russell who was never a craftsman, went away from early works into industrial production about 40 years ago, has been among the many industrial chaps to denigrate and play down craftsmen, and now that William Morris is respectable, and Gimson and the Barnsleys being in the news and salerooms, these dammed chaps begin to claim they knew them and admired them.[53]

From December onwards letters of complaint began to reach Victor Margrie's deputy John Houston, a charming ex-art student with a quirky intelligence who had worked briefly at the V&A, at the Goldsmiths' Company and at the Crafts Centre. Lilian Dring wondered of the CAC: '*Who* and *what is* this organisation. *Who* were the selectors and what were their *craft* qualifications?'[54] Perturbed letters came from the regions wondering at the small number of local craftsmen chosen. Meanwhile invitations to show went out to chosen craftsmen and women who had not yet sent in work. It was decided to raise the standard with loans from corporate bodies like Goldsmiths' Company, from museums and from private collectors.[55] A month before the opening, mindful of public expectations, it was decided, after all, to include some rural crafts. Goodden visited the painter Peggy Angus and came away with some of her Island Stones – pebbles painted under her direction by the islanders of Barra. Falconry furniture, a racing bridle, shepherds' crooks, a yew longbow, fishing rods, baskets and a saddle and irons were gathered together as were musical instruments and clocks and toys to form an ex-catalogue addition to the exhibition.[56] Goodden even briefly toyed with the idea of a living exhibit, a shipwright building a wooden sailing dinghy in the V&A.

The Craftsman's Art was probably the most comprehensively designed crafts exhibition since Henry Wilson transformed the main rooms of Burlington House for the Arts and Crafts Exhibition Society in 1916. Barry Mazur created a striking setting which, as an editorial in *Ceramic Review* pointed out, did 'much to dispel the trestle table and hessian image so commonly associated with the crafts'.[57] Houston remembers the exhibition whimsically but surely accurately as a garden, 'planned for light and shade, views open and closed, with different levels and textures underfoot, along a meandering path between textile hedges and

pools, with variegated borders of pottery and metalwork.'[58] There were pebbles and sand and plants, coconut matting, earth-brown carpeting, chrome steel glass-domed Abstracta cases for metalwork and jewellery (Fig. 412). In the mood of the South Bank Exhibition of 1951 there was a bandstand and white chairs for visitors watching a continuous slide show which projected against cut out two-dimensional trees, with a background of recorded birdsong. The commonly received view of craft as traditional and rural was acknowledged by a under-lit display at the entrance and – a brilliant touch – by a patch of real barley kept in breezy motion by a hidden fan.[59]

Wyndham Goodden explained that he had asked of each object: 'Is this an example of the craftsman's art or is it simply a work of craftsmanship?'[60] Ceramics, which since the 1920s had most effectively combined the claims of art and craft, formed easily the largest part of the show. The selection encompassed work by Bernard Leach, Richard Batterham, Michael Casson, Ray Finch, David and John Leach as well as Hans Coper and two recent graduates of the Royal College, Jacqueline Poncelet and Glenys Barton (Fig. 413). There was also plenty of

whimsy – a box of moulded ceramic sweets embellished with flowers, ceramic houses and gardens and delicate biomorphic looking forms in pinched porcelain. In textiles this whimsical tendency took the form of a macramé jacket, a blouse with appliqué silk buttercups, and illustrational embroideries and tapestries, though the latter were balanced by aggressively expressive wall hangings – three by Tadek Beutlich and two by Kathleen McFarlane – and by Ann Sutton's Pop 'Floor Pad', specially commissioned by the CAC and woven out of brightly coloured knitted tube. The Scottish tapestry weaver Archie Brennan showed *Mr Adam's Apple*, a witty, monumental trompe d'oeil incorporating real table legs.

The silver and metalwork sections included work by established designer makers like Gerald Benney and Robert Welch, but there were also objects which looked as if they might have been made by elves in one of J.R. Tolkien's invented worlds. Michael Rowe, who had been given a special commission by the CAC, offered a complex miniaturised piece of architecture in silver which turned out to be a pomander designed to house fragrant oils. Malcolm Appleby contributed a neo-medieval chess set with individual pieces in carved steel, inlaid with chased and engraved gold and silver. The large display of jewellery was also notable for narrative, complexity and caprice. Bookbinding paid direct tribute to Tolkien with Philip Smith showing his further bindings of two full sets of *Lord of the Rings* forming a 'book wall'. There were more austere bindings by Roger Powell and by Sydney Cockerell in partnership with Joan Rix Tebbutt, but significantly another CAC special commission went to Faith Shannon who produced a hallucinogenic treatment of *Alice Through the Looking Glass* in which the figure of Alice appears to be pushing her way through the boards of the book. Calligraphy, with Op and Pop contributions by David Kindersley and Hella Basu, similarly suggested a craft world experimenting with lysergic acid. A striking Paolozzi-like object – seven toy monitors on a circular tray – turned out to have been designed by a boy of eleven and cast in brass by his parents. Muriel Rose's inter-war discovery, Sam Smith, wood carver and maker of surreal, satiric 'toys', was represented by three pieces. He was to be taken up with enormous enthusiasm by both the CAC and the Arts Council. Turned wooden bowls by David Pye and Richard Raffan fitted in with the generally exquisite nature of many of the exhibits.

Of all the crafts included in *The Craftsman's Art*, furniture had proved the most problematic. The furniture assessors John Makepeace and Sandy MacKilligin both exhibited but Edward Barnsley had withdrawn, Alan Peters had been turned down (even though he wrote the essay on furniture-making in the catalogue)[61] and there was nothing by Neville Neal, Stanley Davies, Eric Sharpe and other members of the Cotswold school. Nor did the show include Peter Hoyte and William Plunkett, the modernist handmakers working in steel, glass and leather. The sparse selection was bulked up by student designs from the Royal College of Art made up by the College's furniture technician Ron Lenthall.[62] The tour de force was John Makepeace's chest of drawers, each drawer pivoted from a stainless steel column. The drawers were made of bent veneers glued onto a colourful acrylic base. Makepeace's playful stacked design obscured the fact that this was an expensive example of fine cabinet making by a highly skilled team.[63]

The Craftsman's Art caught the mood of the moment. It was widely and favourably reviewed, though, significantly, mostly on the consumer pages. Some art critics covered the show. In *The Times* John Russell, noting that there was nothing doctrinaire about the selection, was full of admiration for Sam Smith, for the silversmithing of Robert Marsden and the jewellery of Wendy Ramshaw.[64] Michael Shepherd, in the *Sunday Telegraph*, prophesied enthusiastically that the show would 'become one of the more famous events of art history, so rich a wealth of care, imagination and invention does it reveal.'[65] Lord Eccles himself was well pleased with the CAC's first major exhibition, but warned that the crafts should not go too far in the direction of self-expression: 'If craftsmen opt out of designing and making objects which are both useful and beautiful, who will provide the new public – so vast, so hungry – with the means to express their own taste and enlarge their own personalities?'[66] The most thoughtful response came from John Brandon-Jones, architect, calligrapher and metalworker who had been Master and Honorary Librarian of the Art Workers' Guild, and President of the Architectural

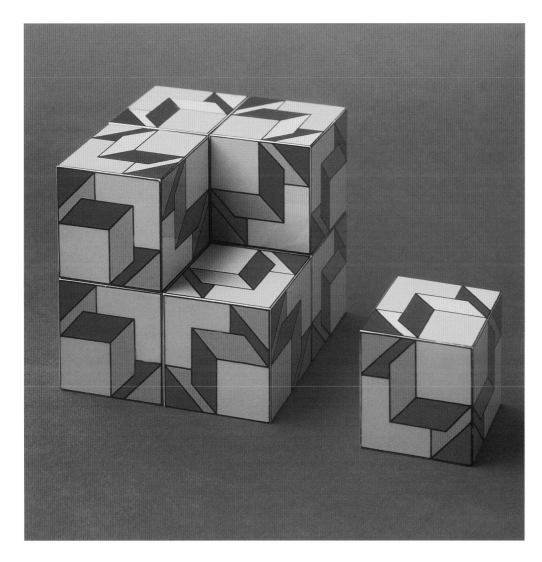

413. Glenys Barton, *Graphic Permutations no 1*, 1972, bone china. 10.5 × 10.5 × 10.5 cm. (Courtesy Angela Flowers Gallery, London. Photo Frank Thurston).

Association and of the Society of Architectural Historians. Brandon-Jones still employed artist craftsmen, usually fellow Art Workers, to adorn his buildings, and he found the decontextualised crafts of *The Craftsman's Art* 'extremely disappointing'. The exhibits were, in his view, 'utterly trivial' with very few 'sensible, simple and beautiful things'.[67] His negative verdict, appearing in the Journal of the Royal Society of Arts, caused a flurry and John Houston was detailed by Reilly to write a reply.[68] Houston argued that improvements in product design had answered the need for 'pleasing and useful objects' and that though present day artist craftsmen shared Morris's view of 'beautiful utility' they placed 'even greater emphasis on sheer enjoyment'.[69] It was a revealing rejoinder. For the rest of the decade 'sheer enjoyment' was to go hand in hand with a more considered intellectual justification for the crafts.

In 1974, the CAC sent a careful selection of work based on *The Craftsman's Art* to the Toronto exhibition *In Praise of Hands*, planned to coincide with the World Crafts Council's tenth-anniversary conference. The World Crafts Council had been founded in 1964 by a wealthy idealistic American, Aileen Osborn Webb.[70] Her internationalist ideas were a cruder variant of Leach's proselytising for a unity of Eastern and Western aesthetics, in which connections and friendship between craftsmen of all races would create harmony between nations. Indeed the lavish book which accompanied the exhibition was prefaced by Leach's adaptation of *The Kizaemon Tea-Bowl*, Yanagi's poetic elegy to a humble vernacular object, while the introductory essay, by the Mexican Nobel Prize winning writer Octavio Paz, was a passionate defence of indigenous craft whose destruction, Paz argued, was bringing about 'the extirpation of the Other'.[71]

The World Crafts Council was a far more inclusive organisation than the CAC. *In Praise of Hands* showed some 500 works from fifty countries and was particularly generous to

traditional crafts from around the world. For Victor Margrie the Toronto conference was a let-down. He found the exhibition to be 'a shock and a disappointment'.[72] In his view it lacked cohesion and he disliked the dominance of traditional craft. Marigold Coleman (the editor of the newly launched CAC magazine *Crafts*) took a similarly negative view. The traditional work had the effect of 'drowning out everyone else and unbalancing the exhibition'. Coleman was worried about the ethics of the conference, writing of a Mexican in traditional dress demonstrating his craft: 'He raised too many questions in my mind about the reasons for his work, the validity of its context, the alternatives open to him and the buying power of his remuneration after others had taken their cut.' She was more at ease with the American hot glass contingent – 'Marvin Lipofsky's gang, blowing glass in the open air with great rock music in the background'.[73] The Toronto experience confirmed the CAC in its identity and purpose. Margrie remained hostile to the WCC thereafter. In 1978 he attended a WCC gathering in Kyoto attended by leading Japanese craftsmen and women but found it: 'depressing, wrongly motivated and confused in its intentions'.[74] For Margrie there was a profound difference in the way 'craft' was understood in Japan and in the West. The implication was that officially at least the Leachean East/West project was over. The intense early modern interest in the traditional crafts of the Far East and of Africa which had so inspired Leach, Cardew, Gill and Mairet between the wars ceased to have quite the same relevance for post-colonial makers in Britain.

ARTICULATING THE OBJECT: CRAFT CRITICISM AND EXHIBITING

During the 1950s and 1960s informed writing about the crafts had taken place in a vacuum. Radical weavers wrote of each other's work in the pages of the *Weaver's Journal*. Potters exchanged ideas in *Pottery Quarterly*. It was mostly a matter of craftsmen and craftswomen speaking to each other. Major exhibitions like *Engelse Ceramiek* arranged by Henry Rothschild for the Stedelijk Museum in Amsterdam in 1953 or *British Artist Craftsmen* which toured America in 1959–60 had catalogues with short factual texts. Ceramics, as before the war, got the lion's share of critical attention. But even Henry Rothschild, whose shop Primavera presented the most adventurous sculptural potters of the 1960s, contented himself with an austere typed price list, nor were many of his ground breaking exhibitions reviewed outside the specialist journals.

The Crafts Advisory Committee wanted better critical coverage for the crafts, in fine art journals and on the arts pages of newspapers as opposed to the consumer sections. But the most prestigious journal dealing with contemporary art, *The Studio*, which had assiduously covered the applied arts since its inception in 1893, was transformed into *Studio International* in June 1964 and thereafter ignored the crafts. And, perhaps surprisingly, it proved impossible to shift the preconceptions of art editors and writers, even though other hitherto ignored subjects – jazz, photography and architecture – made their way onto their pages by the early 1980s. In 1976 Margrie lamented the failure of the CAC 'to convince the national press of the true nature of the work being produced by the artist craftsman of today. Rarely is it reviewed in the same critical terms as painting and sculpture; its perception, intensity and relationship to a changing social order are seldom considered. Instead the crafts are featured as lively relief on the women's pages.'[75] As Lucie-Smith pointed out, craft criticism either tended to be technical (and in specialist journals) or 'woolly headed and rapturous'. Despite Lucie-Smith's call for 'the evolution of a critical method specifically designed to cope with what craftsmen do',[76] appropriate coverage of the crafts was to remain an abiding problem for the CAC.

Nonetheless the CAC initiated a new way of presenting and writing about the crafts, partly through its own exhibitions, through the regional exhibitions which it supported and through its magazine *Crafts*. The aim was to create a discourse for the crafts, with curators and commentators able to frame and answer appropriate questions for an appropriate audience. The model was essentially that of avant-garde fine art practice and criticism. It was an attempt at a fresh start. Thus, although ancestral figures like William Morris or C.R. Ashbee might be referred to in passing, craft history as such was of little interest and freely manipulated to reinforce the newness

of the 'new' crafts. Tellingly, the first twenty-five issues of *Crafts* made no mention of Morris whatsoever. Even the history of the crafts since 1945 was of little interest. The story of studio ceramics in particular was drastically simplified. Hans Coper and Lucie Rie were seen as the sole post-war alternatives to what came to be described as the 'Leach tradition'.[77] But the project to construct a convincing discourse proved difficult. Even though ethnic and traditional crafts, the building crafts and amateur and hobbyist work, together with practice deemed commercial were all firmly excluded, it proved impossible to create a critical language which would encompass the great range of disciplines for which the CAC had responsibility. And the standards which the CAC set proved sadly vulnerable to attack by the early 1980s.

An early CAC exhibition of 1973, featuring the potter Paul Astbury, the bookbinder Faith Shannon and the silversmith Michael Rowe, reveals the CAC's desire to push fine art connections. Astbury showed paintings which drew on Japanese woodcuts and crude images culled from seaside postcards, Shannon showed delicate botanical drawings and Rowe showed a sequence of 'drawings towards objects' which the show's organiser John Houston described as 'somewhere between silverpoint and Klee'[78] and which were preparatory studies for the silver pomander commissioned by the CAC for *The Craftsman's Art*. Thus the show set out to show how the trio moved effortlessly between art and craft and made manifest the boundary blurring confidently predicted in the catalogue for *The Craftsman's Art* in which James Noel White wrote 'Painting is becoming sculpture, is becoming ceramic, is becoming three-dimensional design, is becoming jewellery.'[79]

The CAC's first regional touring show in 1974, of work by the weaver Ann Sutton and the jeweller Gunilla Treen, raised the problematic question of an appropriate audience. The accompanying CAC leaflet had the air of a manifesto. Sutton (whose allegiances in the 1960s had, as we have seen, been distinctly weighted towards fine art) argued that 'solutions to problems are of prime importance (one of the reasons I use knitting as a technique is because it is one of the few structures which can be joined invisibly and integrally). Depersonalised techniques are used – I do not want the mark of the maker.' Treen wrote of her work 'The final decision to be made is whether it shall be a brooch, necklace or bracelet, etc. Because of this a compromise often has to be reached in order for the piece to be worn.'[80] The audience reaction to the show was mixed. Neither Treen nor Sutton offered familiar versions of craft practice. Reports from the regions noted interest from students but 'disapproval' from other visitors who 'found the exhibition difficult to appreciate'.[81]

Sutton / Treen had been organised by Ralph Turner, who in 1974 had been appointed Exhibitions Officer. Turner was a former actor from a Welsh working-class background whose interest in painting and sculpture had been encouraged by Ewan Phillips, a founder member of the AIA and the first director of the ICA.[82] Turner worked in Phillips's gallery in Maddox Street, London, which sold mainly twentieth-century painting and sculpture, some 'ethnic' art and modern jewellery. Jewellery became Turner's particular interest and grew out of his friendship with Helga Zahn, who introduced him to radical continental jewellery and to the work of her contemporaries at the Central School of Arts and Crafts. Turner subsequently managed the Pace Gallery in St Christopher's Place where he continued to show contemporary jewellery together with fine art and ceramics. In 1971 he helped set up Electrum with Barbara Cartlidge with the aim of supporting jewellery which proposed a conceptual approach to the craft. They brought in work from Germany and Holland and, unusually for a commercial gallery, sent touring shows to regional museums.

Turner had a standard based on his knowledge of the most daring contemporary continental jewellery with its links with Dada and Bauhaus performance. He wanted the CAC exhibitions of the 1970s to correct the populist view of the crafts as 'rural, romantic nostalgia'.[83] In the introduction to the 1975 exhibition *Jewellery in Europe: An exhibition of progressive work* he saw a 'new role for the jeweller' which would 'result in work that is not intended to adorn. Indeed the jeweller may react defiantly against this principle and we may be witnessing a transition from the realm of jewellery to that of sculpture, or to a new area which combines the qualities of both fields.'[84] Most of the jewellers favoured by the CAC – Treen, David Watkins, Susanna

414. Susanna Heron, Jubilee neckpiece, 1977, opal acrylic and enamel paint; l. 45.3 cm. (Photo David Cripps).

415. Michael Rowe, *Box*, 1978, silver sheet with soldered copper edges, h. 24.5 cm. (Crafts Council/ Photo David Cripps).

Heron and Eric Spiller – tended to work with a heterodox range of materials (Fig. 414). As Turner explained, such jewellers 'make jewellery to communicate ideas, rather than produce a series of systems for showing glittering symbols of status and wealth'.[85]

The CAC built up a small network of craft commentators. One was John Houston whose essay 'Waiting for Alison'[86] prefaced the catalogue of Alison Britton's solo show in 1979. It was a poetic, adoring evocation of the small world of art-school-trained makers of the late 1970s and a meditation on Britton and her work (Fig. 417) – an extraordinary piece of prose which went far beyond the usual catalogue essay in intensity and eccentricity. It was also accessible in a way that most fine art writing about avant-garde figures in the 1970s was not. Houston provided some of the most sparkling insights into the 'new' crafts of the 1970s, as well as perceptive catalogue essays on older figures like Michael Cardew. But he was an empathiser, unlikely to create a theoretical framework for the crafts. Indeed, he was eloquent on the difficulty of pinning down 'the swarming cluster of meanings' attributed to words like 'artist' or 'craftsman'.[87] He was accurate in tracing the mechanics of the split between 'art' and 'craft' back to the Renaissance. But in the spirit of the joyous mood of the 1970s he was over-optimistic in his predictions that sculptors, painters and makers, trained at the same art schools, getting the same degrees, would begin to work with a common purpose.

For want of a critic able to theorise the 'new' crafts of the 1970s and to signal that craft objects were still being made, but in a multivalent, often ironic spirit, some of the acutest commentary

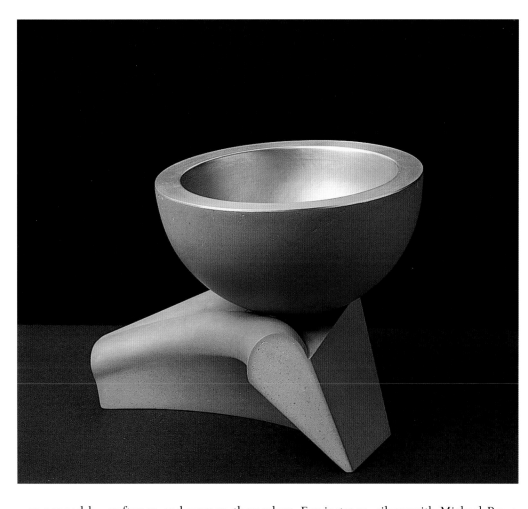

416. Martin Smith, *Borromini Cloister piece No. 2*, 1981, redware and aluminium, 14 × 21 × 16 cm. (Photo Ron Collier).

417. Alison Britton, *Jug with Feathers*, 1978, earthenware, h. 32 cm. (Photo David Cripps).

was penned by craftsmen and women themselves. For instance, silversmith Michael Rowe explained of his CAC exhibition of 1978 that his new work was a conceptual enquiry: 'The cubic box is an archetypal spatial unit and container, but right angle and square are only *moments* in the journey round and about such a box…the boxes are purely about their own space and the characteristics of the sheet metal they are made from.'[88] Rowe's statement, describing a hermetic art in the process of investigating itself – boxes about boxes – sounds a little like the formalism of the American critic Clement Greenberg. Just as paintings could be 'about' flatness and two dimensionality, silversmithing could be 'about' enclosure. But unlike Greenberg, Rowe was an ironist. His boxes, analytical games with perspective, isometric projections returned into three dimensions, were as much as anything a subversion of object making (Fig. 415).

Similarly, the potter Elizabeth Fritsch wrote a catalogue essay identifying pots as potentially allegorical objects 'in which the only essential physical function is the minimal one of containing.'[89] Just as Rowe's notes came with a reading list, Fritsch also set out an impressive range of influences from jazz to Piero della Francesca to Walter Benjamin. A paperback of Benjamin's essays, *Illuminations*, was published by Fontana in 1973 and became cult student reading. Benjamin was an apt choice for an intelligent maker, his writing full of images of craft practices, discussions of the 'aura' of authentic objects, and meditations on the shift from artisanal to industrial ways of making and the impact of this change on memory and experience.[90] Another potter, Martin Smith, matched Rowe and Fritsch's erudition. Smith elucidated his work through a discussion of perspective in painting and architecture, taking in Brunelleschi and analysing city spaces in Arezzo and Rome.[91] Smith, like Fritsch and Rowe, failing to find an interpreter of his work, had to do the job himself (Fig. 416). And it was these kinds of writing which provided the background for most subsequent analysis of the 'vessel', as non-functional pots and containers came to be described, in the subsequent decade.

By the late 1970s the Crafts Advisory Committee (renamed the Crafts Council in 1979) had established its own particular standard. In ceramics this included play with the idea of the vessel, in jewellery a rejection of precious materials and, in all crafts, a reaction against the past

418. Paul Caton holding one of his wooden bowls, Bath 1979. (Photo Phil Sayer).

419. Pierre Degen, *Personal Environment*, 1982, wood, string frame with additions, 140 × 140 cm. (Photo David Ward).

three decades. Ralph Turner, in particular, was determined not to become embroiled in craft 'traditions' of any kind. But unlike the Arts Council (who also purveyed a radical standard in the visual arts in the 1970s), the CAC also set out to create interest in craftsmen, and especially craftswomen, as people. Craftsmen and women were photographed for their catalogues, for *Crafts* and for the CAC annual reports. Most of the portraiture was done by Phil Sayer, whose moody low-lit shots helped apotheosise makers (Fig. 418) just as David Cripps's photography heightened the ambiguities and wit of the objects he recorded. Arguably the iconic craft objects of the 1970s were most widely known through the dazzling images created by Cripps's unerring eye (Fig. 420).[92]

The progressive adventurousness of a generation of younger makers was continually stressed in CAC literature, as was their lack of interest in physically making things. An early article on the potter Glenys Barton in *Crafts* explained: 'She is very much a person of her time, tough, sensitive, highly intelligent, a little alarming and very impressive.' Barton told her interviewer: 'I don't think I really am a craftsman. Making things bores me. I am more excited by the process of conceiving the idea.'[93] (Fig. 413) A review of sculptor turned jeweller David Watkins's work in *Crafts* quoted him as saying; 'If I could possibly make the things by remote control I would. I have an impatience with the whole business of hand crafting the object'.[94] But there were some continuities. The old inter-war negativity toward commoditisation was updated and extended to embrace jewellery. In her solo show catalogue Helga Zahn was presented as questioning 'the accepted values of jewellery. Like many of her contemporaries she is not given to compromise but makes decisive, often defiant statements.'[95] The catalogue essay for Susanna Heron's *Body Work* show of 1980 was similarly a celebration of refusal, presented as a collage of letters from Heron from the United States. The new radical jewellery she was making there was 'far more assertive and aggressive' than her early work which Heron appeared to have dramatically destroyed – 'The last shreds of precious metals and major one-off pieces were lost from a high window in New York City.'[96] The Heron catalogue elevated and idealised the maker as did the literature associated with the solo show devoted to the work of Pierre Degen in 1982 which celebrated his move in the direction of performance art and

sculpture. Degen was a jeweller who had, as the poet Christopher Reid explained, rejected 'gems and precious metals, trinkets and baubles'.[97] The catalogue for his exhibition included a loose-leaf reproduction of a sketch by Degen and some apparently private, poetic jottings and an accompanying booklet with all pages blank save one, on which the artist had handwritten 'Degen' in black crayon. An air of hagiography hung heavily over the whole enterprise, suffocating an interesting body of work (Fig. 419).

But there were limits to the CAC's interest in a fine art approach. Potters who were ambitious to be perceived as sculptors were in a difficult position, in danger of slipping out of sight, unappreciated by either the world of fine art or ceramics. The problem was exemplified by the show *State of Clay* which was toured in 1978 by the Sunderland Arts Centre. *State of Clay* showed few vessels and included one mainstream sculptor, Eduardo Paolozzi. The work was on the whole 'difficult' partly because many of the exhibitors abandoned the familiar domestic scale associated with ceramics. For instance, Percy Peacock's *Impact Imperative* involved some thirty pieces of fired and raw clay, found objects, paint, wax and cloth laid out over an area twenty-five feet by six (Fig. 421).[98] Peacock, trained at the RCA, was the bright hope of the ceramic sculpture movement. His show *Drawings, Objects and Artefacts* toured to the Midland Group Gallery which held an accompanying conference in January 1978. Gordon Baldwin and Glenys Barton spoke with eloquence about the problems facing potters who did not make pots. As Baldwin explained 'every artist needs some material to do his thinking in'. Barton observed that in art schools there was little contact between departments of fine art and other areas. Certainly the statements made by the sculptors at the conference, Nicholas Pope and Barry Flanagan, made it plain that fine artists believed in maintaining divisions and hierarchies. As Pope explained, pottery was 'a marvellous craft which is at its best making things which have a function, whether it be household, religious or whatever'. Barry Flanagan, who had started making pinch and coil pots in 1976, noted that potters' work was 'functional or design orientated'.[99] This was hardly true of Flanagan's own foray into ceramics, coiled or pinched Ur-vessels which depended for their undoubted impact on their position within his oeuvre as a sculptor. But in fact, until the gallery was enlarged in 1982, the CAC did not have the space at Waterloo Place to show the kind of monumental work included in *State of Clay*. Hence the emphasis on the miniaturised radicalism of jewellery and the vessel, and the tendency to tidy the messy incoherent range of craft disciplines into table-top and small wall-sized objects.

The CAC, in comparison with the Arts Council, appeared to be generous towards women practitioners. Of solo and duo shows held by the CAC up until 1981, eighteen were devoted to men and fourteen to women, while women dominated *Ceramic Forms I, II and III*, a CAC/British Council show that toured Europe from 1974 until 1977. But the CAC only wanted contact with appropriate women, highly trained professionals. Thus this parity probably reflected the situation in art schools. There was a high proportion of women to men in textile and ceramics departments. Women opted for these disciplines in part because of the male bias which was still maintained in the fine art departments. Women were, of course, also dominant in crafts with a strong amateur following such as quilting, patchwork, rag rug making and knitting but these only became the subject of exhibitions in the 1980s and were never viewed particularly kindly by the CAC. Overtly feminist craft was also ignored in the 1970s, as it largely had been by the Arts Council until 1978, when five women artists were invited to select the second Hayward Annual show of contemporary art. Indeed, even in the 1980s the Crafts Council never hosted a declaredly feminist exhibition. Feminist events were organised informally by women outside the official system – like the first show staged by the Women's Art Alliance, *Sweet Sixteen and never been shown* and the postal project *Feministo*, which culminated in 1977 in the exhibition *Portrait of the Artist as Housewife* at the ICA.[100] Nonetheless, women were propagandised by the CAC as daring, assertive artists unwilling to compromise on standards. When the Regional Arts Associations asked for a show devoted to craft techniques the Crafts Council sent out *Work In Progress* which featured four innovative women – Ann Sutton, Faith Shannon, the jeweller Catherine Mannheim and the glassmaker Jane Bruce.

Although nostalgia and ruralism were to be avoided at all costs in the CAC's construction of the crafts, they were difficult notions to exclude. For instance, the attractions of craft as a way of life were inadvertently highlighted in the 1975 CAC exhibition *The Camera and the Craftsman*. Most of the makers featured lived in rural places and seemed to have effortlessly integrated life and work, playing with their small children, gathering wood, walking on the beach, breaking bread and drinking soup with their families at midday before returning to their loom, clay wedging, instrument making or blacksmithing. Margrie was disappointed in the show, observing that 'the photographers would appear to have succumbed to a romantic imagery and a sense of privilege prevails.'[101] But these images were widely illustrated in the newspapers for that very reason. The same year, Edward Lucie-Smith's *The World of the Makers*, a photographic survey combining thoughtful interviews with a catholic selection of craftsmen and women, trod much the same ground. It was, Lucie-Smith explained, 'a fan letter – but a fan letter for adults'. Margrie disliked Lucie-Smith's book too, criticising it for presenting 'the myth rather than the real thing'.[102]

The coverage provided by *Crafts* might seem at odds with Margrie's stress on demythologising the crafts. But articles on barge art, Gandolfi cameras, rope-making, bell-casting, basket-making and dolls' houses were clearly too photogenic to exclude and were to inspire whole sections of consumer magazines that started to appear in the 1980s like *World of Interiors* and *Country Living*. Similarly, it proved difficult not to project the crafts as a desirable way of life. There was potential here for tenuous links with the joy in labour ideals of the Arts and Crafts Movement or with Eric Gill's projection of the craft way of life during the 1930s. But by the 1970s the thinking was depoliticised and simplified into biographical articles. Weaver Vanessa Robertson's bold impulse 'led her to drive from London, see and buy the house in Pendeen all in one day five years ago', shortly to be joined by Norman Young 'a fugitive from the whirl of a successful career in film animation'.[103] A series of regional articles tracked down makers in rural havens. In Cumbria the potter Laurie Short lived in an old farmhouse.[104] In Somerset John Leach worked 'in idyllic surroundings', while Candace Bahouth had transformed a redundant chapel into a studio home.[105] In Gloucestershire Ray Finch lived 'all the simplicity of the workshop life, the steady pattern of the days'.[106] The wood-turner Richard Raffan's life 'would be the envy of many a young executive who suddenly realises just how deeply uncommitted he is to the rat race...it is cheering that one man can

421. Percy Peacock, *Impact Imperative* (detail of work in progress) 1978, fired clay, raw clay, found objects, paint, wax, cloth. 762.5 × 183 cm. (Photo Sunderland Arts Centre).

live so simply and satisfyingly.'[107] The crafts were seen to function as an alternative to the rat race, though the CAC, interested as it was in quality, was not tempted to lend support to run-of-the-mill counter-culture activity – candlemaking and tie-and-dye T-shirt production. Nor was it friendly to, or even aware of, the rough-and-ready street culture of Punk. Punk's fanzines like *Ripped and Torn*, *Vomit* and *Sniffin Glue*, record covers made by small producers like Rough Trade and Stiff and the T-shirts produced by Vivienne Westwood and Malcolm McLaren for their King's Road shop Sex were 'hand-made', xeroxed and stapled together or crudely screen printed. But Punk was definitely the wrong kind of hand-made.[108]

THE WORKSHOP: A COUNTER DISCOURSE

Alongside the activities of the CAC there remained a powerful craft counter-discourse opposed to the liberal education provided by art schools and the 'new' craft of the 1970s. Its principal source remained the writings of Bernard Leach (Fig. 422). During the 1970s he published five books, three of them major statements. *The Unknown Craftsman*, his 'adaptation'[109] of essays by Soetsu Yanagi, appeared in 1972 when he was eighty-five and fast losing his sight. This was followed by *Drawings Verse & Belief* (1973), *Hamada Potter* (1975), *The Potter's Challenge* (1976) and his autobiography *Beyond East and West* (1978), appearing when he was ninety-one. Leach could not read Japanese and *The Unknown Craftsman* was translated with the help of Japanese assistants and set down by Leach in his own majestic Edwardian English. Its gospel of humility and abnegation of self and its taste of Zen Buddhist aesthetics provided a framework for craft activity which involved a radical rejection of a whole set of Western values – particularly industrial capitalism. It appealed to the middle-class young and disaffected – quite a feat for an octogenarian writer. Like *A Potter's Book* it remains in print. His subsequent books were more in the nature of compilations orchestrated by his third wife and by his secretary, Trudi Scott. *Hamada Potter* was based on tapes of discussion between Leach and Hamada recorded over three months in a Tokyo hotel room and edited by Janet Leach.[110] An exotic 'Other' with its own sublime emerged from the dialogue, coupled with a rejection of theory and of any intellectualising of the crafts. As Hamada explained: 'Beauty is not in the head or the heart but in the abdomen. One cannot verbalise it; it is beyond verbalisation.'[111] Leach's writings offered a mysterious but reassuring vision of creativity. Makers liked to quote his translation of Yanagi, 'In my heaven of beauty there is a round table without top or bottom at which all are equal',[112] because it poured bland balm on the troubled art/craft debates of the 1970s and 1980s. This kind of non-hierarchical remark seems familiar. It echoes Gill's 'The artist is not a special kind of man, but every man is a

422. Bernard Leach in his St Ives flat examining pots from his collection, 1977. (Photo Peter Kinnear).

423. Janice Tchalenko, bowl mid-1980s, stoneware, diameter 25 cm. (Photo Tim Hill).

special kind of artist' – which Gill borrowed from another non-Western sage, the Ceylonese Ananda Coomaraswamy.

That a figure as eminent as Leach continued to doubt the value of art school education was important.[113] The message to Leach's acolytes was clear and at a Potter's Camp held at West Dean in 1974 three specially invited guests – Elizabeth Fritsch, Glenys Barton and Jacqueline Poncelet, RCA graduates all – were accused of behaving like Pop stars by angry production potters. Their 'exclusive, urban and non-regenerative art' was contrasted unfavourably with the 'traditional' Wrecclesham potters demonstrating at the camp whose work testified to 'an earlier state of self sufficiency, potteries on the edge of clay pits, long slow clay making and bloody hard graft'.[114]

In 1975 a group of production potters attempted to supplement what was seen as the superficial education offered by art schools. The Dartington Pottery Training Workshop was set up with a generous £15,000 grant from the CAC. There were strong links with the vocational course at Harrow School of Art and the Craftsmen Potters Association. David Canter was chairman, David Leach and Michael Casson were directors. A prototype range was created by the workshop's director Peter Starkey and apprentices were taken on. Here was a chance to put into action a Leachean ideal – with pottery made for use by a team who sought no individual glory and who were prepared to hone their skills over several years. The eyes of a section of the pottery world were trained on the workshop's ramshackle sheds. Bernard Leach himself paid a visit while potters as diverse as Henry Hammond and Victor Margrie backed the idea enthusiastically. But Dartington failed because its stoneware range of domestic pottery, decorated in a diffusely Oriental style, was poorly designed. In fact Dartington demonstrated that the best workshops – Caiger-Smith's at Aldermaston for instance – succeeded because of one powerful design intelligence. The principle of 'The Unknown Craftsman' could not readily be resurrected in the late twentieth century. The project, renamed Dart Pottery in 1984, was only saved by the introduction of Janice Tchalenko, a former Harrow School of Art potter of some genius, who created both shapes and decoration which were to delight the consumer market of the 1980s.[115]

Tchalenko was one of a group of potters connected with Harrow School of Art, and making high fired domestic stoneware, who chose to reinvent their practice at the end of the 1970s. They were responding to changes in taste and, in the case of Tchalenko's designs for Dart, created a new fashion for brightly coloured tableware. In part they were sensitive to the agenda set by the Crafts Advisory Committee which appeared to favour the one-off piece,

ceramics as treasure. In 1980 Tchalenko received a grant to develop lush, intensely coloured high-fired glazes (Fig. 423). Walter Keeler, who had taught at Harrow since graduating there in 1963, also developed a new approach by 1980. His pots remained functional but looked sharply designed and aceramic, appearing to 'quote' vessels in other media such as tin cans and leather buckets. Another Harrow tutor, Colin Pearson, had been making 'special' pieces since the late 1960s but in November 1971 he showed the first of a series of remarkable winged vessels thrown loosely and subsequently manipulated, inspired in part by Chinese bronzes. Thereafter he devoted himself entirely to one-off work of increasing monumentality and power (Fig. 424).[116]

Many counter-discourse potters were peculiarly sentimental about workshop training. But the belief that art schools failed to provide a preparation for a life of craft was shared by makers as diverse as the stained-glass artist Patrick Reyntiens and the silversmith Stuart Devlin. In particular the furniture makers Alan Peters and Sandy MacKilligin saw an apprenticeship as an essential stage[117] and, significantly, the most successful attempt to supplement or by-pass a DipAD education was in the area of furniture making. In 1977 John Makepeace set up The School for Craftsmen in Wood (now named Parnham College) at Parnham House, in Dorset. It was a privately run fee-paying two-year course, costing a putative student £3,000 in 1977 (£500 more than the annual fees at Eton College, Britain's most exclusive boarding school)[118] and offered 'more than the conventional art school training, where bureaucracy, numbers and curricula militate against success for the new craftsman in the competitive outside world'.[119] Parnham anticipated a new vision of the crafts – as an efficient small business. Business studies were a crucial component together with a substantial design programme and intensive training in making in the first year. Students lived in, worked long hours and attended lectures three evenings a week.

Like the pottery course at Harrow School of Art, Parnham was strong on skills, but there was no sympathy for the kind of low-level technology favoured by the Harrow potters. The intellectual atmosphere was more sophisticated. There was a broad range of visiting lecturers – including architects, cultural historians and maverick designers like Norman Potter. Each graduate left equipped with 'skills, a personal design philosophy and a set of business objectives'.[120] Crucially, Makepeace unashamedly identified handmade furniture as a luxury product. Parnham provided a workshop training that managed from the start to seem an Establishment venture and which was to train some of the most commercially successful craft furniture makers of the 1980s. Parnham College was not 'alternative' in a social and political sense and had little in common with the counter-culture of the 1970s.

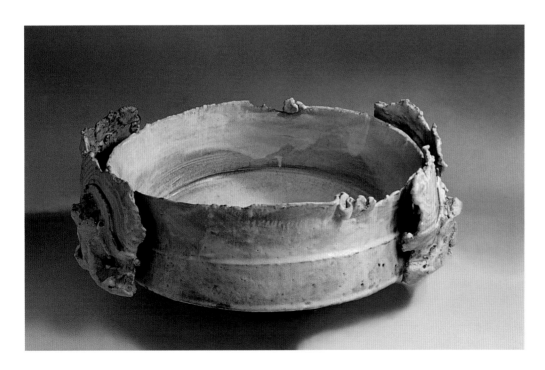

424. Colin Pearson, large bowl, stoneware, 1987, diameter 43 cm. (Colin Pearson).

425. Clifford Harper, 'those poor buggers in the factories', *New Times*, Class War Comix Number 1, *Epic Productions*, 1974.

426. David Poston, neck manacle *Diamonds gold and slavery are forever*, 1975, iron and silver, diameter 15 cm. (David Poston/Photo David Cripps).

As we saw in Chapter Seven, the deployment of craft by the counter-culture in the 1960s had been distinctly amateurish. But the strikes and protests of 1968 at art schools, polytechnics and universities politicised students and as a result counter-culture activities in the 1970s attracted highly educated individuals, with an informed interest in skills and technologies. Some of these activities related to the crafts and were discussed in magazines like *Resurgence* and *The Ecologist* and in the much more radical *Undercurrents* (illustrated by Clifford Harper) and in *New Times*.[121] Radical or alternative technologists took autonomy as a starting point, as a means of counteracting 'the insensitive giganticism of modern societies'.[122] (Fig. 425). The search for autonomy – which mostly focused on solar and wind energy, self-build, light structures inspired by Buckminster Fuller, the recycling of human waste (a subject invariably discussed in tedious detail), gardening activities and workshops reusing scrap – only marginally involved the artist crafts. Its liveliest theorists came out of the architectural schools, in particular the School of Architecture at Cambridge and the Architectural Association in London. But books like Sturt's *The Wheelwright's Shop* continued to be invoked as useful texts as were contemporary primers that went back to basics such as Peter Collingwood's *The Technique of Rug Weaving* and Michael Cardew's *Pioneer Pottery*.

Man-Made Futures, a collection of writings on technology and design published in the early 1970s by the Open University, had a typically overwhelming interest in alternative technologies rather than craft. Nonetheless, some of the contributors validated a craft approach. Ivan Illich argued that passive consumption denied the possibility of 'conviviality' which he defined as 'the opposite of industrial production'.[123] For Illich 'convivial tools' certainly included handtools put to a craft purpose, though he proposed broader definitions which included institutions, governments, postal and telephone services. Design Systems theorists continued to look to the crafts. In *Man-Made Futures* Christopher Alexander, like his ally the designer John Chris Jones, expressed wonder and admiration at what he called 'unselfconscious cultures'[124] where design evolved gradually and traditionally and where design faults were immediately modified and corrected because skills were universal and interchangeable. But perhaps the most surprising tribute to the crafts in *Man-Made Futures* was paid by Meredith Thring, an amateur wood-carver and Professor of Engineering at Queen Mary College, London. Thring argued sweepingly that before the Industrial Revolution craftwork brought fulfilment to a large proportion of the population: 'Those whose lives used

to be filled with creative craftsmanship were generally happy'. He looked to a future where robots would carry out all repetitive and dangerous work, making possible what he called a 'Creative Society'. In this Utopia an 'entirely new system of education will be offered, so that a range of creative arts and crafts are taught which people can enjoy doing for their own sake.'[125] Thring's strange essay, an amalgam of Morris and H. G. Wells, suggests the penetration of anti-industrial feeling to the heart of the establishment.

Another establishment figure, Lord Eccles, similarly saw the crafts as functioning in opposition to science and technology, 'that pair of unstoppable giants' who were turning half the world into 'one well stocked, packaged, heavily advertised supermarket'. The 'monotony of the mass consumption society' had brought about a 'spiritual famine' which Eccles believed could be alleviated by the crafts. Eccles argued that the crafts were on the brink of a marvellous revival because of what he identified as a revolt 'against losing one's identity and becoming like everyone else to suit the convenience of the machines'.[126] All this may seem extraordinary coming from a former Education Minister whose 1956 White Paper set aside £70 million for technological projects. Eccles's speech reveals how widespread was the reaction against the modernisation and growth preached in the 1950s and 1960s, suggesting a loss of faith in technological progress in the 1970s which went far beyond the counter-culture.

Within the craft movement, the chief propagandists for practical autonomy were Harry Davis and Michael Cardew, both of whom had sought a moral purpose for craft through choosing to work in remote non-European areas, Cardew in West Africa and Davis, throughout the 1970s, in Peru. This challenge was also sought by younger makers and the decade saw Joe Finch, son of the potter Ray Finch, and his wife Trudi set up a community pottery at Kolonyama in Lesotho in 1969[127] while in 1979 the potter Mike Dodd worked on the pottery project in the Peruvian Andes started by Harry Davis. The potter Michael O'Brien continued Cardew's Abuja project from 1961, only returning to Britain in 1989. Their testing experiences can be contrasted with the superficial descriptions of craft autonomy in the magazine *Country Bizarre*: 'It isn't difficult to set up as a full-time pottery, using local materials and improvised equipment' claimed one article while another explained that 'spinning with a spindle is very easy to learn and once the knack of it has been acquired a lot of yarn can be produced in a relatively short space of time.'[128] Many of the crafts discussed in this kind of publication – macramé, shell craft and flower pressing – had a distinctly limited scope. *Country Bizarre* and books like John and Sally Seymour's *Self-Sufficiency* were hardly true counter-culture documents. Their function was more therapeutic than practical. It is in fact difficult, if not impossible, to learn to spin from a short article, just as it is unlikely that anyone would make a good job of slaughtering and salting a pig from reading a book, even one embellished with Sally Seymour's pictures and diagrams.[129] But it was nice to read about such matters and to reflect on an alternative life-style.

A handful of art school educated makers, through subjecting their practice to intense scrutiny and by learning anew after college, moved towards the counter-culture. David Poston had been closely involved with the Hornsey College of Art strike and occupation of 1968 while taking its vocational jewellery course. He subsequently evolved a set of values that regulated his making. For political reasons, like a great many 1970s jewellers, he avoided using gold and diamonds because of the conditions under which such materials were won. 'Diamonds and gold and slavery are forever' (Fig. 426) inscribed into a slave's neck manacle necklace was his youthful response to the South African diamond firm De Beers's complex system of patronage through international jewellery competitions and special commissions for prestigious racing events like the Diamond Stakes. Poston was also suspicious of the 'fine art' ambitions of his contemporaries – 'surely no advance towards jewellery as a valid form of its own?'[130] His chosen materials – starting with shells, leather, wire and bottle tops and moving on to whipping, knotting and splicing fibres – were used to create jewellery which was intended to be worn close to the body, unostentatiously, almost privately. Throughout the 1970s Poston experimented with materials, involving in some instances the development of extraordinary skills which, in fact, could only be appreciated by the very knowledgeable. In

427. David Colwell, C₃ Stacking chairs, designed 1989, in production by Trannon Furniture Ltd, frame made from unseasoned steam-bent and turned wood thinnings. (David Colwell/Crafts Council).

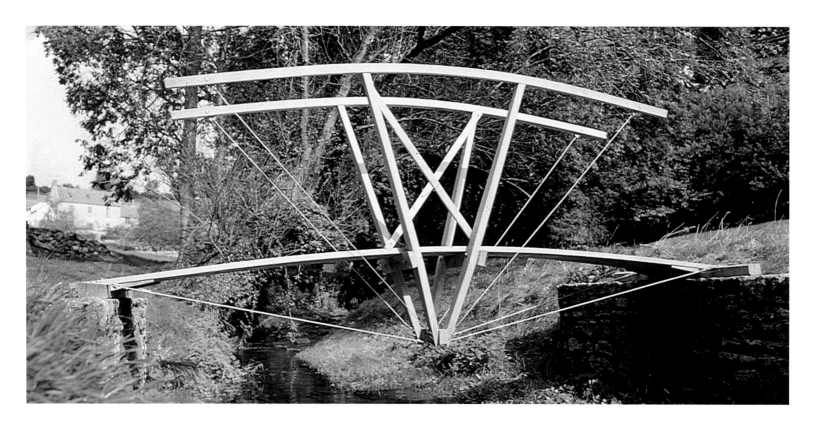

428. Richard La Trobe-Bateman, bowstring truss footbridge 1992, oak and stainless steel, span 4 metres. (Photo Michael Wolchover).

about 1986 Poston virtually abandoned jewellery, wrote a doctoral thesis on third world technology, subsequently working in third world countries on blacksmithing projects which enabled local people to create their own high quality tools.

Alternative approaches did not rule out a desirable craft product. For instance, David Colwell had studied furniture at the Royal College of Art and in the early 1970s had a successful career designing interiors and steel and perspex furniture. From 1977 he worked in a quite different way, moving to a village school in Wales, making steam bent ash furniture, using local wood. As he explained: 'My designs are related to the vernacular. They take the sustainable aspects of a sustainable past – but they are about now.'[131] (Fig. 427) Richard La Trobe-Bateman was a fellow student at the Royal College of Art. Charles Rennie Mackintosh's furniture was an early model but La Trobe-Bateman went on to develop a series of low-tech innovative structures, starting with tables and chairs and in the late 1980s moving on to bridges. By 1978 he was living out of London, studying Herbert L. Edlin's *The Woodland Crafts of Britain: An Account of the Traditional Uses of Trees and Timbers in the British Countryside* and the historian and ecologist Oliver Rackham's *Trees and Woodland in the British Countryside*, from which he gained a new sense of involvement with his material. He started making traditional use of cleft or split green timber and thinking about trees and the environment in a philosophical fashion. It would be absurd to see La Trobe-Bateman as in any sense a 'drop-out' but he was determinedly critical of what he called 'bourgeois furniture', moving from furniture to bridge building,[132] and was passionate about his raw material. These ecological concerns continued to be developed in the 1980s by other makers and gave the crafts a place in wider debates (Fig. 428).

Some of the most potent commentators on craft practice and skill belonged to what the anarchist writer Colin Ward called 'the alternative craft network'.[133] John Brown was a boat builder who was made redundant in 1975 when his employers switched over to plastic hulls: 'After years in a job I loved I had been told to go; my skills were no longer appropriate.'[134] He saw an old Welsh chair in a shop window and, struck by its beauty, he decided to devote his life to carrying on the tradition. He coined the name Welsh Stick Chairs to describe them and his motto was 'add lightness and simplify' (Fig. 429). He set up in a tin shed with no electricity or any other services in the Preseli Hills of West Wales. Stick chairs are built by eye using no drawings or templates, though jigs are used to steam bend the wood. Brown found that each

429. John Brown in his Pembrokeshire workshop with a completed Welsh oak and elm stick chair, *c.* 1989. (Photo John Havard).

430. Michael Bennett, *The Dung Market, Parliament Square, A.D. 2136*, photocollage for *William Morris Today*, I.C.A. 1984. (Michael Bennett/Tate Gallery Archive).

chair was a visual surprise, known only when its constituent parts had been put together. His spiritual inspiration came from the writings of William Morris, Eric Gill, Ananda Coomaraswamy and Soetsu Yanagi and his private project was part of a bigger dream, to see Wales become a nation once again and to see the end of industrialisation and the return of the age of the craftsman, 'when a man who can grow asparagus will be more important than the man who can spell asparagus'.[135]

Brown's artisanal philosophy, fuelled by political dissatisfaction, had something in common with the thinking of the writer and activist Roger Coleman. Coleman studied fine art at Edinburgh in the early 1960s, ran a theatre group and taught at Leeds School of Art, moving to London in 1970 to run a printing co-operative. Returning north, he went on a government scheme in Sheffield to train as a carpenter and joiner. He became a particular admirer of the Dutch designer Gerrit Rietveld, partly at least because of the artisanal background to Rietveld's architecture and furniture. By the mid-1970s Coleman was working as professional joiner for a building firm, keenly aware that the trade was in the process of being de-skilled. He took William Morris as his guide to the nature and purpose of work. Coleman's definition of art as 'freely chosen work; as skill allowed its full expression' was essentially Morrisian.[136]

Coleman was not alone in preferring to view art and craft in the wider context of debates about work in an industrial (or post-industrial) society. In 1984 the ICA staged *William Morris Today* to mark the 150th anniversary of Morris's birth.[137] It was organised by two Morris experts and was informed by left-wing alliances forged over the previous decade, now beleaguered after a second Conservative victory at the polls. What was especially interesting about the exhibition – which involved Coleman, the trade unionist and shop steward at Lucas Aerospace Mike Cooley,[138] the anarchist Colin Ward, the Labour MP Tony Benn and the cultural critic Raymond Williams in seminars and essays – was the absence of any reference to the 1970s craft renaissance. Yet the show was dominated by contemporary work with a sharp political edge, by the photographers Ed Barber and Michael Bennett (Fig. 430), the sculptor Julian Opie and the community architects David Lea and Edward Cullinan. Evidently none of the organisers saw the contemporary crafts as in any way likely to illuminate Morris in the context of the late twentieth century.

The accompanying book of essays similarly ignored modern makers, with the exception of a piece on Michael Murray, the silversmith and stained-glass artist who had worked with Keith

Murray and Ralph Beyer in the 1950s. But he was interviewed because of his Metropolitan Workshop in Clerkenwell, set up 'to create employment opportunities through self-employment'. Even so, his interviewers were clearly doubtful about his concentration on small craft enterprises making what they called 'art goods'.[139] *William Morris Today*, essentially a saraband for 1970s left-wing values, illustrates a continuing antipathy, traceable back to the 1930s, felt by many left-wingers for the artist crafts. The fact that a major show on the contemporary significance of Morris ignored modern makers was shocking but revealing, indicating that the Crafts Council (as the CAC was renamed in 1979) and its constituency appeared remote from larger issues to do with the crafts, such as the very nature of work itself.

'MEET THE CRAFTSMAN'; PUBLIC IMAGES OF THE CRAFTS

The workshop and its autonomous skills and politics of independence – all part of the counter-discourse of the 1970s – were valorised by an increasing fascination with watching weavers, potters or basketmakers at work. This seems to have been a specifically twentieth-century pleasure. In the 1920s and 1930s surviving traditional craft activity drew middle-class visitors to supposedly traditional potteries like Crossroads at Verwood and Fremington Pottery in Devon (Figs 183, 239). Displaying a craft was increasingly a strategy adopted by artist craftsmen and women at inter-war art and craft exhibitions and agricultural shows. By the late 1960s the Council for Small Industries in Rural Areas (until 1968 the Rural Industries Bureau) had already published *A Visitor's Guide to Country Workshops in Britain* for travellers who wanted to see craftsmanship in action. In 1972 the Craftsmen Potters Association published its first edition of *Potters* which listed members with their names and addresses. The second edition in 1974 included maps and made visiting potteries a feasible weekend activity. Similarly the CAC's *Craftsmen of Quality* appeared in 1976 'specially designed as an easy reference book for customers and tourists'.[140] It was of course a sign that such 'work' had become exotic and had passed from necessity into entertainment.

But it was serious entertainment. Consumers of craft tended to desire not only the object itself but also an understanding of the way in which it was made – and therefore, by extension, some sense of intimacy with the maker. And in the 1970s seeing craft skills in action was linked to an increasing fascination with 'the past' and a desire to make it immediate.[141] The 1970s saw an upsurge of amateur activity to do with resuscitating the past, often the relatively recent past. Architectural salvage, genealogical research, metal detecting, steam rallies, collecting old photographs and oral history projects were all components of a genuinely popular movement to amass what Raphael Samuel has called 'Unofficial Knowledge', much of which was aimed at giving roots to an urbanised population who had come to feel increasingly rootless.[142]

A new kind of museum emerged which sought to re-enact the past in a performative fashion. In 1973 Ironbridge opened – an industrial museum with working machinery and with an adjacent industrial village at Blist's Hill tended by 'working' men and women. The North of England Open Air Museum at Beamish in County Durham was similarly a 'living' museum (Fig. 431).[143] Here the crafts were demonstrated, in appropriate settings, as they had been in the Scandinavian folk museums since the turn of the century, at Colonial Williamsburg from the late 1930s[144] and since 1946 at St Fagan's in South Wales. Beamish was an impressive educational venture but by the 1970s numerous unofficial privately run living museums sprang up, signalling the end of real industry and the fact of high unemployment. It was possible to visit small water-powered wool mills in North Wales and listen awhile to the deafening clatter of looms, or to wander over slate quarries and watch quarrymen enacting former jobs like slate splitting. On the whole we seemed to lack the professionalism of the performers in the living museums of North America and the spectacle of unemployed young men and women on a Manpower Services Scheme in the early 1980s making candles in nineteenth-century costume at Ironbridge's Blist's Hill came to seem a vivid image of national decline.[145]

Nonetheless, watching a skilled maker at work was a form of instant understanding and, alert to this increasing appetite for practical knowledge, the V&A brought makers into the museum on two successive years, in 1975 and 1976, to demonstrate their crafts alongside the

431. Rag rug making in Pit Cottage no 4 in the colliery village at Beamish, 1990. (Beamish, The North of England Open Air Museum).

relevant historic examples of, for instance, pottery, lace or jewellery. A little book of poems in praise of craftsmanship by Edward Lucie-Smith written out with calligraphic *éclat* by Anne Hechle memorialised the scheme.[146] In a similar spirit, makers were sent by the CAC on a series of *Meet the Craftsmen* tours of the regions, starting in 1976 and continuing almost annually until 1982. Weavers, potters, instrument makers and knitters displayed their skills in arts centres, corn exchanges, schools and centres for the disabled. The tours were enthusiastically received by the public though in October 1977 some of the younger and more unconventional makers met with derision in a deprived area of central Manchester. Not everyone could match Michael Casson, who on an early tour was able to engage the interest of ardent football supporters at the time of the European Cup Final.[147]

But a mass appreciation of the crafts was best conveyed through television. In April 1976 Casson was able to 'Meet the Nation' when he presented *The Craft of the Potter*, a five part series, on BBC 2. The directors of the series had studied the work of an amateur enthusiast, John Anderson, who made and/or initiated a sequence of films (often with the crucial assistance of the potter Robert Fournier) of potters at work. Anderson's masterpiece was *Isaac Button Country Potter* (1964), an elegiac black and white silent film (Fig. 432) which in turn had been influenced by inter-war British documentaries like John Grierson's *Industrial Britain* with its splendid dramatic shots of steel workers, potters and glass blowers caught close-up in concentration and its serried ranks of dramatically lit pots.[148] *The Craft of the Potter* was followed by *The Craft of the Weaver* presented by Ann Sutton, broadcast in 1980 and repeated in 1982. The most striking television film made about an individual craftsman was Alister Hallum's Arts Council/BBC *Mud and Water Man* of 1973. This went beyond recording the craftsman at work to reveal the potter Michael Cardew as an essentially tragic figure, half angry, half humorous, caught between cultures, a man out of place and time.

The summer Potters' Camps of the 1970s organised by David Canter and the Craftsmen Potters Association, with their gaily striped tents set in grassy fields, were also places out of time, but invariably recalled with joy (Fig. 433). The big throwers were the stars – Ray Finch, Michael Casson, the indefatigable Danny Killick. In 1975 *Crafts* found the potters 'as happy as sandboys, building wonderful ingenious kilns implemented by outrageous pieces of improvised equipment – vacuum cleaners blowing *out* – and encouraged by a troop of dogs, children and other potters'.[149] At Dartington in 1977 the camp was enlarged to include spinning, weaving, glass blowing and even bookbinding. There the blacksmith Ivan Smith

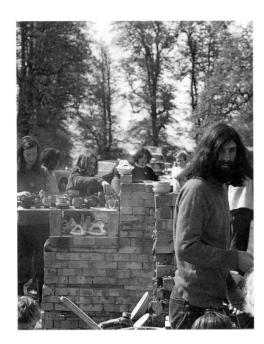

433. Walter Keeler firing a kiln at the CPA Potters Camp, Loseley Park, Surrey, 1973. (Photo Colin Pearson).

'looked more like a magician than a wrought iron worker, the sparks flying as he jabbed and turned the iron in the coals'.[150] A tea ceremony was performed, Morris dancers danced, a salt-glaze kiln was fired.

'Meet the Maker' activities seemed to favour the potter at his (it usually was a he) wheel above all other craft pursuits. But the CAC organised two important conferences based on demonstration and performance which gave a decisive boost to the relatively new hot glass movement and to the ancient craft of blacksmithing. Both Margrie and Coleman had been impressed by the sight of North American hot glass artists at the World Crafts Council conference at Toronto. And during the 1960s and 1970s studio glass courses in British art schools had gained in strength and numbers – with interesting teaching at Birmingham, Leicester College of Art, West Surrey College of Art, High Wycombe, North Staffordshire, Manchester and Sunderland. The CAC decided to encourage this relatively new discipline and organised *Working with Hot Glass*, an international conference with 200 delegates held at the Royal College of Art in September 1976. It was a week of excited interchange with demonstrations by the American originators of hot glass in studio – Dominick Labino, Harvey Littleton and Marvin Lipofsky – and figures from Eastern Europe – above all Stanislav Libenský from Czechoslovakia whose slide show of his more cerebral casting techniques drew a standing ovation. The skills of the Scandinavian and Venetian glass blowers tempered the expressiveness of the Americans. Harvey Littleton was fond of pointing out that 'Technique is cheap'[151] but the professionals from Continental Europe suggested otherwise. The high point was a day of demonstrations with glass artists from all over the world working in pairs – 'Each craftsman built up his own rhythm as he worked – back and forth from the glory-hole, passing the pipes one to another, blowing, shaping, cutting the flow of molten glass, finishing an object and quite often ruthlessly throwing it away.'[152] A film made of the event – all flared jeans, head bands and psychedelic T-shirts – suggests a big party, with an atmosphere of joyful easy making. *Working with Hot glass* was a success, focussing on a fashionable 'new' craft, giving it some technical and intellectual weight, and introducing British glass makers to the international scene. It also introduced a new discipline to British glass which went beyond Sam Herman's expressive approach. Glass artists like Pauline Solven, Ray Flavell, David Kaplan and Rachael Woodman all subsequently went to Scandinavia to broaden and hone their skills. Exactly a decade later the Crafts Council backed another glass conference, also held at the RCA. *Glass in the Environment* pointed up the difference between the late 1980s and the late 1970s. It was a sober affair, dominated by architects in suits, demonstration-free and chiefly concerned with the development of high technology glass for use in architecture, particularly in the context of the visual cliché of the era, the glass atrium. The hot glass movement, with its concentration on creating one-off freely-formed expressive objects, was barely alluded to.

The second dramatically performative workshop and conference looked at the ancient craft of blacksmithing. This art and skill had been kept alive since the 1920s by the Rural Industries Bureau and its successor the Council for Small Industries in Rural Areas (CoSIRA), but in an essentially conservative fashion with a strong reliance on pattern books. The Crafts Council wanted to introduce British smiths to practice on the Continent and in the United States, which was informed by a consciousness of modern art and by much more in the way of original design. The initiative came chiefly from Ivan Smith, a John the Baptist figure in British smithing.[153] Smith set up his workshop in 1971 at Droitwich after nineteen years teaching and working as a wrought-ironwork consultant to CoSIRA and the Welsh Development Agency. He was keenly aware of the limitations of the CoSIRA approach. He had studied Edwin Roth's *Neue Schiedeformen* and the writings of the German blacksmith Fritz Kühn, two of whose books, *Wrought Iron* and *Decorative Work in Wrought Iron and Other Metals*, had been translated and published by Harrap in the 1960s. He had also studied the ironwork designs of Charles Rennie Mackintosh. Aside from Ivan Smith, the Crafts Council were only in touch with two other smiths in the late 1970s, James Horrobin, who had been trained by his father in Somerset, and Richard Quinnell who carried on his father's Rowhurst Forge in Surrey. Both felt isolated. Quinnell recalled that 'I honestly thought we were the last firm of blacksmiths in the world.'[154]

The Council's interventions were orchestrated by its Education Officer Caroline Pearce-Higgins. Planning began in 1977 with a committee led by Margrie, Claude Blair, Keeper of Metalwork at the V&A, Neil Cossons, then director of Ironbridge Gorge Museum, the architect Paul Koralek, Ivan Smith and Richard Quinnell. In September 1978 Quinnell held a 'forge-in' at Rowhurst Forge to launch the British Artist Blacksmiths Association (BABA) and subsequently he and Pearce-Higgins travelled in France, West Germany and Italy making contact with continental smiths. Other initiatives included sending fifteen young British smiths to France to visit workshops in January 1979. In July 1980 an international conference and workshop entitled *Forging Iron* was held at Herefordshire Technical College and at Ironbridge Gorge Museum drawing in 136 participants from all over the world (Fig. 434). There were talks on the pioneering work of modern smiths such as Sam Yellin and Kühn. Demonstrations and talks were given by the greatest modern smiths – Professor Antonio Benetton from Italy, Serge Marchal from France, Alfred Habermann from Czechoslovakia and Albert Paley from the United States. *Forging Iron* was the first truly international gathering of blacksmiths. For the Americans it was the first contact with the high level of traditional skills among the European smiths. For the British smiths, seeing so many new techniques and so many possibilities for expressive work transformed smithing over the subsequent decade.[155] The far reaching effects of the conference were made plain in 1982 when the V&A put on its international exhibition *Towards a New Iron Age*. The show attracted the interest of architects and marked the start of a series of important architectural commissions for blacksmiths.

434. Simon and Antonio Benetton at the *Forging Iron* conference, 1980. (Photo Caroline Pearce-Higgins).

THE MAKER'S EYE

Although the CAC attempted to encourage innovative work through its exhibitions, catalogues and specialist conferences, for most people the crafts were still strongly and sentimentally associated with continuity and tradition. This was made apparent by the press coverage of *The Maker's Eye*, held in 1981 to celebrate the tenth anniversary of the Crafts Council in its new, larger gallery at Waterloo Place. Such a major exhibition could hardly be ignored. The way in which it was reviewed by fine art critics, however, suggested that the project to construct a fresh identity for the crafts had largely failed. *The Maker's Eye* was very different from *The Craftsman's Art*. It was a generous inclusive exhibition entirely selected by makers who had been asked to 'define the idea of craft in terms of his or her personal experience'.[156] All generations were represented. Michael Cardew and Enid Marx had embarked on their creative lives in the inter-war years, David Pye and David Kindersley in the 1940s and 1950s, Alan Peters, Mary Farmer, John Makepeace, David Watkins and Emmanuel Cooper in the early 1960s while Eric de Graaff, Alison Britton, Connie Stevenson and Michael Brennand-Wood had begun their careers in the 1970s.

The exhibition and its handsomely illustrated catalogue, with a statement of intent from each selector, underlines the capacious, multivalent nature of the term 'crafts'. For instance, the potter Alison Britton presented a vivid interpretation which concentrated on her generation of potters and metalsmiths and glass artists, most of whom had left art school in the early 1970s. She argued that, just as a novel by Joyce can be said in part to be 'about' language, 'the objects I have chosen are similarly self-referential, that is, they perform a function, and at the same time are drawing attention to what their own rules are about.' Britton selected vessels or containers which appeared to quote paintings. As she put it: 'Life has been translated into still life and beyond into some ghostlier, more ambivalent form of object.'[157] Like Michael Rowe, whose work she included, Britton identified a modernism which had less to do with functional design and which drew on areas of early twentieth-century painting and literature. Her remarkable piece of writing was illuminated by David Ward who had been commissioned to photograph a group of each selector's choices for the catalogue. In 1974 Ward had married the jeweller Susanna Heron and they often worked collaboratively, using light to inscribe forms on Heron's body and creating interpretative images of her jewellery (Fig. 457).[158] Ward, like David Cripps, brought a poetic sensibility to bear on the photography of objects, heightening the visual impact of Britton's choices by

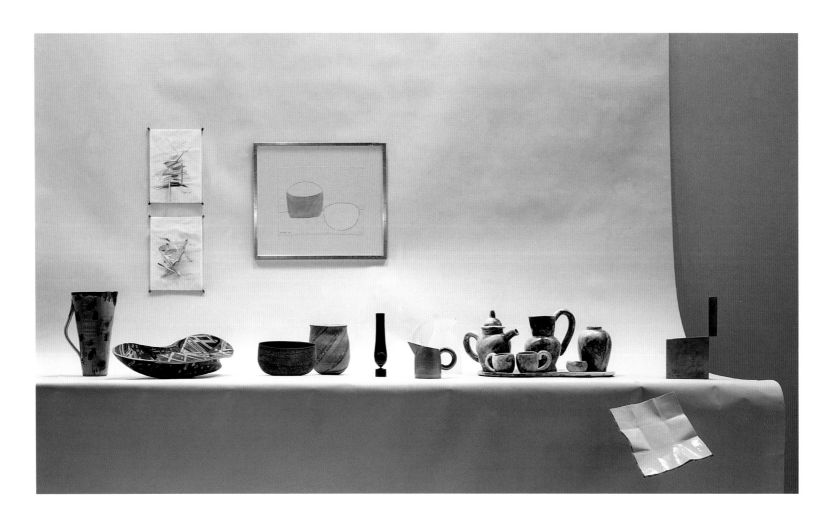

435. Part of Alison Britton's selection for *The Maker's Eye*, 1981 (*l. to r.*) Janice Tchalenko jug, Jacqueline Poncelet dish, Elizabeth Fritsch two bowls, Hans Coper pot, John Davies jug, Steven Newell glass jug, Andrew Lord coffee set, Carol McNicoll plate, Michael Rowe box, (*above*) Pierre Degen bracelets on mounts, William Scott *Aegean Suite no 2*. (Crafts Council/David Ward).

sending an origami-inspired McNicoll plate spinning across the foreground and emphasising the perspectival ambiguity of Fritsch, Rowe and Lord's vessels (Figs 435, 436).

Older selectors proposed a different version of the crafts which was apparently more rooted in practical need. For instance, Cardew's statement was in part a melancholy retrospect on the evils of industrialisation – on the 'dead white stuff' of industrial ceramics and on Western man's arrogant way with nature, 'an enemy to be reduced to servitude'. He suggested a interim definition of a craft – 'that it is useful'[159] – which in the light of his earlier career seemed a narrowing of his vision, a statement made in old age. Nor was it entirely borne out by his selection which included William Staite Murray's majestic *Persian Garden*, the purest of bottle forms by Katharine Pleydell-Bouverie and Cardew's own handsome lidded *Grain Jar*, a descriptive title at odds with its functionless existence in the remarkable collection of studio pottery formed by a Wakefield librarian, William Ismay (Fig. 437).

Enid Marx, another important inter-war maker, similarly warned against 'bottles which will not hold water'.[160] Her choice, reflecting her career and interests, included mass production, the popular art of bargees, the vernacular of Sussex trugs and a range of her own work, from her hand block-printed textiles of the inter-war years to her elegant book jackets for Proust's *Remembrance of Things Past* done for Chatto & Windus in the 1930s. She had a particular admiration for good craftsmen and women who also designed for industry – the typographer and punch cutter Matthew Carter, the weaver and textile designer Margaret Leischner. Her choice was a restatement of the eclectic modernism which she had shared with Muriel Rose, Barron and Larcher and artists like Nash and Ravilious in the early 1930s.

David Pye's essay, characteristically, asked what exactly the crafts comprised, as he had done in books, articles and discussions since the war. But he argued holistically that 'The fine arts, the crafts and industrial production are manifestly part of one continuum. Anything in any part of this continuum can rise to the level of art…the crafts have no frontier.'[161] He included the trade crafts of saddlery, boot-making and tool-making. He was also the only selector to chose

musical instruments – a William Luff violin, Bultitude cello bows and a lute by Stephen Gottlieb. Altogether his vision of the crafts, with an emphasis on fine workmanship, high finish and sensitivity to material, was persuasive. In particular, Pye chose work which had taken long hours to create – a gold bowl engraved with an exquisite 'head of hair pattern' by Malcolm Appleby, a coiled and elaborately slip painted *Optical Bottle* by Elizabeth Fritsch, a carpenter's plane in brass, steel and rosewood and glass bowls engraved by Laurence and Simon Whistler. His selection was in sympathy with his own output of carved and fluted bowls and boxes, made essentially 'for love and not for money'.

The younger selectors, apart from Britton, offered a far less coherent vision in their choices and statements. David Watkins included photographs of the architect Norman Foster's Willis Faber & Dumas headquarters building in Ipswich and his Sainsbury Centre at the University of East Anglia. Emmanuel Cooper juxtaposed a Triumph Bonneville motorcycle with a traditional clippy rug. The alternative fashion culture of the 1970s was gloriously represented by Connie Stevenson. She was the only exhibitor to wander well outside Crafts Council approved territory. Most of the work was certainly hand-made but more in the sense of an inspired collage of existing materials – Andrew Logan's jewellery made of broken glass and resin, George Waud's sheet metal masks, Beverley Bull's necklaces and bags made of wire, chain link and jelly moulds. A black leather ankle boot designed by Malcolm McLaren for the shop Seditionaries belatedly raised the banner of punk. Stevenson's most visible choice, Andrew Logan's ten-foot-high winged horse, *Pegasus: a Monument to Hope* (Fig. 438), made of mirror glass, resin, copper, gold and crystal, won all hearts and ended up on the back cover of the exhibition's catalogue.

Three furniture makers – Alan Peters, John Makepeace and Erik de Graaff – made selections. Makepeace, who had pioneered Rietveld-like frame constructions and expressive Pop-inspired furniture made in collaboration with Ann Sutton at the end of the 1960s and in the early 1970s, emerged as a ruralist.[162] In 1979 he and Ann Sutton had separated. Perhaps

436. Andrew Lord, *Round Grey Shadow* coffee set on a ceramic tray, 1978, earthenware, 47 × 26 × 23 cm. (Leeds Museums and Galleries: Lotherton Hall).

437. Part of Michael Cardew's selection for *The Maker's Eye* 1981, (*top*) Norah Braden bowl; (*middle*) Bernard Leach slipware dish, William Staite Murray jar; (*bottom*) Katharine Pleydell-Bouverie bottle, Michael Cardew, grain jar. (Crafts Council/David Ward).

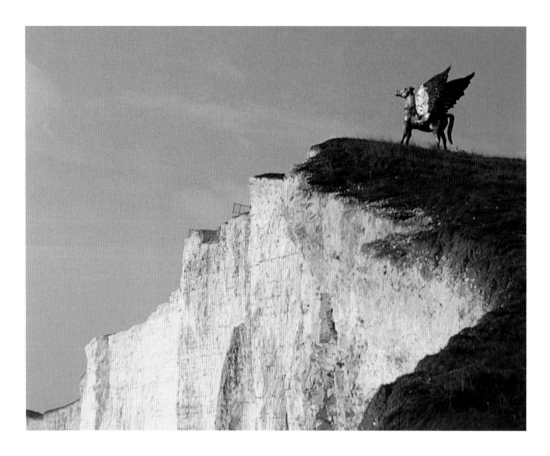

438. Andrew Logan, *Pegasus: a monument to hope*, 1980, mirror, stained glass, resin, copper, gold and crystal, h. 350 cm. (Photo Robyn Beeche).

she had been the modernist in the partnership, for by the time of *The Maker's Eye* Makepeace was moving towards an eclectic neo-gothic organicism. Makepeace's selection took as its starting point an oak settle designed by Ernest Barnsley. It was juxtaposed with a sculpture by David Nash, *Ash branch cubed – (a spreading box)*, a simply made box frame holding a sweep of coppice branches. This was probably the first time that Nash had been included in a craft show, but it was certainly not to be the last. Nash unlocked possibilities for makers working in wood. He celebrated the material's natural energy and instability, making sculpture that revealed how wood shrinks and cracks radically as it dries. In his 1970 Brancusi-like *Table with Cubes* (Fig. 439) Nash investigated the sculptural presence of utilitarian objects. *Table with Cubes*, like Andrew Lord's *Round Grey Shadow* coffee set included in Britton's selection, was a *paragone*-like response to the painterly still life. Nash was also a species of land artist, who in 1979 planted *Ash Dome* in the Vale of Festiniog in North Wales – twenty-two ash trees in a thirty-foot circle which he gradually trained to form a ceiling over the enclosed space. Although Makepeace's other choices were more visually playful – carved, articulated and painted fish by Howard Raybould, a wooden trompe d'oeil still life of a shelf with fruit and bottle by Fred Watson – he also included Nash's true heir in the field of craft, a former Parnham student, Jim Partridge, who had just begun to make spiral bowls out of strips raised up from a disc of wood using a band-saw and simply fixed with nails. Makepeace himself was to take Nash's pastoralism rather more literally, designing chair backs inspired by the living tracery of branches, recreated using complex veneering techniques.

The other furniture selection of interest could hardly have been more different in spirit (Fig. 440). Erik de Graaff took as his starting point a reproduction of a table designed by Charles Rennie Mackintosh in 1908 which has been described as 'the simplest and most complicated piece of furniture that Mackintosh ever designed, a tribute to the generative power of the square'.[163] De Graaff's taste was marked by mimimalist purity. He limited his selection to just five other individuals, calligraphic sequential drawings by Christopher Billett, lights by Ralph Ball, stools by Floris van den Broecke, chairs by Nobuo Nakamura and a sideboard and chair by himself. That neither he nor the majority of his chosen furniture designers – a Scot, a Japanese and two naturalised Dutchmen – can precisely be described as English is suggestive. Van den Broecke and de Graaff were taken up by Ann Hartree's Prescote

Gallery from 1978 and both were given Crafts Council shows in 1980 and by 1981 were on the Crafts Council's Index; but they might not have swum into the Council's remit had not the British furniture industry proved to be so unadventurous. That they received help from the Crafts Council rather than from the Design Council is of interest. Van den Broecke had trained as a painter at Arnheim before going to the Royal College of Art in 1966–9 followed by a later spell at the London College of Furniture learning cabinet making in 1978. Throughout the 1970s he worked as a sculptor as well as a furniture maker, very much in the Dutch constructivist spirit of Gerrit Rietveld, and the early modern de Stijl artists and designers.[164] His furniture of the late 1970s like *Sofa* (1978) and his *SETTLE* of 1985 seemed like an extension of his sculptural interests, upholstered versions of constructed sculpture in which powerful formal elements – rectangles and squares – are juxtaposed and manipulated (Fig. 441). Van den Broecke did not see himself as a craftsman. The skills he used to make his furniture – upholstery and the creation of steel and metal frames – had little to do with the techniques employed by most craft furniture makers. Like Peter Hoyte and William Plunkett, on the CAC Index in the mid-1970s, his place within the craft world was principally due to his low volume production. In the 1980s Van den Broecke did design for industry but he seems to have thrived on the ambiguity of his position as an artist, designer and craftsman.

De Graaff's remoteness from commoditisation was rather more extreme, reminiscent of the hauteur of early Modernist architects like Le Corbusier and Frank Lloyd Wright – though de Graaff's power base was tiny in comparison. He explained:

My starting point is the body. For two years before I went to the Royal College of Art I made no furniture – I just drew the body and its seating positions. Then I built myself a room which was 8' by 12' and in this room I began to arrive at seating. But I did not then and I do not now ever want to make compromises. I saw the bare room in relation to the body and I did not see my work as furniture but as a succession of 'body tools'. The logic of the body tool is basic: for the body to sit, it needs a plane and a supporting structure, and for the body to sit against something, it needs two planes and a supporting structure.

I work by setting myself an intellectual objective and then only when the piece of 'furniture' adheres to all aspects of the objective do I accept it. Only then do I like it. I can

only like something if I really understand it. The idea is the core and if the idea is right and the object fulfils the idea then I come to terms with what it looks like. The X chair was very important. When I had done it I could do nothing else for a year. I travelled. I could not justify making another chair.[165]

De Graaff's attitude can be interpreted as either purist or self-indulgent depending on one's politics and, perhaps, one's income. But both men brought a bracing intellectuality to their furniture practice. It was their resistance to economic realism – tempered in Van den Broecke's case by a career in teaching – which brought them into the Crafts Council's sphere of influence. All through the 1980s the Council continued to nurture and take an interest in furniture designers whose purism and whose inability, or refusal, to adapt to the demands of industry, left them with no obvious patronal home.

The reviews of *The Maker's Eye* were numerous but mixed. Isabelle Anscombe in *The Times Literary Supplement* and Marina Vaizey in *The Sunday Times* and William Packer in *The Financial Times* were full of praise for the sheer range of work on view.[166] But other critics were less kind. 'But what is craft?'[167] asked John McEwen who reviewed the exhibition both in *The Spectator* and in *Crafts* magazine. Making mocking play with the Crafts Council's new terminology he noted – 'once you are a craftsperson there is no avoiding the fact that you are in the upmarket world of art.'[168] (During 1981 the Crafts Council, mindful of the sexist implications of 'craftsman' as a description of all their practitioners, had decided to employ 'craftsman and craftswoman' and the clumsy 'craftspeople' in all their literature.)[169] McEwen's view of the crafts was essentially conservative. He admired the selections by Michael Cardew, Enid Marx and David Pye but disliked choices made by younger makers like Britton and the embroiderer Michael Brennand-Wood. For McEwen the 'oldest and plainest objects still look the best'. Of Stephanie Bergman's stitched and dyed abstract canvases selected by Brennand-Wood, McEwen noted in *The Spectator*, 'This confirms that 'craftspeople' – and the self-consciousness of that word is highly appropriate – are at their most pretentious when their work seeks to identify with painting and sculpture, whereas painters and sculptors invariably seem at their most innocent and exuberant when dabbling in the crafts.' As William Feaver pointed out in *The Observer* the 'problem here isn't so much of trying to define 'craft' as of keeping crafts ordinary, everyday, not set apart.' Feaver too was dismissive of any allusions to

441. Floris van den Broecke, two views of *SETTLE 1985*, 1985, adjustable upholstery on an aluminium frame allowing seating and sleeping, h. 1.5 metres, l. 2 metres. (Floris van den Broecke).

fine art, 'Alison Britton likes bowls and jugs squashed and decorated cubist-fashion.' This was all very well but: 'A painting by Ben Nicholson hangs next to these homages, lording it over them.'[170]

Peter Fuller, a Marxist art critic moving rapidly rightwards, reviewed the show with special attention, setting out his expectations of the crafts in embyro. Like Feaver and McEwen he disliked craft which appeared to be informed by fine art – but for rather different reasons. Since 1979 Fuller had been arguing in a series of articles in *Art Monthly* that the modernist project in fine art had run its course – 'the great promise in modernism had reduced itself to the pornography of despair.'[171] Disgusted and depressed by conceptual art, Fuller turned to the crafts looking for skill, continuity and an affirmation of that 'aesthetic dimension' and 'a shared symbolic order' which the fine art avant-garde appeared to have rejected. He was disappointed with what he found. In the context of *The Maker's Eye* his greatest venom was reserved for Michael Brennand-Wood's selection which 'demonstrated little for me except that when the ethic of modernist self-questioning is embroidered into fabric to produce warps about woofs and woofs about warps all that is worthwhile in weaving, and creative textile making, is quickly destroyed.'[172] Fuller had ardent expectations of the crafts as a counter discourse to that of fine art. His discovery that young makers were influenced by fine art practice and were making self-referential conceptual work that strove to challenge pre-conceptions about a particular craft horrified him. In the early 1980s Fuller launched an influential crusade against the policies of the Crafts Council and against what he perceived as the superficiality of the 'new' crafts. Certainly his criticism of the early 1980s helped to undermine the crafts discourse which had been tentatively encouraged by the Crafts Council. That many of his attacks appeared in *Crafts* magazine only added to the irony of the situation.[173]

The 1970s were a period of extremes for craft practice, of indulgence and discipline, of self expression and 'bloody hard graft'. Some rejected the making process as unimportant. Others gloried in being able to throw forty-five identical mugs in an hour. Each craft had its own technical language and its own fast growing body of technical literature. But the common language that made sense of this multiplicity of activities was almost non-existent. Writers and makers were caught between Leach's lyrical romanticism, the sharp dry prose of David Pye and a prevailing art historical discourse dominated by the writings of Clement Greenberg. But the audience that mattered – collectors who cared about the crafts and the men and women involved in staging shows and events for the newly formed CAC – were conscious of a sense of excitement, of important work being done, often by very young artists whose sensibilities had been sharpened by a lengthy and well funded art education.

Our perception of what the crafts were in the 1970s was partly defined by the activities of the Crafts Advisory Committee and Crafts Council. Domestic scale pottery and jewellery were most keenly supported by the Craft Advisory Committee. In 1974 its Index included sixty-seven potters, twenty-six jewellers, twenty gold and silversmiths and nineteen weavers.

There were only six furniture makers on the Index in 1974 and only thirteen in 1980. All thirteen worked almost exclusively in wood. By 1981 the new furniture maker members included David Colwell, Erik de Graaff and Floris van den Broecke.

But in the 1970s nothing like Coventry Cathedral was built. The crafts appear to shrink in size and to relinquish all links with architecture and public space. This, of course, was not really the case. Stained glass continued to be designed and made; David and Richard Kindersley's architectural lettering grew ever bolder and more ambitious; Geoffrey Clarke, though never part of the official craft constituency, continued to carry out commissions in metal work and stained glass; Peter Collingwood continued to create textile hangings for public space. But on the whole, the crafts inhabited a safe, non-collaborative world of their own. In the 1980s this changed. The tendency was to reach out and make links, however tentative – with architecture, with the world of design and with environmentalists and planners. And the consumer boom of the 1980s had its effect on the crafts as well as on design. The crafts, protean as ever, were ready to transform themselves and take on a new image. They emerged as small businesses, that most vivid, hopeful emblem of Mrs Thatcher's government.

ENTERPRISE CULTURE: THE 1980S

This survey of the 1980s is necessarily an extended sketch rather than a history. But from the perspective of the late 1990s one assertion can be made. The end of consensus politics in Britain and the sweeping changes introduced by Mrs Thatcher's successive governments from 1979 until 1990 were to affect every area of British life. In the case of the crafts, the change was strikingly more to do with context and presentation than with content. The craft disciplines continued to explore formal problems first addressed in the 1970s, albeit with a greater anti-modernist emphasis on surface decoration, historicism and the figurative. The only entirely new visual development was linked to computer-aided design (CAD). The use of CAD created a family of forms which amounted to a computer-generated style, most marked in car design but also striking where employed speculatively by makers. Thus Fred Baier (Fig. 442) and Rebecca de Quin, in disciplines as diverse as furniture making and silversmithing, created work with an instantly recognisable, three-dimensional visual logic. But it was the ways in which craft was written about and consumed which altered most markedly.

One small immediate example. Listen to this voice of 1988: 'Craftspeople are no longer ploughing a quiet furrow in the countryside scraping a living with a clean social conscience. They are making big bucks in big cities with articles in colour supplements and answering-machines to catch the enquiries from Japan.'[1] What is striking is the tone, a new tone of urgent consumerism and strident populism, unexpected in an introductory essay in a highly specialist catalogue of experimental Dutch and British craftwork. Another example. The Royal College of Art degree shows of the 1970s had been fairly anarchic affairs. But by the late 1980s their atmosphere had changed. Indeed, ceramics, glass and silversmithing were displayed with such professionalism that one could be forgiven for forgetting that one was in a school of art. For four years, beginning in 1986, the chainstore Next funded the degree shows, making possible well-produced catalogues of the students' work and much higher standards of presentation. And the involvement of Next was due to the appointment of Jocelyn Stevens as Rector of the Royal College of Art in 1984. Who was he? As the former owner and editor of *Queen* magazine, founder of Radio Caroline and the *Daily Star*, this old-Etonian heir to part of the Hulton *Picture Post* fortune seemed an unlikely Rector for Britain's pre-eminent art school. But this was the 1980s and Stevens was adept at something all important, finding sponsorship for the College. On the principle that there is no such thing as a free lunch, the needs of the sponsors were soon, subtly, to influence students' expectations and students' work.

POLICY REVIEW

The sea-change in British cultural life did not affect the crafts immediately. As we have seen, the achievements of the 1970s culminated in the exhibition *The Maker's Eye* in 1982. Inevitably the policies of the Crafts Council – so confident and so sharply defined – had come to be scrutinised. There was some critical attention from politicians. Lord Donaldson, Labour Minister for the Arts from 1976 until 1979, had praised the Council's emphasis on excellence but asked the Council to encourage wider participation in the crafts by, for instance, addressing the needs of amateurs with the co-operation of the Regional Arts Associations.[2] In May 1979 the Conservatives won the General Election. Mrs Thatcher stood on the steps of 10

442. Fred Baier, The Prism Chair, designed in 1989 using Vamp software by Rubicon Systems Ltd. MDF with a skin of polyester lacquer effects. h. 82 cm. (Carnegie Museum of Modern Art, Pittsburgh/Photo David Cripps).

Downing Street and, misleadingly as it turned out, quoted St Francis of Assisi: 'Where there is discord, may we bring harmony.' Her first Minister for the Arts, Norman St John Stevas, quickly made it plain at a meeting at the Art Workers Guild that although he admired the crafts they were not going to be exempt from a general shift from public to private funding of the arts.[3] Lord Donaldson had won a 26% increase for the Crafts Council for the year 1979/80 which was immediately cut by £19,000 to £1,041,000.[4] In the autumn of 1979 Margrie sent his two deputies, Marigold Coleman and Peter Longman, to meet the Director of the Association for Business Sponsorship of the Arts (ABSA). The meeting confirmed that craft exhibitions, particularly in the then exiguous gallery at Waterloo Place, were unlikely to attract interest of that kind.[5] The reasons were not reported but the complex identity of the crafts, tracked throughout this book, was surely one factor. The crafts, despite the best efforts of the Crafts Council during the 1980s, continued to be resistant to full-blooded commoditisation. Makers themselves evidently accepted that a career in crafts necessarily implied a measure of sacrifice. In 1983 the Crafts Council report *Working in Crafts* appeared. This socio-economic study of the crafts in England and Wales identified about 20,000 makers of whom 54% were women (although of full-time practitioners 61% were men). The average income for full-time male makers from actual craft production was just £3,249.

Ironically, despite these makers' low income, the multivalent identity of the crafts meant that they were asked to fulfil a surprisingly broad range of functions. In 1981–2, for instance, the House of Commons Education, Science and Arts Select Committee made three recommendations – that there should be a wider geographical representation on the Crafts Council's committees, that makers should do more to increase popular access to their work with the help of local authorities and that the Crafts Council should advise the Manpower Services Commission on unemployment training.[6] Implicit in the Education Committee's dry prose was a sense that the Council was too exclusive a body, too divorced from the humdrum world of work, and that the crafts should fulfil social responsibilities from which the fine arts were exempted.

In the Royal Charter granted by the Queen in 1982, the purpose of the Crafts Council was defined as 'to advance and encourage the creation and conservation of works of fine craftsmanship and to foster, promote and increase the interest of the public in the works of

craftsmen and the accessibility of those works to the public in England and Wales'.[7] This question of the Council's commitment to a wider public began to trouble the CAC's creator Lord Eccles. In 1981 he spoke of 'a mistake in the constitution of the CAC in which you find the fatal phrase artist craftsman…I ought to have known the trouble the phrase would give.'[8] In 1984 Eccles wrote to the then Minister for the Arts on the question of balance: 'I would like to see more emphasis within the Council on the market potential for craft work of all kinds, not simply for what might be called work of "international" calibre. This means defining a need for attractive teapots as much as "body jewellery".'[9] Eccles was making a case for 'consumer sovereignty'. That the public were discerning judges of quality and that, in turn, it was the duty of the artist to remain sensitive to the public's needs was a concept at the heart of the Thatcher cultural revolution. Implicit in this endorsement of public taste was a scaling down of state support for the arts.[10]

Lord Eccles's doubts about the privileging of an avant-garde in the crafts were also being raised by the silversmith David Mellor, the Crafts Council's chairman from 1982 until 1984. Mellor was impatient with the Crafts Council's fine art emphasis and, as a successful silversmith, designer and businessman, he believed that there should be more emphasis on short-run batch productions. He was an aggressively hands-on chairman who clashed with his Director (Fig. 443). In 1984 Margrie decided to move on. He had achieved a great deal since the establishment of the CAC in 1971, partly because he had a clear, if narrow, vision of the role of the crafts. But it was a vision which, in the rapidly changing political climate of the 1980s, could easily be attacked as elitist and over-dependent on state support. His primary concern with objects and makers could hardly be faulted but these were drawn from a narrow range. And from 1979 Margrie was being asked to address marketing and sponsorship, those two shibboleths of Mrs Thatcher's enterprise culture.[11]

In addition the Council was under attack from the Regional Arts Associations (RAAs), older organisations which had grown up in the 1950s after the Arts Council had closed its regional offices. The Crafts Council's relatively generous subsidies for two London outlets, the British Crafts Centre (which received £83,000 in 1981/2) and its own shop in the V&A (which paid no rent) did not endear the Council to the RAAs. They handled large budgets to which the Crafts Council contributed a small percentage. Commercial shops and galleries also disliked this apparent favouritism.[12] *Crafts*, the Council's handsomely produced magazine, and the high presentational standard of the Council's exhibitions, which were frequently seen to be rarefied rather than populist, also came in for criticism from the regions. And in the 1980s charges of cultural elitism, whether from the left or the right, had serious implications, giving weight to the government's long term aim to discipline and shrink government funded arts bodies.

Margrie's departure, followed in April 1984 by his deputy Marigold Coleman, effectively meant the end of the period of 'sheer enjoyment'. Margrie's successor, David Dougan, a former head of Northern Arts, felt that the Council was insufficiently committed to regionalism. He embarked on a series of extensive Defoe-like tours which taught him 'how little influence London has when seen from Manchester, Wales or Nottingham, never mind Yorkshire or the North East'.[13] As a result he insisted that a proportion of Council meetings be held out of London. He also ventured to rethink what exactly constituted 'the crafts', even engaging in a correspondence with David Pye. In a lengthy letter Pye set out a spectrum from 'the fine arts, which *make strictly useless things*' to 'craftsmen on whom our civilisation, via industry, wholly depends. These are the tool makers, jigmakers, model makers, prototype makers, instrument makers and others.'[14] Pye urged inclusiveness, favouring batch production, rural crafts, makers of musical instruments and 'skilled makers working to designs provided by others'. In short Pye made the case for a broader remit, as he had to the Crafts Centre of Great Britain back in 1957.

David Dougan's attempts at re-definition were not fruitful. He noted that in its early years the Crafts Council had 'limited its work rather carefully, promoting those crafts where the idea behind the work was at least as important as the excellence of the technique.' But, in an attempt to define the Council's future tasks his language became cloudy, as he wrote of

443. (*left to right*) Alison Britton, Victor Margrie and David Mellor at the launch of *Working in Crafts*, November 1983. (Crafts Council/Ed Barber).

'attitudes to do with striving and growing'.[15] In a *Statement of Policy* published in April 1986 craftsmanship was to be characterised more concretely as 'the dominant impact of an individual maker at all stages of production; a sense of innovation; design content; aesthetic content; technical competence. Broadly, the Crafts Council is particularly concerned with certain materials, for example glass, fibre, wood, clay, and occupies the ground between the Arts Council and the Design Council.'[16] In short, the Council's remit remained unchanged.

In practical terms Dougan was committed to a programme of devolution in every area but above all to the RAAs in order to make the Council, as he put it, 'an enabler rather than a doer'.[17] This shift of emphasis meant that between 1984/5 and 1987/8 funding of the RAAs went up from £246,000 to £393,000, an increase of 59.7% during a period when the Council's own government grant only rose by 13%. In 1984 only one RAA had a full-time craft officer, but by 1987 six RAAs had full-time senior officers. This was an undoubted benefit and was reflected in high quality craft shows put on in the regions in the 1980s. Less usefully Dougan discontinued in-house publishing – which had produced two important historical studies, of the potter William Staite Murray and the weaver Ethel Mairet, Michael Rowe and Richard Hughes's comprehensive *The Colouring, Bronzing and Patination of Metals* as well as handsome catalogues like *The Maker's Eye* and practical handbooks like *Setting up a Workshop*. Dougan was also hostile to the continuing subsidy for *Crafts* which ultimately he hoped could be published commercially.

While he was Director, Dougan did not irrevocably change the Crafts Council. For instance, exhibitions mounted by Ralph Turner continued, informed by the same kind of formalist standard, until his departure in 1989. But change was inevitably brought about in the craft culture by the radical programme of institutional and economic reform being initiated by the government. Marketing the crafts became a priority. Between 1984/5 and 1987/8 the budget for sales development at the Crafts Council went up from £40,000 to £80,000. There was a greater involvement in trade fairs at home and abroad. In 1987 the Council took over the Chelsea Craft Fair which had been built up since 1979 by a Chelsea resident, Lady Powell. In 1989 the Selected Index of Makers and the Information Unit were incorporated into a new Sales Development and Information Section. The Council undertook market research and in 1988/9 received £50,000 from government for projects designed to stimulate craft sales. Of this £15,000 was used to launch Creative Eye, aimed at trade buyers. But Dougan's basic antipathy towards the organisation which he headed created confusion and tension and in 1988 he resigned, arguably leaving the Crafts Council less certain of its goals. In the long term the Council became rather less committed to supporting new work which might be seen to be radical or 'difficult'. But, as we shall see, the Crafts Council survived into the late 1990s with all its functions intact, while the Design Council did not.

SMALL BUSINESS

In the 1980s the encouragement of small businesses became a key government policy, a solution to unemployment and a stimulus to the dormant entrepreneurship which Mrs Thatcher believed had been stifled by the Trades Unions and an overprotective Welfare State. Craftsmen and women had, of course, always operated as small businesses. From its inception the Crafts Advisory Committee had recognised this and had given Setting-Up Grants – funding capital equipment and a year's maintenance – to young makers on a competitive basis. By the mid-1980s this scheme and the government initiatives intended to foster an enterprise culture began to inter-twine. In August 1983 the Manpower Services Commission's Enterprise Allowance Scheme (EAS) became available to anyone over eighteen who wanted to start a business and had been registered for Unemployment or Supplementary Benefit. If they had access to £1000 they were entitled to a guaranteed income of £40 a week for a year plus any further earnings.[18] By 1988 a third of the recipients of Setting Up Grants were receiving their maintenance from the Enterprise Allowance Scheme and the costs of capital equipment from the Crafts Council. That the EAS was popular with makers until its demise in March 1991 was hardly surprising. But what is of interest is that the Crafts Council began to recast its support

444. Small business: the workforce at Dart Pottery, Dartington, Devon 1984, (*l. to r.*) Jules Brunt, Vicki Whelpton, Peter Cook, Rob Whelpton, Steve Course, (*seated*) Janice Tchalenko, Jenny Withers Green. (Photo courtesy Dartington Pottery).

445. Small business: *Poppy*, 1984, stoneware, brush and slip decoration. This was the first tableware design by Janice Tchalenko for Dart Pottery. (Janice Tchalenko).

for makers in the language of enterprise, describing the Setting Up Grants as the equivalent of 'venture capital' and as a speculative high risk investment in the daring and the innovative.[19] The Council were also able to argue that the investment paid off. Although viable businesses were created as a result of the unselective Enterprise Allowance Scheme, the Crafts Council was able to demonstrate very high levels of survival among the recipients of their Setting Up grants. In 1986 it was noted that after ten years 65% of those who had received Setting Up grants were still practising makers.[20] By 1990 a further survey showed that craft businesses were surviving the recession of 1989 and that their survival rate was three times better than the national average for small businesses. 60% of all makers who had been helped by the Crafts Council over the past twenty years were still trading.[21]

But did makers represent all the desirable qualities of enterprise as defined by Mrs Thatcher and ministers like Nigel Lawson and Lord Young? Not entirely. For instance, the Crafts Council had operated a fixed-rate loans system since 1973. But this tended to be under-subscribed because, on the whole, craftsmen and women preferred not to increase their liabilities.[22] Craft businesses kept going because of artistic commitment rather than because of entrepreneurial expansionist risk-taking. Often makers supplemented their incomes with teaching or depended on the support of a partner in steady employment. Even the most successful example of 1980s craft 'enterprise', the Dart Pottery set up in 1984 at Dartington in Devon with Janice Tchalenko as its designer, saw its priorities as first, high design standards, second, a fulfilled workforce and, last, business success. Dart's origins as the Dartington Pottery Training Workshop were kept firmly in view. Because Tchalenko and Dart's directors were anxious that employees and trainees should enjoy their work Tchalenko allowed them a measure of creative freedom in interpreting her designs.[23] Nor did the directors wish to expand from large workshop to factory (Fig. 444, 445). The distinction here was more to do with attitude than production capacity. As the furniture designer David Field with a workforce of ten makers and a turnover of £400,000 a year in 1991 declared, 'we're not a sweatshop. Ideas still come up from the bench.'[24] The commitment and determination needed to run a craft-based workshop fitted the Thatcherite model but, ironically, this commitment was invariably fired by wholly un-Thatcherite ideals.

The true entrepreneurs tended to operate on the margins of the craft world. Luke Hughes & Company grew out of a furniture workshop started by Hughes in Covent Garden in 1981. By 1986 Hughes was sub-contracting work and in 1990 his company raised £300,000 under another enterprise facilitator – the Business Expansion Scheme.[25] Emma Bridgewater started decorating pottery blanks with spongeware designs and by 1990 had bought a factory in Stoke-on-Trent and had been nominated for the Businesswoman of the Year Award. But even their

businesses were shot through with altruism. Hughes was struck by the cramped dilapidated conditions of the Birmingham factory to whom he sub-contracted his early designs. But 'we began to establish a rapport with the cabinet makers on the shop floor; then they would reveal quietly, "It's nice to see your stuff going through; it makes me proud to take the wife into the furniture shop on Saturday or show her the pictures you gave us."' Hughes concluded: 'Well William Morris, what can you add to that?'[26]

In contrast, encounters between designer makers and industry in the 1980s provide vivid snapshots of decline and inflexibility. In the spring of 1985 the chainstore Next Interiors under the artistic direction of Tricia Guild decided to reproduce a range of ceramics by Janice Tchalenko and Carol McNicoll. Although Next were offering £50,000 worth of orders, most Stoke-on-Trent factories saw this as too small to justify retooling and changing working practices. The factories followed a rigid sequence of biscuit and gloss-firing with decorating done using transfers and infilling. True hand-painted decoration had virtually died out at Stoke. The variety of techniques employed by McNicoll and Tchalenko – sponging, slip-trailing and sgraffito – were almost unknown. The small firm Fleshpots, which eventually took on the order, trained a mixed group of BA graduates from local art colleges and workers from within the industry to follow the two potters' methods. The Next experiment resulted in mass-produced ceramics of high quality and originality at reasonable prices but it was not followed through after the departure of Tricia Guild.[27] Next subsequently used designs from other designer makers including the glass artist Simon Moore and the ceramicists John Hinchcliffe and Wendy Barber and the textile team Fay Morgan and Roger Oates. But short-termism ruled: if these designs did not produce the appropriate sales figures the designers were dropped.[28]

In the case of textiles, the decision to move from craft production to a design role touched on issues raised by Ethel Mairet before the war. The weaver Roger Oates had had a purist training at Farnham School of Art, taught by Ella McLeod and her pupil Margaret Bide with their passionate sensitivity to yarn quality. By 1971 he had his own rug weaving studio at Ledbury and supplemented his income through teaching. In 1977, in collaboration with the textile designer Fay Morgan, he began to prototype designs which were woven industrially or, in the case of rag rugs, made by outworkers. As Morgan and Oates explained 'It is impossible for a textile designer-craftsman to make a living solely from the handweaving of fabric. We feel that hand and power production must be linked if any standard of design is to be met and production capacity achieved.'[29] In 1986 they formed the company Morgan & Oates to market and distribute a range of shawls and throws. In search of investment capital they were bought by Pentland Industries, becoming salaried consultants to their own firm. In 1987 they set up Roger Oates Design Partnership concentrating on tufted rugs and flatweave carpets. In effect they moved from craft to design and by the end of the 1980s had come to view the world of pure craft production of textiles with a degree of wonderment and pity.

One craft discipline – working with hot glass – demanded a 'small business' approach. Maintaining a glass furnace is costly and the creation of complex pieces in hot glass demands teamwork. Though studio hot glass in Britain was born out of passionate experimentation with free-blown forms, the movement soon sought a measure of discipline. As the *Hot Glass* conference held at the Royal College of Art in 1976 demonstrated all too clearly, the European glass industry was a repository of enormous skill (as was Whitefriars Glass up until its closure in 1980) and many makers, including Ray Flavell, Pauline Solven, David Taylor, David Kaplan and Rachael Woodman went abroad, chiefly to Sweden, to develop technically.[30] By the 1980s it was possible to discern two strands in British studio glass – firstly, those whose one-off work was balanced by production in hot glass and secondly, a group dedicated to the fine art end of glass work, often employing the less speedy techniques associated with kiln forming and subsequent cold working of the glass. To an extent these two groups operated in different economic universes. The first group was reliant on good design and production for a basic income, selling their work to trade buyers at gift fairs at home and abroad and using the income to fund one-off pieces (studio production glass usually shares all the positive functional

446. Small business: Steven Newell, flattened blown glass jugs, in production since 1980, h. 21 cms. (Newell Glass).

447. Steven Newell, *The Bridge Players*, 1985, blown glass sandblasted and polished, diameter 58 cm. (Photo Karen Norquay).

qualities of factory made glass – unlike much studio production pottery). The second group of glass artists were more dependent on teaching, some design work and on elevating the status of glass-as-sculpture to achieve fine art prices for their work.

As we saw in Part II the studio-sized furnace (although long used by the industry for experimental work) was introduced to British art schools by the American glass artist Sam Herman in the late 1960s. The Royal College of Art, Edinburgh School of Art and the School of Art, Stourbridge, already had small industrial furnaces but until the late 1960s students at these two colleges studied glass as designers and the actual making was carried out by

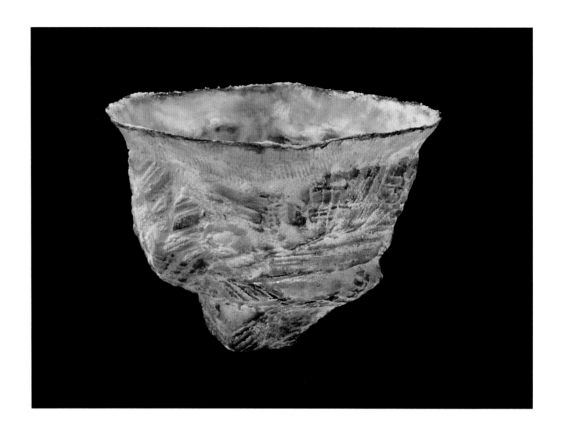

448. Diana Hobson, vase, 1983, *pâte de verre* with metal and enamel colours. 8.5 × 11.3 cm.(Diana Hobson/Crafts Council).

technicians. In 1969 Herman and Graham Hughes and Susannah Robins (chairman and director of the Crafts Centre of Great Britain respectively) set up the Glasshouse in Neal Street, Covent Garden. In effect it was a glass equivalent of the Dartington Pottery Training Workshop but it was far less organised – a place where Royal College of Art postgraduates could make work and sell the results. It was initially managed from 1969 until 1970 by one of Herman's first and most gifted students, Pauline Solven. During those early years many of the future leading figures in hot glass passed through the workshop, mostly working there part-time.[31] But there was an inevitable tension between a loosely organised co-operative venture and good business.

When the Glasshouse moved to larger premises in Long Acre in 1976 it became a Limited Company.[32] Its current directors, Annette Meech, Fleur Tookey, David Taylor and Christopher Williams have worked together for nearly two decades and oversaw a third move to new premises in Islington in 1993. The Glasshouse has always sold a mixture of one-off and production pieces. In the early 1980s the latter included Steven Newell's flattened and winged jugs (Fig. 446), Christopher Williams's mould-blown sandblasted bowls and Annette Meech's glasses with twisted coloured stems. None of the chief participants draw a salary nor did (or do) they share designs. Instead a commission is paid to each individual when a piece of work is sold. Rigorous book-keeping and a constant mix of very different talents enabled the Glasshouse to survive.[33] Most of the other 'small businesses' which came out of the studio glass movement similarly concentrated on hot glass. Cowdy Glass Workshop set up by Pauline Solven and Harry Cowdy in 1978 (closed in 1989),[34] Lindean Mill Glass in Scotland founded in 1977 by David Kaplan and Annica Sandström,[35] Peter Layton's London Glassblowing Workshop founded in 1970, Rachael Woodman and Neil Wilkin's mid-1980s collaboration on bowls using the 'overfang' technique[36] and Wilkin's independent Frome workshop are just a few examples of these hot glass enterprises.

In 1985 Catherine Hough, Simon Moore and Steven Newell set up Glassworks (London) Ltd., one of the most ambitious attempts to create a studio-based production line. To support their own private work the trio evolved a range of eighty functional items. Moore in particular had dazzling glass blowing and manipulating skills learnt from Ronnie Wilkinson, an employee at Whitefriars Glass for thirty years. From 1986 till his death in 1991 Wilkinson was a key figure at the Glasshouse, advising on technique and carrying out restoration work — an

449. Keith Cummings, *Torc*, 1989, glass, copper, silver, lost-wax, kiln formed and electroformed, 25 × 15 × 10 cm. (Keith Cummings).

illustration of the continuing reliance of the artist crafts on the experiential wisdom of artisans. Moore's design intelligence and sharp business sense put him in a special league and in 1992 he set up his own business Simon Moore (London) Ltd.[37] If Moore's work exemplifies Ruskin's definition of the best qualities of glass – '*ductility* when heated and *transparency* when cold', the work of his co-directors at Glassworks was characterised by some of the more familiar tropes of 1980s glass, in particularly an interest in narrative and in abstraction. Newell used sand-blasting to delineate floating neo-primitive figures on massive platters and deep bowls (Fig. 447). Emulating David Taylor, Hough took one of the favoured forms of blown glass – the scent bottle – and, through sandblasting, cutting and polishing, developed it beyond function into the realm of small-scale sculpture.

Blowing glass requires a particular kind of skill only acquired through long practice – it exemplifies tacit or practical knowledge. This did not suit all glass artists. Keith Cummings trained in fine art at Durham from 1958 until 1962. He then taught at Stourbridge College of Art and Technology until 1989 and at Wolverhampton School of Art from 1989 until 1994. He concentrated on kiln-formed glass, combining natural and abstract forms with enclosing metal mounts and clasps. A piece might take eight months to complete (Fig. 449).[38] An extended list of makers in glass shared Cummings's preference for these slower working methods – which had interested *art nouveau* glass artists in the late nineteenth century and which in many instances involved the rediscovery of lost or half-lost techniques. For instance, Diana Hobson began to investigate *pâte-de-verre* in 1980 after a career in the ceramics industry and studying metalwork at the Royal College of Art. Her work suggests all the strengths and weaknesses of the fine art end of studio glass. Hobson's first *pâte-de-verre* pieces were exquisite and remarkably fragile – museum material from the start (Fig. 448). At Pilchurch Glass School in Seattle in 1987 Hobson met Conrad House, a native American artist, and subsequently introduced a new level of narrative and symbolism into her work, mixing in feathers and stones and placing closed sculptural forms precariously on natural limestone plinths. By the early 1990s Hobson was self-declaredly moving 'more into a fine art sphere working with installations'.[39]

In fact the work of many glass artists – Peter Aldridge, Charles Bray, Keith Brocklehurst, Ray Flavell, Stephen Procter, Clifford Rainey, Colin Reid and David Reekie – was evidently meant to be viewed as a branch of abstract or figurative sculpture. Glass artists like Anna

450. The cover of *Crafts* magazine November/December 1984, designed by the magazine's art director David King.

Dickinson, Tessa Clegg, Liz Lowe and Margaret Alston went in a slightly different direction, maintaining an interest in the vessel but creating pieces with a 'timeless' archaeological appearance, comparable to the neo-Oriental pottery of the inter-war years. Both areas of work needed to be promoted as collectable rather than usable. This was done more effectively in Continental Europe and in the United States through a network of galleries and the key German magazine *Neues Glas*. In Britain the two galleries devoted to glass which opened in the 1980s – Dan Klein and Coleridge – only lasted a few years. Klein was, however, an important mediator, subsequently in charge of the twentieth-century decorative art section at Christies, which from 1986 promoted modern glass in sales devoted to twentieth-century decorative arts. Klein wrote numerous books and articles on glass and, crucially, constructed a coherent, stirring 'story' for modern glass aimed primarily at collectors. Glass was 'the newest art form there is' and Klein dated its birth as a creative medium precisely to 1962 when the potter Harvey Littleton and the glass technician Dominick Labino held their 'momentous' seminar at the University of Wisconsin. In Klein's writings glass was always 'exciting' and 'developing' and making 'for the stratosphere'.[40] But the economics of fine art glass were uncertain. High prices were asked for glass (higher certainly than for most studio ceramics) but only in the United States were there sufficient collectors who regarded glass as an art form. The longest surviving small business, the Glasshouse, emphasised design as much as self-expression.

A CALL TO ORDER

If we look back over the literature of Arts and Crafts since the 1880s it is striking how much that was useful to craft practice and philosophy was written by makers themselves – from the Arts and Crafts Exhibition Society's collected *Arts & Crafts Essays* (1893) to Lethaby's Artistic Crafts series to the pamphlets and essays of Eric Gill and Ethel Mairet to Bernard Leach's *A Potter's Book*. Alison Britton's brilliant short encapsulation of her generation's concerns in the Crafts Council's *The Maker's Eye* catalogue of 1982 was a worthy addition to this body of writing. The crafts project continued to be shaped by writing as well as making. Nonetheless, chiefly because of the lively editorship of *Crafts* magazine under Martina Margetts from 1978 until 1987, critics from outside the craft world were drawn into the craft debate. Throughout the 1970s most writing on the crafts had been friendly, even celebratory. As we saw, more complex writing was often penned by makers themselves. By the early 1980s this atmosphere of goodwill was to diminish. The change of mood came slowly but in 1981 Margetts introduced a Comment section for 'personal views' and from then on the magazine began to reflect wider, more combative debates in visual culture, including the numerous calls to order characteristic of much mainstream writing about the arts in the 1980s. In 1984 the magazine was re-designed by David King in a format with heavy red and black underscorings, inspired by Russian constructivist typography (Fig. 450). *Crafts* suddenly began to look revolutionary, an anomaly among subsidised magazines. Its contents had already become explosive, setting out ideas which carried the thinking of the New Right into the craft arena.

This writing was intertwined with other debates within the worlds of fine art, architecture and music during the 1980s. All, in various ways, involved increasingly ferocious attacks on the legacy of modernism. The change of mood reflected a shift closely linked to the enterprise culture being propagandised by the Conservative government. All kinds of groupings, from visitors to museums to hospital patients, were being designated 'customers', thus commodifying social relations previously based on trust.[41] A belief in market forces was central to Conservative thinking on the arts and was taken up almost unconsciously by anti-modern critics hostile to the patronage of bodies like the Arts Council and the Crafts Council. In some of this writing there was a marked emphasis on the needs of the 'customer' or patron. Artists were expected to display virtues such as flexibility, skill and hard work, qualities more associated with service industries than with an avant-garde. As Richard Luce, Mrs Thatcher's Arts Minister from 1985, explained: 'Craftsmen aren't going to sell unless they make what the public want.'[42]

The stormiest and most inflamed writing focused on architecture. Real social concerns were voiced. Young conservationists and architecture critics expressed their disillusion with

the giants of the Modern Movement, their pupils, followers and apologists, blaming them for the shoddier failures of post-war public building and town planning in Britain.[43] The crafts did not generate such a level of debate. But there was vigorous writing in the same reactionary mood which, for example, deplored the drift towards conceptualism in craft, the apparent growing disdain for the functional qualities of ceramics, textiles and jewellery, and a perceived lack of respect for skill and for so-called craft 'traditions'.

As we saw in Chapter Ten, the first powerfully negative voice was that of Peter Fuller, who began to write in *Crafts* in 1981.[44] Fuller's rejection of avant-garde art and his search for a British or even English art of shared values led him to investigate the contemporary crafts. He disliked what he found. By the late 1970s it had become commonplace in craft circles to write optimistically of a blurring of boundaries between fine art and craft. As the distinguished weaver Theo Moorman explained in the catalogue of the show *Textiles North*, which Fuller reviewed in 1982, nothing 'can now halt the encroachment into the world of so-called "Fine Arts" of the craftsman with a valid artistic statement to make'. But Fuller argued differently, reminding his readers of Morris's belief that the fine arts could not flourish without 'the rich subtending soil of the decorative arts and crafts from which, historically, they have sprung'. That 'the crafts increasingly appeal to the debased Fine Arts, in order, quite literally to validate themselves' seemed to him cause for alarm. He wanted the crafts to have no truck with 'the failed modernist experiment' and called for the development of a 'shared symbolic order' which used 'meaningful pattern and effective ornamentation'.[45]

Fuller's views on design complemented his attitude to the crafts. He wanted design to be regulated just at the moment when it was liberating itself, above all from the Design Council's tenets of progressive modernist good taste.[46] Fuller's knowledge of design history was initially shaky but he read voraciously and when he learnt about Gordon Russell's role in the wartime imposition of a 'Utility' design policy on the production of furniture, clothing and ceramics he recognised a model for his own developing ideas. By 1983 Fuller was writing and lecturing on his vision of a two-tier economy for product design. He wanted design to be regulated by what he called a 'modified Russellism'[47] which would impose standards of good practical design while a second tier of handcraft work would provide the 'arena for the resurgence of the aesthetic dimension in production'. The Crafts Council, with its commitment to an adventurous avant-gardism and its focus on what Fuller mockingly termed the 'Artist Crafts Person', was dismissed as detrimental to the crafts. Fuller wanted a national policy based on workshops and craft 'traditions'. He was vague as to what the latter might be, but there would be a concerted attempt to introduce a revival of ornament based on nature and 'collective work rather than individual expression' would be favoured.[48]

Fuller was a brilliantly provocative speaker and in tune with the spirit of the 1980s he was well able to 'think the unthinkable' – a phrase coined by Alfred Sherman, head of the Conservative Centre for Policy Studies.[49] Fuller's unashamedly authoritarian ideas invariably provoked startled protests from horrified Three-Dimensional Design students in art schools up and down the land. Among makers committed to workshop training and makers who felt alienated by the Crafts Council's apparent commitment to a fine art approach, however, his ideas were read with appreciation.[50]

Fuller's greatest sympathies lay with inter-war makers like Bernard Leach and Michael Cardew, whose radicalism and ambivalent attitudes to skill he failed to recognise. In his writings on ceramics Fuller demonised William Staite Murray, Hans Coper and Lucie Rie for encouraging a fine art approach to pottery and, in the case of Coper, for diminishing the importance of throwing. Coper's relations with Leach were inappositely compared to Anthony Caro's rejection of his employer Henry Moore's commitment to figurative sculpture.[51] Coper, as an influential tutor at the Royal College, was held responsible for the 'New Ceramics' of Alison Britton (Fig. 451), Jill Crowley, Elizabeth Fritsch, Carol McNicoll and Jacqueline Poncelet.

Fuller's positive tastes were never put to the test. He was never to organise an exhibition of craftwork which he admired, though his cry 'Give me imitation pearls anyday!'[52] in response to a ambitious exhibition of jewellery put together by Susanna Heron and the painter

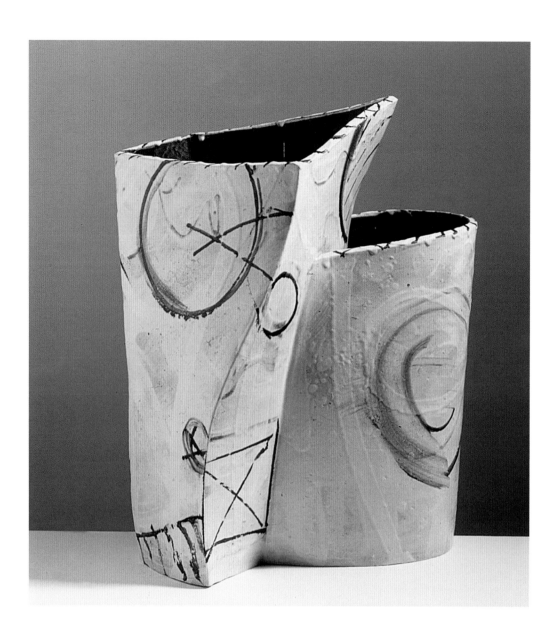

451. Alison Britton, *Double Pot*, 1987, slab-built earthenware, h. 40 cm. (Hove Museum and Art Gallery/Photo David Cripps).

and photographer David Ward is suggestive.[53] But his criticisms of the crafts were of a piece with his fine art criticism. He saw the changes in art school education during the 1970s, in particular the introduction of Basic Design at foundation level, as having undermined both skill and the spiritual, affirmative possibilities of art.[54] His final contributions to *Crafts* appeared in 1986 and in 1988 he launched his own journal *Modern Painters* which was to devote little space to either craft or design, but which was chiefly concerned with the rehabilitation of specifically British painting and sculpture. He was killed in a car crash in 1990. Was Fuller a fully paid up New Right intellectual? His absorption with 'tradition' and his desire to re-introduce a sense of national identity in art, craft and design suggest that he was. But his interest in 'modified Russellism' and in state subsidised workshops suggests that, despite his move from Marxism to a Little England Conservatism, he was nonetheless not ready for 'consumer sovereignty'.

The debates which Martina Margetts fostered in *Crafts* were criticised in turn. The charge of elitism, which had been implicitly made by Fuller when he mocked 'conceptual crafts', was levelled at the magazine. The Craft Officer at Northern Arts, Laurie Short, criticised *Crafts'* 'over-indulgence in presentation and content'. He found the magazine 'self-applauding and narrow-minded. It seems totally unconcerned with the issues of race and social disadvantage which are present in the lives of many members of the crafts community.'[55] The sociologist June Freeman agreed, arguing that 'the structure of our society actually prevents us seeing certain forms of visual imagination when they are practised outside our group'. She was in favour of cultural relativism, suggesting that 'we must give attention to a broader array of craft and craftworkers'.[56] The ideas implicit in Freeman's article, that taste was constructed, that

452. Catherine Reilly, *Lady Ironing*, 1981, mixed media, lifesize illustrating Penina Barnett's article 'Domestic Hiss' *Crafts*, 1982. (Catherine Reilly/Crafts Council).

453. The Durham quilter Amy Emms teaching school children during the *Quilting, Patchwork and Appliqué* exhibition at the Crafts Council in 1983. (Crafts Council/Karen Norquay).

there was no such thing as creative autonomy and that a body like the Crafts Council was acting as a cultural gatekeeper, determining who should be recognised as a maker, would have been familiar to any sociologist or anthropologist.[57] But such ideas were not accepted or developed by the Crafts Council any more than they were by the Arts Council. And in the case of the crafts cultural relativism had particularly alarming implications, theoretically making a place for work by amateurs and by makers without a suitable artistic training.

Perhaps that is why feminist writing on craft, as in the 1970s, continued to be marginalised, despite the appearance of crucial studies which took in the crafts and applied arts such as Anthea Callen's *The Angel in the Studio: Women in the Arts and Crafts Movement* (1979), Rozsika Parker and Griselda Pollock's *Old Mistresses: Women, Art and Ideology* (1981), Judy Attfield and Pat Kirkham's *A View from the Interior* (1989), Cheryl Buckley's *Potters and Paintresses* (1990) and Rozsika Parker's *The Subversive Stitch: Embroidery and the Making of the Feminine* (1984). The last inspired two overtly feminist exhibitions with the umbrella title *The Subversive Stitch* curated by Jennifer Harris and Pennina Barnett for the Whitworth Art Gallery and the Cornerhouse in Manchester in 1988. But a feminist analysis, as one reviewer recorded, was 'still sufficiently unusual to provoke hostility or disdain in some quarters'.[58] Barnett had already written a brief ground breaking article for *Crafts* in 1982 which analysed the role of women in the crafts, especially textiles, from a feminist perspective (Fig. 452).[59] It was the only feminist article to appear in the magazine in the 1980s. Nonetheless, two important shows did come to the Crafts Council's galleries, both organised by June Freeman. *Quilting, Patchwork and Appliqué 1700–1982: Sewing as a Woman's Art* (1983) and *Knitting: A Common Art* (1987) had a strong historical perspective, showed amateur and professional work mainly by women side by side, and attracted large audiences (Fig. 453). A third inspired touring exhibition put together by June Freeman, *The Sugared Imagination* (1989), which dealt with the craft of icing cakes, was considered too thoroughly domestic for the Council's galleries. Again, the potentially rich possibilities of a feminist critique of the crafts were not encouraged by a Council anxious to avoid any perceived association with amateurism and populism. Ralph Turner found a gendered approach patronising, especially the idea 'that textiles and sewing and knitting are a woman's bit and you think, come on! – we've the best potters in Europe here and they're all women so why the hell are we hopping around looking for crochet.'[60]

Yet in the 1980s there was plenty of material for exegesis based on gender. The potter Jill

455. (*opposite*) Michael Rowe, *Conditions for Ornament no. 6*, 1988, brass, copper, tinned finish, 60 × 55 × 44 cm. (Photo David Cripps).

454. Elspeth Owen, two 'wrapped' pots, 1986, earthenware, handbuilt. h. 14 and 10 cm. (Photo James Austin, Cambridge).

Crowley's early work – animated herds of teapots and portrait busts of battered looking city gents – had been popular with the Crafts Council and generous purchases of her work were made for the Council's collection. In 1979, during her pregnancy, she made the first of her 'lady' wallpieces, armless, legless reliefs with breasts and pudenda specifically and rawly delineated. Subsequently, as Crowley explained 'everything went very quiet'.[61] Although later post-partum work included tender little evocations of her daughter's limbs and a sequence of louche, eroticised mermaids, her work was never to be analysed in terms of gender. The apparent inclusiveness of the official craft world – which welcomed work provided it was formally of a high standard – had the effect of precluding other kinds of discussion.

Some useful commentary came from women makers themselves. Elspeth Owen's hand-built pots were highly sophisticated examples of pure form. But in her essay *On Being a Potter*, we learn that their making was intertwined with and affected by other activities such as Owen's engagement with the peace movement.[62] Owen had been on the original walk to Greenham Common in 1981 which resulted in the setting up of the women's camp outside the USA Cruise missile base. She returned many times over the next ten years and as a result her working practices, if not the work itself, were low-tech and provisional, suggesting that she was forever camping out, on the road, roaming and restless (Fig. 454).

Owen's autobiographical account reminds us that there was 'craft' at Greenham, perhaps 'art' too, woven into or attached to the perimeter fence; but a full study of the meaning of craft at Greenham, and of the involvement of other makers such as the textile artist Janis Jefferies, is a history waiting to be written. One book devoted to craft and gender appeared in the 1980s published by Virago. *Women and Craft* opened up another world of craft which honoured amateurs and professionals and which acknowledged the transmission of skills and artistry from mother to daughter, seeing such an interchange as having the same importance as an art school education.[63]

The Crafts Council also paid little attention to ethnic minorities living in Britain and their craft traditions – such as the craftwork associated with the Carnivals in Chapeltown, Leeds, and London's Notting Hill. The work of the educationalist Shireen Akbar suggests what could be done.[64] Akbar sought to encourage creativity and pride in South Asian women living in Britain through art and craft projects. *Our Exhibition* at the Commonwealth Institute in 1982 of art by Bangladeshi children was followed by an exhibition of Bangladeshi textiles, *Woven Air*, held in 1988 at the Whitechapel Art Gallery; and in 1989 Akbar organised *Traffic Art*, an exhibition of paintings on rickshaws at the Museum of Mankind. Her final project took the Mughal tent as a symbol of home and refuge. She inspired South Asian women to work together and embroider, collage and paint tent hangings which were exhibited after Akbar's death in the summer of 1997.

In 1990, however, the Council mounted an exhibition in which makers 'of African, Afro-Caribbean, Asian and Middle Eastern origin' were invited to submit work to an open exhibition *Diverse Cultures*. There were ninety responses and twenty-nine makers were chosen. As all but two of the exhibitors had attended British art schools, the show hardly fulfilled its claim 'to illuminate the new British culture which has risen from the influence and fusion of a diversity of traditions'.[65]

Gender, class and cultural identity were topics little explored by the Crafts Council and its magazine. Much more thought was devoted to questions of skill, to agreed formalist standards and to the relationship of the crafts to the fine arts and to design. Peter Dormer was a former art student and philosophy graduate, who served as a Labour councillor in Ealing in West London from 1978 to 1982 and who in the early 1980s wrote a polemical column in *Art Monthly* on social issues in the arts. Like Fuller, he was particularly keen to prick the craft world's pretensions to fine art status. Initially at least he took a positive interest in the ceramicists whom Fuller had dismissed, putting on a lively idiosyncratic exhibition of their work at the ICA in 1985. But he had already argued that craft practice was an essentially conservative activity[66] in which a 'neglect of good workmanship is a betrayal of the relationship between craftsperson and client. It is a relationship of trust; another of the values which

somehow got buried in the silt of the seventies.'

Discussions about the possibilities of ornament were central to the postmodern debate as it developed in the late 1970s and early 1980s. The creative thinking came from architectural theory, including the popularisation of the term 'postmodern'. As we saw in Chapter Ten, the potter Elizabeth Fritsch and the silversmith Michael Rowe (Fig. 455) were just two makers who clearly saw extraordinary possibilities in ornament as a vehicle for metaphor and narrative and both continued to make increasingly sophisticated work during the 1980s.[67] Dormer, on the other hand, was at pains to emphasise the limited nature of the craft project: 'a world of modest ideas with a straightforward vocabulary of familiar forms which can be used purely decoratively. No pot or chair or table or glass vase can stand translation into a monument…perhaps the word handicraft should be resurrected.'[68] In Dormer's view, contemporary makers were less skilful and more pampered than their predecessors and, worst of all, outside the 'real' economy and too ready to 'seek the apotheosis of uselessness'.[69]

Dormer's negativity towards the crafts had a respectable history running from Thorstein Veblen's theories about 'conspicuous consumption' in an industrial age, to Herbert Read's *Art and Industry* of 1934 and to the critical responses to the adornment of Coventry Cathedral in the early 1960s. Dormer stressed and, by implication, condemned, the middle-class nature of craft activity – at times with a loathing that recalls Jim Dixon's tirade against 'Merrie England' in Kingsley Amis's novel *Lucky Jim*.[70] He also, like Read, believed that the crafts produced unsatisfactory, unstable commodities. Throughout the century the crafts appear to have had the potential to create disorder in the world of work – as the painter William Rothenstein had seemed to suggest when he criticised the impact of Ernest Gimson's furniture workshop in the Cotswolds, noting that Gimson 'withdrew the village blacksmith and carpenter from local occupations to make furniture and ironwork for wealthy men living in towns'.[71] Rothenstein's criticisms were unfair but the crafts movement had, as we have seen, a tendency to confuse such categories as luxuries and necessities. Dormer grappled with these paradoxes not as an historian but as an active critic; in his view the pretensions and ambitions attached to the crafts needed to be rationalised and re-ordered.

On occasion it seemed that for Dormer both fine art and craft were peripheral activities to be contrasted with the essential and valuable work of the designer. Implicit in his writing was an unstated contrast between a female and a male world of creativity. Craft was remote from 'the real world of railway engines and kettles'.[72] Sometimes the moral tone of his disgust recalled the writings of Loos and Le Corbusier. In an admiring essay on the furniture designer Jasper Morrison, Dormer noted Morrison's

repudiation of handcraft which he dislikes as an end in itself. His dislike is not directed at

456. Jacqueline Poncelet, Untitled 1984, T material, coloured clays, glazes and enamels, h. 30.5 cm, l. 79 cm. (Private Collection).

artisans...His discomfort is with the creamy excess of middle-class craftspeople who have retreated from production and whose existence is a luxury, wholly dependent upon the superfluity of wealth created by the manufacturing industry.[73]

For Dormer the 'specialness' of craft derived from its embodiment as the kind of 'practical' or 'tacit' knowledge discussed by Polyani and Oakeshott in the 1960s. The crafts that Dormer admired by the end of the 1980s were the visibly useful ones – sturdy well-designed casseroles by the salt-glaze potter Jane Hamlyn, a broad swathe of hand-made furniture, both one-off pieces and prototypes for mass production and measurably skilful, if more marginal, activities such as calligraphy.

Dormer was not alone in finding the term 'crafts' unhelpful. 'Craft Shops' in rural areas selling anything from Indian silk scarves to mass-produced mugs to furry toys had begun to discredit the word as early as the 1960s. Peter Collingwood came up with an acronym – Cheap Rubbish Assembled For Tourists.[74] In 1987 the British Crafts Centre was renamed Contemporary Applied Arts and in 1989 *Crafts* magazine was given the sub-title 'The Decorative and Applied Art Magazine'. The new nuance of language had certain tactical advantages. As we saw in Chapter Ten, periods in European art which had been dismissed by modernists – Mannerism, Baroque and Rococo – were being studied in a magpie tongue-in-cheek spirit by makers and designers from the 1970s onwards. 'Applied' or 'decorative' art was an appropriate way of describing the work that came out of this new eclecticism.

Undoubtedly the combative writing which appeared in *Crafts* in the 1980s had an effect. Within the craft world the goal of blurring boundaries between art and craft was scrutinised and found wanting. But the Crafts Council's strategies were confused. On the one hand the Council wished to intellectualise and theorise the crafts by encouraging initiatives like the 1987 conference *The Vessel Forum* funded by the Gulbenkian Foundation which sought to project 'the vessel' as a specific art form with its own critical vocabulary and range of references. But on the other hand *Crafts* published a crushing critique by Peter Dormer of the pretentiousness of such a project: '"Vessel" is such a gutless word, so much like "maker" – and so much a part of the new craft vocabulary which with its lack of precision and honesty, seeks to hide the fact that 'makers' of 'Vessels' do not know where or what they are about.'[75]

The prescriptive nature of the debate led two makers, the potter Jacqueline Poncelet and the jeweller Susanna Heron, to withdraw from the craft world in 1985 and 1983 respectively. Between 1973 and 1976 Poncelet had been admired by collectors and curators for her thin-walled cast bone china vessels. They were exquisite, miniaturised, and often painstakingly

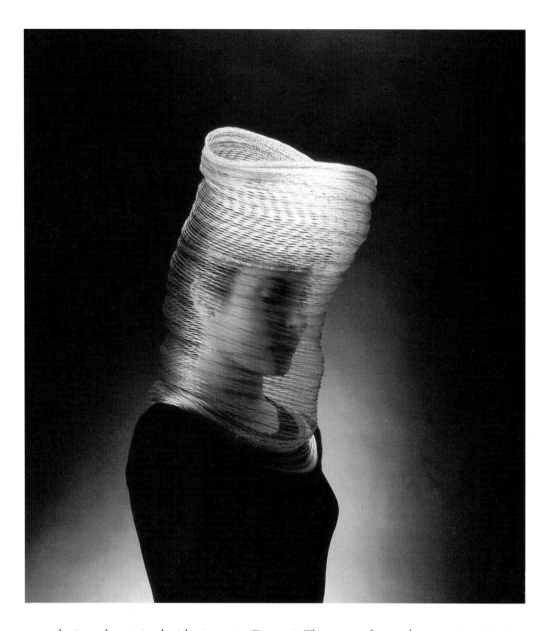

458. Caroline Broadhead, *Veil Neckpiece*, first made in 1982, nylon monofilament, finger woven. h. 45 cm. (Caroline Broadhead/Crafts Council/David Ward).

carved, pierced or stained with pigments (Fig. 251). They were also exploratory, investigating the formal relations of foot and rim. In 1977 her work changed markedly and she began making slab-built forms. She spent 1978–9 in the United States on a British Council Bicentennial Fellowship and in 1981 she had an important show at the Crafts Council which was dominated by oval comma-shaped low dishes decorated with powerful grids of pattern.[76] By 1985 she was casting and assembling pieces which had few links with the 'vessel' even as interpreted broadly by potters like Alison Britton. Pieces had tripod or multiple bases; some could be casually propped against a wall. Analogies were made with claws, crustacea and human body parts (Fig. 456). The work of Susanna Heron followed a similar trajectory – from sweetly decorative work in silver and acrylic to austere curved neckpieces in the late 1970s to work with light and photography with David Ward (Fig. 457) and to what Heron called 'wearable and non-wearable objects' by the early 1980s. These were ingenious constructions using *papier mâché*, cotton, nylon and wire. Although both women were respected members of the craft world as endorsed by the Crafts Council they decided to take a series of simple steps to re-align themselves with the fine art world. They severed all links with the Crafts Council, ceased to show in craft shows and began to work on a different scale, and in Poncelet's case, deliberately eschewing the materials which had been at the heart of her activity as a maker. Nothing could better demonstrate the constructed nature of categories within the visual arts.

What is of interest is that other figures whose work also inhabited a kind of border area between craft and fine art chose to stay and attempt to inhabit both worlds. Caroline Broadhead's work as jeweller can be paralleled with Heron's development – from witty

459. Stephanie Bergman, *Desk Set* 1986, unglazed earthenware, green glaze inside, 18 × 38 × 13 cm. (Stephanie Bergman).

460. Stephanie Bergman, *Pakoras*, 1986, cotton duck, acrylic paint, calico, dye, h. 179 cm. (Nigel Greenwood).

bangles to conceptual pieces. In 1978 she decided she needed to fund her experimental work and with Nuala Jamison set up C&N which produced plastic buttons and jewellery for fashion houses. This freed her to create objects like her extraordinary *Veil Neckpiece* first made in 1982, clearly not wearable except in the context of some kind of performance and best known through a remarkable photograph taken by David Ward (Fig. 458). In 1986 Broadhead was included in a show of 'Conceptual Clothing' at the Ikon Gallery in Birmingham and in 1989 had moved into performance art, staging 'Undercover' at the ICA in London with Fran Cottell, one of the 'Conceptual Clothing' organisers.[77] But within what appeared to be an increasingly conservative craft world she continued to be given a good deal of exposure. Almost a decade later, in 1997, she won the textiles section of the Jerwood Prize for a group of 'Shadow Dresses' – disembodied sculptures which 'constructed an absence' through a pared down outline of a dress and a 'shadow' of crumpled cloth.[78]

Broadhead moved easily between the categories of jeweller, textile artist and performance artist. Stephanie Bergman trained as a painter but in the early 1970s began using painted and dyed fabric which she washed, cut up and sewed together to create large abstract paintings. Or were they textile hangings (Fig. 460)? Art critics discussing her work felt the need to refute any craft connections (the more so as she was a woman).[79] But Bergman herself was untroubled by dangerous associations with 'patchwork quilts and cottage industries' and went on to make ironic aprons, bedspreads and upholstery. In 1984 she had a solo show at the Crafts Council.[80] The following year she exhibited as a painter in the John Moore's exhibition at Liverpool. By 1986 she was also making crude but striking pots which were shown by Nigel Greenwood (Fig. 459). That a leading dealer in cutting-edge contemporary art should choose to exhibit such technically innocent work must have caused studio potters to ponder. Both the sculptor Barry Flanagan and Bergman were taught basic ceramics by the widow of the art critic Adrian Stokes, Ann Stokes, who was also a largely self-taught primitivist in clay. Nigel Greenwood admired Stokes's work too and included thirty of her earthenware side plates decorated with casual swirling brushstrokes and leaves in his selection for the prestigious Hayward Annual in 1985 as symbols of 'openness and goodwill' and evidence of 'a true artist's affinity with everything she touches'[81]. Another self-taught potter, Grayson Perry, whose handbuilt pots carried a mass of sgraffito, sprigging, stamped lettering and photographic transfers, also found that his crude technique backed up by mordant wit and black humour was no bar to acceptance in the fine art world.[82] What was going on? There were clearly areas of taste in the fine art world which endorsed a species of folk primitivism and valued a lack of concern with craftedness in the use of traditional craft

461. (*opposite*) Ewen Henderson, from *Skull Mountain* series, 1993, laminated clays, h. 42 cm. (Photo David Cripps).

462. Michael Brennand-Wood, *Broken English*, 1981 (detail), stitches, collage, acrylics on wood base, 100 × 80 × 4 cm. (Photo James Austin, Cambridge).

materials. It was an aesthetic which more technically sophisticated studio potters found deeply discouraging.

Between the wars, as we have seen, analogies between pots and sculpture were frequently made. But after the Second World War, despite the declaredly sculptural nature of work by potters like James Tower, Gordon Baldwin and Gillian Lowndes, the fine art world appeared largely oblivious to developments in ceramics. One potter who felt the injustice of this keenly was Ewen Henderson. He had studied ceramics at Camberwell School of Art as a mature student from 1965 until 1968 and during the 1970s consolidated a career as a handbuilder of remarkable skill and originality, creating pots and tea bowls which seemed to reach back into the earliest histories of ceramic art. In 1986 Henderson began to create a series of 'upright forms' and 'megalith equivalences' which suggested to one critic, Christopher Reid, that Henderson was spearheading a ceramic avant-garde: 'He has that quality of danger which institutions and academies have come to fear...It is a poignant irony that he has chosen to work on a domestic scale.'[83] By the early 1990s Henderson was making fewer vessels and working on a sculpture garden behind his house filled with his skull and torso forms. At the heart of Henderson's practice there was a tragic dimension. He felt himself, with justification, to be a sculptor, *primus inter pares*, but that world was closed to him, apparently by virtue of the materials he worked with (Fig. 461). His situation was shared by Baldwin, Lowndes and by younger potters like Sara Radstone, Angus Suttie, Henry Pim and Philip Eglin – all of whom may have felt similarly marginalised. But Henderson came to feel angry at the hierarchy of the arts, almost too angry to take pleasure in his own gifts.[84]

These figures will have to stand in for a sizeable proportion of makers whose work operated on the borders between art and craft. In fact it could be argued that a high proportion of the makers discussed in this book inhabited this territory, in that their work comes closer in spirit to fine art than to design. Although in the 1980s, as the writing in *Crafts* suggests, a good deal of criticism worked to discourage this fluidity, nonetheless there was a developing body of criticism which attempted to provide a theoretical basis for craft inhabiting this borderland. By the end of the 1980s and on into the 1990s textiles received the most serious critical attention as makers like Broadhead, Polly Binns, Michael Brennand-Wood (Fig. 462), Alice

463. Trevor Jones, binding of George Orwell, *1984*, facsimile of the extant manuscript, Secker & Warburg, 1984, made in 1984–5; various leathers, canvas, with an onlay of fur and glove leather, eyelets, linen tapes, leather bootlaces, 35 × 25 cm. (Collection of K.D. Duval & Colin Hamilton/photo Michael Barnett/Trevor Jones).

464. Jen Lindsay, binding of *Border Ballads*, Oxford University Press 1925, 1985, native dyed Nigerian goatskin, rough gilt edges, fragment of antler, 25.4 × 16 cm. (Private collection).

Kettle and Clio Padovani used cloth to investigate memory and identity.[85] After the retirement of Constance Howard in 1975, textiles as taught and practised at Goldsmiths' College had continued on an increasingly adventurous course under Audrey Walker and, subsequently, Janis Jefferies. Writing and theory shaped making. One of the most interesting textile artists of the 1980s, Kate Russell, found that it was her art history tutor at Goldsmiths', Sarat Maharaj, who gave her a new ambitiousness for her work.[86]

It was, however, perfectly possible for a craft to develop without a specific theoretical base. Bookbinding in the 1980s went through a period of rapid experimentation even though writing about bookbinding (in, for example, the Designer Bookbinders' journal *The New Bookbinder*) tended to be limited to discussions of technique and the presentation of narrative histories. Senior figures like Philip Smith and Trevor Jones adopted an increasingly histrionic, inter-textual approach to the craft in the 1980s. Smith's disturbing 1987 binding of the *New Testament* incorporated praying balsa wood hands which were sleekly covered in brown goatskin. Jones bound George Orwell's *1984* using old gloves, fur and black hide bootlaces. He wrapped the book in a padded strait-jacket of canvas, press studs and zip (Fig. 463).[87] It was left to a younger generation to explore new simplicities, often inspired by early bindings. Jen Lindsay created aristocratic looking austere bindings (Fig. 464) while Romilly Saumarez Smith turned revealed sewing structures into a new kind of ornament (Fig. 465). In the mid-1990s a dazzling new talent appeared on the scene. Tracey Rowledge had studied fine art at Goldsmiths' College and learnt her binding skills at Guildford College of Further and Higher Education. She was aware of the paradox of making 'gestural marks by means of a non-gestural process' and she invested this process with even greater irony by relying on found material – a doodle on the back of postcard picked up in the street, an impression left by a tracing.[88] She took the calligraphic freedom of Edgar Mansfield and Ivor Robinson to new heights (Fig. 466).

THE DESIGN DECADE

In the atmosphere of hectic consumerism which characterised the 1980s, craft continually re-invented itself – with the help of picture stylists as well as writers, under the banner of design and interior design rather than of craft. The crafts cropped up in an array of new contexts – in eclectic high style interiors, in a range of architecture and landscape projects and in complete restorations or retro-fitting exercises. In 1982 Mrs Thatcher had turned her attention to

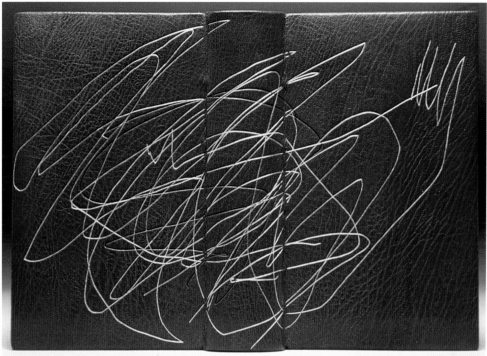

design. She hosted a seminar entitled 'Product Design and Market Success' at Downing Street in the January of that year and in May contributed an article to the Design Council journal *Design*. The Government initiated and funded a Consultancy Scheme in June 1982, offering companies fifteen days of product design consultancy free of charge. It also set up a 'Design for Profit' campaign targeted at 'decision makers in industry'. Both schemes were run by the Design Council.[89]

But the transformation of product design in the 1980s was not entirely due to government or Design Council initiatives. The key design magazine of the period was *Blueprint*, which first appeared in 1983 as 'London's magazine of design, architecture and style'. *Blueprint* accurately recorded a particular moment in British culture in which appropriate, knowing consumption became a crucial signifier among high-earning men and women working in a whole range of expanding service industries – public relations firms, advertising agencies, film production companies, city banking and stockbroking firms. Semiology, as popularised by the French sociologist Roland Barthes, made it possible to consume while indulging in reflections on the nature of consumption. Craft exhibitions were fully listed in *Blueprint* and occasionally reviewed, but *Blueprint*'s true focus was the apotheosis and glamorisation of individual designers and architects, usually male, who were invariably pictured looking remote and authorial before a product or a building.[90]

Blueprint developed an agenda which had already been partly set out in the writings of a former lecturer in the History and Theory of Art at the University of Kent, Stephen Bayley. He offered a semiotically aware version of object fetishism which focused mostly on early modern product design. Bayley saw design as 'the art of the twentieth century'. Dismissing 'stacking bricks in the name of art', Bayley argued that 'to design a vacuum cleaner which is in use for sixty years is a towering intellectual achievement and that is why I have compiled a book about the men who made that their business'.[91] In effect, Bayley was trying to erase the difference between design and fine art and present an alternative set of male geniuses and concomitant art objects, the Brownie box camera, the B3 Wassily chair, the Zippo lighter, the Anglepoise light. His approach was modelled on a massively simplified art history, offering a chronological sequence of images of desirable objects.[92] By 1981 Bayley was Director of the Conran Foundation's Boilerhouse Project based at the V&A. There he staged exhibitions like *The Good Design Guide: 100 Best Ever Products* of 1985 which endorsed further lists of consumer goods from 501 Levis to the Oyster wrist watch to the Muddy Fox mountain bike. Some of

465. Romilly Samaurez Smith, binding of *The Stanbrook Abbey Press*, 1995, vellum, resist dyed goat and calfskin, open joint binding, calligraphy by Alison Urwick, 32.7 × 24.8 cm. (Photo Jacqui Hurst).

466. Tracey Rowledge, binding of James Joyce's *Ulysses*, 1996, deep red goatskin, tooled blind in palladium and four types of gold, 19.9 × 19.9 cm. (Private Collection. Photo Prudence Cuming Associates Limited).

these objects of desire were contemporary and in production but, partly because of Bayley's proselytising, other products (early modern chair designs for instance) were put back into manufacture in the 1980s to satisfy a growing if exclusive consumer demand for what were coming to be called 'design classics'.

By the mid-1980s shops had sprung up to cater for this knowing form of consumerism. Paul Smith's menswear shops sold Mont Blanc pens and Iittala glass vases designed by Alvar Aalto together with Filofaxes, Joseph's Pour La Maison stocked Eileen Gray chairs and Espresso coffee machines while Oggetti sold Swiss army knives, Bauhaus building blocks, Zippo lighters, the Eileen Gray mirror and the Aalto vase.[93] Although much craft might seem at odds with 1980s consumption, certain craft objects were co-opted into 1980s retro-chic and intense commodification. Sotheby's held its first sale of twentieth-century craft in 1980 and Christies held regular sales from 1986. Pots by Hans Coper, Lucie Rie and Elizabeth Fritsch were designated 'classics' alongside *art moderne*, Utility and 1950s 'contemporary' design. Coper's work was particularly sought out. His pieces were as instantly recognisable as a Breuer chair and, from the consumers' point of view, functioned as a useful addition to an array of objects by named designers. By 1998 a Lucie Rie tea service appeared as a marker of taste and experience in Alan Hollinghurst's cultish gay novel *The Spell*.

Retro-chic took many forms. A key aspirational magazine of the decade, *Interiors*, launched in November 1981, ran a regular *Craftsman* page. *Interiors* was not interested in cutting-edge design nor in the artist-crafts promoted by the Crafts Council but in skilled workmanship which could feed into scholarly exercises in restoration and retro-fitting. Thus there were regular articles on hand block silk printing, pewterers, hand printed wallpapers, stained glass and plasterwork. The column was known to the *Interiors* staff as the 'Little Men' slot, as in 'I know a marvellous little man who makes the most wonderful...'[94]

'Design classics' embodied narrative in the form of nostalgia. In much 1980s design this took the form of metaphor and simile. The leaders in this approach were the Italian design groups Studio Alchymia, set up in 1976, and Memphis, formed in 1980/1, all of whose products were richly referential, frequently quoting the design tropes of the 1950s.[95] In Britain this narrative of nostalgia was exemplified by the work of the Argentinian Daniel Weil, whose Degree Show at the Royal College of Art in 1981 showed a series of radios in which the constituent parts were exposed in shrink-wrapped PVC bags. Weil's Radio Bags appeared to carry references to the components of do-it-yourself crystal sets of the 1950s and to the new world of packaging technology as well as signalling the end of formal black box design solutions for electronic goods (Fig. 467).[96] The crafts had tapped this rich narrative seam early on, in the form of the 'two-faced' ambiguous objects of the late 1970s made by potters like Andrew Lord (Fig. 436).

The buoyant economy of the middle years of the decade saw a remarkable growth in galleries, mostly selling fine art. But two galleries, opened in 1982, specialised in craft. Aspects concentrated on a broad range of experimental work and published a quarterly newssheet filled with dramatically lit photographs of makers and objects,[97] and Anatol Orient focused at first on textiles and ceramics. Aspects, despite Crafts Council backing, closed in 1986 but Anatol Orient moved from Islington to Covent Garden in 1984 and in 1986 to the Portobello Road in West London. By 1984 Orient was signing potters as his exclusive artists and in 1988 a new injection of funds enabled him to re-open as Michaelson and Orient. Orient's taste was eclectic but he had a particular fondness for the neo-rococo and figurative ceramics. He took adventurous risks with the young generation – too many for the pocket of his partner Michaelson – and in 1990 the gallery closed. So too did many of the fine art galleries in the Portobello area as the recession hit hard.[98]

The most successful venture of the 1980s was the old Crafts Centre of Great Britain, subsequently the British Crafts Centre and renamed Contemporary Applied Arts in 1987. Tatiana Marsden, its director from 1983 to 1997, had an unerring eye. For what? She was a Yugoslavian graduate of the Royal College of Art, schooled in a restrained modernist aesthetic which she brought to bear on the great confusion of objects deemed craft. She had a gift for juxtaposing

work intelligently – showing the jeweller Julia Manheim with the furniture maker Richard La Trobe-Bateman or grouping the jeweller Caroline Broadhead, the potter Martin Smith and the craftsman in wood Jim Partridge and showing the tapestry weaver Marta Rogoyska with the glass artist Steven Newell. She encouraged makers to stretch themselves and make new kinds of work in new media. Above all she made the crafts plausible to collectors, conveying an urgent sense of their importance, albeit from a highly disciplined formalist position.

467. Daniel Weil, *Bag Radio* first designed in 1981 at the Royal College of Art. (Daniel Weil/Pentagram Design Ltd).

468. Andrew Logan, *Mirror tree Hi-Fi Unit* shown in *Furniture↔Sculpture* 1979. (Icon Gallery, Birmingham).

UTOPIAN INTERIORS

In 1979 the Ikon Gallery in Birmingham put on the show *Furniture↔Sculpture*, demonstrating that there was more to furniture than the three-piece suite, stripped pine kitchens and diet of cut-price good taste being effectively purveyed by Habitat (Fig. 468). Some of the exhibitors involved – Floris van den Broecke, Erik de Graaff and Fred Baier – were to be taken up by the Crafts Council. Others, like the sculptors Helen Chadwick and David Nash, became significant players in the fine art world. One exhibitor, the architect Nathan Silver, was the author, with Charles Jencks, of *Adhocism: The Case for Improvisation* (1972), an anti-modern tract which made the case for 'new methods of repersonalising the impersonal products of an industrial society' and allowing 'consumption based on individual desire'.[99] Others, like Andrew Logan and Duggie Fields, had already formed loose alliances which centred on a London-based, high camp culture of style which was to have an important influence on the crafts and design of the 1980s.

The activities of Fields and Logan have a history which can be traced back to William Morris's

469. Duggie Fields, the interior of the artist's flat in Earl's Court Square, late 1970s. (Photo Chris Garnham).

Red House. In 1856 Morris had married Jane Burden, an ostler's daughter whom Rossetti had picked up in a theatre. This unorthodox union inspired Morris to create, in collaboration with the architect Philip Webb, a utopian safe haven which could provide an alternative to the upper-class Victorian milieu in which Morris had been brought up.[100] After Morris, artists and designers went on creating interiors which were, in effect, oppositional sites for social and intellectual unorthodoxy. This is certainly one way of achieving an understanding of the interior of the flat created by Margaret and Charles Rennie Mackintosh in 1900 in Glasgow or of the interior of Charleston in Sussex decorated by Duncan Grant and Vanessa Bell from 1916.

Fields and Logan's utopian interiors had a similar function. They were sanctums or dreaming rooms[101] expressing a rejection of post-war 'good design' and, rather more to the point, of a range of orthodoxies. As early as 1969 Andrew Logan, then an architecture student at Oxford Polytechnic, had transformed his bedroom into a Shangri-La of cloud-painted walls, a daffodil bedside light and a bedspread of greengrocer's fake grass – 'for him everything is make believe: in a thousand smashed mirrors he has stolen all the world's bad luck.'[102] Logan created a whole series of memorable interiors for himself. In one the Sex Pistols played one of their first gigs in 1976 and Jordon performed the ballet later immortalised in Derek Jarman's 1978 film *Jubilee*. In 1972 Logan launched the first of his Alternative Miss World contests which gloriously subverted the real thing and enabled a bizarre grouping of friends and camp followers to become 'Queen for a day'. Logan was also a great maker. His jewellery, crowns and sculptures, all encrusted with fragments of mirror glass, made, as we have seen, a surprise star appearance in the Crafts Council's galleries in 1982. The painter Duggie Fields moved in the same world. In 1978 he completed the interior of his Earls Court flat in which every surface, including the floor, was alive with brush marks. He made his own furniture and integrated his classicising cartoon-strip paintings with the rest of the interior (Fig. 469). Fields designated himself and Logan 'Post-Modern', a term he had taken from Charles Jencks's book *The Language of Post-Modern Architecture* of 1977.[103]

An analogous series of utopian interiors was created by the film maker Derek Jarman. In 1971 he was living in a warehouse in Bankside: 'When I wasn't painting I worked on the room and slowly transformed it into paradise. I built the green house bedroom, and a flowerbed that blossomed into blue Morning Glories and ornamental gourds with blue flowers.'[104] Jarman had his own craftsmen, Daniel Gray and Andy the Furniture Maker (Fig. 470). Both were recyclers, able to take massive sleepers, salvaged beams and bits of dock timber and transform them into thrones and tables and beds of a kind that suited Jarman's films and his interiors. Jarman's films of the late 1970s and early 1980s, in particular *Jubilee, The Tempest* (1979) and *Caravaggio* (1986) were of a piece with this pursuit of worlds where freedom and a certain degree of magic could triumph. *The Tempest*, filmed at Stoneleigh Abbey, a time-capsule country house filled with gilded Venetian chairs, tattered silk curtains and old mirrors, was a particularly visually inspirational film. Jarman's final dream space, evolved in the 1980s, was an extraordinary garden around a tin shack on a desolate windswept beach in Kent dominated by views of Dungeness nuclear power station. It was a true outsider's topography made out of the flotsam and jetsam of the beach, swiftly becoming a place of pilgrimage for young artists and designers.

470. Andy the Furniture Maker, *Falklands Chair*, 1982, recyled wood. (Andy the Furniture Maker).

The ceramicist Carol McNicoll was friendly with Andrew Logan and with Piers Gough, an architect also on the fringes of this world. In 1982 Gough designed McNicoll's flat in a converted piano factory in North London, mixing in pastel 1950s bathroom suites, gleaming exposed flexible ducting, pleasing decay, monumental cast iron Victorian radiators and a mass of eclectic tiling carried out by McNicoll herself. Her bedroom was painted by Michael Scott and Jaoa Penalva, decorators of the Wag Club in 1983 and of Nigel Coates's Metropole in Toyko in 1985. Both Gough and McNicoll were intimate with what was left of light industrial London, able to pick up a heavy duty cooker here and a massive stainless steel work surface there. The McNicoll flat, like Gough's own house in the East End, was a triumph of bricolage, improvisation and salvage.

Paul Nash had written in *Room and Book* in 1932 that it was the duty of the artist to invade the house as a designer. In the 1980s, however, senior mainstream fine artists had little to offer compared to Logan and his circle. It was a situation analogous to the 1880s when most painting and sculpture were locked into academicism. The Arts and Crafts Exhibition Society had been founded in 1880 on the premise that makers and designers, rather than fine artists, were the real radicals. Thus the extraordinary aura of Logan, Jarman, Gough and McNicoll's interiors can be contrasted with the Arts Council show *Four Rooms* which toured in 1984. It included the neat, careful arrangements made by the painter Howard Hodgkin and the sculptor Anthony Caro, academicians within the institutionalised avant-garde. Joanna Drew, the Arts Council's Director of Art, noted in the *Four Rooms* catalogue, artists' interventions have 'frequently challenged conventional notions of living and working spaces'.[105] But this was hardly the case with Hodgkin's printed chintz sofa fabrics and Caro's highly crafted wooden *Child's Tower Room*. Both men had their designs carried out on their behalf – not a bad thing in itself, but revealing of the way in which the rigid hierarchisation maintained by the fine art world inhibited much craft or design activity other than excursions into print making.

SALVAGE BAROQUE

The most publicised interior of the 1980s was the architecture critic Charles Jencks's West London home. His Thematic House, despite Jencks's former ad hoc interests, was hardly ad hoc or alternative. Jencks and his wife Maggie Keswick worked on a handsome budget and the scheme was heavily programmatic and intellectualised. Although highly skilled artisans were employed, they worked to Jencks's designs and to those of other luminaries like the sculptor Eduardo Paolozzi and the architect Terry Farrell (Fig. 471). Jencks's interior came to seem emblematic. When Stephen Calloway, a flamboyantly dressed aesthete and a assistant curator in the V&A Print Room, outlined five retro-chic interior styles for the mid-1980s he included 'Post-modern' – exemplified by the 'new symbolic architecture of Jencks's house' – and 'New Baroque' – in part inspired by the films of Derek Jarman, for which the '*mise-en-scène* was a ruined palazzo in a post-holocaust landscape'.[106]

In the context of the 1980s Jarman and associated figures like Logan appeared innocently creative. As Logan explained 'I just use things that nobody else wants.'[107] Logan turned rubbish into treasure and he wittily underlined his transformative powers by opening a museum of his work in Powys, mid Wales in 1991.[108] But in this period of intense commodification increasing numbers of consumers sought to express and individualise themselves through the creation of unique interiors. The connection between subversive private, utopian interiors, recycled rubbish and a saleable product was made by a former architecture student Ron Arad when he opened his shop One Off in Covent Garden in 1981.[109] 'Scaffolding and a classic Rover seat. You pull the lever to tilt them back', noted Derek Jarman after seeing some pleasing chairs in a friend's flat in November 1981.[110] One Off moved from site to site in Covent Garden in the 1980s, with each interior working as a crucial context for Arad's work. The stair in his Neal Street showroom (1984–7) was made of cantilevered concrete beams wired for sound leading down into a basement with a sand-covered floor. Subsequent premises in Shelton Street were transformed by a lining of pieces of sheet steel haphazardly collaged into a gleaming metal cave. Arad's was a curiously indulgent form of making, deliberately unplanned, with no drawings to guide his workforce. But Neal Street and Shelton Street were the ideal setting for pieces like the Rover chair, the Tinker chair (Fig. 472) and Arad's concrete stereo system, in which speakers, turntable and amplifier were embedded in damaged blocks of reinforced concrete.

Arad inhabited what was to become a typically 1980s borderland. Some of the work was literally hammered into shape by Arad and his assistants; there are no two identical examples of the series of chairs called the *Big Easy*. Other chair designs were put into manufacture by firms like Vitra. As Arad explained: 'Projects may start either on the drawing board or on the work bench. One has no priority over the other. In the same way as the office avoids rehearsed solutions, the workshop avoids specialising and becoming a craft studio.' The idea of craft as such held few charms for Arad, even if many of his pieces could hardly have been more highly crafted. Arad was to some extent making a virtue of the necessity to make as well as design his furniture. As he explained: 'I invented my profession. If this had been Milan it would have been different – there is a lot of work for designers and an industry thirsty for designers. Here, who would you go to?'[111]

The transition from private to public space was made even more decisively by Nigel Coates.[112] Architectural Association (AA) trained, in 1983 Coates had nothing built to his credit except the interior of his own flat, a place of pleasing decay and interesting paint effects. As a tutor at the AA in 1983 he set up NATO (Narrative Architecture Today) with his students. The group did not build; they drew, published a magazine and put on exhibitions. Evidently they also read, taking ideas on communication from Jean Baudrillard, on institutions from Michel Foucault and on the city and the street from Marshall Berman. Arguing that the planned, zoned Modern Movement vision of the city had failed, Coates and NATO proposed to celebrate a London that was a confusion of tangled road/rail junctions, noisy with skips and building sites. Coates's own drawings – crayon scribbles which eschewed plans and sections – set the tone.

If NATO did not make buildings they certainly made things, invariably crudely recycled from urban detritus, in the spirit of Jarman's furniture makers. Narrative architecture meant minimum intervention; the drama of the street, the proliferation of street culture in the form of shops and themed clubs were all potential 'situations' for creativity. Coates was well aware of the utopian interiors created by Logan and Jarman. NATO designed an arcadian house for Jarman with a tiled roof which swept to ground level and giant classical volutes shoring up the outer walls. It was set in an Italianate landscape complete with a goat. NATO manifestos and models were replete with a kind of *arte povera* in which red-light districts, embassies, Common Market wine lakes and flyovers jostled chaotically. When Coates finally did get to build, his commissions were for clubs and restaurants in Japan and shop interiors at home. Though this fell far short of his intention to create a 'Gamma City' informed by postmodernist theory, the projects enabled him to employ a team of makers, including potters, painters and furniture makers (Fig. 474).

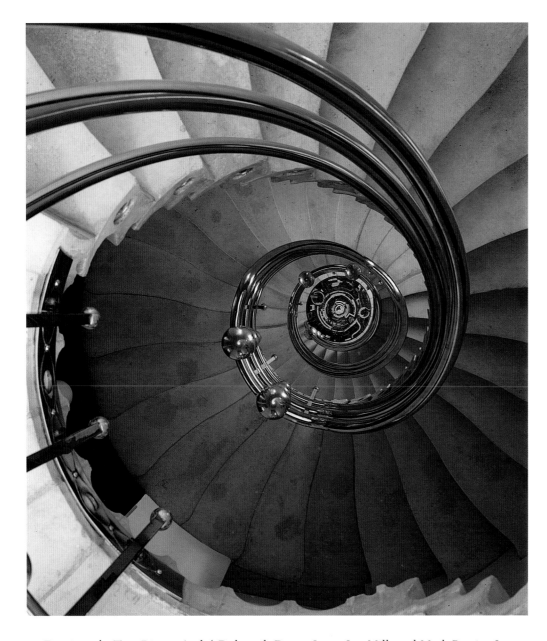

Furniture by Tom Dixon, André Dubreuil, Danny Lane, Jon Mills and Mark Brazier-Jones, all employed on projects by Nigel Coates, at first sight looked like exercises in conspicuous parsimony on a grand scale. They drew on all kinds of sources of inspiration, from old newsreel images of the blitzed London of the 1940s to a transmuted counter-culture which Dada-ised *The Whole Earth Catalog*'s access to tools. Few craft and design writers and curators could resist the blackened workshops inhabited by these young Vulcans with their array of oxyacetylene torches, metal mangles and electric grinders.[113] Their perverse shift to third world design strategies was generously read as a commentary on the extremes of wealth and poverty within London. Extreme work aptly appeared to characterise extreme times. In 1987 Mrs Thatcher swept to her third victory in the polls. The previous four years had been boom years for men and women in the service industries, especially in the City. The ending of Stock Market restrictive practices in October 1986 (the Big Bang), the lifting of exchange controls and the lowering of the top rates of taxation made London the financial centre of Europe.[114] At the same time the share of manufacturing in Britain's Gross Domestic Product fell from 25.4% in 1979 to 19.5% in 1986.[115] The fragility of an economy so dependent on financial services was pushed home overwhelmingly by the Stock Market crash of October 1987 and gave the salvage baroque approach to furniture making a prophetic edge. If the affluent bubble of services burst, if the City, so grossly wealthy yet apparently fragile, went down decisively, people would start making things again, neo-primitive objects like these, roughly factured using low-level industrial techniques.

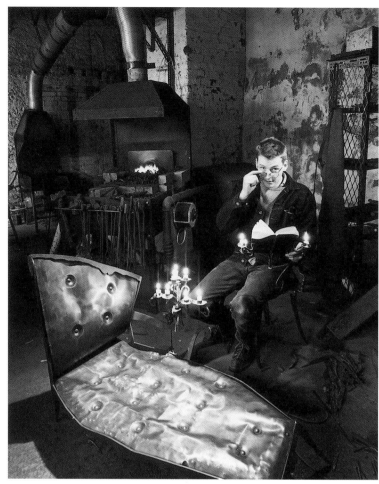

472. Ron Arad, two *Tinker* chairs, 1988, mild steel and stainless steel, welded and forced into shape by panel beating. Pictured in the interior of One Off, Shelton Street, Covent Garden. (Photo Howard Kingsnorth).

473. Jon Mills in his studio, 1987. (Crafts Council/Patrick Shanahan).

The performative charms of craft were re-presented in a more anarchic spirit than that of the meadowy potters' camps. It was exciting to see a gloomy forge used by the young Jon Mills, the son of a Birmingham industrialist whose eye had been educated by Dan Dare comics and Heath Robinson drawings (Fig. 473). It was entertaining to watch handsome Danny Lane smash a slab of tempered glass to smithereens with a spanner and reassemble it into a polished but menacing chair or table. Lane, an American who had studied stained glass with Patrick Reyntiens at Burleighfield and painting with Cecil Collins at the Central School, was a neo-romantic for the 1980s (Fig. 475). His furniture looked subversive while functioning as a good investment.[116] Tom Dixon was the wittiest of the group. He learnt to weld in order to mend his motor bike and took to demonstrating the skill on stage at his night-club, the Titanic. His masterpiece, the S chair, first made in 1988, was a parody of one of the icons of early modern chair design – a cantilevered steel frame chair which he put on a ring base and regendered and made pastoral by covering it with rush (Fig. 476). Dixon briefly worked under the sobriquet Creative Salvage with André Dubreuil who had been an antique dealer and *trompe d'oeil* painter in the late 1970s and who was steeped in furniture history. Dubreuil's early chairs, the Spine chair and the Paris chair of 1988, were fanciful but could be read as examples of reasoned design. But by the 1990s his work came to illustrate the limitations of the salvage baroque movement; his sideboards and corner cabinets became wayward overblown tributes to European furniture history, a series of anti-rational and anti-Platonic forms.[117]

This world of rough-and-ready facture was largely male dominated. But one particularly interesting woman maker came out of the 1980s furniture movement. Mary Little graduated from the Royal College of Art in 1985. The chair she showed in her degree show – ergonomically sound and visually accomplished – was hailed by design magazines around the world. Little's chair was never developed beyond plans for limited batch production – although a version was bought by the Vitra Design Museum in Germany – and she ended up working in Italy. On her return in 1988 she carried on designing for French and Italian firms

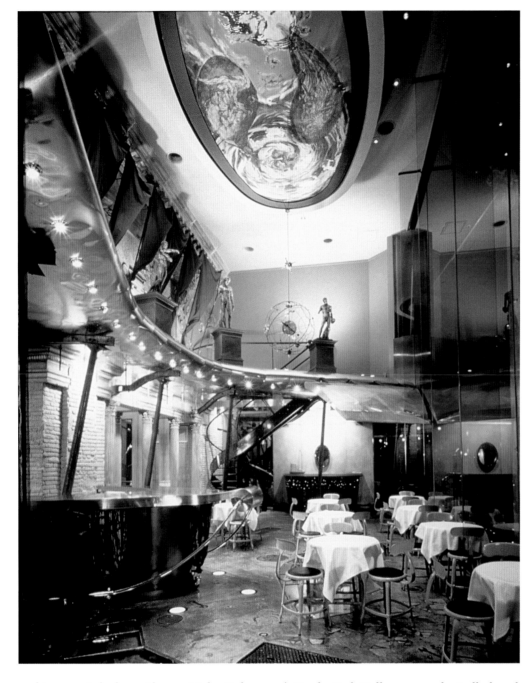

474. Nigel Coates in collaboration with Jasper Conran, Ron O'Donnell, André Dubreuil, Adam Lowe, David Philips, Zaza Wentworth Stanley, Caffe Bongo, Parc department store, Tokyo, 1986. (Photo Eddie Valentine Hames).

and in 1990/1 had a residency at John Makepeace's Hooke Park College, an ecologically-based training centre which is discussed in more detail below.[118] This tentative move in the direction of craft was consolidated in 1992 when Little was given a Crafts Council award. She was committed to design for mass production but turned to the Crafts Council because, as with Floris van den Broecke, she was having to make her own work. Her difficulties in finding a manufacturer – shared with figures like Ron Arad – and in not having a large studio were disadvantages which she turned into strengths. As a child, like many women, she had learnt to sew and make clothes. She began to use these skills as a needlewoman in a sequence of one-off chair designs. All had metal armatures and were, in effect, anthropomorphised, upholstered developments of her Degree show chair, rich in allusions to quilting, costume and High Victorian drawing room furniture (Fig. 477).[119]

The dramatic collapse of British manufacturing in the early 1980s had a marked effect on a generation of designers like Arad, Little and another Royal College graduate, Jasper Morrison. As Morrison eloquently explained, the beleaguered designer of the 1980s was forced to build 'his own factory, not with bricks, but from the sprawling backstreets teeming with services and processes for materials both common and uncommon to his trade'. This in itself could be inspirational. Design by this route 'offers an approach with an almost limitless range of

materials and ways of treating them'.[120] Morrison admired 'the skill of the simple peasant who has a practical solution to every problem, turning the useless into the useful with the greatest economy of means'. Morrison's own early furniture abounded with elegant solutions using ready made components – a glass-topped table supported by a couple of bicycle handlebars, a hat stand made of the legs of office chairs and a batch produced chair using, very recognisably, a laundry box manufacturer's available tooling and materials (Fig. 478).

By the end of the decade the furniture makers discussed above were being co-opted into the crafts constituency, in some instances unwillingly. Ron Arad, in particular, did not care for the association. In 1987 the Crafts Council mounted *The New Spirit in Craft and Design* to survey this new work, described by Ralph Turner as 'Youth's reaction against everything that is thought normal, tasteful, safe, middle-aged or middle-class'. Arad absented himself but Dixon, Dubreuil, Danny Lane, Mary Little, Jasper Morrison, Jon Mills, and other fashionable figures like the self styled Judy Blame of the House of Beauty and Culture all exhibited. The show was designed by Meredith Bowles and John Kember who, Ralph Turner recalled, were 'boys, very young'. They would 'come in cross dressing one day and at other times looking like country gentry'.[121] Although they painted out the windows at Waterloo Place and hung corrugated iron flags outside, their attempts to turn the Crafts Council's spruce galleries into an apocalyptic wasteland were only a partial success (Fig. 479).

In retrospect Turner decided the show had been a mistake because 'it spawned so much dreadful work'. The objects in the *The New Spirit in Craft and Design* nonetheless appealed to a Crafts Council worried about the lack of appropriate coverage for the crafts. The co-opted 'craft and design' in *The New Spirit in Craft and Design* constituted a checklist of the visual tropes supposedly characteristic of the postmodern arts. Eclecticism, irony, parody, kitsch, camp,

475. Danny Lane, the first *Etruscan* chair, fractured and polished glass, threaded steel rods, floor levelling components, 1985, 90 × 50 × 40 cm. (Danny Lane Studio).

476. Tom Dixon, *S chair*. The first 60 were designed and made by Dixon from 1988 in his London workshop; subsequently they have been produced in Italy by Capellini, welded steel frame and rush upholstery. (Tom Dixon/Cappellini spa).

484. Radford & Ball, Andrew Cooper, Clifford Rainey, glass screen, Lime Street Station, Liverpool, 1984, sandblasted, h. 3 metres, l. 125 metres. (Photo Alex Laing).

1984. In 1987 the Department of the Environment and the Calouste Gulbenkian Foundation sponsored the publication of *Art for Architecture*, a handbook for commissioning, edited by the prime mover of the ICA conference, the painter Deanna Petherbridge.

But in the wake of the conference the Crafts Council's interventions remained low-key. A craft commissioning scheme was set up in 1982 which promised to grant matching funding for commissions in public spaces. The scheme was abolished in 1986 apparently because of lack of interest. This seems odd. The scheme supported some pleasing interventions – a majestic engraved glass screen for Lime Street Station, Liverpool, commissioned by British Rail in 1984 from the partnership Radford & Ball working with another glass artist, Clifford Rainey (Fig. 484), a table and chairs for the high table of Pembroke College by Richard La Trobe-Bateman in 1984, ironwork by Giuseppe Lund for the Ruskin Museum in Sheffield in 1983 and tapestries for Queen Mary's Hospital, Sidcup, designed and made by Marta Rogoyska in 1984 with strong community involvement. In 1991 the Council launched a scheme with a strongly corporate flavour – the Founder Friend scheme, which offered 'contemporary style, traditional quality' and free commissioning advice, a free loan service from the Crafts Council's collection and corporate entertainment opportunities at the Crafts Council's Gallery.[145]

From 1987 Contemporary Applied Arts ran a more focused scheme called *Art Means Business*. This was aimed at corporate clients and its brochures skilfully employed the rhetoric of 1980s enterprise culture. A group of silk wallhangings by Sally Greaves-Lord commissioned by Savills plc reinforced 'the stylish forward-looking image the company wishes to project'[146] (Fig. 485). For one CAA client, commissioning craft was 'a means of creating a tangible demonstration of our corporate approach and identity'. Reassuringly CAA brochures like *Art Means Business* stressed that the crafts represented a 'viable long-term investment'[147] – just like fine art. Arguably a special kind of 'corporate' crafts came to the fore in the mid-1980s,

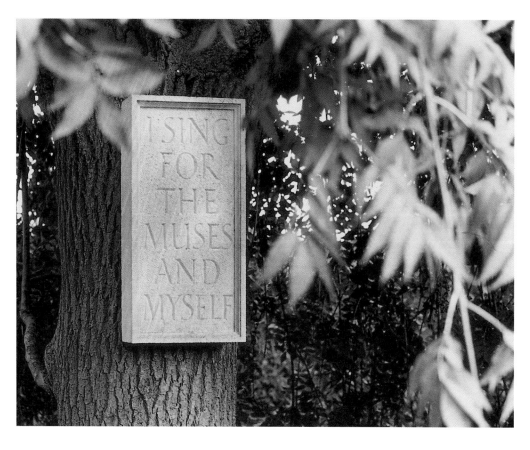

In 1993 a course in Visual Islamic and Traditional Arts, initiated in 1984 by Keith Critchlow at the Royal College of Art, moved to the Prince of Wales's Institute. The courses (MA, MPhil and DPhil were offered) certainly recognised craft. Students were encouraged to take up activities such as ceramics, stained glass, woodcarving, icon painting, calligraphy and gilding but, again, not in the context of the development of twentieth-century creative art. The department's literature, which noted that 'The distinction between "Fine Art" and "craft" is entirely modern', appeared to propose a retreat into the past.[141] An essentialist vision of Islamic art and culture was presented to students, stripped of political and social context.[142] Not surprisingly the degree shows were dominated by pastiche, created by students who were presumably drawn by the reassuringly 'timeless values'[143] the department offered to impart.

By the end of the decade the Prince's outbursts and initiatives came to seem marginal. His credibility was badly dented in 1991 through his association with crudely neo-classical plans for the redevelopment of Paternoster Square adjacent to St Paul's Cathedral. Constitutionally his position meant that he was unable to give his best ideas any political edge. In any case, at Bracken House in the City[144] and at Burlington House in Piccadilly, modernists like Michael Hopkins and Norman Foster were engaged on restoration commissions which demanded an understanding of old materials and building craft skills. By the early 1990s it was pragmatic modernists like Richard MacCormac who provided the most opportunity for makers. For his Soanian accommodation block for St John's College, Oxford, he commissioned a remarkable gate, designed by the jeweller Wendy Ramshaw and made by the blacksmith Ian Lamb (Fig. 483) and a glass screen made and designed by the stained-glass artist Alexander Beleschenko. There was, nonetheless, a sense of an opportunity lost in the 1980s. The crafts as supported by the Crafts Council did not include the building crafts at a time when a kind of Arts and Crafts Movement was reaching into modernist architectural practice.

Many of these crucial concerns had been examined at the conference *Art and Architecture* held at the ICA in 1982. Although only one session allowed for a discussion of the crafts, out of this event came a more focused commitment to public art and craft in the context of architecture. The organisation Art & Architecture was set up by Crosby and others as a network of interested artists and architects. *Art Within Reach*, a collection of essays on artists, makers, architects and patrons in the context of public art, was published by *Art Monthly* in

BATTLE OF BRITAIN
MONUMENT

480. Theo Crosby, Pedro Guedes and Michael Sandle, *Battle of Britain Monument*, 1987. (Pentagram Design Ltd).

481. Robert Adam, Crooked Pightle House, Hampshire 1990. (Robert Adam).

Hamilton Finlay provided a mass of work for stone carvers and letter cutters. Michael Harvey in particular carved inscriptions for Hamilton Finlay's classicising garden at Stonypath in Lanarkshire. Anyone who worked with Hamilton Finlay was introduced to a wayward intelligence and became part-creator of some of the most remarkable site-specific work of the post-war period (Fig. 482). But some, like the letter-cutter Ralph Beyer, found the poet's interest in the writings of Saint-Just, in the Terror after the French Revolution and in the Third Reich as representing 'the catastrophic sublime'[132] hard to bear. Beyer carved four panels for Hamilton Finlay in 1987 and then withdrew from the collaboration.[133]

As with Crosby's much cruder *Battle of Britain Monument*, the revival of the decorative iconographies of the past seemed problematic. For one thing, such schemes allowed makers few freedoms. And some makers must have reflected that a rich symbolic language and the sense of place associated with Valhallas and Sacred Groves had forever been discredited by their association with Nazi Germany, Stalinist Russia and Fascist Italy. Even if these unhappy parallels did not come to mind, it seemed clear that the rules of decorum, in which a style reflects its subject, were going to be difficult to recreate. Debates about decorum and decoration remained lively up until the nineteenth century but were massively simplified in the twentieth century. Le Corbusier proposed his own drastically simplified rules in 1925 – 'A Coat of Whitewash. The Law of Ripolin'.[134] The DIA had called for fitness for purpose. Inter-war makers looked to pure form and abstraction. Attempts to revive a complex, public decorative language in the 1980s suggest the difficulty of recuperating the subtler connections between decoration and social meaning. Crosby had mockingly seen the crafts as characterised by 'market stalls and earnest striving'[135] but in the 1980s this might have appeared a preferable option to the grand project.

There were younger architects who, unlike Theo Crosby, had worked with the classical language of architecture throughout their careers. But the New Classicists, whether technically adventurous like Robert Adam and John Outram, or intensely conservative like Quinlan Terry, John Simpson, Demetri Porphyrios and Leon Krier, provided few creative opportunities for makers. This was understandable. All, in different ways, were attempting to relearn a complex language that chiefly allowed scope for the building crafts of brick-laying and stonework.[136] Robert Adam was the most innovative New Classicist, employing a group of makers to adorn the house he built for his family in Hampshire and collaborating with David Birch of the London Pottery Company Ltd on terracotta mouldings which he used in this and other projects. But, again, details for his house like the stair and banister made by Douglas Kingbury, Sally Hamer's carved swag over the front door and Richard Bent's wrought ironwork were all designed by Adam (Fig. 481).[137] Closer, richer collaborations had been arrived at in the 1960s and 1970s by the architect Roderick Gradidge and the muralist and the interior designer Anthony Ballantine on a series of profoundly eclectic pub interiors, ranging in style from neo-Byzantine to art nouveau.[138]

Nonetheless, it is easy to see why contemporary makers did not rush to form alliances with the architects and critics at the heart of the more reactionary architectural developments of the 1980s. Many of the supporters of the New Classicism became courtiers, briefing the Prince of Wales who was to enter the architecture debate as *arbiter elegantiae* in 1984.[139] In a speech given at the RIBA's 150th anniversary Gala at Hampton Court he damned a proposed Mies van der Rohe building to be sited next to Mansion House in the City of London as 'a glass stump' while Ahrends Burton Koralek's plan for the National Gallery extension in Trafalgar Square was dismissed as a 'monstrous carbuncle'. His initial interest was in the community architecture of Rod Hackney and the neo-vernacular of Edward Cullinan but by 1988 he came to see the New Classicism as the appropriate style for major public buildings. The creative crafts were not central to the Prince's 'vision' nor were they much discussed at his Prince of Wales's Institute of Architecture, which he launched in 1992. Skills like casting in bronze, wrought ironwork and timber construction were emphasised on both the foundation and post-graduate courses – but within a tradition, invariably a classical tradition.[140] Similar skills were discussed in the Prince's magazine *Perspectives* launched in 1994.

popular exhibitions with a passionate conservationist message. Colin Amery and Dan Cruickshank's book *The Rape of Britain* (1975) was a devastating attack on city planning and redevelopment since the war. From the point of view of the crafts Charles Jencks's *The Language of Post-Modern Architecture* of 1977 was an important book. Drawing heavily on Robert Venturi's *Complexity and Contradiction in Architecture* (1966) Jencks argued for radical eclecticism, for an architecture which embraced historicism, the decorative and the vernacular.

All this had significance for the crafts. In the context of an emerging new historicism the architect Theo Crosby was an important figure. Crosby had been the driving force behind the exhibition *This is Tomorrow* of 1956. By 1965 he was working in partnership with the graphic designers Colin Forbes and Alan Fletcher and in 1972 they formed the Pentagram Design Partnership, one of the leading design firms of the subsequent two decades. By the mid-1970s Crosby had become disillusioned with the way in which modernist architecture had developed. From 1979 until 1983 he directed the refurbishment of Unilever House, a magnificent 1920s Art Deco office block. The building was, he explained, 'an exemplar of everything the Modern Movement truly hated'.[125] Crosby aimed to 'accept and restore the original elements of decoration wherever possible, to understand and extend this language and also to enrich it with the work of modern artists and craftsmen'. He came up with some exuberant additions to an already complex scheme, commissioning the sculptor Nicholas Munro, the blacksmith Richard Quinnell and the glass partnership Diane Radford and Lindsey Ball to work closely to his designs.

Crosby's vision for the crafts in the 1980s incorporated some of the social purpose of the Arts and Crafts Movement and of 1970s counter-culture thinking. He pointed out that the glut of trained artists and makers combined with permanent mass unemployment created a need 'to establish convivial tasks, that give pleasure in making and satisfaction in achievement'.[126] Crosby's involvement with the crafts was, nonetheless, problematic. He sought the revival of the building crafts, which were mostly outside the Crafts Council's remit, seeking out artisans who could repair clocks, carve keystones and make iron gates, decorative panels and floor patterns. Yet, as he complained when he joined the Crafts Advisory Committee in 1975, it was 'difficult to find craftsmen prepared to work to another's design'.[127] By 1976 Crosby was pointing out that: 'The word 'decoration' is becoming respectable again and there is much to be done.'[128]

Although Crosby remained on the Crafts Advisory Committee till 1979, he felt that the subsequent Crafts Council never made proper links with architects. Crafts Council makers expected to be treated like fine artists. This was not Crosby's vision for the crafts. He believed passionately in a return to ornament and decoration which would be designed by the architect and executed by the maker. At the Crafts Council *Forging Iron* conference in 1980 there was a 'difficult' session when Crosby explained to assembled smiths that in his view their role was to be executive rather than creative.[129] By 1987, in a booklet *Let's Build a Monument*, Crosby expressed real impatience with the crafts of the day: 'Potters, ironsmiths and all the crafts have shaken off their roots, the useful antecedents, and begun to see themselves as artists: autonomous, responsible only to themselves, dependent on modish taste, on their business capacities and promotional skill.' As a result 'the craftsmen are trained *not* to be involved, to despise buildings'.[130]

In 1987 Crosby published plans for a projected *Battle of Britain Monument*, designed in collaboration with the sculptor Michael Sandle (Fig. 480). This was to be five hundred feet high and was to cost thirty million pounds. The role offered to makers and sculptors involved carving inscriptions, engraving glass screens and working on a twenty-foot-high continuous frieze in low relief depicting 'thousands of incidents, portraits, stories from the retreat from Dunkirk to the surrender on Luneberg Heath in 1945'.[131] Its crude symbolism inadvertently put in question all Crosby's useful proselytising for the return of ornament in architecture and his campaigns for a percent for art to be spent on building projects.

Makers had reason to feel cautious about collaborations which resurrected the classical and the monumental. During the 1970s and 1980s the poet, sculptor and landscape gardener Ian

479. Interior shot of *The New Spirit in Craft &
Design*, Crafts Council, 1987, showing TV sets
containing jewellery, tufted rug by Helen Yardley,
chair by André Dubreuil. (Crafts Council/Photo
Ed Barber).

Correspondingly, by the 1970s the autonomy of fine art was taken for granted. A key word used to praise fine art was 'ambitious' and ambitious art allowed for no compromise or collaboration. Sculptors did not entirely abandon the idea of a public role, but it had to be on their own terms. The 1970s had seen some disastrous examples of public sculpture commissions, the most memorable failure being the *City Sculpture Project* of 1972 funded by the Peter Stuyvesant Foundation.[123] Some sixteen sculptors were invited to create work for sites in eight cities. There was no advance public consultation and some pieces were completely destroyed by vandals, others damaged and not maintained and most rejected by the communities in which they had been placed. The sculptors involved made few concessions. As William Tucker, one of the artists involved, explained: 'the making and appreciation of sculpture is a fundamentally *private* activity: and if…it re-enters the public world, it does so on its own terms.'[124]

The 1970s also saw less hermetic theoretical writing about the public spaces of the city. The debate had been opened in 1961 in the United States in Jane Jacobs's study *The Death and Life of Great American Cities: the failure of town planning* which argued for the primacy of the street and neighbourhoods within cities and against zoning, super highways and massive rehousing. Her ideas were only taken up gradually in Britain. Colin Buchanan's *Traffic in Towns* of 1963 and his *Bath. A study in Conservation* of 1966 voiced disquiet at the destruction of city centres. By the early 1970s Nicholas Taylor's *The Village in the City* (1972) attacked the idea that high-rise housing was the only way to achieve high urban density while Malcolm MacEwan's *Crisis in Architecture* (1974) expressed disquiet within the architecture profession. The late seventies saw a powerful combination of conservationists and architecture critics who did much to undermine the public's faith in both architects and planners. *The Destruction of the Country House* (1975) and *Change and Decay: The Future of Our Churches* (1977), both put on at the V&A, were genuinely

477. Mary Little, *Harold,* 1994, steel frame, polyurethane foam, silk and wool, h. 90 cm. (Photo Steve Speller).

allegory and simulation were present in abundance. No wonder the Crafts Council continued to court this kind of work and want to count it in as 'craft'. It took the crafts into magazines like *The Face* and *Blueprint* and by extension into the academia of highly theorised cultural studies burgeoning in the polytechnics. Thus in the 1980s the Crafts Council operated as an unusual kind of cultural gatekeeper, inviting all kinds of unlikely design, fashion and fine art *in* as well as keeping other unsuitable work, often more readily definable as craft, *out*.

ART AND ARCHITECTURE

The utopian interiors of the late 1970s and early 1980s were a subversive response to functional modernism, an acceptance and celebration of the anarchic chaos of everyday urban life. But the 1980s also saw more practical attempts at what W.R. Lethaby had called 'Town Tidying'. It was argued that a sense of place, a *genius loci* could be restored to cities and to parts of the countryside by involving artists and makers in public commissions. New buildings could be humanised by introducing the kind of 'percent for art' legislation which already was in place in many European countries and in North America. But the history of public art and craft since the war had been complex. The 1950s, with the Festival of Britain at its start and the consecration of the Coventry Cathedral at its end, had been a decade of promise. But during the 1960s and early 1970s architects and planners shunned the decorative. Concrete reliefs by William Mitchell (Fig. 383) and Fred Millett were the rare examples of integrated adornment for public housing; in general architects would barely consider collaboration with artists or craftsmen. Sculptures like Geoffrey Clarke's *Spirit of Electricity* for Thorn House (1961) and Barbara Hepworth's *Winged Figure* for John Lewis (1963) which were actually attached to the sides of buildings were dismissed by damning phrases like 'brooch on the wall' or 'costume jewellery.[122]

478. Jasper Morrison, two *Wing Nut* chairs, 1984, assembled out of folding panels of hardboard, h. 80 cm., on *A rug of many bosoms*, 1985, designed by Jasper Morrison. (Jasper Morrison: Office for Design).

exemplified by the 1987 Crafts Council/Business Design Centre exhibition *Top Office*.[148] Speculative offices were created for 'Top People' ranging from Anita Roddick to Mrs Thatcher, each containing between ten to twenty craft objects. A memorable photograph was taken of Mrs Thatcher in her 'office' together with a David Leach tea set, a fire basket by Stuart Hill, a handtufted rug by Peter Podmore and a gilt mirror frame by Christine Palmer carved with 'the flora and fauna of Mrs Thatcher's native Lincolnshire'. Just out of sight were some glass by Christopher Williams, a Katherine Virgils hanging and book bindings by Jeff Clements and Angela James (Fig. 486).

The corporate crafts were a part of the confident optimism of the mid-1980s which was only gradually undermined by a succession of economic set-backs, heralded by the Stock Market crash of 1987, the collapse in house prices in 1989 and the devastating losses experienced by Lloyds 'names' in 1992. The basic kit might include a specially commissioned sweeping desk (Fig. 487), a handsome handtufted rug and a striking wall hanging that would serve to emphasise the spaciousness of the fashionable atrium effect of a double height foyer. Corporate craft commissions bred stars like the textile artist Sally Greaves-Lord, the creator of painted murals and large-scale discharge-printed silk banners and floor coverings, who cut her teeth on a collaboration with the architects Powell Tuck Connor Orefelt and D'Avoine for headquarters for a video company in Camden Town.[149] Rushton Aust was another corporate choice, using a variety of dyeing, printing and collage techniques to create large wallhangings. Both offered a handsome decorative modernism which evoked memories and snatches of Bloomsbury interiors, St Ives painting, hard edge abstraction and, in Aust's case, a touch of English chintz and whimsy. Another corporate favourite was the Dovecot Studios which wove eleven tapestries between 1984 and 1986 for the American company Pepsico Inc. based on designs by the American artist Frank Stella. The tapestry weaver Marta Rogoyska also came into her own in the 1980s. Like Greaves-Lord and Aust, Rogoyska studied iconic modern painting, especially late Matisse. She quoted from such art with elegance and her work was the antithesis of the sculptural sisal and jute hangings of the 1970s. The successful corporate stars

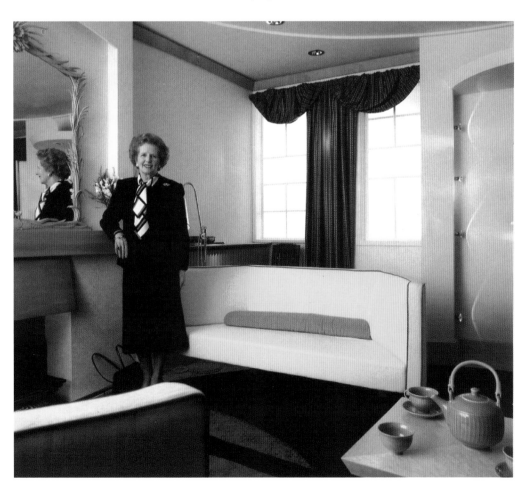

ART MEANS BUSINESS

Contemporary Applied Arts
Commissioning Service

485. Leaflet for Contemporary Applied Arts showing a hanging by Sally Greaves-Lord for Savills plc, late 1980s. (Photo Joel Degen).

486. Mrs Thatcher in her Top Office, 1987. (Photo David Banks).

487. Floris van den Broecke, office desk for Janice Blackburn, Blackburn House, Hampstead. (Photo Joel Degen).

488. Kate Malone putting her *Optimistic Jug*, 1991 for Homerton Hospital, London into the kiln. (Photo Karen Robinson).

of the late 1980s, including fine artists like Bruce McLean and Howard Hodgkin, effectively turned early modern painting into a decorative style.

A reaction against the perceived soullessness of the modern built environment led to a proliferation of independent agencies set up to act as mediators between architects, sponsors, local government and artists of all kinds. Common Ground (1983) focused on schemes in the countryside while the Artangel Trust (1985), the Public Art Commissions Agency in Birmingham (1987), the London-based Public Art Development Trust (1983) and the Yorkshire based Public Arts (1986) mostly concentrated on city sites. In the early 1980s British Rail's Community Unit set up an environmental partnership budget to fund art works in and around railway stations. Hospitals began to commission art (Fig. 488). By the end of the 1980s there were courses on public and site specific art at art colleges at Canterbury, Chelsea, Dundee, Glasgow, Kingston, Sutherland, Wimbledon and Winchester.[150] A sequence of Garden Festivals, initiated by Michael Heseltine as a way of alleviating inner city blight, began with the Liverpool Garden Festival in 1984 followed by Festivals at Stoke-on-Trent in 1986, Glasgow in 1988, Gateshead in 1990 and Ebbw Vale in 1992. The Garden Festival held at Gateshead had a strong craft component which included a show house full of craftwork 'rich in decorative and symbolic interest' as well as outdoor lettering and seating projects.[151]

The Garden Festivals raise the question of cultural politics. The public and corporate artistic initiatives of the 1980s took place in a charged atmosphere. Based on schemes to revitalise West Germany after the last war, the Garden Festivals were to compensate for collapsed industry, and in the case of Liverpool as a panacea for riot and civil disorder. The public sculpture of the 1980s paid frequent tribute to industrial decline and the disappearance of industrial skills. At Gateshead, Ray Smith was cagey about the symbolism of his *Red Army* of 1,100 gesturing figures in painted sheet steel. But the fact that the 'army' was manufactured at Swan Hunter, one of the few remaining shipyards on Tyneside, made an ironic point (Fig. 489). The facture of the blander examples of public sculpture was also hedged about with irony. *The Great Blondinis* by John Church was a collaboration between the sculptor and the last six craftsmen in the British Rail Engineering Workshop which at one time had 14,000

employees.[152] In Middlesbrough, Claes Oldenburg's sculpture *A Bottle of Notes* was constructed with Arts Council backing in a local shipyard. Peter Palumbo, then chairman of the Arts Council, optimistically saw Oldenburg's sculpture as putting 'the city on the map again and enabling old shipbuilding firms to transfer to other areas of work'.[153]

Many public art schemes worked, often rather artificially, to create a sense of place and identity in a degraded environment. In Swansea, under the guidance of the city architect Robin Campbell, the so-called Maritime Quarter was embellished with over one hundred carved inscriptions and sculptural towers and markers that simulated folk memory in the form of tributes to seafarers and ships and even to a local nineteenth-century quack doctor named Baron Spolesco (Fig. 490). What seems clear is that 'public art' was almost as protean a concept as 'crafts'. In the 1980s it reflected hopes and anxieties for 'community', for multi-cultural harmony and for all kinds of conservation projects. But it was also co-opted by canny property developers to enhance the value of essentially private sites like the burgeoning 'Business Parks' characteristic of the decade. In that kind of context 'a sense of place' increasingly was associated with what the American architecture critic Oscar Newman called 'defensible space'.[154]

One craft in particular was able to provide the mix of embellishment and practical security associated with defensible space. The most dramatic example of this new tendency had been the installation in December 1989 of massive ten-foot-high neo-Victorian gates at the entrance to Downing Street.[155] In the late 1970s the GLC had toyed with the idea of de-privatising London's squares by removing their railings. But the 1980s saw the return of railings and gates along with an array of Victorianising street furniture, employed with particular flamboyance by the Tory flagship council of Westminster and subsequently by metropolitan councils of all political persuasions. These were usually cast iron, but the Crafts Council initiatives in the late 1970s and the major V&A exhibition *Towards a New Iron Age* of 1982 brought the craft of the blacksmith to the attention of architects and developers.[156]

One of the earliest and most striking commissions was undertaken by Alan Evans who in 1981 completed handsome web-like gates for the Treasury in the crypt of St Paul's Cathedral (Fig. 491) while in 1982 Jim Horrobin made bold power-hammered gates for the ironwork galleries of the V&A. These functioned as an exhibit but also served to secure the gallery. In 1981 Hampshire's enlightened chief architect Colin Stansfield Smith launched a limited competition for gates for the medieval Great Hall at Winchester intended to commemorate the wedding of the Prince of Wales and Lady Diana Spencer. An important part of the brief was the requirement that the design would make it impossible to push 'an explosive device' between the gates' interstices. The Great Hall led into a newly built Crown Court where IRA terrorists had already appeared before judges.[157] The resulting gates, made in 1982–3 by Antony Robinson, successfully combined beauty and the brief's peculiarly contemporary utility. This was a dramatic example of this robust craft's application to the problem of 'defensible space'.

The skills of blacksmiths were also appreciated by developers during a property boom which took off in the early 1980s. Railings and grilles by James Horrobin and Terry Clark commissioned for Oriel House, Connaught Place, London, in 1983 and other work by Horrobin – eleven gates for luxury flats at Crown Reach on Millbank (1983), a screen and portcullis-like grille for Richmond House, Whitehall (1983–4) and two large gates for the Police Administration Centre in Rampayne Street, Pimlico (Fig. 492) – all combined decorativeness and security. Similarly twenty-four forged steel panels, made by Alan Evans in 1989 for the major Rosehaugh Stanhope office development at Broadgate next to Liverpool Street Station, were partly intended to prevent vans (especially a van filled with explosives) from entering an 'office park', which included £3.5 million worth of art works and which hovered between public and private.[158]

As we have seen, blacksmithing in Britain was invigorated by contact with Continental and American smiths in the late 1970s, orchestrated in part by the Crafts Council. But another important architecturally dependent craft, stained glass, received little attention until the 1986 conference *Glass in the Environment* organised by the Crafts Council, the Royal College of

489. Ray Smith *Red Army*, 1990, detail of 1100 painted steel figures fabricated by Swan Hunter, North Tyneside for the National Garden Festival, Gateshead, 1990, each figure h. 37.1 cm. (Photo Harriet McDougal).

490. Swansea, Maritime Quarter, *Copper Flame* seat and monument designed by Robin Campbell 1985–8. (The Planning Department, City and County of Swansea/Photo Robin Campbell).

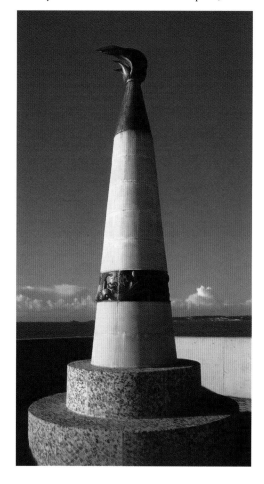

Art and the Royal Institute of British Architects.[159] The stained glass renaissance in Britain just after the war had been largely confined to ecclesiastical commissions and drew on contemporary painting practice in Britain and in France. But in the 1970s young British stained-glass artists found a new model in German twentieth-century glass. The tradition there was strong, from the inter-war work of Thorn Prikker and Josef Albers to the postwar achievements of Joachim Klos, Johannes Schreiter and Ludwig Shaffrath. The German influence, crudely summarised, meant the abandonment of figurative designs and of painting on glass in favour of a mix of biomorphic and rigorously geometric abstraction and the calligraphic non-functional use of leads. Schreiter, Klos and Shaffrath had all visited Swansea Institute of Higher Education where Tim Lewis ran an influential course in architectural stained glass. Many of the stained-glass leaders of the 1980s were Swansea trained.

But the most important figure in British stained glass in the late 1970s and 1980s was Brian Clarke who, as one of the last recipients of a local Authority Junior Art Scholarship, became a full-time art student aged eleven, first at Oldham, then at Burnley School of Art and at North Devon College of Art and Design.[160] Clarke had met Johannes Schreiter in 1974 while on a travelling fellowship and took the German's ambitiousness of scale and abstraction as a starting point. After completing a series of remarkable windows for churches in the late 1970s, mostly in his home county of Lancashire, Clarke gave up ecclesiastical work. In 1979 he published his firebrand manifesto *Towards a new constructivism* which hailed punk rock as a model for a fresh start in all the arts.[161] From 1978 he had his designs made up for him, a decision which went against the grain of British stained glass as practised by artist craftsmen and women since the early twentieth century. By the early 1980s the personable Clarke had found fame as a painter and formed important friendships with architects, including Will Alsop, Future Systems, Norman Foster, Nigel Coates and the Japanese Arata Isozaki. He worked on a dramatic scale – the most striking examples in Britain being the 260-foot-long canopy for the Victoria Street arcade in Leeds made in collaboration with the architects Derek Latimer and Company (1990) and the 3,000-foot-square barrel vault over Joseph Paxton's nineteenth-century thermal baths as part of a conversion to a shopping mall at Buxton in Derbyshire (1987) (Fig. 493). Both were notable for brilliantly orchestrated grids of colour softened by floating organic motifs which Clarke christened 'amorphs'. Although the scaled-down nature of his collaboration with Norman Foster at Stansted Airport, completed in 1992, was a disappointment, Clarke

491. Alan Evans, steel gates for St Paul's Cathedral Treasury, 1981, h.2.7 metres. (Alan Evans/Crafts Council/Graham Portlock).

492. James Horrobin, Gates for Rampayne Street Metropolitan Police Building, Pimlico, 1983, mild steel, h. 2.5 metres. (Photo James Horrobin).

494. (*above*) Graham Jones, a detail of the glass for the entrance foyer at Colemore Gate, Birmingham, 1989, etched, plated and stained hand-blown glass, 80 square metres. (Photo Graham Jones).

493. (*left*) Brian Clarke, Cavendish Arcade, Thermal Baths, Buxton, stained glass, 1987, 290 square metres. (Brian Clarke).

achieved dramatic results at Arata Isozaki's Lake Sagami Country Club (1989) and at Alsop and Störmer's Hôtel du Département in Marseille (1994) where he advised on the deep luminous blue cladding of the exterior.

No other British glass artist who came to maturity in the 1980s matched the scale and ambitiousness of Clarke's output, but most, again under German influence, worked semi-abstractly, using lead lines expressively and, on the whole, eschewing painting on glass. Swansea graduates Mark Angus, Susan Bradbury, David Pearl and Graham Jones all took these German influences in different directions. Angus, the most committed to ecclesiastical work, developed a graphic symbolism, reminiscent of Schreiter and of elements of 1960s pop psychedelia. Bradbury opted for a rhythmic abstraction with suggestions of landscape. Pearl's predominately secular glass used aerial photography and computer generated colours and images on geometric grids. Jones's approach was boldly expressive. Unlike most of his contemporaries he painted his glass (Fig. 494).

All glass artists faced major problems over context and content. For many architects and public art agencies, glass was almost exclusively associated with church interiors and angelic choirs. In 1986 Alex Beleschenko, another Swansea graduate, completed a window for an Arup Associates development at Stockley Business Park. Instead of using lead calmes to hold the glass in place he created a mosaic of glass held between two sealed laminated panels (Fig. 495). The effect was airy and secular and gave rise to a series of prestigious commissions for Beleschenko using similar techniques – a glass column at Reading Station in 1985 for British Rail, a hanging screen in the Birmingham International Convention Centre in 1991 and the screen for St John's College, Oxford, completed in 1994.

Some of the most striking public commissions were relatively modest and in the best sense unoriginal – such as an Art Déco canopy made in 1984 for the shop Liberty by another Swansea graduate, Amber Hiscott. Nor was stained glass necessarily the most effective architectural intervention. Etched or sandblasted glass, as with Ray Bradley's 1973 screen for

495. Alexander Beleschenko, window for offices in Stockley Business Park, 1986, antique glass between glass panels, 57 square metres. (Photo Arup Associates).

Bar Hill church in Cambridge and with Diane Radford and Lindsey Ball's collaboration with Clifford Rainey at Lime Street Station, Liverpool, worked equally effectively. Neon was used particularly imaginatively by Ron Haselden in many contexts and gave a sense of place to the interior of Chipping Norton School in a 1989 project which involved the pupils in its design and construction.

Of the older generation, figures like Alan Younger created stained-glass windows which were relatively easy to read, powerfully painterly and convincingly religious. Two still more senior figures, John Piper and Patrick Reyntiens, made a triumphant return to figurative stained glass. For Piper the process began in the 1970s when he returned to an accessible neo-romanticism which worked well for church windows honouring figures like Peter Fleming and Benjamin Britten. His career as a stained-glass artist culminated in his windows (made by Reyntiens) for the chapel of Robinson College, Cambridge.[162] Reyntiens, whose glass of the 1970s and early 1980s had epitomised pop graphics, began making small, complex, heavily painted and sgraffitoed figurative panels in the mid-1980s, taking as their theme passages from Ovid's *Metamorphoses*. But his window for Southwell Minster, completed in 1998, was a disappointment – an array of static Arts and Crafts angels which do not bear comparison with his mythological scenes. Ecclesiastical windows were a harsh test in a profoundly secular age; Graham Jones's Poets window in Westminster Abbey must sadly be accounted another missed catch.

Not all public art need be physically large. The Lichfield Cathedral silver project which employed seventeen silversmiths on the design and making of ceremonial plate from 1990/1 was an ambitious public art commission. As we saw in Chapter Seven, Goldsmiths' Company, under the art direction of Graham Hughes, was responsible for daring patronage in the 1950s and 1960s, with splendid silver candelabra, maces, jugs and table centres going as gifts to new

universities like Sussex and Warwick. Some twenty to thirty years later taste had changed. The Lichfield Cathedral Chapter were advised by Gerald Benney (still a splendid silversmith but an increasingly predictable one) and by Rosemary Ransome Wallis, Hughes's successor at Goldsmiths'. Her taste, essentially conservative, favouring high finish and displays of skill, was reflected in the Lichfield commission. Practically every piece 'quoted' the cathedral's architecture – from the Victorian floor tiles to the ceiling bosses – with the result that many of the pieces were uncomfortably reminiscent of 'heritage' giftware.[163] A contrast can be drawn with a series of commissions at Lincoln Cathedral. There a modernist approach was established in 1960 when Louis Osman designed a Treasury for the Cathedral with powerful abstract glass by Geoffrey Clarke. In the 1980s Keith Murray became the adviser to the cathedral Chapter and Fabric Council. He was responsible for the potter Robin Welch's 1984 set of massive candleholders commemorating the founding of the Gilbertine Order, followed in 1986 by a sculptural canopy for the shrine-like head tomb of St Hugh (Fig. 496), the twelfth-century Bishop of Lincoln. Designed by the jeweller David Poston and fabricated in mild and stainless steel by the blacksmith Alan Evans the canopy soared above the tomb like a beautiful piece of engineering.[164]

Silver benefited from one 'retro' tendency of the 1980s – a return in some quarters to

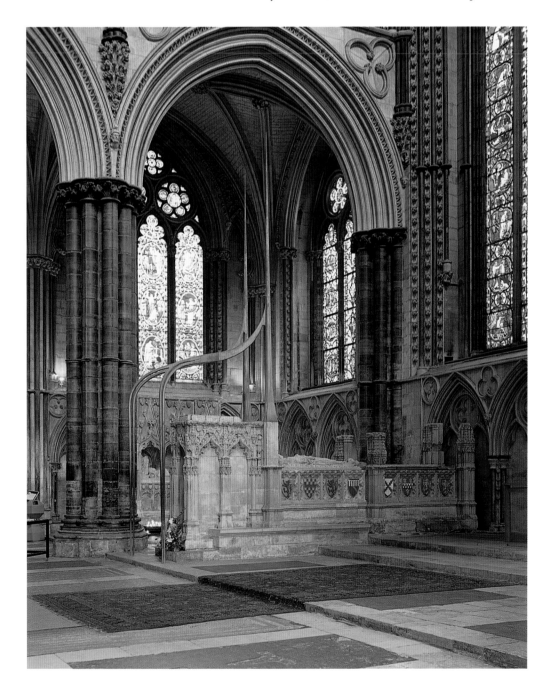

496. David Poston, canopy for the tomb of St Hugh, Lincoln Cathedral 1986, fabricated by Alan Evans and Richard Quinnell Ltd in mild and stainless steel. (Photo Heather Lees).

497. Malcolm Appleby, silver parcel-gilt salt, pepper and mustard made by Hector Miller, engraved by Appleby with myths of creation and destruction. (The Silver Trust. Photo courtesy of the Worshipful Company of Goldsmiths).

498. Kevin Coates, St George's centrepiece, silver parcel-gilt, mosaic work, lapis lazulite, mother of pearl, coral, ebony and amber, ebony. (The Silver Trust. Photo courtesy of the Worshipful Company of Goldsmiths).

formal dining, a phenomenon recorded indirectly in the consumer pages of *Interiors* magazine. In 1987 the Silver Trust was conceived by Lady Henderson (the wife of the British Ambassador to Paris), the fashion designer Jean Muir and Gerald Benney. The aim was to raise funds for a commissioned full table service (including centrepieces) for loan to 10 Downing Street and British embassies abroad. The last major campaign of this kind had been the restrainedly modern Embassy silver range designed by David Mellor in the 1960s (Fig. 297). In marked contrast, many of the Silver Trust's commissions were characterised by lavish complexity – from Malcolm Appleby's salt, pepper and mustard engraved with creation and destruction myths to Kevin Coates's essay in patriotism, his St George's Centrepiece (Figs 497, 498).

CODES AND MESSAGES

The 1980s saw a talented band of letter cutters and calligraphers campaigning for more involvement in architectural and design commissions. But both crafts were in an anomalous position, having been virtually excluded from the colleges of art since the introduction of the Diploma of Art and Design in the early 1960s. The Royal College of Art had created a precedent by dropping the teaching of calligraphy in the early 1950s. It might be thought that the discipline would have survived within Graphic Design departments but the few skilled calligraphers at art colleges in the 1960s were not replaced when they retired. Lettercutting was only taught at the City and Guilds of London Art School on a wide-ranging lettering course started in the early 1970s by Berthold Wolpe. Thus workshops like those run by David Kindersley, by his son Richard, who had set up in 1966, by John Skelton and by David Holgate had an important role in training would-be practitioners. The institutionalised teaching of calligraphy was largely kept going by one remarkable woman, Ann Camp, who started a course in 1979 at the Digby Stuart College at Roehampton Institute. She was in a direct Johnstonian line, having been taught by Dorothy Mahoney and Mervyn Oliver, but she allowed her students great freedom to develop. A whole gifted generation – Ewan Clayton, Hazel Dolby, Gerald Feuss, Lily Lee, John Nash, Brody Neuenschwander, Sam Somerville and Alison Urwick – trained with Ann Camp. As she taught students from sixteen countries her influence was international. The only actual art school to take the craft seriously was Reigate School of Art where illuminating and heraldry were given special attention and where from 1985 sign writing and architectural lettering were introduced.

Despite these disadvantages, in the 1980s both lettering and calligraphy came to symbolise the kind of craft which epitomised skill and an element of discipline.[165] One area where a species of neo-conservatism made important sense was in the carving of headstones. There had always been clients who wanted an alternative to the mass produced stones with machine chopped lettering provided by most monumental masons. In 1934 the sculptor Gilbert Ledward had set up the firm Sculptured Memorials and Headstones, involving Eric Gill and his workshop, the architect Sir Edwin Luytens and the sculptors Alan Durst and Richard Garbe. But the 1980s saw a new interest in the pleasing and consoling diversity of eighteenth- and early nineteenth-century headstones. Senior figures like David Kindersley and John Skelton and younger letter cutters like Sarah More, Alec Peever, Tom Perkins and Simon Verity all rose to the challenge. In 1988 Memorials by Artists was founded by Harriet Frazer in memory of her stepdaughter, dedicated to making the commissioning of a headstone by an independent letter-carver as simple and as painless as possible.

Architectural lettering had a less contested role than architectural glass but it took an imaginative architect to go beyond a metal sign and scaled up type forms. The 1970s and 1980s saw nothing as moving as Eric Gill's memorial inscriptions to the dead of the Great War or anything on the scale of Ralph Beyer's Tablets of the Word in Coventry Cathedral. As we saw, the poet and sculptor Ian Hamilton Finlay reinvented the genre of elegiac inscriptions, often with a disturbing political edge, providing interpretative work for many letter carvers. One such was Michael Harvey. In 1990/1 Harvey designed the most ambitious lettering commission of the decade. This was a frieze of names of early Renaissance painters carved (with the help of Brenda Berman and Annet Stirling of Incisive Letterwork) into the ashlar

limestone wall alongside the grand staircase in Robert Venturi's National Gallery extension. Harvey used robust vernacular letter forms based on Victorian display typography, neatly alluding to the Victorian rediscovery of early Italian art. The grandeur of conception went hand in hand with an element of parodic irony, which honoured the playful allusive character of Venturi's architecture (Fig. 499).

The key campaigner for the use of architectural lettering was Richard Kindersley, who pointed out that most architects fell back on a variation of Univers or Helvetica in steel or transfer letters. While this worked for internal signage Kindersley argued that lettering on the exterior of a building should be more expressive and more integrated with the architecture.[166] Richard Kindersley was interested in variety and he made letters out of cast concrete and bronze as well as carving into brick and ashlar stone. His best work recalled the signage of Ralph Beyer and Edward Wright (Fig. 500). Some memorable public commissions took the form of calligraphy. In 1974 Ann Hechle wrote out Vita Sackville-West's *The Land* on the wall of her sitting-room (and was pictured by David Cripps sitting before it like a beautiful young tigress) (Fig. 501) and this was followed in 1977 by some powerful calligraphy on the wall of the Inscriptions Room at the Roman Baths Museum at Bath. At the close of the 1980s Incisive Letterwork (the partnership of Brenda Berman and Annet Stirling) emerged as impressive designers and letter cutters. Almost all their work was carved in stone, and they were involved

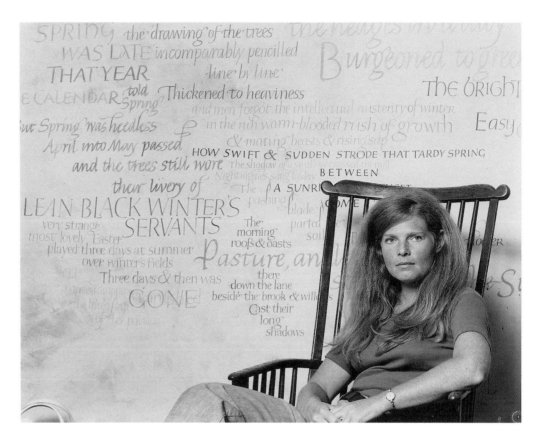

501. Ann Hechle in her sitting room in 1974. On the wall are passages from V. Sackville-West's poem *The Land*, written in oil paint. (Photo David Cripps).

502. Ewan Clayton, a detail of *Spring Fire Birds* by the Persian poet Rumi, 1990, Chinese ink on Whatman's pre-war paper, 60.5 × 80 cm. (Photo Ewan Clayton).

in its quarrying. Some of their finest inscriptions were done in collaboration with Ian Hamilton Finlay. Because of their deep engagement with their material, they brought an informal grandeur to a wide range of commissions (Fig. 503).[167]

One burning question emerged in the 1980s. What effect would the new design and printing technologies, involving personal computers (especially the Apple Macintosh) and digital imaging, have on calligraphy and lettering? In effect the PC democratised hand lettering, graphics and typographic design and production. As Robin Kinross explains, from the mid-1980s onwards personal computers made a new intimacy with typographic design possible:

In another apparent return to earlier conditions, typeface production (sometimes still called the 'cutting' of the final letterform) can now be put back into the hands of the designer. There has been a flourishing of small, independent type-producers, and a few signs

that the possibility of everyone being able to design their own typeface, or modify a given one, might have good results.[168]

Thus the PC made possible the ideal to which Eric Gill had referred in the context of metal type, when he argued that the designer of the type and the creator of the type – the punch cutter – should be one and the same person. One response from the world of craft lettering to some of the cruder do-it-yourself typefaces of the 1980s was a reiteration of the educational value of calligraphy as a training for typographers. And for those who were already designing type its usefulness became immediately apparent. For instance Michael Harvey used Fontographer, a special type design software,[169] and programmes of this kind enabled other hand letterers like the letter cutter Tom Perkins to design desk-top fonts.

The PC also emerged as a new creative tool for calligraphy itself. At a practical level the new technology meant that the work of creating book jackets or packaging could be done more efficiently. A piece of writing could be scanned into a computer and worked on and sent off on a disc. But in addition software programmes like MacPaint offered calligraphers a vocabulary of forms, just as the broad-edged pen or the chisel had done. Although the computer was 'just another tool' it had its own logic and limitations and possibilities. The calligrapher Ewan Clayton found himself thinking about the relationship between straight lines and curves and began to play with layers and depth. Layering, that liberating software tool pioneered in the Apple drawing programmes, fed back into Clayton's own calligraphy (Fig. 502). At a still deeper level Clayton has argued that the PC encouraged hand letterers to rethink the purpose of their work and join in a wider debate, participating, as Clayton has, in the philosophical seminars on the nature of the document led by David M. Levy (another Roehampton trained calligrapher) at the Xerox Palo Alto Research Centre (PARC) in California.[170]

The technological revolution fostered debate and interest. In 1988 Letter Exchange, an inclusive body embracing 'all aspects of good lettering', was founded by Lily Lee, whose design practice encompassed book jackets, record sleeves and packaging, and David Quay, a graphic and typographic designer. Both were at home with the new technology. But Letter Exchange also worked to address old familiar problems that had been aired in Society of Scribes and Illuminators' meetings in the 1950s and 1960s – how to broaden the application of calligraphy and letter cutting and yet maintain standards, how to range from rolls of honour to book jackets to CD covers to architectural lettering, how, in short, to be modern.

OUT OF THE WOOD

The increased support for the ecology movement in the late 1970s and 1980s necessarily touched the crafts. Friends of the Earth and Greenpeace, both founded in 1969, began to run well-focused, dramatically orchestrated environmental campaigns[171] and in 1973 the Ecology Party was formed, changing its name to the Green Party in 1986 and fighting its first election in 1987.[172] By the 1980s a recognisable ecologically-concerned lifestyle had developed which involved wholefood shops, recycling of bottles and paper, open-air festivals and vegetarianism.[173] Many makers had pioneered this kind of living during the 1960s and were 'natural' Greens. In 1986 the ecological stakes were raised after an explosion at the Russian nuclear power station at Chernobyl. Clouds of radioactive dust rose high into the air, falling as rain over large areas of Northern Europe, including North Wales and the Lake District. The disaster inspired the editor of *Crafts* to devote the July/August issue to 'the theme of Ruralism – not in a nostalgic or sixties drop-out vein, but as a reflection of contemporary culture'.[174]

As we have seen, furniture makers like Richard La Trobe-Bateman and David Colwell were taking an interest in woodland crafts and sustainable development by the end of the 1970s. In the 1980s a younger furniture maker, Lucinda Leech, visited Ecuador and Bolivia to inspect sustainable forest development and became involved with projects initiated by the Ecological Trading Company. She explained: 'I am trying to demonstrate that tropical timber can be used not only to create furniture but also as a positive contribution to the environment. The many exciting new projects I have visited can only continue if timber is bought and used. The

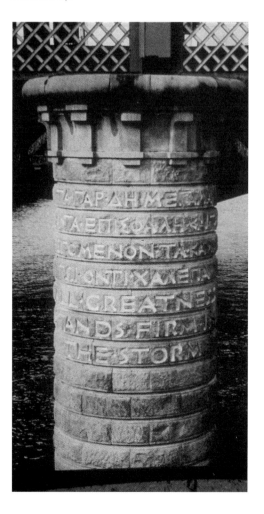

503. Incisive Letterwork (Annet Stirling and Brenda Berman) in collaboration with Ian Hamilton Finlay. 'All greatness stands firm in the storm' Plato, in Greek and English, carved with power tools into a granite pillar, River Clyde Bridge, Glasgow, 1990. (Photo Incisive Letterwork).

ultimate result will be adequate timber supplies for all of us – for ever.'[175] The blacksmith Alan Evans was similarly environmentally conscious – using solvent-free paints and 'making objects of physical quality that last.'[176]

The most decisive attempt to combine craft practice with ecological concerns was made by John Makepeace. In 1983 he raised funds to purchase Hooke Park, 330 acres of woodland near his headquarters at Parnham House. His aim was to revive woodland crafts by training students to set up entrepreneurial woodland industries using roundwood thinnings, a by-product of good forestry. With the help of the German architect and structural engineer Frei Otto, the structural engineer Edmund Happold and Richard Burton of Ahrends Burton Koralek, a 'Prototype House' was completed in 1986 using roundwood thinnings and innovative metal joints and steel cables.[177] The same group was responsible for a further building using freshly-felled timber to create compressed arches which were covered with two polymer membranes. A sculpture made by Andy Goldsworthy in 1987 using second grade distorted timber added further eco-credibility to the venture. But Makepeace had problems with the financing of Hooke Park as an educational establishment. Early courses were funded by the Manpower Services Commission, by the European Social Fund, the Department of Employment and local Councils. Links were made with Bournemouth University. A contract with Habitat in the early 1990s saw students working on what amounted to a production line two or three days a week.[178] Makepeace's conflation of entrepreneurship and ecology proved unworkable and the students protested.

Makepeace made the important connection between crafts associated with woodlands and ecology. But, as we have seen, the Crafts Council, like the Crafts Centre of Great Britain from 1948, had never regarded woodland or other vernacular crafts as coming within its remit. Ralph Turner had taken in a few exhibitions which included 'traditional' work – *Davies Brothers Gatesmiths: 18th Century Wrought Iron in Wales* in 1977, *Weaving: The Irish Inheritance* and *Welsh Harps* both in 1980. But in 1983 he spoke of the time being right for an exhibition of 'dry-stone walling, hurdle-makers, fencing and so on'. There is little doubt that such a show held in London would have been a success, such was the hunger for 'authentic' country skills.[179] Nothing came of the idea but in 1986 the Council staged *David Drew: Baskets*, accompanied by a photographic record of Drew planting, harvesting and preparing his own willows.

Between the wars, figures like Muriel Rose and H.J. Massingham had assembled substantial collections of British basketry. In the late 1940s Henry Rothschild had been able to travel from the Somerset Levels to Norfolk, collecting locally made baskets for an exhibition (Fig. 261). For Rothschild traditional baskets seemed a natural adjunct to both the artist craft of ceramics and good mass produced textiles. But by the late 1980s indigenous basket making was in decline. Imports were cheaper, good materials were in short supply and the multiple uses for baskets – in agriculture, fishing and trapping as well as for storage – had shrunk. As traditional practice began to collapse the Crafts Council began to take an interest. Turner noted of the David Drew exhibition: 'this exhibition of baskets represents the first of its kind in the Council's history. Never before have we arranged a solo exhibition for so traditional a maker. It says much for the talents of David Drew that he has instilled in us so much confidence.'[180]

The Crafts Council's confidence may have been due to Drew's background. Drew was not continuing a family tradition; in fact he had always wanted to go to art school. He had been taught by Alastair Heseltine, who himself had turned to basketry after training at Hornsey College of Art. In 1982 Drew was awarded a John Ruskin Guild of St George Busary to enable him to acquire land for willow growing in Somerset. To have applied for such a grant at all is suggestive and ties in with the way that his work was perceived. Drew made indisputably fine baskets but it was the passing of an indigenous basket making industry which made it possible to romanticise both the man and his work. In the accompanying catalogue Alastair Heseltine praised Drew's rejection of commercialisation and Richard Boston, founder editor of the ecology magazine *Vole*, wrote lyrically about his way of life:

the way David Drew lives and works is about as far from industrialisation as is possible in

504. David Drew making a basket, 1986. (David Drew/Crafts Council/Chris Chapman).

twentieth-century Britain...life at the thatched house at Higher Hare Farm, Somerset, can't have changed much since it was built in the seventeenth century...he makes no use of what he calls 'alien' material in his baskets. Rarely nails, no glue, no varnish. (Fig. 504)

Lois Walpole, featured in *Crafts* in 1984, and given a small show in that year, was a more typical recipient of Crafts Council patronage. Her first attempt at basketry was not a basket: 'It was a six foot naked black athlete in wood and cane which I made whilst I was a sculpture student at St Martin's School of Art.'[181] She abandoned sculpture in favour of painting and in 1982 she began 'using my painting ideas in baskets'. She admired Drew's baskets but 'the eternal 'natural' colours bored me rigid'. Walpole, who went on to make baskets which she wove in painted cardboard, packing tape and plastic strips and which on occasion were scaled up to giant size, swiftly became a favoured Crafts Council maker. As a teacher at the London College of Furniture she also became an influential exponent of 'New Basketry', in line with the Crafts Council's backing for 'New Jewellery' and 'New Ceramics'. In the long term, however, Drew recast the boundaries of the craft of basketry even more effectively. In 1993 he and his wife moved to Villaines les Rochers, south of the Loire valley in France, a cave dwelling village and a centre for basket making. Drew's creative contact with an indisputably 'authentic' basket making culture provoked the interest of a powerful range of metropolitan cultural mediators – anthropologists and cultural historians as well as curators from the world of fine art and craft.[182]

Art, craft and ecology were most successfully braided in the work of Common Ground. Founded in 1983 by Sue Clifford and Angela King, veterans of Friends of the Earth, Common Ground tapped into the poetics of ecology, seeking to 'promote the importance of our common cultural heritage – common plants and animals, familiar and local places, local distinctiveness and our links with the past'. Common Ground involved writers, fine artists and makers in projects like *Parish Maps* and *New Milestones* which attempted to create a 'sense of place' or, in their phrase, 'Local Distinctiveness' as a form of localised rural resistance. A typical project was a series of celebratory exhibitions about trees held in during 1989. One show, *Out of the Wood: The Tree as Image and Symbol*, was a collaboration with the Crafts Council. The theme was a resonant one, not least because two years previously, on the morning of 17 October 1987, the nation woke to find a landscape of tree-strewn devastation. The Great Storm, like Chernobyl, had an effect on the national psyche and prompted a series of exhibitions and furniture making projects in 1988 which focused on the environment and, more practically, found uses for the fallen timber.[183]

But in many ways *Out of the Wood* revealed how out of touch the Crafts Council was with ecological and environmental issues. The emphasis was on wit and irony, with pop-up trees in

recycled paper, Peter Freeman's Green Man fashioned out of neon lights, Daphne Krinos's oak-leaf jewellery and Richard Artschwanger's punning Log Book made of carved wood and woodgrain effect formica. Potters like Mike Dodd, Phil Rogers and Richard Batterham, who knew a good deal about wood because they made and used ash glazes, were omitted from a distinctly urban gathering. Jim Partridge, given a small accompanying show of his own, emerged as the true woodsman of the exhibition (Fig. 505). He had moved on from domestic-scale bowls to public art projects. In 1986/7 in partnership with Liz Walmsley, he made a walkway and a footbridge in Grizedale Forest as part of a Sculpture Project set up in 1977 – an intervention which was more convincing than much of the commissioned sculpture there. He also took part in projects using fallen timber from the Great Storm, making seats and benches in wood in Kent and Essex for the Common Ground and the Woodland Trust.

The relationship between the crafts and the tangle of green and ecological issues was a complicated one. At the time of the *Out of the Wood* exhibition Rosemary Hill addressed the matter in *Crafts*.[184] The list of makers she deemed 'green' was an interesting one. David Colwell and David Drew were understandable choices, Susan Bosence was a less obvious candidate. Textile printing, even using vegetable dyes and hand blocks, can never be intrinsically 'ecological'. Bosence's links with Dartington Hall seemed to have drawn Hill, but, as we saw in Chapter Three, there had been nothing very 'green' about farming practice as pioneered there between the wars. The other makers chosen hardly formed a movement. The potter Michael Casson took an interest in conservation and was researching ways of eliminating chlorine emissions from his salt glaze firings. The stained-glass artist Lawrence Lee rightly identified his craft as long-lasting. In the end the equation was a shaky one. Indeed it could be argued that craftsmen and women produced uneconomically and almost always, with the exception of basket makers and furniture makers, used some poisonous, polluting substances. And ironically, in the image conscious 1980s, the political Greens were careful not to make links with the crafts. As Jonathon Porritt, then director of Friends of the Earth, explained:

> As for the idea of 'taking up the crafts', the Ecology Party can't be accused of that, in fact it has deliberately avoided it. We have a lot of trouble with people thinking we're homespun and I remember that it was suggested that we should attempt to canvas craftspeople in particular, and the feeling was that, while there was probably a lot of natural support for us among them, that wasn't how we wanted to be seen.[185]

THE WILDING REPORT

The status of craft may have been complex and contradictory but the practice of the crafts continued to command respect – particularly when under threat. In December 1988 Richard Luce, the Minister for the Arts, asked Richard Wilding, a distinguished retired civil servant, to examine the structure of support and funding for the arts in England. The purpose was to rationalise and to cut costs. In September 1989 Wilding presented his report *Supporting the Arts*. Most of the report was devoted to restructuring the Regional Arts Associations, but, almost *en passant*, Wilding recommended that the Crafts Council lose its Royal Charter and merge with the Arts Council. During his consultation he had found overwhelming support for the merger, particularly among the Crafts Council's old adversaries, the Regional Arts Associations. Wilding argued that the Crafts Council's budget was negligible and that the Council 'cuts little ice with either the RAAs or local authorities'. Finally he argued that the Crafts Advisory Committee had been founded in 1971 because the Arts Council had refused to accept the crafts as worthy of support. He had been assured by the Arts Council that 'this point of view is entirely out of date as far as they are concerned'.[186]

But Wilding had failed to consult the craft constituency, an omission which weakened his case, and he had little understanding of the hands-on nature of the Crafts Council's activities.[187] His recommendations were greeted with a storm of protest in the craft world and by a surprising number of lengthy pro-Crafts Council articles, including attacks on the report in the weekly *The Spectator*, *The Sunday Times*, *The Financial Times* and *The Observer*.[188] Wilding's

casual assumption that the crafts would be safe in the hands of the Arts Council reminded craftsmen and craftswomen of the prejudice and difficulty they had experienced in pursuit of fine art status. A petition was presented to Richard Luce and on 13 March 1990 he announced that the Crafts Council should remain independent. Practically all Wilding's other recommendations were implemented.

The survival of the Crafts Council can be contrasted with the fortunes of the Design Council in the late 1980s (although as I write a Labour government seems poised to revive Wilding's proposal). As we have seen, the decade had witnessed a leap in knowledgeable consumer interest in design. This came about almost despite the Design Council which suddenly began to look old-fashioned and paternalistic and ripe for 'restructuring'. In 1988 its shop at the Design Centre in the Haymarket was closed. In 1993 John Sorrell, head of the corporate identity firm Sorrell and Newell, became its chairman, charged by the Department of Trade and Industry to undertake a review of the Design Council's future purpose and function. His report, accepted in March 1994, made 200 members of staff redundant (at the cost of £4 million)[189] and ended the Council's public activities centred on its bookshop and exhibitions spaces at the Design Centre. The new slim-line Design Council with a staff of forty was relaunched in 1994 and operated from behind the scenes.[190] Its activities were built round research 'partnerships', the issuing of papers and reports, conferences and 'brainstorming' sessions and (for a brief spell) the offer of design advice at a local level through the government's Business Links scheme. National identity was researched and it was found that world-wide the British were perceived to be 'proud, civilised and cultured, but not adventurous or visionary.'[191] A day out at the Design Centre, taking in an instructive exhibition, returning home triumphant with a Design Council-approved kettle or set of wine glasses was no longer an option and for the general public the Design Council vanished from view.

But the Crafts Council, which had come into being under the wing of the Council of Industrial Design, maintained its presence in the 1990s – putting on exhibitions, running a shop and a café, purchasing for the Council's collection and giving out information. The complex identity of craft worked in its favour. It was not quite art, nor was it quite design. But it touched people's lives in unexpected ways. An ambivalent attitude to progress and industrialisation was very much part of the intellectual baggage of the educated classes in Britain. This ambivalence, in which property developers practised as amateur silversmiths and cabinet ministers collected fine bindings, was more a matter of feeling than logic. But it ensured support for the crafts in high places.

From 1992 funding for the Crafts Council and the Arts Council had come from the Department of National Heritage. This newly created Department had taken over the responsibilities of the Office of Arts and Libraries and added to its remit Sport, Heritage, Tourism and the newly created National Lottery. Thus since the Second World War government funding for the crafts (and by implication their *raison d'être* in government eyes) had shifted from the Board of Trade to the Department of Education & Science to the Office of Arts & Libraries to the Department of National Heritage, which by 1997 had been recast as the Department of Culture, Media and Sport. Did this mean that the crafts, once forced into the strait jacket of providing inspiration to industry, was now seen, together with the rest of the arts, as a branch of 'heritage' or even as an adjunct to tourism? It was still not quite clear how the crafts should be defined. In September 1990 a revision of the Council's corporate plan suggested the abandonment of the term 'artist craftsman or person'. Instead the crafts were cautiously redefined as 'appropriate workmanship allied with appropriate design'.[192] In this we hear the pragmatism of a David Pye rather than the romanticism of a Bernard Leach.

In 1994 the Crafts Council published a 400-page report, *Crafts in the 1990s* based on nearly 2,000 responses to questionaires. The crafts in this instance were defined by omission – no fine arts or photography, no building crafts, no crafts related to perishables such as flower arranging (or, presumably, cake decoration). The most widely practised crafts were textiles and ceramics – as they had been at the time of the Council's last survey in 1983. Women practitioners (57%) out-numbered men (43%). Of the estimated 25,000 makers, 57% had a

formal qualification but well over half regarded themselves as 'mainly self taught'. Earnings, calculated as profits, were low – £9,500 for full-time men and £6,500 for full-time women. But the combined turnover for makers in 1992 was calculated at £400 million – 'a significant sector of the small-business economy'.

FALLS THE SHADOW

At the beginning of the 1990s I began to think about writing a history of the crafts in Britain, surveying most of the century, ending in 1989. This was going against the grain of the preferred emphasis at that time. The general view was that craft needed to be defined and then theorised in order to take its place alongside video, time-based art and film as an appropriate subject for cultural studies departments in universities. In pragmatic terms this was probably true – theorise or die! But in fact craft objects reified or embodied theory – commenting profoundly on the world of things and on consumption, on fine art, design, mass production and the nature of materials – visually rather than verbally.

Nonetheless, the contest between object and word, between textile and text *is* often an unequal one. At one conference I heard a paper in which a complementary studies tutor demonstrated (with slides) how he had rescued one of his MA students from a career making handsome earthenware pots. The student's practice was 'liberated' by a course of reading – taking in semiology, concepts of nature, commodity theory and so on. In no time the student was making tented 'performance landscapes' out of rip-stop nylon, PVC tube, carbon fibre and rubberised cord which commented on the 'constructedness' of nature. It was a curious occasion – a well received paper given at a Crafts Council funded conference whose content seemed to indicate that craft practice was inappropriate in the late twentieth century. But I soon came to realise that the ethnography of the crafts, and an ethnography seemed to be what I was attempting, was rich in such oddities.

In the summer of 1989 I was at Aberystwyth Arts Centre in North Wales attending an International Potters' Camp. The star attraction was Asebe Magaji, a potter from Tatiko, a small Gwari village in Nigeria. All her materials, including fuel for firing, had been flown over from Nigeria. Vague memories surfaced of the British Empire Exhibitions where men and women from far-flung corners of the Empire were set to weave or make pots in jaunty pavilions or beside mock waterfalls. And indeed for the whole weekend spectators crowded round Asebe Magaji whenever she worked, an oppressive crush of bodies, filming, photographing and devouring her every action. Starting with a cylinder of clay which she punched and pulled up into shape she was able speedily to form a perfectly symmetrical classical-looking thin walled vessel – ideal for holding and cooling water. This was placed in a carefully built bonfire and fired in about twenty minutes. Her 'equipment' consisted of an old rag and a piece of gourd, nor was she drawn to the lavish array of 'potters' tools' and handbooks on sale at the Arts Centre. Asebe Magaji indicated, with a quiet disregard of her audience, that most of the cultural interchange would be one way – from her to us. Many of the themes touched on in Part I of this book surfaced first during those sunny two days at Aberystwyth.

My sense of the paradoxical nature of craft this century had already been shaped by reading Michael Cardew's remarkable letters written from West Africa to his wife Mariel from 1942 onwards. Cardew was an employee of Empire but was sensitive to its depredations, whether mulling over an unfortunate teaching experiment carried out in Ibadan in 1910 or writing an extended essay on the 'Fatal Impact' of the First World on the Third. In many ways Cardew came to seem the exemplary maker of our time. His life as a potter made him alternately fiercely miserable and supremely happy (Fig. 506). He asked himself hard questions and drove himself to the limits both physically and spiritually. He was always poor by middle-class standards. Over the next few years I met many makers who were running successful businesses which produced well-designed objects made by hand and others who were working financially and socially on the edge. But Cardew and other inter-war makers continued to exert the greatest hold over my imagination. Inter-war women like Phyllis Barron and Ethel

Mairet seemed particularly remarkable, making their way in a society of extreme stasis, operating as modernists on the margins of consumption.

I take 1989 as a rough ending for this book, so I have missed a generation of makers who came to maturity in the 1990s. What I have described is a specifically twentieth-century phenomenon involving a creative ambivalence towards modernity and, on occasion, towards functional modernism. Throughout the century the crafts have operated as a series of experiments, giving as much pleasure to the maker as to the user. After the Second World War this pleasure became more widely available as the crafts, like all the arts, became democratised. This democracy, created by the principle of free higher education in art, crafts and design, may soon be undermined. As I write the crafts still stand for an inordinate level of joy in labour and do not, so far, seem the preserve of a few.

This book has set out to look at the crafts in the context of visual and social and, up to a point, political culture. As such it bears little resemblance to equivalent surveys of twentieth-century fine art. The kind of diachronic route march through a series of schools and groupings which until recently has served as a 'history' of art does not work for the crafts. They seem to demand discursiveness, not least because they are so hard to pin down. In the course of this book I have said a good deal about the crafts' uncertain and fragile identity and their constructedness. This might irritate a maker, immersed in a discipline, mixing up slip or preparing to cut letters in stone or, even, grappling with computer software. No one disputes that individual crafts have strong identities and standards but these often operate within a closed circle of makers and their collectors and patrons. It is the collective identity of the crafts that is inchoate. Two important themes, however, run through this entire book. Firstly, there is the acute active response by individual makers to visual events – for instance to the idea of truth to materials in the 1920s, to School of Paris painting in the 1950s, to the demand for an extreme mannerism in the 1980s and to the honed-down elegant recycling of the 1990s. Then there is the ease with which craft appears to embody ideas and currents of thought – to stand for 'Englishness' in both World Wars, to supply a multiplicity of meanings at the South Bank exhibition of the Festival of Britain, to stand for the counter-culture in the 1970s and for evidence of a corporate soul in the 1980s. What I hope this book demonstrates is that the complexities and ironies which lie behind the continuation of craft practice necessarily belong to any enquiry into the artistic and intellectual history of the twentieth century.

NOTES

ABBREVIATIONS AND CONVENTIONS

The place of publication is London, unless otherwise specified.

All papers relating to the Crafts Advisory Committee (since 1979 the Crafts Council) are being deposited in the Archive of Art and Design of the National Art Library in an accruing archive which at present holds material up until 1997. The Crafts Council itself holds an archive of all material published by the CAC/CC, a complete set of the Committee/Council minutes, a photographic archive relating to its exhibitions and to its magazine *Crafts*, files on individual makers and a computerised *Photostore* of images which includes archival material as well as slides of work by makers on the Crafts Council's Index. As I write, the future of the Crafts Council is uncertain. The author holds tapes of conversations cited in the text. Researchers may also wish to consult the National Electronic and Video Archive of the Crafts (NEVAC) at the University of the West of England, Bristol and the Ceramic Archive at the School of Art, University of Wales, Aberystwyth.

Abbreviations have been kept to the minimum but the following have been used for sources and institutions referred to in the text and notes:

AAD Archive of Art and Design, National Art Library, 23 Blythe Road, London W14 0QF

ARG *Autobiography* Artifex (A. Romney Green), 'Work and Play: The autobiography of a small working master in prose and verse', 3 volumes *c*.1940, typed manuscript in the National Art Library, Victoria and Albert Museum

Cardew, *Autobiography* Michael Cardew, *A Pioneer Potter: An Autobiography*, Collins 1988

CAC Crafts Advisory Committee (1971–9)

Carruthers (1992) Annette Carruthers, *Edward Barnsley and his Workshop: Arts and Crafts in the Twentieth Century*, White Cockade Publishing, Oxon 1992

CC Crafts Council (April 1979–)

CoID Council of Industrial Design (in April 1972 renamed the Design Council)

CPA Craftsmen Potters Association (since 1991 the Craft Potters Association). Its accruing archive is held by the Ceramic Archive, School of Art, University of Wales, Aberystwyth

CSC Crafts Study Centre, Holburne Museum, Bath (A new home is being sought for this important archive and it is likely to move within the next two years)

DHA Dartington Hall Archive, Totnes, Devon

DIA Design and Industries Association

Harrod, *Conference* Tanya Harrod (ed.), *Obscure Objects of Desire: reviewing the crafts in the twentieth century. Conference Papers*, Crafts Council 1997

Haslam (1984) Malcolm Haslam, *William Staite Murray*, Crafts Council/Cleveland County Museum Service 1984

ICA Institute of Contemporary Arts, London

ICC Peter Cox (ed.), *The Report of the International Conference of Craftsmen in Pottery and Textiles at Dartington Hall, Totnes, Devon July 17–27, 1952*, typescript, Dartington Hall 1954 (the National Art Library of the V & A holds a copy).

LCC London County Council

Leach, *Memoirs* Bernard Leach, *Beyond East and West: Memoirs, Portraits & Essays*, Faber & Faber 1978

NAL National Art Library, Victoria & Albert Museum, London

PRO The Public Record Office, London

RIB Rural Industries Bureau (renamed the Council for Small Industries in Rural Areas (CoSIRA) in 1968 and in 1988 renamed the Rural Development Commission.)

RIBA The Royal Institute of British Architects, London

WCG Archive of the Worshipful Company of Goldsmiths, London

Watson (1990) Oliver Watson, *British Studio Pottery: The Victoria and Albert Museum Collection*, Phaidon/Christies/Victoria & Albert Museum 1990

V&A The Victoria & Albert Museum, London

PREFACE

1. For the importance of a period eye see Michael Baxandall, *Painting and Experience in Fifteenth Century Italy: A Primer in the Social History of Pictorial Style*, Oxford University Press 1972.

2. Peter Wollen, *Raiding the Icebox: Reflections on Twentieth-Century Culture*, Verso 1993.

3. Christopher Reed, Introduction and '"A Room of One's Own": The Bloomsbury Group's Creation of a Modernist Domesticity', in Christopher Reed (ed.), *Not At Home: The Suppression of Domesticity in Modern Art and Architecture*, Thames and Hudson 1996.

4. Penny Sparke, *As Long As It's Pink: The Sexual Politics of Taste*, HarperCollins 1995.

5. Pat Kirkham, *Charles and Ray Eames: Designers of the Twentieth Century*, MIT Press, Cambridge MA, 1995.

6. Marshall Berman, *All That is Solid Melts into Air: The Experience of Modernity*, Verso 1983, p.14.

7. For a more sophisticated development of this idea see Jürgen Habermas, 'Modernity – An Incomplete Project', in Hal Foster (ed.), *Postmodern Culture*, Pluto Press 1985, pp.3–15.

CHAPTER ONE

1. Fiona MacCarthy, *William Morris: A Life for Our Time*, Faber & Faber 1994, p.405; Bruges, Stedelijke Musea, *Collectie Frank Brangwyn: Catalogous*, Generale Bank 1987.

2. Bernard Leach, *Beyond East and West: Memoirs, Portraits & Essays*, Faber & Faber 1978, p.66; hereafter Leach, *Memoirs*.

3. Bernard Leach, *A Potter's Book*, Faber & Faber 1940, p.1.

4. Leach, *Memoirs*, pp.117–18. On the furniture see Edmund de Waal, 'Beyond the Potter's Wheel', *Crafts* 129, July/August 1994, pp.42–5.

5. *The Journals of Thomas James Cobden-Sanderson 1879–1922*, Richard Cobden-Sanderson 1926, vol. 1, pp.211–12.

6. *The Art of the People* (1879) in *The Collected Works of William Morris* with an introduction by his daughter May Morris, 1910–15, repr. Russell & Russell, New York 1966, (hereafter Morris, *Collected Works*) vol. xxii, p.50.

7. Peter Floud, 'The Inconsistencies of William Morris', *The Listener*, 14 October 1954, p.616.

8. On Morris the businessman see Charles Harvey and Jon Press, *William Morris: Design and Enterprise in Victorian Britain*, Manchester University Press 1991.

9. *Art and Its Producers* (1888) in Morris, *Collected Works*, vol. xxii, p.352.

10. Peter Floud, 'The Crafts Then and Now', *The Studio*, April 1943 reprinted in John Houston (ed.), *Craft Classics since the 1940s: An Anthology of Belief and Comment*, Crafts Council 1988, pp.49–53.

11. See David Pye, *The Nature and Art of Workmanship*, Cambridge University Press 1968, Chapter 10.

12. See David Pye's illuminating essay 'The Art of Workmanship 1', *Crafts History One*, Combined Arts, Bath 1988, pp.143–52.

13. Luther Hooper, *Hand-Loom Weaving*, John Hogg 1910, p.323.

14. A.R. Orage, 'Politics for Craftsmen', *Contemporary Review*, 91, June 1907, p.787. For Orage see Philip Mairet, *A.R. Orage. A Memoir*, University Books Inc., New York 1966, and Tom Steele, *Alfred Orage and the Leeds Arts Club 1893–1923*, Scolar Press 1990.

15. On Guild Socialism see Stanley Pierson, *British Socialists: The Journey from Fantasy to Politics*, Harvard University Press, Cambridge MA, 1979, pp.201–26. Trades Unions in particular continued to be criticised in Arts and Crafts circles. See Harold Speed, 'The Commercial Spirit and Modern Unrest', *Fortnightly Review*, May 1918 – 'It should be a crime to produce a shoddy article. The Trades Unions, if they had the right spirit, would refuse to work for any firm that produced them.' and John Gloag, *Artifex or the Future of Craftsmanship*, Kegan Paul 1926, p.25 – 'a largely class-selfish, protective organisation that attracts to its administration the pettifogging, lawyer-like type of being instead of the real craftsmen, the people who know their trade, its conditions, materials and methods'.

16. Eric Gill, 'The Failure of the Arts and Crafts Movement', *The Socialist Review*, December 1909, p.291.

17. Ibid., p.299.

18. Ibid., p.299.

19. Ibid., p.293.

20. Graham Wallas, *The Great Society: A Psychological Analysis*, Macmillan 1914, p.347. Wallas's daunting calculation decided Leonard Elmhirst against a role for pure handicrafts in his rural reconstruction projects at Dartington Hall. See Michael Young, *The Elmhirsts of Dartington: The Creation of an Utopian Community*, Routledge & Kegan Paul 1982, p.207. This figure was also quoted by the Design and Industries Association but upped to 500 hours. See Joseph Thorp (ed.), *Design in Modern Printing. The Year Book of the Design and Industries Association*, 1927–8, p.118.

21. Thorstein Veblen, *The Theory of the Leisure Class*, Macmillan, New York 1899, p.163.

22. See S.K. Tillyard, *The Impact of Modernism 1900–1920: The Visual Arts in Edwardian England*, Routledge 1988, pp.127–31, on the ways in which Fry introduced the public to Post-Impressionism employing the critical language of the Arts and Crafts Movement.

23. Omega Workshops Ltd. Artist Decorators, 33 Fitzroy

Square (c.1915 photocopy in the National Art Library).

24. See Nikolaus Pevsner, 'Omega', *Architectural Review*, August 1941, pp.45–8.

25. See Basil Gray, 'The Development of Taste in Chinese Art in the West 1872 to 1972', *Transactions of the Oriental Ceramic Society*, vol. 39, 1972, pp.19–37; (Roger Fry), 'Wedgwood China', *Athenaeum*, 15 July 1905, pp.88–9; Roger Fry, 'The Art of Pottery in England', *Burlington Magazine*, March 1914, pp.330–5; Roger Fry, 'The Artist's Vision', *Athenaeum*, 1919 reprinted in *Vision and Design*, Chatto & Windus 1920.

26. See Alan Crawford, *C.R. Ashbee: Architect, Designer and Romantic Socialist*, Yale University Press 1985, pp.340–1, 366–7.

27. Linda Parry, *Textiles of the Arts and Crafts Movement*, Thames and Hudson 1988, p.89.

28. See General Committee Meetings 19 May, 11 July, 29 October 1913, Arts and Crafts Exhibition Society papers AAD 1/51–1980, Archive of Art and Design, National Art Library (hereafter AAD).

29. See Paul Greenhalgh, 'Morris after Morris', in Linda Parry (ed.), *William Morris*, Philip Wilson/V&A 1996, p.364.

30. *Manchester Guardian*, 19 August 1916.

31. Henry Wilson, Inaugural Address: 'Education and the Handicrafts', New Ideals in Education Conference; Henry Wilson, 'The Convalescent as Artist-Craftsman', *The Sociological Review*, Summer 1918, Henry Wilson Archive, Royal College of Art. On the New Ideals in Education Group see W.A.C. Stewart, *Progressives and Radicals in English Education 1750–1970*, Macmillan 1972, p.353. The idea that war was a preparation for an Arts and Crafts revival was echoed by Thomas Okey, basket maker, who in his contribution to *Handicrafts and Reconstruction: Notes by members of the Arts and Crafts Exhibition Society*, John Hogg 1919, pp.35–6, observed that 'A hatred of the factory, of the office, of suburbanised industries has been engendered by the open-air training of our soldiers.'

32. H.W., 'Architects, Sculptors and Monuments', *Manchester Guardian*, 19 August 1916. Henry Wilson Archive, Royal College of Art.

33. *The Builder*, 20 October 1916, p.245.

34. See *The Star*, 6 October 1916, p.2; *Morning Post*, 7 October 1916; *Daily Chronicle*, 10 October 1916; *The Scotsman*, 10 October 1916; *Daily News*, 7 October 1916; *Graphic*, 21 October 1916.

35. *Daily News*, 10 October 1916.

36. *The Builder*, 20 October 1916, p.246.

37. Virginia Woolf, *Roger Fry: A Biography*, Hogarth Press 1940, p.205.

38. C.R. Ashbee, 'English Arts and Crafts at the Royal Academy', *The American Magazine of Art*, vol. 8, no. 4, February 1917, pp.137–45.

39. *The Builder*, 20 October 1916.

40. C.R. Ashbee to Henry Wilson, 16 August 1915, Henry Wilson Archive, Royal College of Art.

41. Ernest Gimson to Henry Wilson, 20 October 1915, Henry Wilson Archive, Royal College of Art.

42. Ernest Gimson to Henry Wilson, 15 June 1917, Henry Wilson Archive, Royal College of Art.

43. See typescript headed 'Association of Architecture, Building and Handicraft', 9 July 1917, Henry Wilson Archive, Royal College of Art.

44. Selwyn Image to Henry Wilson, 19 September 1915, Henry Wilson Archive, Royal College of Art.

45. C.H. Whall to Henry Wilson, 8 August 1915, Henry Wilson Archive, Royal College of Art.

46. Minutes of General Committee, Arts and Crafts Exhibition Society, 26 November 1916, AAD 1/51–1980.

47. A.J.P. Taylor, *English History 1914–1945*, Oxford University Press 1945, p.120.

48. Henry Wilson, 'The Convalescent as Artist-Craftsman', *The Sociological Review*, Summer 1918.

49. Reprinted in *Handicrafts and Reconstruction: Notes by members of the Arts & Crafts Exhibition Society*, John Hogg 1919, pp.134–9.

50. See General Committee Minutes, 18 December 1918,

Arts and Crafts Exhibition Society, AAD 1/53–1980.

51. Roger Fry Papers, 11/16, Modern Archive Centre, King's College, Cambridge.

52. 'On the Encouragement of Small Industrial Centres to Assist in the Reconstruction of Rural Life and in the Employment of Discharged Soldiers. With a preliminary note upon the relation of Hand-work to such reconstruction' presented to the Rt. Hon. Christopher Addison, M.D., by the Design and Industries Association in February 1918.

53. Parliamentary Papers 1922, Appendix xiv.

54. W.R. Lethaby, 'Education for Industry', in *Handicrafts and Reconstruction: Notes by members of the Arts and Crafts Exhibition Society*, John Hogg 1919, p.87.

55. His plans were set out in the Minutes of the General Committee, 18 December 1918, Arts and Crafts Exhibition Society, AAD 1/53–1980

CHAPTER TWO

1. 'A Personal Letter from Bernard Leach', typed ms, 1934–5, Leach Papers 977, Crafts Study Centre, Holburne Museum, Bath, hereafter CSC.

2. Edward Johnston, *Writing & Illuminating & Lettering*, John Hogg 1906, p.240.

3. For a good account of the early development of studio pottery, see Oliver Watson, *British Studio Pottery: the Victoria and Albert Museum Collection*, Phaidon/Christies/Victoria & Albert Museum 1990, pp.16–24. Hereafter Watson (1990).

4. See Malcolm Haslam, *English Art Pottery 1865–1915*, Antique Collectors' Club, Woodbridge 1975; Geoffrey Godden, *British Pottery: An Illustrated Guide*, Barrie and Jenkins 1974; Peter C.D. Brears, *The English Country Pottery. Its History and Techniques*, David and Charles, Newton Abbot 1971. See Rachel Gotlieb, 'The Critical Language and Aesthetic Criteria of Art-Pottery Manufacturers and Studio-Potters 1914–1934', RCA/V&A MA thesis 1987, for confusions of identity between art and studio pottery.

5. Michael Cardew, *A Pioneer Potter: An Autobiography*, Collins 1988, p.27; hereafter Cardew, *Autobiography*.

6. Roger Fry, 'The Art of Pottery in England', *Burlington Magazine*, March 1914, pp.330–5.

7. Clive Bell, *Art*, Chatto and Windus 1914, p.8.

8. Ibid., p.58.

9. Roger Fry, 'The Art of Pottery in England', *Burlington Magazine*, March 1914, p.335.

10. Wells attracted some interesting contemporary comment. See Frederick Lessore, 'The Art of Reginald F. Wells', *Artwork*, no. 8, vol. 2, Dec–Feb 1926–7, p.234; Ernest Marsh, 'R.F. Wells Sculptor Potter', *Apollo*, vol. 1, 1925, pp.283–9; Bernard Rackham, 'The Pottery of Reginald F. Wells', *The Studio*, vol. xc, December 1925, pp.359–63.

11. Richard Dennis, *Charles Vyse 1882–1971*, Richard Dennis/Fine Art Society 1974. Celadon and *tenmoku* are both stoneware iron glazes. Celadon is a greyish-green or blue and *tenmoku* a lustrous black/brown breaking to rust on rims and edges. Chün is an ash glaze which fires to an opalescent blue to purple. Tz'ŭ-chou describes stoneware produced in north China from the seventh to the fourteenth century, characterised by bold decoration which is incised, sgraffitoed, brushed or moulded or employs a combination of these techniques. Bernard Leach, *A Potter's Book*, Faber & Faber 1940, contains good vivid descriptions of most of the glazes and decorative techniques that I mention.

12. Graham M. McLaren, '"A Complete Potteress" – The Life and Work of Dora Lunn', *Journal of the Decorative Arts Society*, 13 (1989), pp.33–8.

13. Margot Coatts, *The Oxshott Pottery: Denise and Henry Wren*, Crafts Study Centre, Holburne Museum, Bath 1984.

14. Gordon Forsyth, 'Pottery', in *Reports on the Present Position and Tendencies of the Industrial Arts as Indicated at the Exhibition of Modern Decorative and Industrial Arts, Paris 1925*, Department of Overseas Trade 1927, p.134.

15. This section is indebted to Malcolm Haslam's excellent study *William Staite Murray*, Crafts Council/Cleveland County Museum Service 1984; hereafter Haslam (1984).

There is also much of value in Sarah Riddick, *Pioneer Studio Pottery: The Milner White Collection*, Lund Humphries/York City Art Gallery 1990.

16. Haslam (1984), p.10.

17. On fine art and ceramics see Tamara Preaud and Serge Gauthier, *Ceramics of the Twentieth Century*, Phaidon/Christies, Oxford 1982, p.82

18. Anna Gruetzner Robins, *Modern Art in Britain 1910–1914*, Barbican Art Gallery/Merrell Holberton 1997, p.130

19. Bernard Rackham, Herbert Read, *English Pottery. Its development from early times to the end of the eighteenth century*, Ernest Benn Ltd., 1924, p.4.

20. Haslam (1984), p.71,

21. H.S. Ede, 'Ben Nicholson. Winifred Nicholson and William Staite Murray', *Artwork*, no. 16, vol. 4, Winter 1928, no. 16, pp.262–9.

22. *Catalogue of Pottery, Paintings and Furniture by Staite Murray*, Alex. Reid & Lefevre Ltd., November 1930.

23. See especially Ede, *op.cit.*, p.267. Haslam (1984) quotes the important reviews of Murray's work. Murray and studio pottery in general were discussed in *The Times* by Charles Marriott from 1924–40, in *The Studio*, in *Apollo* (founded 1925), in *Artwork* (1924–31) and in the short-lived *Arts and Crafts* (1925–9) as well as in less specialist magazines like *The New English Weekly* (founded 1933) and *G.K.'s Weekly* (founded 1925). There was also interesting coverage in the *Pottery Gazette and Glass Trade Review*.

24. Herbert Read, 'Art and Decoration', *The Listener*, 7 May 1930, p.805.

25. Barry Hepton (ed.), *Sam Haile Potter and Painter 1909–1948*, Bellew Publishing/Cleveland County Council 1993.

26. Crafts Study Centre, Holburne Museum, Bath, *A Fine Line. Henry Hammond 1914–89 Potter and Educationalist*, 1992.

27. Paul Rice, Christopher Gowing, *British Studio Ceramics in the 20th Century*, Barrie & Jenkins 1989, pp.78–83.

28. For a more detailed discussion of the 1930s 'problem' see below pp.118–20.

29. Cardew, *Autobiography*, p.98.

30. Peter Fuller, 'The Proper Work of the Potter', in Peter Dormer (ed.), *Fifty Five Pots and Three Opinions*, The Orchard Gallery, Londonderry 1983, p.21

31. On Leach see Watson (1990); Leach, *Memoirs* (1990); Bernard Leach, *Hamada Potter*, Kodansha International, Tokyo 1975; Edmund de Waal, *Bernard Leach*, Tate Gallery 1998.

32. For an overview see Anna Gruetzner Robins, *Modern Art in Britain 1910–1914*, Barbican Art Gallery/Merrell Holberton 1997. For Murray's involvement in the London avant-garde see Haslam (1984).

33. Bernard Leach, 'The Meeeting of East and West in Pottery', *The Far East*, 12 June 1915, p.314.

34. *Pottery Gazette and Glass Trade Review*, 1 December 1920 – 'The progress of this Cornish innovation will be watched with more than ordinary interest.'

35. Leach, *Memoirs*, p.73. Also see Sarah Riddick, *Pioneer Studio Pottery: The Milner White Collection*, Lund Humphries/York City Art Gallery 1990, p.63.

36. Leach, *Memoirs*, p.119.

37. A phrase used by Katharine Pleydell-Bouverie in a letter of 5 October 1927, Leach Papers 2497, CSC.

38. Oliver Watson, *Bernard Leach – Potter and Artist*, Artis Inc., Japan 1997, p.19. See also Bernard Leach, *Hamada Potter*, Kodansha, Japan 1990, pp.162–5, 170–1.

39. For an acerbic account of the Leach pottery see May Davis, *May*, privately printed, Nelson, New Zealand 1990.

40. For an overview see Crafts Council/Crafts Study Centre, Holburne Museum, Bath, *Katharine Pleydell-Bouverie: A Potter's Life 1895–1985*, 1986. For contemporary criticism in which sculptural, architectural and even musical connections are made see W.A. Thorpe, 'English Stoneware Pottery by Miss K. Pleydell-Bouverie and Miss D.K.N. Braden', *Artwork*, no. 24, vol. 6, Winter 1930, pp.257–65. Paul Rice, Christopher Gowing, *British Studio Ceramics in the 20th Century*, Barrie & Jenkins 1986, pp.56–64 gives a lively, affectionate account of Braden and Pleydell-Bouverie's work.

41. The best introduction is Cardew, *Autobiography*.

42. Staite Murray quoted in Haslam (1984) p.70 and Leach, *Memoirs*, p.146.

43. The key book is Sarah Riddick, *Pioneer Studio Pottery: The Milner White Collection*, Lund Humphries/York City Art Gallery 1990.

44. Eileen M. Hampson, 'Henry Bergen: Friend of Studio Potters', *Journal of the Northern Ceramics Society*, vol. 8, 1991, pp.74–89.

45. Watson (1990), p.38.

46. Maureen Batkin, 'Alfred and Louise Powell', in Mary Greensted, *The Arts and Crafts in the Cotswolds*, Alan Sutton 1993, p.100. For the social context see Jacqueline Sarsby, 'Alfred Powell: Idealism and Realism in the Cotswolds', *Journal of Design History*, vol. 10, no. 4, 1997, pp.375–97.

47. Alfred H. Powell, 'Arts & Crafts: Pottery', *The Highway*, vol. ix, no. 101, February 1917, pp.79–81.

48. Watson (1990), p.153.

49. Dora Billington, *The Art of the Potter*, Oxford University Press 1937, p.110.

50. This point is well made in Moira Vincentelli, 'Potters of the 1920s: Contemporary Criticism', in G. Elinor, S. Richardson, S. Scott, A. Thomas, K. Walker (eds), *Women and Craft*, Virago 1987.

51. Moira Vincentelli, Anna Hale, *Catalogue of Early Studio Pottery in the Collections of University College of Wales, Aberystwyth* 1986.

52. Anna Gruetzner Robins, *Modern Art in Britain 1910–1914*, Barbican Art Gallery/Merrell Holberton 1997, pp.116–37.

53. Frank Rutter, 'Modern English Pottery and Porcelain', *Apollo*, vol. 11, December 1925, p.133.

54. Charles Marriott, *British Handicrafts*, British Council 1943, pp.33–4; W.B. Honey, *The Art of the Potter*, Faber & Faber 1946, p.15.

55. Tanya Harrod, 'Marianne Straub: Sources of Inspiration', *Crafts*, 97, March/April 1989, p.32.

56. Helen E. FitzRandolph and M. Doriel Hay, *The Rural Industries of England and Wales: The Decorative Crafts and Rural Potteries*, vol. iii, Clarendon Press, Oxford 1927, pp.39–40.

57. Ibid., p.15.

58. Ibid., p.40.

59. Ibid., p.71. and Geoff Spenceley, 'The Lace Associations: philanthropic movements to preserve the production of hand-made lace in late Victorian and Edwardian England', *Victorian Studies*, June 1973, pp.433–52.

60. The literature on Haslemere is extensive. See *Some Aims of the New Crusade*, Fellowship of the New Crusade, Bayswater and Haslemere 1901. This and other ephemera relating to Blount and his associates may be consulted at the Haslemere Educational Museum, Haslemere, Surrey. Also Maude E. King, 'The Haslemere Hand-Weaving Industry', *Women's Employment*, 4 April 1902, pp.2–4; Hermann Muthesius, *Der Kunstgewerbliche Dilettanismus in England*, Berlin 1900; R.E.D. Sketchley, 'Haslemere Arts and Crafts', *Art Journal*, 1906, pp.337–42; E.W. Swanton, *A Country Museum: The Rise and Progress of Sir John Hutchinson's Educational Museum at Haslemere*, Haslemere 1947; Greville Macdonald, *Reminiscences of a Specialist*, George Allen and Unwin 1932, pp.372–415; Linda Parry, *Textiles of the Arts and Crafts Movement*, Thames and Hudson 1988, p.127; T.D.L. Thomas, 'Rustic Renaissance: Arts and Crafts in Haslemere', *Country Life*, 15 April 1982, pp.1082–3; Malcolm Haslam, *Arts and Crafts Carpets*, David Black 1991, pp.174–9.

61. The Peasant Art Society, to which was added a Peasant Arts Fellowship in 1911, (both amalgamated into the Peasant Arts Guild by 1924) had distinguished members like G.K. Chesterton and Cecil Sharp (one-time vice-president of the Guild. They contributed to Maude King's magazine *The Vineyard* whose articles concentrated on a happy peasantry watched over by an enlightened ruling class.

62. Lynne Walker, Colston Sanger, 'Inval Weavers', *Craft Quarterly* (Newcastle), 1, Summer 1981, pp.2–6.

63. Godfrey Blount, *The Blood of the Poor: an introduction to Christian Social Economics*, A.C. Fifield 1911, p.53.

64. For a good overview see Margot Coatts, *A Weaver's Life: Ethel Mairet 1872–1952*, Crafts Council/ Crafts Study Centre, Holburne Museum 1983. There is also a fine unpublished life written from the inside by her pupil Margery Kendon in the possession of Kendon's niece Susan Rogers.

65. Ethel Mairet, 'Hand-Weaving and the Textile Trade', *News-sheet of the Guild of Weavers, Spinners and Dyers*, no. 7, Spring 1934.

66. Taped conversation with Hilary Bourne, 10 December 1991.

67. Thomas Hennell, *British Craftsmen*, Britain in Pictures, Collins 1946, p.40. Kendon's niece Susan Rogers has a small archive of her fascinating unpublished writing, including letters written from Wales in 1934 on a trip investigating country wool mills, a series of letters of 1936 concerning textiles in County Mayo in Ireland and a Highland diary kept in 1942. See also Margery Kendon, *The Ladies College, Goudhurst*, privately printed, The Old House, Bilsington, Ashford, Kent 1963 – a history of her school. Her cousin Frank Kendon was assistant Secretary to the Syndics of Cambridge University Press and was involved in the publication of several classic accounts of craft practice including Walter Rose, *The Village Carpenter*, Cambridge University Press 1937.

68. Alan Crawford to the author, 19 January 1994.

69. Crafts Study Centre, Holburne Museum, *Weaving by Elizabeth Peacock*, 1979. I have also benefited from a conversation with Ella McLeod, 9 June 1994.

70. Radcliffe Hall, *The Unlit Lamp*, Cassell 1924.

71. Alice Hindson, *Designer's Drawloom: An Introduction to Drawloom Weaving and Repeat Pattern Planning*, Faber & Faber 1958, p.176. See also the Hooper mss, 86 NN 36 in the National Art Library, Victoria and Albert Museum and Luther Hooper, *The New Draw-Loom. Its Construction and Operation described for the use of Handicraft Pattern Weavers*, Sir Isaac Pitman and Sons Ltd 1932.

72. For the London School of Weavers and Kensington Weavers see Hilda Breed, 'Dorothy Wilkinson', *The Journal: Quarterly Journal of the Guild of Weavers, Spinners and Dyers*, no. 63, September 1967, pp.989–92.

73. Central Saint Martins College of Art and Design, *Bold Impressions: Block printing 1910–1950*, 1995.

74. Phyllis Barron, 'My Life as Block Printer', transcript of a talk given at Dartington Hall on 22 February 1964 on a Ministry of Education Course organised by Robin Tanner, CSC.

75. See Judith Collins, *The Omega Workshops*, Secker and Warburg 1984, p.82.

76. Charles Harrison, *English Art and Modernism 1900–1939*, Allen Lane/Indiana 1981, p.115. Adeney also showed with the Cubist/Vorticist section of the London Group earlier in March 1915 where his work was admired by Wyndham Lewis – 'His gentle logic plays round the heaviness of Cézanne like summer lightning'. Walter Michel, C.J. Fox (eds), *Wyndham Lewis on Art: Collected Writings 1913–1956*, Thames and Hudson 1969, p.86.

77. On Thérèse Lessore see Arts Council of Great Britain, 1981, *Late Sickert. Paintings 1927 to 1942*, pp.97–8.

78. See Philip Mairet, *Autobiographical and Other Papers*, C.H. Sisson (ed.), Carcanet Press, Manchester 1981, pp.17–18, 42, 45; Cheltenham Art Gallery and Museum, *William and Eve Simmonds*, 1980, pp.23–5. On Larcher's missing years see Mary Lago, *Christiana Herringham and the Edwardian Art Scene*, University of Missouri Press, Columbia, 1996, p.288, note 26.

79. For Detmar Blow's truncated relations with 'Bendor', 2nd Duke of Westminster see Jessica Douglas Home, *Violet: the Life and Loves of Violet Gordon Woodhouse*, Harvill Press 1996, p.236; Leslie Field, *Bendor: the Golden Duke of Westminster*, Weidenfeld and Nicolson 1983: George Ridley, *Bend'Or Duke of Westminster: a personal memoir*, Robin Clark 1985. While a member of the Grosvenor Estate Board of Management from 1916–33, Blow gave Barron big commissions, including the continuous provision of curtains and loose covers for 'Flying Cloud' (1922,1923,1924,1927,1928,1930); furnishing for Bourdon House (1923,1929, 1931); for Mimizan House (1925) for the Duke's lover Coco Chanel (1925); for the yacht 'Cutty Sark' (1927, 1928, 1931) for 66 Brook Street (1928,1931); for coming-out balls (1928,1932); for 11 North Audley Street (1929); for St Saens Château (1929); for Eaton Hall (1931). For an early review see Roger Fry, 'Hand Printed Stuff by Phyllis Barron and Dorothy Larcher', *Vogue*, vol. 67, no. 8, late April 1926, p.68.

80. See Camden Arts Centre, *Enid Marx*, 1979; Alan Powers, 'Enid Marx: Sources of Inspiration', *Crafts*, 103, March/April 1990, pp.34–7; Alan Powers, *Modern Block Printed Textiles*, Walker Books 1992, pp.38–43.

81. Paul Nash, 'Modern English Textiles', *Artwork*, vol. 2, no. 6, January–March 1926, p.84. See also letters from Tom Heron to Paul Nash, Nash Papers, Tate Gallery Archive.

82. Alex Reid and Lefevre Ltd, *Barbara Hepworth and Ben Nicholson*, 1933. See York City Art Gallery, *The Nicholsons. The Story of Four People and their Designs*, 1988, and Jeremy Lewison, *Ben Nicholson: Between Art and Craft* in Tanya Harrod (ed.), *Obscure Objects of Desire: the Conference Papers*, Crafts Council 1997; hereafter Harrod, *Conference*.

83. Hazel Berriman, *Crysède: The Unique Textile Designs of Alec Walker*, Royal Institution of Cornwall, Truro 1993.

84. Patrick Heron, 'Tom Heron: a biographical note', *Journal of the Decorative Arts Society*, no. 4, 1980, pp.34–9.

85. Paul Nash, 'Modern English Textiles', *The Listener*, 27 April 1932, p.607; Allan Walton's papers are in the National Archive of Art and Design, AAD 6–1980; fabric for Walton by Grant and Bell is illustrated in Derek Patmore, *Colour Schemes for the Modern House*, The Studio Ltd 1933.

86. Paul Nash, 'Modern English Textiles I', *The Listener*, 27 April 1932.

87. Paul Nash, 'Modern English Textiles', *Artwork*, vol. 2, no. 6 Jan–March 1926, p.84.

88. Hilary Diaper (ed.), *Theo Moorman 1907–1990: Her Life and Work as an Artist Weaver*, The University Gallery, Leeds 1992.

89. Christine Boydell, 'The Decorative Imperative: Marion Dorn's Textiles and Modernism', *Journal of the Decorative Arts Society*, no. 19, 1995, pp.31–40.

90. Christine Boydell, 'Textiles in the Modern House', in *The Modern House Revisited*, Twentieth-Century Architecture 2, The Twentieth-Century Society 1996.

91. Linda Parry (ed.), *William Morris*, Philip Wilson/V&A 1996, pp.291, 295.

92. Scottish Arts Council, *Master Weavers: Tapestry from the Dovecot Studios 1912–1980*, Canongate, Edinburgh 1980.

93. See Hugh Trevor Roper, 'The Invention of Tradition: The Highland Tradition of Scotland', in Eric Hobsbawm, Terence Ranger (eds.), *The Invention of Tradition*, Cambridge University Press 1983, pp.15–41 and Judith Ennew, 'Harris Tweed: Construction, retention and representation of a cottage industry', in Esther N. Goody (ed.), *From Craft to Industry: the ethnography of proto-industrial clothing production*, Cambridge University Press 1982, pp.166–99.

94. Jude Burkhauser (ed.), *Glasgow Girls: Women in Art and Design 1880–1920*, Canongate, Edinburgh 1990.

95. Quoted in Constance Howard, *Twentieth-Century Embroidery in Great Britain to 1939*, B.T. Batsford Ltd 1981, p.92.

96. Mary Hogarth, 'Modern Embroidery', *The Studio*, 1933.

97. Rebecca Crompton, *Modern Design in Embroidery*, B.T. Batsford 1936, p.4.

98. Joan Edwards, *Textile Graphics by Lilian Dring*, Bayford Books, Dorking, 1988, p.10.

99. John Gloag, *English Furniture*, A.& C. Black, 1934, p.152, and John C. Rogers, *Furniture and Furnishing*, Oxford University Press, 1932, p.68.

100. See Alan Peters, 'The Gentle Touch', *Crafts*, 120, January/February 1993, pp.42–3; Judith E. Hughes, 'Reminiscences of a Cabinet Maker', in Jill Seddon, Suzette Worden (eds), *Women Designing: redefining design in Britain between the Wars*, University of Brighton, 1994, pp.16–19.

101. Noted by William Rothenstein as a 'disquieting sign of the times', in *Men and Memories 1900–1922*, Faber & Faber 1932, vol. ii, p.85. For Lethaby the taste for antiques inflicted 'great injury on an essentially noble craft'. See 'Art and Labour', in *Imprint*, vol. 1, no. 1, 1913, p.3. In the 1930s J.B. Priestley was puzzled that 'we take such

pains to copy exactly what our forefathers made'. See J.B. Priestley, *English Journey*, William Heinemann Ltd/Victor Gollancz Ltd, p.388. Noel Carrington, speaking for the DIA, dismissed 'antique collecting' as 'mere infantile regression', in *Design in the Home*, Country Life Ltd., (1933) revised edition 1938, p.133. The problem was exemplified by Edwin Lutyens's design for Queen Mary's Doll's House, completed in 1924 and intended as 'a little model of a house of the twentieth century'. It was furnished with accurate copies of seventeenth- and eighteenth-century pieces. See A.C. Benson, 'Introduction', in A.C. Benson, Sir Lawrence Weaver (eds.), *The Book of the Queen's Doll's House*, Methuen 1924, p.10. For a general discussion see Stefan Muthesius, 'Why do we buy Old Furniture? Aspects of the authentic Antique in Britain 1870–1910', *Art History*, vol.11, no.2, June 1988, pp.231–54.

102. William Lethaby, Alfred Powell and F.L.M. Griggs, *Ernest Gimson His Life and Work*, Shakespeare Head Press, Stratford-upon-Avon, 1924, p.13.

103. Annette Carruthers, *Edward Barnsley and his Workshop: Arts and Crafts in the Twentieth Century*, White Cockade Publishing, Oxon, 1992, p.22; hereafter Carruthers (1992). The crucial research for the 'Cotswold School' has been carried out by Mary Greensted (formerly Comino) and Annette Carruthers. See citations below.

104. Norman Jewson in *By chance I did Rove* (1951), Gryffon Publications, Barnsley, nr Cirencester, 1986, p.48, contrasts the freeholders of Oakridge with the Sapperton tenants. H.J. Massingham, *Shepherd's Country: A Record of the Crafts and People of the Hills*, Chapman & Ward 1938, p.278 marks out the South Cotswolds as having 'fallen into the hands of a squirearchy more powerful and readier to enforce its rights than in the north'.

105. Mary Comino, *Gimson and the Barnsleys 'Wonderful furniture of a commonplace kind'*, Evans Brothers Ltd, 1980, p.194: Carruthers (1992), pp.52–3; Annette Carruthers, Mary Greensted, *Good Citizen's Furniture: The Arts and Crafts Collection at Cheltenham*, Lund Humphries/Cheltenham Art Gallery and Museum, 1994, p.110.

106. Carruthers (1992) is the key source.

107. What the furniture maker Robin Nance called 'the close-knit Bedalian mantel' enveloped Barnsley, the furniture maker Eric Sharpe, most of the Powell family including Roger Powell the bookbinder and various Gimson nephews. See Nance to Eric Sharpe 20 September 1958, Oliver Morel Archive, Abbot Hall Art Gallery, Kendal. For a critical view of this home-spun community see Helen Thomas, *World without End*, William Heinemann 1931.

108. Carruthers (1992) p.97.

109. Carruthers and Greensted, *op. cit.*, p.130.

110. The key source for A. Romney Green's thinking is his autobiography written under the name Artifex, 'Work and Play: The Autobiography of a small working master in prose and verse', 3 vols c.1940 in the National Art Library together with a collection of published articles, mss and photographs; hereafter ARG *Autobiography*. The Oliver Morel Archive at Abbot Hall Art Gallery, Kendal also contains useful material.

111. Green, Lloyd and Adams, *William Curtis Green 1875–1960*, catalogue of an exhibition at the RIBA Heinz Gallery, 1978. Also see Clive Aslet, 'Craftsmanship in Classicism', *Country Life*, 26 January 1978, p.229. Romney Green does not name his schoolmasters but on the manuscript of his autobiography another hand has added 'Lake and Thomson of Charterhouse'.

112. For the flavour of Romney Green's thinking during the Second World War see A. Romney Green, 'An Election Address', *The New English Weekly*, 11 April 1940, p.365.

113. A. Romney Green, *Instead of a Catalogue*, New Handworkers' Gallery, 1928, p.19.

114. A. Romney Green, 'Principles and Evolution of Furniture Making I–V', *Burlington Magazine*, vol.xxi, 1912, pp.35–47, 102–9, 161–4, 224–8, 325–8.

115. A. Romney Green, *Woodwork in Principle and Practice*, vol. 1, Douglas Pepler, Ditchling, Sussex, 1918, p.xiii.

116. See ARG *Autobiography*, chapter IV, 'Learning and Teaching', p.42.

117. Stanley Davies to Eric Sharpe, 4 March 1929, yellow folder, letters to Eric Sharpe from other craftsmen, Oliver Morel Archive, Abbot Hall Art Gallery, Kendal.

118. Davies's publications privately printed for clients include *A Woodworker Speaks* (adapted from a 1933 BBC radio broadcast); *This Woodwork*, n.d. but available in the 1930s; *The Common Art of Woodwork*, 1936 (from *Practical Education and School Crafts*); *Fine Craftsmanship*, 1954.

119. Robin Nance to Eric Sharpe, 1 June 1930, Yellow folder: letters to Eric Sharpe from other craftsmen, Oliver Morel Archive, Abbot Hall Art Gallery, Kendal.

120. Robin Nance, 'My World as a Woodworker', *Cornish Review*, 8, Summer, 1951.

121. Wendy Hinchmough, *C.F.A. Voysey*, Phaidon 1995, sensitively documents the relationship. On the Simpsons in general see Eleanor Davidson, *The Simpsons of Kendal: Craftsmen in Wood 1885–1952*, Visual Arts Centre, University of Lancaster 1978. In addition, Simpson papers have been deposited by Miss Jean Simpson in the Cumbria Record Office, Kendal.

122. 6th Annual Report of the Red Rose Guild, January 1927, Red Rose Guild Archive, CSC.

123. Bernard Leach to Philip Mairet, 11 April 1928, in New Handworkers' Gallery file, CSC.

124. Edmund de Waal, 'Beyond the Potter's Wheel', *Crafts*, 129, July/August 1994, pp.42–5.

125. Gordon Russell, *Designer's Trade: the Autobiography of Gordon Russell*, Allen & Unwin 1968, pp.100, 117, and Percy A. Wells, 'Mr Gordon Russell: I', *Architects' Journal*, 20 January 1926, p.150.

126. Nikolaus Pevsner, 'Patient Progress Two: Gordon Russell', in *Studies in Art, Architecture and Design*, vol. ii, Thames and Hudson, 1982, p.216.

127. Wells, *op.cit.*, p.151, was struck by the 'guild' atmosphere at Russell & Sons.

128. For what he admired see S. Gordon Russell, 'Thoughts on Furniture Design', *Artwork*, vol.1, October 1924, pp.84–8.

129. Pevsner, *op.cit.*, p.217. Mary Greensted points out that they were also very like Gimson's simpler pieces.

130. John Gloag, 'Mr Gordon Russell and Cotswold Craftsmanship', *Architects' Journal*, 15 August 1928, p.223.

131. Pevsner, *op.cit.*, p.218

132. Red Rose Guild Committee Meeting, 29 October 1929, Red Rose Guild Archive, CSC.

133. For Roger Powell and Edward Barnsley's reactions see Carruthers (1992), pp.87, 147.

134. Jeremy Myerson, *Gordon Russell: Designer of Furniture*, Design Council, 1992, p.61.

135. Jack Pritchard, *View from a Long Chair*, Routledge and Kegan Paul, 1984, p.111.

136. Christopher Wilk, *Marcel Breuer: Furniture and Interiors*, The Architectural Press, London, 1981, p.135, and Myerson, *op.cit.*, p.63.

137. Henry Wilson, *Silverwork and Jewellery*, John Hogg 1902, pp.414–24, 131, 127.

138. Report by the Council for Art and Industry. *Design in the Jewellery, Silversmithing and Allied Trades*, HMSO 1937, p.13, 43.

139. For the Vittoria Street School of Jewellery and Silversmithing see Birmingham Museum and Art Gallery, *Finely Taught, Finely Wrought: The Birmingham School of Jewellery and Silversmithing 1890–1990*, 1990. From 1907 the Central School of Arts and Crafts ran a Junior Day Technical School for boys aged 13–14 in collaboration with the trade. Sheffield Art School ran a similar system for which see Sheffield City Museums, *Joyce R. Himsworth, Sheffield Silversmith*, 1978, p.4.

140. Sheffield City Museums, *op.cit.*

141. John Farleigh, *The Creative Craftsman*, G. Bell and Sons 1950, p.150.

142. Birmingham Museum and Art Gallery, *op.cit.*, p.24.

143. Charles Thomas to George Ravensworth Hughes, 6 July 1946 in Fellows File for Charles Thomas, Archive of the Worshipful Company of Goldsmiths, hereafter WCG.

144. Stabler and his wife Phoebe should be further researched. See Hamilton T. Smith, 'Harold Stabler, worker in enamels and metals', *The Studio*, February 1915; his obituary in the *Journal of the Royal Society of Arts*, 27 April 1945, and

Goldsmiths Journal, May 1945, vol. ii, no. 315, p.44; a thesis by M. Cauldfield, 'Harold Stabler 1872–1945', WCG. See also Victoria and Albert Museum, *The Poole Potteries*, 1978.

145. See R.F. Proffitt, 'Harold Stabler/K.S.I.A. – The Old Hall Connection, *Quarto*, vol. xxx, no. 3, October 1992 which suggests that stainless steel tea/coffee sets made in Staybrite by the Keswick School of Industrial Art were made under Stabler's influence.

146. On Ramsden see Eric Turner, 'Introduction', in *English Silver: Masterpieces by Omar Ramsden from the Campbell Collection*, David A. Hanks and Associates, New York 1992; Ghenete Zelleke, 'Omar Ramsden and Alwyn Carr: An Arts and Crafts Collaboration', *Art Institute of Chicago Museum Studies*, vol. 18, no. 2, 1992, pp.168–82; City Museum and Art Gallery, Birmingham, *Omar Ramsden 1873–1936*, 1973. For the interior of St Dunstan's see Violet King, 'A Studio Home', in *Ideal Home*, September 1928. For Leslie Durbin's account of working for Ramsden see John Farleigh, *The Creative Craftsman*, G.Bell and Sons Ltd., 1950, pp.75–82. For an account of the Pax and Three Kings mazers see AAD 1/128–1980, cuttings relating to the 1938 Arts and Crafts Exhibition Society.

147. Omar Ramsden, 'English Silver and Its Future', *Journal of the Royal Society of Arts*, 30 November 1928, pp.51–71.

148. See George Ravensworth Hughes, *The Worshipful Company of Goldsmiths as Patrons of their Craft 1919–53*, Goldsmiths' Hall, 1965.

149. Lecture file relating to R.M.Y. Gleadowe, 'Nature and Modern Design', 20 March 1930, WCG.

150. J.E. Barton, 'Modern Forms in Art with some suggestions as to their influence on silver design', 27 October 1932, N.1.10, WCG.

151. See Jowett's response to H.G. Murphy on 'Form', 23 November 1933, N.1.12, WCG.

152. Frank Dobson, Edward Maufe, RMY Gleadowe, 'Presentation, Ceremonial and Church Plate. Design, demand and supply', 23 January 1939, WCG archive.

153. Murphy, *op.cit.* Also see H.G. Murphy, 'British Silver Today', *The Studio*, January 1936, pp.36–42.

154. Bernard Cuzner, *A Silversmith's Manual*, N.A.G. Press Ltd 1935, p.219. Also Bernard Cuzner, Omar Ramsden, 'Design and Application of the Plastic Arts to Gold and Silver', 22 January 1934, N.1.14, WCG.

155. G.R. Hughes, *The Worshipful Company of Goldsmiths as patrons of their craft 1919–53*, Goldsmiths' Hall 1965, p.51.

156. Charles Thomas to G.R. Hughes, 17 August 1951, Charles Thomas Fellows File, WCG.

157. Alan Powers, 'Catherine Cobb: Sources of Inspiration', *Crafts*, 133, March/April 1995, pp.44–7.

158. For an overview of the period see Peter Hinks, *Twentieth-Century British Jewellery 1900–1980*, Faber & Faber 1983. For the most sensitive appraisal of Arts and Crafts jewellery see Alan Crawford, *C.R. Ashbee, Architect, Designer & Romantic Socialist*, Yale University Press 1985, pp.347–67. Also Birmingham City Museum and Art Gallery, *Arthur and Georgie Gaskin*, 1982 and Elizabeth Cumming, *Phoebe Anna Traquair 1852–1936*, Scottish National Portrait Gallery, Edinburgh 1993.

159. Anna Pyne, 'George Hunt: Twentieth-Century Art Jeweller', *The Antique Collector*, vol. 61, no. 2, February 1990 pp.54–8. On imports see Council for Art and Industry, *Design in the Jewellery, Silversmithing and Allied Trades*, HMSO 1937.

160. See Peter Hinks, *Twentieth-Century British Jewellery 1900–1980*, Faber & Faber 1983 and Spink and Son Ltd, *Antique and Twentieth-Century Jewellery*, 1992.

161. Quoted in Edward Johnston, *Writing & Illuminating & Lettering*, John Hogg 1906, p.170.

162. See James S. Dearden, *John Ruskin, The Collector with a Catalogue of the Illuminated and Other Manuscripts formerly in his Collection*, The Bibliographical Society 1966.

163. See John Nash, 'Calligraphy', in Linda Parry (ed.), *William Morris*, Philip Wilson/V&A, 1996, pp.296–309.

164. Johnston, *op.cit.* (1906), p.378.

165. Edward Johnston, *Lessons in Formal Writing*, Heather Child and Justin Howes (eds), Lund Humphries 1986, p.23

166. Noel Rooke, 'Written Beauty' reprinted in Edward

Johnston, *Lessons in FormalWriting*, Heather Child and Justin Howes (eds), Lund Humphries 1986, p.49.

167. Johnston, *op.cit.* (1906), p.51.

168. There is no good modern book on Dolmetsch but Margaret Campbell's dull biography *Dolmetsch:The Man and hisWork*, Hamilton 1975, may be consulted. Jessica Douglas-Home's *Violet:The Life and Loves of Violet Gordon Woodhouse*, Harvill Press 1996, is good on links between modernism and early music as is S.T. Tillyard, *The Impact of Modernism:TheVisual Arts in Edwardian England*, Routledge 1988.

169. See W.R. Lethaby, 'Writing and Civilisation', in *Catalogue of the First Exhibition of the Society of Scribes and Illuminators 1922*, pp.3–6.

170. Edward Johnston, *Lessons in FormalWriting*, Heather Child and Justin Howes (eds), Lund Humphries 1986, p.203. For a gripping account of this collaborative venture see John Dreyfus, *Italic Quartet: A Record of the Collaboration between Harry Kessler, Edward Johnston, EmeryWalker and Edward Prince in the Making of the Cranach Press Italic*, Cambridge University Press 1966. Also L.T. Owens, *J.H. Mason 1875–1951*, Frederick Muller, Ltd 1976.

171. See Robin Kinross, *Modern Typography*, Hyphen Press 1992, pp.38–40.

172. Quoted in Wilfrid Blunt, *Cockerell: Sydney Carlyle Cockerell, friend of Ruskin and Morris and Director of the Fitzwilliam Museum*, Cambridge University Press 1964, p.95.

173. Edward Johnston, 'Review of *Lettering* by Grailly Hewitt', *Artwork*, Winter 1928, vol. vii, no. 28, p.294.

174. Johnston, *op.cit.* (1906), p.333.

175. Priscilla Johnston, *Edward Johnston*, Faber & Faber 1959, p.191.

176. Ibid., p.234.

177. See the chapter 'Formal Penmanship defined by the Thing', in Edward Johnston, *Formal Penmanship and Other Papers*, Heather Child (ed.), Lund Humphries 1971; Edward Johnston, *Lessons in FormalWriting*, Heather Child and Justin Howes (eds), Lund Humphries 1986, pp.40, 162.

178. Tate Gallery, *Pound's Artists: Ezra Pound and theVisual Arts in London, Paris and Italy*, 1985, p.39.

179. Heather Child, Heather Collins, Ann Hechle, Donald Jackson (eds), *More than FineWriting: IreneWellington Calligrapher (1904–1984)*, Pelham Books 1986, p.34.

180. John Farleigh, 'Irene Wellington – Calligrapher', in *The Creative Craftsman*, G. Bell and Sons Ltd., 1950, pp.121–2. Most writing about Johnston as a teacher is hagiographical in tone. For an alternative view see Donald Jackson, 'Irene Wellington in the context of her time – a personal view', in Heather Child, Heather Collins, Ann Hechle, Donald Jackson (eds),*More than FineWriting: Irene Wellington Calligrapher,* Pelham Books 1986, pp.28–37.

181. P. Johnston, *op.cit.* (1959), p.251.

182. Draft constitution June 1921, Papers of the Society of Scribes and Illuminators, AAD 4/1–1982.

183. Madelyn Walker to W.R. Lethaby, 14 October 1926, Papers of the Society of Scribes and Illuminators, AAD 4/9–1982.

184. Scale of Charges Committee, March 1925, Papers of the Society of Scribes and Illuminators, AAD 4/1–1982.

185. Madelyn Walker to Mrs Beattie, 27 June 1927, Papers of the Society of Scribes and Illuminators, AAD 4/9–1982.

186. On 'trade' and craft relations see Bernard C. Middleton, 'English Craft Bookbinding 1880–1980. A brief survey of trends', *The Private Library:The Quarterly Journal of the Private Libraries Association*, third series, no. 4,Winter 1981, pp.139–69.

187. P. Johnston, *op.cit.* (1959), p.175.

188. On Fairbank see A.S. Osley (ed.), *Calligraphy and Palaeography: Essays presented to Alfred Fairbank on his 70th Birthday*, Faber & Faber 1965; John Fairbank, 'The Work of Alfred Fairbank 1895–1982', *Letter Arts Review*, vol. 11, no. 4, 1994, pp.20–7. On the general interest in good writing see Ambrose Heal, *The EnglishWriting-Masters and their Copy-Books 1570–1800: a bibliographical dictionary and a bibliography*, introduction by Stanley Morison, Cambridge University Press 1931; Pat Kirkham, *Harry Peach*, Design Council 1986, pp.80–1; Jeremy Myerson, *Gordon Russell: Designer of Furniture*, Design Council 1992, pp.26–7.

189. Nicolete Gray, *XIXth Century Ornamented Types and Title Pages*, Faber & Faber (1938) 1976, p.1.

190. Eric Gill, *Autobiography*, Jonathan Cape 1940, p.94.

191. Ibid., p.119.

192. Ibid., p.118.

193. (Roger Fry), 'The Grafton Gallery', *The Athenaeum*, no. 4084, 3 February 1906, p.145.

194. Johnston, *op.cit.* (1906), p.355.

195. Eric Gill, *Autobiography*, p.120.

196. William Rothenstein, *Men and Memories: Recollections of William Rothenstein 1900–1922*, vol. ii, Faber & Faber 1932, p.89.

197.Eric Gill, *An Essay on Typography*, Hague & Gill 1931, p.72.

198.Eric Gill, *Autobiography*, p.159.

199. Walter Shewring (ed.), *Letters of Eric Gill*, Jonathan Cape, 1947, p.28.

200. *Vasari on Technique*, trans. Louisa S. Maclehose, J.M. Dent, 1907.

201. Eric Gill, 'Arts and Crafts: Sculpture', *The Highway*, vol. ix, no. 105, June 1917, p.143.

202. Ibid., p.143.

203. Henri Gaudier-Brzeska quoted in Ezra Pound, *Gaudier-Brzeska: A Memoir*, Laidlaw & Laidlaw (1916) 1939, p.26.

204. Shewring *op. cit.*, pp.36–37.

205.Ibid., p.271.

206. Eric Gill, *Autobiography*, p.173.

207. Shewring, *op. cit.*, p.306.

208. I owe these succinct phrases to Robin Kinross, 'Eric Gill sans politics', in *Solidarity Journal*, 22/23, Winter 1989–90, pp.14–17.

209. Martin Harrison, *Victorian Stained Glass*, Barrie & Jenkins London, p.63. For Whall in general see Peter Cormack, 'Recreating a Tradition: Christopher Whall (1849–1924) and the Arts and Crafts Renascence of English Stained Glass', in Nicola Gordon Bowe (ed.), *Art and the National Dream*, Irish Academic Press, Dublin 1993. Also Peter Cormack, 'Writers and Thinkers: Christopher Whall', *Crafts* 153, July–August 1998, p.22. The important series of stained-glass exhibitions and catalogues produced by the William Morris Gallery are all the work of Peter Cormack who had done more than anyone to create a history for this inter-war period in stained glass.

210. Sarah Brown, *Stained Glass: An Illustrated History*, Studio Editions 1992, p.30.

211. See the excellent*Women Stained Glass Artists of the Arts and Crafts Movement*, William Morris Gallery, Waltham Forest Libraries and Arts Department, 1986, p.1.

212. On Mary Lowndes's political activities see Lisa Tickner, *The Spectacle of Women: Imagery of the Suffrage Campaign 1907–14*, Chatto & Windus, London 1987.

213. Notes on stained glass (for Cicely), Moira Forsyth papers, AAD/1991/10.

214. Typescript 'For Talk', Moira Forsyth Papers AAD/1991/10.

215. For Clarke and Geddes see Nicola Gordon Bowe and Elizabeth Cumming, *The Arts & Crafts Movements in Dublin & Edinburgh 1885–1925*, Irish Academic Press.

216. See Nicola Gordon Bowe, David Caron, Michael Wynne, *Gazeteer of Irish Stained Glass*, Irish Academic Press, 1988.

217. William Morris Gallery, Waltham Forest Libraries and Arts Department, *Karl Parsons*, 1988.

CHAPTER THREE

1. 'Of beautiful Cities' was Lethaby's contribution to the Arts and Crafts Exhibition Society publication *Art and Life, and the Building and Decoration of Cities*, Percival 1897.

2. John Houston (ed.), *Craft Classics since the 1940s: An Anthology of Belief and Comment*, Crafts Council 1988, p.8.

3. Peter Davey, *Arts and Crafts Architecture*, Phaidon 1995, pp.82–3.

4. John Gloag, 'Mr Gordon Russell and Cotswold Craftsmanship', *Architects' Journal*, 15 August 1928, p.220. See Cheltenham Art Gallery and Museums, *Gazetteer of Arts and Crafts Architecture in the Cotswold Region*, 1992, p.9.

5. H.J. Massingham, *Shepherd's Country: A Record of the Crafts and People of the Hills*, Chapman and Ward 1938, p.79.

6. John Gloag tracked down H.J. Gooding and interviewed him about his American adventure for *Architects' Journal*, 9 January 1929. See John Gloag, *Men and Buildings*, Country

Life Ltd 1931, pp.173–81 for an account of the project.

7. Victor Bonham-Carter, *Dartington Hall:The History of an Experiment*, Phoenix House 1958, pp.27–9.

8. See Mary Comino, *Gimson and the Barnsleys 'Wonderful furniture of a commonplace kind'*, Evans Brothers Ltd, 1980, pp.132–6; Catherine Gordon, 'The Arts and Crafts of the Cotswold Region', in Mary Greensted, *The Arts and Crafts Movement in the Cotswolds*, Alan Sutton, Stroud 1993, pp.64–5; Simon Biddulph, Mary Greensted, *Rodmarton Manor:The Story of an Arts and Crafts House*, n.d.

9. A point made by Peter Davies in *Arts and Crafts Architecture*, Phaidon 1995, p.165. Mary Greensted notes, however, that Barnsley would have wanted to maintain rural skills and economic structures – often the sawyers were a father and son team.

10. George Sturt, *TheWheelwright's Shop*, Cambridge University Press, 1923, pp.32–40.

11. William Rothenstein, *Men and Memories: Recollections of William Rothenstein*, vol. ii, Faber & Faber 1932, pp.277–8.

12. Peter Anson, *Fashions in Church Furnishings 1840–1940*, The Faith Press 1960, p.312.

13. Hove Museum and Art Gallery, *Eric Gill and the Guild of St Joseph and St Dominic*, 1991; Brocard Sewell, 'H.D.C. Pepler', in *Like Black Swans: Some People and Things*, Tabb House, Padstow, Cornwall 1982, pp.126–56.

14. Hove Museum and Art Gallery, *Eric Gill and the Guild of St Joseph and St Dominic*, 1991, pp.66–9 and Margot Coatts, 'Ditchling Days', *Crafts*, 111, July/August 1991, p.28.

15. Eric Gill, 'Church Furniture', *Architectural Review*, vol. ixii, July 1927, pp.52–3.

16. Rev. Hewlett Johnson, Dean of Manchester, 'Our Churches', *Architectural Review*, vol. ixii, July 1927, p.6.

17. Conrad Noel, *Autobiography*, Sidney Dark (ed.), J.M. Dent, 1945, p.87. Also Reginald Groves, *Conrad Noel and the Thaxted Movement*, Merlin Press 1967.

18. See below, p.141.

19. Anthony Hill, 'N.F. Cachemaille-Day: A Search for Something More', *The Thirties Society Journal*, no. 7, n.d, pp.20–7.

20. For Maufe's views on church adornment see Edward Maufe, *Modern Church Architecture*, Incorporated Church Building Society 1948, p.7.

21. For the correspondence between Maufe and Forsyth see AAD/1991/10.

22. See Veronica Sekules, 'The Ship Owner as Art Patron: Sir Colin Anderson and the Orient Line 1930–1960', *Journal of the Decorative Arts Society*, no. 10, 1985, pp.22–3.

23. Southampton City Art Gallery, *Art on the Liners: A Celebration of Elegance at Sea*, 1986.

24. Tate Gallery, *Mural painting in Great Britain 1919–1939. An Exhibition of Photographs*, 25 May–30 June 1939; Hans Feibusch, *Mural Painting*, A. & C. Black 1946. On a wartime scheme see Kenneth Clark, *The Other Half*, John Murray 1977, p.56.

25. Richard Cork, 'Overhead Sculpture for the Underground Railway in British Sculpture', in *British Sculpture in the Twentieth Century*, Sandy Nairne and Nicholas Serota (eds), Whitechapel Art Gallery 1981, pp.90–101.

26. Walter Shewring (ed.), *Letters of Eric Gill*, Jonathan Cape 1947, p.242.

27. See Priscilla Johnston, *Edward Johnston*, Faber & Faber 1959, pp.198–204.

28. Shewring, *op. cit.*, pp. 266–7.

29. William Aumonier, *Modern Architectural Sculpture*, Architectural Press 1930, pp.129, 141. They were also included in Paul Nash, 'Modern British Furnishing', *Architectural Review*, vol. lxvii, January 1930, p.45.

30. For a fascinating attempt to redress the balance see Peyton Skipwith and Benedict Read, *Sculpture in Britain Between theWars*, Fine Art Society 1986.

31. Nash, *op.cit.*, pp.43–8; Paul Nash, *Room and Book*, Soncino Press Ltd 1932; Nigel Vaux Halliday, *More than a Bookshop: Zwemmer's and Art in the Twentieth Century*, Philip Wilson 1991.

32. Nash, *op.cit.* (1930), p.45.

33. Alan Powers, 'A Zebra at Villa Savoie: interpreting the Modern House', in *The Modern House Revisited*, Twentieth-century Architecture 2, The Twentieth Century Society 1996, pp.16–25.

34. Jeremy Lewison, *Ben Nicholson*, Tate Gallery, 1993, p.46.

35. Christopher Hussey, 'High and Over, Amersham, Bucks', *Country Life*, 19 September 1931, pp.302–7.

36. See Anthony Cleminson, 'Silver End Beginnings', *Architectural Review*, vol. clxvi, no. 995, November 1979, pp.302–4. See also W.F. Crittall in the *DIA Quarterly Journal*, new series no. 13, October 1930, on the workers' housing at Silver End which had adjacent workshops for weaving and making furniture rather in spirit of Rodmarton Manor. W.F. Crittall and Messrs Joseph's New Farm, Great Easton (1934) exemplifies the mix of modernism and crafts. See 'Sale of the contents of New Farm, Great Easton, Great Dunmow, Essex', Phillips, Cambridge, Wednesday 22 July 1987.

37. Paul Nash, *Room and Book*, Soncino Press Ltd 1932, p.28.

38. For his support for these artists see Paul Nash, 'Modern Textiles', *Artwork*, vol. 2, no. 6, Jan–March 1926, pp.80–7; Paul Nash, 'Modern Textiles 1', *The Listener*, 27 April 1932, 'Modern Textiles 11', *The Listener*, 15 June 1932.

39. Paul Nash, *Outline: An Autobiography*, Columbus Books 1988, p.86.

40. Paul Nash, 'Modern British Furnishing', *Architectural Review*, vol. lxvii, January 1930, p.47.

41. On Paris 1925, see England: Department of Overseas Trade, *Reports on the Present Position and Tendencies of the Industrial Arts as indicated at the Industrial Exhibition of the Modern, Decorative and Industrial Arts, Paris 1925*, 1926; Frank Scarlett, Marjorie Townley, *A Personal Recollection of the Paris Exhibition*, Academy Editions 1975; Harold Stabler to Harry Peach 17 September 1925 in Box 6 PeH/6/18, Peach archive, RIBA Library.

42. See H.H. Peach, 'An Impression' and M. McLeish, 'A Commentary', in *DIA Quarterly Journal*, new series, no. 1, September 1927, pp.6–11.

43. British Institute of Industrial Art, *Catalogue of the British Institute of Industrial Art Autumn Exhibition Illustrating British Industrial Art for the Slender Purse*, Victoria & Albert Museum, 9 November–18 December 1929.

44. Darcy Bradell, 'The Textile Designs of Paul Nash', *Architectural Review*, vol. lxiv, October 1928, p.163.

45. See *The Listener*, 27 April 1932, p.607.

46. Quoted in Nigel Vaux Halliday, *More than a Bookshop: Zwemmer's and Art in the Twentieth Century*, Philip Wilson 1991, p.107. In 1933 Zwemmer's also put on 'Sculpture with a Background of Handprinted Stuffs' which juxtaposed Henry Moore's pupils and a group of hand block printers.

47. Serge Chermayeff, 'Phases of Furnishing Fashion: Modernism', *The Cabinet Maker and Complete Home Furnisher*, 28 June 1930, p.734.

48. Wells Coates, '"Furniture Today – Furniture Tomorrow" Leaves from a Meta-Technical Notebook', *Architectural Review*, vol. lxxii, July 1932, p.34.

49. Nash, *op.cit.* (1930), p.43.

50. 'A Letter from Le Corbusier' in C. Geoffrey Holme, Shirley Wainwright (eds), *The Studio Year-Book, Decorative Art*, The Studio Ltd 1929, p.4.

51. Bruno Taut, *Modern Architecture*, The Studio Ltd 1929, p.207.

52. Moira Forsyth's Reports to the American Chinaware Corp., 31 March 1930, Moira Forsyth Papers, AAD/1990/10.

53. Cardew *Autobiography*, p.25, and verbal communication with David Leach. For another account of Leach's austere home see Harry Davis, 'Handcraft Pottery – Whence and Wither', *Ceramic Review*, 93, May–June 1985, p.12, and David Whiting, *David and Jessamine*, Galerie Besson 1997.

54. Doris Pleydell-Bouverie, 'My Cousin: An Appreciation', in Crafts Council, Crafts Study Centre, Bath, *Katharine Pleydell-Bouverie: A Potter's Life 1895–1985*, 1986, p.20.

55. Susan Bosence quoted in Barley Roscoe, 'Phyllis Barron and Dorothy Larcher', in Mary Greensted, *The Arts and Crafts Movement in the Cotswolds*, Alan Sutton, Stroud 1993, p.137.

56. See Douglas Percy Bliss, *Edward Bawden*, Pendomer Press 1979; Mary Schoeser, *Marianne Straub*, Design Council 1984; Alan Powers, 'Country Life', *Crafts*, 143 November/December 1996, pp.36–41.

57. John Gloag's *English Furniture*, A. & C. Black 1934, was illustrated with objects from his own home. For his earliest thoughts on interior decoration see Helen and John Gloag, *Simple Furnishing and Arrangement*, Duckworth & Co. 1921.

58. Alison Light, *Forever England: Femininity, Literature and Conservatism between the Wars*, Routledge 1991, p.35.

59. Herbert Read (ed.), *Unit One: The Modern Movement in English Architecture, Painting and Sculpture*, Cassell 1934, pp.19–20

60. Ibid, pp.90–1 for the Nicholson interior. For Read see Benedict Read and David Thistlewood (eds), *Herbert Read: A British Vision of World Art*, Leeds City Art Galleries/Lund Humphries 1993, p.60.

61. Barley Roscoe, 'The Biggest and Simplest Results', *Crafts*, 144, January/February 1997, pp.30–5 gives a full account of this commission.

62. Light, *op.cit.*, p.10.

63. On this modernist marginalisation of the home see Penny Sparke, *As Long as It's Pink: The Sexual Politics of Taste*, HarperCollins 1995, Chapter Five, and Christopher Reed (ed.), *Not at Home: The Suppression of Domesticity in Modern Art and Architecture*, Thames and Hudson 1996, pp.7–17.

64. 'Introduction', *The Studio Year Book, Decorative Art 1929*, p.2.

65. John Gloag, *Men and Buildings*, Country Life Ltd 1931, p.192.

66. Ross McKibbin, *Classes and Cultures: England 1918–1951*, Oxford University Press 1998, p.521.

67. See Homi Bhabha, 'The Third Space', in J. Rutherford (ed.), *Identity: Community, Culture, Difference*, Lawrence and Wishart, 1990.

68. This is not an exhaustive list but known supportive partnerships include Dorothy Larcher and Phyllis Barron, Enid Marx and Margaret Lambert, Barbara Allen and Hilary Bourne, Elizabeth Peacock and Molly Stobart, Evie Hone and Maine Jellett, Joan Howson and Caroline Townsend, Katharine Pleydell-Bouverie and Norah Braden. A list of craftswomen simply known to be unmarried would be far longer.

69. This is true of much of the material held by the Crafts Study Centre (CSC) especially material relating to Katharine Pleydell-Bouverie, Phyllis Barron and Dorothy Larcher, Elizabeth Peacock and Ethel Mairet.

70. See 2420, 2422–76, 2492–520 Leach papers, CSC.

71. Striking attempts at retrieval include Moira Vincentelli, 'Potters of the 1920s: Contemporary Criticism', in G. Elinor, S. Richardson, S. Scott, A. Thomas, K. Walker (eds), *Women and Craft*, Virago 1987; Pat Kirkham, 'The Inter-War Handicraft Revival', in J. Attfield and P. Kirkham (eds) *A View from the Interior: Feminism, Women and Design*, The Women's Press 1989; and J. Seddon, S. Worden (eds), *Women Designing: Redefining Design in Britain Between the Wars*, University of Brighton 1994; Cheryl Buckley, *Potters and Paintresses*, The Women's Press, 1990.

72. On these women see Moira Vincentelli, *Catalogue of Early Studio Pottery in the Collections of University College of Wales, Aberystwyth*, 1989, and George Wingfield Digby, *The Work of the Modern Potter in England*, John Murray 1952, p.29.

73. See Margaret Strobel, *European Women and the Second British Empire*, Indiana University Press 1991, p.36.

74. P. Morton Shand, 'Typeforms in Great Britain', *Die Form*, 5, 1930, pp.312–16.

75. Walter Gropius, 'The Formal and Technical Problems of Modern Architecture and Planning', *Journal of the Royal Institute of British Architects*, 19 May 1934, p.682.

76. Herbert Read, 'Art and Decoration', *The Listener*, 7 May 1930, p.805.

77. Herbert Read, *The Meaning of Art*, Faber & Faber 1931, pp.22–3.

78. Herbert Read, *Art and Industry*, Faber & Faber 1934, p.123.

79. Anthony Bertram, 'Selling Pictures. An Organisation and a Gallery', *Design for Today*, May 1934, p.162.

80. Ibid., p.162.

81. Herbert Read (ed.), *Unit One: The Modern Movement in English Architecture, Painting and Sculpture*, Cassell, 1934; Herbert Read to Ben Nicholson, 23 November 1934,

quoted in Jeremy Lewison, *Ben Nicholson*, Tate Gallery 1993, p.47.

82. Geoffrey Grigson, 'In Search of English Pottery', *The Studio*, vol. 110, no. 512, November 1935, pp.256–63.

83. Memo from the Department of Overseas Trade to the Gorrell Committee, PRO BT 57/35.

84. Great Britain and Ireland, Board of Trade, *Art and Industry. Report of the Committee appointed by the Board of Trade under the Chairmanship of Lord Gorrell on the production and exhibition of articles of good design and every-day use*, HMSO 1932, p.12.

85. Read, *Art and Industry* 1934, p.173.

86. Richard Stewart, *Design and British Industry*, John Murray 1987, pp.52–62.

87. See *Catalogue of Exhibition of British Industrial Art in Relation to the Home*, 20 June–12 July, Dorland Hall, Lower Regent Street 1933; Folder of comments on Dorland Hall, NAL; Noel Carrington, *Industrial Design in Britain*, George Allen and Unwin Ltd, 1976, pp.135–46; on the design of the exhibition see Alan Powers, 'Oliver Hill as an Exhibition Designer', *The Thirties Society Journal*, no. 7, n.d. pp.28–9.

88. Folder of Comments on Dorland Hall, London, Notice of Exhibition of British Industrial Art in relation to the Home, NAL.

89. Nikolaus Pevsner, *Pioneers of the Modern Movement*, Faber & Faber 1936, p.42.

90. Nikolaus Pevsner, *An Enquiry into Industrial Art in England*, Cambridge University Press 1937, p.188.

91. John Gloag, *Artifex or the Future of Craftsmanship*, Kegan Paul, Trench, Trubner and Co. Ltd 1926, p.55.

92. Read, *Art and Industry* 1934, pp.123, 127.

93. Antony Hunt, *Textile Design*, 'How to do It' series no. 15, The Studio Ltd 1937, p.54.

94. Ethel Mairet, *Hand-Weaving To-Day. Traditions and Changes*, Faber & Faber 1939, p.15.

95. Harry Norris to Bernard Leach, 13.11.36, Leach papers 2923, CSC.

96. Marianne Straub, 'Beginning at the Beginning', in *Report of the International Conference of Craftsmen in Pottery and Textiles at Dartington Hall, Totnes, Devon July 17–27 1952*, Dartington Hall 1954, p.33; hereafter ICC.

97. 'In Memoriam Alastair Morton', *Quarterly Journal of the Guilds of Weavers, Spinners and Dyers*, no. 47, September 1963, p.535; Margot Coatts, *A Weaver's Life: Ethel Mairet 1972–1952*, Crafts Council/Crafts Study Centre, Holburne Museum, Bath, 1983, pp.122–4.

98. Alec B. Hunter, 'The Craftsman and Design in the Textile Industry', *Journal of the Royal Society of Arts*, 12 March 1948, p.231.

99. Hunter, *op. cit.* 12 March 1948, pp.224–36; Alec Hunter, 'The Craftsman and the Textile Industry', in ICC; Mary Schoeser, *Marianne Straub*, Design Council 1984, pp.72–7; Hilary Diaper (ed.), *Theo Moorman 1907–1990: Her Life and Work as an Artist Weaver*, The University Gallery, Leeds, 1992, p.6.

100. General Committee meeting, 3 July 1922, Arts and Crafts Exhibition Society Papers, AAD 1/53–1980.

101. General Committee meeting, 13 October 1922, Arts and Crafts Exhibition Society Papers, AAD 1/53 1980.

102. See W.R. Lethaby, *Home and Country Arts* (1923), a collection of essays reprinted from the National Federation of Women's Institutes journal *Home and Country*.

103. Press cuttings for the 1926 Arts and Crafts Exhibition, AAD 1/29–1980.

104. J.G., 'Arts and Crafts Exhibition', *The Cabinet Maker and Complete House Furnisher*, 23 January 1926, p.143.

105. *The Times*, 21 January 1926 in AAD 1/29–1980.

106. See Alan Powers, 'The Missing Chapter', *Crafts*, 113, November/December 1991, p.18.

107. A.S. Osley (ed.), *Calligraphy and Palaeography: Essays presented to Alfred Fairbank on his 70th birthday*, Faber & Faber 1965, p.8.

108. Frank Pick, 'Society Today', in Arts and Crafts Exhibition Society, *Catalogue of the Fiftieth Anniversary Exhibition*, 1938.

109. J.B Priestley, *English Journey*, William Heinemann Ltd/Victor Gollancz Ltd 1934, p.252.

110. For an account of the founding of the Guild see 'Red

Rose Guild of Art Workers Scrap Book 1920–1933'. For discussions of standards see, typically, Committee minutes 24 October 1928, Red Rose Guild papers, CSC.

111. Committee minutes November 1927, Red Rose Guild papers, CSC.

112. Ibid.

113. Committee minutes 29 October 1929, Red Rose Guild papers, CSC.

114. Committee minutes 16 April 1931 and 4 October 1928, Red Rose Guild papers, CSC.

115. Committee minutes 8 November 1927 and 24 October 1928, Red Rose Guild papers, CSC.

116. Committee minutes 28 October 1931, Red Rose Guild papers, CSC.

117. John Farleigh, 'Welcome! Machinery', in Four Papers, Arts and Crafts Exhibition Society 1935.

118. General Committee minutes, 23 October 1934, AAD 1/62 – 1980.

119. This may seem odd coming from Alfred Powell, with his links with Wedgwood, but both he and his wife were dedicated to bringing artistic fulfillment into industry. For this correspondence see the Oliver Morel Archive, Eric Sharpe file, Abbot Hall Art Gallery, Kendal.

120. Meg Sweet, From Combined Arts to Designer Craftsmen: The Archives of the Arts and Crafts Exhibition Society, Craft History One, Combined Arts, Bath 1988, pp.15–16.

121. Ibid., p.16.

122. Barry Mills at the Bolton Metro Library and Archive kindly sent me a folder of press cuttings on Harry Norris and his wife Edith, a stained-glass artist. Also see his correspondence in the Margaret Pilkington papers, Whitworth Art Gallery, Manchester and an important letter to Michael Cardew, 23 March 1942, Seth Cardew papers.

123. Harry Norris to Margaret Pilkington n.d., but probably 1936, Margaret Pilkington papers, Whitworth Art Gallery, Manchester.

124. Harry Norris 19 June 1937 'Memo on the position of the crafts and the RRGA', Margaret Pilkington papers, Whitworth Art Gallery, Manchester.

125. Margaret Pilkington to Harry Norris, n.d., probably 1937, Margaret Pilkington papers, Whitworth Art Gallery, Manchester.

126. Bernard Leach to Michael Cardew, 27 March 1942, Seth Cardew papers.

127. Harry Norris to Margaret Pilkington, 16 January 1938, Margaret Pilkington papers, Whitworth Art Gallery, Manchester.

128. Harry Norris to Bernard Leach, 9 November 1936, Leach Papers 2922, CSC.

129. Harry Norris to Margaret Pilkington n.d. circa 1938, Margaret Pilkington papers, Whitworth Art Gallery, Manchester.

130. Harry Norris to Margaret Pilkington, 29 June 1939, Margaret Pilkington papers, Whitworth Art Gallery, Manchester.

131. Carruthers (1992), p.89.

132. Michael Cardew, 'Industry and the Studio Potter', Crafts: The Quarterly of the Red Rose Guild, vol. 11, no. 1, pp.9–12; Bernard Leach, 'The Contemporary Studio Potter', Journal of the Royal Society of Arts, 21 May 1948, p.366.

133. Michael Cardew to Bernard Leach, 13 December 1938, Leach papers 2940, CSC; Henry Bergen to Bernard Leach, 8 March 1938, Leach papers 3200, CSC. Bergen reports on Katharine Pleydell-Bouverie's dislike of Murray's designs but assumes that they were slip-cast not thrown.

134. J.H. Mason, 'The Place of Hand-work in Modern Civilization', in Four Papers, Arts and Crafts Exhibition Society, 1935 and Edward Spencer, 'The Use and Abuse of Machinery', Fortnightly Review, vol. xc, July–December 1911, pp.891–8.

135. See especially, Eric Gill, Art and a Changing Civilization, John Lane, The Bodley Head Ltd 1934.

136. Most of the galleries and exhibiting societies mentioned here are represented by exhibition catalogues held by the National Art Library in the V&A. Also see the section 'Art galleries and dealers selling ceramics', in Moira

Vincentelli, Anna Hale, Catalogue of Early Studio Pottery in the Collections of University College of Wales, Aberystwyth, 1986 and Barley Roscoe, 'Artist Craftswomen Between the Wars', in G. Elinor, S. Richardson, A. Thomas, K. Walker (eds), Women and Craft, Virago 1987.

137. See Home Arts and Industries Association, Catalogue of an Exhibition and Sale of British Handicrafts, Drapers Hall 30 October–4 November 1933.

138. Margot Coatts, The Oxshott Pottery: Denise and Henry Wren, Crafts Study Centre, Holburne Museum 1984, pp.17–18.

139. See the Daily Mail Ideal Home catalogues from 1908 onwards. Also Deborah Sugg, Ideal Homes, Design Museum, 1993.

140. Phyllis Barron, 'My Life as a Block Printer', transcript of a talk given at Dartington Hall on 22 February 1964 on a Ministry of Education course organised by Robin Tanner, CSC.

141. Lynne Walker and Colston Sanger, 'Inval Weavers', Craft Quarterly, issue 1, Summer 1981, pp.2–6.

142. Eleanor Davidson, The Simpsons of Kendal: Craftsmen in Wood 1885–1952, University of Lancaster Visual Arts Centre 1978, p.48.

143. Judith Collins, The Omega Workshops, Secker and Warburg 1983, p.140.

144. The Artificers Guild needs investigation but there are useful references in ARG Autobiography; Helen E. FitzRandolph, M. Doriel Hay, The Rural Industries of England and Wales: The Decorative Crafts and Rural Potteries, vol. iii, Oxford: Agricultural Economics Research Institute 1927, pp. 15, 40–1, 73, 122; Leach, Memoirs, p.144. There is a small archive on Spencer in the library of the Worshipful Company of Goldsmiths.

145. Jeremy Myerson, Gordon Russell: Designer of Furniture, Design Council 1992.

146. Pottery and Etchings by Bernard Leach, Cotswold Gallery, 1923. See also Cardew, Autobiography, p.73 and Mary Comino, Gimson and the Barnsleys 'Wonderful furniture of a commonplace kind', Evans Brothers Ltd 1980, p.199.

147. Bernard Leach, Hamada Potter, Kodansha International, Tokyo 1990, p.139.

148. The Redfern Gallery's shows can be pieced together by scanning Artwork starting with vol. 3, no. 10, June–August 1927, p.xiii. The National Art Library holds its press cuttings 1923–59 and some catalogues. The Redfern exhibited embroidered pictures by Frances Richards throughout the 1950s.

149. Haslam (1984), p. 32.

150. Denis E. Browne to Bernard Leach 29 July 1936, Leach archive 2889, CSC.

151. National Society (of painters, sculptors, engravers, potters), 1930.

152. In 1947 the National Society dropped pottery in favour of painting, drawing, engraving and sculpture. But by then it was an increasingly conservative grouping.

153. Cardew, Autobiography, p.83.

154. Ibid., p.84.

155. See Hazel Berriman, Crysède: The unique textile designs of Alec Walker, Royal Institution of Cornwall, Truro 1993, pp.21–2.

156. Berriman, op.cit., p.21.

157. See Hazel Clark, '"Modern Textiles" 1926–1939', Journal of the Society of Decorative Arts, 12, 1987, pp.47–54; Hazel Clark, Joyce Clissold and Footprints, Central St Martins College of Art and Design 1993.

158. Christine Boydell, 'The Decorative Imperative: Marion Dorn's Textiles and Modernism', Journal of the Decorative Arts Society, no. 19, 1995, pp.31–40.

159. Talk given by Geoffrey Dunn, Saturday 24 November 1979, Thirties archive, AAD 5/8–1980 and Jennifer Hawkins Opie, 'Geoffrey Dunn and Dunn's of Bromley: Selling Good Design – a Lifetime of Commitment', Journal of the Society of Decorative Arts, 10, 1986, pp.34–9.

160. See Susanna Goodden, At the Sign of the Four Poster: A History of Heals, 1984, and Hilary Diaper (ed.), Theo Moorman 1907–1990, The University Gallery, Leeds, pp.4, 27–8.

161. From 1925 the magazine Artwork carried a useful 'Art Directory of Artists, Artworkers and Related Industries' which gives an insight into the range of outlets for every kind of craft, including imports.

162. See Philip Mairet, Autobiographical and Other Papers, C.H. Sisson (ed.), Carcanet, Manchester 1981.

163. For an outline of Mairet's plans see Philip Mairet to Bernard Leach, 23 February 1928, Leach papers, 562, CSC.

164. Bernard Leach to Philip Mairet, 11 April 1928, New Handworkers' Gallery papers, CSC.

165. Bernard Leach to Philip Mairet, 12 October 1928, New Handworkers' Gallery papers, CSC.

166. Michael Cardew to Philip Mairet, December 11 1928, New Handworkers' Gallery papers, CSC.

167. This rare pamphlet was published by the New Handworkers' Gallery in 1928 and also appeared in The Studio, vol. vcvi, no. 427, October 1928, pp. 231–3.

168. Philip Mairet, ABC of Adler's Psychology, Kegan Paul 1928 and Mairet, op.cit. 1981, pp.131–3. For interesting references to Mairet's circle see the American poet John Gould Fletcher's Life is my Song, Farrer and Rhinehart, New York 1937, pp.357–8. Fletcher also corresponded with and wrote about Leach. See John Gould Fletcher, 'The Pottery and Tiles of Bernard Leach', Artwork, vol. vii, Summer 1931, no. 26, pp.117–23.

169. Editorial and 'The Arts and Crafts Bureau', The Arts and Crafts: A Monthly Review of Arts and Handicrafts, vol. 1, no. 2 1928, pp.51–3.

170. Bernard Leach to Philip Mairet, 28 September 1928, New Handworkers' Gallery papers, CSC.

171. Phyllis Barron to Philip Mairet, 27 March 1930, New Handworkers' Gallery papers, CSC.

172. See Barley Roscoe, 'Artist Craftswomen between the Wars', in G. Elinor, S. Richardson, S. Scott, A. Thomas, K. Walker (eds), Women and Craft, Virago 1987, pp.139–42; Isabelle Anscombe, A Woman's Touch: Women in design from 1860 to the present day, Viking 1984, p.147.

173. See Kate Woodhead, 'Muriel Rose and the Little Gallery', V&A/RCA MA thesis, 1989 and Enid Marx, 'The Little Gallery', Matrix, 7, Winter 1987, pp. 103–4. The Muriel Rose archive held at the CSC contains correspondence with her clients, photographs, diaries and newspaper cuttings.

174. For the fullest account of Dunbar Hay Ltd see transcript of a talk given by Cecilia, Lady Sempill on 24 November 1979 in the Thirties archive, AAD 5/7–1980.

175. Bernard Leach, A Potter's Outlook, New Handworkers' Gallery 1928, p.27.

176. A full even-handed account of British Art in Industry is given in Nikolaus Pevsner, Industrial Art in England, Cambridge University Press 1937, pp.164–9.

177. Muriel Rose to Bernard Leach, 17 January 1935, Leach papers 2574, CSC.

178. Quoted in Richard Stewart, Design and British Industry, John Murray, 1987, p.60.

179. On Hill's involvement see Alan Powers, Oliver Hill: Architect and Lover of Life 1887–1968, Mouton Publications 1989, pp.42–5.

180. Janet Raden, Sir Archie Roylance's 'clean-run' comrade in Buchan's John McNab (1925), would fit the bill.

181. Christian Barman, The Man who built London Transport: A Biography of Frank Pick, David and Charles, Newton Abbot, 1979, p.175; Noel Carrington, Industrial Design in Britain, George Allen & Unwin Ltd, p.125.

182. W.R. Lethaby, Town Tidying, was reprinted in Form in Civilisation. Collected essays on art and labour, Oxford University Press 1922.

183. Barman, op.cit., p.176.

184. Frank Pick, 'Foreword', Guide to the pavilion of the United Kingdom, 1937.

185. P.M. Taylor, The Projection of Britain: British Overseas Publicity and Propaganda 1919–1939, Cambridge 1981, p.120.

186. Barman, op.cit., p.194.

187. J.M. Richards, 'The Problem of National Projection', Architectural Review, September 1937, p.106.

188. Ibid.

189. Council for Art and Industry. Paris exhibition – British Pavilion. Views of Members of the Council. PRO, Board of Trade, PRO BT 57/19 336/37 Paris 37.

190. Paul Greenhalgh, Ephemeral Vistas: The Expositions Universelles, Great Exhibitions and World's Fairs 1851–1939,

Manchester University Press 1988, pp.137–8.

191. For an overview see Michael Young's penetrating *The Elmhirsts of Dartington: The Creation of an Utopian Community*, Routledge & Kegan Paul 1982 and Victor Bonham-Carter's more pedestrian *Dartington Hall: The History of an Experiment*, Phoenix House 1958.

192. Young, *op.cit.*, pp.91, 339.

193. Leach, *Memoirs*, p. 162.

194. See William Boyd, Wyatt Rawson, *The Story of the New Education*, Heinemann 1965; Robert Skidelsky, *English Progressive Schools*, Penguin, Harmondsworth 1969.

195. Young, *op.cit.*, pp. 263–1.

196. As seen above Leonard Elmhirst had read Veblen and had noted Graham Wallas's calculation that individuals in William Morris's utopian community outlined in *News From Nowhere* needed to work a 200 hour week to match mass production. Young, *op.cit.*, p.270.

197. Victor Bonham-Carter, 'Dartington Hall 1925–56. A Report ' (typed ms), Dartington Hall Ltd, vol. 1, 8 Textiles, Dartington Hall Archive, hereafter DHA.

198. Heremon Fitzpatrick, 'Some Impressions and Details of a Tour amongst the Welsh Textile Workers', Progress Reports A. 1926–1934, C. Textiles 1. DHA.

199. H. Hague, Textile Report, Progress Reports A 1926–1934, C Textiles 1. DHA.

200. Mark Kidel, 'Ten Days at the Mill', C. Textiles 3., DHA.

201. Elizabeth Peacock to Dorothy Elmhirst, 26 June 1938, DWE General SI.D. Hall Banners, (Peacock) DHA.

202. Young, *op.cit.*, p.293 and *Gardens Catalogue*, Dartington Hall Ltd 1935.

203. *A Dartington Anthology 1925–1975*, Dartington Press Ltd, p. 35.

204. 'Dartside' brochure, Staverton Builders Ltd, n.d., DHA.

205. See Oliver Watson (1990); Victor Bonham-Carter, 'Dartington Hall 1925–56. A Report ' (typed ms), Dartington Hall Ltd, vol. 11, A The Arts, DHA; also David Jeremiah, 'Beautiful Things: Dartington and the Art of the Potter and Weaver', in Harrod, *Conference*.

206. Young, *op.cit.*, pp.196–7.

207. Soetsu Yanagi to Leonard Elmhirst, 4 August 1929, T Arts Applied 3, Bernard Leach, General correspondence 1926–1979, DHA.

208. Bernard Leach to Leonard Elmhirst, 11 December 1931, T Arts Applied 3, Bernard Leach, General correspondence, 1926–1979, DHA.

209. Bernard Leach to Leonard Elmhirst, 11 December 1931, T Arts Applied 3, Bernard Leach, General correspondence 1926–1979, DHA.

210. Bernard Leach to Mrs K. Starr, 20 December 1923, 2542 Leach Archive, CSC.

211. Bernard Leach to Leonard Elmhirst, 4 December 1934, T Arts Applied 3, Bernard Leach, General correspondence 1926–1979, DHA.

212. See Harry Davis to Bernard Leach 19 April 1935, 2597, Leach Papers, CSC; Harry Davis, 'Handcraft Pottery – Whence and Whither', *Ceramic Review*, 93, May/June 1985, pp.10–17.

213. Bernard Leach, *A Potter's Book*, Faber & Faber 1940, p.258.

214. Bernard Leach to Dr Slater, 19 September 1935, T Arts Applied 3, Bernard Leach, General correspondence 1926–1979, DHA.

215. Dr Slater to Leonard Elmhirst, 3 December 1935, T Arts Applied 3, Bernard Leach, General correspondence 1926–1979, DHA.

216. 'Memorandum on the re-organisation of the Leach Pottery', 21 June 1937, T Arts Applied 3, Bernard Leach, General correspondence 1926–79, DHA.

CHAPTER FOUR

1. Raymond Williams, *The Country and the City*, Chatto & Windus 1973.

2. See Ruskin's passage on 'this English room of yours', in *The Stones of Venice* vol. 11 in E.T. Cook, Alexander Wedderburn (eds), *The Works of John Ruskin*, Library Edition, George Allan, 1903–12, vol. x, 104, p.193.

3. Karl Marx, *Capital*, vol. 1, Lawrence & Wishart 1954, especially Part 1, Section 4, 'The Fetishism of Commodities and the Secret thereof', pp.76–87.

4. See Peter Conrad, *The Victorian Treasure House*, Collins 1973, pp.71–105.

5. Roger Fry, 'Art and Socialism', in *Vision and Design*, Chatto and Windus 1928, pp.67–9.

6. Quoted in Idris Parry, 'Rilke and Things', in Harrod, *Conference*, p.14.

7. Rilke to Dr Alfred Schaer, 16 February 1924, translated by Ralph Beyer.

8. Quoted in Anna Bramwell, *Ecology in the 20th Century: A History*, Yale University Press 1989, p.190.

9. See Esther Leslie, 'Walter Benjamin: Traces of Craft', in Harrod, *Conference*, p.24.

10. D.H. Lawrence, *Women in Love* (1922), Penguin Books, Harmondsworth 1960, pp.400–1. Nigel Wheale (ed.), *The Postmodern Arts*, Routledge 1995, pp.10–14 and Christoph Asendorf, *Batteries of Life. On the History of Things and their Perception in Modernity*, University of California Press 1993, both develop parallel ideas about anxiety about objects in this period.

11. Frank Lloyd Wright, *An Autobiography*, Faber & Faber 1945, pp.130–1.

12. Le Corbusier, *The Decorative Art of Today*, translated James I. Dunnett, The Architectural Press, 1987.

13. ARG *Autobiography*, vol. II, part VI, p.24, and part IX, p.26.

14. Cardew, *Autobiography*, p.11.

15. Michael Cardew, 'The Craftsman's Use of Scientific Development', in ICC.

16. See below, pp.187–8, and Tanya Harrod, '"The Breath of Reality": Michael Cardew and the Development of Studio Pottery in the 1930s and 1940s', *Journal of Design History*, vol. 2, nos 2–3, 1989, p.152.

17. Robin Tanner, *Double Harness: An Autobiography*, Impact Books 1990, p.111.

18. Katharine Pleydell-Bouverie in a review of Gillian Naylor's 'The Arts and Crafts Movement', in *Ceramic Review*, no. 13, February 1972, pp.14–15.

19. Cardew, *Autobiography*, p.16.

20. A. Romney Green, 'Principles and Evolution of Furniture Making – 1', *Burlington Magazine*, vol. XXI, April 1912, pp.36–41.

21. ARG Autobiography, vol. II, part IX, p.26.

22. *This Woodwork. Stanley W. Davies, Hand-made Furniture*, Windermere n.d. *c.*1939.

23. A. Romney Green to Philip Mairet, 5 May 1928, New Handworkers' Gallery Papers, CSC.

24. Quoted in Thomas Hennell, *British Craftsmen*, William Collins 1943, pp.40–1.

25. See Judith Ennew, 'Harris Tweed: construction, retention and representation of a cottage industry', in Esther N. Goody (ed.), *From Craft to Industry: the ethnography of proto-industrial cloth production*, Cambridge University Press 1982, pp.166–99.

26. Sarah Brown, *Stained Glass: An Illustrated History*, Studio Editions, 1992, p.30.

27. Patricia Baines, *A Linen Legacy: Rita Beales 1889–1987*, Crafts Study Centre, Bath, p.38.

28. Bernard Berenson, *Aesthetics and History*, Constable 1950, p.51. Berenson was writing from an inter-war perspective as he was 'years writing this essay' which was completed in 1941.

29. Ibid., p.23.

30. Ibid., p.53.

31. Ibid., p.133.

32. Edward Johnston, *Writing & Lettering & Illuminating*, John Hogg 1906, p.204.

33. A. Romney Green, 'Principles and Evolution of Furniture Making – 11', *Burlington Magazine*, vol. XXI, 1912 , p.102.

34. Bernard Rackham, 'Glass Painting as an Art for To-day – Part 11', *Artwork*, vol. 2, no. 6, Jan–March 1926, p.113.

35. Quoted in Holly Tebbutt, 'Industry or Anti-Industry? The Rural Industries Bureau: Its Objects and Work', V&A/RCA MA thesis 1990, p.63.

36. Crafts Council/Crafts Study Centre, *Katharine Pleydell-Bouverie: A Potter's Life 1895–1985*, 1986, p.31.

37. Ibid., p.29.

38. Isabelle Anscombe, *A Woman's Touch: Women in Design from 1860 to the Present Day*, Viking 1984, p.159.

39. Frances Woollard, 'On hand-printed Textiles', DIA *Quarterly Journal*, new series, no. 3, March 1928, p.5.

40. Thomas Hennell, *British Craftsmen*, William Collins 1943, p.18.

41. Edward Johnston, 'Signwriting', lecture given at Leicester 1906 in Heather Child, Justin Howes (eds.), *Edward Johnston, Lessons in Formal Writing*, Lund Humphries, 1986, p.91.

42. Ibid., p.41.

43. Ibid., p.153.

44. Margot Coatts, *A Weaver's Life: Ethel Mairet 1872–1952*, Crafts Council/Crafts Study Centre, Bath, 1983, p.83.

45. Rosemary Edmonds and Muriel Rose, 'The Work of Jean Milne', *The Journal, Quarterly journal of the Guild of Weavers, Spinners and Dyers*, no. 9, March 1954, pp.264–5.

46. Margery Kendon, 'Newport in County Mayo' (1936) manuscript in the possession of Susan Rogers, p.23.

47. See Rebeccca Crompton, *Modern Design in Embroidery*, B.T. Batsford 1936.

48. See above p.55.

49. Brocard Sewell, 'H.D.C. Pepler', in *Like Black Swans: Some People and Themes*, Tabb House, Padstow, Cornwall 1982, p.146.

50. On the fashion for Bergson *c.*1910–20 see Rachel Gotlieb, 'The Critical Language and Aesthetic Criteria of Art-Pottery Manufacturers and Studio-Potters 1920–34', V&A/RCA MA thesis, 1987, Chapter 4.

51. William Staite Murray, 'Pottery and the Essentials in Art', *Arts League of Service Bulletin 1923–1924*, 1925 and 'Pottery from the Artist's Point of View', *Artwork*, vol. 1, no. 4, May–August 1925, pp.201–5.

52. Quoted in Haslam (1984), p.70.

53. Ibid., pp.66–8.

54. Leach, *Memoirs*, p.146.

55. Bernard Leach, *A Potter's Book*, Faber & Faber, 1940, p.19.

56. Cardew, *Autobiography*, p.25.

57. Bernard Leach, *A Potter's Book*, Faber & Faber 1940, p.228.

58. Elizabeth Peacock to Dorothy Elmhirst, 16 December 1828, DWE. General SI, D, Hall Banners (Peacock), DHA.

59. ICC, p.113.

60. See Anthony Baker, *The Quest for Guido*, The Private Library, 2nd series, vol. 2:4, Winter 1969.

61. Roderick Cave, *The Private Press*, Faber & Faber 1971, p.195.

62. Margot Coatts, *A Weaver's Life. Ethel Mairet 1872–1952*, Crafts Study Centre/Crafts Council 1983, p.60.

63. On this point see Igor Kopytoff, 'The cultural biography of things', in Arjun Appadurai (ed.), *The Social Life of Things: Commodities in Cultural Perspective*, Cambridge University Press 1986, p.76.

64. John Farleigh, 'Craftsmanship 1 – The Crafts – the Past, Present and Future', *Journal of Royal Society of Arts*, 5 December 1947, p.29.

65. C.R. Ashbee, 'Journals', early June 1915, Modern Archive Centre, King's College, Cambridge. My thanks to Alan Crawford for this reference.

66. See Stanley Pierson, *British Socialists: The Journey from Fantasy to Politics*, Harvard University Press, Cambridge MA, 1979.

67. This idea runs through much of his writing but see, for instance, *The Journals of T.J. Cobden-Sanderson 1879–1922*, Richard Cobden-Sanderson, 1926, vol. 1, p.268.

68. See Margaret Cole, 'Guild Socialism and the Labour Research Department', in Asa Briggs, John Saville (eds), *Essays in Labour History 1886–1923*, vol. ii, Macmillan 1971, p.263.

69. Penty was a partner in the family firm Penty and Penty in York in the 1890s. His work was inspired by Norman Shaw and the Georgian architecture of York and he lived in a cottage filled with simple furniture of his own design. By 1902 he was in London where he was to work with Sir Raymond Unwin on Hampstead Garden Suburb, designing furniture with Charles Spooner and Fred Rowntree, made by their firm Elmdon and Company formed in 1905. In 1905 he was living with A.R. Orage in Hammersmith.

70. A.J. Penty, *Tradition and Modernism in Politics*, Sheed & Ward 1937, p.138.

71. See S.T. Glass, *The Responsible Society: The Ideas of the English Guild Socialists*, Longmans 1966.

72. ARG *Autobiography*, part II, chapter VIII, p.32–5.

73. See Glass, op.cit., p.43.

74. Margaret Cole, *op.cit.*, pp.273–80.

75. Holly Tebbutt, 'Industry or Anti-Industry? The Rural Industries Bureau: Its Objects and Work', V&A/RCA MA thesis 1990, pp.108–9.

76. Walter Shewring (ed.), *The Letters of Eric Gill*, Jonathan Cape 1947, pp.467–8. For his doubts about the Cole version of Guild Socialism see Gill's article, 'The Guild Hutch', *The Game*, vol. IV, no. 2, February 1921, pp.23–8.

77. A.J. Penty, *Post-Industrialism*, George Allen 1922, p.117.

78. S.G. Hobson, *Pilgrim to the Left: Memoirs of a Modern Revolutionist*, E. Arnold & Co. 1938, p.176.

79. John Gloag, *Artifex or The Future of Craftsmanship*, Kegan Paul 1926, p.12.

80. Cicely Hamilton, *Theodore Savage. A Story of the Past or the Future*, Leonard Parsons 1922, p.296. On Hamilton's circle see Johanna Alberti, 'The Turn of the Tide: Sexuality and Politics 1928–31', *Women's History Review*, vol. 3, no. 2, 1994, pp.169–90.

81. Hamilton, *op.cit.*, p.173.

82. Gloag, *op.cit.*, p.25.

83. Hilaire Belloc, *The Servile State*, (1912), 3rd edition with new preface, Constable & Co. Ltd., 1927.

84. Eric Gill, *Sculpture. An Essay on Stone-Cutting, with a preface about God*, St Dominic's Press, Ditchling 1924, p.14.

85. ARG *Autobiography*, vol. II, p.17; also *G.K.'s Weekly*, 18 February 1937.

86. H.J. Massingham, *Remembrance: An Autobiography*, B.T. Batsford 1942, p.32.

87. H.J. Massingham, *Country Relics*, Cambridge University Press 1939, p.178.

88. K.L. Kenrick, 'The Liverpool Exhibition', *G.K.'s Weekly*, 17 December 1927, p.844.

89. J.V.D.K., 'On Dealing with Craftsmen', *G.K.'s Weekly*, 18 February 1928, p.972.

90. *G.K.'s Weekly*, 25 February 1928, p.988.

91. See *G.K.'s Weekly* 1925–37, then *G.K.'s Weekly and the Weekly Review* 1937–38.

92. *The Distributist*, new series, vol. iii, no. 1, May 1934, p.11; no. 2, June 1934, p.18; no. 3, July 1934, p.31.

93. *The Distributist*, vol. iii, no. 4, 1934, p.39.

94. On McNabb see Brocard Sewell, 'Father Vincent McNabb', in *Like Black Swans. Some People and Themes*, Tabb House, Padstow 1982, pp.111–14.

95. J.F. Scanlan (trans.), *Art and Scholasticism*, Sheed & Ward 1930, pp.7–10.

96. Timothy Elphick, 'The Foundation of the Guild of St Joseph and St Dominic', in *Eric Gill and the Guild of St Joseph and St Dominic*, Hove Museum and Art Gallery 1990, pp.7–13.

97. Ibid., pp.11–12.

98. John V.D. KilBride, 'George Maxwell of Ditchling Common', *Journal of the Guild of Weavers, Spinners and Dyers*, June 1957, no. 22, pp.3–4.

99. See *Translation of the Encyclical of his Holiness Pope Pius XI 'On the Reconstruction and Perfection of the Social Order'*, Catholic Social Guild, Oxford 1934.

100. *The Cross and the Plough, Journal of the Catholic Land Association of England and Wales*, Sutton Coldfield, SS. Peter and Paul, 1939, p.5.

101. *The Cross and the Plough*, Ladyday, 1948.

102. Katharine Pleydell-Bouverie to Bernard Leach, 11 June 1926, Leach papers, 2420, CSC. Also see Susan Faulkner, *A Ditchling Childhood 1916–1936*, Iceni Publications, Suffolk 1994. As Douglas Pepler's daughter she gives a sharply critical account of the lot of women in the Ditchling Guild community.

103. Cardew, *Autobiography*, p.50.

104. Dom Bede Griffths, *The Golden String*, The Harvill Press 1954, p.61.

105. Ibid., p.85.

106. See John L. Finlay, *Social Credit: The English Origins*, McGill Queens University Press, Montreal and London, 1972.

107. See A. Romney Green to Mairet 1 April 1928, New Handworker papers, CSC; on the Chandos Group see Maurice Reckitt, *As It Happened: An Autobiography*, J.M.

108. Reggie Turvey to Bernard Leach 2 February 1935, 2598, Leach Archive, CSC.

109. Eric Gill to the editor of *The Engineer* 3 May 1935 in Walter Shewring (ed.), *The Letters of Eric Gill*, Jonathan Cape 1947, p.330.

110. ARG *Autobiography*, vol. II, part VIII, p.37.

111. Eric Gill to the Editor of the *New English Weekly*, 15 November 1934 in Shewring, *op.cit.*, p.312.

112. Quoted in David Bradshaw, 'T.S. Eliot and the Major', *T.L.S.*, 5 July 1996, p.15.

113. See Lynda Morris, Robert Radford, *The Story of the Artists International Association 1933–1953*, Museum of Modern Art, Oxford 1983.

114. Ibid., pp.14, 26.

115. Ibid., p.29.

116. Eric Gill to the Editor of *The Catholic Herald*, 3 November 1934, Walter Shewring (ed.), *The Letters of Eric Gill*, Jonathan Cape 1947, pp.307–9.

117. Eric Gill to Philip Henderson, 29 May 1935, Shewring, *op.cit.*, p.335.

118. Ibid., p.309.

119. See Eileen M. Hampson, 'Henry Bergen: Friend of Studio Potters', *Journal of the Northern Ceramic Society*, vol. 8, 1991, pp.73–90.

120. Cardew, *Autobiography*, pp.95–101.

121. Henry Bergen to Bernard Leach, 14 February 1935, Leach papers 2407, CSC.

122. Bergen to Leach 7 August 1937, Leach papers 3181, CSC.

123. Ibid.

124. Bergen to Leach 21 August 1937, Leach papers 3183, CSC.

125. Bergen to Leach 3 September 1937, Leach papers 3185, CSC.

126. Bergen to Leach 18 September 1937, Leach papers 3189, CSC.

127. Bergen to Leach n.d. c. 1937, Leach papers 3210, CSC.

128. Bergen to Leach 13 August 1937, Leach papers 3182, CSC.

129. The correspondence between Richard de la Mare and Bernard Leach runs from October 1936 to November 1940, Leach papers 2943–3113, CSC.

130. Eric Hobsbawm, 'Morris on Art and Socialism', *Our Time*, April 1948, vol. 7, no. 7., p.176.

131. Quoted in *Internationale Handwerks Ausstellung*, Berlin 28 May–10 July 1938.

132. See Design Center, Stuttgart, *Frauen im Design: Berufsbilder und Lebenswege seit 1900*, 1989, pp.234–3.

133. See G.R. Hughes, 'Note of a visit of G.R. Hughes, H.G Murphy and R. Hill to Berlin, May/June 1938 in conjunction with the International Exhibition of Handicrafts', Box O.11.3, WCG.

134. See Richard Griffiths, *Fellow Travellers of the Right: British Enthusiasts for Nazi Germany 1933–9*, Constable 1980, pp.308, 309, 312–13.

135. H.J. Massingham, *Remembrance: An Autobiography*, Batsford 1942, p.142. On Gardiner in general see Andrew Best (ed.), *Water Springing up from the Ground. An Anthology of the Writings of Rolf Gardiner*, Springhead, Fontmell Magna, Shaftesbury, Dorset 1972. For two views of Gardiner see Anna Bramwell, *Ecology in the 20th Century. A History*, Yale University Press 1989, pp.112–22 and Patrick Wright, *The Village that Died for England: The Strange Story of Tyneham*, Vintage 1995, pp.150–202.

136. Rolf Gardiner, *England Herself: Ventures in Rural Restoration*, Faber & Faber 1943, p.13.

137. Ibid., p.100–7.

138. See the pamphlet *First Wessex Festival School and Tour of English and German Singers and Players, August–September 1933*, Springhead 1933, Rolf Gardiner file, DHA.

139. Rolf Gardiner to Leonard Elmhirst, 16 June 1933, Rolf Gardiner file, DHA.

140. Rolf Gardiner to Leonard Elmhirst, 28 September 1933, Rolf Gardiner file, DHA.

141. Rolf Gardiner, *The English Folk Dance Tradition: An Essay*, Neue Schule Hellerau, A-G., Hellerau bei Dresden 1923, p.30.

142. Rolf Gardiner, 'Generations and Leadership', *The New English Weekly*, 12 December 1940, p.89.

143. Apart from a handful of Labour M.P.s led by Oswald Mosley only the declining Liberal Party used Keynesian theory to justify intervention to alleviate unemployment and fought the 1929 election on that basis.

144. See the film *Today We Live* (1936 Strand Films) for the NCSS and the Land Settlement Association which contrasted life in Rhondda Valley and South Cerney in the Cotswolds. Also two other Strand films *Here is the Land* (dir. Stanley Hawes) and *Eastern Valley* (dir. Donald Alexander).

145. See Ralph H.C. Hayburn, 'The Voluntary Occupational Centre Movement 1932–39', *Journal of Contemporary History*, 6, 1971, pp.156–71; Margaret Brasnett, *Voluntary Social Action: A History of the National Council for Social Service 1919–1969*, NCSS 1969, Chapter Four.

146. Thomas Jones, *A Diary with Letters 1931–1951*, Oxford University Press 1954, p.85.

147. Hayburn, *op.cit.*, pp.159, 65.

148. On working class leisure see Chapters 4, 5 and 8 of Ross McKibbin, *The Ideology of Class: Social Relations in Britain 1880–1950*, Oxford University Press 1991.

149. Pilgrim Trust, *Men without Work*, Cambridge University Press 1938, p.285.

150. Henry Durant, *The Problem of Leisure*, Routledge, 1938, p.106. On Durant see McKibbin, *op.cit.*, pp.148–9.

151. 'Notes and Comments', *Rural Industries*, Special Unemployment Number, Spring 1933, no. 30, p.5.

152. J.B. Priestley, *English Journey*, William Heinemann Ltd/Victor Gollancz Ltd, 1934, p.282.

153. Ellen Wilkinson, *The Town that was Murdered: The Life Story of Jarrow*, Victor Gollancz Ltd., 1939, p.232.

154. See Margaret Cole, 'Guild Socialism and the Labour Research Department', in Asa Briggs, John Saville, *Essays in Labour History 1886–1923*, Macmillan, 1971, pp.282–3.

155. Allen Hutt, *The Condition of the Working Class in Britain*, Martin Lawrence Ltd., 1933, p.185.

156. Harold Stovin, *Totem: The Exploitation of Youth*, Methuen & Co., 1935, p.153.

157. Ibid., p.154.

158. Lord Lymington, *Famine in England*, H.F. and G. Witherby Ltd., 1938. On Lymington see Anna Bramwell, *Ecology in the 20th Century. A History*, Yale University Press 1989, pp.117–18 and Patrick Wright, *The Village that Died for England: the Strange Story of Tyneham*, Vintage 1996, pp.171–5.

159. Rolf Gardiner, *England Herself: Ventures in Rural Restoration*, Faber & Faber 1943, p.62.

160. Arthur R. Cobb, 'Grith Fyrd camps', *Rural Industries*, Autumn 1932, no. 28, pp.8–10. For a less rosy view see Harold Stovin, *Totem: The Exploitation of Youth*, Methuen 1935.

161. J.W. Scott, 'Homecrofting', *G.K.'s Weekly*, 7 January 1937; 14 January 1937.

162. Pilgrim Trust, *Men without Work*, Cambridge University Press 1938, p.360.

163. Ibid., p.161.

164. Ibid., p.157.

165. ARG *Autobiography*, part III, p.8.

166. Ibid., part iii, introduction to chapter x.

167. A.R. Green, 'Wood Working for the Unemployed', *Rural Industries*, a series appearing from Summer 1933 to Autumn 1934.

168. For an excellent account of the RIB quilt initiative see Holly Tebbutt, 'Industry or Anti-Industry? The Rural Industries Bureau: Its Objects and Work', V&A/RCA MA thesis 1990.

169. 'The Quilting Industry', *Rural Industries*, December 1928, p.13.

170. 'Notes', *Rural Industries* no. 14, Winter 1929, p.8.

171. Muriel Rose Archive, CSC has an album of photographs of quilts, an order form sent to quilters by the Little Gallery and Muriel Rose's diary of her visits to quilters in Durham in 1934 and South Wales in 1939.

172. *Rural Industries*, Winter no. 17, 1939, p.8.

173. Tebbutt, *op.cit.*, p.50.

174. Illustrated in Noel Carrington, *Design in the Home*, Country Life Ltd, 1933, pp.31, 188.

175. This point was made in 'The Quilting Industry', *Rural*

Industries, 13 December 1928, p.11.

176. Mavis FitzRandolph, 'The Welsh Quilt Wives and their Work', *Rural Industries*, June 1928, no. 11, p.10.

177. Tebbutt, *op.cit.*, p.80.

178. Quoted in Tebbutt, *op.cit.*, p.80.

179. Ibid., p.80.

180. Reported in *Rural Industries*, Autumn 1930, no. 20, p.3.

181. A. Romney Green, 'The Life of a Small Working Master', mss talk, Folder 2, Early Work, NAL.

182. Brocard Sewell, 'H.D.C. Pepler', in *Like Black Swans: Some People and Themes*, Tabb House, Padstow, 1982, p.138.

183. Bernard Leach, *A Potter's Challenge*, Souvenir Press 1976, p.18

184. See Tate Gallery, *St Ives 1939–64: Twenty-Five Years of Painting, Sculpture and Pottery*, Revised Edition, Tate Gallery 1985, p.134. This section is based on a taped conversation between the author and Dicon Nance, 17 July 1991.

185. This section is based on an interview with Sidney Tustin conducted by Walter Keeler and Alex MacErlain, 27 May 1994 for the National Electronic and Video Archive of the Crafts, Faculty of Art, Media and Design, University of the West of England, Bristol.

186. Bernard Leach, *A Potter's Book*, Faber & Faber 1940, p.258.

187. Harry Davis, 'Handcraft Pottery – Whence and Whither', *Ceramic Review*, 93, May–June 1985, p.12.

188. Ibid., p.14.

189. Ibid., p.17.

190. Harry Davis to Bernard Leach, 19 April 1935, Leach papers 2597, CSC.

191. Harry Davis, 'Harry Davis, Potter', unpublished autobiography p.27. Davis Family archive.

192. Sir George Trevelyan, 'The Workshop of Peter Waals: A Tribute from a Pupil', in *Ernest Gimson*, Leicester Museum 1967.

193. Gordon Russell, *Designer's Trade*, George Allen & Unwin 1968, p.128.

194. Eric Gill, *Autobiography*, Jonathan Cape 1940, p.119.

195. J.H. Mason, 'The Place of Hand-work in Modern Civilization', in *Four Papers*, Arts and Crafts Exhibition Society 1935.

196. L.T. Owens, *J.H. Mason 1875–1951 Scholar-Printer*, Frederick Muller Ltd., 1976, p.26.

197. ARG *Autobiography*, part 11, chapter IX, p.16.

198. David Pye, *The Nature and Art of Workmanship*, Cambridge University Press, 1968, p.20.

199. Clive Bell, *Art*, Chatto & Windus, 1914, p.36.

200. F.R. Leavis, Denys Thompson, *Culture and Environment: The Training of Critical Awareness*, Chatto & Windus 1959, p.1.

201. See Iain Wright, 'F.R. Leavis, the Scrutiny Movement and the Crisis', in *Cultures and Crisis in Britain in the Thirties*, J. Clark, M. Heinemann, D. Margolies, C. Snee (eds), Lawrence and Wishart, 1979.

202. Adrian Bell, review of Thomas Hennell's *Change on the Farm*, *Scrutiny* vol. 11, no. 4, March 1934, pp.409–11.

203. Gordon Russell, *Designer's Trade: the Autobiography of Gordon Russell*, George Allen & Unwin Ltd., 1968, p.20.

204. Bernard Leach, 'The Contemporary Studio Potter', *Journal of the Royal Society of Arts*, 21 May 1948, p.371.

205. Katharine Pleydell-Bouverie to Bernard Leach, 8 August 1931, Leach papers 2508, CSC.

206. Michael Cardew, 'The Craftsman and the Machine', typed ms 1933, Cardew papers.

207. Cardew, *Autobiography*, p.73.

208. Dorothy Hartley, *Made in England* (1939) Century, 1987, p.172.

209. Ibid., p.xi.

210. See Annette Carruthers, 'Writers and Thinkers: Freda Derrick', *Crafts*, 131, November/December 1994, pp.18–19.

211. Thomas Hennell, 'Country Craftsmen: the Potter', *Architectural Review*, vol. XCIV, August 1943, pp.49–51, appearing posthumously with Hennell's other essays in the series as J.M. Richards (ed.), *The Countryman at Work*, Architectural Press 1947.

212. H.J. Massingham, *Remembrance: An Autobiography*, Batsford 1942, p.2.

213. H.J. Massingham, *Country Relics*, Cambridge University

Press 1939, p.103. Also see *Shepherd's Country: A Record of the Crafts and People of the Hill*, Chapman and Ward, 1938, pp.103–5 for more lyrical meditations on the breast plough.

214. Massingham, *op.cit.* (1939) p.108.

215. H.J. Massingham, *The English Countryman. A Study of the English Tradition*, B.T. Batsford 1942, p.54.

216. Massingham, *op.cit.*, (1942) p.142.

217. H.J. Massingham, *Shepherd's Country. A Record of the Crafts and Peoples of the Hills*, Chapman & Ward, 1938, p.269.

218. Massingham, *op.cit.* (1939) p.184.

219. Massingham, *op.cit.* (1939) p.93.

220. J.B. Priestley, *English Journey*, William Heinemann Ltd/Victor Gollancz Ltd 1934, p.50.

221. Ibid., p.51.

222. As F.L.M. Griggs said of Gimson 'With his wife he taught Sapperton how to "enjoy itself"'. See William Lethaby, Alfred Powell, F.L.M. Griggs, *Ernest Gimson: His Life and Work*, Shakespeare Head Press, Stratford upon Avon 1924, p.32.

223. Leach, *Memoirs*, p.138.

224. Cardew, *Autobiography*, p.74.

225. See for instance J. M. Synge, *The Aran Islands* (1907) Penguin, Harmondsworth, 1992.

226. Margery Kendon, 'Newport in County Mayo' (1936), ms in the collection of Susan Rogers.

227. May Morris, 'Weaving and Textile Crafts', in *Handicrafts and Reconstruction: Notes by members of the Arts and Crafts Exhibition Society*, John Hogg 1919, p.44.

228. Amelia Defries, *Purpose in Design. A survey of the new movement seen in studios and factories and at the Exposition Internationale des Arts et Techniques appliqués à la Vie moderne*, Paris 1938, p.59. It would be good to know more about Defries, one of the few women writing on design between the wars and author of, *inter alia*, *The Fortunate Islands. Being adventures with a negro in the Bahamas*, Cecil Palmer 1929; *The Interpreter: Geddes. The Man and his Gospel*, George Routledge and Sons 1927; *Sheep and Turnips: Being the Life and Times of Arthur Young*, Preface by R.A. Butler, Introduction by Montague Fordham, Methuen 1938.

229. Nicola Gordon Bowe, Elizabeth Cumming, *The Arts and Crafts Movements in Dublin & Edinburgh 1885–1925*, Irish Academic Press, Dublin 1998.

230. Ella McLeod, 'The Diary of a Visit to Brittany Summer 1938', p.46, typescript in the possession of the author.

231. Margot Coatts, *A Weaver's Life: Ethel Mairet 1872–1952*, Crafts Council/Crafts Study Centre, Bath, 1983, pp.84–93.

232. Michael Cardew, *A Pioneer Potter*, Collins, 1988, p.32.

233. Cecil Sharp, *English Folk-Song. Some Conclusions*, Maud Karpeles (ed.), E.P. Publishing Ltd., Wakefield 1972, pp.151–2; For fine insights into this process see Georgina Boyes, *The Imagined Village: Culture, Ideology and the English Folk Revival*, Manchester University Press, 1993, pp.1–21.

234. Sir George Trevelyan, 'The Workshop of Peter Waals: A Tribute from a pupil', in *Ernest Gimson*, Leicester Museum 1969, p.40.

235. For a good overview see Tebbutt, *op.cit.*

236. G.E. Marston, 'The Educational Value of Handicrafts', *Rural Industries*, Autumn 1933, p.71.

237. Tebbutt, *op.cit.*, p.91.

238. Tebbutt, *op.cit.*, p.105.

239. For a critical look at the RIB's policies see W.M. Williams, *The Country Craftsman: A Study of Some Rural Crafts and the Rural Industries Organisations in England*, Dartington Hall Studies in Rural Sociology, Routledge, Kegan, Paul, 1958.

240. Enid Marx, Dorothy Lambert, *English Popular and Traditional Art*, Collins, 1946, p.8.

241. On this aesthetic see Richard Morphet, 'Eric Ravilious and Helen Binyon', in Helen Binyon, *Eric Ravilious: Memoir of an Artist*, Lutterworth Press 1983, p.8.

242. Edward Gordon Craig, 'Puppets and Poets', *The Chapbook: A Monthly Miscellany*, no. 20 February 1921. For an overview of inter-war puppetry see Cyril W. Beaumont, *Puppets and the Puppet Stage*, The Studio Ltd., 1938.

243. Crafts Council, *The Omega Workshops 1913–19: Decorative Arts of Bloomsbury*, 1984, pp.30–1; Denise Hooker, *Nina Hamnett: Queen of Bohemia*, Constable, 1986, p.86, 99.

244. Michael Young, *The Elmhirsts of Dartington*, Dartington Hall Trust, Totnes 1996, p.221.

245. Binyon, *op.cit.*, pp.13–17.

246. For Simmonds see William Rothenstein, 'The Marionettes of William Simmonds', *Creative Art: A Magazine of Fine and Applied Art*, vol. v, no. vi, December 1929, pp.855–8; Cheltenham Art Gallery and Museum, *William and Eve Simmonds*, 1980; Jacqueline Sarsby, 'String Movement', *Crafts*, no. 128, May/June 1994, pp.24–9. His papers, diaries and photographs are in the Tate Gallery Archive.

247. Roger Lipsey, *Coomaraswamy: His Life and Work*, Bollingen Series LXXXIX, Princeton 1977, vol. 3, p.60.

248. William Morris, *The Art of the People* (1879), in *The Collected Works of William Morris* with an introduction by his daughter May Morris 1910–1915, repr. Russell & Russell, New York 1966, vol. XXII, p.36.

249. See Robin Skelton, 'The Indian Collections 1798 to 1978', *Burlington Magazine*, no. 297, 1978, pp.301–3; Partha Mitter, *Art and nationalism in colonial India 1850–1922*, Cambridge University Press 1994, pp.308–12.

250. Roger Fry, 'Oriental Art', *The Quarterly Review*, no. 422, January 1910, p.225.

251. See *Ajanta Frescoes being reproductions in colour and monochrome of frescoes in some of the caves in Ajanta after copies taken in the years 1909–11 by Lady Herringham and her assistants*, India Society, Oxford University Press 1915, p.20.

252. Ella McLeod, 'Monograph on Elizabeth Peacock 1880–1969', in *Weaving by Elizabeth Peacock*, Crafts Study Centre, Holburne Museum, Bath 1979, p.7.

253. Amelia Defries, 'Craftmen of the Empire: A Comparative Study of Decorative and Industrial Arts', *Architectural Review*, vol. lv, June 1924, p.269.

254. On Coomaraswamy see Roger Lipsey, *Coomaraswamy: His Life and Work*, Bollingen Series LXXXIX, Princeton, 1977, vol. 3. Also Tapati Guha-Thakurta, *The making of a new 'Indian' art: artists, aesthetics and nationalism in Bengal 1850–1920*, Cambridge University Press 1992.

255. Ananda Coomaraswamy, *Medieval Sinhalese Art. Being a monograph on medieval Sinhalese arts and crafts, mainly as surviving in the eighteenth century, with an account of the structure of society and the status of the craftsman*, Essex House Press, Broad Campden 1908.

256. See, especially, the appendices to Coomaraswamy's *The Indian Craftsman* with a foreword by C.R. Ashbee, Probsthain & Co, 1909.

257. See above p.154.

258. Philip Mairet, *Autobiographical and other papers*, C.H. Sisson (ed.), Carcanet, Manchester 1981, p.44.

259. Lipsey, *op.cit.*, p.29.

260. Ananda Coomaraswamy, *Art and Swadeschi*, Madras, Ganesh Press 1911.

261. S. Durai Raja Singam, 'Gandhi and Ananda Coomaraswamy', in S. Durai Raja Singam (ed.), *Ananda Coomaraswamy: Remembering and Remembering Again and Again*, Kuala Lumpur 1974, pp.310–16.

262. See Alan Crawford, 'Ananda Coomaraswamy and C.R. Ashbee', in Singam, *op.cit.*, pp.239–42.

263. See Malcolm Yorke, *Eric Gill: Man of Flesh and Spirit*, Constable 1981, p.63; Fiona MacCarthy, *Eric Gill*, Faber & Faber 1989, p.99.

264. *Visvakarma: Examples of Indian Architecture, Sculpture, Painting, Handicraft, Chosen by Ananda Coomaraswamy. First series: One hundred examples of Indian sculpture*, Introduction Eric Gill, privately printed 1912–14, p.7.

265. Leach, *Memoirs*, p.299.

266. Ananda Coomaraswamy, *Art and Swadeschi*, Madras, Ganesh Press 1911, pp.138, 140.

267. Philip Mairet, *Autobiographical and Other Papers*, C.H. Sisson (ed.), Carcanet, Manchester, 1981, p.187.

268. Edward Said, *Orientalism: Western Conceptions of the Orient*, Penguin Books, Harmondsworth, (1978) 1991; C.R. Ashbee, foreword to Ananda Coomaraswamy, *The Indian Craftsman*, Probsthain & Co, 1909.

269. Barbican Art Gallery, *Japan and Britain: An Aesthetic Dialogue 1850–1930*, Tomoko Sato and Toshio Watanabe (eds), Lund Humphries, 1991.

270. Basil Gray, *The Development of Taste in Chinese Art in the West*

1872 to 1972, Transactions of the Oriental Ceramic Society, vol. 39, 1972, pp.30–1.

271. Roger Fry, 'Chinese Art', in Roger Fry et al., *Chinese Art: An Introductory Review of Painting, Ceramics, Textiles, Bronzes, Sculpture, Jade etc.*, Burlington Monograph, B.T. Batsford 1925, p.1.

272. Roger Fry, 'Oriental Art', *Quarterly Review*, no. 422, January 1910, p.227.

273. Oscar Wilde, 'The Decay of Lying' (1889), quoted in Barbican Art Gallery, *Japan and Britain*, op.cit., p.40.

274. Waley in particular had no desire to do so. See Ivan Morris, 'Arthur Waley', *Encounter*, December 1966, p.54.

275. Paul Nash, *Room and Book*, Soncino Press Ltd., 1932, p.28.

276. Wells Coates, 'Furniture Today – Furniture Tomorrow. Leaves from a Meta-Technical Notebook', *Architectural Review*, vol. lxxii, July 1932, p.34.

277. Sherban Cantacuzino, *Wells Coates: A Monograph*, Gordon Fraser, 1978, p.11.

278. F. Morley Fletcher, *Wood-block Printing: a Description of the Craft of Woodcutting and Colour Printing Based on the Japanese Practice*, John Hogg 1916, p.86.

279. Paul Nash, 'Modern English Textiles', *Artwork*, Jan–March no. 6, vol. 2, 1926, p.84.

280. London County Council, *Prospectus*, Central School of Arts and Crafts, 1928–9; Central Saint Martins, *Bold Impressions: Block Printing 1910–1950*, 1995.

281. See Yuko Kikuchi, 'Hybridity and the Oriental Orientalism of *Mingei* Theory', *Journal of Design History*, vol. 10, no. 4, 1997, pp.343–54.

282. See Edmund de Waal, 'Homo Orientalis: Bernard Leach and the Image of the Japanese Craftsman', *Journal of Design History*, vol. 10, no. 4, 1997, pp.355–262.

283. See especially Lafcadio Hearn, *Gleanings in Buddha's Fields: Studies of Hand and Soul in the Far East*, Kegan Paul, 1903.

284. For an account of their relationship, see Leach, *Memoirs*, chapter 6.

285. Bernard Leach, 'The English Potters', *The Listener*, 2 January 1947, p.20.

286. Leach, *Memoirs*, p.64.

287. Bernard Leach, 'The Meeting of East and West in Pottery – Part III', *The Far East*, 12 June 1915, p.312.

288. Ibid., p.313.

289. Bernard Leach, 'The Meeting of East and West in Pottery – Part II', *The Far East*, 5 June 1915, p.289.

290. Ibid., p.291.

291. Bernard Leach, 'The Meeting of East and West in Pottery', *The Far East*, 29 May 1915, p.248.

292. Soetsu Yanagi, *The Unknown Craftsman*, adapted by Bernard Leach, Kodansha International, Toyko and New York 1972, p.94. But in Bernard Leach, *Hamada Potter*, Kodansha International Toyko and New York 1975, p.162, a different version is proposed by Hamada in which the term is decided upon by Hamada, Yanagi and Kawai in 1926 while travelling by train through a remote part of Japan.

293. For a discussion of this see Yuko Kikuchi, 'The Myth of Yanagi's Originality: The Formation of *Mingei* Theory in its Social Context', *Journal of Design History*, vol. 7, no. 4, 1994, pp.247–66.

294. See Yuko Kikuchi, op.cit. (1994), p.258.

295. Leach, *Memoirs*, pp.78–9.

296. Bernard Leach, *A Potter in Japan*, Faber & Faber 1960, p.161.

297. Soetsu Yanagi, *The Unknown Craftsman*, Kodansha International, Tokyo and New York (1972) 1989, p.194.

298. Leach, op.cit. (1960), p.161.

299. Yanagi, op.cit., p.208.

300. Yanagi, op.cit., p.134. The talk as given appears in ICC, pp.78–98.

301. 'Some Modern Potters', *Artwork*, no. 19, Autumn 1929, p.192.

302. See *The Leach Pottery 1920–1946*, Berkeley Galleries 1946, unpaginated.

303. Bernard Leach, *A Potter's Outlook*, New Handworkers' Gallery, 1928, p.33.

304. Bernard Leach, 'Foreword', *Exhibition of Contemporary Japanese Crafts, 5 May–23 May*, The Little Gallery (1935).

305. Janet Leach, 'Diary' 1953–4, Leach Archive, 311, CSC.

306. This section based on a conversation with William Marshall, 9 August 1991. I was forbidden to use a tape recorder.

307. See Sydney Cardozo, 'Rosanjin', *Craft Horizons*, April 1972, pp.38–43, 65–6.

308. Bernard Leach, 'Diary' 1954, Leach Archive 313, CSC.

309. Bernard Leach, 'Diary' 1954, Leach Archive 313, CSC.

310. See a copy of Yoshiko Uchida, *We Do Not Work Alone. The Thoughts of Kanjiro Kawai*, Folk Art Society, Kyoto, Japan 1953 heavily annotated by Leach, 542, Leach Archive, CSC.

311. Bernard Leach, *A Potter in Japan*, Faber & Faber 1960, pp.206–7.

312. Robert Goldwater, 'Judgements of Primitive Art 1905–1965', in D.P. Biebuyck (ed.), *Tradition and Creativity in Tribal Art*, Berkeley, Los Angeles, 1969, pp.24–41.

313. Roger Fry, 'Negro Sculpture', *Athenaeum*, 1920, reprinted in *Vision and Design*, Chatto & Windus 1928, p.100.

314. William Rothenstein, 'The Development of Indigenous Art', *Oversea Education*, vol. 1, no. 1, October 1929, p.5.

315. Ibid., p.4.

316. Quoted in Richard Carline, *Draw They Must: A History of the Teaching and Examining of Art*, Edward Arnold 1968, p.176.

317. Carline, op.cit., p.176.

318. For Murray see *African Arts*, vol. vi, no. 4, 1973 (memorial issue). In Muriel Rose, *Artist Potters in Britain*, Faber & Faber, 1970, p.34, Murray is incorrectly described as having preceded Harry Davis and Michael Cardew at Achimota – an error repeated in Garth Clark, *Michael Cardew: a portrait*, Faber & Faber 1978, p.44.

319. K.C. Murray, 'The Condition of Arts and Crafts in West Africa', *Oversea Education*, vol. iv, no. 4, July 1933, p.177.

320. Ibid., pp.176–7.

321. See 'Local Journals and Other Items', *Oversea Education*, vol. v, no. 4, July 1934, pp.203–4 and Margaret Trowell, 'Suggestions for the treatment of handwork in the training of teachers for work in Africa, *Oversea Education*, vol. vii, no. 2, January 1936, p.81.

322. Trowell, op.cit. p.80.

323. G.A. Stevens, 'The Aesthectic Education of the Negro', *Oversea Education* vol. 1, no. 3, April 1930, p.91.

324. Stevens, op.cit., p.94.

325. *Nigerian Wood-Carvings, Terracottas and Water-colours*, Zwemmer Gallery, 6 July–21 August 1937, p.2.

326. H.V. Meyerowitz, 'The West African Institute of Industries, Arts and Social Science', typescript of radio talk broadcast from the Ikoyi Studio, 1 August 1944, p.3, Cardew archive, CSC.

327. 'Arts and Crafts at Achimota College', *Oversea Education*, vol. xiv, no. 3, April 1943, p.121 and 'The Institute of West African Arts, Industries and Social Science', *Man*, nos 85/86, September–October 1943, p.112.

328. Eva Meyerowitz to Michael Cardew, 20 April 1978, with an account of Bamoko and two photographs of Maison Artisanat, Cardew papers, CCS.

329. H.V. Meyerowitz, op.cit., p.5, and H.V. Meyerowitz, *A Report on the Possibilities of the Development of Village Crafts in Basutoland*, Morija Printing Works, 1936, pp.23–6.

330. 'The Institute of West African Arts, Industries and Social Science', *Man*, nos 85/86, September–October 1943, p.112.

331. *African Arts*, vol. vi, no. 4, 1973, p.74.

332. H.V. Meyerowitz, *The Making of Things*, African Home Library, Sheldon Press, 1943. This consists of a series of broadcasts Meyerowitz made on Accra radio in 1941.

333. 'Arts and Crafts at Achimota College', *Oversea Education*, vol. xiv, no. 3, April 1943, pp.120–1. Also 'Harry Davis, Potter', Chapter 4, unpublished typescript autobiography of Harry Davis. Davis family archive.

334. Christopher Cox to Michael Cardew, 28 February 1942, Seth Cardew papers.

335. Taped conversation with Dicon Nance, 17 July 1991.

336. Michael Cardew to Mariel Cardew, 14 September 1942, Seth Cardew papers.

337. Ibid., 4 October 1942.

338. Ibid., 29 August 1943.

339. Ibid., 4 April 1943.

340. Cardew, *Autobiography*, pp.144–5.

341. Michael Cardew to Mariel Cardew, 21 January 1944, Seth Cardew papers.

342. Michael Cardew, 'Design and meaning in preliterate art', in Michael Greenhalgh and Vincent Megaw (eds.), *Art in Society*, Duckworth 1978, p.16.

343. Michael Cardew to Mariel Cardew, 27 July 1945, Seth Cardew papers.

344. Ibid., 15 August 1945.

345. Ibid., 16 September 1945.

346. Bernard Leach, *A Potter's Outlook*, New Handworkers' Gallery, 1928.

347. Michael Cardew, 'Diary', 3 April 1946, Seth Cardew papers.

348. Michael Cardew, manuscript autobiography, pp. 480, 492–4, Cardew papers, CSC.

349. Manuscript headed 'Notes of an Exhibition organised by the British Council, Accra Dec. 1947. Notes on the Exhibits illustrating Pottery Making at Vumë (River Volta), Gold Coast', p.1, Seth Cardew papers.

350. Michael Cardew, 'Ladi Kwali', *Craft Horizons*, April 1972, p.34.

351. 'Pottery Manufacture in West Africa', *The Pottery Gazette*, 1 December 1911, pp.1346–7.

352. Cardew, op.cit. (1972), p.35.

353. Michael Cardew, 'The Fatal Impact', in Garth Clark, *Michael Cardew*, Faber & Faber, 1978, p.223.

354. Ibid., p.219.

CHAPTER FIVE

1. See Harry Norris, 'The Red Rose Guild of Craftsmen', *Pottery Quarterly: A Review of Ceramic Art*, Spring 1954, 1. p.35.

2. Angus Calder, *The Myth of the Blitz*, Jonathan Cape, 1991, pp.180–2 but the whole of the chapter 'Deep England' is of interest in this context.

3. This figure is quoted in Martin Chisholme, 'The Artist-Craftsman Today. Has he any future?', *Our Time*, vol. 6, no. 6, January 1947, p.125. The same figure is quoted in Denys Val Baker, *Britain Discovers Herself*, Christopher Johnson, 1950, p.51, and *The Leach Pottery 1920–1946*, Berkeley Galleries, June 1946, n.p.

4. *Picture Post*, 13 July, 1940, p.9.

5. Calder, op.cit. p.201.

6. David Mellor, '"Recording Britain": A History and Outline', in David Mellor, Gill Saunders, Patrick Wright (eds), *Recording Britain: A Pictorial Domesday of Pre-War Britain*, David & Charles, Newton Abbot, 1990.

7. Michael Powell, *A Life in Movies: An Autobiography*, Methuen 1986, p.437. See also Nannette Aldred, 'A Canterbury Tale: Powell and Pressburger's Film Fantasies of Britain', in David Mellor (ed.), *A Paradise Lost: The Neo-Romantic Imagination in Britain 1935–55*, Lund Humphries, Barbican Art Gallery, 1987, pp.117–24.

8. Powell, op.cit., p.447.

9. John Cornforth, *The Inspiration of the Past: Country House Taste in the Twentieth Century*, Viking 1985, p.86.

10. Aldred, op.cit., p.118.

11. David Cannadine, *G.M. Trevelyan: A Life in History*, Harper Collins, 1992, pp.169–73.

12. *Exhibition of Modern British Crafts*, British Council, 1942. See also James Noel White's gossipy *The Unexpected Phoenix 1: The Sutherland Tea Set*, Crafts History 1, 1988, pp.49–72.

13. See Kate Woodhead, 'Muriel Rose and the Little Gallery', V&A/RCA thesis 1989, p.117. Also Leach papers, 3459–61, CSC.

14. White, op.cit., p.50.

15. Ibid., pp.69–72 for Bernard Leach's account of the debacle.

16. British Council, *Exhibition of Modern British Crafts*, 1942, p.9.

17. Ibid., p.10.

18. Sir Patrick Duff reported in the *Ottawa Evening Citizen*, 31 May 1943.

19. 'The British Council Arts and Crafts Exhibition, USA and Canada 1942–5: Miss Rose's Report to the Fine Arts Committee', 15 November 1945, Muriel Rose archive, CSC.

20. For American responses to the exhibition see 'British

Council Exhibition of British Crafts, U.S.A. 1942/3 (Extracts from letters and reports)', British Council archive.

21. R.R. Tomlinson, 'Sword of Honour for Stalingrad', *The Studio*, vol. 127, no. 613, April 1944, p.129.

22. George Ravensworth Hughes, *The Worshipful Company of Goldsmiths as Patrons of their Craft 1919–1945*, Goldsmiths' Hall, 1965, pp.39–44: Susan Hare, 'The Stalingrad Sword', *Goldsmiths Review*, 193, 1992, pp.34–7.

23. Bernard Leach, 'The Contemporary Studio Potter', *Journal of the Royal Society of Arts*, 21 May 1948, p.366. Also Bernard Leach, 'The English Potter', *The Listener*, 2 January 1947, pp.19–20 on the young clamouring for training after 'the bitter destructive experience of the war'.

24. Jocelyn Brooke, *The Orchid Trilogy*, Penguin, Harmondsworth 1981, p.88.

25. On Rothschild see Shipley Art Gallery, *Primavera: Pioneering Craft and Design 1945–1995*, Tyne and Wear Museums 1995.

26. *Geoffrey Whiting, Potter: A Retrospective Exhibition*, Aberystwyth Arts Centre, 1989, p.11.

27. Cardew, *Autobiography*, p.127. 'At the age of forty-one, full of ignorance, misconceptions, illusions about the world and about myself, infatuated by something without even knowing what it was, I was about to embark on a new life'.

28. Nicholas Pearson, *Alec Pearson: A Line Through Life*, Conservatory Gallery n.d.; Helen Frayling, 'Alec Pearson' (obituary) *Independent*, 27 March 1990; Nicholas Pearson, *Alec Pearson – Tapestries, Drawings and Water-colours*, 1989. (This is a leaflet with a full bibliography).

29. William Newland, 'Pottery and the Institute', *Alumnis: the Review of the Institute of Education Society*, University of London, no. 4, August 1985, pp.20–3.

30. Goldsmiths' College, *Constance Howard, Christine Risley and Eirean Short*, 1985, p.8.

31. Joan Edwards, *Textile Graphics by Lilian Dring*, Bayford Books, Dorking, 1988, p.12, and Constance Howard, *Embroidery in Great Britain 1940–1963*, B.T. Batsford Ltd 1983, p.6.

32 Andrew Saint, *Towards a Social Architecture: The Role of School Building in Post-War England*, Yale University Press 1987, pp.17–31.

33 Carruthers (1992), pp.96–7.

34 Fiona MacCarthy, 'David Pye: Sources of Inspiration', *Crafts*, 100, September/October 1989, p.47.

35. See *Sam Haile Painter and Potter 1909–1948*, Barry Hepton (ed.), Cleveland County Council/Bellew Publishing 1993. Also see Thomas S. Haile, 'Of Art, the Artist and World War II', *Tomorrow*, November 1944 and December 1944. On Haile's political views see Lynda Morris and Robert Radford, *The Story of the Artists International Association 1933–1953*, MOMA, Oxford 1983.

36. *Handblock Printed Textiles: Phyllis Barron and Dorothy Larcher*, Crafts Study Centre, Holburne Museum, Bath 1978, n.p.

37. Cynthia Weaver, 'Enid Marx: Designing Fabric for the London Passenger Transport Board in the 1930s', *Journal of Design History*, vol. 12, no. 1, 1989, pp.35–46.

38. *Utility Furniture and Fashion 1941–1951*, Geffrye Museum, Inner London Education Authority, 1974, p.13.

39. Geffrye Museum, *op.cit.*, p.13. But also see Judy Attfield, '"Then We Were Making Furniture, and Not Money": a case study of J. Clarke, Wycombe Furniture Makers', *Oral History*, Autumn 1990, vol. 18, no. 2, pp.54–7, which argues that for highly skilled furniture makers the Utility scheme involved a de-skilling process in which no carving or elaborate decoration was being done or being taught.

40. See Perry Anderson, *Components of the National Culture in English Questions*, Verso 1992, especially pp.60–70. For a counter argument as regards design émigrés see Robin Kinross, 'The New Typography in Britain after 1945', in *From the Spitfire to the Microchip: Studies in the History of Design from 1945*, Design Council 1985, pp.45–9.

41. Robin Kinross, *Modern Typography: an essay in critical history*, Hyphen Press 1992, pp.108–10.

42. For Rie's early career, see John Houston (ed.), *Lucie Rie: a survey of her life and work*, Crafts Council 1981, pp.11–21.

43. Cheryl Buckley, *Potters and Paintresses: Women Designers in the Pottery Industry 1870–1955*, Women's Press 1990, pp.135–9; Cheryl Buckley, 'Women and Modernism: A Case Study of Grete Marks 1899–1990', in Jill Seddon, Suzette Worden (eds), *Women Designing: Redefining Design between the Wars*, University of Brighton 1994; Design Center Stuttgart, *Frauen im Design: Berufsbilder und Lebenswege seit 1900*, 1989, vol. 1, pp.224–7.

44. See PRO BT 57/7 A 107/35, Note of interview with Dr Gropius. This appears to have been conducted by G.L. Wilkinson of the Board of Trade: ' It is difficult to gauge the potentialities of a man like this on the basis of a half-hour talk, but it is true, I suppose, that he has achieved an international reputation in the field of industrial art.' Wilkinson noted that Gropius's English was not good and suggested he might be tried out with some teaching at the Royal College of Art.

45. Sigrid Wortmann Weltge, *Bauhaus Textiles: women artists and the weaving workshop*, Thames and Hudson, 1993, pp.113–14, 124; Design Center Stuttgart, *Frauen im Design*, 1989, vol. 1, pp.208–11.

46. Weltge, *op.cit.*, p.127.

47. Tanya Harrod, 'Ralph Beyer: Sources of Inspiration', *Crafts*, 102, January/February, 1990, pp.42–3.

48. Conversation with Tadek Beutlich, 4 July 1994.

49. There is a copy of *International Craftsmanship Today* in the Heal's archive, Folder 1940, AAD 2/24–1978.

50. Editorial, *Crafts*, vol. 1, no. 4, 1941.

51. Anthony Gardner, 'Sodom and Gomorrah', *Crafts: The Quarterly of the Red Rose Guild*, vol. 11, no. 1, 1942, pp.17–18. On Gardner, an eccentric interesting figure, see Dorothy Harrop, 'Craft Binders at Work 11: Anthony Gardner', *The Book Collector*, vol. 22, no. 2 Summer, 1973.

52. Harry Norris to Margaret Pilkington n.d. post-1939, Margaret Pilkington papers, Whitworth Art Gallery, Manchester.

53. Harry Norris to Michael Cardew, 23 March 1942, Seth Cardew papers.

54. Ibid.

55. This is reported by Margaret Pilkington in *Crafts: The Quarterly of the Red Rose Guild*, vol. 2, no. 1, 1942.

56. Carruthers (1992), p.83.

57. Harry Norris, 'The Red Rose Guild of Craftsmen', *Pottery Quarterly*, Spring, 1954, 1, p.35.

58. See Reports for 1941 and 1942, Scrapbook 1934–50, Red Rose Guild Archive, CSC. These ideas were also echoed by Edward Barnsley and Roger Powell, see Carruthers (1992), p.88.

59. Nikolaus Pevsner, 'Foreword', Arts and Crafts Exhibition Society. *Catalogue of the 18th Exhibition. Held at the Wallace Collection, Hertford House, Manchester Square 1941*.

60. Arts and Crafts Exhibition Society. *Catalogue of the 19th Exhibition. Held at the National Portrait Gallery, Trafalgar Square, 1944*.

61. Carruthers (1992), p.88–9. Farleigh's new manifesto is set out in 'On Exhibitions' in *It Never Dies. A Collection of Notes and Essays 1940–1946*, Sylvan Press, 1946, pp.67–72.

62. Kenneth Clark, *The Other Half: A Self-Portrait*, John Murray 1977, p.28.

63. *Report on Nine Years' Work of the Central Institute of Art and Design*, September 1948. The societies involved included the AIA, the Arts and Crafts Exhibition Society, the British Society of Master Glass Painters, the DIA, the Embroiderers' Guild, the Guild of Memorial Craftsmen, the Senefelder Club, the Red Rose Guild of Artworkers, the Society of Mural Painters, the Society of Decorators and Painters in Tempera, the Society of Scribes and Illuminators, and the Society of Wood-Engravers.

64. See Report for the years 1941 and 1942, Scrapbook 1934–56, Red Rose Guild Archive, CSC. Also the Editorial in *Crafts: the Quarterly of the Red Rose Guild*, vol. 1, no. 2, pp.1–8 and *Bulletin*, Central Institute of Art and Design, vol. 1, no. 1, 31 December 1940.

65. 'Craft Training of the Disabled', *Crafts*, vol. 1, no. 3, 1941, p. and 'Editorial', *Crafts*, vol. 1, no. 2, 1941, p.7.

66. Lord Fraser of Lonsdale, *My Story of St Dunstan's*, Harrap 1961, p.250.

67. Minutes of the First Meeting of the Joint Committee of the Arts and Crafts Exhibition Society and the Red Rose Guild, 20 January 1943, AAD 1/819–1980.

68. See the Crafts Centre of Great Britain minutes starting 20 July 1946, AAD 1/819–1980.

CHAPTER SIX

1. See Richard Stewart, *Design and British Industry*, John Murray 1987, pp. 64–73, and Robert Hewison, *Culture and Consensus: England, art and politics since 1940*, Methuen 1995, p.43.

2. Crafts Centre of Great Britain, *Rules 1948*, Bircham 1948, p.3.

3. 5th meeting of Crafts Centre of Great Britain, 10 May 1947, AAD 1/819 – 1980.

4. Public Record Office BT 64/2354. This Board of Trade file is devoted to the setting up of the Crafts Centre of Great Britain

5. Graham Maclaren, 'A Special Relationship', *Crafts*, 121, March/April 1993 pp.40–1 and PRO BT 64/2436.

6. Crafts Centre of Great Britain, 'Relief on Approved Craftwork', 1948 in AAD 1/824 – 1980. On the way in which this scheme raised the standard of silversmithing see Michael Farr, *Design in British Industry. A Mid-Century Survey*, Cambridge University Press 1955, pp.34–5.

7. Scottish Craft Centre, *The First Five Years*, 1955, p.9.

8. This section relies on Elizabeth Cumming, 'Living Tradition or Invented Identity? The restructuring of the Crafts in Post-War Edinburgh', in Harrod, *Conference*, pp.68–9.

9. Gordon Russell, *Designer's Trade*, George Allen & Unwin Ltd 1968, pp.132–3.

10. 68th Meeting of the Crafts Centre of Great Britain, 10 January 1953, AAD 1/820–1980.

11. Emergency meeting of the Crafts Centre of Great Britain, 1 May 1951, AAD 1/819–1980.

12. For example, 45th Meeting of the Crafts Centre of Great Britain, 21 July 1950, AAD 1/819–1980.

13. On the early days of the CPA see Rosemary R. Wren, 'The First Ten years', in *Studio Ceramics Today*, Emmanuel Cooper, Eileen Lewenstein (eds), Craftsmen Potters Association 1983, pp.9–16.

14. This contact with an 'authentic' country pottery was not quite what it seemed. A. Harris & Sons of Wrecclesham near Farnham had been founded in 1873. It soon started producing 'Art Pottery' under the guidance of a local painter W.H. Allen (1863–1943) inspired by sixteenth-century greenware in the V&A. Only after World War II did the Pottery concentrate on functional horticultural pots. See P.D.C. Brears, *Farnham Potteries*, Phillimore & Co., Chichester, 1971.

15. 72nd Meeting of the Crafts Centre of Great Britain, 27 June 1953, AAD 1/820–1980.

16. Conversation with Sheila Pocock, 19 August 1997.

17. 105th Meeting of the Crafts Centre of Great Britain, 18 May 1957. David Kindersley archive.

18. Ken Baynes, 'What are the crafts doing? Notes on the Creative Craftsman Exhibition at the RIBA', *Crafts Review*, 5, 1960, pp.13–14.

19. 'How can the crafts be helped?', *Crafts Review*, 6, 1960/61, p. 74.

20. 'Image of a Crafts Centre', Crafts Centre file, David Kindersley Archive in two versions –23 November 1961 and 6 January 1962.

21. Annual report of the Crafts Centre of Great Britain, 1 April 1961–31 March 1962 quotes the relevant letter from the Board of Trade, Crafts Centre file, David Kindersley Archive.

22. Parliamentary Debates, House of Commons, 5th series, vol. 658, 1961–62, col. 217–220.

23. David Kindersley to Gerald Lacey, 6 June 1962, Crafts Centre file, David Kindersley Archive.

24. Parliamentary Debates, House of Commons, 5th series, vol. 6559, col 1785–1794.

25. David Kindersley to Sheila Pocock, 26 March 1962, Crafts Centre file, David Kindersley Archive.

26. Gordon Russell to David Kindersley, 4 February 1963, enclosure entitled 'The Future of the Crafts Centre of Great Britain', Crafts Centre file, David Kindersley Archive. Also CoID Council minutes C(63)C, 1963, The

Design Council Archive, University of Brighton.

27. Council of Industrial Design, 18th Annual report, 1962–3, p.6.

28. Annual Report of the Crafts Centre of Great Britain, 1 April 1962 – 31 March 1963, Crafts Centre file, David Kindersley Archive. Also Paul Reilly's speech at the crafts reception 10 June 1963, AAD 1/824–1980.

29. See C(63)5, Confidential draft memo from the CoID to the Board of Trade on 'Design Centre Exhibition of British Craftsmanship', in CoID minutes 1963, The Design Centre Archive, University of Brighton.

30. Richard Stewart, *Design and British Industry*, John Murray 1987, pp.209–13. Also see Minutes of the Crafts Centre of Great Britain, 20 November 1963, David Kindersley archive.

31. For a slightly different perspective on this see Nigel Whiteley, *Design for Society*, Reaktion Books 1993, pp.164–5.

32. Council of Industrial Design, 19th Annual Report, 1963/64, p.3.

33. Minutes of the 132nd meeting of CoID, 20 September 1963, The Design Council Archive, University of Brighton.

34. Cyril Wood to David Kindersley, 2 December 1963, Crafts Centre file, David Kindersley Archive. For a sympathetic view of Wood, see his obituary in the *Royal Society of Arts Journal*, no. 5215, vol. cxxii, June 1974, pp.459–60.

35. The phrase comes from *Craftsmanship is alive and kicking*, published Cyril Wood OBE, Swyre, Aldsworth, Northleach, Glos., n.d. This exhibition was funded by the Bristol furniture retailer Crofton Gane.

36. Conversation with Ann Sutton, 22 March 1994.

37. AAD 1/822–1980.

38. 25th January 1964, Minutes of an Extraordinary General Meeting of the Crafts Centre of Great Britain, Crafts Centre file, David Kindersley Archive. Also Crafts Council of Great Britain, Newsletter no.1, February 1964, AAD 1/224–1980.

39. 'Crafts Council of Great Britain: 2nd June 1964', Crafts Centre file, David Kindersley Archive. Also 'Laying the Foundations: The first annual report of the Crafts Council of Great Britain 1964/5' AAD 1/821–1980.

40. See meetings on 30 September 1964 and 21 October 1964, Crafts Council (Centre) of Great Britain, Crafts Centre file, David Kindersley Archive.

41. 'A Phoenix rises from the dust', *Design*, 209, May 1966, p.27.

42. Graham Hughes to Keith Allison, 28 October 1969, Graham Hughes Archive.

43. See Chapter Ten, p.396.

44. 'Craftsmanship: A plan to promote the prosperity and enjoyment of the Fine Crafts with some account of the motives and methods of the Crafts Council of Great Britain' AAD 1/823–1980.

45. *Craftsmanship Today*, 40 Haymarket, London sw1, 27 May–31 July 1965, Foreword by Gordon Russell, Eileen Lewenstein Archive. Crafts Council of Great Britain Newsletter, July 1965, AAD 1/822–1980.

46. Crafts Council of Great Britain, *Craftsmanship and Industry*, Herbert Art Gallery and Museum, Eileen Lewenstein archive.

47. Ibid.

48. For the exhibition, see Ken Baynes, 'Designing by Making', *Design*, 199, July 1965, pp.28–39.

49. 'The crafts also have an important contribution to make in the field of education and leisure pursuits as well as in their influence on good design.' *A Policy for the Arts: the First Steps*, (Cmnd 2601), vol. xxix, Parliamentary Papers 1964–5.

50. Blackman was the first chairperson of the Federation of British Craft Societies formed in 1970 as a new national body to represent makers' interests.

51. Ted Heath to Audrey Blackman, June 1970, sent as a notice to all members of the Society of Designer-Craftsmen, Society of Designer-Craftsman file, David Kindersley Archive.

52. Conversation with Ann Sutton, 22 March 1994.

53. Graham Hughes to the Rt. Hon George Darby MP,

Minister of State at the Board of Trade, 8 March 1968 and Graham Hughes to Michael Morris, Board of Trade, 11 December 1968, David Kindersley Archive.

54. Crafts Council of Great Britain, *The Hand and Mechanisation: Report on a Pilot Scheme. A Plan for the Future*, 1968.

55. M.S. Morris, Board of Trade, to Graham Hughes, 6 March 1969, David Kindersley Archive

CHAPTER SEVEN

1. Peter Hennessy, *Never Again: Britain 1945–1951*, Vintage 1993, p.160.

2. *Constance Howard, Christine Risley, Eirian Short*, Goldsmiths' College, University of London 1985, p.22.

3. Bernard Leach, 'The Contemporary Studio Potter', *Journal of the Royal Society of Arts*, 21 May 1948, p.366.

4. Ibid., p.371.

5. For a full list of those who attended and transcripts of some of the talks see ICC. Also see Margot Coatts, 'The Dartington Conference of 1952', in *Dartington: 60 Years of Pottery 1933–1993*, David Whiting (ed.), Dartington Cider Press 1993, p.37–41, and Margot Coatts and Peter Cox, 'An Earlier Generation', *Studio Pottery*, 10, August/September 1994, pp.18–28.

6. Bernard Leach to Philip Mairet, 27 June 1952, 6497, Leach archive, CSC.

7. ICC, p.139.

8. G.F. Wingfield Digby to Peter Cox, 1 May 1952, 6463, Leach archive, CSC.

9. ICC, p.137

10. Murray Fieldhouse has an interesting archive of pamphlets by Wilfred Wellock and a set of his Orchard Lea Papers as well as publications by the Community Service Committee, the Community Advisory Group and the Central Board for Conscientious Objectors. His desire to live in a craft community developed while serving in the RAF and reading this kind of literature. See his article 'Dimension for Living: Some social implications of pacifism', in *Peace News*, 25 August 1961, pp.6–7.

11. ICC, p.58.

12. Ibid., p.61.

13. Soetsu Yanagi, 'The Japanese Approach to the Crafts' and 'The Buddhist's Idea of Beauty', in ICC, pp. 19–24, 78–98.

14. ICC, p.7.

15. Ibid., p.17.

16. *Architectural Review*, vol. 112, November 1952, p.344.

17. Robin Tanner, *Double Harness. An Autobiography*, Impact Books 1990, p.145–6; Tony Birks, *Hans Coper*, Collins 1983, pp.27.

18. Tanner, op.cit., pp.144, 163–7.

19. Conversation with Ella McLeod, 9 June 1994.

20. On McLeod's sensibility see Ella McLeod, 'Diary of a Visit to Brittany, Summer 1938', typescript in possession of the author. Herbert Read, *Art and Industry*, Faber & Faber 2nd edn 1944, p.127 and L.E. Simpson and M. Weir, *The Weaver's Craft*, Dryad Press, Leicester, 1952, figs 14a,b, and 15 illustrate Howell's School work under McLeod's guidance.

21. See *Athene*, Double Craft Number, vol. 7, nos 1 & 2, 1955, Society for Education through Art with contributions from Henry Hammond, Ella McLeod, Seonaid Robertson, Gwendolen Mullins, Willi Soukop, Michael Cardew, Donald Potter and Helen Pincombe. Also see Seonaid Robertson, Audrey Martin, Edith Ray, 'Three Views of a Conference', *Athene*, vol. 5, no. 1, November 1950, pp.12–14 and Henry Hammond, 'Why a Craft Conference', *Athene*, vol. 6, no. 2, May 1953, p.59.

22. For a lively account of a Pendley Manor weekend see *Pottery Quarterly*, vol. 6, no. 21, Spring 1959, p.25. For the fascinating Dorian Williams see his *Pendley and a Pack of Hounds*, Hodder & Stoughton 1959. In the late 1960s he became famous as the BBC show jumping commentator, rather to the detriment of activities at Pendley.

23. Quotation from leaflet circulated to members of the course. It also lists those who attended. Colin Pearson Archive.

24. Michael Cardew, *Pioneer Pottery*, Faber & Faber 1969, p.254.

25. On Abuja see Michael Cardew, 'Pioneer Pottery at Abuja', *Nigeria: A Quarterly*, vol. 52, 1956, pp.38–9. Also Cardew, op.cit. (1969).

26. Gwendolen Mullins, 'A Village Craft Workshop', *Athene*, Double Craft Number, vol. 7, nos. 1 & 2, Society for Education through Art, p.16.

27. Conversation with Barbara and Gwendolen Mullins, 28 June 1994. Gwendolen Mullins also kindly lent me a tape in which she gives an account of her creative life.

28. The Mullins Trust papers have, according to Gwendolen Mullins, been lost. There is some documentation in the Muriel Rose archive, CSC.

29. Charles Bourne, 'The Spinner's Tale', *Crafts*, 104, May/June 1990, pp.22–5. For Roberts's obituary see *Crafts*, 110, May/June 1991, p.13.

30. Harry Davis, 'Harry Davis Potter', typescript of unpublished autobiography, Davis family archive, p.17.

31. The story of the Barry Summer School needs to be written. There is a brief account in *The Arts in Wales 1950–1975*, Meic Stephens (ed.), Welsh Arts Council 1979, p.72. Further information from conversations with Noel Upfold and Diana Setch, August 1994, and Ann Sutton 22 March 1994.

32. For a lively account of Sutton's teaching at Barry see 'Barry Summer School', *Journal of the Spinners, Dyers and Weavers*, December 1965, p.812.

33. See Alastair Grieve, *Constructivism after the Second World War in British Sculpture in the Twentieth Century*, Sandy Nairne and Nicholas Serota (eds), Whitechapel Art Gallery 1981, p.164 and Alastair Grieve to the Editor, *Art Monthly*, March 1982, no. 54, p.17.

34. George Sturt, *The Wheelwright's Shop*, Cambridge University Press 1963, pp.19–20.

35. Denys Thompson, 'A Cure for Amnesia', *Scrutiny*, vol. 2, no. 1, June 1933, p.3.

36. Michael Polanyi, *Personal Knowledge: Towards a Post-Critical Philosophy*, Routledge & Kegan Paul 1958, pp.49–131.

37. Michael Oakeshott, 'Rationalism in politics', in *Rationalism in Politics and other Essays*, Methuen 1962, p.11.

38. Part of this essay appeared in *Ark*, Summer 1957, pp.9–12.

39. Quoted in C. Thomas Mitchell, *Redefining Designing: From Form to Experience*, Van Nostrand Reinhold, New York 1993, p.40.

40. Mitchell, *op.cit.*, p.47.

41. Norman Potter, *Models & Constructs: margin notes to a design culture*, Hyphen Press 1990, p.98.

42. Ibid., p.124.

43. Norman Potter, *What is a Designer: Things: Places: Messages*, 3rd revised edition, Hyphen Press 1989, p.79.

44. Ibid., p.81.

45. Ibid., p.83.

46. Quoted in ibid., p.85.

47. Potter, *op.cit.* (1990), p.83.

48. Harry Davis, *In Defence of the Rural Workshop*, Crowan Pottery, Cornwall 1954, n.p.

49. Harry Davis, 'Harry Davis Potter', typescript of his unpublished autobiography, p.88. Davies family archive.

50. Harry Davis, 'Talk for the Australian Broadcasting Commission 25 May 1975', typed transcript, p.4.

51. Harry Davis, 'Talk for Australian Broadcating Commission March 1982', typed manuscript pp.5–6. For more on the Davises values see May Davis, *May*, Nelson, New Zealand 1990.

52. Michael Cardew, *Pioneer Pottery*, Faber & Faber 1969, pp.245–7.

53. From Cardew's essay 'The Fatal Impact' (1971) in Garth Clark, *Michael Cardew: A Portrait*, Faber & Faber 1978, p.218.

54. Michael Cardew, 'Design and Meaning in Preliterate Art', in Michael Greenhalgh and Vincent Megaw (eds.), *Art in Society*, Duckworth 1978, pp.15–20. Also Tanya Harrod, 'Writers and Thinkers: Michael Cardew', *Crafts*, 126, January/February 1994, pp.18–19.

55. On Pye in general see Marigold Coleman, 'Wood and Workmanship', *Crafts*, 20, May–June 1976, pp.36–9; Abigail Frost, 'Words and Workmanship', *Crafts*, 71, November/December 1984, pp.14–15, and Frost's

obituary of Pye in the *Independent*, 6 January 1993. For an early articulation of his ideas see David W. Pye, 'Standards in Contemporary Furniture', *The Listener*, 26 July 1951, pp.135–6. See also 'Meet the Moderns', *Furnishings from Britain*, December 1949, p.54.

56. David Pye, 'Handwork: Its Significance Today', *Design*, 111, March 1958, pp.55–7.

57. The conflation of these two terms is discussed in Tim Benton, 'The Myth Of Function', in *Modernism in Design*, Paul Greenhalgh (ed.), Reaktion Books 1990, pp.41–52.

58. David Pye, *The Nature of Design*, Studio Vista 1964, p.10.

59. Pye, *op.cit.* 1964, p.60.

60. David Pye, *The Nature and Art of Workmanship*, Cambridge University Press 1968, p.10.

61. Ibid., 1968, p.63.

62. Ibid., 1968, pp.76–7.

63. Ibid., 1968, p.76.

64. Ibid., 1968, p.81.

65. Bernard Leach, 'The Contemporary Studio Potter', *Journal of the Royal Society of Arts*, 21 May 1948, pp.366–7.

66. For government art examinations from 1899 onwards see *Art Education: documents and policies 1768–1975*, Clive Ashwin (ed.), Society for Research into Higher Education 1975, pp.82–92.

67. *Prospectus 1960–1*, Goldsmiths' College, University of London.

68. Ashwin (ed.), *op.cit.* (1975), p.84.

69. Christopher Frayling, *The Royal College of Art: One Hundred and Fifty Years of Art and Design*, Barrie and Jenkins 1987, p.173.

70. Conversation with Ann Sutton, 22 March 1994.

71. Conversation with Victor Margrie, 9 September 1988.

72. For Howard see Tanya Harrod, 'Sources of Inspiration: Constance Howard, *Crafts*, 127, March/April 1994, pp.38–41; for Clements see E.G. Clements, 'Design Matters', in *Finely Taught Finely Wrought: The Birmingham School of Jewellery and Silversmithing 1890–1990*, Birmingham Museum and Art Gallery 1990, pp.55–7.

73. William Johnstone, *Points in Time*, Barrie & Jenkins Ltd, 1980, p.211.

74. See David Robbins (ed.), *The Independent Group: Postwar Britain and the Aesthetics of Plenty*, MIT Press, Cambridge MA, 1990.

75. Maurice de Sausmarez, *Basic Design: The Dynamics of Visual Form*, Studio Vista 1964, p.11. See also Victor Pasmore, Harry Thubron, Richard Hamilton, Tom Hudson, *The Developing Process*, King's College, University of Durham 1959.

76. David Thistlewood, *A Continuing Process: The New Creativity in British Art Education 1955–66*, ICA 1981, p.28.

77. M. Tucker (ed.), *Alan Davie: the Quest for the Miraculous*, University of Brighton and Barbican Art Gallery, London 1993, gives an overview but ignores Davie's jewellery. On Davie, Kessel and Hamilton at the Central School see William Johnstone, *Points in Time: An Autobiography*, Barrie and Jenkins Ltd 1980, p.256, and Anton Ehrensweig, *The Hidden Order of Art*, Paladin 1967, pp.120–1.

78. Ehrensweig, *op.cit.*, (1967), p.120.

79. Robbins (ed.), *op. cit.* (1990), p.192.

80. William Johnstone, *Points in Time*, Barrie & Jenkins Ltd 1980, p.247.

81. Dora Billington, *The Art of the Potter*, Oxford University Press, 1937, pp.110–11.

82. Dora Billington, 'The Younger English Potters', *The Studio*, vol. cxlv, no. 730, March 1953, pp.78–85 and 'The New Look in British Pottery: The Work of William Newland, Margaret Hine and Nicholas Vergette', *The Studio*, vol. cxlix, no. 742, January, 1955, pp.18–21.

83. Conversation with Ian Auld, 23 November 1988.

84. Conversation with Gordon Baldwin, 3 October 1988.

85. Jacqueline Mina, 'Self Portrait', *Jewellery Studies*, 6, 1993, p.60.

86. Aidron Duckworth, 'Three-Dimensional Basic Design', *Architectural Design*, May 1962, pp.257–9.

87. Tanya Harrod, 'The Modern Jewellery of Gerda Flöckinger', in Margot Coatts (ed.), *Pioneers of Modern Craft*, Manchester University Press, 1997, pp.137–8.

88. Michael Farr, *Design in British Industry: A Mid-Century Survey*, Cambridge University Press 1955, p.180.

89. William Johnstone, *Points in Time*, Barrie & Jenkins Ltd 1980, p.245.

90. *Calendar*, Royal College of Art 1955–6, pp.17–18.

91. Johnstone, *op.cit.*, p.282.

92. Cardew, *Autobiography*, p.196.

93. John Lewis, *Such Things Happen: the life of a typographer*, Unicorn Press, Stowmarket, 1994.

94. R.D. Russell, 'Furniture Today: Tuppence Plain, Penny Coloured', in *The Anatomy of Design*, Royal College of Art 1951, pp.45–53.

95. 'Box and Cox', *Ark*, no. 2, February 1951. These were memoranda passed between Russell and Darwin, with Darwin writing nostalgically of a summer spent staying in country houses filled with Hepplewhite and gilded and painted Empire furniture.

96. Constance Howard, *Twentieth-Century Embroidery in Great Britain 1940–1963*, B.T. Batsford Ltd. 1983, p.55.

97. Carruthers (1992), pp.117–19.

98. *First Report of the National Advisory Council on Art Education*, HMSO 1960, p.4. Also Ashwin, *op.cit.*, 1975, pp.90–2. For a craft perspective on education see Clive Ashwin, Anne Channon, Joseph Darracott, *Education for Crafts: A Study of the Education and Training of Craftspeople in England and Wales*, Middlesex Polytechnic/HMSO 1988, pp.10–23.

99. *First Report* (1960), p.6.

100. *Second report of the National Advisory Council on Art Education: vocational courses in colleges and schools of art*, HMSO 1962, p.4.

101. Ashwin, Channon, Darrracott, *op.cit.*, p.17.

102. Conversation with Constance Howard, 13 December 1993.

103. Constance Howard, *Twentieth-Century Embroidery in Great Britain 1940–1963*, B.T. Batsford Ltd. 1983, p.140.

104. 'Chairman's Notes', *The Scribe*, no. 40, Summer 1987, p.2.

105. Fiona Adamceski, 'Outside Tradition', *Crafts*, 2 May/June 1973, p.20–3.

106. 'Training the Potter', in *Year Book 1966*, Craftsmen Potters Association, p.29.

107. On the course at Harrow see Michael Casson, Victor Margrie (eds), *The Harrow Connection*, Ceolfrith Press, Northern Centre for Contemporary Art 1989, especially pp.33–5.

108. See 'Training the Potter', in *Year Book 1966*, The Craftsmen Potters Association, pp.19–34 for a lively debate about the course. For reviews of Harrow diploma shows see *Pottery Quarterly* vol. 8, no. 32, 1965, pp.100–3 and Emmanuel Cooper, 'Pottery at Harrow', *Ceramic Review*, 4, August 1970, p.16.

109. For a trenchant summary see Stuart Macdonald, *The History and Philosophy of Art Education*, University of London Press Ltd 1970, pp.360–4.

110. Students and Staff of Hornsey College of Art, *The Hornsey Affair*, Penguin Educational Special 1969, p.106.

111. Theodore Roszak, *The Making of the Counter Culture*, Faber & Faber, 2nd edition, 1971, p.13.

112 Ibid. p.13.

113. The counter-culture reading list is set out in *The Whole Earth Catalog*. See, for instance, *The (updated) Last Whole Earth Catalog*, Penguin Books 1975. Further clues to youthful reading can be found in Roszak, *op.cit.*, and Oz Guinness, *The Dust of Death: A Critique of the Counter Culture*, Intervarsity Press, Illinois 1975. Also see Geoffrey Ashe, 'Letter from an Over 30 Year Old', *International Times*, 37, 9–22 August 1968 on the similarity between inter-war and counter-culture concerns.

114. *The (updated) Last Whole Earth Catalog*, Penguin Books, Harmondsworth 1975, p.160. Also see Michael Hopkins, 'Technology comes to Town', *RIBA Journal*, May 1992, p.397 on the *Catalog* as 'a wondrous fund of information'.

115. ICC, p.58.

116. *The (updated) Last Whole Earth Catalog*, Penguin Books, Harmondsworth, 1975, p.152.

117. *International Times*, 35, 12–25 July 1968.

118. Idem, 10, 13–26 March 1967, p.12.

119. Idem, 28, 5–18 April, p.13.

120. Gary Snyder, 'Why Tribe?', *International Times*, 28, 5–18 August, 1968.

121. Hyde Park Diggers, 'Workshops and Industry', *International Times*, 31, 17–30 May 1968, p.2.

122. Julian Beck, 'Paradise Now', *International Times*, 35, 12–25 July 1968.

123. Emmanuele Petrakis, 'Underground', *International Times*, 40, 20 September – 3 October 1968, p.4

CHAPTER EIGHT

1. Quoted in Nikolaus Pevsner, *Industrial Art in England*, Cambridge University Press 1937, p.217.

2. D.K. Jones, *Stewart Mason: The Art of Education*, Lawrence & Wishart 1988, p.27.

3. See Henry Rée, *Educator Extraordinary: The Life and Achievement of Henry Morris 1889–1961*, Peter Owen 1985, pp.92–3. On Nan Youngman see Rée, *op.cit.*; *The Story of the Artists International Association 1933–1953*, MOMA, Oxford 1983, pp.31–7; Peter Black, 'Nan Youngman', *Independent*, Friday 28 April 1995.

4. Constance Howard, *Twentieth-Century Embroidery in Great Britain 1940–1963*, B.T. Batsford Ltd. 1983, pp.21,24,53.

5. See Rée, *op.cit.*, pp.118–24, and *A Matter Done: An Account of the Digswell Arts Trust*, Digswell Arts Trust, Welwyn Garden City 1967.

6. Andrew Saint, *Towards a Social Architecture: The Role of School Building in Post-War England*, Yale University Press 1987, p.93.

7. Stuart Maclure, *Educational Development and School Building: aspects of public policy*, Longmans 1984, p.47.

8. Stewart Mason in Institute of Education, *The Arts in Education*, University of London 1963, p.16. Also see D.K. Jones, *Stewart Mason: the Art of Education*, Lawrence & Wishart 1988.

9. Mervyn Levy, 'Pioneering Patronage for Schools: British Art in Leicestershire', *The Studio*, September 1963, pp.92–7; Alec Clifton-Taylor, 'Contemporary Painting and Sculpture for Leicestershire Schools', *Connoisseur*, April 1961, pp.185–8; *Growing up with art. The Leicestershire collection for schools and colleges*, Arts Council 1980.

10. Constance Howard, *Twentieth-Century Embroidery in Great Britain 1940–1963*, B.T. Batsford Ltd. 1983, p.21.

11. Tanya Harrod, 'Margaret Traherne: Sources of Inspiration', *Crafts*, 134, May/June, 1995, p.48.

12. In the mid-1960s Mason fell under the influence of Bryan Robertson, then director of the Whitechapel Art Gallery. His taste 'went abstract' to the dismay of Clifton-Taylor. See Jones, *op.cit.*, pp.82–93.

13. See Dennis Stevens's obituary by John Warner, *Independent*, 29 July 1988; Jane Pavitt (ed.), *The Camberwell Collection: Object Lesson*, Camberwell College of Arts 1996.

14. Jones, *op.cit.*, p.29.

15. Herbert Read, 'The Future of Art in Industrial Civilisation', in *The Grass Roots of Art*, Lindsay Drummond Ltd. 1947, p.67.

16. See Worshipful Company of Goldsmiths, *Seven Golden Years*, 1974; Judith Bannister, 'Silver for the New Universities', *Country Life*, 29 January 1970, pp.236–7.

17. Veronica Sekules (ed.), *The University of East Anglia Collection*, University of East Anglia 1984.

18. G.S. Chaffey, 'Catalogue of Works of Art and Silver and Items of Historic Interest', The University of Sussex, April 1988, typescript.

19. For these collections see Katherine Eustace and Victoria Pomery, *The University of Warwick Collection*, University of Warwick 1991; Richard Cork and Eugene Rosenberg, *Architect's Choice: Art in Architecture in Great Britain since 1945*, Thames and Hudson 1992.

20. Peter Floud, 'The Crafts Then and Now', *The Studio*, vol. cxlv, no. 721, April 1953, reprinted in John Houston (ed.), *Craft Classics since the 1940s: An Anthology of Belief and Comment*, Crafts Council 1988, pp.49–53.

21. See the Heal's archive especially *Bulletin Number 17*, PL7 AAD 2–1978, and *The Craftsman's Market*, leaflet, PL7, AAD 2–1978. On the closure of The Craftsman's Market see 'Editor's Diary', *Crafts Review*, 6 (1960–61), pp.76–7.

22. Taped interview with David Leach conducted by Anna Hale, 15 November 1993, for the National Electronic and Video Archive of the Crafts, Faculty of Art, Media & Design, University of the West of England, Bristol.

23. On Utility and export problems see Frances Hannah, *Ceramics*, Bell & Hyman 1986, pp.71–7.

24. Shipley Art Gallery, *Primavera: Pioneering Craft and Design 1945–1995*, Tyne & Wear Museums 1995.

25. For a good example of this CoID design vocabulary see Bernard Hollowood, *Pottery and Glass: The Things We See – No 4*, Penguin Books, Harmondsworth, 1947, p.4.

26. 'Terence Conran at Simpson's', *Architectural Review*, vol. 112, no. 667, July 1952, p.55.

27. *Quant by Quant*, Cassell 1966, p.42; conversation with Gerda Flöckinger, 5 March 1994.

28. See Douglas Newton, 'Printed Textiles', *Architectural Review*, vol. III, no. 663, March 1952, p.190 for a commission for the architect Eugene Rosenberg of Yorke, Rosenberg and Mardall.

29. Anton Ehrensweig, *The Hidden Order of Art: A Study in the Psychology of Artistic Imagination*, Paladin 1970, p.119 and fig.4.

30. See Terence Conran, *Printed Textile Design*, The Studio Publications 1957, p.32.

31. *This is Tomorrow*, Whitechapel Art Gallery 1956. Also see David Robbins (ed.), *The Independent Group: Postwar Britain and the Aesthetics of Plenty*, MIT Press, Cambridge MA 1990, p.201.

32. See leaflet *Time Present* produced by the directors of Hull Traders Ltd. London, October 1957, Kenneth Clark archive. Much of the exhibition appeared in New York at the store Lord & Taylor and was illustrated in *The Ambassador: The British Export Magazine*, no. 9, September 1958, pp.44, 45.

33. See below pp.287–8.

34. Frederick Gibberd, *Metropolitan Cathedral of Christ the King, Liverpool*, Architectural Press 1968, pp.67–74.

35. Conversation with Ann Sutton, 22 March 1994.

36. Dora Billington, 'The New Look in British Pottery: The Work of William Newland, Margaret Hine and Nicholas Vergette', *The Studio*, vol. cxlix, no. 742, January 1955, pp.18–21.

37. T.S. Eliot, *The Confidential Clerk*, Faber & Faber 1954, p.38.

38. Herbert Read, 'The True Philosophy of Art', *The New English Weekly*, 11 July 1940, p.143.

39. Bernard Leach to Geoffrey Whiting, 7 November 1955, David Whiting archive.

40. See illustrations in the section 'Wheelmade Pottery, Repetition Production', in Michael Casson, *Pottery in Britain Today*, Alec Tiranti 1967.

41. Ken Baynes, 'Designing by making', *Design*, 119, July 1965, p.35.

42. Watson (1990) pp.181–2, and John Houston, 'The Winchcombe Pottery', in *An Exhibition of Work by Ray Finch*, Craftsmen Potters Shop, 18–29 September 1979.

43. See Chapter Four, p.167.

44. *Pottery Quarterly*, vol. 7, no. 26, 1961, pp.68–9.

45. Bernard Leach, 'Introduction', in *David Leach: A Monograph*, Robert Fournier (ed.), Fournier Pottery, Tanyard Lacock, Wiltshire 1977, p.6. David Leach's career has been exhaustively documented in the form of taped interviews and video by the National Electronic and Video Archive of the Crafts, Faculty of Art, Media & Design, University of the West of England, Bristol.

46. David Leach, 'Porcelain Body', *Ceramic Review*, 2, April 1970, pp.5–6.

47. H.C. Davis, *In Defence of the Rural Workshop*, Crowan Pottery, Praze, Cornwall.nd. 1954.

48. Harry Davis, 'Harry Davis Potter', unpublished autobiography c.1986, p.91. Davis family archive.

49. Leach, *Memoirs*, p.216.

50. Michael Cardew, 'Pioneer Pottery at Abuja', *Nigeria: A Quarterly*, vol. 52, 1956, 38–59.

51. Sarah Riddick, *Pioneer Studio Pottery. The Milner White Collection*, Lund Humphries/York City Art Galleries 1990, p.29.

52. Ibid., p.57.

53. Quoted in a mischievous profile of Casson by Tony Birks, 'Michael Casson: the man in the middle of the road', *Ceramic Review*, 24, November/December 1973, p.4.

54. Conversation with Michael Casson, 8 April 1989, partially quoted in Tanya Harrod, 'Michael Casson: Sources

of Inspiration', *Crafts*, 99, July/August 1989, p.43.

55. Watson (1990), pp.157–8.

56. 'Workshop: Aldermaston Pottery', *Ceramic Review*, 5, October 1970, p.4.

57. Alan Caiger-Smith, *Pottery, People, and Time: A Workshop in Action*, Richard Dennis, Old Chapel, Shepton Beauchamp, Somerset, 1995, p.9.

58. Ibid., p.9.

59. The sculptor Donald Potter, a pupil of Eric Gill, taught crafts, especially pottery, at Bryanston, exercising a powerful influence on many of his pupils, including the young Terence Conran, Batterham and the stoneware potter Mike Dodd.

60. Tarby Davenport, 'Prolific Dorset Potter', *Design*, 236, August 1968, pp.37–8.

61. See Geoffrey Whiting, 'Making Teapots', *Pottery Quarterly*, vol. 2, no. 7, Autumn 1955, pp.101–16.

62. Red Rose Guild of Craftsmen, *Catalogue of the Thirty-seventh Annual Exhibition*, Whitworth Art Gallery, 1961, pp.6–7, 32–3.

63. On Whiting's Japanese tastes see Edmund de Waal, 'Saying More with Less', in *Geoffrey Whiting Potter: A Retrospective Exhibition*, Aberystwyth Arts Centre 1989, pp.23–5.

64. Conversation with William Marshall, 9 August 1991.

65. *Ceramic Review* was the forum for Whiting's fulminations against the the 'star' system in ceramics – see 'Off-Centre', *Ceramic Review*, 41, September/October 1976, 'Quo Vadis?', *Ceramic Review*, 84, November/December 1983 and 'Showman Potter', *Ceramic Review*, 106, July/August 1987.

66. Edmund de Waal, *Bernard Leach*, Tate Gallery 1998.

67. 'Gwyn Hanssen Talking', *Ceramic Review*, 11, September/October 1971, p.5.

68. Watson (1990), p.192.

69. Museum of Modern Art, Oxford, *The Raw and the Cooked*, 1993, p.42.

70. Craftsmen Potters Association, *Year Book 1966*, p.41.

71. *Picasso in Provence*, Arts Council 1950.

72. See John Chappell, 'Letter from Vallauris', *Pottery Quarterly*, 7, Autumn 1955, pp.107–8. Also see Tanya Harrod, 'Picasso's Ceramics', *Apollo*, vol. cxxix, no. 327, May 1989, pp.337–41. For the industry's view see 'Picasso and the Potters', *Pottery Gazette and Glass Trade Review*, April, 1946, p.233.

73. Bernard Leach, *A Potter's Book*, Faber & Faber 1940, p.14; Bernard Leach, 'The Contemporary Studio-Potter', *Pottery Quarterly*, Summer 1958, vol. 5, no. 18, p.47, discusses Picasso's 'disastrous' effect on potters and notes that his followers in Paris are known as 'les Picassiettes'. Leach goes on to use the phrase in *A Potter in Japan*, Faber & Faber 1960, p.203.

74. For the potter William Newland's account of Picasso's influence see 'William Newland, Pottery and the Institute', *Alumnis: The Review of the Institute of Education Society*, University of London, no. 4, 4 August 1985, p.23.

75. *Victor Pasmore Hans Seiler Christopher Wood Collages and Ceramics*, Redfern Gallery, May 1952.

76. Robert Melville, 'Pots in Rows', *Architectural Review*, 116, no. 693, September 1954, p.191. For a negative reaction from the ceramics industry see 'Caviar to the General', *Pottery and Glass*, vol. xxx, no. 11, November 1952, p.70.

77. Quoted in Aberystwyth Arts Centre, *William Newland: Its all there in front of you. Ceramic work from 1947 to the present*, 1996, p.25.

78. See Watson (1990), p.450, and William Newland, 'Recent Ceramic Art', *World Review*, December 1952, p.32. Also unpublished typescript, n.d. sent to author where Newland explains: 'In the 50's/early 60's, the vast number of students who wanted to study Pottery did so for two reasons – Picasso, Miró etc and the André Malraux theory of surge in art expression after wars and slumps.

At the Institute of Education I had 1,000 students who wanted to pot. All with the exception of "Old Soldiers" were young Marion Richardson products – "The picture from the imagination" and "The one off" – bored with repetition.'

79. Reviewed by Murray Fieldhouse in the first issue of *Pottery Quarterly*, 1, Spring 1954, pp.43–6. James Tower was also reviewed in Robert Melville, 'Pots in Rows',

Architectural Review, vol. 116, no. 693, September 1954, pp.193. Drawings of work in 'William Newland, Margaret Hine and Nicholas Vergette, The Crafts Centre of Great Britain 12 July–7 August', in *Pottery Quarterly*, 3, Autumn 1954, pp.39–41.

80. Illustrated in *Pottery Quarterly*, 7, Autumn 1955, Fig. 4.

81. Ken and Kate Baynes, 'Eating out can be fun', *Design*, 206, January 1966, pp.29–37.

82. For Wyne Reeves see Watson (1990), pp.270–1. On her joint work with Kenneth Clark see 'A London Pottery', *Pottery Gazette and Glass Trade Review*, October 1960, pp.1272–3. Clark designed metalwork and was consultant designer to Pountneys and Denby. See Dilys Rowe, 'Will china's new "feel" come from the studio?', *Manchester Guardian*, 1 July 1959, p.4. On the influence of Klee, see Lesley Jackson, *The New Look: Design in the Fifties*, Thames and Hudson 1992, pp.62–4. See also Sarah Levitt, *Pountneys: The Bristol Pottery at Fishponds 1905–1969*, City of Bristol Museum & Art Gallery 1990.

83. The show was well illustrated in *Architectural Review*, vol. liii, no. 665, May 1952, pp.338–9.

84. See Watson (1990), p.254; also *James Tower 1919–1988: A Retrospective Exhibition*, 28 January–25 February 1989, Hove Museum and Art Gallery; *Corsham A Celebration: The Bath Academy of Art 1946–72*, Michael Parkin Gallery, London 1989.

85. Conversation with Ian Auld, 23 November 1988.

86. 'Exhibitions', *Pottery Quarterly*, 1, Spring, 1954, p.45.

87. Dora Billington, 'The Younger English Potters', *The Studio*, vol. cxlv no. 720, March 1953, pp.78–85 reprinted in John Houston (ed.), *Craft Classics: An Anthology of Belief and Comment*, Crafts Council 1988.

88. For the best account of Rie and the impact of British studio pottery see John Houston in John Houston (ed.), *Lucie Rie*, Crafts Council, 1981, pp.11–21. See also Tony Birks, *Lucie Rie*, Alphabooks/A. & C. Black 1987. A.C. Sewter, 'Lucie Rie – Potter', *Apollo*, vol. lix, no. 348, February 1954, pp.40–1, argued that in the long term Leach had a beneficial influence on Rie: 'She has now revealed, however, a much greater awareness of the expressive quality of the profile'.

89. For the best account of Rie's techniques see Nigel Wood, 'An Appreciation of Lucie Rie's Materials and Techniques', in *Lucie Rie*, Crafts Council 1992, n.p.

90. Lesley Jackson, *The New Look: Design in the Fifties*, Thames & Hudson 1991, p.34, links the use of fine thread-like lines by the Finn Tapio Wirkkala and by Rie to the influence of the constructivist work of Naum Gabo. Birks, *op.cit.* (1987), p.44 links her sgraffito to prehistoric pots seen by Rie on a visit to Avebury in the late 1940s.

91. Rie was introduced to Wedgwood by the Director of the Design Council, Sir Paul Reilly. See Paul Reilly, *An Eye on Design*, Max Rheinhardt 1987, p.161.

92. The best account of Coper's career is Tony Birks, *Hans Coper*, Collins 1983.

93. Both George Wingfield Digby, *The Work of the Modern Potter in England*, John Murray, 1952, p.84, and Muriel Rose, *The Artist Potter in England*, Faber & Faber 1955, p.24, make it plain that Coper saw himself as painter and sculptor.

94. Garth Clark, 'Thinking of Cardew and Africa', *Studio Pottery*, 13, February/March 1995, p.40.

95. Craftsmen Potters Association, *Year Book 1966*, p.7.

96. In *Coper/Collingwood*, Victoria & Albert Museum, 1969, n.p.

97. For moving and revealing tributes from former students Elizabeth Fritsch, Glenys Barton and Alison Britton see 'Hans Coper', *Crafts*, 54, January/February 1982, pp.34–6.

98. See David Queensberry's tribute in 'Hans Coper', *Crafts*, 54, January/February 1982, p.34.

99. On this group see Tony Birks, *The Art of the Modern Potter*, Country Life Ltd 1976, Tanya Harrod, *Potted History: A selective survey of the last twenty years of British ceramics*, Gardner Centre Gallery, University of Sussex 1986, pp.12–18 and Ewen Henderson, *Pandora's Box and the Tradition of Clay*, Crafts Council 1995.

100. Conversation with Gordon Baldwin, 3 October 1988.

101. See Tanya Harrod, 'Gordon Baldwin: Sources of Inspiration', *Crafts*, 96, January/February 1989, pp.44–5;

Watson (1990) pp.47–8, provides a good bibliography. The best overview is John Houston, *Gordon Baldwin, a Retrospective View*, Cleveland County Museum Service 1982. For an illustration of his work *c.*1954 see *Pottery Quarterly*, 3, Autumn 1954, plate 9. For later work see Charles S. Spencer, 'The Experimental Work of Gordon Baldwin', *The Painter and Sculptor: A Journal of the Visual Arts*, vol. 2, no. 3, Autumn 1959.

102. *Ruth Duckworth, Claire Zeisler*, Moore College of Art, Philadelphia, Pennsylvania, 12 October–17 November 1979 has a complete bibliography. For a sense of her creative partnership with sculptor and furniture designer Aidron Duckworth (they styled themselves A. and R. Duckworth Associates Ltd until her departure for the USA) see Aidron Duckworth, 'Three dimensional basic design', *Architectural Design*, May 1962, pp.257–9. Also see Tanya Harrod, 'Free Spirit', *Crafts*, no.85, March/April 1987, pp.32–4.

103. Ruth and Aidron Duckworth, 'Pottery in a Vacuum', *Pottery Quarterly*, vol. 7, no. 26, 1961, p.56.

104. On Auld see Watson (1990), p.147; Geoff Hassell, *Camberwell School of Arts and Crafts: Its students & Teachers 1943–1960*, Antique Collectors Club, Woodbridge, Suffolk, 1995, p.31.

105. Christopher Gowing, Paul Rice, *British Studio Ceramics in the Twentieth Century*, Barrie & Jenkins 1989, p.146.

106. *The Times*, 21 August 1969, p.5.

107. Tanya Harrod in *Gillian Lowndes: New Ceramic Sculpture*, Crafts Council, 1987, p.3.

108. Tony Birks, *Art of the Modern Potter*, Country Life Ltd 1976, pp.139–45, illustrates this early work. On p.135 Birks quotes Hans Coper: 'She will make a shape which is more drainpipe than anything else, yet somehow it is a pot'.

109. Ian Auld, 'Letter from Nigeria', *Ceramic Review*, 11, September/October 1971, p.7.

110. See Sue Harley, 'Ian Auld and Gillian Lowndes', *Ceramic Review*, 44, March/April 1977, p.5 for illustrations of some inspirational Nigerian objects.

111. See Murray Fieldhouse, 'Hamada, Crafts Centre, March', *Pottery Quarterly*, Spring, vol. 5, no. 17, 1958, p.35; Soetsu Yanagi, 'Teabowls by Koyetsu and Hamada', *Pottery Quarterly*, vol. 8, no. 31, 1964, pp.48–50.

112 Watson (1990), p.210. Also see Emmanuel Cooper, 'Obituary', *Independent*, 13 September 1997.

113. Conversation with Dan Arbeid, 4 September 1997.

114. 'Contemporary American Ceramics, American Embassy', *Pottery Quarterly*, vol. 8, no. 29, 1963, pp.31–3.

115. Victoria & Albert Museum, *American Studio Pottery*, HMSO, 1968.

116. Birks, *op.cit.*, 1976, pp.8–21.

117. Conversation with Ann Sutton, 22 March 1994.

118. Tony Hepburn, 'American Ceramics 1970', *Ceramic Review*, 7, January/February 1971, pp.10–11.

119. Birks, *op. cit.*, p.10.

120. 'Robert Welch', *Mobilia*, August 1967; 'David Mellor Industrial Designer', in *Design in Sheffield*, Summer/Autumn 1964, pp.34–8.

121. Louis Osman, 'Gerald Benney', *The Studio*, vol. 158, no. 800, December 1959, p.142.

122. Mark Brutton. 'Mellor's Industrial Revolution', *Design*, 316, April 1975, pp.62–5; Sheffield Galleries and Museums Trust, *David Mellor: Master Metalworker*, 1998.

123. Graham Hughes, *Modern Silver throughout the World 1880–1967*, Studio Vista 1967, p.57.

124. L.G. Durbin, 'Silversmithing', in John Farleigh (ed.), *Fifteen Craftsmen on their Crafts*, The Sylvan Press 1945, pp.60–8; John Farleigh, 'Leslie Durbin Goldsmith', in *The Creative Craftsman*, G. Bell & Sons Ltd 1950, pp.75–90, and Leslie Southwick, 'Craftsman Renowned', *Antique Dealer and Collectors Guide*, February 1993, pp.36–9.

125. Leslie Durbin, *Silver in Church*, booklet n.d.

126. Fiona MacCarthy, *British Design since 1880: A Visual History*, Lund Humphries 1982, p.152.

127. Mark Brutton, 'Mellor's Industrial Revolution', *Design*, 316, April 1975, pp.62 5.

128. Robert Welch, *Hand and Machine*, The Mill, Chipping Campden 1986.

129. Conversation with Robert Welch, 7 June 1994. Also see

130. Jeremy Myerson, 'Robert Welch: Sources of Inspiration', *Crafts*, 115 March/April 1992, p.47.

130. Welch, *op.cit.* (1986), p.49.

131. Graham Hughes, *Modern Silver throughout the World 1880–1967*, Studio Vista 1967, p.98.

132. Graham Hughes, 'British Modern Silver: 1', *The Studio*, vol. clix, no. 801, January 1960, p.3.

133. The Worshipful Company of Goldsmiths library holds a helpful press release on Louis Osman compiled *c.*1964 by Francis Butters Ltd. Also see 'Designs by Louis Osman', *The Architectural Review*, May 1969, pp.359–62; Graham Hughes, 'Louis Osman', *The Connoisseur*, vol. 155, 1964, pp.177–81.

134. Osman's King's College Chapel was dismantled in 1983 as were his arrangements for the Principal's Lodge at Newnham College. His crown for Prince Charles apparently bankrupted Osman. See 'Goldsmith's Troubles started with job for Prince's Investiture', *Sunday Telegraph*, 14 January 1979.

135. On Clarke see J.P. Hodin, 'Geoffrey Clarke: Maker of Art', *The Studio*, May 1963, pp.210–14; *Geoffrey Clarke*, Redfern Gallery, 1964; *Geoffrey Clarke RA. Sculpture and Works on Paper 1950–1994*, Yorkshire Sculpture Park 1994; Peter Black, *Geoffrey Clarke Symbols for Man: Sculpture and Graphic Work 1949–94*, Ipswich Borough Council Museums and Galleries/Lund Humphries 1994.

136. Walter Hussey, *Patron of Art. The Revival of a Great Tradition among Modern Artists*, Weidenfield & Nicholson 1985, pp.102–3, 107, 109, 110, 131.

137. *Geoffrey Clarke. Etchings and Small Sculpture: An Exhibition in the Friends' Room of the Royal Academy*, 1994.

138. See Robert Burstow, "The Geometry of Fear": Herbert Read and British Modern Sculpture after the Second World War', in *Herbert Read: A British Vision of World Art*, Benedict Read and David Thistlewood (eds), Lund Humphries/Leeds City Art Galleries 1993.

139. Jeremy Myerson, 'Brian Asquith: Sources of Inspiration', *Crafts*, 124, September/October 1993, pp.44–7.

140. Robert Welch, *Hand and Machine*, The Mill, Chipping Campden, 1986, p.17.

141. *Stuart Devlin*, 1974, n.p. Devlin is best understood through his own publicity material. There is a good collection in the WCG archive. See also Ursula Robertshaw, 'Stuart Devlin's Gold', *Illustrated London News*, March, 1975, pp.61–3 and *Hello!* magazine, 11 December 1993.

142. Conversation with Gerald Benney, March 1994.

143. Michael Farr, *Design in British Industry: A Mid-Century Survey*, Cambridge University Press 1955, pp.50–1.

144. Conversation with Gerda Flöckinger, 5 March 1994.

145. Worshipful Company of Goldsmiths and the Victoria & Albert Museum, *International Exhibition of Modern Jewellery 1890–1961*, 26 October–2 December 1961.

146. For an involved and perceptive view of the period see Graham Hughes, *Modern Jewellery 1890 1963*, Studio Books 1963.

147. 'The Duke of Edinburgh's Prize for Elegant Design 1966', *Design*, 209, May 1966, p.32.

148. Ibid., pp.28–34.

149. These ideas are discussed in Peter Wollen, *Raiding the Icebox: Reflections on Twentieth-Century Culture*, Verso 1993, pp.1–30.

150. That Flöckinger's work was seen as the epitome of 1960s culture is suggested by its inclusion in the Central Office of Information funded film *Opus: Impressions of British Art and Culture* (1967) which also included artists Eduardo Paolozzi and Alan Davie, designer Mary Quant, footage from Peter Brook's film *Marat/Sade* as well as performances from the Beatles and Dudley Moore.

151. *Flöckinger/Herman. Jewellery by Gerda Flöckinger. Glass by Sam Herman*, Victoria & Albert Museum 1971. This was the second in a short-lived series organised by the Circulation Department. The first, devoted to Hans Coper and Peter Collingwood, was held in 1969.

152. *Helga Zahn: A Retrospective Assessment 1960–76. Jewellery, Prints and Drawings*, Crafts Advisory Committee 1976.

153. Crafts Council, *Bryan Illsley: Work in wood, metal and paint*, 1984; Brewery Arts, Cirencester, *Breon O'Casey: Man and Materials*, 1996.

154. Peter Dormer, 'Wendy Ramshaw – Designer', in *Wendy Ramshaw. From Paper to Gold*, South Bank Centre 1990.

155. Sara Bowman, 'Embroiderers at Home: women of the Sixty-Two Group', in *Women and Craft*, Elinor, Richardson, Scott, Thomas and Walker (eds), Virago 1987, p.151.

156. Christine Risley, 'A Personal Account', in *Constance Howard, Christine Risley, Eirian Shaw*, Goldsmiths' College 1995, p.15. This point is amplified by Risley in Christine Risley, 'Machine Embroidery, Looking Back and Looking Forward – A Personal Viewpoint', in *Celebration: To commemorate the 10th Anniversary of the Canadian Embroiders' Guild* 1981.

157. 'Needlework Development Scheme', *Design*, 33, September 1951, pp.5–12 and Constance Howard, *Twentieth-Century Embroidery in Great Britain 1940–1963*, B.T. Batsford Ltd 1983, pp.21–2, 64.

158. Constance Howard, 'A Personal Account', in *Constance Howard, Christine Risley, Eirian Shaw*, Goldsmiths' College 1985, pp.7–13.

159. Tanya Harrod, 'Constance Howard: Sources of Inspiration', *Crafts*, 127, March/April 1994, p.40.

160. Dora Billington, 'Contemporary Needlework Pictures', *The Studio*, vol. cl, no. 750, September 1955, p.66.

161. Ibid., p.67.

162. Christine Risley, 'A Personal Account', in *Constance Howard, Christine Risley, Eirian Shaw*, Goldsmiths' College 1985, p.15.

163. Beryl Dean, *Ideas for Church Embroidery*, B.T. Batsford Ltd 1968, p.21. Also see her rather less adventurous *Ecclesiastical Embroidery*, B.T. Batsford Ltd. 1958. For an entertaining 1990s perspective on her achievements see Rosemary Hill, 'As Ye Sew', *Crafts*, 108, January/February 1991, pp.42–5.

164. Howard, *op.cit.* (1983), p.104.

165. Conversation with Hilary Bourne, 10 December 1991. On Bourne and Allen's work in the Royal Festival Hall see 'Special Issue: Royal Festival Hall', *Architectural Review*, vol. 109, no. 654, June 1951, pp.361, 365. 'Woven Furnishing Textiles', *Architectural Review*, vol. 114, no. 682, October 1953, p.265 notes Allen and Bourne 'the weavers who specialise in work for architects'. There is a brief biography of Hilary Bourne in *The Journal*: the Quarterly Journal of the Guild of Weavers, Spinners and Dyers; hereafter *The Journal*, no. 37, March 1961, p.242.

166. Conversation with Tadek Beutlich, July 1994.

167. See Peter Collingwood, 'Two Tapestry Weavers', *The Journal*, 17, March 1956, pp.568–70. On Crook's subsequent career in New Zealand see Doreen Blumhardt, Brian Brake, *Craft New Zealand: The Art of the Craftsman*, Reed, Wellington, 1981, p.25.

168. 'In Memoriam Alastair Morton', *The Journal*, 47, September 1963, p.525.

169. Conversation with Hilary Bourne, 10 December 1991.

170. Peter Collingwood, 'Moving with the Times', *The Journal*, no. 7, September 1953, pp.192–5.

171. Ann Sutton, 'Talking Point', *The Journal*, no. 35, September 1960, p.187.

172. Peter Collingwood, 'A Weaving Project', *The Journal*, no. 33, March 1960, pp.115–22.

173. Theo Moorman, 'An Experimental Approach to Weaving', *The Journal*, no. 20, December 1956, pp.672–5.

174. Theo Moorman, 'Weaving in the Twentieth Century', in *Theo Moorman 1907–1990. Her Life and Work as an Artist Weaver*, Hilary Diaper (ed.), The University Gallery Leeds 1992, p.24. This is an exemplary survey of a maker's life and work but also see Hilda Breed, 'Theo Moorman', *The Journal*, no. 71, Autumn 1969, pp.1221–6.

175. On the impact of Polish weaving in the USA see Mildred Constantine and Jack Lennor Larsten's optimistically entitled *Beyond Craft: the art fabric*, Van Nostrand, New York, 1973, p.44. For an overview of the British scene see Irene Waller, *Fine-Art Weaving*, B.T. Batsford Ltd 1979.

176. On the impact of American painting in Britain see Frances Spalding, *British Art Since 1900*, Thames and Hudson 1986, pp.184–6, and Serge Guilbaut, *How New York Stole the Idea of Modern Art: Abstract Expressionism, Freedom, and the Cold War*, University of Chicago Press 1988.

177. Peter Collingwood, 'An American Trip', *The Journal*, no. 45, March 1963, pp.463–8.

178. Peter Collingwood, 'A Three Dimensional Hanging', *The Journal*, no. 48, December 1963, p.566.

179. See the catalogue *Weaving for Walls: Modern British Wall Hangings and Rugs*, exhibition arranged by the Circulation Department of the V&A with the co-operation of the Guilds of Weavers, Spinners and Dyers, 1965.

180. Peter Glenn, 'Weaving for Walls', *The Journal*, no. 56, December 1965, p.793.

181. On Barry Summer School see above p.226. On *Pendant 10* see 'Seven Wall Hangings and their Case Histories', *The Journal*, no. 56, December 1965, pp.802–3.

182. Ibid., pp.797–8.

183. Conversation with Ann Sutton, 22 March 1994,

184. A sentiment much applauded by Ann Sutton in her review of the show in *The Journal*, no. 70, Summer 1969, p.1194 – 'It is good to have a fellow thinker in the weaving world'.

185. *Stock List*, Farnborough Barn Ltd, September 1966, Ann Sutton archive.

186. 'Once upon a time in an antique shop', *Knitting News*, 15 October 1969, p.4.

187. Press Release, Crafts Centre of Great Britain, *Ann Sutton – Exhibition September 10th – 24th 1969*, Ann Sutton archive.

188. *The Journal*, no. 72, Winter 1969, pp.1265–6.

189. The Association for Textile Arts, *Newsletter*, no. 6, September 1971. Revel Oddy archive.

190. Mildred Constantine, Jack Lennor Larsen, *Beyond Craft: the art fabric*, Van Nostrand, New York, 1973, p.118. 'Britain's great artist in fiber is Polish-born Tadek Beutlich'. Also see Kathleen McFarlane, 'Tadek Beutlich', *Crafts*, 51, July/August 1981, pp.17–21.

191. For a heart-felt tribute for this late work from another weaver see Theo Moorman, 'Weaving in the Twentieth Century', in Diaper (ed.), *op.cit.*, pp.34–5.

192. See 'Kathleen McFarlane', in Irene Waller, *Fine Art Weaving*, B.T. Batsford Ltd 1979, pp.84–9.

193. This account draws heavily on Maureen Hodge, 'A History of the Dovecot', in *Master Weavers: Tapestry from the Dovecot Studios 1912–1980*, Canongate, Edinburgh, 1980, pp.39–43.

194. See Scottish Committee of the Arts Council of Great Britain, *The Jubilee of Dovecot Tapestries 1912–62*, Edinburgh International Festival 1962.

195. See Archie Brennan, 'Transposition of a Painting into a Tapestry', in *Master Weavers: Tapestry from the Dovecot Studios 1912–1980*, Canongate, Edinburgh, 1980, pp.33–6.

196. On Hodge's early career see Waller, *op.cit.*

197. There is an archive of Joyce Clissold material at the Central School of Art and Design. Also see *Joyce Clissold: Textiles, Collages, Drawings 1930–1982*, Waterman Arts Centre, Brentford 1982. Also see Chapter Three, note 157.

198. On her wallpapers see *A Popular Art – British Wallpapers 1930–1960*, Silver Studio Collection, Middlesex Polytechnic, 1990. On Angus in general see Tanya Harrod, 'Peggy Angus: Sources of Inspiration', *Crafts*, 108, January/February 1991, pp.32–5 and Tanya Harrod, 'Peggy Angus', *Independent*, 2 November 1992, p.27.

199. Terence Conran, *Printed Textile Design*, The Studio Publications 1957, pp.69–84.

200. See the preface by Deryn O'Connor to Susan Bosence, *Handblock Printing and Resist Dyeing*, David and Charles, Newton Abbot 1985. Also Alan Powers, 'Susan Bosence: Sources of Inspiration', *Crafts*, 121, March/April 1993, pp.44–7 and Barley Roscoe, 'An interview with Susan Bosence', in *Colour into Cloth: a celebration of Britain's finest hand-coloured textiles 1900–1994*, Crafts Council 1994, pp.12–14.

201. Bosence, *op.cit.*, p.10.

202. Valerie Mendes, 'Marion Dorn, Textile Designer', *Journal of the Decorative Arts Society*, 1978, no. 2, pp.24–35.

203. E.O. Hoppé, 'Batik', *Artwork*, no. 2, October 1924, pp.88–91; *The Nicholsons: A Story of Four People and their Designs*, York City Art Gallery, 1988.

204. On O'Connell see Grace Coltrane, *The Crafts Movement in Australia: A History*, New South Wales University Press

1992; Susan Bosence, *Handblock Printing and Resist Dyeing*, David and Charles, Newton Abbot 1985, p.40; *Michael O'Connell 1898–1976*, Christine McGegan (ed.), The Gallery, Over Haddon 1977. For a further bibliography see Jill Betts's excellent 'Michael O'Connell and his Festival of Britain Wall Hanging', *Folk Life*, vol. 35, 1996–7.

205. For details of O'Connell shows at Heal's see AAD 2–1978.

206. Peter Floud, 'The Crafts Then and Now', *The Studio*, vol. lcxlv, no. 721, April 1953, reprinted in John Houston (ed.), *Craft Classics since the 1940s: An Anthology of Belief and Comment*, Crafts Council 1988, p.51.

207. Noel Dyrenforth, *The Technique of Batik*, B.T. Batsford Ltd 1988, p.7.

208. 'Merry-go-round', *The Times*, Monday 23 October 1967.

209. Arts Council, *An Exhibition of Modern English and French Bindings from the collection of Major J.R. Abbey*, 1949, p.4. James could have added the amateur Madeleine Kohn (1892–1940) who worked in Paris and from 1931 with the McLeish family. See Victoria & Albert Museum, *British Art and Design 1900–1960*, 1983, pp.92–3. On Fisher see Dorothy Harrop, 'George Fisher and the Gregynog Press', *The Book Collector*, vol. 19, no. 4, Winter 1970, pp.465–77.

210. Arts Council, *op.cit.*, p.4.

211. Dorothy Harrop, 'Crafts Binders at Work III: Roger Powell', *The Book Collector*, vol. 22, no. 4, Winter 1973, pp.479–86, and Roger Powell and Anthony Gardner, 'Bookbinding', in *Fifteen Craftsmen on their Crafts*, John Farleigh (ed.), Sylvan Press 1945, pp.1–10; Nicholas Pickwood, 'Powell Multiscient', *The New Bookbinder*, vol. 2, 1982, pp.3–16.

212. Dorothy Harrop, 'Craft Binders at Work IV: Sydney Morris Cockerell, *The Book Collector*, vol. 23, no. 2, Summer 1974, pp.171–8; John Farleigh, *The Creative Craftsman*, London 1950, pp.91–103. Also on the 'ram' see Joan Rix Tebbutt, 'Remembering Sandy', *The Scribe*, Summer 1988, 43, pp.15–16.

213. On the Reimann School see Mansfield's account in Roy Harley Lewis, *Fine Bookbinding in the Twentieth Century*, David and Charles, Newton Abbot, 1984, p.40. On its early days in Weimar Germany see Design Center, Stuttgart, *Frauen im Design: Berufsbilder und Lebenswege seit 1900*, vol. 1, pp.239–41.

214. John Mason, 'The Future of Fine Bindings', *The Studio*, vol. cxlii, no. 407, November 1951, p.130. On Mansfield see Trevor Jones and James Brockman, *Twenty-Five Fine Bindings Designed by Edgar Mansfield and realised by James Brockman*, K.D. Duval, Frenick, Foss, 1993; Edgar Mansfield, *Modern Design in Bookbinding: The Work of Edgar Mansfield*, with an introduction by Howard M. Nixon, Owen 1966; Margot Coatts, 'Edgar Mansfield: Sources of Inspiration', *Crafts*, 131, November/December 1994, pp.44–7.

215. Jones, Brockman, *op.cit.*, pp.21–4.

216. Edgar Mansfield, 'Bookbinding Design: the Contemporary Approach', *The Studio*, vol. 156, no. 789, December 1958, p.181.

217. Dorothy Harrop, 'Craft Binders at Work VI: Ivor Robinson', *The Book Collector*, vol. 25, no. 1, Spring 1976, pp.45–52.

218. Dorothy Harrop, 'Craft Binders at Work XII: Trevor Jones', *The Book Collector*, vol. 31, no. 2, Summer, 1982, pp.153–69.

219. Dorothy Harrop, 'Craft Binders at Work VII: Jeff Clements', *The Book Collector*, vol. 25, no. 4, Winter 1976, pp.507–13.

220. Dorothy Harrop, 'Craft Binders at Work X: Elizabeth Greenhill', *The Book Collector*, vol. 28, no. 2, Summer 1979, pp.199–209.

221. Trevor Jones, 'The Guild of Contemporary Bookbinders 7 April 1955–7 December 1968', *The New Bookbinder*, vol. 10, 1990, pp.13–30.

222. Marigold Coleman, 'Three British Bookbinders', *Crafts*, 1 March 1973, pp.26–31; Dorothy Harrop, 'Craft Binders at Work: Faith Shannon', *The Book Collector*, vol. 37, no. 3, Autumn 1988, pp.333–50; D'Este Bond, 'Faith Shannon: Sources of Inspiration', *Crafts*, 122, May/June 1993, pp.36–9.

223. Dorothy Harrop, 'Craft Binders at Work IX: Charles Philip Smith', *The Book Collector*, vol. 27, no. 2, Summer 1978, pp.169–90.

224. Philip Smith, *The Lord of the Rings and other Bookbindings of Philip Smith*, privately printed 1970, p.2.

225. Philip Smith, *New Directions in Bookbinding*, Studio Vista 1974, p.115.

226. Ibid., p.12.

227. The tributes appeared in *Edward Johnston, Calligrapher*, Charles Pickering (ed.), privately printed by permission of the Society of Scribes and Illuminators at Maidstone College of Art 1948 and reprinted in Edward Johnston, *Essays in Formal Writing*, Heather Child and Justin Howes (eds), Lund Humphries 1986.

228. C.M. Lamb (ed.), *The Calligrapher's Handbook*, 1956, superseded by Heather Child (ed.), *The Calligrapher's Handbook*, A. & C. Black 1985.

229. Society of Scribes and Illuminators, Report of Years ending 1951–2, AAD 4/3–1982.

230. Society of Scribes and Illuminators, Report of the Years 1952–3, 53–54, AAD 4/3–1982.

231. Society of Scribes and Illuminators, Heather Child, 'Crafts Centre 1961, AAD 4/3–1982.

232. Society of Scribes and Illuminators, General meeting of the Society, 11 October 1963, AAD 4/3–1982.

233. *Lettering Today: a survey and reference book*, John Brinkley (ed.), Studio Vista 1964, p.9.

234. See Richard Hollis, 'Nicolete Gray', *The Guardian*, 10 June 1997, p.16.

235. Nicolete Gray, *XIXth Century Ornamented Types and Title Pages*, Faber & Faber 1938, p.1.

236. Nicolete Gray, 'Calligraphy', *Architectural Review*, 112, no. 671, November 1952, p.284.

237. Ibid., p.286. This idea was developed in her *Lettering as Drawing*, Oxford University Press 1971.

238. Nicolete Gray, 'David Jones', *Signature*, new series 8, 1949, pp.46–54.

239. Nicolete Gray, 'David Jones and the art of lettering', *Motif*, 7, Summer 1961, p.69.

240. Heather Child in 'Calligraphy and Lettering', *Artifex: Journal of the Crafts*, vol. 2, 1969, p.8, made a rare acknowledgement, arguing that Jones can be seen as a forerunner of a group of letterers 'who are experimenting with the pattern and expression of words, who use words as symbols and semi-abstract shapes, and who desire to communicate in intuitive and unconventional ways.' But she explains, 'This is not calligraphy as the SSI sees it'.

241. On Reynolds Stone see Myfanwy Piper, *The Wood-Engravings of Reynolds Stone*, Art and Technics 1951 and *Reynolds Stone 1909–1979* with an introduction by Ruari McLean, Victoria & Albert Museum 1982.

242. Michael Harvey, *Lettering Design: Form and Skill in the Design and Use of Letters*, Bodley Head 1975, p.9. Also see *Michael Harvey Lettering Designer*, nd, privately printed.

243. For Kindersley's account of his apprenticeship with Gill see David Kindersley, *Mr Eric Gill: Further Thoughts by an Apprentice*, Cardozo Kindersley Editions Cambridge 1990. On Kindersley's lettering see a helpful unpublished BA dissertation by Ruth Cunningham, 'David Kindersley – alphabetician', University of Reading 1983. Also Montague Shaw, *David Kindersley and his Workshop*, Cardozo Kindersley Editions Cambridge 1989 and David Kindersley and Lida Lopez Cardozo, *Letters Slate Cut: Workshop Practice and the Making of Letters*, Lund Humphries 1981. Also Lottie Hoare, 'David Kindersley', *Independent*, Saturday 4 February 1995 and Lottie Hoare's first volume of a biography of David Kindersley (forthcoming).

244. Nicolete Gray described this serifed alphabet as 'without personal character, and as near as it can be to being disembodied', in *Lettering on Building*, The Architectural Press 1960, p.69.

245. Published as *Variations on a Theme of 26 Letters*, privately printed, 1969; *Graphic Sayings*, Kindersley and Skelton, Cambridge 1971, and *Graphic Variations*, Cardozo Kindersley Publications, Cambridge, 1979.

246. Cunningham, *op.cit.*, p.26.

247. See Nicolete Gray, *Lettering on Building*, The Architectural

Press 1960; James Mosley, 'English Vernacular', *Motif*, II, 1963/4. In the same issue of *Motif* see Gray's account of her Arts Council touring exhibition *Lettering on Building*. Also James Sutton, *Signs in Action*, Studio Vista, 1965.

248. Nicolete Gray, *Lettering on Building*, The Architectural Press 1960, p.67. On the background to the revival of Trajanic letters see James Mosley, 'Trajan Revived', *Alphabet*, I, 1964, pp.17–36.

249. Beyer's work was acknowledged with reservations by Nicolete Gray, by James Sutton, James Mosley and extensively by Alan Bartram in his *Lettering in Architecture*, Lund Humphries 1975. Beyer was commissioned to cut the letters *a r* in stone in lower-case Clarendon for the front cover of the *Architectural Review*, vol. 118, no. 703, July 1955. The result was described by the editors as being 'without subservience' to 'the Trajanic tyranny'. See Ralph Beyer, 'The First Forty Years', *Dot the I.*, Journal of Letter Exchange, Spring 1991, pp.48–53; Jane Stevenson, 'Ralph Beyer: A Study of Informality and Expression in Lettercutting', BA dissertation, University of Reading 1988; Tanya Harrod, 'Ralph Beyer: Sources of Inspiration', *Crafts*, 102, January/February, 1990, pp.42–3.

250. *Die Katakombenwelt: Grundriss, Ursprung und Idee der Kunst in der romischen Christengemeide*, Tubingen 1927 and *Frühchristliche Sinnbilder und Inschriften*, Bärenreiter-Verlag, Kassel and Basel 1964.

251. For conservatism among the key figures in the Society of Master Glass-Painters see the Very Rev. Eric Milner-White, Dean of York, 'How to choose stained glass', in *Churches, Artists and People*, 13th Report of the Central Council for the Care of Churches, Church Information Board 1959, pp.27–34, where Milner-White recommends 'use heraldry wherever possible'. Also the speech given to the Society by the Archbishop of Canterbury, Lord Fisher reported in the *Journal of the British Society of Master Glass-Painters*, xiv, no. 2, 1965, p.122.

252. See the Hugh Easton archive, AAD 5/4 – 1983.

253. *Journal of British Society of Master Glass-Painters*, vol. ix, no. 4, 1946, pp.102–3. On the influence of Ninian Comper see Martin Harrison, *Victorian Stained Glass*, Barrie & Jenkins 1980, p.72.

254. On Milner-White and the *Guardian* article see *Journal of the British Society of Master Glass-Painters*, vol. xii, no. 2, 1957, pp.132–3. On the Dean generally see Sarah Riddick, *Pioneer Studio Pottery: The Milner White Collection*, Lund Humphries/York City Art Gallery 1990.

255. See Dagmar Hayes, *Ervin Bossanyi, The Splendour of Stained Glass*, Friends of Canterbury Cathedral 1965.

256. See Chapter Two, pp.91–4.

257. *Journal of the British Society of Master Glass-Painters*, vol. ix, no. 4, 1946, p.101.

258. On Lee see Rosemary Hill, 'Lawrence Lee: Sources of Inspiration', *Crafts*, 98, May/June 1989, pp.42–3.

259. Lawrence Lee, 'Modern Secular Stained Glass: A decorative technique being developed at the Royal College of Art', *Architectural Design*, May 1951, pp.143–4. Also *Windows for Coventry: The ten stained glass windows for the nave of Coventry Cathedral*, Royal College of Art 1956, pp.1–3.

260. See *Windows for Coventry*, Royal College of Art 1956.

261. Martin Harrison, 'Introduction', in *John Piper: Painting in Coloured Light: an exhibition of stained glass and related works*, Kettle's Yard 1982; Tanya Harrod, 'Talking About Angels', *The Spectator*, 18/25 December 1993, pp.85–6.

262. H.C., *The John Piper Windows executed for Oundle School by Patrick Reyntiens*, Nene Press, Oundle School, 1956.

263. 'No painter stretched his executive interpreter more cruelly' claimed Reyntiens in *The Beauty of Stained Glass*, The Herbert Press 1990, p.196. But the stained-glass historian Peter Cormack argues that Piper's cartoons and drawings provided a detailed guide.

264. Ian Dunlop, 'Alice in the Stained Glass: The Reyntiens windows at Christ Church, Oxford', *Country Life*, 15 November 1984.

265. *A Small Anthology of Stained Glass*, Arts Council 1955.

266. *Modern Stained Glass*, Arts Council 1960–1.

267. Tanya Harrod, 'Margaret Traherne: Sources of Inspiration', *Crafts*, 134, May/June 1995, pp.46–9.

268. *Journal of the British Society of Master Glass-Painters*, xiv, no. 4, 1968–9, p.219.

269. Ibid., xiv, no. 3, 1967, p.175.

270. Ibid., xiv, no. 4, 1968–9, p.219.

271. For Hutton see Margaret Brentnall, *John Hutton: Artist and Glass Engraver*, The Art Alliance Press, Philadelphia 1986.

272. Laurence Whistler, *Point Engraving on Glass*, Walker Books, 1992.

273. *The Engraved Glass of David Peace*, Ruskin Gallery, Sheffield Arts Department 1990.

274. This section draws heavily on Pauline Solven, 'Great Britain', in Finn Lynggaard (ed.), *The History of Studio Glass: How it all began*, Glass Museum, Ebeltoft, Denmark 1998, forthcoming.

275. On the general background see Dan Klein, *Glass: A Contemporary Art*, Collins, 1989. Also Jorgen Schon-Christensen, 'Hot Glass Now', *Crafts*, 22 September/October 1976, pp.21–8; Peter Layton, 'The Glass Menagerie', *Crafts*, 61, March/April 1983, pp.34–6; Tanya Harrod, 'Sam Herman: Sources of Inspiration', *Crafts*, 105, July/August 1990, pp.46–7.

276. Penny Sparke, *Furniture*, Bell & Hyman 1986, pp.73–81.

277. For a description of the construction of the 'Allegro' chair see Advertisement in *Studio Year Book. Decorative Art*, 1949, p.viii.

278. *Studio Year Book. Decorative Art*, 1957–8, p.6.

279. A.E. Bradshaw, *Handmade Woodwork of the Twentieth Century*, John Murray 1962. Bradshaw argued that the hand craftsman tends to be a traditionalist – 'How far he can come to terms with "contemporary" forms which originate with the industrial designer is a matter he must resolve for himself', p.ix.

280. Noel Carrington, *Design and Decoration in the Home*, B.T. Batsford 1952, p.62.

281. Sparke, *op.cit.*, p.47. Ercol advertisements are very revealing – see *Architectural Review*, vol. cxxxvi, no. 816, 1965, pp.242. Also Ercol Furniture Ltd's booklet *At Home. The Ercol Book of Interiors*, 1985 on how the firm adapted to changing fashions. In the 1950s advertisements proclaimed 'a grace and comfort that are as modern as tomorrow'. By the 1980s the firm emphasised tradition and launched a heavy Jacobethan 'Old Colonial' range and the limited edition 'Blenheim Bureau' made from oaks felled in the grounds of Blenheim Palace.

282. This point was made in *Studio Year Book. Decorative Art*, 1958–9, p.6.

283. Tanya Harrod, 'Sandy MacKilligin: Sources of Inspiration', *Crafts*, 132, January/February 1995, pp.46–9.

284. Ken Baynes, 'Designing by Making', *Design*, 119, July 1965, p.29 and *Architectural Design*, 5, 1968, p.245, for his CoID award-winning rocking chair and coffee table.

285. Baynes, *op.cit.*, p.32.

286. *Studio Year Book: Decorative Art*, 1957–8, p.53

287. *Craftsmen of Quality*, Crafts Advisory Committee 1976, pp.182–6.

288. Conversation with John Makepeace, 3 May 1994.

289. 'Keeping Alive Old Skills in the Age of Machines', *Coventry Evening Telegraph*, 13 April 1963, p.6, illustrates a Barnsley-like chest but also see *Designer Craftsmen 1963*, Herbert Art Gallery and Museum, Coventry, 29 June–4 August 1963.

290. Alan Peters, *Cabinet Making – The Professional Approach*, Stobart and Son Ltd. 1984.

291. *John Makepeace Furniture*, illustrated brochure c.1995.

CHAPTER NINE

1. Bernard Leach to Leonard and Dorothy Elmhirst, 7 November 1945, Arts Applied 3, Bernard Leach, general Correspondence 1926–79, DHA.

2. John Halkes, 'Denis Mitchell', *The Independent*, 25 March 1993, p.30.

3. See Robin Kinross, *Modern Typography*, Hyphen Press 1992, pp.117–18. Froshaug was a close friend of Norman Potter whose anti-crafts ideas were discussed in Chapter Seven. They shared an admiration for Lewis Mumford.

4. Sven Berlin, *The Coat of Many Colours*, Redcliffe Press, Bristol, 1994, p.227.

5. Sven Berlin, *The Dark Monarch: A Portrait from Within*, The Gallery Press 1962, p.22. This book provoked four successful libel actions and was withdrawn at the end of 1962.

6. J.P. Hodin, *Cornish Renaissance*, Penguin New Writing, 39, Harmondsworth 1950, p.115.

7. *St Ives Times*, 12 October 1946 and draft no. 981 in Leach archive, CSC.

8. Robin Nance, 'My World as a Wood Worker', *Cornish Review*, 8, Summer 1951, p.38.

9. Conversation with Sam Vallely, a former craftsman at the Nance workshop, 24 July 1993.

10. Guido Morris, 'My Work as a Printer', *Cornish Review*, 3, Autumn 1949, p.62. On Morris in general see Anthony Baker's enchanting essay 'The Quest for Guido', *The Private Library*, 2nd series, vol. 2, no. 4, Winter 1969, pp.139–87.

11. John Farleigh, *The Creative Craftsman*, G. Bell & Sons Ltd 1950, p.239.

12. Sven Berlin, *The Coat of Many Colours*, Redcliffe Press, Bristol 1994, p.192.

13. Robin Kinross, 'Technics and Ethics: the Work of Anthony Froshaug', *Octavo*, no. 1, 1986, pp.4–9; Robin Kinross, 'Workshop Dissidents in Post-War Britain: Anthony Froshaug, Norman Potter, and Their Circle', in Harrod, *Conference*, pp.383–9.

14. 'Guido Morris', in John Farleigh, *The Creative Craftsman*, G. Bell & Sons Ltd. 1950, p.239.

15. Guido Morris, 'My Work as a Printer', *Cornish Review*, 3, Autumn 1949, p.64.

16. Alan Bowness, *A Note on the history and purpose of the Penwith Society*, Penwith Society of Arts, Tenth Anniversary Exhibition, Arts Council 1960, p.4.

17. Henry Trevor, 'The Penwith Society', *Cornish Review*, Summer 1950, p.66.

18. For a development of this idea see David Thistlewood, 'MOMA and the ICA: A Common Philosophy of Modern Art', *British Journal of Aesthetics*, vol. 29, no. 4, Autumn 1989, especially pp.323–4.

19. These were republished as a composite essay entitled 'Submerged Rhythm: A Potter's Aesthetic', in Patrick Heron, *The Changing Forms of Art*, Routledge & Kegan Paul 1955, pp.57–65.

20. See Patrick Heron, 'Tom Heron: A Biographical Note', *Journal of Decorative Arts Society*, no. 4, 1978, pp.34–8, and Hazel Berriman, *Cryséde: The Unique Textile Designs of Alec Walker*, Royal Institution of Cornwall, Truro 1993.

21. Patrick Heron, 'Round the London Art Galleries', *The Listener*, 13 September 1951, p.428.

22. Patrick Heron, 'Submerged Rhythm: A Potter's Aesthetic', in Heron, *op.cit.* (1955), p.59.

23. Ibid., p.65.

24. This account is based on a taped conversation with Breon O'Casey, 4 August 1991.

25. Quoted in Christopher Reid, 'A Personal View', in *Bryan Illsley – Work in Wood, Metal and Paint*, Crafts Council 1984, pp.21–2.

26. Ibid., p. 10.

27. This section is based on taped conversations with Janet Leach, 6 August 1991, 23 July 1993.

28. Christopher Reid, 'A Personal View', in *Bryan Illsley – Work in Wood, Metal and Paint*, Crafts Council 1984, p.20.

29. Council of Industrial Design, *Britain Can Make It*, 1946, p.134.

30. Ian Cox, *The South Bank Exhibition: A Guide to the Story It Tells*, HMSO 1951, p.8.

31. Mary Banham and Bevis Hillier (eds), *A Tonic to the Nation: The Festival of Britain 1951*, Thames and Hudson 1976, p.63.

32. Quoted in Lionel Esher, *A Broken Wave: The Building of England 1940–1980*, Penguin, Harmondsworth 1983, p.303.

33. Ibid., p.49.

34. Banham and Hillier (eds), *op.cit.*, p. 186.

35. Barry Curtis, 'One Continuous Interwoven Story (The Festival of Britain)', in *The Block Reader in Visual Culture*, Routledge 1996, p.212. This article is full of insights that have shaped my reading of the South Bank exhibition.

36. Cox, *op.cit.*, p. 8.

37. The 'South Bank' issue of *Architectural Review*, vol. 110,

no. 656, August 1951 provides the fullest guide to the appearance and mood of the different pavilions.

38. 32nd Meeting of the Crafts Centre of Great Britain, 18 June 1949, AAD 1/819–1980.

39. Council Minutes, 42nd meeting, 12 November 1948, The Design Council Archive, University of Brighton.

40. Council of Industrial Design, 5th Annual Report, 1949–50, p.13.

41. *Festival of Britain 1951: Crafts Associations*, A. Murray to Colonel Rowe, 24 November 1950, 1 December 1950, 5278, The Design Council Archive, University of Brighton.

42. *Festival of Britain Handicraft List*, 5512, The Design Council Archive, University of Brighton. Eight furniture makers, including Edward Barnsley and Robin and Dicon Nance, a glass engraver and three craft silversmiths, including Leslie Durbin, were featured in *Design Review*.

43. Cox, *op.cit.*, p.8. For a full list of objects see *Catalogue of Exhibits: South Bank Exhibition*, HMSO 1951.

44. See Jill Betts, 'Michael O'Connell and his Festival of Britain Wall Hanging', *Folk Life*, vol. 35, 1996–7, pp.1–18.

45. See Constance Howard, *Twentieth-Century Embroidery in Great Britain 1940–1963*, B.T. Batsford 1983, p.49.

46. Illustrated in Noel Carrington, *Design and Decoration in the Home*, B.T. Batsford Ltd 1952, p.104. Davies is also mentioned in David Pye's *The Nature and Art of Workmanship*, Cambridge University Press 1978, p.20, and above, pp.172–3.

47. RIB Information Officer to A.S. Thomas, April 1949, 5278, The Design Council Archive, University of Brighton.

48. South Bank Demonstrators file, 5464, The Design Council Archive, University of Brighton.

49. Cox, *op.cit.*, pp.67–8.

50. On the Royal College of Art involvement with the South Bank Exhibition, especially the Lion and Unicorn Pavilion see Christopher Frayling, *The Royal College of Art: One Hundred and Fifty Years of Art and Design*, Barrie & Jenkins 1987, pp.147–50.

51. Ella McLeod, 'Commission for the Festival of Britain 1951', in *Weaving by Elizabeth Peacock*, Crafts Study Centre, Holburne Museum, Bath 1979, pp.16–19.

52. The title of this show came from Thomas Moore's poem *Intercepted Letters*:
 'A Persian's Heaven is easily made;
 'Tis but black eyes and lemonade'.
 For Jones's account of mounting the show see Banham and Hillier (eds), *op.cit.*, pp.129–32. For thoughts on the show and the Lion and Unicorn Pavilion see Alex Seago, *Burning the Box of Beautiful Things. The development of post-modern sensibility*, Oxford University Press 1995, pp. 60–1.

53. 'CoID: Progress Report', *Architectural Review*, vol. 110, no. 660, December 1951, p.352.

54. Banham and Hillier (eds), *op.cit.*, p.17.

55. 45th meeting of the Crafts Centre of Great Britain, 21 July 1950; 46th meeting of the Crafts Centre of Great Britain, 1 September 1950, AAD 1/819–1980.

56. *Architectural Review*, vol. 114, no. 682, October 1953, p.265.

57. John McKean, *Royal Festival Hall: London County Council, Leslie Martin and Peter Moro*, Phaidon 1992, and 'Special issue: Royal Festival Hall', *Architectural Review*, vol. 109, no. 954, June 1951, pp.361, 365, 405.

58. For a general account see Ian McCallum, 'Prestige and Utility: Time-Life's London Offices', *Architectural Review*, vol. 113, no. 675, March 1953, pp. 157–72.

59. Lionel Brett, 'Towards the New Vernacular', *Design*, no. 51, March 1953, p.13.

60. Brett, *op.cit.*, p.14.

61. See Richard Cork and Eugene Rosenberg, *Architect's Choice: Art in Architecture in Great Britain since 1945*, Thames and Hudson 1992, pp.14–15; Timothy Lingard, *Michael Rosenauer: Architect 1884–1971: A Biographical Sketch*, Fine Art Society 1988.

62. See Reyner Banham, 'The Style: "Flimsy…Effeminate"?', in Banham and Hillier (eds), *op.cit.*, pp.190–8.

63. Nikolaus Pevsner, *The Englishness of English Art* (1956)

64. Penguin, Harmondsworth, 1964, p.181. This originated as the Reith Lectures broadcast in 1955. See also Pevsner's articles on the Picturesque in the *Architectural Review*, vol. 95, 1944, vol. 96, 1944, vol. 101, 1948, vol. 103, 1948.

64. Whitechapel Art Gallery, London, *This is Tomorrow*, 1956, p.76.

65. Theo Crosby, who largely organised the exhibition, resisted calls to involve Ben Nicholson and Barbara Hepworth. See David Robbins (ed.), *The Independent Group: Postwar Britain and the Politics of Plenty*, MIT Press, Cambridge MA, 1990, p.59.

66. Whitechapel Art Gallery, *op.cit.*, p.59.

67. A point made in Cork and Rosenberg, *op.cit.*, p.17.

68. John Summerson, 'Introduction', in Trevor Dannatt, *Modern Architecture in Britain*, B.T. Batsford Ltd 1959, p.27.

69. See Anthony Holloway and William Mitchell, 'London County Council experiment with the integration of the arts', *Architectural Design*, July 1959, pp. 285–8. Also Oliver Cox and Fred Millett, 'Mural Technique Today', *Architectural Review*, vol. 130, no. 774, August 1961, pp.88–100.

70. Basil Spence, *Phoenix at Coventry: The Building of a Cathedral*, Geoffrey Bles Ltd, 1962, p.1. On the art and craft in the Cathedral see Louise Campbell, *To Build a Cathedral: Coventry Cathedral 1945–1962*, University of Warwick 1987 and her still more invaluable *Coventry Cathedral: Art and Architecture in Post-War Britain*, Clarendon Press, Oxford, 1996.

71. Spence, *op.cit.*, p.14.

72. Ibid. p.14.

73. Louise Campbell, *Coventry Cathedral: Art and Architecture in Post-War Britain*, Clarendon Press, Oxford 1996, p.2.

74. Peter Hammond, 'A Liturgical Brief', *Architectural Review*, vol. 123, no. 735, April 1958, p.244.

75. Ibid.

76. Peter Hammond (ed.), 'Towards a Church Architecture', Architectural Press, 1962, p.23; hereafter Hammond (1962). See also Elaine Harwood's excellent 'Liturgy and Architecture: the Development of the Centralised Eucharistic Space in the Twentieth-Century Church', Twentieth-Century Architecture 3, *Journal of the Twentieth Century Society*, 1998, pp.49–74.

77. Hammond (1962), p.26.

78. Hammond (1962), p.34.

79. Illustrated in Hammond (1962) and in Robert Maguire and Keith Murray, *Modern Churches of the World*, Dutton Vista 1965, p.102.

80. James A. Whyte, 'The Theological Basis of Church Architecture', in Hammond (1962), pp.189–90.

81. Basil Spence, 'The Architectural Function of the Windows', in *Windows for Coventry: The ten stained glass windows for the nave of Coventry Cathedral*, Royal College of Art, June 1956.

82. Louise Campbell, *To Build a Cathedral. Coventry Cathedral 1945–62*, University of Warwick 1987, p.50.

83. It was translated by Oscar Wilde's son Vyvyan Holland and published by the First Editions Club in 1930.

84. Taped conversation with Geoffrey Clarke, 16 June 1994.

85. Reyner Banham, 'Coventry Cathedral', *New Statesman*, 25 May 1963, reprinted in *Design by Choice*, Penny Sparke (ed.), Academy Editions 1981, p.70.

86. Campbell *op.cit.* (1987), p.65.

87. Campbell *op.cit.* (1996), pp.176–85.

88. See Oskar Beyer, *Frühchristliche Sinnbilder und Inschriften*, Bärenreiter-Verlag, Kassel 1954.

89. Basil Spence, *Phoenix at Coventry: The Building of a Cathedral*, Geoffrey Bles 1962, p.75.

90. Nicolete Gray, 'Lettering at Coventry Cathedral', *Typographica*, no. 6, 1962, p.38. Also see Dr Oskar Beyer, 'The graphic word', *Church Building*, January 1964, no. 11, pp.9–14, and Ralph Beyer, 'The inscriptions and lettering in Coventry Cathedral', *Coventry Cathedral Review*, 1962.

91. Hammond (1962), p.28.

92. Hammond (1962), p.27.

93. In Trevor Dannatt, *Modern Architecture in Britain*, B.T. Batsford Ltd 1959, p. 26.

94. Reyner Banham, 'Coventry Cathedral', *New Statesman*, 25 May 1963, reprinted in Reyner Banham, *Design by Choice*, Penny Sparke (ed.), Academy Editions 1981, p.69.

95. Ibid., p.70.

96. Peter Hammond, 'A Liturgical Brief', *Architectural Review*, vol. 123, no. 735, April 1958, p.255.

97. See Robert Maguire and Keith Murray, 'Church at Bow Common, London', *Church Building*, October 1962, no. 7, p.15. For further reading see 'A Modern Church on Liturgical Principles', *Architectural Review*, vol. 128, no. 766, December 1960, pp.400–5, and Robert Maguire and Keith Murray, 'An Apology for St Paul's, Bow Common', *Church of England Newspaper*, 13 January 1961.

98. Taped conversation with Keith Murray, 26 May 1995.

99. Ibid.

100. Maguire and Murray, 'Church at Bow Common', *Church Building*, no. 7, October 1962, p.17.

101. Ibid., p.16.

102. Ibid., p.18.

103. The full quotation from the description of Jacob's dream in Genesis, chapter 28, verse 17, has resonance considering the bleak site for the church: 'And he was afraid, and said, How dreadful is this place! This is none other but the house of God, and this is the gate of heaven.'

CHAPTER TEN

1. Parliamentary Debates, House of Lords, 5th series, vol. 313, 3 December 1970.

2. Bernard Leach, *A Potter's Book*, Faber & Faber 1940, p.1.

3. Parliamentary Debates, House of Lords, 5th series, vol. 323, 28 July 1971.

4. On Eccles and the Arts Council see Robert Hewison, *Culture and Consensus: England, art and politics since 1940*, Methuen 1995, p.172.

5. The CoID, from 1972 the Design Council, carried out the CAC's administrative and financial work until the late 1970s. The Design Council's Deputy Director Mervyn Unger was the CAC's Financial Controller and Sir Paul Reilly its Chief Executive, 1971–7. See Paul Reilly, *An Eye on Design: An Autobiography*, Max Rheinhardt 1987, p.83.

6. Peter Longman, 'The Crafts Council's Development from the Design Council', June 1983, typescript, Crafts Council Archive.

7. The founding of the CAC coincided with the publication of Philip Rawson's *Ceramics*, Oxford University Press 1971 with suggestive chapter headings such as 'Memory-Traces and Meaning', 'Metaphor and Conceit' and 'Ceramics as Treasure'.

8. See *Craftsmanlike*, Fred Brookes (ed.), Sunderland Arts Centre, Ceolfrith Press 1978; Angela Wrigglesworth, 'Museums Collect', *Crafts*, September/October 1980, p.18, in which Roy Strong explains 'The late sixties and seventies were the crafts decades'; also Edward Lucie-Smith, 'A New Vocabulary', *Crafts*, 24 January/February 1977, pp.29–31 and 'For Better or Worse', *Crafts*, 54, January/February 1982, p.14; David Pye, Preface, *The Nature and Art of Workmanship*, Cambridge University Press 1978.

9. Edward Lucie-Smith, 'A New Vocabulary', *Crafts*, 24, January/February 1977, p.29.

10. Edward Lucie-Smith, *The Story of Craft: The Craftsman's Role in Society*, Phaidon 1981, p.275.

11. Edward Lucie-Smith, 'A New Vocabulary', *Crafts*, 24, January/February 1977, p.29.

12. Editorial, *Crafts*, 23 November/December 1976, p.7.

13. Misha Black, 'The Axe or the Adze?', *Crafts*, 21, July/August 1976, p.15. On Black's ambivalent attitude towards design practice see *The Black Papers on Design*, April Blake (ed.), Pergamon Press, Oxford 1983.

14. Lord Queensberry, 'The Designer, the Craftsman and the Manufacturer', *Journal of the Royal Society of Arts*, no. 5234, vol. cxxiv, January 1976, p.89. Extracts from this talk appear as 'The Wrong Direction', *Crafts*, 19, March/April 1976, pp.17–19.

15. Taped conversation with Michael Rowe, 9 November 1995.

16. Alastair Best, 'Going Against the Grain', *Designers' Journal*, no. 43, January 1989, p. 71.

17. See John Houston, *Fred Baier: Furniture in Studio*, Bellew

Publishing 1990, p.22 and a talk given by Fred Baier at the Art Workers' Guild, 17 February 1996.

18. See above p. 265; Craftsmen Potters Association, *Year Book 1966*, p. 41.

19. See David Ward, 'Work in the Collection; a broader context and related activities', in *The Jewellery Project: New Departures in British and European Work 1980–83*, Crafts Council 1983, pp.6–12, for a check-list of these kinds of influences.

20. 'No living artist commands a higher regard among the younger generation than Marcel Duchamp', in Richard Hamilton, 'Introduction' *Marcel Duchamp*, Tate Gallery 1966.

21. Charles Madge and Barbara Weinberger, *Art Students Observed*, Faber & Faber 1973.

22. England and Wales: National Advisory Council on Art Education, *The Structure of Art and Design Education in the Further Education Sector*, HMSO 1970, p.8.

23. Reyner Banham, 'Books', *Crafts*, 58, September/October 1982, p.56.

24. John Houston, *Richard Slee: Ceramics in Studio*, Bellew Publishing 1990, p.28.

25. See Alison Britton, 'Sèvres with Krazy Kat', *Crafts*, 61, March/April 1983, pp.18–23. Bevis Hillier's pioneering *Art Déco*, Studio Vista 1968 was followed by his *The World of Art Déco*, Studio Vista 1971. Gillo Dorfles's *Kitsch* appeared in an English translation in 1970 followed by Jacques Sternberg's *Kitsch*, Academy Editions 1972. On the retro interests of the period see *The Seventies*, Preston Polytechnic and Library 1980, with essays by Hillier and Lucie-Smith. On the fashion for Art Déco in the early 1970s see Derek Jarman, *Dancing Ledge*, Quartet Books 1984, p.93.

26. Christopher Frayling, 'From Itten to Ikat', *Crafts*, 92, May/June 1988, pp.38–41.

27. Taped conversation with Paul Astbury, 26 September 1995.

28. Glenys Barton, 'The Search for Order', *Ceramic Review*, 34, July/August 1975, p.4.

29. Peter Dormer, 'Forms and Heresies', in *David Watkins*, Leeds City Art Galleries and Crafts Council 1985, p.8.

30. *Painting with Words: The Calligraphy of Donald Jackson*, Minneapolis Institute of Arts, 1988.

31. Alison Britton, 'Sèvres with Krazy Kat', *Crafts*, 61, March/April 1983, p.22.

32. Robert Waterhouse, 'Malcolm Appleby', *Crafts*, 6, January/February 1974, p.15.

33. Taped conversation with Ann Sutton, 22 March 1994.

34. Jane Norrie, 'Oxford Blues', *Crafts*, 79, March/April 1986, p.57.

35. See *Crafts*, 27, July/August 1977, p.14.

36. Andy Pittaway (ed.), Bernard Scofield, *Country Bizarre's Country Bazaar*, Arch Press, 1974.

37. For a snap-shot of some galleries see *Showbusiness – The Role of the Craft Gallery*, CAC 1976.

38. On Strangeways see Abigail Frost, 'End of an Era', *Crafts*, 85, March/April 1987, p.46.

39. John Houston writes amusingly on the walking teapots in *Crafts*, 13, March/April 1975, p.48.

40. John Houston, *Richard Slee: Ceramics in Studio*, Bellew Publishing, London 1990, p.21.

41. For an account of 401 ½ see *Artist Craftsmen of 401 ½ and Fosseway House Workshops 1970–1980*, John Houston (ed.), Commonwealth Institute, London 1980.

42. Michael Casson, 'Central ceramics', *Crafts*, 10, September/October 1974, p.31.

43. 'Victor Margrie Talking', *Ceramic Review*, 19, January/February 1973, p.7, and Box 31, File 24: Conference of Craft Societies 1973, AAD/1991/4/1. Also Victor Margrie, 'View from the Bridge', *Crafts*, 61, March/April 1983, pp.10–12.

44. Fourth meeting of the CAC, 24 February 1972, CACM(7)2, p.3, Crafts Council archive.

45. John Pope-Hennessy, 'Foreword', in *Coper/Collingwood*, Victoria & Albert Museum 1969.

46. Notes of a meeting held to discuss the National Craft Exhibition (NCE),19 May 1972, Box 26, Preliminary Folders i–v, AAD/1991/4/1.

47. Notes of a meeting held to discuss the NCE, 28 July 1972, ibid.

48. *The Sunday Times*, 17 September 1972, File: 'The Craftsman's Art' press cuttings, Box 30, AAD/1991/4/10.

49. Sir Paul Reilly to Victor Margrie, 15 August 1972, Box 26, AAD/1991/4/1.

50. Seventh meeting of the CAC 13 September 1972, CACM (72) 5, p.6, Crafts Council archive.

51. John Houston, 'Back to the Future', *Crafts*, 100, September/October 1989, p.32.

52. File: Correspondence with craftsmen invited to exhibit, Box 28, AAD/1991/4/1.

53. Carruthers (1992), p.147.

54. File: Letters of praise or blame, Lilian Dring to John Houston 20 December 1972, Box 29, AAD/1991/4/1, This file is full of interesting letters from the disaffected, including Roger Powell, Alan L. Thompson, Ann Hechle, Beresford Pealing, Richard Batterham.

55. File: Loans. See David Pye to Victor Margrie, 11 January 1973, Box 28, AAD/1991/4/1,– 'I have heard – at second hand – that one of the selectors whom I highly respect considers the standard of work submitted so far for the exhibition is far too low'.

56. File 17: Traditional Skills, Box 28, AAD/1991/4/1.

57. Editorial, 'The Craftsman's Art', *Ceramic Review*, 21, May/June 1973, p.3.

58. John Houston, 'Back to the Future', *Crafts*, 100, September/October 1989, p.32.

59. On the look of the show see Houston, *op.cit*. Also *Ceramic Review*, 22, July/August 1973, p.14. For the exhibits see the well illustrated catalogue *The Craftsman's Art*, CAC, 1973.

60. File: Letters of praise or blame, Wyndham Goodden to W.A. Lincoln, President of the excluded Marquetry Society, 7 March 1973, Box 26, AAD/1991/4/1.

61. File: Letters of praise or blame, Alan Peters to John Houston, 4 April 1973, Box 29, AAD/1991/4/1.

62. On Lenthall see David Pye, 'First Off', *Crafts*, 58, September/October 1982, p.13.

63. For another version of this piece see Christopher Wilk (ed.), *Western Furniture 1350 to the present day in the Victoria and Albert Museum London*, V&A/Philip Wilson 1996, pp.218–19.

64. John Russell, 'Craft with Room for Everyone', *The Sunday Times*, 25 March 1973.

65. Michael Shepherd, 'Art', *The Sunday Telegraph*, 1 April 1973.

66. 'Keynote speech given by Viscount Eccles at the General Assembly of the World Crafts Council held on June 10, 1974', circulated with the minutes of the 15th meeting of the CAC, CACM (74) 3, Crafts Council Archive.

67. John Brandon-Jones, 'The Craftsman's Art', *Journal of the Royal Society of Arts*, no. 5202, vol. cxxi, May 1973, pp.402–3.

68. File: Letters of praise or blame, Sir Paul Reilly to J.S. Studmere, editor of the *Journal of the Royal Society of Arts*, 14 May 1973, Box 29, AAD/1991/4/1.

69. John Houston, 'Correspondence', *Journal of the Royal Society of Arts*, no. 5203, vol. cxxi, 1973, p.475.

70. See *A Guide to the World Crafts Council*, WCC 1988.

71. Octavio Paz, 'Use and Contemplation', in *In Praise of Hands: Contemporary Crafts of the World*, New York Graphic Society 1974, p.21.

72. Report on the Tenth Anniversary Conference and Sixth Biennale Meeting of the General Assembly of the WCC 1974 circulated with the Minutes of the fifteenth meeting of the CAC, 10 July 1974, CACM (74) 3, Crafts Council archive.

73. Marigold Coleman, 'Personal View', *Crafts*, 10, September/October 1974, p.10.

74. Eighth General Assembly and International Conference Kyoto Japan, World Crafts Council 1978, p.133, and Victor Margrie's Report, CAC (78), 4/4. Crafts Council archive.

75. Secretary's Report circulated with the 25th meeting of the CAC 27 October 1976, CACM (76) 4, Crafts Council archive.

76. Edward Lucie-Smith, 'A New Vocabulary', *Crafts*, 24, January/February 1977, pp.30,31.

77. This simplified account was first outlined by Ian Bennett,

'British Studio Pottery – Beliefs and Attitudes', in *British 20th Century Studio Ceramics*, Christopher Wood Gallery 1980. It was taken up by, *inter alia*, Oliver Watson, 'The development of Studio Pottery in Britain', in *British Ceramics and Textiles*, Scharpoord, Knokke-Heist, Belgium, 1981, in essays by Martina Margetts and Peter Fuller in Peter Dormer (ed.), *Fifty Five Pots and Three Opinions*, The Orchard Gallery, Londonderry, 1983, in essays by Peter Dormer and Martina Margetts in *Fast Forward: New Directions in British Ceramics*, ICA 1985, in John Houston, 'Ceramic art: orientating the object', in *British Ceramics*, Museum Het Kruithuis, 's-Hertogenbosch, Holland 1985.

78. File: 1974, John Houston to Faith Shannon 25 June 1973, Box 13, AAD/1991/4/5.

79. James Noel White, 'The craftsman's role in the ecology of culture', in *The Craftsman's Art*, CAC 1973, p.11.

80. *Sutton/Treen: Notes and Technical Information*, CAC 1974.

81. File: Sutton/Treen, Box 14, AAD 1991/4/5.

82. See Phillips's obituary by Bernard Denvir, *Independent*, 3 June 1994.

83. Ralph Turner, 'Crafts Council Exhibition Policy', April 1980, circulated with the minutes of the 4th meeting of the Crafts Council 24 April 1980, Crafts Council archive.

84. Ralph Turner, Preface, *Jewellery in Europe: An exhibition of progressive work*, Scottish Arts Council, CAC 1975.

85. *In Line – Eric Spiller/Warren Seelig*, CAC, 1978.

86. John Houston, 'Waiting for Alison', in *The Work of Alison Britton*, Crafts Council 1979.

87. John Houston in *Image and Idea*, British Council 1980–1, pp.5–6.

88. Statement by Michael Rowe to accompany his exhibition *Michael Rowe: Objects in Metal*, CAC 1979.

89. Elizabeth Fritsch, *Pots About Music. Recollections of the artist*, Leeds Art Galleries 1978, n.p.

90. See Esther Leslie, 'Walter Benjamin, Traces of Craft', in Harrod, *Conference*.

91. Martin Smith, 'Forms around a Vessel', in *Martin Smith*, Leeds Art Galleries 1981.

92. See *David Cripps – Photographer*, CAC, 1979. But Cripps has contributed to the elusive quality of the 'craft story' by keeping no systematic records of his work.

93. Fiona Adamczeski, 'Outside Tradition', *Crafts*, 2, May/June 1973, p.20.

94. Arnold Wilson, 'David Watkins', *Crafts*, 13, March/April 1975, p.48.

95. Ralph Turner, 'Introduction', in *Helga Zahn. A retrospective assessment 1960–1976. Jewellery, prints and drawings*, CAC 1976.

96. See 'Notes by Sarah Osborn', in *Susanna Heron: Body Work*, CAC 1980, p.6.

97. *Pierre Degen: New Work*, Crafts Council 1982.

98. David Vaughan (ed.), Tony Knipe, *State of Clay*, Sunderland Art Centre 1978.

99. For a detailed account of this conference see 'Sculptors in Limbo', *Crafts*, 33, July/August 1978, pp.32–9.

100. On these shows see Rozsika Parker and Griselda Pollock, *Framing Feminism: Art and the Women's Movement 1970–1985*, HarperCollins 1987.

101. Secretary's Report circulated for twentieth meeting of CAC on 29 October 1995. CAC 75, 4/5, Crafts Council archive.

102. Victor Margrie, 'Books', *Crafts*, 16, September/October 1975, pp.50–1.

103. Tina Margetts, 'Weaving from Cornwall', *Crafts*, 28 September/October 1977, pp.17–22.

104. 'Working in Cumbria', *Crafts*, 14, May/June 1975, p.12.

105. 'Working in Somerset', *Crafts*, 16 September/October 1975, p.11–12.

106. Marigold Coleman, 'Ray Finch's Workshop', *Crafts*, 11, November/December 1974, p.13.

107. Sally Bradbery, 'Turning to Wood', *Crafts*, 10, September/October 1974, p.34.

108. Catherine McDermott, *Street Style: British Design in the 80s*, Design Council 1987, provides some 1970s background. For a series of dazzling insights into the period see Jon Savage, *England's Dreaming: Sex Pistols and Punk Rock*, Faber & Faber 1991.

109. See Soetsu Yanagi, *The Unknown Craftsman: A Japanese Insight into Beauty*, adapted by Bernard Leach, Kodansha

International, Tokyo and New York, 1972.

110. See Bernard Leach, *Hamada Potter*, Kodansha International, Toyko and New York, 1975. The making, or perhaps compilation is the better word, of the book is described in Janet Leach's Foreword, p.10.

111. Ibid., p.195.

112. See Bernard Leach, *The Potter's Challenge*, David Outerbridge (ed.), Souvenir Press 1976, p.20. This book is another compilation based on taped interviews with the editor and on Leach's earlier *A Potter's Portfolio* which had appeared in 1950.

113. See Leach and Hamada in discussion 'Hamada', *Crafts*, 4, September/October 1973, pp.17–19.

114. Peter Crotty, 'Potter's Solidarity at West Dean: A Personal Report', *Ceramic Review*, no. 31, January/February 1975, p.2. On Wrecclesham pottery see Chapter Six, note 14.

115. See Tanya Harrod, 'Design and Production; Janice Tchalenko and Dart Pottery', in *The Harrow Connection*, (eds) Michael Casson, Victor Margrie, Ceolfrith Press 1989, pp.74–6, and Michael Casson, 'A Vision of Production; The DPTW 1975–1983', in *Dartington: Sixty Years of Pottery 1975–1983*, David Whiting (ed.), Dartington Cider Press, Dartington, Devon, 1993, pp.43–6.

116. See Michael Casson, 'Colin Pearson Porcelain and Black Basalt Ware', *Ceramic Review*, 13, January/February 1972, p.18, Watson (1990), p.225.

117. For Reyntiens see 'Rethinking Stained Glass', *Crafts*, 4, September/October 1973, p.26; on Peters and MacKilligin see 'Pros and Cons', *Crafts*, 20, September/October 1976, p.28.

118. Noted by Jeremy Myerson in *Makepeace: A Spirit of Adventure in Craft and Design*, Conran Octopus 1995, p.70.

119. See *Crafts*, 27, July/August 1977, pp.10–11.

120. See *Prospectus*, the Parnham Trust, n.d., p.4.

121. *New Times* was illustrator Clifford Harper's series of six 'Class War Comix' which set out plans for an anarchist craft-based utopian society. See also Peter Harper, Godfrey Boyle and the editors of *Undercurrents* (eds), *Radical Technology*, Wildwood House 1976, which carried articles on self-build, weaving, shoemaking, woodwork, etching, papermaking, metalwork and the ideal 'Community Workshop' – illustrated with Clifford Harper's visionary Rapidiograph drawings. My thanks to Robin Kinross for showing me this material.

122. Harper, Boyle and the editors of *Undercurrents*, op.cit., p.134.

123. Ivan Illich, 'Convivial Technology', in Nigel Cross, David Elliott and Robin Roy (eds.), *Man-made Futures: Readings in Society, Technology and Design*, Open University and Hutchinson Educational 1974, p.340.

124. Christopher Alexander, 'The unselfconscious process', in ibid., p.247.

125. M.W. Thring, 'Machines for a creative society', in ibid., p.305.

126. 'Keynote speech given by Viscount Eccles at the General Assembly of the WCC held on June 10 1974', circulated with the minutes of the 15th meeting of the CAC, CACM(74)3, Crafts Council archive.

127. Joe and Trudi Finch, 'Lesotho Workshop', *Ceramic Review*, 12, November/December 1971, pp.10–11.

128. Andy Pittaway and Bernard Scofield (eds), *Country Bizarre's Country Bazaar*, Arch Press 1974, p.51.

129. Sally and John Seymour, *Self-Sufficiency: The Science and Art of Producing and Preserving Your Own Food*, Faber & Faber 1973.

130. Talk given by David Poston at Goldsmiths' Hall, 11 February 1976, typed ms, David Poston, Crafts Council file.

131. Rosemary Hill, 'Friends of the Earth', *Crafts*, 100, September/October 1989, p.45.

132. Conversation with Richard La Trobe-Bateman, 30 September 1995. Also see Richard La Trobe-Bateman, 'Current Furniture', *Crafts*, 41, November/December 1979, pp.38–44; Alastair Best, 'Going with the Grain', *Designers' Journal*, no. 43, January 1989, pp.68–71.

133. Colin Ward, 'The Question of Survival', *Crafts*, 59, November/December 1982, p.16.

134. John Brown, *Welsh Stick Chairs*, Abercastle Publications, Newport 1990, p.33.

135. Ibid., p.87.

136. See Roger Coleman, *The Art of Work: an epitaph to skill*, Pluto Press, 1988.

137. On the organisation of this show see the uncatalogued ICA papers, Box XV, Tate Gallery Archive.

138. On Cooley and the 'Lucas Plan' for worker control combined with socially useful design see Nigel Whiteley, *Design for Society*, Reaktion Books 1993, pp.107–9.

139. 'Interview with Michael Murray', in *William Morris Today*, Institute of Contemporary Art 1984, pp.103–6.

140. *Craftsmen of Quality*, Crafts Advisory Committee, 1976, p.5.

141. See Colin Sorenson, 'Theme Parks and Time Machines', in *The New Museology*, Peter Vergo (ed.), Reaktion Books 1989, p.61.

142. For a fascinating discussion of 'Unofficial Knowledge' and 'Living History' see the sections so titled in Raphael Samuel, *Theatres of Memory*, Verso 1994.

143. See Peter Johnson and Barry Thomas, *Tourism, Museums and the Local Economy: The Economic Impact of the North of England Open Air Museum at Beamish*, Edward Elgar 1992: Ironbridge Gorge Museum Trust, Blists Hill Open Air Museum, *A Guide to the Site and Exhibits*, 1975.

144. See William B. Rhoads, 'Colonial Revival in American craft: Nationalism and the Opposition to Multicultural and Regional Traditions', in *Revivals! Diverse Traditions. The History of American Twentieth-Century Craft 1920–1945*, Janet Kardon (ed.), Harry N. Abrams Inc., New York, 1995, pp.53–4.

145. Especially see Bob West, 'The Making of the English Working Past: a critical view of Ironbridge Gorge Museum', in *The Museum Time Machine: Putting Cultures on Display*, Robert Lumley (ed.), Routledge 1988, pp.58–9. For other hostile accounts of 'heritage' activities see Robert Hewison, *The Heritage Industry: England in a Climate of Decline*, Methuen 1987 and Paul Reas and Stuart Cosgrove, *Flogging a Dead Horse: Heritage Culture and its Role in Post-Industrial Britain*, Manchester 1993.

146. See *The Makers*, V&A Museum 1976, and *Your Guide to Man and Made*, V&A 1976, and *The Makers* (with poems by Edward Lucie-Smith, calligraphy by Ann Hechle, etching by Ann Brunskill, etc.) V&A and World's End Press 1976. For Sir Roy Strong's verdict on the scheme see Minutes of the twenty-first meeting of the Crafts Advisory Committee, 14 January 1976. CACM (76) 1, p.5, Crafts Council archive.

147. The tours are discussed in the CAC minutes: 23rd meeting, 7 July 1976, 25th meeting, 26 January 1977, 27th meeting, 24 June 1977, 29th meeting, 27 January 1978, 31st meeting 12 July 1978, 33rd meeting, 24 January 1979, 34th meeting, 26 April 1979, Crafts Council archive. See also *The work of the Crafts Council 1977–1980*, Crafts Council 1980, p.8 and Victor Margrie, 'View from the Bridge', *Crafts*, 61 March/April 1983, p.10.

148. See John Anderson, 'If I don't, nobody else will', *Newsletter of the Film and Video Group of the Royal Photographic Society*, September 1994.

149. *Crafts*, 16 September/October 1975, p.10.

150. *Crafts*, 28 September/October 1977, p.12.

151. Dan Klein, *Glass: a Contemporary Art*, Collins 1989, p.11.

152. Kim Evans, 'Hot Glass conference', *Crafts*, 23, November/December 1976, p.10.

153. See Caroline Pearce-Higgins, 'Forged Ironwork Today', in *Towards a New Iron Age*, V&A 1982, p.10.

154. Quoted in Amina Chatwin, *Into the New Iron Age: Modern British Blacksmiths*, Coach House Publishing, Cheltenham 1995, p.33.

155. Caroline Pearce-Higgins, 'Report on 'Forging Iron' – International Conference and Workshop. Herefordshire Technical College and Ironbridge Gorge Museum 22–28 July 1980', October 1980, CC(80)4/5, Crafts Council archive.

156. Victor Margrie 'Introduction', in *The Maker's Eye*, Crafts Council 1981.

157. *The Maker's Eye*, Crafts Council 1981, p.16.

158. Sara Osborne, 'Notes', in *Susanna Heron: Body Work*, Crafts Council 1980.

159. *The Maker's Eye*, p.20.

160. Ibid., p.44.

161. Ibid., p.56.

162. Jeremy Myerson's *Makepeace: A Spirit of Adventure in Craft and Design*, Conran Octopus 1995, disappointingly illustrates very few of Makepeace's early works.

163. Alan Crawford, *Charles Rennie Mackintosh*, Thames and Hudson 1995, p.46.

164. See *Themes and Variations*, Wolverhampton Art Gallery, 1973; *Floris van den Broecke: fantastic furniture*, Whitechapel Art Gallery 1974; *Furniture↔Sculpture*, Ikon Gallery, Birmingham 1979; Alison Britton, 'Taking up the Chair', *Crafts*, 76, September/October 1985, pp. 33–6.

165. Quoted in Peter Dormer, *The New Furniture: Trends and Traditions*, Thames and Hudson 1987, p.133.

166. See Isabelle Anscombe, 'Crafts and Craftspersons', *The Times Literary Supplement*, 29 January 1982; Marina Vaizey, 'Design for Living in the Machine Age', *Sunday Times*; William Packer, 'The Case for the Crafts', *Financial Times*, 19 January 1982.

167. John McEwen, 'The Stroke of 12', *The Spectator*, 23 January 1982, p.24.

168. John McEwen, 'The Maker's Eye', *Crafts*, 56, May/June 1982, p.49.

169. Minutes of the ninth meeting of the Crafts Council 30 July 1981 CCM (81) 3, Crafts Council archive.

170. William Feaver, 'The Boilerhouse', *Observer*, 24 January 1982.

171. For these articles see Peter Fuller, *Beyond the Crisis in Art*, Writers and Readers Publishing Co-operative Society 1980, quotation from p.17.

172. Peter Fuller, 'The Maker's Eye', *Art Monthly*, March 1982 no. 54, p.13. The article was reprinted in Peter Fuller, *The Naked Artist*, Writers and Readers Publishing Co-operative Society 1983.

173. See Peter Fuller, 'Textiles North', *Crafts*, 55, March/April 1982; 'Fabric and Form', *Crafts*, 59, November/December 1982; 'The Jewellery Project', *Crafts*, 63, July/August 1983, p.46. Also see Peter Fuller, 'The Proper Work of the Potter', in *Fifty Five Pots and Three Opinions*, Peter Dormer (ed.), The Orchard Gallery, Londonderry, 1983, pp.19–26, for his reading of twentieth-century ceramic history.

CHAPTER ELEVEN

1. Crafts Council, *London Amsterdam: New Art Objects from Britain and Holland*, 1988, p.23.

2. Draft minutes of 23rd meeting of the CAC, 7 July 1976, pp.1–2, Crafts Council archive.

3. Director's Report to the 2nd meeting of the Crafts Council, 24 October 1979, Crafts Council archive.

4. Draft minutes of the first meeting of the Crafts Council, 12 July 1979, p. 4, Crafts Council archive.

5. Draft minutes of the 2nd meeting of the Crafts Council, 24 October 1979, p.3, Crafts Council archive.

6. House of Commons Papers, Education, Science and Arts Select Committee, 8th report, *Public and private funding of the arts*, HC 49, 1981/2.

7. Crafts Council Report 1982–5, p.3.

8. Peter Dormer, 'History Man', *Crafts*, 53, November/December 1981, p.18.

9. Extract from letter from Lord Eccles to the Minister for the Arts, 29 January 1984, CC(84)1/7, Crafts Council archive.

10. On 'consumer sovereignty' see Russell Keat and Nicholas Abercrombie, *Enterprise Culture*, Routledge 1991, *passim*. For the idea being argued in its most robust form see *Art of the State*, Adam Smith Institute 1989.

11. The term 'Enterprise Culture' was coined by Mrs Thatcher's then Chancellor, Nigel Lawson. See Robert Hewison, *Culture and Consensus: England, art and politics since 1940*, Methuen 1995, p.210.

12. See Letters, *Crafts*, 59, Novemeber/December 1982, pp.8–9 and Letters, *Crafts*, 61, March/April 1983, pp.8–9.

13. Crafts Council Report, 1982–5, p.4.

14. Quoted in draft Policy Review 1985, CC(85)3/4, pp.2–4, Crafts Council archive.

15. Director's Report, Crafts Council Report 1985–6, p. 4.

16. *Statement of Policy*, Crafts Council, London, April 1996, p.2.

17. Draft Policy Review 1985, CC(85)3/4, p.4, Crafts Council archive.

18. On the scheme see David Allen, *Enterprise Allowance Evaluation: the First Eighteen Months*, Manpower Services Commission, Sheffield, January 1987. On its relation to the crafts see Sue Tyler, 'The Bottom Line', *Crafts*, 89, November/December 1987, p.13.

19. Barclay Price, 'The Setting Up Grant: A Short History of the Scheme', in *Can't Stop Me Now: The Creative Lives of Twenty Craftspeople*, Crafts Council 1991, p.9.

20. Crafts Council Annual Report 1986–7, p.4.

21. Crafts Council Annual Report 1990–1, p.10.

22. Crafts Council Annual Report, 1985–6, p.6

23. See Northern Centre for Contemporary Art, *The Harrow Connection*, (eds) Michael Casson, Victor Margrie, Ceolfrith Press, Sunderland 1989, pp.74–5.

24. *Can't Stop me Now: The Creative Lives of Twenty Craftspeople*, Crafts Council 1991, p.17

25. Luke Hughes, 'Comment', *Crafts*, 131, November/December 1994, pp.22–5; *Crafts*, 105, July/August 1990, p.11.

26. Luke Hughes, 'Comment', *Crafts*, 131, November/December 1994, p.25.

27. Tanya Harrod, Martina Margetts, 'Bridging the Divide', *Crafts*, 80 May/June 1986, p.51.

28. Patricia Baker, 'The Next Context', *Crafts*, 97, March/April 1989, pp.48–9.

29. Welsh Arts Council, *The House in the Yard: Textiles from the Workshop of Fay Morgan and Roger Oates*, 1978.

30. See Ray Flavell, 'The Role of Colleges of Art and Design', in *Contemporary British Glass*, Crafts Council 1993, p.19.

31. Makers connected with the Glasshouse include Pauline Solven 1970–5; Jane Bruce 1973–9; Steven Newell 1973–84; Dillon Clarke 1970–5; Fleur Tookey 1972–; Annette Meech 1972–; David Taylor 1974– ; Catherine Hough 1980–4; Simon Moore 1982–4; Christopher Williams 1978–.

32. In 1972 Pauline Solven, Jane Bruce, Annette Meech, Steven Newell and Fleur Tookey formed a co-operative to run the Glasshouse. The Limited Company formed in 1976 was given a grant of £10,000 by the Crafts Advisory Committtee to buy equipment backed by an overdraft facility guaranteed by Ravenhead Glass.

33. I am grateful to Annette Meech for information about the Glasshouse. See also Museum of Decorative Art, Copenhagen, *The Glasshouse*, 1982.

34. See 'Cowdy Glass finds a niche in the craft enterprise culture', *The Times*, 8 December 1985.

35. Dan Klein, 'Graal – Taking up the Challenge', *Craftwork*, no. 6, Winter 1984.

36. Rosemary Hill, 'Double Act', *Crafts*, 75, July/August 1985, pp.16–21. For a further collaboration see Margot Coatts, 'Premier Glass', *Crafts*, 100, May/June 1991, pp.22–5. For Wilkin's subsequent career see Edwina Larner, 'A Blow for Independence', *Crafts*, 138, January/February 1996, pp.18–21.

37. See Fiona Adamczewski, 'Glass Magician', *Crafts*, 92, May/June 1988, pp.22–5.

38. See *Contemporary British Glass*, Crafts Council 1993, p.24. For his sensibility see *Techniques of Kiln-formed Glass*, A. & C. Black 1997.

39. *Contemporary British Glass*, Crafts Council 1993, p.25; also see Jeremy Theophilus, 'Diana Hobson: Sources of Inspiration', *Crafts*, November/December 1991, pp.44–7.

40. See Dan Klein, 'Introduction', in *Contemporary British Glass*, Kuala Lumpur 1988; Dan Klein, *Glass: a contemporary art*, Collins, 1989. For a more detailed, accurate account of 'origins' see Pauline Solven, 'Great Britain', in Finn Lynggard (ed.), *The History of Studio Glass – How it all began*, Glass Museum, Ebeltoft, Denmark, forthcoming.

41. Paul du Gay, 'Organising Identity: Entrepreneurial Governance and Public Management', in Stuart Hall, Paul du Gay, *Questions of Cultural Identity*, Sage Publications 1996, pp. 153, 160, 165.

42. Rosemary Hill, 'View from the Top', *Crafts*, 84, January/February 1987, p.13.

43. On some of the background see Alan Powers, 'By George', *Things*, 7, Winter 1997–8, pp.144–50. For a neat chronology of the architecture debate see Gavin Stamp, 'Another Vision of Britain', *The Spectator*, 13 January 1990, pp.8–12.

44. His first article appeared in *Crafts*, 52, September/October 1981, p.52.

45. Peter Fuller, review of 'Textiles North', *Crafts*, 55, March April 1982, pp.49–50.

46. On Design Council taste, see Nigel Whiteley, *Design for Society*, Reaktion Books 1993, pp.163–5.

47. Peter Fuller, 'Should Products be Decorated?', *Design*, 416, August 1983, pp.37–45.

48. Peter Fuller, 'Magic Carpets', *Crafts*, 64, September/October 1983, p.15.

49. Paul Morris, 'Freeing the Spirit of Enterprise', in Russell Keat and Nicholas Abercrombie (eds.), *Enterprise Culture*, Routledge 1991, p.22.

50. For example, 'Letters', *Crafts*, 64, September/October 1983, pp. 8–9 and 'Letters', *Crafts*, 91, March/April 1988, p.11.

51. For Fuller's skewed history of studio pottery see 'The Proper Work of the Potter', in Peter Dormer (ed.), *Fifty Five Pots*, The Orchard Gallery, Londonderry 1983. For the Caro analogy see Fuller's review of 'Fast Forward', *Crafts*, 75, July/August 1985, p.48.

52. Review of 'The Jewellery Project', *Crafts*, 63, July/August 1983, p.46.

53. So too were the 'traditional' earrings which Fuller would mockingly dangle before students to illustrate his point about shared aesthetic values.

54. See Peter Fuller, 'The Necessity of Art Education', in his collection of essays *The Naked Artist*, Writers and Readers Publishing Co-operative Society 1983, pp.21–34.

55. 'Letters', *Crafts*, 88, September/October 1987, p.13.

56. June Freeman, 'In Praise of Quality', *Crafts*, 92, May/June 1988, pp.13–14.

57. See for instance Janet Wolff, *The Social Production of Art*, Macmillan, London 1981.

58. Joanna Banham, 'Subversive Stitch', *Crafts*, 92, May/June 1988, pp.44–5.

59. Pennina Barnett, 'Domestic Hiss', *Crafts*, 54, January/February 1982, pp.18–21.

60. Taped conversation with Ralph Turner, 6 September 1995.

61. Tanya Harrod, 'Jill Crowley', *Ceramic Review*, 114, November/December, 1988, pp.28–31.

62. Elspeth Owen, 'On Being a Potter', *Ceramic Review*, 114, November/December 1988, pp.8–11.

63. Gillian Elinor, Su Richardson, Sue Scott, Angharad Thomas, Kate Walker (eds), *Women and Craft*, Virago Press 1987. For a review see *Crafts*, 91, March/April 1988, pp.53–4.

64. See Akbar's Obituary, *The Times*, 19 March 1997, p.21. Also Janis Jefferies, 'Eastenders?', *Crafts*, 92, May/June 1988, pp.42–3.

65. See John Houston's review in *Crafts*, 106, January/February 1991, pp.52–3.

66. Peter Dormer, 'Comment!' *Crafts*, 69, July/August 1984, pp.12–13.

67. See Rosemary Hill, 'Containing Genius', *Crafts*, 96, January/February, 1989, pp.24–7.

68. Peter Dormer, 'The ideal world of Vermeer's little lace-maker', in John Thackara (ed.), *Design after Modernism: Beyond the Object*, Thames and Hudson 1988, pp.142–3.

69. Peter Dormer, *The Appearance of Craft*, Craft History One, Combined Arts 1988, p.80.

70. See Dormer's marvellous essay 'New Jerusalem and the Domestic Landscape', in *Our Domestic Landscape: Craft and Design for the Home*, Cornerhouse, Manchester 1987.

71. William Rothenstein, *Men and Memories. Recollections of William Rothenstein 1900–1922*, vol. ii, Faber & Faber 1932, pp.274–5.

72. Peter Dormer, 'A Few Degrees Above Zero', *Crafts*, 64, September/October 1983, p.42.

73. Peter Dormer, 'Introduction', in *Jasper Morrison: designs, projects and drawings 1981–1989*, Architecture Design and Technology Press 1990, p.8.

74. Peter Collingwood, 'Treasured Island', *Crafts*, 62, May/June 1983, p. 40.

75. *Crafts*, 91, March/April, 1988, p.15.

76. See Richard Deacon, 'Introduction', in *Jacqui Poncelet: New Ceramics*, Crafts Council 1981.

77. Her career is mapped by John Houston in *Caroline Broadhead: Jewellery in Studio*, Bellew Publishing Ltd/Crafts Council 1990.

78. See Pamela Johnson in *Under Construction: Exploring Process in Contemporary Textiles*, Crafts Council 1996, pp.28–30 and her essay 'Moments of Being', in *The Jerwood Prize for Applied Arts 1997: Textiles*, Crafts Council/Jerwood Foundation 1997.

79. See the discussions in Griselda Pollock and Roszika Parker, *Old Mistresses: Women, Art and Ideology*, Routledge and Kegan Paul 1981, pp.78–9; Pennina Barnett, 'Art or Craft...who decides?', in *Craft Matters: 3 Attitudes to Contemporary Craft*, John Hansard Gallery/West Surrey College of Art and Design, 1985.

80. *Stephanie Bergman – Work on Canvas: dyed and painted* with an introduction by Alison Britton, Crafts Council 1984.

81. *The Hayward Annual 1985: A Journey through Contemporary Art with Nigel Greenwood*, Arts Council of Great Britain 1985, pp.21–2.

82. See Louisa Buck, 'Art Rage', *Crafts*, 97, March/April 1989, pp.38–41.

83. Christopher Reid, *Ewen Henderson: A Retrospective View 1970–1986*, British Crafts Centre, 1986.

84. For the fullest expression of his views see David Whiting, 'Interview with Ewen Henderson', in *Pandora's Box*, Crafts Council 1995, pp.4–7.

85. See Pamela Johnson's essay *Under Construction: Exploring process in contemporary textiles*, Crafts Council 1996 and her article 'Material Culture', *Blueprint*, February 1998.

86. Meg Sweet, 'Kate Russell: textile artist crossing boundaries', *Quilters Review*, no. 11, Summer 1991, p.6. For an example of Maharaj's dazzling writing see his 'Arachne's Genre: Towards Inter-Cultural Studies in Textiles', *Journal of Design History*, vol. 4, no. 2, 1991, pp.75–96.

87. For an account of this binding see Trevor Jones, 'Confessions of an Unrepentant Designer Bookbinder', *The New Bookbinder*, vol. 8, 1988, p.23.

88. 'Recent Bindings', *The New Bookbinder*, vol. 16, 1996, p.72; Margot Coatts, 'Bound to Please', *Crafts*, no. 151, March/April 1998, pp.34–7.

89. Nigel Whiteley, *Design for Society*, Reaktion Books 1993, pp.196–7.

90. See *Blueprint*, no. 100, September 1993 – Special Tenth Anniversary Issue, pp.33–6 and almost any cover of *Blueprint*.

91. Stephen Bayley, *In Good Shape: Style in Industrial Products 1900 to 1960*, Design Council 1979, pp.10–11.

92. For critiques of Bayley's approach see Adrian Forty, *Objects of Desire: Design and Society 1750–1980*, Thames and Hudson 1986, pp.6–10 and Daniel Miller, *Material Culture and Mass Consumption*, Blackwell, Oxford, 1987, p.142.

93. See 'The Conspicuous Consumer', *Blueprint*, December/January 1984/5, p.5.

94. Rosemary Hill, 'Writing about the studio crafts', in Peter Dormer (ed.), *The Culture of Craft*, Manchester University Press 1997, p.195.

95. Barbara Radice, *Memphis: Research, Experiences, Results, Failures and Successes of New Design*, Thames and Hudson 1985.

96. For an interesting reading of Weil's *Small Door* radio of 1986 see Peter Dormer, *The Meanings of Modern Design: Towards the Twenty-First Century*, Thames and Hudson 1990, p.29.

97. Tanya Harrod, 'Aspects', *Crafts*, 57, July/August 1982, pp. 28–31; *Crafts*, 81, July/August 1986, p.9.

98. Wilson & Gough opened in 1989 in Brompton Cross near Knightsbridge and was publicised as a showcase 'for contemporary crafts, steering a course between the art gallery's aridity and the craft shop's clutter'. It only survived a couple of years. See *Crafts*, 79, March/April 1998, p.9.

99. Charles Jencks and Nathan Silver, *Adhocism: The Case for Improvisation*, Secker & Warburg 1972, pp.55, 67.

100. Tim Hilton, *The Pre-Raphaelites*, Thames and Hudson 1970, p.169.

101. A phrase I borrow from Robert Harbison's *Eccentric Spaces*, Secker & Warburg 1989.

102. Derek Jarman, *Dancing Ledge*, Quartet Books 1984, p.121.

103. On Logan and Fields see Terence Malloon, 'Notes on Style in the Seventies.1.Modes of Perceiving', *Artscribe*, no. 12, June 1978, pp.13–16.

104. Jarman, *op.cit.*, p.105.

105. Preface, *Four Rooms*, Arts Council 1984.

106. See Charles Jencks, *Towards a Symbolic Architecture: The Thematic House*, Academy Editions 1985; Stephen Calloway, *Design for Interiors*, V&A 1986, p.28.

107. Terence Malloon, 'Notes on Style in the Seventies 1. Modes of Perceiving', *Artscribe*, no. 12, June 1978, p.15.

108. Michael Thompson, *Rubbish Theory*, Oxford University Press 1979, illuminates these transformative processes.

109. See Deyan Sudjic, *Ron Arad: Restless Furniture*, Fourth Estate/Wordsearch 1989.

110. Jarman, *op.cit.*, p.222.

111. Taped conversation with Ron Arad, 31 January 1993.

112. See Rick Poynor, *Nigel Coates: The City in Motion*, Fourth Estate/Wordsearch 1989. Also see issues of *NATO* magazine, NATO/ Architectural Association 1983–5.

113. See Janet Abrams, 'The Taste of Rust', in *City Steel: Contemporary Metal Furniture*, Crafts Council 1991, pp.3–5, for a typical response.

114. Anthony Sampson, *The Essential Anatomy of Britain: Democracy in Crisis*, Hodder & Stoughton 1992, p.87.

115. Kenneth O. Morgan, *The People's Peace: British History 1945–1989*, Oxford University Press 1990, p.508.

116. Appropriately in 1997 Danny Lane and another salvage baroque figure, Mark Brazier-Jones, made Cruella de Ville's furniture for a scary Disney remake of *101 Dalmatians*. *Crafts*, 145, March/April 1997, pp.35–7.

117. Jonathan Glancey, 'Things that go bump in the night', *Blueprint*, 47, May 1988, p.40.

118. Deyan Sudjic, 'Out of the Wood', *Blueprint*, 71, October 1990, p.38.

119. Liz Farelly, 'The Attraction of Opposites', *Blueprint*, 107, May 1994, pp.34–6.

120. Quoted in Peter Dormer, *The New Furniture: Trends and Traditions*, Thames and Hudson 1987, p.137.

121. Taped conversation with Ralph Turner, 6 September 1995.

122. Quoted in Frederick Gibberd, *Metropolitan Cathedral of Christ the King, Liverpool*, Architectural Press 1968, p.108.

123. See Sandy Nairne, Nicholas Serota (eds.), *British Sculpture in the Twentieth Century*, Whitechapel Art Gallery 1981, pp.28–30.

124. William Tucker, 'Notes on sculpture, public sculpture and patronage', *Studio International*, January 1972, vol. 183, no. 940, p.9.

125. Theo Crosby, 'Unilever House: Towards a New Ornament', *Pentagram Papers* 9, 1984.

126. Ibid.

127. Draft minutes of the 20th meeting of the Crafts Advisory Committee, 29 October 1975 CACM(75)4, Crafts Council archive.

128. Theo Crosby, 'Craft Skills – a discussion paper submitted to the Committee', January 1976, CAC76 1/2, Crafts Council archive.

129. Caroline Pearce-Higgins, *Report on 'Forging Iron' – International Conference and Workshop, Herefordshire Technical College and Ironbridge Gorge Museum 22–8 July 1980*, Crafts Council, October 1980, CC980)4/5, p.5, Crafts Council archive.

130. Theo Crosby, *Let's Build a Monument*, Pentagram Design Ltd 1987, n.p.

131. Michael Sandle, Theo Crosby, Pedro Guedes, *The Battle of Britain Monument*, Pentagram Design Ltd 1987, n.p.

132. See Yves Abrioux, Stephen Bann, *Ian Hamilton Finlay: A Visual Primer*, Reaktion Books 1985, pp.214–19.

133. The four panels were entitled *Presocratic Inscription* and were included in the show *Pastorales*, Galerie Claire Burrus, Paris 1987.

134. Le Corbusier, *The Decorative Art of Today*, The Architectural Press 1987, p.185.

135. Theo Crosby, *Let's Build a Monument*, Pentagram Design Ltd 1987, n.p.

136. 'Demetri Porphyrios House in Kensington', in Andreas Papadakis (ed.), *Prince Charles and the Architecture Debate*, Academy Editions 1989

137. See *Classical Design in the late Twentieth Century: Recent Work of Robert Adam*, Winchester Design 1990.

138. Tim Knox, 'Roderick Gradidge: Sources of Inspiration', *Crafts*, 140, May/June 1996, pp.46–9.

139. For an overview see Papadakis (ed.), *op.cit.*, 1989.

140. See Alan Powers's rather dewy-eyed account of a degree show, 'A Degree of Serenity', *Perspectives on Architecture*, August 1995, p.51.

141. See *The Visual Islamic and Traditional Arts Degree Show*, The Prince of Wales's Institute of Architecture, 1997, p.20.

142. See Emma Clark, 'Keith Critchlow's pioneering work', *Arts and the Islamic World*, no. 24, October 1993, pp.47–50.

143. Ibid., p. 47.

144. 'Office Revival, City of London', *Architectural Review*, 143, May 1992; Bob Maguire, 'Frontis', *RIBA Journal*, July 1992, pp.6–12; Michael Hopkins, 'Technology comes to Town', *RIBA Journal*, May 1992, pp.395–404.

145. Pamela Johnson, 'Quid Pro Quo', *Crafts*, 111, July/August 1991, p.19.

146. CAA Commissioning Service, *Art Means Business*, n.d.

147. Ibid.

148. See Helena Barrett, 'Rooms at the Top', *Crafts*, 89, November/December 1987, pp.44–5.

149. Jan Cummings, 'Esprit de Corps', *Crafts*, 68, May/June 1984, pp.16–19.

150. Richard Weston, 'The Education of Architects', in *The Arts Business*, Summer 1990, Southern Arts, p.36.

151. On the art, but not the craft, in the Garden Festivals see Sara Selwood, 'Public Art, Private Amenities', *Art Monthly*, February 1991. On Gateshead see *Crafts*, 104, May/June 1990, p.11; Stephanie Brown, 'Hothouse Hybrids', *Crafts*, 105, July/August 1990, pp.38–41; and *Festival Landmarks: Art, Craft, Poetry and Performance Art at the National Garden Festival, Gateshead*, NGF '90, 1990.

152. Malcolm Miles, *Art for Public Places: Critical Essays*, Winchester School of Art Press, Winchester, Hampshire, 1989, p.153.

153. 'The Arts Business', *Southern Arts*, Summer 1990, p.7.

154. Charles Jencks, *The Language of Post-Modern Architecture*, (1976) Academy Editions 1977, p.9.

155. For the background see Gervase Webb, 'It's time to pull down those iron gates Tony', *Evening Standard*, 12 June 1997, p.12.

156. For a detailed account of blacksmithing in the 1980s see Amina Chatwin, *Into the New Iron Age: Modern British Blacksmiths*, Coach House Publishing, Cheltenham 1995.

157. Deanna Petherbridge (ed.), *Art for Architecture*, HMSO 1987, pp.41–3.

158. See *Broadgate Visitor's Guide*, Broadgate Estates plc, Autumn 1991; Callum Murray, 'The Art of Development', *Architects' Journal*, 24 October 1990, pp.25–8; Richard Cork, 'Open Season', *The Listener*, 20–7 December 1990.

159. For a review of the conference see Amber Hiscott, *Crafts*, 81, July/August 1986, p.8.

160. On Clarke see Martin Harrison, 'Eloquence from Intractability', in *Brian Clarke Architectural Artist*, Academy Editions 1994; Rick Poynor, 'Master of the Matrix', *Blueprint*, April, no. 66, 1990, pp.32–5.

161. In Brian Clarke (ed.), *Architectural Stained Glass*, John Murray 1979, p.11.

162. See Martin Harrison in Ann Compton (ed.), *John Piper; painting in coloured light*, Kettle's Yard Gallery, Cambridge 1983.

163. For an alternative view see Margot Coatts, 'Holy Order', *Crafts*, November/December 1991, pp.23–5 and Dean and Chapter of Lichfield Cathedral, *The Lichfield Silver*, 1991.

164. Peter Wylde, 'Forging a Head-shrine', *British Blacksmith*, no. 46, December 1987, p.11.

165. See Peter Dormer's fascinating account of an attempt to learn calligraphy in *The Art of the Maker*, Thames and Hudson 1994, pp.40–57.

166. See Richard Kindersley and Martin Jennings, 'The Letterers are willing', *Crafts*, 56, May/June 1982, pp.14–15 and Kindersley's contribution to Mitzi Sims, *Sign Design: Graphics Materials Techniques*, Thames and Hudson 1991, pp.158–61.

167. See Brenda Berman and Annet Stirling, 'Touching the Stone', in Harrod, *Conference*, pp.403–7.

168. Robin Kinross, *Modern Typography*, Hyphen Press, 1992, pp.137–8.

169. See Michael Harvey, 'Digital Lettering', *The Scribe: the Journal of Scribes and Illuminators*, Summer 1996, no. 67, pp.3–6.

170. I must thank Ewan Clayton for a useful conversation on these matters. See also his exhibition *Codes and Messages: Lettering Today*, Crafts Council 1995. For further thoughts on computers and handlettering see David M. Levy, 'Reflections on Documents, Computers and the Crafts of Calligraphy', *The Scribe: the Journal of the Society of Scribes and Illuminators*, Summer 1994, no. 61, pp.3–8, and Brody Neuenschwander, *Letterwork: Creative Letterforms in Graphic Design*, Phaidon 1993.

171. Phil Nacnaughten, John Urry, *Contested Natures*, Sage 1998, p.49.

172. Anna Bramwell, *Ecology in the 20th Century: A History*, Yale University Press 1989, pp.228–9.

173. See Phil Macnaghten and John Urry, *Contested Natures*, Sage Publications 1998, p.56.

174. *Crafts*, 81, July/August 1986, p.1.

175. Quoted in Roger Coleman, *By Accident or Design? The 1992 Kelmscott Lecture*, William Morris Society 1996.

176. Alan Evans, 'The Dissident Workshop', in Harrod, *Conference*, p.409.

177. See Peter Dormer, 'The Alternative Bough House', *Crafts*, 113 November/December 1991, pp.26–9.

178. 'Hooke Park tries new balancing act', *Design Week*, 11 December 1992, p. 9.

179. 'In the Eye of the Crafts', *Crafts*, 61, March/April 1983, p.44.

180. *David Drew: Baskets*, Crafts Council, 1986.

181. Lois Walpole, 'Urban Basket Maker', *Crafts*, 68, May/June 1984, p.20.

182. See Mary Butcher, 'Eel-traps without eels', *Journal of Design History*, vol. 10, no. 4, 1997, pp.417–29. This article looks at Drew's basketry in the context of traps and snares. Drew disputes its title, pointing out that he *does* catch eels in his traps – as well as on occasion exhibiting them.

183. *Crafts*, 90, January/February 1988, p.54.

184. Rosemary Hill, 'Friends of the Earth', *Crafts*, 100, September/October 1989, pp.42–5.

185. Rosemary Hill, 'Outlook', *Crafts*, 81, July/August 1986, p. 15.

186. Richard Wilding, *Supporting the Arts. A Review of the Structure of Arts Funding*. Presented to the Minister for the Arts September 1989, p.71.

187. See Crafts Council Minutes 1 November 1989 CCM(89)3, pp.2–5, Crafts Council archive.

188. For instance Tanya Harrod, 'Mindless Merger', *The Spectator*, 28 October 1989, pp.44–7; William Packer, 'Artists and Craftsmen Out in the Cold', *Financial Times*, 21 October 1989; Georgie Greig, 'Crafts Council to be Closed', *The Sunday Times*, 17 September 1989.

189. Design Council Annual Review, 1996, p.30.

190. See Christopher Lorenz, 'The Design Council on a Crash Diet', *Financial Times*, 24 September 1993; John Sorrell, 'Steering into Clearer Water', *Design*, Spring 1995.

191. *Designing to compete: how design can make companies more competitive*, Design Council Red Paper 1, April 1998, p.40.

192. See Tony Ford, Revision of the Corporate Plan September 1990, CC(90)4/3, Crafts Council archive.